THE VICTORIAN VISION

George Elgar Hicks,
The General Post Office,
One Minute to Six. Detail.
Oil on canvas, 1860.
Museum of London.

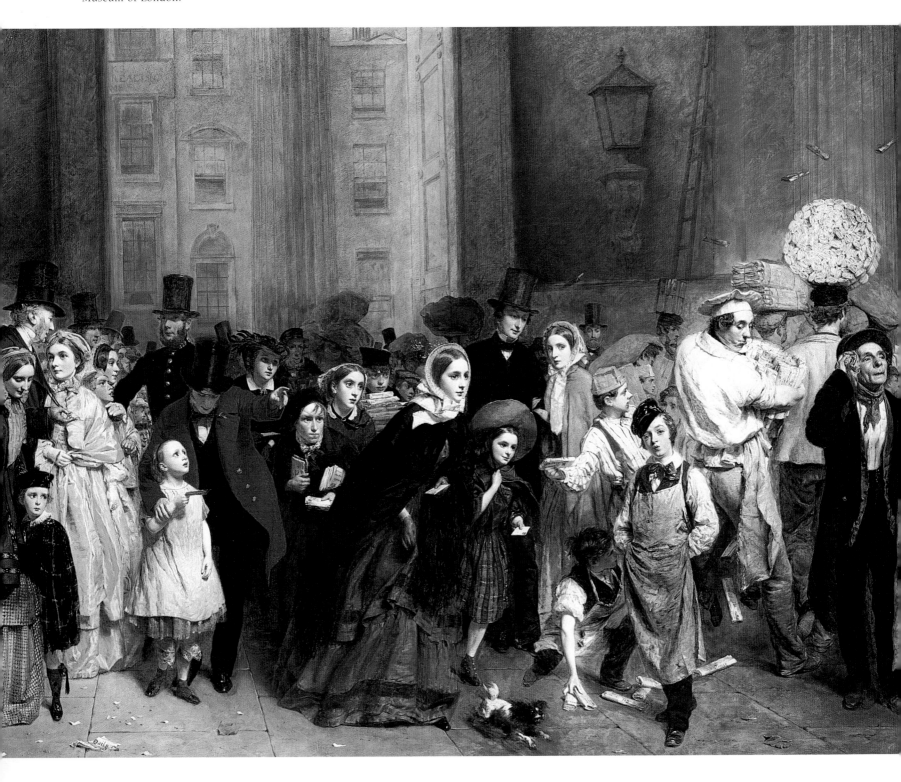

THE VICTORIAN VISION

INVENTING NEW BRITAIN

EDITED BY

JOHN M. MACKENZIE

V&A Publications

First published by V&A Publications, 2001

V&A Publications
160 Brompton Road
London SW3 1HW

Designed by Janet James

ISBN 1851773274

A catalogue record for this book is available from the British Library

Colour separation in Italy by Colorlito, Milan
Printed and bound in Italy by Artegrafica SpA, Verona

Every effort has been made to seek permission to reproduce those images whose copyright
does not reside with the V&A, and we are grateful to the individuals and institutions that
have assisted in this task. Any omissions are entirely unintentional and details should
be addressed to the Publishers. *Note*: The National Army Museum is seeking information
about Georges C. Scott, painter of *Crossing the Tugela Bridge Under Fire* (plate 227)

Jacket illustrations:
FRONT: *Imperial Federation Map of the World* (see plate 228)
BACK: *St Paul's and Ludgate Hill* (see plate 156)

V&A Publications
160 Brompton Road
London SW3 1HW
www.vam.ac.uk

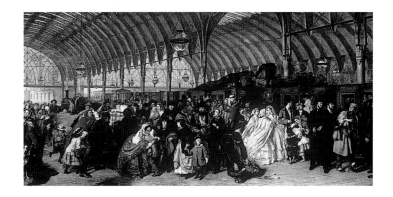

CONTENTS

LIST OF CONTRIBUTORS

JOHN M. MACKENZIE is Professor of Imperial History at Lancaster University. He has written widely on the culture of imperialism, including *Propaganda and Empire* (1984) and *The Empire of Nature* (1988). He is consultant curator of Inventing New Britain: The Victorian Vision (V&A, 2001) and is co-organiser of the major conference on the Victorians taking place in South Kensington in the same year.

PAUL ATTERBURY is a specialist in nineteenth- and twentieth-century art and design, with an interest in the history of technology. He was the curator of the V&A's Pugin: A Gothic Passion in 1994, and is co-curator of Inventing New Britain: The Victorian Vision (V&A, 2001). Publications include *Victorians at Home and Abroad* (V&A Publications, 2001).

TIM BARRINGER is Assistant Professor in the Department of the History of Art, Yale University. He has published widely on nineteenth-century visual culture and is the author of *The Pre-Raphaelites: Reading the Image* (1998). He is the editor (with Tom Flynn) of *Colonialism and the Object: Empire, Material Culture and the Museum* (1998).

ANTHONY BURTON, now Senior Research Fellow in Museology and Museum History in the Research Department of the V&A, was from 1981 to 1997 Head of the Bethnal Green Museum of Childhood, a branch of the V&A. His book *Children's Pleasures* (V&A Publications, 1996) bases its wide view of the history of childhood on the museum's collections of books, toys and costume.

SUZANNE FAGENCE COOPER is a Research Fellow at the V&A and a lecturer in the Faculty of Design at Buckinghamshire Chilterns University College, with a particular interest in images of music in the Victorian visual arts. She is co-curator of Inventing New Britain: The Victorian Vision (V&A, 2001), author of *The Victorian Woman* (V&A Publications, 2001) and co-author of *Victorians at Home and Abroad* (V&A Publications, 2001).

PAUL GREENHALGH is Head of Research at the V&A. He was formerly a tutor at the Royal College of Art and Head of Art History at Camberwell College of Arts. He has published widely on British and European visual culture post-1840, including *Ephemeral Vistas* (1988), *Modernism in Design* (1990), *Quotations and Sources on Design and the Decorative Arts* (1993) and *Art Nouveau, 1890–1914* (V&A Publications, 2000), published to accompany the major exhibition at the V&A of the same title.

ANNA JACKSON is an Assistant Curator in the Far Eastern Department at the V&A. Her research interests include the relationship between East Asia and Europe in the nineteenth and early twentieth centuries. She is also responsible for the Museum's collection of Japanese textiles and dress, and is the author of *Japanese Country Textiles* (V&A Publications, 1997) and *Japanese Textiles in the Victoria and Albert Museum* (V&A Publications, 2000).

JAN MARSH is the author of *The Pre-Raphaelite Sisterhood* (1985) and biographies of Dante Gabriel and Christina Rosetti. She has written widely on gender and society in the nineteenth century. She is currently Visiting Professor at Humanities Research Centre, University of Sussex, and working on Victorian representations of ethnicity.

DELIA MILLAR has been working on the nineteenth-century watercolours in the Royal Collection since 1977, and published the definitive catalogue of *The Victorian Watercolours and Drawings in the Collection of Her Majesty the Queen* in 1995. She also wrote the catalogue for the exhibition, Views of Germany from the Royal Collection, held at Coburg (1998), Berlin (1999) and Edinburgh (2000). Her other works include *Queen Victoria's Life in the Scottish Highlands* (1985). She is married to Sir Oliver Millar, Surveyor Emeritus of the Queen's Pictures.

HARRIET RITVO is Arthur J. Conner Professor of History at the Massachusetts Institute of Technology. She is the author of *The Animal Estate: The English and Other Creatures in the Victorian Age* (1987) and *The Platypus and the Mermaid, and Other Figments of the Classifying Imagination* (1997).

JAMES RYAN is Lecturer in Human Geography at the Queen's University of Belfast, Northern Ireland. He is author of *Picturing Empire: Photography and the Visualization of the British Empire* (1997) and co-editor (with Joan M. Shwarz) of *Picturing Place: Photography and the Geographical Imagination* (2000).

JONATHAN SWEET is an art and design historian and museum curator. He has worked at the V&A, the National Gallery of Victoria, Melbourne, and in the Museum Studies unit of Deakin University, Burwood, Victoria. He has researched colonial exhibition design and representation extensively and was a contributor to the Royal Ontario Museum publication *Victorian: The Style of Empire* (1996).

ROBERT THORNE is a Senior Associate of Alan Baxter & Associates (architects) and a Visiting Professor at the School of Architecture, Liverpool University. He is the author of books and articles on nineteenth-century industrial and commercial buildings, and also edits the journal *Construction History*.

JOHN K. WALTON is Professor of Social History at the University of Central Lancashire, Preston. He is the author of numerous works on the Victorian period. His most recent book is *The British Seaside: Holidays and Resorts in the Twentieth Century* (2000).

FOREWORD

How we describe and interpret the Victorians reveals as much about ourselves as about them. We now take them seriously: we once did not. This fascinating book, published to accompany a major exhibition, leads us back into a time not all that distant from our own, but separated from us by great divides. It both records and evokes the Victorian past through pictures as well as words, and it is a pleasure to write a brief foreword to it. The text and pictures, clearly integrated, speak for themselves as does a great exhibition, an event the Victorians themselves loved.

You can start in any chapter, as you can start in any place in an exhibition, and get entangled at once in what is now called 'the Victorian experience'. Yet it is important to remember that there was not one standard Victorian to experience it. The contrasts between class and class were as obvious as the contrasts between past and present, which interested the Victorians just as much; and there were contrasts too between periods within the long reign of Queen Victoria, which were often as strong as the contrasts between the Victorian experience and that of their predecessors and successors. The experiences of men and women were very different too.

We are probably more visually aware at the beginning of the twenty first century than the Victorians were, but less sensitive to words, and to me the words that the Victorians used – many of them newly coined – remain as revealing as the images. The Victorians were always looking for 'signs of the times'. We inherit from them large parts of our vocabulary and many of our metaphors, a large number of them derived from the railways. We inherit a wide range of buildings and, above all, an impressive material infrastructure, much of it underground.

I started my reading of this book with chapter six, on industry, transport and communications, sensing that these offer keys both to Victorian language and to the Victorian experience. Time speeded up. So did contact with 'strangers' and a sense of the world. In telling a story clearly this chapter also poses questions about values as well as about facts. The term 'Victorian values' has often been used with too little thought and, above all, too little knowledge to inspire confidence. After reading this book, beginning perhaps with chapter five on 'Religion and Doubt', values would seem the right word; while John MacKenzie in his introduction identifies another key word, 'visions'.

The death of the aged queen in January 1901 was a far more significant event to her British and imperials subjects – and to many others too – than the end of the nineteenth and the beginning of the twentieth century. There was doubt in 1900 as to when the old century ended and the new one began, but there was no doubt whatever about the importance of the queen's death, which seemed to many contemporaries to mark the end of an 'epoch'.

It still remains useful for historians to divide the reign into parts, usually three – early, middle and late – but the continuities and discontinuities meant different things to different generations. For those alive when Queen Victoria died, there were private as well as public landmarks in the years behind them. We start our own exploration in this book with the queen, whose private landmark was the death of her husband, Albert, the Prince Consort, in 1861. The sense of personal loss she felt then was greater than the sense of collective loss – the same word was used – that was felt by most of her subjects (a revealing word), in 1901.

The book and the exhibition will inevitably draw attention to the relationships between the public and the private, the old and the young (including children), and tradition and innovation. It is entirely fitting that the place where the exhibition is being held is called the Victoria and Albert Museum.

ASA BRIGGS

INTRODUCTION

JOHN M. MACKENZIE

The Victorians were a people of visions. Their visions were partly inspired by the immense social problems they inherited from their predecessors and, additionally, created for themselves. They were also influenced by the intellectual ferment of their age; by the political turmoil of Europe; by the technological advances that gave them a sense of riding a tiger of progress; and by a new awareness of the wider world in which they were set (plate 1). Their visions ranged from those of the Chartists of the 1840s, who envisaged a parliamentary system not unlike our own (with the exception of women's suffrage), to those who saw heroes and strong men as providing the only solution to the problems of leading society. They embraced those who ransacked the past for inspiration for a new architecture and art appropriate to a modern age, and those who were convinced of the elevating and progressive effects of a modern science and technology. They also stretched from those who clung to a liberal individualism to those who increasingly regarded collectivism as providing the only solution to social problems. They inherited the continuing controversy of parliamentary reform, unpopular poor laws, religious toleration and debates about the redemptive power of reforming legislation. They argued unceasingly about the appropriateness of trade unions; about the structure of society and the tensions between stasis and fluidity; about the potential for feminine emancipation and female suffrage; about education and sport; about the need for reform in the military and the navy; and about the problems of race and imperialism.

They almost always placed these debates and visions within a global context. They felt themselves to be the first generations who could truly embrace the world, travel freely within it, dominate it, classify it, visualise it, think about it and ultimately, transform it. Their art, architecture and design were also filled with that wider awareness, with a strange mix of a very real sense of superiority with a desire to learn from other spiritual and artistic traditions. Whereas Europeans in previous centuries had often fantasised about the rest of the world and had expressed those fantasies in art and design (like the celebrated craze for chinoiserie in the eighteenth century), the Victorians thought that they could encounter, influence and benefit from the reality, a reality unveiled by the possibilities of their technology and their power. For subsequent generations in the twentieth century it seemed that they were simply indulging in different forms of fantasy.

This book, and the exhibition which it accompanies, sets out to examine these wider preoccupations of the Victorians. British history, including the histories of art and design, has often been far too introspective. There was scarcely a single development of the Victorian age which was not powerfully influenced by the global context in which the Victorians operated. It was an interactive time, a period of conquest and aggrandisement certainly, but also an era of mutual modification and transformation for both Europeans and peoples across the world. The arrogance of power was often tempered by assimilative processes, hybridities resulting from

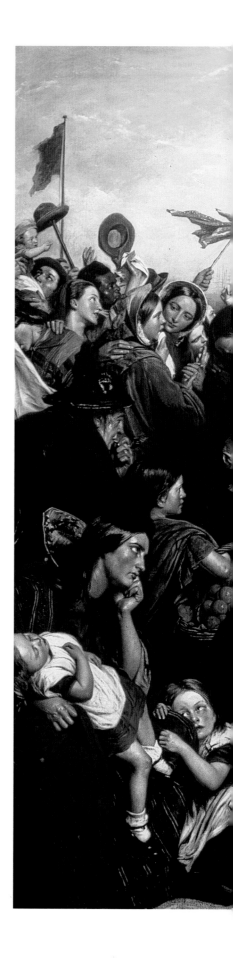

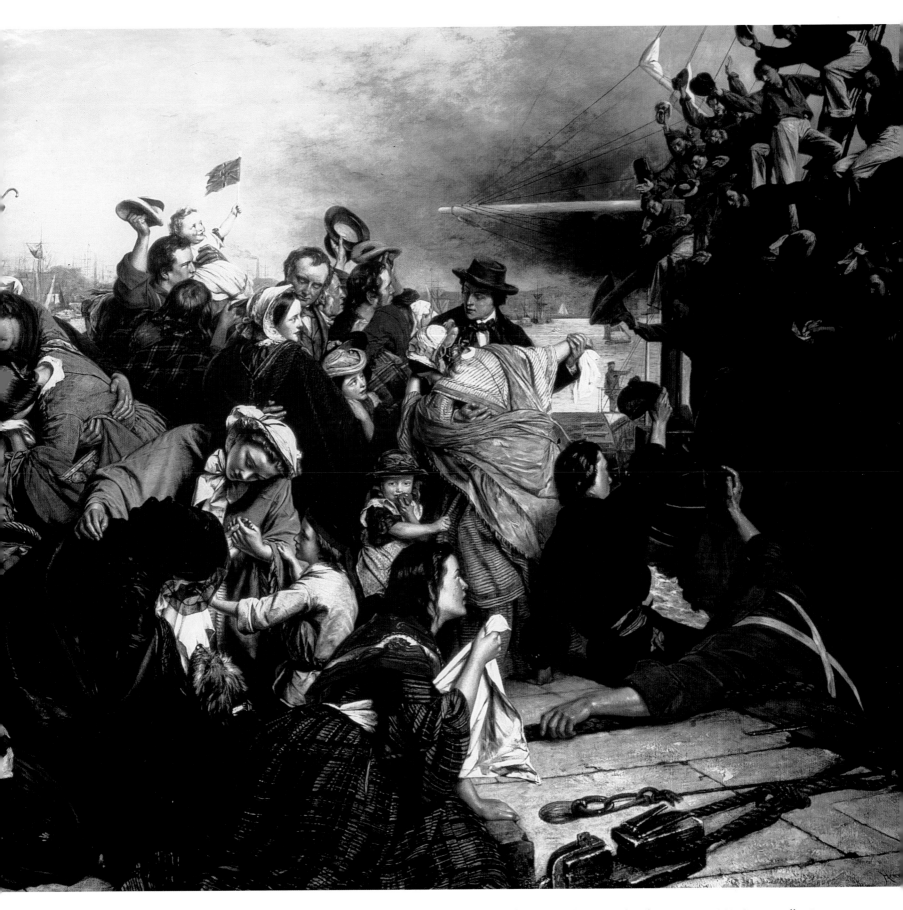

1 Henry Nelson O'Neil, *The Parting Cheer*. Detail. Oil on canvas, 1861. Private collection.

fascinations with other traditions. The extraordinary queen who gave her name to the era was fully alert to these developments, even though she never travelled outside Europe. She herself adopted a global vision and, despite the limitations of her education, she knew and corresponded with many of the prophets and visionaries of her time. She has given her name to the supposedly dominant values of her age, even though her relationship with some of them was somewhat ambiguous.

Victorian visions embraced a renewed evangelical religiosity, a reformed society imbued with ideals of hard work, temperance, thrift and adherence to duty. They promoted a civic pride which would supply fresh water, public medical services, cheap transport and energy that would banish misery, malnutrition and disease. Some looked to the recreation of craftsmanship to restore the dignity of labour and ameliorate the soullessness of the factory system. Victorians also yearned for the application of morality to art and diplomacy, a programme that would ultimately reform the world, banishing slavery and war, spreading the virtues of their own civilisation, together with a modern cargo of manufactured goods, science, technology and medicine, to the entire globe. But their conviction in their own superiority led them to formulate racial ideas which have been deeply repugnant to subsequent generations.

Inevitably, some of these visions were mutually contradictory. It was characteristic of the age that each was represented by prophets or visionaries who were revered or reviled, sometimes in equal measure. John Bright (1811–89) was the prophet of free trade, an economic policy that he viewed as so elevating that it would lead to peace and understanding across the world. Commerce and community were thus intertwined. Yet Bright rejected other aspects of a radical programme. David Livingstone (1813–73) popularised another conjunction of commerce, with Christianity and consequently with civilisation. He became the leading prophet of the Victorian view of the enlightening effects of exploration, of missionary endeavour combined with the practical life and of slave trade abolition, the 'running sore' of the world. He also attempted one of the holy grails of the Victorian period, the reconciliation of science and religion. In 1857, for example, on his celebrated visit to Cambridge, he was hailed by some of the great scientists of the age as a notable scientist, as well as a missionary doctor and explorer.[1]

John Ruskin (1819–1900), whose life was almost exactly coterminous with that of Queen Victoria herself, was the prophet of a moral approach to art combined with a revival of the Gothic, of the potential for a union of science, nature and spirituality, of the elevation of the worker through crafts, good taste and an escape from industrialism. For some commentators he is a forerunner of modern ecological ideas. His anxiety about the social and environmental pollution of the factory system led him to remark that the British Empire, on which the sun never set, might become an empire on which the sun never rose. His ideas influenced William Morris and many others in Britain, the Empire and overseas. Marcel Proust, Leo Tolstoy and Mahatma Gandhi all proclaimed a considerable debt to his thinking.[2]

Samuel Smiles (1812–1904), like Livingstone a Scots doctor, became the prophet of all the virtues most associated with the Victorian age, technological progress (he wrote about the lives of the engineers), the gospel of work, character, thrift and duty (the latter three all titles of books). His most famous work was *Self-Help*, first published in 1859. Like Livingstone's

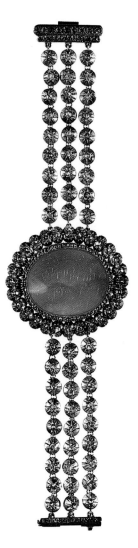

2 Diamond bracelet presented to Florence Nightingale.
National Army Museum.

Missionary Travels and Researches of 1857, it was an extraordinary best-seller, selling more than a quarter of a million copies in the nineteenth century. Conceived in the new tradition of the success manual, it illustrated the manner in which individual advancement, regardless of social origins, could be achieved through energy, drive and character. Many of the figures celebrated by Smiles had created their success in imperial exploits. The Empire became the standard location for heroism, professional advancement, and commercial and military success. The book was translated into many languages and, intriguingly, was particularly influential in Japan. It was the favourite reading matter in the libraries of Mechanics' Institutes and similar organisations in Britain and everywhere from British Columbia to New Zealand.[3]

The Victorians produced women visionaries too. Florence Nightingale (1820–1910; plates 2 and 3), born a year after the queen, was the prophet of nursing care, of army medical reform, sanitation and hospital building, endlessly campaigning and pressurising politicians from her

3 Jerry Barrett, *The Mission of Mercy: Florence Nightingale Receiving the Wounded at Scutari*. Oil on canvas, 1857. By courtesy of the National Portrait Gallery, London.

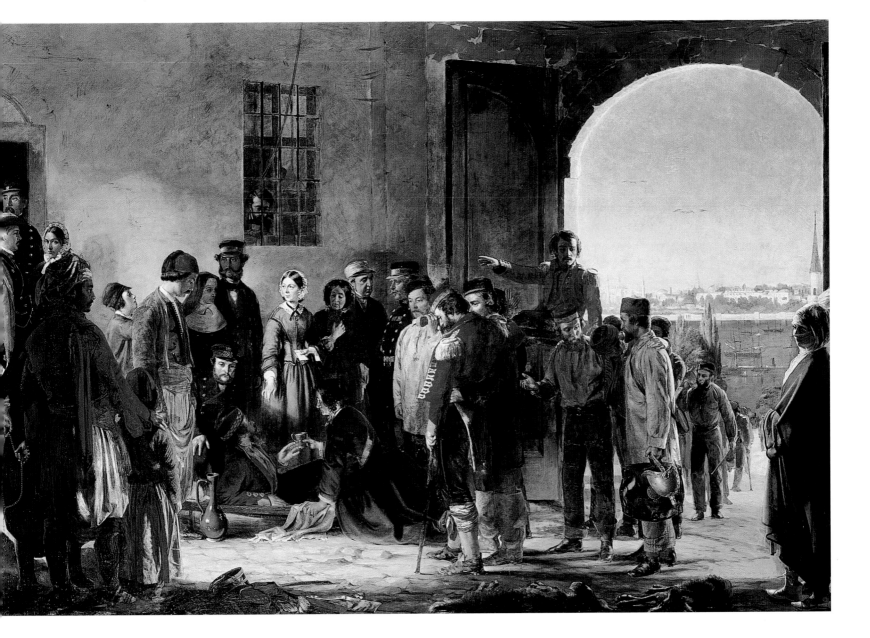

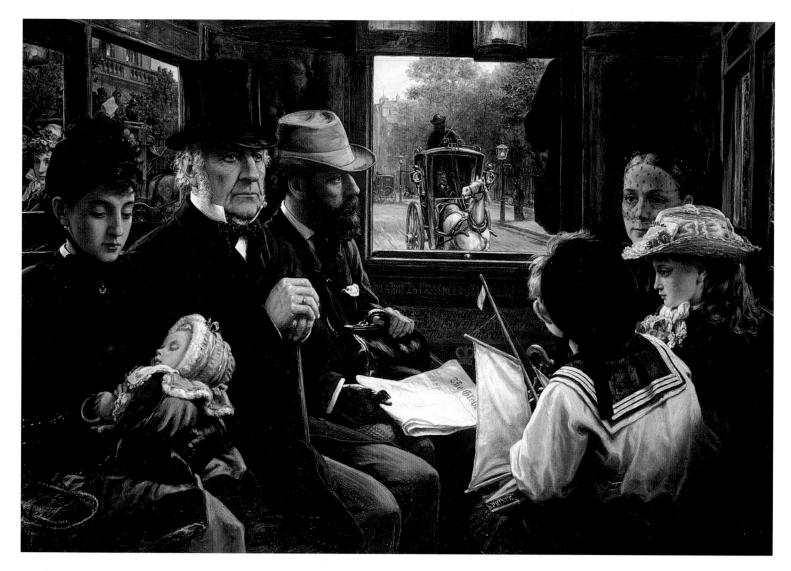

sick-bed. Perhaps the most influential woman of the age, apart from the queen herself, she was the first to be granted the Order of Merit (by Victoria's son, Edward VII). Angela, Lady Burdett-Coutts (1814–1906), was the prophet of philanthropy, distributing her vast wealth to causes, religious, educational, social and agricultural, which attracted her. She demonstrated to Victorian women the opportunities for influence which philanthropy and 'good causes' offered. She was also the first woman to become a baroness in her own right (in 1871).

This list of Victorian prophets and visionaries could embrace many other figures, like John Stuart Mill (1806–73), Matthew Arnold (1822–88), Henry Cole (1808–82), Edwin Chadwick (1800–90), Isambard Kingdom Brunel (1806–59), Harriet Martineau (1802–76), William Morris (1834–96), James Clerk Maxwell (1831–79), Joseph Lister (1827–1912), even those famously antithetical politicians, Benjamin Disraeli (1804–81) and William Ewart Gladstone (1809–98; plate 4). What is striking is that almost all of these figures rooted their ideas and their actions in a conglomerate cultural soil that included belief in, or at least lip-service to, evangelicalism, a sense of technological superiority, confidence in the potential for benign change and a conviction of the need to think on a world scale. If the Victorians developed, in the electric telegraph, the

4 Alfred Morgan, *An Omnibus Ride to Piccadilly Circus – Mr Gladstone Travelling with Ordinary Passengers*. Oil on canvas, 1885. Christie's Images, London/Bridgeman Art Library.

world's first internet, they can also be seen as the originators of globalisation, an attempted systematic mastery of all aspects of the world, not least the visual globalisation of photography. They were the progenitors, in however embryonic forms, of many of the characteristics of the late twentieth and early twenty-first centuries. Surprisingly, the queen herself was emblematic of much of this.

Few would regard Queen Victoria as a 'modern' figure and yet there are intriguingly modern elements to her complex make-up. Victoria was not the simple, solemn and severe person conveyed by photographs, portraits and statuary. She represented a curious personal blend of the eighteenth and the nineteenth centuries. She has been credited with saving the monarchy after the reigns of her uncles, George IV and William IV, particularly as she stood in the way of other potential successors such as the Duke of Cumberland. She has also been credited, under the influence of Prince Albert (plate 5), with turning the monarchy into a bourgeois institution, thus bringing it into tune with the dominant class of her age. She supposedly redefined and dignified the monarchy, distancing it from aristocratic pretension and overblown triumphalism, taking it closer to the people in the process.[4]

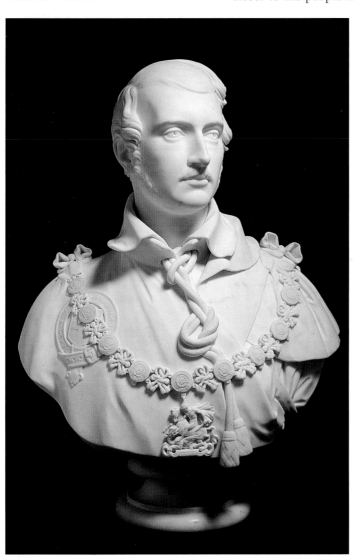

5 Edward Hodges Bailly, *Albert, Prince Consort.* Marble, 1841. V&A: A.34–1964.

Yet all of these views are simplifications. As a young woman, Victoria loved parties, enjoyed the gaiety of the season and stayed up half the night. Despite the problems of her childhood she was invariably full of life and laughter. It was Albert who introduced a new sobriety to her, symbolised by their habit of going to bed early and their intense attention to duty.[5] Yet something of the mischievous young woman stayed with her all her life, re-emerging after her long period of profuse mourning for the Prince Consort. Despite the visage that she formally presented to the world, it is known that she smiled and laughed a lot. She sang well and danced expertly. As Lady Millar describes in the next chapter, she liked to sketch and paint; she greatly enjoyed the theatre and music.[6] Felix Mendelssohn considered them both to be quite musically accomplished. After Albert's death, the queen denied herself the pleasures of the theatre, but she continued to enjoy music. From 1887 command performances took place at Windsor and elsewhere. She loved the Savoy operas of Gilbert and Sullivan and had *The Gondoliers* performed at Windsor and *The Mikado* at Balmoral. She was seen to sing along with the numbers and probably knew the operettas from sheet music versions. She established a warm relationship with Sir Arthur Sullivan and greatly approved of his musical contributions to the Jubilees and to such events as the opening of the Colonial and Indian Exhibition in 1886.[7]

Queen Victoria was fascinated by the past and, with Albert, she set herself into a Saxon and medieval ethnic tradition. She liked a drink and, despite the temperance movements of her age, she never seems to have objected to heavy drinking at her court. She enjoyed a whisky with

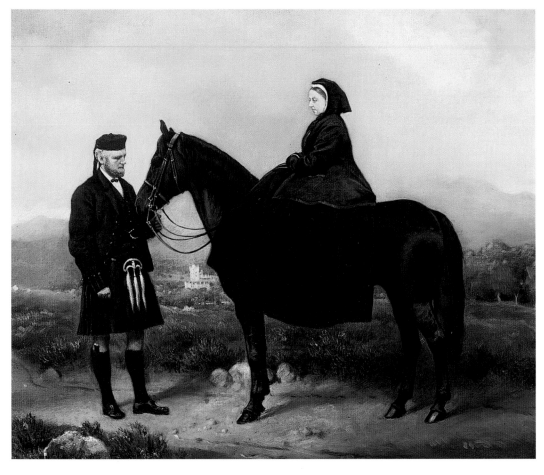

6 Charles Burton Barber, *Queen Victoria Seated on 'Florrie', John Brown in Attendance, Balmoral in the Distance*. Oil on canvas, date unknown. The Forbes Magazine Collection, New York.

her bibulous friend John Brown. The queen was highly emotional, suffering what we would now call dramatic mood swings; she was headstrong, stubborn, flighty one might almost say. She was a sensual person, who took some pleasure in sex, and was highly susceptible to male charms, not only in her marriage with Albert, but also in her relationships with Lord Melbourne, Benjamin Disraeli and the ghillie John Brown (plate 6). (Early in her reign she was known as Mrs Melbourne; later as Mrs Brown.) Although no radical, and fully aware of the significance of the class system in maintaining order, the queen had a genuine feeling for at least the respectable working classes, the common soldiery and the various peoples of her far-flung empire. Her vast correspondence reveals her to have been free of racist attitudes or comments.

The queen was also a woman of affairs. Starting her reign as a Whig, she ended it as a Tory imperialist. She had opinions on almost everything; she attempted to influence the composition of governments, taking a particularly intense interest in foreign affairs and reading, and sometimes influencing the drafting of many Foreign Office despatches. She had pronounced views on European diplomacy, always favouring, for example, the Ottoman Empire over Russia. Victoria followed imperial affairs very closely and was greatly interested in, and sometimes distressed by, what was carried out in her name throughout the world. Yet she was thoroughly opposed to any imperial retreat. For example, after the death of General Gordon in Khartoum in January 1885 (plate 7), she insisted, vainly as it turned out, that the British should not withdraw from the Sudan.[8]

7 G. W. Joy, *General Gordon's Last Stand*. Detail. Oil on canvas, c.1893. Leeds Museums and Galleries (City Art Gallery). G. W. Joy's painting of the death of General Gordon in Khartoum, exhibited at the Royal Academy in 1893, became a celebrated 'tableau vivant' and has been reproduced in modern films. It almost certainly bears no relation to reality. General Gordon was probably cut down in the streets of Khartoum and would not have been clothed in full-dress uniform.

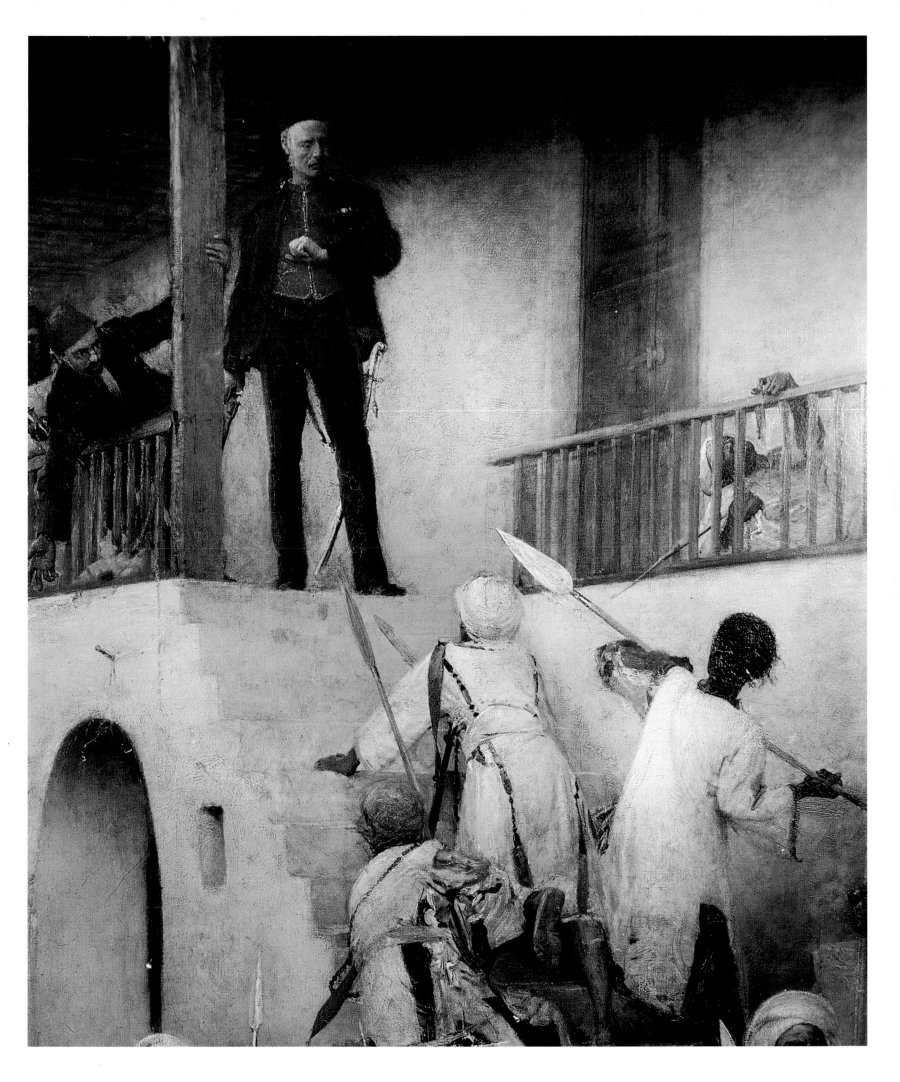

QUEEN VICTORIA AND
THE REINVENTION OF CHIVALRY

Medieval chivalry was fully rediscovered in the Victorian age. Together with Gothic architecture, chivalry seemed to offer a romantic image of a secure, socially cohesive and visually appealing past. The queen was intrigued by the Eglinton Tournament, a pseudo-medieval event held in 1839 at Eglinton Castle, Ayrshire, by its owner, the Earl of Eglinton. From 1840 Prince Albert brought German visions of romantic chivalry to the British court. The Bal Costumé or fancy-dress ball of May 1842, with two thousand guests, was described as a 'scene of such brilliance and magnificence as had not been seen since the days of Charles II'. Prince Albert and Victoria were dressed as Edward III and Queen Philippa. Landseer painted the couple in their costumes and the queen also sketched them. Lavish souvenirs were printed. Other guests also attended in elaborate medieval costumes. Albert was subsequently painted in medieval armour and Victoria as a medieval damsel, both in miniatures. Copies of these were set into a jewel casket made by Elkington & Co. and exhibited at the Great Exhibition of 1851. Chivalric themes were pursued in subsequent paintings, artefacts (such as a christening cup), and funerary monuments for Prince Albert and the Duke of Clarence.

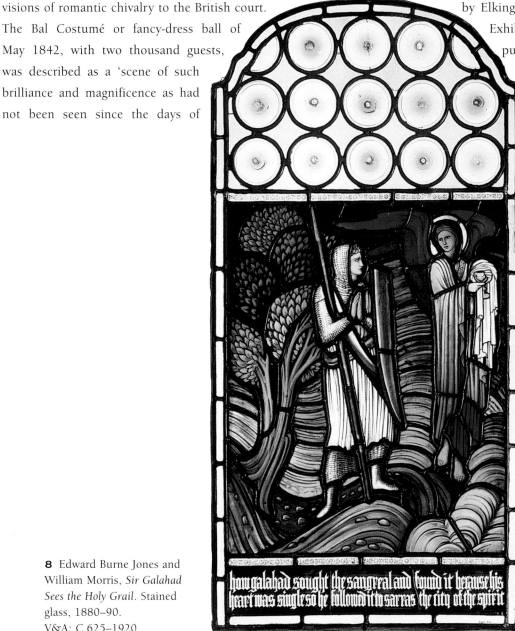

8 Edward Burne Jones and William Morris, *Sir Galahad Sees the Holy Grail*. Stained glass, 1880–90. V&A: C.625–1920.

9 Edward Onslow Ford, *St George and the Dragon*. Bronze and mixed media, 1850. National Museums and Galleries on Merseyside.

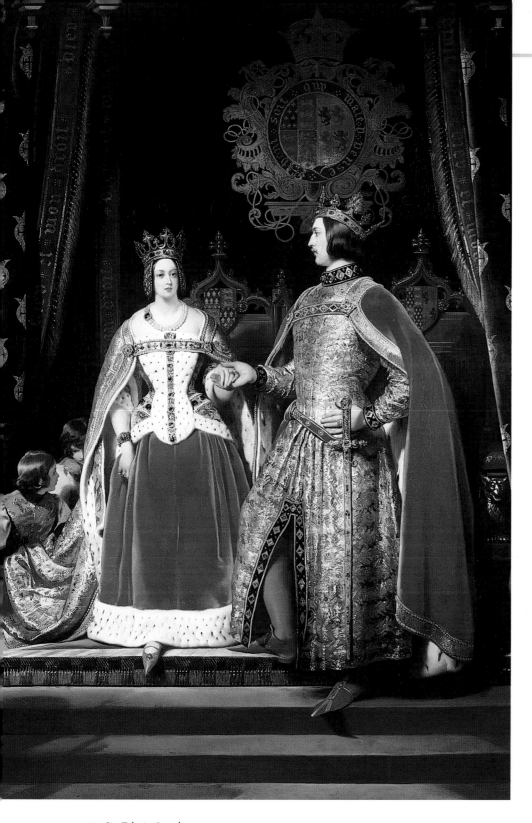

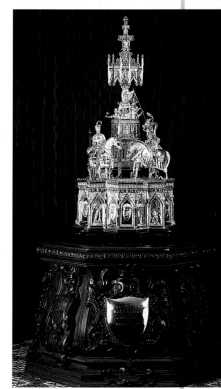

11 Eglinton Trophy. Silver, 1839. Designed by Charles Sykes for R.S. Garrard, London. Cunninghame District Council.

12 Edward Corbauld, *Archibald, Earl of Eglinton, Dressed for the Tournament*. Oil on canvas, 1840. V&A: P.5–1981.

10 Sir Edwin Landseer, *Queen Victoria and Prince Albert at the Bal Costumé of 12 May 1842*. Detail. Oil on canvas, 1842. The Royal Collection © HM Queen Elizabeth II.

Together with Albert, Victoria emphasised and lent credence to many of the cultural traits of the age. She occupied houses, Osborne and Balmoral, that were supposed to be in tune with their surroundings and their climates, respectively coolly Italianate and Scots baronial. She developed a cult of Scotland and ensured that it was turned into a playground for the English élite. She heightened the powerful Victorian distinction between the domestic and the wild through her attitudes to animals. Animals that shared their working or social lives with humans should be protected and cared for. The queen reserved strong affections for pets, particularly dogs, and had many of them painted. The wild, however, was fair game for the hunter, symbolised by the traditions brought from southern Germany by her beloved Albert. The aristocratic tradition of dominating the environment through the hunting and shooting of game was greatly developed during her period, symbolised particularly by the cult of stalking the stags of red deer and the shooting of grouse. While still fit, Victoria enjoyed riding and walking in the hills, endowing 'scenery' with any number of wells, memorials and 'Queen's views'. She was keen on fishing and sketching, bringing up her nine children to follow these interests, and she was eager that all of this activity, with the gendered relationships that were often implied in it, should be captured in the art of such painters as Landseer and Franz Xavier Winterhalter. As the next chapter demonstrates, Victoria was a patron and enthusiastic purchaser of all forms of art. She was greatly influenced by Albert's considerable achievements in the Great Exhibition of 1851 and considered this one of the high points of her reign. She continued to be influenced by aspects of design derived from it. She assiduously visited the exhibitions of the last two decades of the century and was intrigued by the increasingly imperial vision of the world which they presented.

But the queen did not enjoy unalloyed popularity. Early in her reign, she was frequently unpopular and was even, on occasion, booed in the streets. Her 'widowhood at Windsor' during the 1860s and early 1870s, when she made very few public appearances, once more brought her considerable unpopularity. There were a number of assassination attempts against her and republicanism was considered such a serious political option, particularly in the early 1870s, that senior politicians such as Sir Charles Dilke and Joseph Chamberlain expected a republic to be declared within a generation.

The greatest paradox of all was the fact that the little widow dressed in black with her white cap of mourning aspired both to a simple lifestyle and to imperial pretensions. At Osborne Victoria and Albert created the Swiss cottage so that their children would learn to perform ordinary domestic tasks. Later, she had built a cottage at Balmoral, Glesallt Sheil near Loch Muick, where she could retreat into a simpler life. Part of the attraction of John Brown was that he introduced her to ordinary Highland people on the Balmoral estate and nearby. The queen ranged freely between the apparently ordinary, domestic sphere and the global, imperial stage. The royal family became a model for the Victorian ideal; yet it was also satirised (particularly early in her reign) for its expense to the state. Each royal birth was seen as another royal mouth for the taxpayer to feed.

However, Victoria's adulation of her husband and elevation of the family ideal also had its down side. After Albert's death Victoria's mourning seemed at first to chime with the extravagant

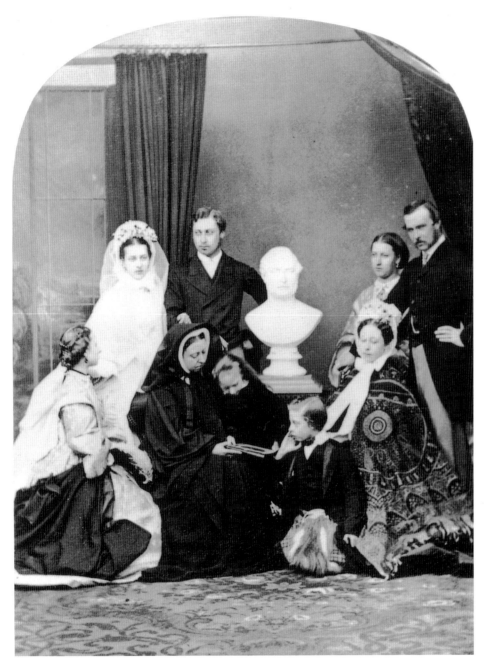

13 Photograph taken after the wedding of Alexandra and Albert Edward, Prince and Princess of Wales, 1863. The Royal Archives © HM Queen Elizabeth II.

approach to bereavement of her times. An extraordinary series of mourning photographs were taken of the queen with various members of the family around the bust of Albert – the Prince and Princess of Wales had to be photographed in this gloomy pose on their wedding day (plate 13). Yet British society recognised that the queen was carrying this to such excess that she was failing in her public duties. Disraeli, as always, wittily punctured Victoria's yearning for reunion with the Prince Consort. When the queen offered to visit him on his deathbed, he declined, reputedly remarking that she would only wish him to take a message to Albert.

Yet Victoria was alert to the necessary grandeur of her position. There seems to be good evidence that she herself wished to be an empress, so that she was not upstaged by the emperors of Europe or by her own daughter Victoria, the Crown Princess and future Empress (albeit briefly as it turned out) of Germany. After Disraeli had delighted her with the title Empress of India in 1876, she insisted on signing herself Victoria RI (*Regina Imperatrix*) and ensured that these initials appeared on coins, medals and seals, as they were to do until the reign of her great-grandson George VI. Although many British parliamentarians were anxious about a title which they saw as synonymous with European autocracy, and insisted that it should apply only to India, in fact it came to be used, at least informally, throughout Britain and the entire Empire.[9] Victoria was displayed as an empress in statues everywhere (see chapter 10). She was also quite happy to adorn her widow's weeds with grand accessories, including the *koh-i-noor* diamond, for important occasions.

QUEEN VICTORIA AND THE INVENTION OF SCOTLAND

Victoria and Albert visited Scotland in 1842, 1844 and 1847. They were enchanted with all that they saw, although the third visit was marred by much rain. In 1848 they bought (unseen) the old castle of Balmoral, formerly the home of Sir Robert Gordon, brother of the future Prime Minister, the Earl of Aberdeen. Other local estates, Birkhall and Abergeldie, were added to its lands. Victoria and Albert soon decided that they had bought a perfect holiday home and moved there for six weeks each autumn. The castle was completely remodelled and the grounds much improved. Highland retainers – pipers and ghillies – recreated a vision of a Highland past.

14 James Fenton, *Scottish Pebbles*. Brooch, semi-precious stones set in silver, *c*.1865. V&A: Circ.278–1961.

Victoria and Albert were by no means the first to treat Scotland as a holiday playground, but their royal seal of approval meant that the 'glorious twelfth' (the start of the grouse shooting season on 12 August) and autumn deer stalking, together with all other forms of shooting and fishing, became virtually part of the British constitution: Parliament always rose in time for the élite to decamp to Scotland and the state opening did not occur until they had all returned by the end of October. Foreign visitors and ministers were expected to wait on the queen at Balmoral.

Highland Games became a tourist rage for wealthy visitors from Europe as well as from within the United Kingdom. The royal patronage of the Braemar games was started by Victoria and continues to this day. Ironically, a Protestant German couple was helping to recreate the Scottish imagery of a Stuart, Jacobite past.

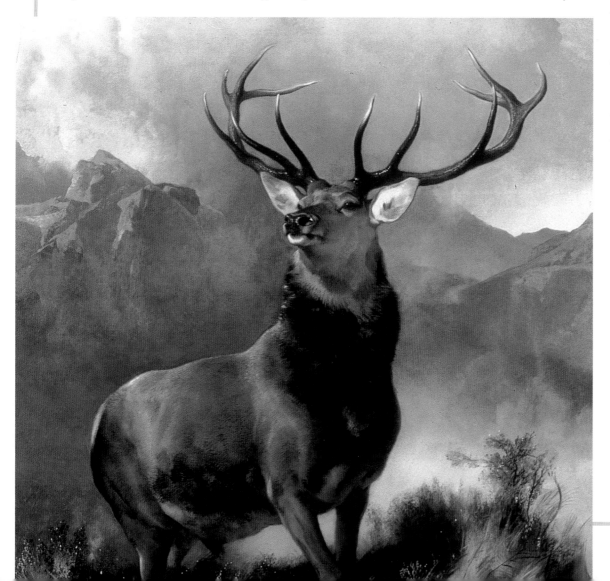

15 Edwin Landseer, *The Monarch of the Glen*. Detail. Oil on canvas, 1851. United Distillers and Vintners Collection.

16 Franz Xavier Winterhalter, *Albert Edward, Prince of Wales, with Prince Alfred*. Oil on canvas, 1849. The Royal Collection © HM Queen Elizabeth II.

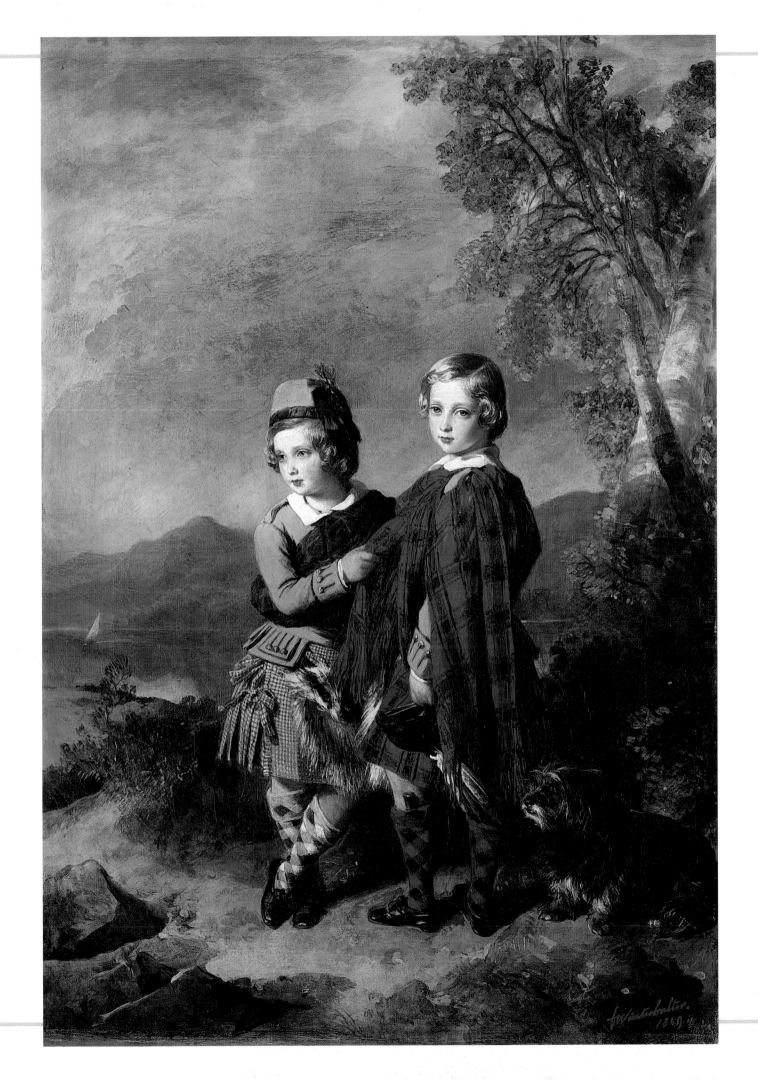

Victoria's personality and interests developed right through the various phases of her reign. Starting out as a teenage girl queen, she ended up as an elderly global empress. As we have seen, in her earliest years on the throne she was a Whig, with much that is eighteenth century about her social life and habits, even if she was already conscious of distancing herself from the dissipation of her predecessors. Under the influence of Albert, she set about training herself in the duties of monarchy, applying herself to constant hard work. During this period, the queen was frequently pregnant and relied on Albert to carry out many of her duties. Nevertheless, she became involved in his projects such as the 1851 exhibition, and took a close interest in foreign policy, culminating in anxieties about the Boer War. The Indian Mutiny brought the Empire to the fore. After Albert's death, it was the Empire which helped to bring her back to her duties and from the middle 1870s imperial affairs captured her attention more and more.

The queen's experience ran parallel with the major cultural and political developments of the age. The 1870s represent, in many respects, a key decade. By that time, newspapers were relatively free of the stamp and other duties which had kept their price high and largely out of the hands of the working classes. Radical papers of the past, like the *Daily Telegraph* and the *Pall Mall Gazette*, developed an increasing interest in imperialism. Older illustrated journals – the *Illustrated London News,* the *Graphic* and the *Sphere* – acquired considerable middle-class circulations and were strongly devoted to both royalty and Empire.[10] The spectacle and drama of imperial events lent themselves particularly well to the engravings which appeared in such papers. Soon the 'new journalism' was making papers both more exciting and more accessible. All this culminated with the founding of the *Daily Mail* in 1896. It proclaimed itself in its first leader as adhering to no party; its party was the Empire, an institution which by then seemed to be above party. Newspapers published at a penny or a halfpenny could now be purchased by almost all members of the population. Moreover, a tradition of local and Sunday newspapers, the main reading matter of the working classes, was overtaken by national papers, distributed by rail throughout the country.

By the 1870s a party political system much more akin to that of today was also in place. Although there were some areas of agreement between the parties, the Liberals, led by Gladstone, believed in budget retrenchment, individualism and the rolling back of state intervention. Lip-service was paid to a non-aggressive foreign policy and a non-interventionist imperialism, which was often overtaken by events. The Conservatives, led by Disraeli from 1868, seemed to be a party of greater state intervention, more prepared to indulge in social tinkering and imperialist activity. John Ruskin, in his inaugural lecture as Slade Professor of Art at Oxford in 1870, proclaimed that Britain should found colonies 'as far and as fast as she is able'.[11] Disraeli's Crystal Palace speech in 1872 seemed to proclaim just such a forward policy, although it would be a mistake to imagine that the early to mid-Victorian years were somehow a period of pause in imperial advance. Nevertheless, a sequence of events in the 1870s mark these years out as the first of a new, romantic and highly visible imperialism. These included the death of David Livingstone in 1873 and the return of his body from Central Africa

17 '*New Crowns For Old Ones!*', Punch, cartoon, 1876. V&A: NAL. 1 May 1876 Victoria is proclaimed Empress of India – Disraeli hands her the imperial diadem.

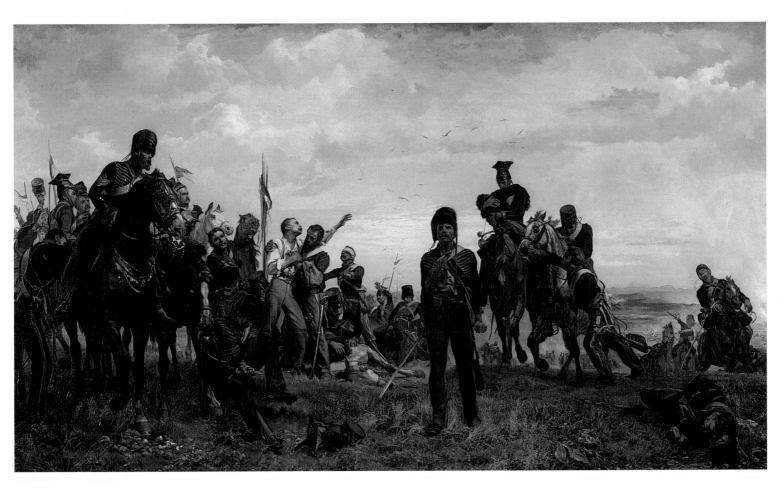

18 Lady Elizabeth Butler, *Balaclava*. Oil on canvas, 1876. Manchester City Art Gallery.

for the all-but state funeral in Westminster Abbey, attended by the Prince of Wales; the Ashanti War in the Gold Coast (Ghana) of 1874; the purchase of the Suez Canal shares in 1875; the visit of the Prince of Wales to India and Ceylon in the winter of 1875–6; the passing of the Royal Style and Titles bill in 1876 (plate 17) and the proclamation of the queen at an immense durbar in India in 1877; the 'jingoism' of the Russo-Turkish War of 1877–8 culminating in the Conference of Berlin and Disraeli's acquisition of Cyprus; and the forward events that led to disasters in Afghanistan and the Zulu War in South Africa in 1879. All these reflected a new mood.[12] From this moment onwards to the end of her reign, imperial events, reverses as well as triumphs, punctuated every single year (plate 18). The queen took a keen interest in them all. As subsequent chapters will illustrate, these events were strongly represented in all aspects of late Victorian culture.

The queen was also associated with one of the most significant developments of the later part of her reign, the coming of the mass market. Despite her innate conservatism, she was often intrigued by new developments and became associated with them. In the Victorian age there was no ban upon the use of images of the royal family in advertising, and the queen was repeatedly associated with products and transportation systems. She was shown approving of the 'monarch' bicycle or drinking Cadbury's cocoa while travelling on the royal train, and appeared in many other advertisements. The royal warrant was distributed very widely and any number of firms in England and Scotland proudly displayed it.

Towards the end of her reign, the Queen was even filmed at Balmoral and she can be seen smiling on celluloid, something she never permitted in her more solemn photographs and portraits. Yet by that time she had little to smile about. The country was again at war. She lived through the humiliating reverses to her generals Buller and Methuen of the 'black week' in October 1899. She visited wounded soldiers at the military hospital at Netley. She paid a final visit to Ireland, long riven by nationalist aspirations and the troubles associated with them, in 1900. The diplomatic isolation of Britain ensured that she was lampooned in cartoons all over Europe. She waited anxiously through the siege of Mafeking, thinking of the parallel of General Gordon at Khartoum in 1885, and participated in the celebrations of its relief in May 1900. When she left Windsor soon afterwards she was welcomed with a banner reading 'Welcome to the Queen of Mafeking'. Her global reach was emphasised to the end of her reign.

Much had changed between 1837 and 1901. As the contributions to this book demonstrate, it was a time of almost revolutionary transformations in every walk of life. By the 1890s the queen must have felt out of sympathy with so-called *fin-de-siècle* decadence, with the art of the period, and the wave of new design associated with art nouveau. Within her own lifetime, the reaction to supposed Victorian taste had already set in. The Glasgow School of Art and Design, in the forefront of a European movement, was pointing in new directions, even while clinging at times to older fascinations with nature and the properties of materials such as metal. Yet the death of the queen, in January 1901, was a powerful psychological blow. Coming during the Boer War, on the edge of a new and rather frightening century, the ending of the 63-year reign seemed like a disturbing break with a more solid and secure past. Despite all the vicissitudes of her life, Victoria had come to symbolise a sense of security and power which the British were never again to recapture. No previous monarch had reigned so long; none had come to be so inseparably associated with her age (with the possible exception of Elizabeth I); and above all none had seemed to represent such global influence, such economic, political, technical and intellectual expansion.

This book is organised in a threefold form in order to symbolise such connections. It opens with surveys of the complexities of Victorian society from the queen downwards. In the second section, technologies of the Victorians are explored in order to form a bridge to the third – the wider world which they surveyed and dominated. Throughout, the focus is mainly upon the products of Victorian people, primarily in the realms of art and design, artefacts and other forms of material culture.

Neither the exhibition nor this book can presume to be comprehensive and that is itself symbolic both of the enormous range and depth of Victorian production and of the considerable dynamic for change which took place during the reign. Much more can be seen in the many museums, not least those in South Kensington, London, which were themselves one of the truly significant products of the Victorian period.

Thus, the chapters that follow chart the manner in which Victoria stamped her personality, her tastes and her perspectives upon her age. They also examine the ways in which the world influenced not only Victoria but the society and culture that she came supremely to represent. Her people passed through unprecedented changes in lifestyle during this period, particularly in the areas of home and leisure, education and the conception of childhood. Quiet revolutions

took place in gender roles, and in associated developments in health and medicine, as well as in science and religion. These often involved major historical paradoxes. It was a time when the separation of gender spheres was taken to new heights, but more women than ever before worked in productive settings, such as factories and mills. Women began to aspire to a whole range of influences, as well as to professions that had not admitted them in the past. And overall, it was a female monarch that symbolised the massive outreach of Victorian power. Moreover, new technologies facilitated the connecting of Victorian people, male and female, to the world which they strove to embrace, understand and dominate.

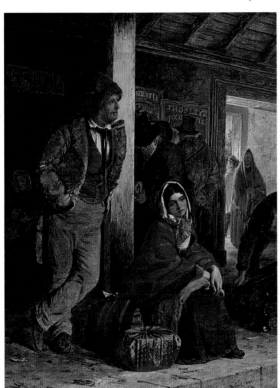

19 Erskine Nicol, *The Emigrants*. Oil on canvas, 1864. Tate Gallery © 2001.

New techniques also influenced industry, engineering, building and architecture, as well as the (often related) visual worlds of art, design and photography. As a result, painting and reproduction were transformed. As the Victorians looked outwards, their global gaze was more encompassing than that of any previous society or generation. New intellectual disciplines, for example geography, anthropology and philology, were developed to help with the classification and fathoming of a world that seemed to be fully discoverable for the first time. Exhibitions offered panoptic visions of Empire, industry, trade, art, design and enthnography. The realms of nature were reconceptualised and reconstructed. History and archaeology offered visions of a past which were vital to the location of the Victorians in the present. Visions of golden ages and past splendours, together with concepts of degeneration and progress, were never far from their thoughts.

But these processes were far from being one-way. Victorian influence radiated outwards into the world, not least through the peoples who emigrated to North America, southern Africa, Australia and New Zealand (plate 19), as well as the traders, officials, engineers, soldiers and sailors who penetrated almost every quarter of the globe. Yet the Victorians were themselves bombarded with new influences from the Far East, from India and from Africa. People from Asia and Africa also came to study in Britain, to cast a critical eye upon the manners and mores of the people who seemed to be, however briefly, masters of the world. They became involved in social and political campaigns. They adapted ideas and customs and returned to their own societies to develop the resistance that would ultimately bring the British Empire down. Yet British society was also indelibly imprinted with these global connections and influences. The Victorians were not involved in a one-way trade. However convinced of their superiority they might be (and not all were), they became virtual cultural and spiritual sponges, absorbing ideas from everywhere. Since the Victorian age was a visual one, par excellence, such influences, and the syncretic forms which they established, were most prominent in the realms of art and design. The contributions to this book are concerned with the fresh appreciation and understanding of Victorian tastes and ideas which developed in the late twentieth century. They are also devoted to reinterpreting the interpenetration of the culture of Victorian Britain with the world which it truly encompassed. Victorian visions were certainly global in scale. In the centennial year of the death of Queen Victoria, it is apparent that many of the problems identified in her reign are still with us, and that the Victorians helped to form the modern age.

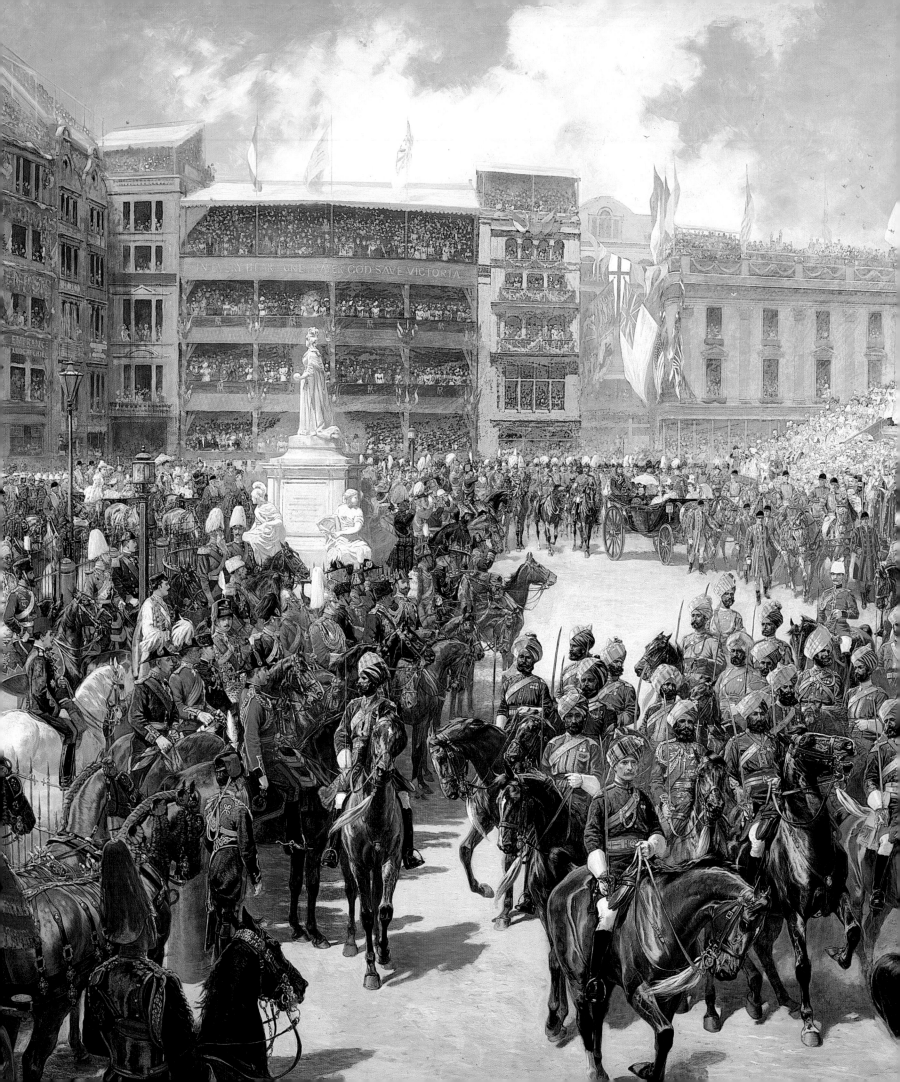

SOCIETY

CHAPTER ONE

ROYAL PATRONAGE & INFLUENCE

DELIA MILLAR

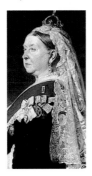

A few months after the death of Prince Albert, the Prince Consort, Lady Eastlake wrote:

If any one had ventured to prophecy that this untried youth and foreigner was to be foremost in the ranks of every form of intelligence, foremost in plans of active philanthropy, foremost in diligence, order, and judgement, in purity of morals, and the practice of every domestic virtue, he would have been scouted as a dreamer of dreams.

She believed that his one object had been 'the good and the happiness of our Queen'.[1] She was sustained by her total belief in him; he was unfailingly kind to her; and his achievements would have been impossible without her support.

Coming from Hanoverian stock, Queen Victoria had ascended the throne at the age of 18, with a powerful sense of queenship and with strong public support. The prince, whom she married three years later, was, on the other hand, looked upon with suspicion in many quarters. The Great Exhibition of 1851 was the event which turned public feeling in the prince's favour.

20 Heinrich von Angeli, *Queen Victoria*. Detail. Oil on canvas, 1890.
The Royal Collection © HM Queen Elizabeth II.

21 John Charlton, *'God Save the Queen': Queen Victoria Arriving at St Paul's Cathedral on the Occasion of the Diamond Jubilee Thanksgiving Service, 22nd June 1897*. Detail. Oil on canvas, 1899.
The Royal Collection © HM Queen Elizabeth II. With Princess Helena and the Princess of Wales, the queen drove through enthusiastic crowds to attend the short service on the steps of the cathedral. The Prince of Wales, the Duke of Connaught and the Duke of Cambridge rode beside the carriage.

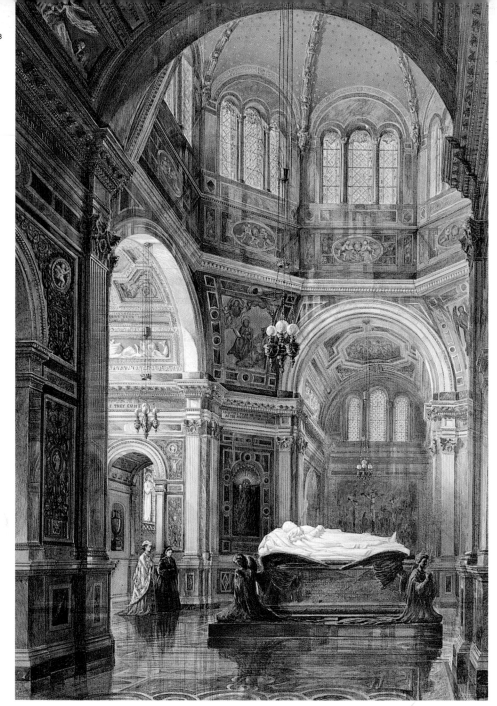

22 Henry William Brewer, *The Royal Mausoleum, Frogmore, with Queen Victoria*. Watercolour and bodycolour, 1869. The Royal Collection © HM Queen Elizabeth II.
Queen Victoria and a female figure walking from the Chapel of the Altar towards the tomb of the Prince Consort in the Mausoleum. His marble recumbent effigy, designed by Baron Marochetti, was placed in position in 1868. Beyond the tomb is the Chapel of the Crucifixion with the altarpiece by Nicola Consoni.

Queen Victoria was a relatively uncomplicated person, with simple reasons for her actions.

Her nature abounded in contradictions, but she possessed rare common-sense. Her great hold on her people came from the fact that . . . she had the ideals, the tastes, the likes and dislikes of the average clean-living, clean-minded wife of the average British professional man, together with the strict ideals as to the sanctity of the marriage-tie, the strong sense of duty, and the high moral standard such wives usually possess.[2]

As a girl she had shown that she had a quick and orderly mind. She had worked hard at her lessons; she spoke and wrote German and French, understood Italian and some Latin. She enjoyed visits to the theatre, had a passion for the opera, but also liked relatively low-brow entertainments – visits to see waxworks, lion tamers or midgets. Her mother had taken the young princess on various 'progresses' round her future realm.

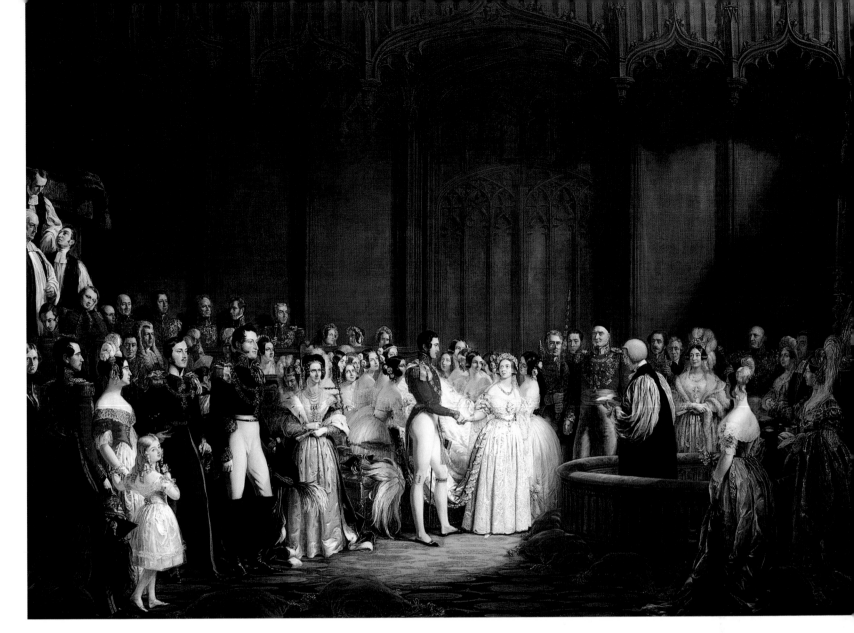

23 Sir George Hayter, *The Marriage of Queen Victoria, 10 February 1840*. Detail. Oil on canvas, 1842. The Royal Collection © HM Queen Elizabeth II. Commissioned by the queen and completed after endless sittings, Prince Albert praised the painting, but said it was too large to hang in any room. It was finally placed in the Corridor at Windsor with its back to the light, between windows, which saddened the artist.

In June 1837 Princess Victoria knew that her uncle, William IV, was dying: she awaited the event 'with calmness & quietness; I am not alarmed at it and yet I do not suppose myself quite equal to all; I trust however that with *good will, honesty,* and *courage* I shall not, at all events, fail.'[3] Four months later, she told her half-sister: 'Every body says that I am quite another person, since I came to the throne. I look and am so very well. I lead such a pleasant life; just the sort of life I like. I have a good deal of business to do, and all that does me a world of good.'[4] In the first years of her reign Queen Victoria leant heavily on the experience of her mentor, Lord Melbourne.

In 1838 the queen decided that she had no intention of marrying for at least two more years but, on the second visit of her cousin Prince Albert to England, she found him 'grown, changed & embellished' and decided differently: 'It was with some emotion that I beheld Albert – who is *beautiful*.'[6] They married on 10 February 1840 (plate 23). The prince was later to feel that, although his home life was 'very happy and contented', it was not easy to fill his position with proper dignity as he was 'only the husband, and not the master in the house'.[7] The annuity of £50,000 normally given to royal consorts on their marriage was cut to £30,000. This was a perpetual grievance to the prince, crippled as he was in his 'means of usefulness to the country and to the throne'.[8] He was distressed to be unable to contribute when £100,000 was urgently

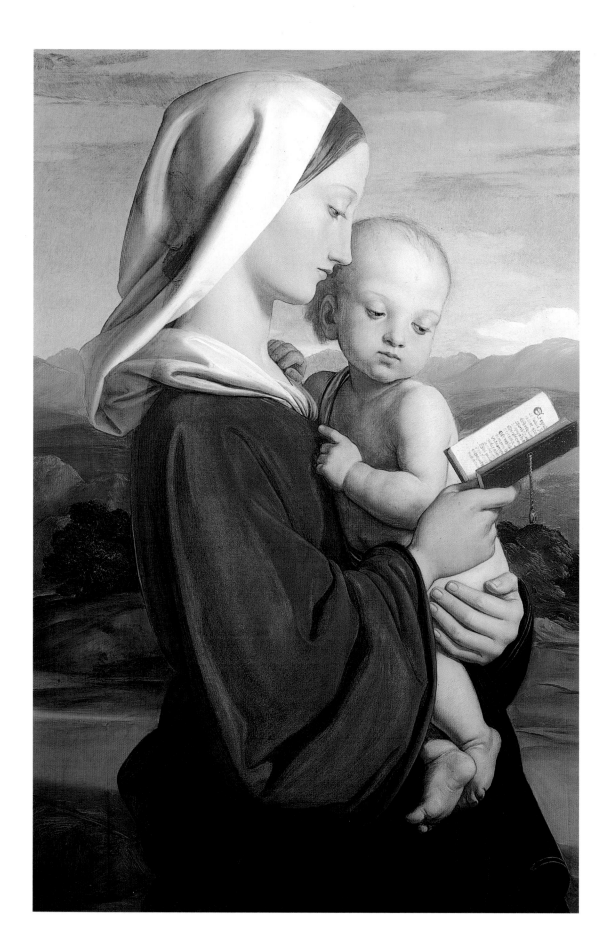

24 William Dyce,
The Madonna and Child.
Oil on canvas, 1845.
The Royal Collection
© HM Queen Elizabeth II.
Acquired by Prince Albert
before it was exhibited at
the Royal Academy in 1846.
The queen thought it
exquisitely painted and
like an Old Master, in the
style of Raphael.

needed to set up the Great Exhibition; he could never buy expensive pictures and had often to be subsidised by the queen in his purchases. Although Balmoral Castle was bought in his name she paid for it. Thereafter, by his hard work and wisdom the prince won for the Crown and the royal family the respect and popularity that the queen's raffish predecessors had forfeited. He had a far greater influence than the queen on the arts and sciences in this country at this important period. In her widowhood he lived on in the queen's mind as the source of all wise decisions. She aimed always to do whatever she felt that Albert would have done: 'It is *you* who have entirely formed me.'

The prince enjoyed the company of intellectual men, but the queen felt at a disadvantage: 'The Prince is bored with the sameness of his chess every evening. He would like to bring literary and scientific people about the Court, vary the society, and infuse a more useful tendency into it.'[9] Before her accession Lord Melbourne, essentially a Regency figure, had told the queen, 'I never will have anything to do with artists; I wished to keep out of it all, for they're a waspish set of people', and King Leopold, son-in-law of George IV, had warned her that dealings with artists, 'require great prudence; they are acquainted with all classes of society, and for that very reason dangerous; they are hardly ever *satisfied*, and when you have too much to do with them, you are sure to have *des ennuis*'.[10] The prince, however, liked to meet craftsmen and workmen: 'Whether he spoke to a painter, a sculptor, an architect, a man of science, or an ordinary tradesman, they would each think that the speciality of the Prince's mind was his own particular pursuit.'[11] He enjoyed being closely involved with the working artist, and surprised Frith by his understanding. The painter found that Prince Albert's recommendations could improve his pictures 'in every instance'.[12] Not all artists appreciated the prince's approach: George Richmond, when drawing the Prince of Wales, had his work glazed before Prince Albert saw it, to prevent him from indicating on the drawing itself any alterations he thought would improve it.

On the other hand the upper classes in England neither liked nor understood the prince:

The 'old' royal family always were jealous of him & I fear contributed much to make his difficult position more difficult still... they resented the reforms instituted by the young couple and altogether disapproved of everything that was not as it used to be . . . It must have been terribly hard for a young man such as he was when he came to England to be always misunderstood – to have all his efforts to do some good turned into ridicule, to have always to efface himself – it is only his wife's love, her unbounded respect for him, her wish that he should ride supreme in the household that made life endurable to him, that prevented his existence from being a perfect martyrdom.[13]

At first the prince was given little employment, but the queen soon discovered 'the value of an active right hand and able head to support her . . . Cabinet Ministers treat him with deference and respect. Arts and science look up to him as their especial patron . . . The good and the wise look up to him with pride and gratitude as giving an example, so rarely shown in such a station, of leading a virtuous and religious life'.[14] After his death the queen told Sir Theodore Martin: 'His taste for art was very wonderful, & it was his inventive genius; – all sorts of things being made & adapted from his designs or suggestions & this for the highest Art – to mere objects of usefulness.' No less important: 'He had also a peculiarly gentle, tender as well as poetic cast of mind.'[15]

QUEEN VICTORIA'S TASTE IN ART

Queen Victoria had definite views on art. She had drawing lessons from the age of eight, visited exhibitions and, in her journal, noted pictures that she liked. She learnt to paint in oils and to etch; painting in watercolours gave her pleasure all her life. In her early years on the throne Queen Victoria told Lord Melbourne that she wished, but feared to buy pictures.[16] Haunted by the extravagances of her uncle George IV, she regretted that she was not rich enough to buy the large English historical paintings that she most admired. After her marriage she came to rely entirely on the prince's taste. On her accession the queen appointed George Hayter to be her Painter of History and Portrait. He had painted – for the King of the Belgians – the most important portrait of her made before that date.[17] She thought him: 'out and out *the best* Portrait painter in my opinion',[18] but by 1841 he had become 'worthy, *trouble-some* Hayter', and she no longer wanted his help to teach her to etch.[19] He received no further royal commissions but, like Sir William Ross, was knighted in 1842. Sir David Wilkie's painting of her first Council, which at first she liked, was later dismissed as 'one of the worst pictures I have ever seen, both as to painting & likenesses'.[20] She thoroughly disliked her official portraits by Wilkie and Shee.

In 1841 Melbourne had warned the queen that 'the English are certainly very jealous of foreigners' and that 'enlightened and able men' were concerned that the prince would recommend foreign painters.[21] However, it was the queen who, in 1845, 'fired a terrible broadside at English artists, both as regards their works and . . . as regards their prices, and their charging her in particular outrageously high'. She forgot 'the additional time and trouble they bestow on things for her', often 'being obliged to give up all their other engagements for the day', being kept waiting or finally hearing that the queen could not sit that day, or that they were not given permission to exhibit their picture.[22] In May 1842 Franz Xavier Winterhalter paid his first visit to England to paint her. She already owned his portrait of her aunt Louise, Queen of the Belgians, with her elder son. For more than twenty years Winterhalter was to paint portraits of her family (plate 25) which delighted the queen, who decided that his work would in time rank with that of Anthony Van Dyck.[23] The Austrian, Heinrich von Angeli, succeeded Winterhalter as her favourite portrait painter (see plate 20):

Although the queen had every desire to encourage art generally, she invariably refused to be influenced in any way by other people's opinions, and having fixed ideas of her own she clung to what she liked. In portraiture she considered the likeness to be of paramount importance and the artistic merit of the picture itself to be quite a secondary matter. Therefore she admired Angeli, while artists like Watts were unintelligible to her, and the Impressionist school she treated as a joke.[24]

The queen was fascinated by people: their character and their appearance. She built up a huge collection of portraits of her family and friends, in oils, watercolours, miniatures, lithographs, engravings, photographs and busts, but her 'exclusive employment of foreigners, Winterhalter & Angeli for royal portraits, when Englishmen like Millais & Watts were flourishing in England' was deeply resented.[25]

25 Franz Xavier Winterhalter, *The First of May, 1851*. Oil on canvas, 1851. The Royal Collection © HM Queen Elizabeth II. Painted to commemorate the visit of the Duke of Wellington to his godson on his first birthday, on the day of the opening of the Great Exhibition. In 1871 the queen had to explain to the Duke of Connaught that the picture merely showed an 'Event'. The casket, which he had always been led to believe was only to be opened on his 21st birthday was, in fact, just a pretty box taken from her table.

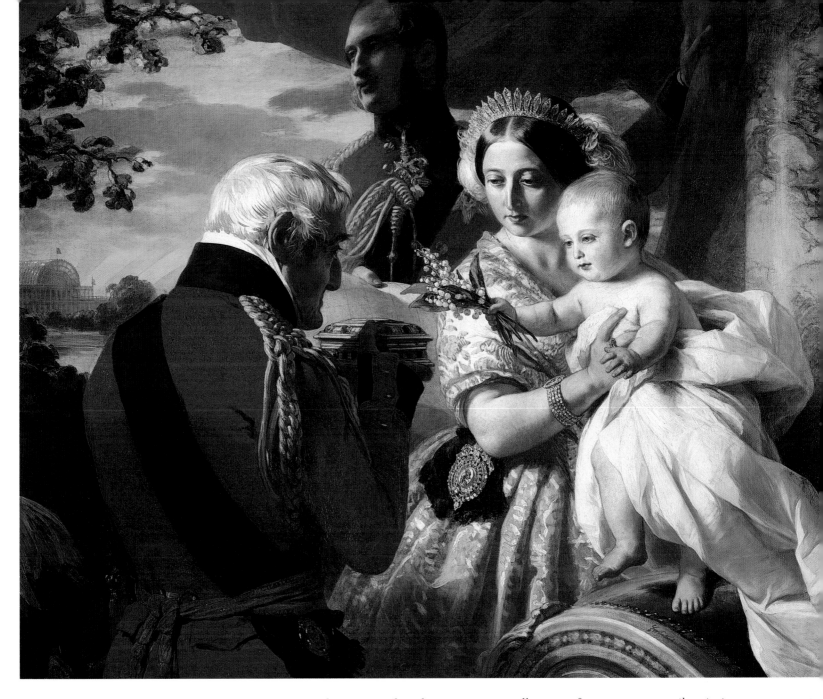

The queen and prince gathered an extensive collection of contemporary oil paintings. ('It is my beloved Albert, who encourages all the *real* talent & is trying to improve the taste in the arts which exist here.')[26] They gave each other pictures as presents so that 'the pleasure these give us becomes in this way a twofold pleasure'.[27] The prince acquired Edward Corbould's *Woman taken in Adultery* in 1842, and two years later his *Joan of Arc*. They continued to buy Corbould's work; he taught drawing to their children and arranged tableaux for them to perform on their parents' birthdays.

Inevitably, paintings of ceremonies were commissioned throughout the reign from George Hayter, C. R. Leslie, John Phillip, G. H. Thomas, E. M. Ward , S. P. Hall, Nicolas Chevalier, John Charlton (plate 21), W. E. Lockhart and others. Before her accession and early in her reign the queen had her ponies painted by George Morley. Sperling painted their horses in the 1840s for Prince Albert. Edwin Landseer, whom the queen decided early on was the cleverest artist there was, painted her dogs (plate 26). John Martin's *The Eve of the Deluge* was the prince's most

dramatic contemporary purchase, painted for him in 1840, whereas the most expensive modern picture acquired by the queen was William Frith's *Ramsgate Sands* which she saw at the Royal Academy in 1854 (plate 37). She bought Frederick Leighton's first exhibit at the Royal Academy, *Cimabue's Madonna carried through the Streets of Florence*: 'The young man's father said, that his future career in life, would depend on the success of this picture.'[28] Other artists believed that royal patronage helped them early in their careers. Gustave Doré, when introduced to the queen in 1875, remembered 'with gratitude the encouraging influence of some of the Prince Consort's words' in his 'admirable speeches on art'.[29] At the Royal Academy dinner in 1851 Albert had recommended:

kindness towards the artist personally as well as towards his production. An unkind word of criticism passes like a cold blast over their tender shoots, and shrivels them up, checking the flow of the sap, which was rising to produce, perhaps, multitudes of flowers and fruit. But still criticism is absolutely necessary to the development of art, and the injudicious praise of an inferior work becomes an insult to superior genius.[30]

No paintings by J. M. W. Turner were acquired. Nor did the queen and prince patronise the Pre-Raphaelites, although the queen asked to see Millais's *Christ in the Carpenter's Shop*. She admired the detail in Maclise's *Scene from Undine*. To Prince Albert she gave the first version of Johann Overbeck's *Religion glorified by the Fine Arts*, a work which would have impressed the prince, steeped as he was in the German Romantic tradition. Paintings were regularly acquired from the Royal Academy, watercolour societies and other exhibitions. The queen made her own decisions, but deferred to the prince's taste. She liked the work of John Phillip, and 'the great artist & kind old friend' Edwin Landseer painted all his life for the queen.[31] They bought continental pictures by Verboeckhoven, Baron Wappers, Meissonier and Ary Scheffer. She later recalled 'how anxiously nervous I always felt knowing what taste he had – what a judge of Art he was – & how gt. was my joy – if any Picture I had ordered or bought gave him real pleasure & really surprised him! And often I was successful – Landseers in bygone days – & various foreign & English Artists in oil & water colours I gave him.'[32]

With her love of her Empire, and perhaps especially of India, the queen was later to welcome presents such as Marshall Claxton's *Cove of Sydney* and views of Canada by Homer Watson. She was proud to own Val Prinsep's huge *Proclamation of The Queen as Empress of India*, and commissioned studies of her Indian subjects by Rudolf Swoboda. She acquired many military scenes. George Thomas worked extensively for her, and after the Crimean War painted *The Presentation of the Crimean Medals* and *The Queen distributing the first VCs*. The queen gave the prince a reduced replica of Noel Paton's *Home: The Return from the Crimea*, shown at the Royal Academy in 1856 and stated by the *Athenaeum* to be 'the best work the late War has yet called forth'.[33] In 1874 she managed to acquire Lady Butler's *Roll Call*. Later Caton Woodville's *The Guards at Tel-el-Kebir* was commissioned and, distressed by the death of General Gordon, his *Too Late*, and the *Memorial Service for General Gordon*. Edouard Détaille's large canvas of the Prince of Wales and the Duke of Connaught at a review at Aldershot was the Prince of Wales's Jubilee present to his mother.

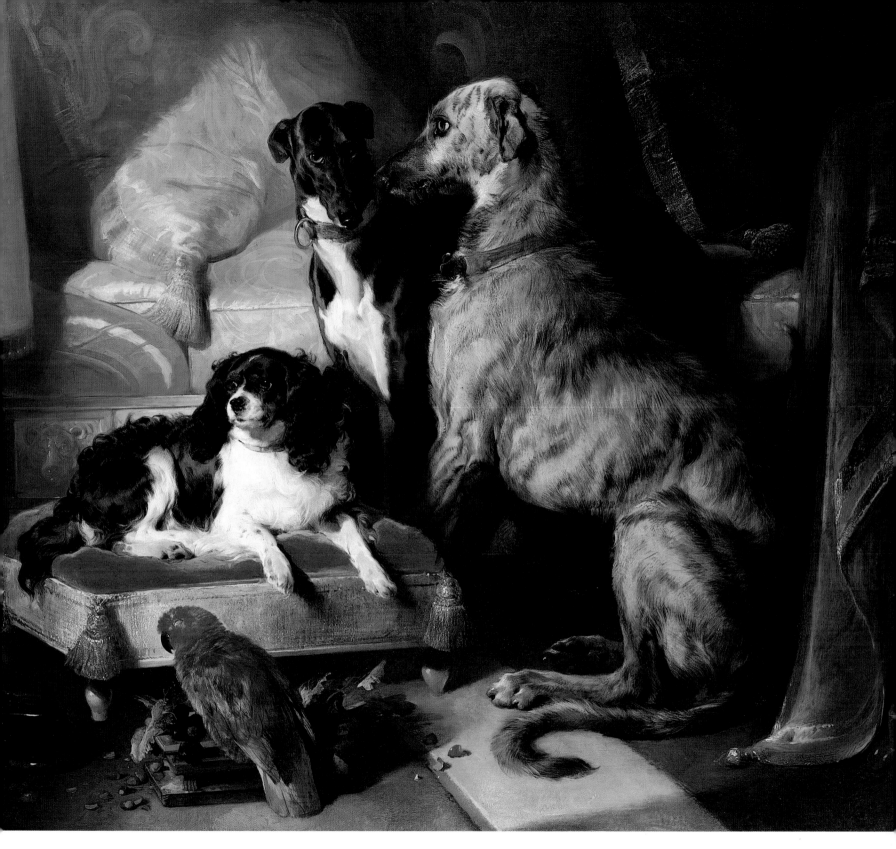

26 Sir Edwin Landseer, *Hector, Nero and Dash with the Parrot, Lory*. Oil on canvas, 1838. The Royal Collection © HM Queen Elizabeth II.
This painting of her greyhound, Scottish deer hound (then a rare breed) and favourite spaniel with her parrot was much admired by the queen.

SCULPTURE

In the mid-nineteenth century contemporary sculpture was a largely neglected art in England. G. F. Waagen who toured and described works in English collections believed that nine-tenths of the sculpture executed in England was busts or portrait statues.[34] In 1861 the Prince Consort received leading sculptors to discuss the position of sculpture and to arrange for statues to be placed in the Horticultural Gardens at South Kensington. Works could be exhibited which, though produced every year in England, were rarely seen except by the enlightened patrons who commissioned them. *The Art Journal* hoped that sculpture might finally 'obtain the consideration and the position to which it is undoubtedly entitled'.[35] The queen and prince built up a large collection of contemporary works by English and foreign sculptors and copies after the antique, which was chiefly housed in their new 'Italianate villa' on the Isle of Wight. Today the Royal Collection probably contains the largest number of such pieces in any collection. Portrait busts were commissioned from Francis, John Gibson, Theed the Younger, Wolff, Carlo Marochetti (see effigy in plate 22) and Boehm. In Rome, Ludwig Gruner acquired copies from the antique of *Augustus* and *Isis,* and heads by Theed, for the queen to give the prince, while he gave her studies of the royal children by Mary Thornycroft (plate 27).[36]

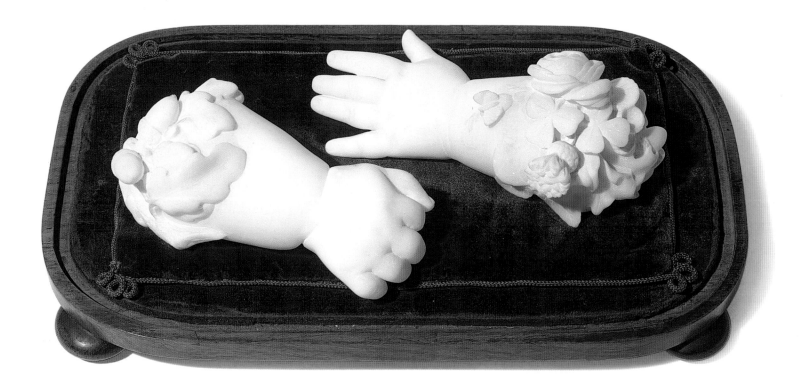

27 Mary Thornycroft, hands of the royal children. Marble, 1843. The Royal Collection © HM Queen Elizabeth II.

28 John Thomas, *Windsor Castle: The Queen's Audience Room*. Watercolour, c.1860. The Royal Collection © HM Queen Elizabeth II. Architect, sculptor and draughtsman, Thomas worked extensively in the Print Room, Upper Library and Dairy at Windsor. This, the culmination of his work there, shows his realised design for the redecoration of this room, completed in 1861. It was especially important for the queen as she had spent the first evening of her married life here, and it was to be the room in which the Prince Consort's coffin rested on the night before his funeral.

In 1846 John Gibson, whose work was recommended by Charles Eastlake, and who lived mainly in Rome, was asked to send designs by English sculptors working there. In 1847 he completed a full-length statue of the queen in classical dress. Gibson told the queen that he deplored 'the lack of taste in this country' but that Prince Albert had 'already done a great deal to improve art, & by degrees to raise the whole standard'.[37] In 1863 Gibson was summoned to Osborne where the queen, in cheerful mood, led him 'through rooms full of statues and pictures – modern works executed at Rome by Italian, German, and three Englishmen' including his own. He would have seen many recent acquisitions, including John Bell's *Andromeda* fountain bought from the Great Exhibition and William Theed's *Cupid and the Marine Monsters*. The fountain basins lined with ornamental metallic lava, theoretically inexpensive, durable and damp resistant, proved unsatisfactory and soon had to be replaced – Prince Albert's choice of new material was not invariably successful.

Royal commissions for John Thomas, another of Prince Albert's favourite sculptors, included the reliefs of *War* and *Peace* for Buckingham Palace, a frieze of heads of the kings of England for the queen's Audience Room at Windsor Castle (plate 28), the decoration of the Print Room and the design of the Model Dairy at Windsor. The statue of the prince's favourite greyhound, Eos, was modelled by the prince but cast by Thomas.

When the Prince Consort died William Theed the Younger was chosen by the queen to take the death mask. His commissions for memorial sculpture included her statue of the prince for Coburg, with copies made for Sydney, New South Wales, and for Britain's Grimsby and Bishop's Waltham. Theed made the statue of the Duchess of Kent for her Mausoleum (using photographs taken for Winterhalter's portrait) and the life-size group of the queen and prince in 'Saxon' dress. The few sculptors knighted later in the queen's reign included Joseph Boehm, John Steell and Hamo Thornycroft. The queen's employment of another foreigner, Baron Carlo Marochetti, was unpopular but, when she heard of his death, she considered 'he will be a terrible loss here where we have so little genius'.[38] The *Art Journal* noted sharply, when designs for the Albert Memorial were under discussion: 'This will be the most glorious opportunity for *British* sculptors to show what they can really do.'[39] Gilbert Scott was knighted for his designs for it in 1872 (plate 30).

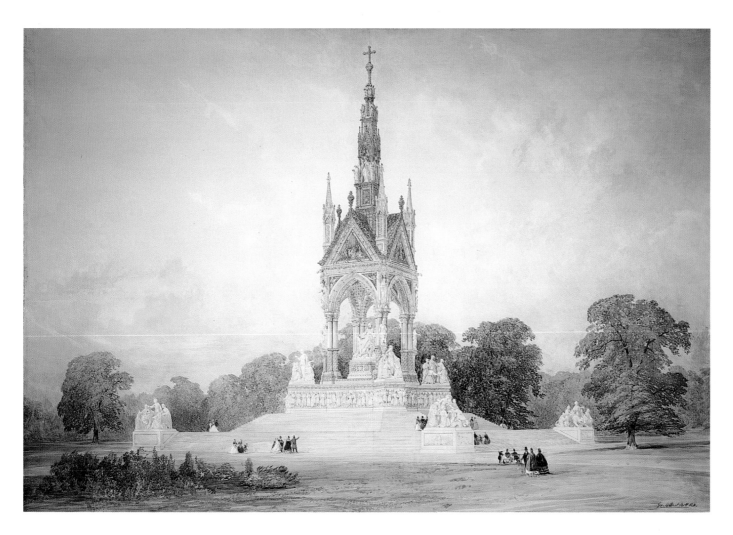

30 Sir George Gilbert Scott, *Design for the Albert Memorial.* Watercolour, 1862-3. The Royal Collection © HM Queen Elizabeth II. Presented to Queen Victoria by the artist, it is his 'original drawing' which was submitted with designs by six other architects in February 1863. The Memorial was completed by 1 July 1872. Scott was knighted in August, but the statue was not unveiled until March 1876.

THE ROYAL COLLECTION:
REPRODUCTIONS, CATALOGUES AND ALBUMS

In 1852 Samuel Carter Hall, editor of the *Art Journal*, received permission to reproduce 150 works from the old and modern Royal Collection. Plates of two paintings and a piece of sculpture appeared each month from January 1855 to December 1861, and were later reproduced in four monumental volumes published as the *Royal Gallery of Art*. The sycophantic Hall particularly praised the acquisitions for Osborne: 'There are few collections of Modern Art so extensive in number and so admirable in choice, as theirs; nor are there any which afford such cheering evidence of judicial patronage – patronage which aids not only the artist who has achieved fame, but also him who is labouring ardently and hopefully to earn honourable distinction.'[40]

Prince Albert brought order to the queen's inherited collections. He initiated a catalogue of the pictures (it is still in regular use); he sorted old prints, duplicates and 'many vy improper & indecent ones' acquired by George IV which were removed;[41] he arranged many of the prints in albums (as seen in plate 31) while the queen read to him, and he set up the Print Room at Windsor Castle, where Thomas Carlyle encountered him, a 'handsome young gentleman, very jolly and handsome in his loose greyish clothes . . . a pair of strong steady eyes with a good healthy briskness in them. He was civility itself in a fine simple fashion.'[42] In their new Print

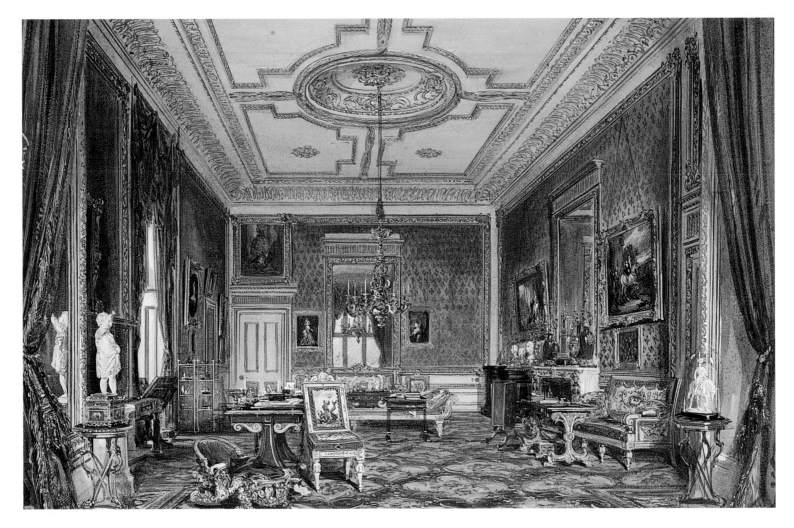

Room the prince and queen also sorted and catalogued the coins and, from 1848, arranged for 200 miniatures to be reframed. Thousands of watercolours and drawings were added to her collection. In 9 Souvenir Albums they mounted about 600 watercolour views of places that they visited together and events they had attended. In 1842 Prince Albert began to collect a *corpus* of material on Raphael, planned as the first of a series of such studies, to be followed by Michelangelo. All available prints and photographs of works by, or attributed to, Raphael, were collected. In June 1853, five months after its formation, the queen and prince became Patrons of the Photographic Society of London. About 2,000 photographs were included in the Raphael Collection and, on its completion in 1876, it became the first art photograph library, and a model for modern methods of studying an artist's work. After the prince's death, and in his memory, Queen Victoria lent the Raphael Cartoons to the South Kensington Museum (the Victoria and Albert Museum) to be more easily seen and studied.

The prince sorted hundreds of pictures neglected in store at Hampton Court Palace. In 1848 a large group of early German and Netherlandish pictures was acquired from a princely relation, and put on exhibition at Kensington Palace. Such paintings had never before been shown in England and the prince was anxious that other public galleries should be equally welcoming to visitors.

31 Joseph Nash, the Elder, *Views of Windsor Castle: The Queen's Sitting Room*. Detail. Watercolour and bodycolour, 1846-7. The Royal Collection © HM Queen Elizabeth II. Showing, on the right wall, two of the queen's favourite paintings – Grant's *Queen Victoria Riding Out* and Landseer's *Windsor Castle in Modern Times*. There are albums and portfolios by the window.

ROYAL COMMISSION OF THE FINE ARTS AND FRESCOES

In the autumn of 1841 Sir Robert Peel, on succeeding Lord Melbourne as Prime Minister, appointed Prince Albert to be President of the Royal Commission of the Fine Arts. This gave him his 'first initiation into public life'.[43] A scheme had to be organised to decorate the interior of the new Palace of Westminster, built to replace the old palace which had been destroyed by fire in 1834. The prince, delighted to become better acquainted with some of the most distinguished men of the day, saw this opportunity for state patronage as a chance to arouse government interest in the arts. The Commission had decided in 1836 on a scheme of historical murals to celebrate the achievements of the nation. The medium was to be fresco, in emulation of schemes in this rediscovered technique currently being carried out in Germany and France. The prince's first suggestion that German painters should be brought to England was badly received, and he realised that English artists must be taught the technique. Ruskin thought fresco 'a splendid sea for the strong swimmer, but you might as well throw a covey of chickens into the Atlantic as our R.A.'s into fresco'.[44]

For the first competition, with which the prince was closely involved, large cartoon drawings in chalk or charcoal had to be made, showing subjects from British history or illustrating Spenser, Shakespeare or Milton. In July 1843, the 140 entries shown in Westminster Hall created a sensation. Charles Eastlake, Secretary to the Commission, was gratified that 'many of the most wretchedly dressed people prefer the sixpenny' catalogue rather than the abridged penny one, and earnestly followed 'the subjects with the books in their hands'.[45] In 1847 completed pictures were exhibited at Westminster Hall to show which artists could actually paint in fresco. Prince Albert apparently talked of nothing but *The Battle of Meanee* by Edward Armitage, which the queen finally acquired, although at first thought herself 'not rich enough'.[46] Frescoes were commissioned from William Dyce, Daniel Maclise, Cope and Horsley, but the true fresco technique proved unsatisfactory in the English climate. The German method, recommended by Prince Albert, of painting in watercolour on a dry wall and then spraying it with waterglass, proved to be the best technique. In 1850 Sir Robert Peel died: by then the first impetus for the scheme was gone; Charles Eastlake became President of the Royal Academy in that year, and Director of the National Gallery in 1855; the prince had other work and was planning the Great Exhibition. By the late 1850s damp was damaging the newly completed frescoes and the paint was beginning to blister and peel off. The artists thought their payment unduly mean. After the death of the prince, the Commission was wound up: the scheme was not a complete success but the 'frescos' remain 'the most remarkable English attempt in that medium since the close of the Middle Ages'. The queen and prince commissioned William Dyce to paint the monumental fresco on the staircase at Osborne ('a magnificent painting, so well drawn, conceived & executed').[47]

In 1842, as a private trial to allow artists to experiment with the new technique, the prince and the queen, as one of the earliest public acts of the reign, had commissioned Edward Blore to build a little pavilion in the gardens of Buckingham Palace. Eight Royal Academicians – Charles Eastlake, William Etty, Clarkson Stanfield, C. R. Leslie, Edwin Landseer, Daniel Maclise, Sir William Ross and Thomas Uwins – were invited to decorate the walls of the main Octagon Room in fresco: 'The Prince has done that which the Nation could not do without injustice –

32 David Roberts, *The Inauguration of the Great Exhibition, 1 May 1851*. Oil on canvas, 1852. The Royal Collection © HM Queen Elizabeth II. Prince Albert, seen in the centre, reads the report of the Commissioners to the queen, who stands between the Prince of Wales and the Princess Royal.

commissioned the painters of established fame, who are most likely to be successful.'[48] The royal patrons visited the pavilion daily. Etty was paid off with forty pounds. Dyce, who understood fresco technique, replaced Ross, but thought their work badly paid. He disliked having 'a Prince looking in on you every ten minutes or so'.[49] Uwins enjoyed the prince's involvement: 'The more I see him, the more I find in him to admire.'[50] Ludwig Gruner, who was probably introduced to the prince by Eastlake, became involved with the project. He designed decorations for the two side rooms and replaced Eastlake as director of works. The Garden Pavilion was completed by July 1845 and Gruner published *Her Majesty's Pavilion in Buckingham Palace Gardens*, in which the prince insisted that not only the names of the artists but also those of the workmen and manufacturers should be recorded.

PRINCE ALBERT AS PATRON AND ADMINISTRATOR

Prince Albert succeeded the Duke of Sussex as President of the Society of Arts in 1843. Founded in 1754 'for the Encouragement of Arts, Manufacturers and Commerce of the Country', the Society had held the first exhibition of works of art by contemporary artists in 1760, nine years before the founding of the Royal Academy. When the prince took office the Society was in financial straits, but he impressed on its members that the main object of its future existence 'must be the application of science and art to industrial purposes', and under his presidency the membership rose from 685 to 1,700, and a Royal Charter was granted in 1847.[51] Henry Cole was among those who worked with the prince, later his great ally in planning the 1851 exhibition and involved with him in the creation and establishment of the South Kensington Museum. The scheme for the first great international exhibition, to be held in Hyde Park, was only evolved in 1849. The prince was enthusiastic, and met with much discouragement, but the Great Exhibition of 1851 was an enormous success (plate 32). Members of the Society of Arts organised the 1862 exhibition, and, until the late 1880s, were involved with the development of the site in South Kensington. It was perhaps Prince Albert's main achievement that, even before it was known that a profit of £180,000 had resulted from the Great Exhibition, he was making plans to buy thirty acres in Kensington Gore and create museums, colleges of art and music and scientific institutions at South Kensington – something never before considered in England – as well as devoting a considerable part of the surplus fund to the purchase of land 'for a building for the National Gallery'.[52] The Prince Consort's last public function was to open the newly completed Horticultural Gardens at South Kensington on 5 June 1861.

The Exhibition of Art-Industry in Dublin in 1853 had included pictures, among them items from the Royal Collection. This persuaded other owners to lend. When the queen and Prince Albert visited the exhibition in August, the prince 'was especially interested . . . *by every new & useful discovery*'.[53] The important exhibition of Art Treasures of the United Kingdom, held in Manchester, was opened by Prince Albert on 5 May 1857. Again, when it was heard that the queen and prince would lend from their collection, other owners followed their example. Paintings had been excluded from the 1851 exhibition and the 1,550,000 visitors to the Manchester exhibition had their first opportunity to see a very impressive display of paintings, watercolours and prints, as well as photographs, Celtic and Anglo-Saxon antiquities, and

sculpture. The photographic exhibits helped to illustrate the interests of the royal couple in photography (see chapter 9). The prince had sat for photographers for the first time in 1842, in Brighton and London, and they lent over sixty photographs to the Manchester exhibition.

In 1847 Prince Albert, after a contested election, became Chancellor of Cambridge University. At that time the main purpose of the University was to train men for the Church, with the emphasis on the study of classics and mathematics. Natural sciences, modern languages, literature, law and history were neglected. The prince was shocked when he compared this with syllabuses at the universities of Bonn, Berlin and even Edinburgh. He instituted the Chancellor's Gold Medal for History and soon a new Moral Sciences Tripos was established. By the autumn of 1848, despite constant opposition, his plan for a reform of the studies at Cambridge was carried by a large majority. The prince's efforts to do 'something in my own name for my adopted country'[54] and to instil the love of learning for its own sake was to make him, perhaps, the greatest chancellor that the University has ever had. He was anxious also that science, until then almost excluded from school and university education, should be recognised and encouraged. Allied to his work for Cambridge, in 1859 the Prince Consort became President of the British Association.

The queen and the prince enjoyed the theatre. From the age of nine the young Victoria had often visited the theatre with her mother and had drawn theatrical scenes and figures as illustrations of productions. In 1852 the prince gave her a large album in which to mount watercolours of performances they saw together. For nine years, from 1850, Charles Kean's archaeologically correct productions (many being of plays by Shakespeare) were often played for the royal family at Windsor Castle. Royal patronage gave dignity to Kean's productions and made theatre-going more respectable than hitherto.

The queen loved music, had a charming voice and played the piano well. When Prince Albert arrived in England, Sir William Sterndale Bennett, then a recent student at the Royal Academy, told his Leipzig publisher that England was 'a dreadful place' for serious classical music, and he hoped that the queen's husband would 'do something to improve our taste'.[55] The prince presided over the Concerts of Ancient Music from April 1840 and selected many of the programmes, which had to consist of music composed more than 25 years earlier. He included many earlier compositions and lesser known works by Mozart, Gluck and Handel. The prince chose programmes for the Philharmonic Society, whose concerts were conducted on occasion by Wagner and Mendelssohn. The music of J. S. Bach was almost unknown in England before the arrival of Prince Albert, but on first hearing the St Matthew Passion at Windsor in April 1850 the queen found it fine, but a little fatiguing. The prince transformed the queen's private wind band into a full orchestra; formerly, whenever they held a dance, they had to hire string players. This orchestra gave the first performance in England of Schubert's C major Symphony. The prince composed and played on organs at Buckingham Palace and Windsor: 'It does one good to see Prince Albert's real love for music coming out when he is at his ease.'[56] In 1842 the queen and prince played with Felix Mendelssohn. At the prince's instigation Wagner's *Lohengrin* was heard for the first time in England in the drawing-room at Windsor; on the queen's eightieth birthday she was 'simply enchanted' by a performance of three acts from the opera that she attended in the Waterloo Chamber.[57]

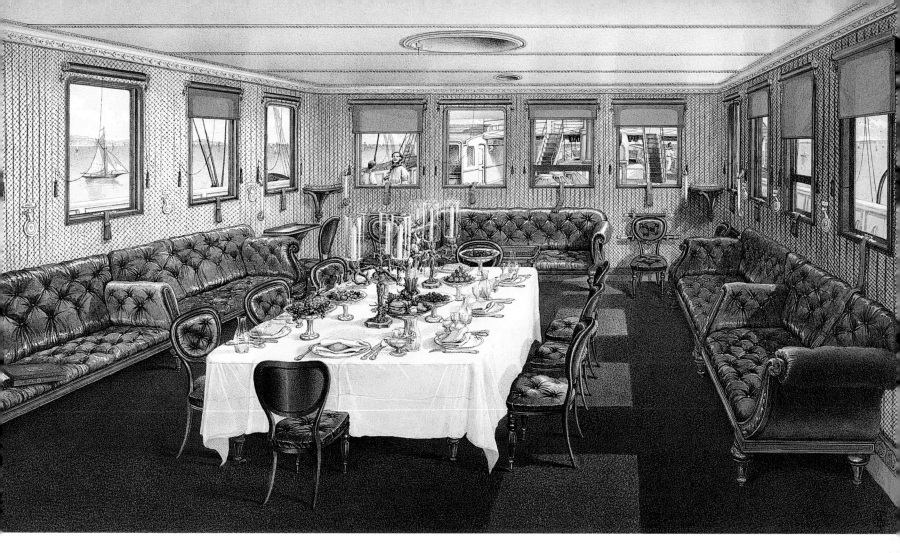

33 Edwin Aaron Penley,
*Views of the interior of the
Royal Yacht, 'Victoria and
Albert II': The Dining Saloon.*
Watercolour, 1864.
The Royal Collection
© HM Queen Elizabeth II.
This and five other views of
the interior of the yacht,
which was designed mainly
by Prince Albert, were
painted as mementos for
the queen after his death.
The deck can be seen
through the windows in
the distance, and Osborne
House is visible on the left.

One of the prince's first acts after his marriage was to reorganise the establishment in the palaces. An economical, sound and effective administration was created. The prince told Sir Robert Peel that without change 'there can neither be order nor regularity, neither comfort and security, nor outward dignity'.[58] In the mid-1840s at Buckingham Palace new wings were being built and the quadrangle enclosed to give more space for the increasing family. Ludwig Gruner, so successful as supervisor at the Garden Pavilion, was appointed 'an advisor in art to Her Majesty' in 1845. Prince Albert found Gruner a person with whom he could work, but was inevitably criticised for choosing yet another privileged foreigner to design and oversee his schemes for building and redecorating, both at Buckingham Palace and at Osborne House. From 1856, when Gruner was appointed director of the Print Room at the Royal Museum at Dresden, he was paid a retaining fee, but made only one visit a year to England. He was later closely involved with the designs of the Mausoleums of the Prince Consort and the Duchess of Kent.

When she came to the throne Queen Victoria had never been abroad and she envied the prince his time of study in Flanders, Italy and elsewhere before their marriage. Their first visit to Scotland in 1842 involved such a slow and uncomfortable journey in the old royal yacht that they returned south in a hired vessel. A new yacht, the *Victoria and Albert I*, was commissioned and her maiden voyage in 1843 was along the south coast, followed by a visit across the Channel to the Château d'Eu. It was now possible to sail around the coast of Britain and see, and be seen by, more of the queen's subjects. The *Victoria and Albert II* replaced the yacht in 1855 and was used for the rest of the reign (plate 33). In 1845 Queen Victoria visited Coburg, making

her longest journey by rail, 200 miles, to Cologne. By 1860 she travelled much faster by the new railroad and, by the end of her life, she could journey quickly and effectively, theoretically incognita, to Italy and the south of France. The queen enjoyed modern improvements around her. She first saw the railroad in 1837, with a steam carriage, 'enveloped in clouds of smoke and making a loud noise'.[59]

After three earlier visits to Scotland the royal couple, in 1848, leased and later purchased Balmoral Castle (plate 34). This enabled them to escape the crowds who followed them at Windsor or Brighton. Like his father, Ernest I, Duke of Saxe-Coburg-Gotha, the prince had a passion for architecture and enjoyed being closely involved with practical building projects. He organised the construction of Osborne House and Balmoral Castle with the builders Thomas Cubitt and William Smith, but was really himself the architect. They created healthy, comfortable and light surroundings,

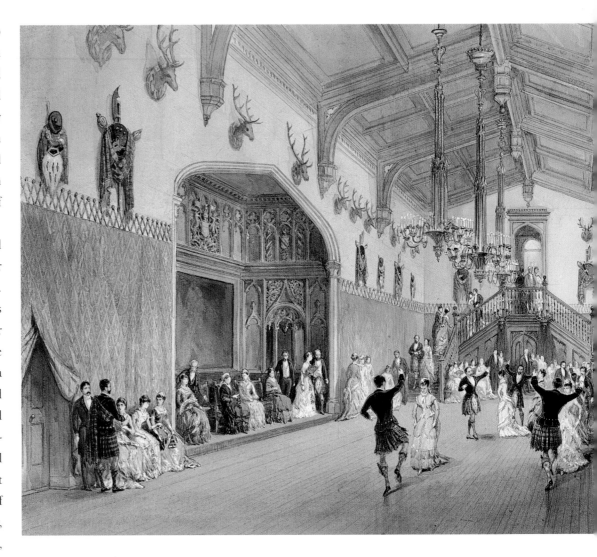

34 William Simpson, *Balmoral Castle: the Ballroom*. Watercolour and bodycolour, 1882. The Royal Collection © HM Queen Elizabeth II.

suitable for bringing up a family of nine children. At Balmoral the prince used fireproof bricks, thus not only encouraging new ideas in his own house, but spreading ideas for safety innovations.

At Windsor the prince diverted roads in order to gain more privacy. Aviaries were built for a collection of water fowl, and new kennels for the queen's dogs. The German 'dachs' breed introduced by the queen became popular in England through her encouragement. The prince, as Ranger of Windsor Great Park, took in hand several more farms on the Windsor Estates 'with a view to occupy myself a little with farming', and became interested in new theories and technological improvements.[60] The new Home Farm in Windsor Home Park, built in the later 1850s, was most successful, and he built a model dairy. At the Royal Agricultural Show at York in 1848 he assured his audience that 'science and mechanical improvement have in these days changed the mere practice of cultivating the soil into an industrial pursuit, requiring capital, industry, machinery, and skill and perseverance in the struggle of competition', which also demand 'higher efforts and a higher intelligence'.[61] He experimented with the steam plough, used new methods of farm accounting, joined the Smithfield Club, and exhibited cattle and pigs. The twenty years of the prince's interest coincided with the period when farming was

at its most prosperous and great agricultural improvements were being made. The Windsor Royal Association was set up in 1850. An annual flower show was held and prizes were given for the best-kept cottages and allotments on the estate – but tenants were disqualified if they worked on Sundays.

The Prince Consort's influence was felt in many and varied fields; his first speech, delivered in English, at Exeter Hall in London in June 1840, was as President of the Society for the Extinction of the Slave Trade and the Civilisation of Africa. As Master of Trinity House he worked to achieve a fair wage for the ballast-heavers, and worked for the regulation of factory labour. He designed model lodging houses for the working man and encouraged the setting up of Working Men's Clubs.

VICTORIA AND THE PRINCE CONSORT'S DEATH

All through their years together this intelligent and sensitive man had guided and sustained the queen: 'He is so good, and loves me for myself'.[62] But he wore himself out by overwork. After his death the devastated queen told her uncle, King Leopold, that not only she 'but England, my unhappy country, has lost *all* in losing him'.[63] For the last forty years of her life the queen felt that she was only waiting to join her beloved husband in an afterlife: 'How dreadful to be always lacking his advice & working in the dark without his unerring eye & great taste, striving to keep to indications of his wishes. For me, who am so ignorant about art, & constantly used to be satisfied, with what I ought not to have been, it is most difficult to decide things.'[64] No picture was to be moved without her permission. If a carpet or a wallpaper had eventually to be replaced because it wore out, it had to be replaced with something as closely identical as possible. Photographs of the arrangement of her rooms were taken to insure that no changes were made.

During the long period of mourning and seclusion, the queen never failed to carry out the business of government or deal with the necessary paperwork. She followed in detail the progress of the various wars fought during her reign, from the Crimean War onwards, and she took a deep interest in her troops and their welfare. In 1868 she witnessed a march-past of 24,000 soldiers and although very tired she felt 'greatly pleased and gratified'.[65] She travelled overnight from Balmoral to Windsor to see off her troops to the Boer War; for them she crocheted shawls and to each of 'her' soldiers at the front was sent chocolate, with a coloured print of herself on the box. She visited the military training camp at Aldershot and military hospitals because she felt it would have been the wish of the Prince Consort. It became an enormous effort to her to fulfil public engagements, but she decided to open Parliament in 1866. She visited prisons and hospitals, and laid the foundation stone of the new St Thomas's Hospital in London in 1868. She attended a garden party at Buckingham Palace where she struggled to recognise people after nearly eight years in seclusion and found it 'puzzling and bewildering'.[66] Inevitably, much of her time was taken up with discussing memorials to the Prince Consort. The creation of the Mausoleum at Frogmore was her prime objective and this she evolved with Ludwig Gruner. She took a close interest in the details of creating the Albert Memorial and the Royal Albert Hall in London, as well as the many statues to his memory.

VICTORIA'S TRAVELS AND THE END OF HER REIGN

In 1869 a new railway coach, with communicating compartments, replaced the old one, hallowed by its use by Prince Albert. After great efforts and difficulties the queen escaped incognita to spend some weeks in Switzerland in August 1868. There she assured the crown princess she would see no 'sights' and was unequal to the effort of visiting picture galleries or exhibitions. However, she enjoyed the splendid countryside and returned home better for the interlude. Paintings of the area were duly commissioned on Winterhalter's recommendation.[67] It was the queen's only visit to Switzerland, but in 1879 she stayed at Baveno on Lake Maggiore. At last she was travelling to places the prince had never visited and she believed that he would have been glad to see her taking an interest in all she saw. Following the queen's visits to the Continent, 'Victoria' proliferated as the name of hotels, halls and steamships.

Queen Victoria struggled with the joys and pains of her large family growing up, their matrimonial plans and, later, enjoyed her grandchildren. She made decisions, but not always the wisest ones. Her *Leaves from the Journal of Our Life in the Highlands* (1868; plate 35) sold thousands of copies, to the disapproval of her children and her entourage. She was proud of her sortie into this literary vein, and felt that by reading it her subjects would appreciate her marriage and good, simple private life. *More Leaves* was published in 1884.

Out of the public eye Queen Victoria was almost forgotten. For three years she did not show herself in public in London until, finally, after one particular Court, she drove from Buckingham Palace to Paddington station in her open carriage. She told her uncle Leopold, with some satisfaction, that when the Prince and Princess of Wales drove in London 'naturally *for them* no one stops, or *runs*, as they always did, and do doubly now for *me*'.[68] Eventually the long seclusion was abandoned. She unwillingly consented to attend the Thanksgiving Service in St Paul's Cathedral (27 February 1872) to celebrate the recovery of the Prince of Wales from the dreaded typhoid which had killed the Prince Consort. On 1 May 1876 she was declared Queen Empress of India. She opened, with splendour, the Colonial and Indian Exhibition at South Kensington in 1886, replying in her own words to a presentation address.

In 1887 the queen celebrated her Golden Jubilee in triumph. On 11 May she visited the Abbey to see the preparations for the service and, that day, before returning to Windsor, she went to Earls Court to see Buffalo Bill's Wild West show, which she found 'very extraordinary and interesting'.[69] The queen seemed to have regained something

35 Titlepage of the Hindi translation of Queen Victoria's *Leaves from the Journal of Our Life in the Highlands*. The Royal Collection © HM Queen Elizabeth II.

of the energy of her youth. On 20 June she drove in semi-state through the City, greeted with enormous enthusiasm by her subjects; she gave audiences and entertained guests to lunch and a large dinner in the evening. For the service in Westminster Abbey on 21 June she wore a black satin dress and a bonnet trimmed with lace and diamond ornaments, and all her orders. The service included the prince's setting of the *Te Deum*. The celebrations included garden parties, reviews at Aldershot and Spithead and the laying of the foundation stone of the Imperial Institute in Kensington.

The queen was at last visibly taking up the reigns of government again. Thereafter the throne came to be seen with unprecedented 'love and reverence'.[70] Still inspired by the prince's example, and almost in spite of herself, she became a great queen. She was fascinated with the wonders of modern science. She could listen at home on the telephone to speeches being made at the mayor's banquet in Liverpool. There were cinematograph films of her family and W. & D. Downey's cine-film of the Tsar and Tsarina visiting Balmoral in October 1896. She spoke on a phonograph cylinder to King Menelik in Abyssinia. As she left Buckingham Palace for St Paul's Cathedral on 22 June 1897, she 'touched an electric button, by which I started a message which was telegraphed throughout the whole Empire. It was the following: "From my heart I thank my beloved people, may God bless them!"'[71]

One of the queen's last public appearances was on 17 May 1899 when she drove to South Kensington to lay the foundation stone of Sir Aston Webb's monumental building, the newly named Victoria and Albert Museum: 'I trust that it will remain for ages a Monument of discerning Liberality and a Source of Refinement and Progress.' Her words could have been written by the Prince Consort.[72] In April 1900 she gave up her visit to the Continent in order to visit Ireland. Encouraged by the enthusiasm and affectionate loyalty, she wrote: 'It was really a wonderful reception I got and most gratifying.'[73]

By the time she died the queen had lost three of her children. She suffered ill-health, failing sight, lack of appetite and sleeplessness: 'It is hard at eighty one . . . I pray God to help me to be patient and trust in Him, who has never failed me.'[74] When, two days before she died:

news of her approaching end had been made public, astonished grief swept the country. It appeared as if some monstrous reversal of the course of nature was about to take place. The vast majority of her subjects had never known a time when Queen Victoria had not been reigning over them . . . She herself, as she lay blind and silent, seemed to those who watched her to be divested of all thinking – to have glided already, unawares into oblivion.[75]

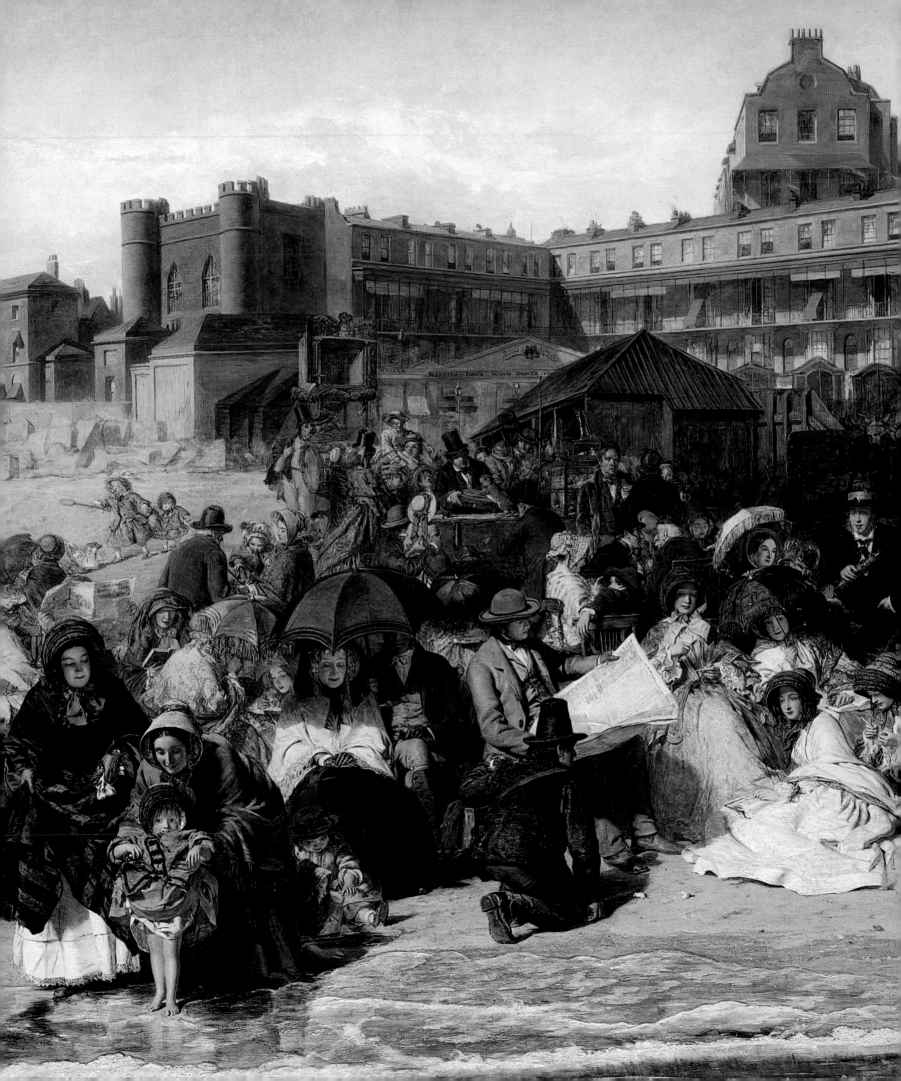

HOME AND LEISURE

JOHN K. WALTON

One of the key themes running through the contemporary representation of Victorian Britain was the family, as icon of morality, respectability, security and comfort.[1] The domestic hearth, with its coal fire and clutter of treasured possessions and souvenirs, was presented as the cosy core of an oasis of serenity, where men who had struggled with the elements, striven to master the market or embroiled themselves in the various levels of political conflict could find rest and recreation, in the sense of purposeful relaxation to prepare for renewed exertions. Home was the ultimate private space which was proverbially 'the Englishman's castle', defended from the prying eyes and unwanted interference of neighbours and governments. The ideal home required a wife fully committed to the demanding domestic duties which were required to sustain cleanliness, pleasant surroundings and a regime of properly cooked meals at regular intervals.

36 and **37** William Powell Frith, *Ramsgate Sands: 'Life at the Seaside'*. Details.
Oil on canvas, 1854. The Royal Collection © HM Queen Elizabeth II.
Frith's panorama of the beach at Ramsgate shows a resort popular with Londoners,
which (along with Margate) was fed by the Thames steamers as well as the
rather circuitous Kentish railway system. This celebration of the capaciousness of the
seashore (all human life is here, as the *News of the World* used to say) is stronger on
inclusion than exclusion and on harmony than conflict; but it does express the capacity
of the seaside holiday to be most things to most people.

This was during a period when domestic technology was improving, but only slowly, and rarely in labour-saving ways. The nuclear family was completed by a suitable number of children, well-schooled and orderly, and augmented frequently by living-in domestic servants, and less so by elderly parents, cousins or more distant relatives.[2] Authority was vested in the father, domestic management in the mother, and the male right to rule was as God-given as the constitution, however the workings of the latter might change in detail.[3] These assumptions about what home should be, entwined with the belief that such domestic arrangements were the foundations on which stability, prosperity, good governance and Empire were necessarily based, formed an enduring dominant and orthodox discourse throughout Victoria's long reign.

The celebration of such values was not new in the 1830s, but their dominance practically coincided with the accession of the young queen. From the aristocracy to craft-workers and tradespeople, the monogamous marriage and the separation of workplace and home, public and private, as male and female domains became the expected norm, while the provincial middle classes moved out from their central workshops, warehouses and counting houses to the drawing-rooms and gardens of suburban Edgbaston in Birmingham or Manchester's appropriately named Victoria Park.[4] Among skilled workers, the growing aspiration to earning a 'breadwinner wage' and keeping a wife and family in domestic respectability was a strong mid-century theme, helping to fuel campaigns to marginalise waged work outside the home for women and (on a widening definition) children.[5] There were dissenters who preferred to maximise family income from multiple sources – families in which men, women and children worked side by side, or contributed on a casual or seasonal basis as and when they could, remained common throughout the reign among small businesses like lodging-houses or fish and chip shops as well as among the urban poor; but such arrangements were increasingly viewed with suspicion from without.[6] The ideal of the 'closed, domesticated nuclear family', to quote Laurence Stone's view of the emergent norm among the eighteenth-century aristocracy, was firmly in the ascendant.[7]

For its fullest and most satisfying expression, however, this ideal required appropriate resources and domestic consensus; and in practice these were forthcoming in widely varying degrees. This was a very unequal society. The aristocracy and gentry, and the wealthy upper middle classes who increasingly consorted with them (drawn more from the ranks of London bankers, financiers and merchants than from factory masters), could afford splendour which went dangerously beyond the realms of the domestic, with labyrinths of specialised rooms, furniture which might call up images of the hunting field or of exotic fauna, marble fireplaces, artistic masterpieces, hothouses to provide pineapples and peaches for groaning tables, landscaped parks and gardens and a demanding round of hospitality and display.[8] Here, as moralists warned, the virtues of domesticity were all too likely to be swamped by leisure and luxury, while the troops of servants, hierarchically ordered, who ministered to every need (including, all too often, the sexual importunities of the young master), undermined the virtues of direct involvement in the running of the household, while by their ubiquitous presence paradoxically denying the privacy and domestic segregation which were central to the domestic ideal in its fullest Victorian form.[9]

The problem of how to assimilate servants into family life also afflicted the mainstream Victorian middle class, the professionals, manufacturers and traders for whose circumstances and aspirations the ideal was most firmly and (in material terms) attainably constructed. This was a rapidly expanding group, drawing in its wake a parallel growth in the numbers of domestic servants, the fastest-growing and most numerous female occupational group almost throughout the Victorian years. Servants took on the dirty drudgery which would have polluted and demeaned the middle-class housewife, but in so doing themselves became 'matter out of place', to be hidden away in kitchen and scullery except when cleaned up and coiffed to answer the door and receive guests.[10] As regards their employers, the historian R. S. Neale proposed a useful division between a solid, well-established middle class with property, capital, comfortably off relations and confident taste and discrimination at its back, and a less secure 'middling class' of newer and more recent affluence, always terrified of falling back into the abyss from which it had arisen.[11] It is also tempting to suggest an overlapping but far from identical broad distinction between the 'respectable' and the more hedonistic, even disreputable middle classes: the churchgoing, thrifty and family orientated, and the gamblers, drinkers, habitués of clubs and music halls, and keepers of mistresses. The challenge posed to respectable orthodoxy by the latter group, whose tastes and enjoyments often linked it with raffish aristocrats, reprobate working men and women of equivocal (or indeed unequivocal) reputation, provoked reinforcement for the bastions of ostentatious worthiness and, in the process, spread the growth of that emblematic Victorian vice, hypocrisy.[12]

Appearances certainly mattered. The need to sustain them helped to perpetuate a pattern of late marriage among the Victorian middle classes, as young men waited until they could sustain the 'paraphernalia of gentility' of carriage, three servants and expensive schooling for the children.[13] This in turn encouraged disreputable patterns of behaviour among the rising generation, whether students, clerks awaiting promotion, or others on the lower rungs of middle-class preferment, not always excluding junior clergy. Styles and presentation of clothing were badges of status, with clean, pressed linen an especially telling marker, keeping legions of laundresses in business.[14] Domestic exteriors and interiors were also pressed into service, with increasing complexity as sub-divisions of the middle classes proliferated from mid-Victorian times. Outward impressions might be graduated from the bay window, patterned brickwork, ornamental doorcase and pocket-handkerchief lawn which marked out the lower levels of precarious Pooterish pretension, to the spires, stained-glass and shrubbery of the outer suburban villa with its tennis court and pergola.[15] Indoors, the presentation of self, servants and style to guests might introduce a minefield of conflicting choices and signals. Furniture and decor were often supposed to mark distinctions between the solid middle classes and the *nouveaux riches*. Thus Rosemary Allwood identifies the setting for G.E. Hicks's painting *Changing Homes* of 1862 as the home of recently ascended social climbers:

Like the Veneerings in their mansion, 'Stucconia', the family is 'brand-new'. Gilded furniture – like the new rococo chair with its aniline dyed magenta stripes – and white and gold plasterwork were very popular with newly-rich Victorians.[16]

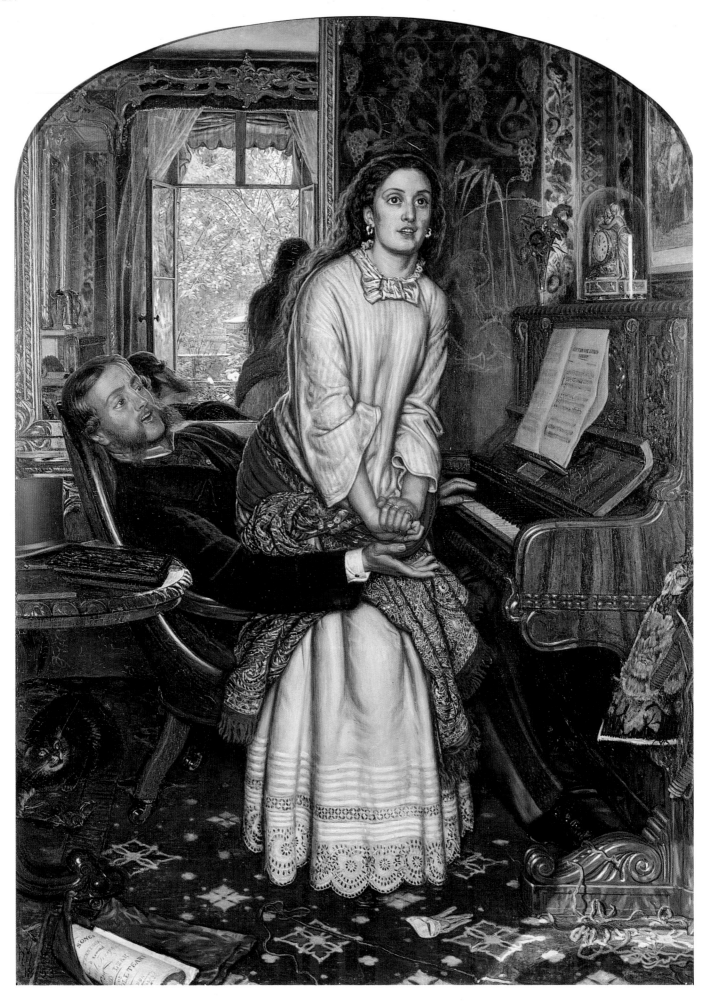

38 William Holman Hunt, *The Awakening Conscience*. Oil on canvas, 1853. Tate Gallery © 2001.

39 Titlepage from Mrs Beeton's *Book of Household Management* (1859). The British Library.

Dickens is here called in as witness to the bad taste exhibited by a family who lacked heirlooms and had been seduced by the vulgar vividness of the new chemical dyestuffs: a reminder of the persisting tension between tradition and innovation in Victorian society, which applied as strongly to consumption as anywhere else. To what extent contemporaries shared this retrospective reading is unclear. *The Times* did denounce the picture's bland sentimental prettiness, including its undue attention to millinery; and the moral agenda is at one remove from the effect deliberately sought by Holman Hunt's *The Awakening Conscience* (plate 38), where the mistress starts up from the embrace of her lover in a richly furnished house that is not a 'home' in the approved sense, and which betrays its superficiality and immorality through 'the shining newness of the furniture', which 'suggests by contrast the complete severance from the old home' and the descent into what contemporaries saw as prostitution.[17] Here indeed was the raffish middle class at play, perhaps in London's St John's Wood district where artists and rich men's mistresses lived cheek by jowl; and this is, in turn, a reminder that middle-class Victorian marriages did not always, or perhaps even often, resemble the ideal. The popular press reported salacious divorce cases with great glee to titillate the working-classes on Sunday mornings, especially after the Divorce Act of 1857; while domestic violence surfaced here as well as in working-class districts, and regular, well-publicised cases of wives poisoning spouses by the slow and debilitating method of arsenic kept husbands aware of the perils of their situation.[18] Children often spent much of their time with servants, even where a governess could not be afforded, while boys were increasingly dispatched to the harsh environment of the so-called public schools.[19] Even the servants were often capable of asserting themselves and profiting from 'arrangements' with tradesmen, while their knowledge of family secrets led householders to fear undesirable relationships, theft and burglary.[20]

This unease was also in evidence in dealings with near-equals. Personal comportment, servants and cooking were all on display when a family entertained; and the enduring success of the almost-eponymous Mrs Beeton (plate 39), who gave her name to a genre in which she had many Victorian precursors and rivals, demonstrates the widespread need for guidance and reassurance, especially for women who had moved beyond their mothers' sphere of experience.

Advice on how to deal with servants, how to prepare elaborate dishes, how to manage a household budget without losing face and how to participate in the demanding rituals of leaving cards and exchanging hospitality, was clearly at a premium in these rapidly changing times.[21] This was a ritualistic society, but fashions changed within it, with tangible consequences. Thus fashions for extended mourning, marked by ostentatious dress and ornamentation, promoted the jet mining and working industry to a dominant place in Whitby's economy during the 1850s, employing over 1,000 people. Queen Victoria's endorsement of jet when mourning Prince Albert in 1861 kept demand high, and the peak lasted until the late 1860s, whereupon changes in fashion (coupled with competition from new sources of supply) brought the numbers down to perhaps six hundred in 1883, with continuing decline thereafter. In such ways the fluctuating rituals of the comfortably off in Victorian Britain might give and then take away employment in a small provincial town.[22]

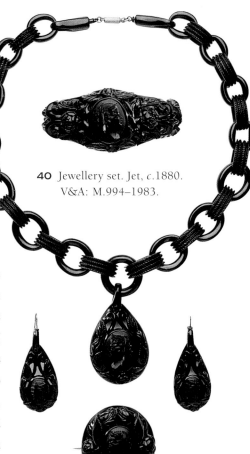

40 Jewellery set. Jet, *c.*1880.
V&A: M.994–1983.

Questions of taste might pose problems in other ways. At the other extreme from rococo chairs with magenta-striped fabrics stood the work of William Morris's firm, which produced stained glass, tapestries (plate 41) and wallpapers while seeking to re-create medieval craftsmanship, colours, and pride and fulfilment in work.[23] Wall and floor coverings were another Victorian growth industry, with sufficient impetus to revitalise the ailing economy of Lancaster, make huge fortunes for its two leading entrepreneurial families, and generate a lot of employment elsewhere too.[24] Morris's contribution was of a different order. He was a pioneer socialist who rejected the grimy artificiality of industrial society; but the key paradox was that he, too, profited from the labours of his workforce, and he was unable to produce household articles at a price the working class could afford. Instead, Morris became, in effect, a brand-name attached to a niche market, a claim to status and cultural capital on the part of

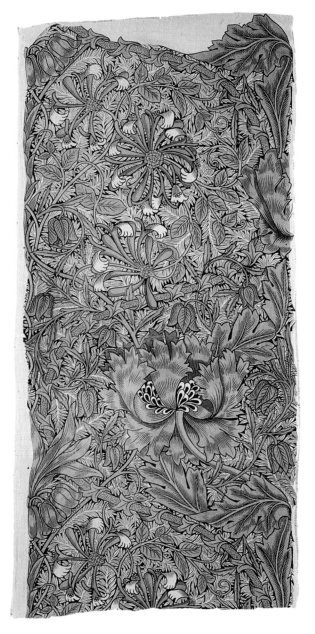

41 William Morris,
Honeysuckle. Furnishing
fabric, printed silk, 1875–6.
Printed by Thomas Clarkson.
V&A: Circ.491–1965.

42 Fern garden seat. Cast iron, *c*.1880. Coalbrookdale, Ironbridge Gorge Museum Trust.

middle-class consumers identifying with a particular version of taste and discernment.[25] One of Morris's mentors, John Ruskin (another, in very different idiom, was Karl Marx), retreated from the poisonous 'storm-cloud' of polluting industrialism to Brantwood, on Coniston Water, extending an existing house by accretion, filling it with works of art and natural history specimens, and making an informal garden in the woods above the lake-shore. Here he would sit, on a simple wooden seat, watching carefully trained rills of water splashing over stones and mosses. This was the epitome, and for many the fountainhead, of an aspiration towards contemplation, withdrawal and communing with nature, which became widespread in the late nineteenth century as an articulate minority movement among the lower-middle and skilled working classes, encouraged by the wide diffusion of Ruskin's own writings, and helping to encourage the popularity of walking, cycling and early footpath protection and access movements.[26] But the dominant tastes of the time were more elaborate and technology led, although retreating from the High Victorian extravagances which the Great Exhibition of 1851 had ushered in and tended to celebrate. A wrought-iron Coalbrookdale garden seat (plate 42), from which a formal and controlled garden layout could be surveyed, constitutes a much more convincing symbol of mainstream middle-class taste, although the appreciation of ferns which this example celebrates reflects a popular collecting craze of the mid-Victorian years, which expressed Ruskinian enthusiasms in ways which bore a very uneasy relationship to his own beliefs.[27]

A similar tension was expressed in the combination of celebrating technology and sentimentalising relationships which characterised the Victorian home. On the one hand there were real innovations which added quality, predictability, control and security to household processes. Piped water was the most important innovation: the big storage reservoir was largely a Victorian development, and fortunate or enterprising urban areas were able to tap into the pure supplies of distant upland catchments, as Liverpool reached out to Rivington Pike and then into Wales, while Manchester went to the Peak District and then, controversially, to Thirlmere in the

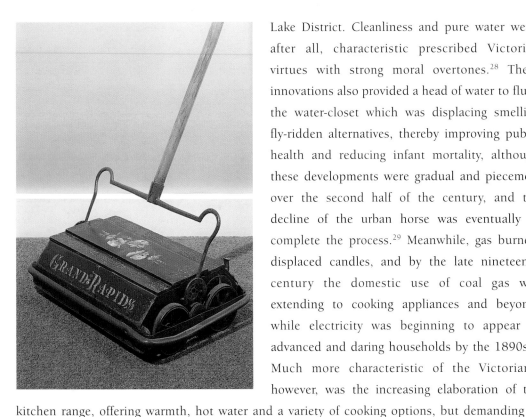

Lake District. Cleanliness and pure water were, after all, characteristic prescribed Victorian virtues with strong moral overtones.[28] These innovations also provided a head of water to flush the water-closet which was displacing smellier, fly-ridden alternatives, thereby improving public health and reducing infant mortality, although these developments were gradual and piecemeal over the second half of the century, and the decline of the urban horse was eventually to complete the process.[29] Meanwhile, gas burners displaced candles, and by the late nineteenth century the domestic use of coal gas was extending to cooking appliances and beyond, while electricity was beginning to appear in advanced and daring households by the 1890s.[30] Much more characteristic of the Victorians, however, was the increasing elaboration of the kitchen range, offering warmth, hot water and a variety of cooking options, but demanding worship by acolytes enslaved to rituals of fire-setting, ash-removing and blackleading, and playing host to silverfish and other heat-seeking unofficial domestic fauna. For most purposes, in most households, coal remained king, as fire manipulation systems became more effective but the continental stove was resisted. The blazing fire-grate remained the central symbol of domestic comfort and harmony, despite the draughts (of some symbolic significance, perhaps) which swirled icily at the backs of rooms. Its continuing profligacy contributed materially to the smog which made the wintry outside world all the more forbidding, and the smuts, which increased the drudgery of domestic washing. Coal's hegemony

43 'Grand Rapids' Bissell carpet sweeper. 1895. Science Museum, London/Science and Society Picture Library.
As it is pushed along, the wheels of the carpet sweeper rotate a brush underneath. The brush dislodges the dirt and sweeps it inside.

44 Hand operated wooden washing machine. 1890.
Made by William Sellers of Keighley, Yorkshire. Science Museum, London/Science and Society Picture Library.
Turning the large wheel continuously in one direction causes a backwards and forwards movement – the tub automatically reverses the direction at every stroke. The mangle is operated by another handle.

intensified the treadmill labour of dusting around and behind the plethora of ornaments and dust-attracting fabrics, and it was sustained in better-off households by the enduring availability of cheap domestic servants.[31] In other respects, and perhaps for similar reasons involving cheap or unwaged female labour, Victorian entrepreneurial inventiveness was lacking in the potentially lucrative domestic technology sector: even washing machines remained primitive, unreliable and unusual (plate 44), and only the sewing machine, from the 1860s, made significant headway.[32] What innovations there were remained socially skewed in their application: dumb-waiters and, at an extreme, narrow-gauge railways from kitchen to table remained aristocratic foibles, and few could hope to emulate the transfer of hydraulic technology from shipyard to great-house kitchen

45 Victorian Christmas Card. V&A: E.1118–1933.

which Sir William Armstrong was privileged to enact at Cragside, Northumberland.[33]

The tendency to sentimentalise Victorian domesticity was founded on an ideal which only the better-off families had the resources to meet, even in purely material terms. The 'angel in the house' could not remain aloof from dust, dirt and drudgery even at lower-middle-class level, where a single servant, however exploited, necessarily left some contaminating labour to her mistress.[34] And, as reform campaigners were well aware, working-class families' need for extra sources of income meant that children usually had to contribute as early as possible, as the market place overwhelmed any notion of the idealisation of childhood innocence.[35] The ideological imperative to keep the home invulnerable to external inspection and regulation set limits to the aspirations of reformers of manners and morals, although the legions of abandoned children and rough sleepers provided legitimate targets for philanthropy.[36]

But the ideal working-class home was relentlessly presented as a haven of domestic peace, where women filled their allotted roles and did not go out drinking or fritter time away with gossiping friends. This failed entirely to understand the culture of low and irregular wages in which people lived for today, used the pawnbroker as bank and wardrobe, sustained neighbourhood groups of borrowing, lending and sharing, and viewed the great festivals like Christmas as an excuse for a binge.[37] The Victorian reinvention of Christmas, with the tree imported from Germany and popularised by Prince Albert, the cards (plate 45), gifts and (from the 1860s) avuncular persona of Santa Claus (another import, from the United States), came from the top down; and although it celebrated paternalism and charity (the reformed Scrooge, Good King Wenceslas), its depictions of working-class contentment were comfortable idealisations. The same applied, more generally, to the iconography of the picturesque thatched cottage and the contented rural labourer, which bore little resemblance to the well-documented struggles to exist confronted by the rural poor. The cat in the cottage window is a misleading symbol (plate 46).[38] Gustave Doré's depictions of urban destitution provided a salutary symbolic corrective.[39] At the very bottom of the social scale, the 'residuum' was the object of fear and fascination, as tramps and the denizens of common lodging houses were pitied and condemned, but the apparent freedom of their lifestyle from respectable

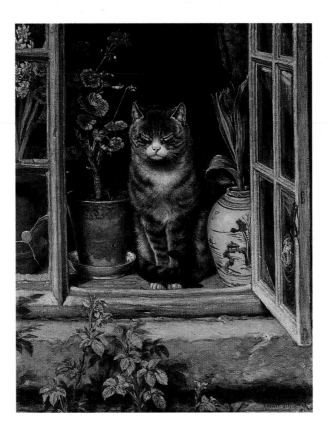

46 Ralph Hedley,
Cat in a Cottage Window.
Oil on canvas, 1881.
Laing Art Gallery, Newcastle.

47 Frederick Walker,
The Vagrants. Oil on canvas,
1868. Tate Gallery © 2001.

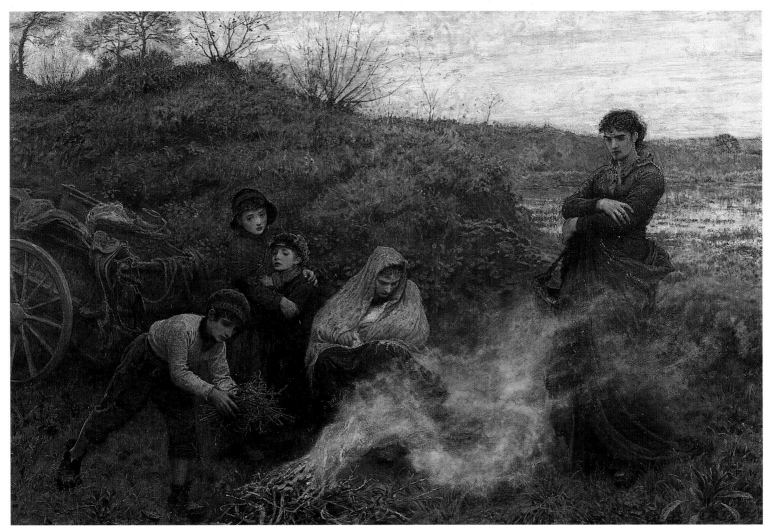

constraints and labour discipline might also provoke a touch of envy. Such ambivalence was particularly obvious in attitudes to gypsies, who were stigmatised as thieves and vagabonds, but also romanticised as the proud bearers of distinctive racial and linguistic traditions, meriting the respect that went with serious anthropological investigation.[40]

None of this denies that working-class living standards improved considerably during Victoria's reign, offering wider access to security through health insurance and trade union membership, as well as opening out new opportunities for spending on the cornucopia of cheap pleasures and popular items of consumption which became available in response to the visible expansion of demand. Improvements in real wages began in earnest among the 'labour aristocracy' of skilled and supervisory workers in the 1850s and 1860s, as earnings outpaced prices, trade depressions bit less damagingly than they had during the 'Hungry Forties', and the threat of technological unemployment receded. Life remained precarious lower down the scale, but after a short burst of inflationary wage increases in the boom of the early 1870s, the rest of the reign saw a steady growth in purchasing power right across the working class, as prices fell and cheap new commodities came in from the Americas and the Empire.[41] Even at the turn of the century, large numbers of workers in unskilled, casual or 'sweated' occupations still had no margin above subsistence, as the very limited diets of many thousands of families living at 'round about a pound a week' in the poorer areas of London, Liverpool, Birmingham or Salford bore witness. The Edwardian Salford described in Robert Roberts's autobiography bore witness to this, with its efforts at keeping up a respectable front (curtains in front but not rear windows, donkey-stoned doorsteps and the virtuous routine of Monday as washing-day), juxtaposed with ubiquitous dirt and hand-to-mouth expedients for getting by, and much cooking still done on the frying-pan above an open fire in the absence of the most basic domestic technology.[42]

With rising real wages went improvements in living conditions and easier access to commercial entertainment in the growing and multiplying urban centres, including the rapidly developing systems of seaside resorts which burgeoned on every accessible coastline. From the 1860s new houses were increasingly built to minimum standards prescribed by local authority regulations, and even where they were merely 'two up and two down' or little more, they had a little private space at the back and scope for furnishing a 'best room' for Sunday rest and display. Souvenirs from seaside trips, usually tokens of filial affection, colonised mantelpieces and sideboards, while the democratisation of wall and floor coverings, together with the growing availability of soft furnishings and even of cheap pianos on hire-purchase, softened the necessary austerity of working-class homes. Household soaps and patent cleansers combined with the gas and water supply improvements to make domestic cleanliness more accessible, while patent meat extracts like Bovril took some of the drudgery out of cooking. By the end of the nineteenth century most working-class households were benefiting from these developments, despite the persisting poverty of the 'slums'. Such essays in domestic consumerism, aided by practical contributions from increasingly domesticated husbands, significantly marched hand in hand with declining alcohol consumption and tighter restraints on pub licensing on the new 'by-law' estates during the last quarter of the nineteenth century, as home and family began to challenge workplace and pub as the defining influences on male working-class identity.[43]

This was to be a long and never-completed process, however, and it was complicated by the emergence of new commercialised urban pleasures which took working-class men (especially) out of the home to destinations other than the pub. To some extent they grew out of it, as from the early Victorian years the music hall evolved out of the more informal pub 'free-and-easy', with the professionalisation of acts, a shift to purpose-built premises and the banishment of drink from the auditorium. The big purpose-built music halls of the 1850s onwards, starting in Lancashire as well as London, celebrated both popular patriotism on an imperial stage, and the shared values of local communities, while sending up snobbery and pretension. Local government increasingly sought to marginalise alcohol and prostitution, and owners became reluctant to offend, especially as their interests lay in attracting a broad cross-section of potential customers by respecting a shifting shared definition of consensual respectability. Fire and other safety regulations could be manipulated to enforce compliance, although performers' expertise in innuendo and *double entendre* limited the efficacy of attempts at censorship. Those who wanted something rougher, earthier, cheaper or simpler could still go to less glamorous performances in back-street pubs, but the big music halls made a significant difference to popular leisure habits, drawing in growing numbers of respectable women as well as men towards the turn of the century, and both shaping and responding to popular attitudes and values through their catch-phrases and idols.[44]

The rise of commercial (and indeed amateur participant) sport also took working-class men out of the home, mainly at the weekend, which was itself a Victorian concept, growing out of the spread of the Saturday half-holiday and the decline, from the 1850s, of the custom of taking 'St Monday' off.[45] Football became the predominant spectator sport during the last quarter of the nineteenth century, as its decline as local calendar custom with minimal local rules and mass participation was transected from the 1860s by the codification of rules derived from the public-school tradition, and the acceptance of the middle-class versions of the game (handling and dribbling, and with strict limitations on space and time) by a broader popular constituency. As teams captured local loyalties and embodied local identities in industrial towns, so professionalism began to spread and working-class teams overturned

48 Edward Henry Potthast, *The Barnum and Bailey Greatest Show on Earth*. Poster, 1895. V&A: E.448–1939.

the hegemony of army officers and public-school old-boys, remaking the game in their own image. This was grudgingly accepted by the rulers of Association football, enabling the Football League to develop from 1888, but the same issues split the handling game, and northern, professional Rugby League split off from Union in 1895. But it was Association football that became 'the people's game', drawing crowds of tens of thousands in the big cities, with cloth caps predominating overwhelmingly, and enabling sporting entrepreneurs to invest in new stadia with towering grandstands. Below this level were tiers of lesser teams, although we hear less about the game as a working-class participant sport. What the game embodied, as to a lesser extent did cricket, was the loyalties to neighbourhood and town which were crystallising as raw industrial centres became settled communities with their own customs and ways of life, depending on the world market but settling into their own insularity as industrial societies.[46] Cricket followed a different trajectory, with players from different classes much more likely to combine in the same team, and the county rather than the town or city providing the

49 Calcutta Cup. Silver, 1878. Made by Jellicoe of Calcutta. Scottish Rugby Football Union.

geographical basis for the game at its highest commercial level. Here, working-class players were segregated as professionals and social inferiors; but the village game, rightly or wrongly, was often romantically presented as bringing together squire, blacksmith and labourer, young and old, in sporting harmony. By the turn of the century, however, the fiercely competitive Lancashire leagues could be a different matter. At the top end of the sporting scale international matches were becoming popular towards the end of the reign, and long series of competitions for trophies like the cricket's Ashes or Rugby Union's Calcutta Cup began to accrue their own folklore and halls of fame (plate 49). Test Match cricket, in particular, had moved a long way from the original visit by a team of native Australians, who were viewed more as curiosities than sportsmen, to bring the far-flung parts of the settler empire into mutually reinforcing ritual conflict, the less-amiable aspects of which were mainly reserved for the future.[47] The music hall and football match became regular excursions, punctuating the mundane weekly routine, and attracting white-collar workers from shops and offices as well as the better-off among the working class itself. Occasional spectacles added spice, as circuses and exhibitions visited (plate 48), offering glimpses of ever more exotic fauna and ways of life. These might be incorporated into year-round entertainment programmes at places like Manchester's Belle Vue, with its fireworks and tableaux showing battles or vivid versions of the architecture and costumes of distant cultures. More usually they coincided with the great local fairs and wakes, calendar customs which were exploited by travelling showmen and provided increasingly elaborate alfresco entertainment for the locals.[48] There were also great annual sporting festivals which brought all classes together to share the spectacle, though from different vantage points according to ability to pay.

SPORT

Victorian England invented sport as we know it, and exported a wide range of activities to the formal and informal empire, wherever British economic influences generated expatriate settlement. Association football and lawn tennis, especially, vie with the beach holiday as the most important worldwide British cultural export apart from the English language itself. Football was reinvented by the Victorians, as the declining tradition of mass games between one end of a village or town and the other gave way to the codified sport, limited in space, time and numbers and governed by rules, which emerged from the 'public' schools and was spread by muscular Christians among the industrial working classes. These in turn took over the game for their own purposes, and it became a great spectator sport from the 1870s onwards, as clubs became

50 New Year card, depicting boys playing rugby. Watercolour. V&A: Bud 1.1.51.

emblems of civic pride and (paradoxically, in a sense) began to hire in professionals, especially from Scotland and north-eastern England, as the FA Cup knock-out tournament gathered momentum after 1872 and a national Football League was formed in 1888.

Alongside these masculine spectator sports were developed games which could be played on the well-tended lawns of country houses and middle-class villas, and which incorporated ladies as part of decorous courtship rituals. Croquet and lawn tennis were prominent among these mid-Victorian developments, and archery also had a vogue in this guise. Golf, which was to become another meeting-ground for the sexes, was still a masculine preserve in Victorian times, spreading rapidly from the Scottish links to colonise seaside resorts and salubrious suburbs in the late nineteenth century.

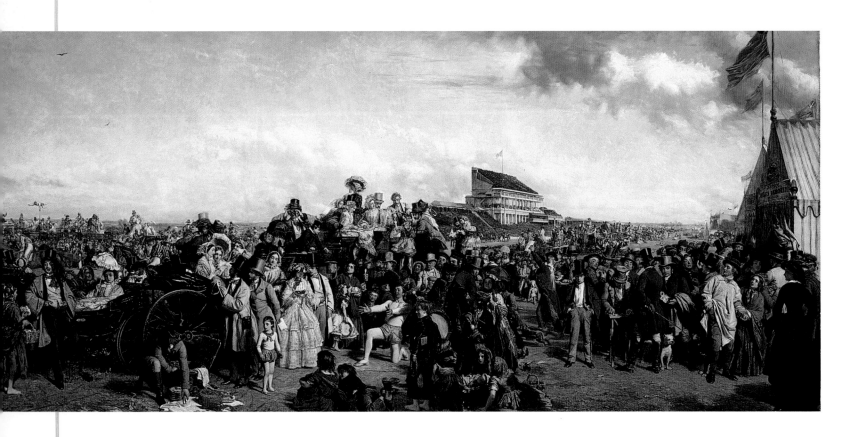

52 *Australian Aboriginal Cricketers*. MCC
Photo Library.
Cricket came to be a classic vehicle for what
was supposed to be amicable sporting
competition between the settler colonies. The
first tour party to visit England was composed
of native Australians, and test matches for the
theoretical custodianship of 'the Ashes' (so
named when 'English cricket' was cremated
after defeat by the Australians) attracted
growing media attention and large crowds
towards the end of the century. This nurtured
a distinctive brand of cricket reporting, with
aspirations to 'fine writing' which all too
readily descended into cliché.

53 Charles March Gere, *The Tennis
Party*. Detail. Oil on canvas, 1900.
Cheltenham Art Gallery and Museums.
Tennis was invented for just this sort
of occasion: a relaxed summer
afternoon on which the young of both
sexes could meet on the lawns of
country houses and comfortable
suburban villas, in a setting which
excluded the socially unsuitable.

51 William Powell Frith, *Derby Day*. Detail. Oil on canvas, 1856-8.
Tate Gallery © 2001. The Derby meeting at Epsom in Surrey was the great popular
event in the metropolitan sporting character. The social contrasts between the
fashionable, the poor and the 'dangerous classes' were so visibly in evidence that
the scene was ideal for this popular and much-reproduced genre painting.

54 John Q. Pringle, *Repairing the Bicycle*. Oil on canvas, *c*.1889. Glasgow
Museums: Art Gallery and Museum, Kelvingrove.
During the last two decades of the century the bicycle rapidly came to represent
new freedoms, especially for women, the lower middle classes and the upper
working classes. It was an easier means of escape from town and chaperone than
the horse. Cycling clubs, which proliferated in the 1890s, included radical
organisations like the Clarion Club, which preached romantic socialism in the
countryside. Looking after the bicycle, especially when it was second-hand and
unreliable, became an early example of 'do-it-yourself' and the application of
the craftsman's skills to leisure.

Derby Day at Epsom was perhaps the greatest of these. Its upper-class popularity made it impossible to transact parliamentary business, while special trains and a variety of road conveyances brought a seething mass of humanity, from costermongers, card-sharps and gypsies upwards, creating an action-packed, picaresque panorama with endless scope for the painter or journalist. The Derby was also a highlight of the betting year for the thousands of regular working-class punters who kept the illegal but popular street bookmakers in business; and the big race meetings generally brought together the raffish of all classes, from lordly enclosure through the merchants in the grandstand to the 'roughs' and prostitutes in the beer tent. But other sports were capable of generating an accompanying carnival or saturnalia, including a classic Victorian invented tradition, the Boat Race between Oxford and Cambridge Universities. This somehow attracted a popular following and regularly featured an epidemic of drunken pranks and assaults on the police, especially but not exclusively by undergraduates.[49]

This is a reminder of the persisting roughness of much popular culture, despite attempts at reform, and extending to those members of the higher classes who joined in with enthusiasm. The 'popular' blood sports of bull-baiting and cock-fighting were officially suppressed at the beginning of the reign, although the latter survived strongly at dawn meetings and on enclosed premises throughout the period and beyond. The investigative journalism of (for example) Henry Mayhew in London and Hugh Shimmin in Liverpool exposed a grubby mid-Victorian pub underworld of pugilism, dog-fighting, competitive ratcatching, bawdy songs, scantily clad dancers and prostitution, which embraced young men from offices and counting houses as well as labourers.[50] Such activities were part of a culture of rough masculinity which prioritised strength, vigour and determination, and within which women were always vulnerable to assault and sexual molestation. Awareness of this helped to construct the codes of respectability which restricted the public spaces that were comfortably accessible to women, who preferred to distance themselves from jostling, profanity and innuendo; and in working-class neighbourhoods gossip played an important part in policing them, although it could do little or nothing to prevent violence directed at wives and partners within the home.[51]

Not that the leisure of 'respectable' working-class women was confined to home and family, though even here the rise of the cheap popular press and the increasing availability of (for example) sheet music and knitting patterns helped to reduce the monotony. Church and chapel offered sociability, and many pubs had small rooms set aside for female customers. Saturday-night shopping might mix pleasure with necessary labour, especially where markets included showy auctioneers who entertained with their patter, or small-scale fairground attractions. Once or twice a year, too, the pleasures of the seaside increasingly beckoned to those working-class families who could afford them.[52]

The seaside had been a popular holiday destination before the railways: the medical fashion for sea-bathing which had taken hold in the eighteenth century was built on traditional bathing and drinking customs at the high tides which followed the harvest, when there was said to be 'physic in the sea'. The Lancashire coast already received thousands of visitors on foot or in carts in the 1820s and 1830s. Sailing vessels and steamers also opened out Gravesend and Margate to unpretentious Londoners in the late eighteenth and early nineteenth centuries. Cheap rail fares

encouraged travel over longer distances, and in the 1840s they were often provided by Sunday schools and temperance organisations, anxious to lure people away to a physically and morally healthier destination than the fairgrounds and beer-houses of traditional holidays in their home towns. The railway companies themselves soon recognised a paying proposition, with the London to Brighton line well to the fore; and in parts of northern England savings clubs enabled families to enjoy a few days of unpaid holiday. The Lancashire cotton towns led the way, with holidays of up to a week being widely enjoyed by the 1890s, and Blackpool became the world's first predominantly working-class seaside resort. Southend was not far behind. Even in Lancashire, with its high family incomes, labourers and families with young children were lucky to manage a day-trip; but the seaside holiday soon became prized by working-class women as a week's relief from domestic responsibilities, coupled with access to the beach and the distinctive entertainments of the popular seaside resort, from Punch and Judy to piers and pleasure palaces. Child-care and food shopping chores remained, as the system was to buy food for the landlady to cook; but the popular seaside holiday offered the nearest approach to shared leisure and the companionate marriage that Victorian working-class women were likely to achieve.[53]

55 Paul Martin,
On Yarmouth Sands.
Platinum print, 1892.
V&A: PDP

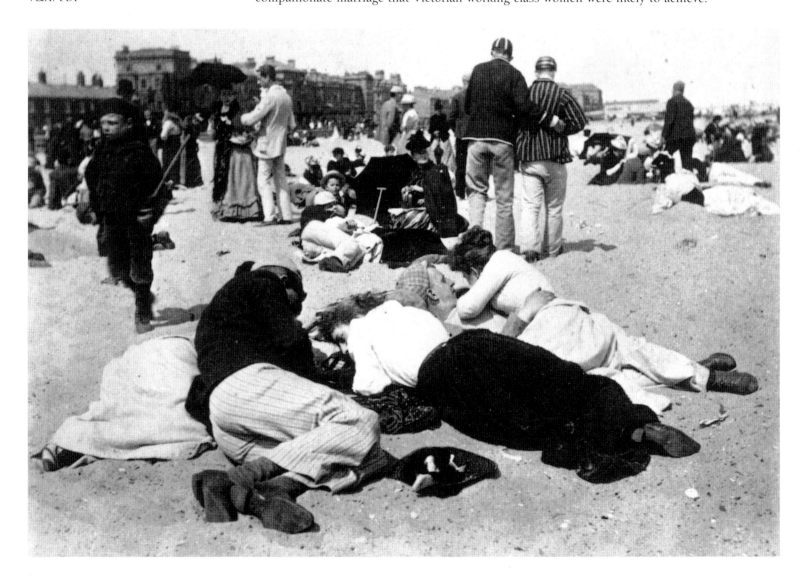

THE SEASIDE

The seaside was already becoming an attractive subject for painters by the beginning of Victoria's reign, and visitors and their activities were becoming legitimate subjects for the artist's gaze. Photographers were quick to move in on seaside scenes, and from the 1860s onwards growing numbers made a living out of portraits of holidaymakers as well as taking more picturesque scenes for guide-books, albums and, by the turn of the century, postcards. Views of the seaside embellished living-rooms, cafés and railway compartments, where they were used to advertise the resorts served by the company. The seaside, with its associations with health, pleasure, the sublime (especially featuring raging seas) and the picturesque (landscapes and fisherfolk), became one of the most popular and ubiquitous of subjects for domestic contemplation, especially as one of its central associations was with the holiday as emblem of idealised family relationships expressed through shared pleasures. Thus the seaside holiday shored up one of the most cherished of Victorian institutions, which was one of the reasons why boisterous trippers caused such panic and dismay when they invaded the preserves of their 'betters' at weekends and times of popular festivals. Class conflict was every bit as much in evidence at the seaside as at the workplace, and efforts to take the sting out of it were every bit as assiduous.

56 Punch and Judy booth and puppets. V&A: Misc.19-1968.

The classic entertainments of the Victorian seaside were aimed at the mainstream market in most resorts: the comfortable middle-class family. A few popular resorts catered for the emergent 'mass' market, with fairgrounds, music halls and opulent pleasure palaces; but the enduring image of the seaside has focused, reasonably enough, on the alfresco pleasures provided by pierrots, minstrels and Punch and Judy shows. Seaside resorts might try to emphasise their staid respectability when seeking the regular patronage of their mainstream markets, but there was much more to them than this, as most representations of seaside entertainment, read carefully, tend to demonstrate only too clearly.

57 End-of the-pier entertainers. Postcard, *c.*1900.
Private collection.
As promenade and pleasure piers began to proliferate along
British shorelines, every resort with pretensions to growth
and dynamism had to provide one. Between the 1860s
and the turn of the century their number had increased
to over eighty. The pier was the scene of a growing variety
of entertainments, including steamer excursions and
fashionable promenading; and it was the most popular site
for the band to play and pierrot or minstrel entertainment
to be held.

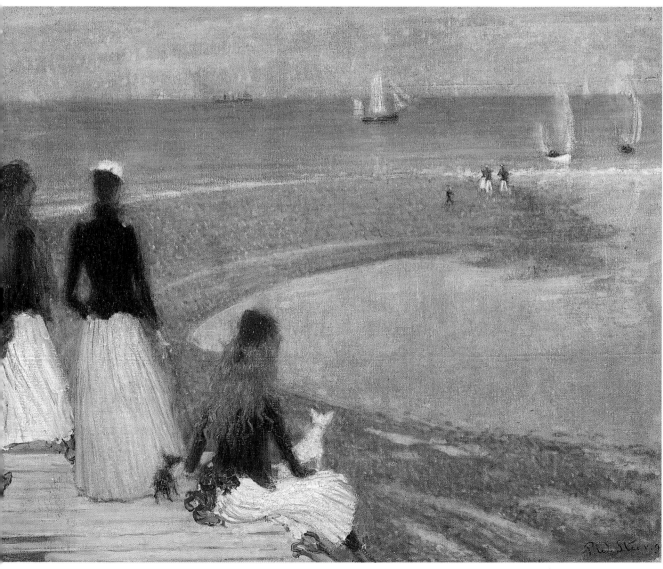

58 Philip Wilson Steer,
The Beach at Walberswick.
Oil on wood, *c.*1889.
Tate Gallery © 2001.

Their 'betters' sometimes resented their presence, but they also had a much wider range of choices. Working-class visitors might colonise stretches of sea-front at Blackpool or Brighton, but large areas even of these resorts excluded the amusements they preferred and sought to impose an alien tranquillity which could be pursued more convincingly where landowners and local government were in harmony, or in smaller and remoter resorts which saw no profit in the tripper's sixpence. Sophisticated resorts like Torquay, or little fishing villages like Staithes, played host to the world of fashion or the artistic professionals who enjoyed tranquillity, simplicity, the picturesque and the 'authentic'. Artists preferred, and transmitted images of, the latter kind of place, as witnessed by the output of James Guthrie's summer of 1883 in the rustic tranquillity of Cockburnspath. Cornwall was similarly privileged, but trains and steamers also made continental Europe accessible, and English colonies developed at Boulogne and Dieppe, extending subsequently to (for example) Pau in the French Midi, where expatriates could enjoy fox-hunting and golf. The English were even more in evidence as holidaymakers in resorts across Europe, in the Alps and at the German spas, as well as at Deauville, Biarritz or on the French Riviera. There was plenty of scope for the comfortable middle classes to avoid their aspiring inferiors, although they deeply resented the opportunities that Thomas Cook provided for clerks and schoolmistresses from the 1860s; and there was also a layer of truly exclusive resorts where aristocrats and plutocrats could haunt the casinos and display their wealth to each other.[54] The fashion for picturesque mountain tourism, coupled with the celebration of rusticity and invented traditions, also helped to open out upland areas of Britain, especially the Highlands of Scotland in the wake of Queen Victoria's 'discovery' of Balmoral; and the exclusive pleasures, again overwhelmingly masculine, of deerstalking and grouse-shooting provided distinctive aristocratic attractions on land which was otherwise of negligible market value.[55]

Resorts and holidaymaking became crucibles of competitive consumption, as the spas had been before them; but another Victorian theme was the development of middle-class consumerism closer to home, especially through shopping, sport and suburbia. It was shopping, above all, that drew middle-class housewives out of the home and into town centres whose amenities were being improved both by local government (pavements, lighting, policing) and by private enterprise (spacious new shops, department stores and cafés, which provided comfortable spaces for refreshment and recuperation). As commerce retreated from parts of city centres, the space was occupied by shops, with clothing and personal display especially to the fore. The key transitional decades were the 1870s and 1880s, when female unease at sharing city-centre public spaces with prostitutes, and vulnerability to the unwanted attentions of predatory men, gave way before the adaptation of urban environments to the new commercial imperatives. The hat shop, and indeed the department store, became overwhelmingly a female space. Men were marginalised, although they had their own consuming passions, as specialist shops for tobacco, alcohol, hunting and sporting equipment (as well as clothes) bore witness. Middle-class childhood was also tugged into the market-place, as the toy industry developed in sophisticated ways and specialised shops began to appear. Above all, in its own way, shopping liberated middle-class women from suburban rustication, giving them choices while also subordinating them to a demanding regime of consensual but competitive consumption. As a reason for coming

59 HMV Gramophone. 1896. Hand-driven and mechanically governed gramophone with a 7-inch turntable. Science Museum, London/Science and Society Picture Library.

into the city centre, it no doubt helped to open out the theatre (especially in London's West End) and the concert as evening entertainment. Uneasy mockery greeted the lower middle classes (the wives of clerks such as the fictional Mr Pooter) when they invaded this territory during the 'sales': they were presented as easily duped, lacking the cultural capital to make appropriate purchasing decisions, and reactions to them paralleled the heavy-handed satire which had been levelled at the first Cook's tourists, who came from similar backgrounds. All this illustrated the pervasive unease about status which helped to fuel consumption and display, boosted by increasingly common advertising campaigns on hoardings and in the press.[56]

Much of middle- and upper-class leisure was homosocial: women with women, men with men. But from the 1860s onwards shared sports came into vogue, acting as legitimising devices for courtship and flirtation, and taking place in exclusive social spaces, free from taint of gambling and debauchery, which were a world away from the race meeting or football stadium. Croquet led the way, followed closely by lawn tennis. Both were eminently suited to the large gardens of country houses and suburban villas, and the tennis party became a suburban institution. Archery was another possibility. The late Victorian spread of golf, with its own specialised private landscape, was more resistant to female participation, and gentlemen remained attached to the public-school team games of their youthful socialisation; but these were important innovations, supplemented indoors by piano duets, charades, whist and a lengthening list of new and traditional parlour games. All required the right equipment, of appropriate standard, sustaining the accelerating pace of a middle-class consumer revolution which had begun in parallel with the early industrialisation of the eighteenth century and accelerated in step with it. By the end of the century it was becoming easier to accompany these activities with music from a gramophone (plate 59), and to capture them on camera, as new technologies of pleasure began to proliferate in earnest.[57]

The cornucopia of commercially provided luxuries, comforts and enjoyments which engulfed the expanding middle classes created as much insecurity as pleasure, especially when the pressure to consume came up against enduring values which emphasised the work ethic and puritan abstention and accumulation. It is easy to exaggerate the importance of the latter: already in the early 1860s French academic Hippolyte Taine was commenting on the rampant consumerism of the metropolitan middle classes. Above all, the Victorians were, or became, enthusiastic consumers as well as hard-working producers, and of course the two phenomena were intimately connected. By the 1880s and 1890s the contagion had spread to most of the working classes, and it become tempting, and even legitimate, to speak of the 'coming of the mass market'. 'Mass' is a dangerous label, however: consumption patterns remained divided by gender, age, region, aspiration and, above all, spending power. In a widening range of senses, Victorian England might be said to have become a consumer society, in the sense that identities were increasingly being defined by how people consumed and especially by how they displayed that consumption, and consumer messages in advertising and other texts and images were becoming more pervasive; but in other senses involving access, agency and control it was very far from being a consumer democracy.[58]

THE THEATRE

The growth of the theatre in Victorian Britain offers a particularly telling challenge to persistent conventional views based on Evangelical dominance and stifling respectability. Such values were never dominant (except in strictly limiting the range of activities which were officially thinkable on a Sunday, and restraining the public visibility of drinking and gambling). The stridency with which they were advocated early in the reign shows that their proponents were engaged in an uphill struggle. So, after early attacks, the Victorian theatre flourished, especially if we take a generous definition of the stage which embraces music hall (a Victorian invention), musical comedy (with the rise of Gilbert and Sullivan) and other genres. Queen Victoria herself was an eager theatre-goer until her widowhood. The dramatic and histrionic arts were particularly dynamic and popular in the last quarter of the century, with the rise of London's West End as 'theatreland' and the rise of provincial circuits and repertory theatres, as well as the growth of popular theatre in the resorts. Media and artistic interest marched in step, fuelled by the emergence of star personalities who attracted cult followings, from Sir Henry Irving to 'Champagne Charlie' Townsend. Gender issues were also significant, as the stage became a more respectable calling for actresses (although suspicions as to character and morality were enduring), and music hall performers like Jenny Hill were able to use their sketches to present an assertive working-class female perspective on life's problems.

60 View of the auditorium of the Wyndhams Theatre, Shaftesbury Avenue, London. Built by Australian-born W. G. R. Sprague, the theatre opened on 16 November 1899.

61 Cover from a music sheet: *Ta-Ra-Ra-Boom-Der-Ay*, with Lottie Collins. Colour lithograph, *c*.1891. V&A: HRB.f.153–30.

62 Dudley Hardy, *A Gaiety Girl*. Colour lithograph, 1893. V&A: E.379–1921.
The new, luxurious music halls and variety theatres brought 'the chorus girl' into being. Like her more accessible cousin the barmaid, she exuded a 'parasexuality' which fuelled fantasies while remaining ultimately detached and distant, except to favoured admirers who increasingly included aristocrats and the sons of wealthy industrialists. This, at least, was the legend, and there were some cross-class marriages to sustain it. The cheerful, practical, well-intentioned chorus girl, as at the Gaiety Theatre, became as popular a stereotype as the 'warm-hearted tart' who approximated to earlier prejudices about women on the stage.

63 Walter Sickert, *The Old Bedford Music Hall*. Detail. Oil on canvas, 1894–5. Fitzwilliam Museum, University of Cambridge.

SMALL ADULTS:
Education and the Life of Children

ANTHONY BURTON

It is often said that it was in the nineteenth century that childhood was invented, that childhood (in other words) came to be regarded as a distinct state of being, with its own values and culture. This is, on the whole, true, though childhood is only one among many areas of human life which achieved greater identity and complexity in that period.

It is also often said that, up to the nineteenth century, children were treated as miniature adults. This is one of those catchy ideas that, when closely examined, is reduced almost to nothing by a host of qualifications. For instance, there could never have been any possibility of treating infants as miniature adults, and older children could be treated as adults only to varying degrees in various circumstances.[1]

Childhood presumably occupies the years that ensue between infancy and adulthood. Adulthood is usually regarded as beginning with puberty, but social and psychological factors may be just as important markers as biological changes. So the chronological limits of childhood must remain imperfectly defined. The years of childhood (however defined) were shaped in the Victorian period, as were many aspects of life, by various cultural, social and economic factors: population growth, industrialisation, changing understanding of human psychology, the increase of privacy, better provision of education and healthcare, social legislation and the growth of prosperity and consumerism. In analysing the ways in which childhood was constructed, it is necessary too to have regard to social class, for upbringing, schooling and the development of a child's consciousness depended greatly on where a family stood in the social hierarchy.

64 Elizabeth Adela Armstrong Forbes, *School is Out*. Detail.
Oil on canvas, 1889. Penlee House Gallery and Museum, Penzance.

Two interrelated factors above all conditioned the construction of a world of childhood. One was the education provided for children. However disagreeable education might sometimes seem to participants, it is an area of experience fenced off specially for children, and, as we all know, cannot fail to be formative. The other factor was leisure time. In the time left over from schooling, what was available for children to experience which was specially shaped for them?

In all but the poorest classes, the upbringing of infants would have involved not just care from their parents, but also, in varying degree, the aid of servants. In most households a nurse-maid would have been available, who might have suckled the child as well as cared for it. This practice of 'wet-nursing' was sanctioned by long tradition; a wet-nurse might live in with a family, or a child might be boarded out with a nurse until it was weaned.[2] Some women made a profitable business out of running 'baby farms', which were an effective way of banishing illegitimate children from notice, and only began to come under statutory control in the 1870s. In very poor families, which could not afford servants, the care of babies was often delegated to older girl children. Many a caricature or photograph of street urchins, in the late nineteenth century, includes a puny little girl staggering under the weight of an infant sibling entrusted to her uncertain care (plate 65).

65 Phil May, *Little Mothers*, from Guttersnipes: Phil May's ABC. Line illustration, 1897. V&A: G 29 B 25.

The nursemaid evolved during the Victorian period into that great British institution, the nanny: an infant-minder who specialised in this vocation, and eventually might be professionally trained. In many families the nanny came to exert more influence on her charges than their mother. It seems, though, that the name 'nurse' was still preferred, and 'nanny' came in only as this functionary reached the summit of her influence at the end of the century.[3]

The first steps in educating a child would be undertaken by a nanny or nursemaid, and then a tutor or governess might take over. Only rich families would be able to employ as tutors intelligent young men with university training. A tutor might seem, on the face of it, to offer the best sort of education, for he would place at the disposal of an individual child the entire talents

66 Richard Redgrave,
*The Governess: 'She sees no kind
domestic visage near'*. Detail.
Oil painting, 1844. V&A: FA 168.

and attention of an adult. But it did not necessarily work, and one need look no farther than the royal family for a notable instance of tutorial failure. Queen Victoria and Prince Albert spared no pains to educate their eldest son, the Prince of Wales, who was tutored by Henry Birch (Eton and King's, Cambridge) and then by Frederick Gibbs (Fellow of Trinity, Cambridge). Neither of these assiduous, learned men was able to inspire academic interests or even industrious habits in the future king, who remained dilatory and pleasure-loving.

Being taught by a governess might be a pleasure, but could, for some children at least, be an affliction. Being a governess was often an affliction too.[4] Many well-educated young women had to go into teaching because they needed for financial reasons to make a living, and no other

career was available. If they were fortunate they might find congenial employers, and even see something of the world if they worked for a family which lived for a time abroad. But their role in a household was a difficult one. Their status was ambiguous, for they were not really part of the family but were a cut above the servants; thus, 'a private governess', as Charlotte Brontë wrote to her friend Ellen Nussey (8 June 1839), 'has no existence, is not considered as a living and rational being except as connected with the wearisome duties she has to fulfil'. The novels of the Brontë sisters give many insights into the plight of the governess. Richard Redgrave's painting, (plate 66), also poignantly evokes her loneliness. A weary governess sits in the schoolroom, while behind her, in the window, her charges are to be seen, playing happily and carelessly in the sunny garden. But she is set apart from them by the work that awaits her attention; and the letter she holds, a fragile link with her own far-away family, is black-edged and brings bad news.

Victorian girls might well have received their entire education from a governess, since good secondary schools for girls began to appear only in the latter part of the century, the pioneers being the North London Collegiate School, founded by Miss Frances Mary Buss in 1850, and the Cheltenham Ladies' College (1854) where Miss Dorothea Beale became Headmistress in 1858. (Both ladies were famously said not to feel Cupid's darts.) Many more such schools were created by the Girls Public Day School Company, founded in 1872.[5]

A wider range of schooling was available for boys. Its highest level was to be found in the nine élite schools known as 'public schools', which still occupy a commanding position in English education.[6] These were Eton, Harrow, Winchester, Shrewsbury and Rugby (which was said to offer 'a crash course in manliness'); and (in London) Westminster, Charterhouse, St Paul's and Merchant Taylors'. The last two were day schools but all the others were boarding schools. There were equivalents in Scotland and elsewhere. Some of these schools were founded in the late Middle Ages, when England was still a Catholic country, but what animated all of them was the vigorous advancement of English education in the early years of the Protestant Reformation, which also caused the creation of many endowed grammar schools. The public schools subsisted to some extent on endowments, like the grammar schools, but also (as they still do) on the lavish fees that the rich could afford to pay for their sons' education.

In the early nineteenth century the public schools, despite their prestige, were at a low ebb, lacking in discipline, badly staffed, offering squalid conditions for students, and regulated only by the administration of corporal punishment on a grand scale. Reform came at the hands of Dr Thomas Arnold, Headmaster of Rugby from 1828 until 1841. His achievement was to raise the moral tone of his school, partly by his own overwhelming moral intensity, and partly by organising his staff and senior boys (prefects) into a much more vigilant disciplinary authority than had been customary in public schools. He was not an innovator in curricular matters; his school aspired to character formation rather than academic excellence. The fame of the school was spread when Thomas Hughes portrayed it in his boys' story, *Tom Brown's Schooldays* (1857). Squire Brown has these expectations for his son: 'If he'll only turn out a brave, helpful, truth-telling Englishman, and a gentleman, and a Christian, that's all I want.' These expectations were exactly what Arnold, and other headmasters like him, strove to satisfy.

Reformed public schools on the Rugby model aroused intense group loyalty, and the public schools drew their pupils from such a narrow range of society that they had a strong common interest anyway. Public-school pupils had privileged entry to the universities, and important positions in the adult world were largely filled by public-school men. Hence a public-school education provided the means to success in later life, through an 'old boys network'. But Arnold's Rugby was a force for idealism as well as worldly advancement. Arnold's son Matthew, the poet (who was himself perhaps somewhat singed by his father's burning zeal), paid tribute, in verses on 'Rugby Chapel', to the products of a humane education, who were:

Not like the men of the crowd
Who all round me to-day
Bluster or cringe, and make life
Hideous, and arid, and vile;
But souls temper'd with fire,
Fervent, heroic, and good,
Helpers and friends of mankind.

Inspired by Arnold's example, other older schools were revived (notably Uppingham by headmaster Edward Thring), and new schools were founded (Marlborough, Wellington, Haileybury), which joined an expanded cohort of public schools.

In the reforming atmosphere of the mid-century, many centres of financial privilege were investigated, and the public schools did not escape. A Royal Commission was set up to investigate them in 1861. Although it proposed reforms, on the whole it enhanced the prestige of public-school education, and inspired further foundations (for example, Clifton and Malvern, both in 1862). In emulation of the public schools came a group of schools founded by an Anglican clergyman, the Reverend Nathaniel Woodard, including Lancing, Hurstpierpoint and Ardingly. And the major Roman Catholic boarding schools which, after banishment abroad, resettled in England (at Stonyhurst, Ampleforth and Downside) when at the beginning of the century conditions became easier for Catholics, were also swept along in the wake of the public schools.

The sons of middle-class families, who could not aspire to the top layer of schools, might have attended one of the old grammar schools. There were hundreds of these, mostly endowed in Tudor times, and located throughout the country; but by the Victorian period they tended to be constrained either by the diminution of their endowments or by the limitations of their original statutes. A legal decision in 1805 determined that if they had been set up to teach Latin and Greek grammar, they must not teach anything else, more modern subjects being prohibited to them. Means were eventually found for them to modernise.

Alternatively, middle-class boys could go to the many private academies set up by men with various levels of qualifications and experience. The novels of Dickens introduce us to some of these schools (for it was at such schools that Dickens himself received an unsatisfactory education), such as Dr Blimber's school in *Dombey and Son* (1846–8) and the Salem Academy in *David Copperfield* (1849–50), which was set up by the whispering sadist Mr Creakle after he had

gone bankrupt in the hop business. Creakle's school, said Matthew Arnold, is 'the type of our ordinary middle class schools', and it was to be regretted that the middle classes were 'satisfied that so it should be'.[7]

Unless a boy chanced to live close to a town grammar school, he would almost inevitably have to live at his school as a boarder – whether he attended a public, grammar or private school. For boarders, one of the emotional high-points of school life was the moment when term ended and, with the cry of 'Home for the Holidays', they could go back to their families. The railways took some of the excitement out of this moment, which, in the early Victorian period, was signalled by careering horse-carriages crammed with exuberant schoolboys. Peter Parley's *Tales About Christmas* (London, 1838, pp. 177–8) recalls the end of term as a 'season of delight', when a boy:

mounts the steps of the chaise, whose rattling wheels are to convey him to his happy home. Long before the chaise comes up, the wild mirth of the merry madcaps, inside and out, had reached our ears. There were, at least, half a dozen inside each chaise, some flourishing their caps, some waving their flags inscribed with that dear word 'Home,' and all shouting, or blowing a blast on their horns, or peppering right and left at the passers by, with pea-shooters.

These words were illustrated with a charming wood-engraving by George Cruikshank. And many other artists depicted the scene for other children's books and magazines (plate 67).

67 Kenny Meadows, frontispiece for *Home for the Holidays; a pleasant remembrance of my early days. By the editor of 'the Playmate'*. Hand-coloured wood-engraving, 1848. V&A: L5250–1961.

The schooling so far described, for the more privileged parts of society, was available (subject to some changes and developments) throughout the century. For the lower classes, educational provision was very weak and patchy at the start of the Victorian period. If children from poor families got any schooling at all, it would probably be at a charity school (many were founded by the Society for Promoting Christian Knowledge during the eighteenth century, but tended to be small and precarious) or at a 'dame' school, the kind of school any half-literate old woman (or man) might choose to set up in their cottage. One of these is featured in Dickens's *Great Expectations* (1860–61): he describes how the children scuffled among themselves while the schoolmistress, Mr Wopsle's great-aunt, snoozed until, roused by the increasing hubbub, she 'collected her energies, and made an indiscriminate totter at them with a birch rod'. The education that a poor child would receive would be no more than the basics of reading, writing and arithmetic – 'elementary' education only, for at the earliest opportunity poor children were sent out into the world to earn a living. The practical requirements of work were such that more girls remained illiterate until compulsory schooling for all began in the 1870s.

Many people in authority felt that poor people did not need education in order to do the work that was required of them, and that education might give them ideas above their station. Gradually, however, the more enlightened view prevailed that educating the workforce would be good for the country, and might even be a good thing in itself. In a characteristically English way, progress was not made by bold government decisions, but by complicated and hesitant developments in both the public and the private spheres. Early in the century systematic elementary education was organised by two religious associations: from 1808 by the British and Foreign School Society, a Nonconformist association following the methods of the Quaker Joseph Lancaster; and from 1811 by the National Society for Promoting the Education of the Poor in the Principles of the Established Church, following the methods of the Scottish clergyman Andrew Bell. Both societies used teaching methods analogous to the industrial methods springing up all around in factories. A sort of mass-production teaching system was devised, so that, by using strictly regimented teaching drills and by delegating the supervision of sub-groups to senior pupils ('monitors'), a single teacher could instruct a class of (so it was said) a thousand pupils.

The two societies, representing rival religious groups, were disinclined to co-operate. The state intervened cautiously in 1833 to give grants to both of them (they raised most of their funds themselves), and from 1839 this task was entrusted to a small government department concerned with elementary education. It was not until W. E. Forster's Education Act in 1870 that the state at last became dominant in the provision of elementary education, and more time passed before elementary education became compulsory (to the age of 11), in 1880, and free, in 1891. This legislation was 'gender-blind', although sex segregation continued in the classroom and the playground. The use of monitors, now called pupil teachers, was maintained even when the government took over the task of teacher-training, but in the later years of the century the London School Board led the way towards the separate class teaching to which we are accustomed today. Training was gradually professionalised, and by 1901 there were 230,000 teachers in England and Wales, of whom 75 per cent were women. For at least some poor children, then, the experience of education might have been of interaction with a congenial

group under the friendly care of a dedicated adult – the kind of situation depicted in Elizabeth Forbes's painting *School is Out* (see plate 64).[8]

If poor children were at work, they could not be at school (the Sunday school movement tried to intervene in the little free time that working children might have had), and *vice versa*, so legislation relating to child labour and to education had an impact in both fields. It was, in fact, labour legislation that made an impact first. Peel's Factory Acts of 1802 and 1819 and the Factory Act of 1833 restricted the hours which children worked, and made some provision for their education. It is worth noting that it was not only humanitarian reformers who campaigned altruistically against child labour; the working-class agitators for a ten-hour working day in the early 1830s used the plight of children as a stalking-horse in seeking a reform that would benefit adults too.

Progressive social reformers in the early Victorian period devised a shrewd method of campaigning, which could be applied to most causes: the investigation of an abuse by an official commission, followed by its exposure through a detailed report, leading to the arousal of public opinion; then, in the favourable climate thus created, the enactment of new legislation, backed up by inspection. So far as children were concerned, this method never worked to more telling effect than in the *Report of the Commission on the Employment of Children and Young Persons in the Mines*, which led to the Mines Act of 1842. This was the first such report to include illustrations, which sought the greatest possible immediacy and authenticity. It was too soon, of course, for the camera to record the shocking truth: the illustrations were sketches reproduced as wood-engravings. But a deliberately crude style was adopted, to try to suggest a direct and hasty transcript of reality. This seems to have worked. The 'diagrams and sketches, made on the spot by the Assistant-Commissioners . . . caused great commiseration among all those who could feel for poor people; and great annoyance and disgust to those who could not, or would not. Lord Londonderry declared that the sketches were offensive – made him quite sick – and were "calculated to inflame the passions"'.[9] These are perhaps the most important images in the entire, copious iconography of childhood in the nineteenth century (plate 68).

68 Wood-engraving from the *Report of the Commission on the Employment of Children and Young Persons in the Mines* (London, 1842). V&A: National Art Library (Forster Collection, printed books 6737).

Further legislation to protect poor children employed as chimney-sweeps (1864), in agriculture (1867) and in other areas followed, so that in deciding the fate of children the scales tilted away from work in favour of education. 'By the end of the century,' historian Eric Hopkins concludes, 'schooling replaced work as the recognised occupation of boys and girls from five onwards to at least twelve'.[10]

The fact that reformers among the well-to-do felt a sympathetic concern for children must have had not a little to do with the way in which the idea of childhood and the experience of children had been explored in literature. 'Within the course of a few decades' – the period of the Romantic Movement in the late eighteenth and early nineteenth centuries – 'the child emerges from comparative unimportance to become the focus of an unprecedented literary interest, and, in time, the central figure of an increasingly significant proportion of our literature.' These are the words of Peter Coveney, in his book *The Image of the Child*. He goes on to suggest that 'the child could serve as a symbol of the artist's dissatisfaction with the society which was in process of such harsh development about him', for 'in childhood lay the perfect image of insecurity and isolation, of fear and bewilderment, of vulnerability and potential violation'.[11] The poetry of Blake and Wordsworth, and the fiction of Dickens and other Victorian novelists, must have aroused in adult readers a sense of how the world felt to a child, which they might otherwise have found it easy and convenient to ignore.

If literature enhanced adults' understanding of the world of childhood, it also provided for children a more accurate reflection of their world. Literature specially written for children began to appear in noticeable quantity in the eighteenth century. Much of what was published in the later eighteenth and early nineteenth century was attractively illustrated with convincing scenes of child life, but texts conveyed a grown-up outlook which was genially but inexorably imposed on young readers. As the flow of children's literature increased from a trickle to a stream in the Victorian period, there was still plenty of such hack writing. 'It is very obvious,' said a critic in the *Quarterly Review*, June 1844, 'that there are a set of individuals who have taken to writing children's books, solely because they found themselves incapable of any other, and who have had no scruple in coming forward in a line of literature which . . . presupposed the lowest estimate of their own abilities.' The writer argues that children deserve to read not what adults condescend to hand down to them, but what actually appeals to them. 'A genuine child's book is as little like a book for grown people cut down, as the child himself is like a little old man. Children are distinguished from ourselves less by an *inferiority* than by a *difference* in capacity.'

Thus the child's-eye-view gradually became acceptable in children's books. The greatest Victorian classics of this kind were, perhaps, Lewis Carroll's *Alice* books, Edward Lear's verses, and Robert Louis Stevenson's *Child's Garden of Verses*, with fiction by George Macdonald, Mrs Ewing, R. M. Ballantyne and Mrs Molesworth deserving honourable mention. In the works of Ballantyne (among many others of poorer quality) children were introduced to exploits throughout the Empire. By the end of the century, best-selling authors like G. A. Henty and Gordon Stables had come to specialise in such excitements.

Besides texts, Victorian children were treated to ever more accomplished illustrations, especially in colour. In the early decades of the nineteenth century, illustrations printed in black

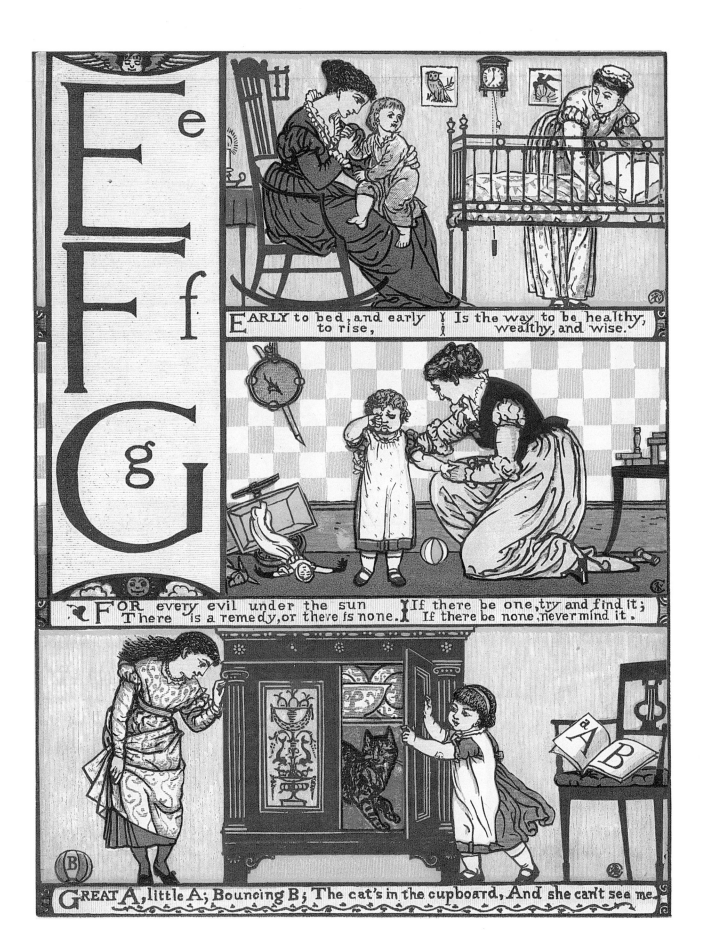

E e
F f
G g

EARLY to bed, and early to rise, Is the way to be healthy, wealthy, and wise.

FOR every evil under the sun There is a remedy, or there is none. If there be one, try and find it; If there be none, never mind it.

GREAT A, little A; Bouncing B; The cat's in the cupboard, And she can't see me.

and white from woodblocks or metal plates had to have colour added to every copy by hand. The results could have a lively charm, though they often accompanied short, trivial texts. From the 1840s a larger version of such booklets, known as 'toy books', greatly increased the supply of illustrated literature. Colour printing by lithography, fully developed by the 1860s, made possible a further expansion, especially in books illustrated by such talented artists as Walter Crane (plate 69), Kate Greenaway and Randolph Caldecott.[12] Routledge and Warne were publishers who 'made the desires and applause of children their study' in their toy books, said a writer in *Once A Week* (5 January 1867), and as a result of their efforts 'every bookseller's shop is a grand posy of colour'.

Children were equally well served by toy shops, which flourished in the Victorian period.[13] Little shops selling children's toys displayed in small-paned bow windows are often illustrated in early nineteenth-century children's books. In London in the second half of the century, such shops (of which an entire street could be found in the Lowther Arcade; plate 73) were joined by larger-scale enterprises, like Messrs Hamley's 'Noah's Ark' Toy Warehouse in High Holborn, J. T. Theobald's West End Conjuring and Model Manufactory in Kensington, and W. Stevens's Model Dockyard in Aldgate. Perhaps the best known toy-seller was W. H. Cremer of Regent Street. It was no accident that he was of German extraction: most toys were imported from Germany, and Cremer's shop started out under the name 'The German Fair'. All sorts of cheap toys made of wood and papier mâché – jumping-jacks, miniature carousels, farm animals, soldiers – came from Germany, as well as increasing quantities of tin toys and colour-printed games and books.

To reconstruct the shape of toy retailing in the provinces is difficult except by very local investigation. In principle, it should be possible to track down toy dealers through the post-office directories efficiently produced throughout the Victorian period, but the term 'toys' could still mean, as it always had, 'fancy goods'. 'Children's toys' is never used as a category. So a 'fancy repository and toy warehouse' may mean no more than an adult gift shop. But when such a shop advertised (as did Charles Henry of 18 Market Street, Manchester) a range including leather goods, Japan ware, and things made from tortoiseshell and papier mâché, and added toys as a distinct category alongside these, there seems a good chance that children were the intended market for the toys. Louis Ahlborn of 48 and 50 Whitechapel, Liverpool, was described as a 'wholesale small ware, hard ware & toy warehouse' but the name of his shop, 'The Golden Rocking Horse', seems to give his game away clearly enough. In Lancaster, John Lawson opened his 'Rocking-Horse Shop' in 1837, complete with the appropriate sign outside. It has sold toys, among many other things, from Victorian times to the present day. No doubt most toys were bought from little corner newsagents then, as they are now.

The new profusion of toys undoubtedly offered more fun. Toys might also (conscientious parents were apt to think) have an improving effect upon children. 'A toy is as great a fact to a child as is any truth to a philosopher', commented a critic in the *Art Journal* (1857, p. 357). 'The perception of children is by no means so obtuse as their elders may, in their self-complacency, suppose; there are very few children, indeed, who will not appreciate and choose the best constructed toys shown to them; if they obtain them, they will keep them carefully.' Thus is 'good taste fostered'. Toys might also have more or less educational content.

69 Walter Crane, page from *Baby's Own ABC from The Blue Beard Picture Book*. Coloured wood-engraving, 1875. V&A: 60 Y 166. Walter Crane illustrated many 'toy books'. Some were fairy tales, which evoked from him bright, dense designs full of allusions to historic art, while some, like this ABC, illustrated the life of children, in a somewhat idealised 'Arts and Crafts' style.

THE CHILD AS CONSUMER

70 Brass cradles manufactured by R.W. Winfield of Birmingham. Lithographic illustration from *Great Exhibition of the Works of Industry of all Nations, 1851. Official Descriptive and Illustrated Catalogue* (London, 1851), vol. 2. V&A: EX.1851.33.
At the Great Exhibition of 1851 Queen Victoria lent a much admired royal cradle, elaborately carved in boxwood by the pre-eminent English wood-sculptor of the time, W. G. Rogers. For those who could not afford such unique items, the Exhibition offered mass-produced but luxurious items such as the brass cradles shown here, exhibited by R. W. Winfield of Birmingham.

WE CANNOT HAVE OUR CAKE AND EAT IT TOO.

WHAT can be more foolish than to buy things you do not want, merely because you happen to have money in your pocket?

You should keep it there till you do want something.

This would be much wiser.

LONDON TOY WAREHOUSE.

71 Page, with wood-engraved illustration, from Solomon Lovechild's *Little Tales for the Nursery*, third ed. (London, c.1850). V&A: Bethnal Green Museum of Childhood; Renier Collection.
It could be argued that children are essentially carefree and uninhibited consumers. Victorian morality, however, did its utmost to keep them in check. This page shows the beginning of an uplifting story about Bob Turner: 'The moment Bob receives his four pence, he goes out to spend it.'

72 Illustration from *Wonders of a Toy-Shop* (London, c.1852). Hand-coloured wood-engraving. V&A: National Art Library.
Shops selling toys for children became popular in the first half of the 19th century. There were 'toyshops' in the 18th century, but then 'toy' meant an elegant knick-knack for adults. Children's toys would have been bought at general stores, or from travelling salesmen. The illustration shown here, from a children's book of the 1850s, shows a proper children's toyshop.

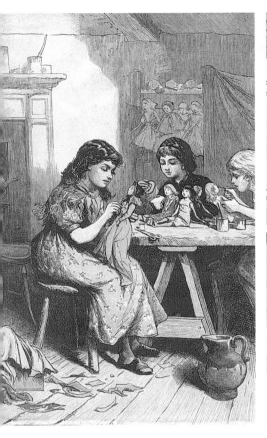

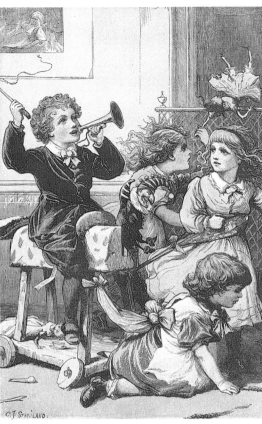

74 C.J. Staniland, *Dollmakers and Dollbreakers*, illustration from *The Graphic Magazine Christmas Number* (1878). Colour wood-engraving. V&A: PP 8 D.

Children are exemplary consumers, not only because of their acquisitiveness but because they often consume goods to destruction, thus stimulating further production. In this pair of images from the Christmas number of an illustrated magazine, rich children who smash up toys are contrasted with the poor children who earn a pittance making them. The moral message here focuses on seemly behaviour by the rich rather than relief of the poor.

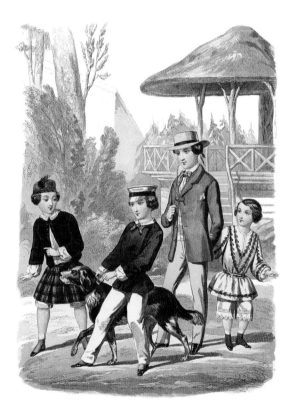

73 T. Crane and E. Houghton, *The Lowther Arcade*, from Felix Leigh's *London Town*. Colour wood-engraving, 1883. V&A: 60 V 159.
By the later 19th century, one London street above all others had become recognised as the prime site of juvenile consumerism: the Lowther Arcade. This consisted of two rows of lock-up shops facing each other across a covered arcade, in a building over the way from Charing Cross Station. By the 1860s almost all the shops were occupied by toy dealers, whose wares overflowed on to stalls along the street.

75 Fashion plate from the *Gazette of Fashion* (October 1851). Coloured engraving. V&A: E.513–1946.
Toys were not the only goods consumed by children. For the well-off classes, dress was increasingly important not only functionally, but for what it could contribute to image-making. Little girls' dress ranged widely over fashionable styles, often copying what was in vogue for Mama, and even little boys could take their pick among various sorts of allusive dress: versions of military or naval uniform (notably the 'sailor suit'), or of national dress (like the Scottish outfit in this illustration), or of historical dress such as 'Fauntleroy' suits.

Most Victorian board games imparted a lesson in history, geography, biblical knowledge or morals. Dolls and dolls' houses, as always, served to train little mothers. (France came gradually to dominate the market in dolls, notably dolls with porcelain heads, prevailing over German dolls and also over wax-headed dolls, which were an English speciality.) Many mechanical or 'optical' toys such as magic lanterns or steam engines, which became popular towards the end of the Victorian period, imparted to boys some understanding of scientific principles.

Of course, such toys also aroused pure fascination: who could resist a 'Locomotive Engine, on Six Brass Wheels . . . fitted with Starting Lever, Two Gauge Taps, Wind Guard, Two Steam Domes, Safety Valve, Whistle, two Slide Valve Cylinders . . . Two Eccentrics, Waste Steam to blow through Funnel . . . ?' It is a relief to find that there were mischievous toys too: the 'Magician's Cabinet' of conjuring tricks, the mechanical frog ('when wound up, hops about the table to the horror of all'), the magic whistle ('any person blowing this whistle except the owner their face becomes covered with flour or charcoal'), and so on. Nor should we forget Victorian toy theatre, cut out from 'penny plain' or 'twopence coloured' cards and staged on the nursery table.

To enjoy all these playthings a child would need some domestic space. It was only in the nineteenth century that it became customary to allocate to children living space which they could regard as their own. In thus gaining ground, children were sharing in the more widespread enjoyment of privacy which has steadily developed in western society over the last six centuries. Since adults were much more in control of the world than children could ever be, it can be argued that children got space of their own not so much because they deserved it but because adults did not want to share their space with children.

Whatever the reason, English parents were especially known for keeping their children at a distance. In his influential manual, *The Gentleman's House; or, How to Plan English Residences, from the Parsonage to the Palace*, first published in 1864, Robert Kerr opens a section on 'The Children's Rooms' with the words:

The principle of Privacy, which was laid down at an early stage of our investigation, whereby in every Gentleman's House a distinct separation should be made between the Family and Servants, has a similar application here; that is to say, the main part of the house must be relieved from the more immediate occupation of the Children.

He concedes 'that the mother will require to have a certain facility of access' to her children, but assumes that no one else will want to see them. Accordingly, he recommends placing a nursery suite (which, at its most lavish would include day and night nurseries, bathroom, scullery and nurse's room) out of the way, somewhere near the servants' quarters. The result of the thorough application of segregation was that, as a German observer remarked, 'a stranger may visit' an English house 'without being in the least aware that there are children in it'.[14]

Whatever the motives for giving children rooms of their own, one consequence was that in due course sympathetic adults began to give thought to how these rooms should be furnished and decorated. Practical considerations came first – good ventilation, ample sunlight, robust and easily cleanable wall and floor surfaces. But, as Mrs Beeton's *Housewife's Treasury* advised, the nursery should be 'the most cheerful and merriest place in the whole house'. The architect

76 Nursery wallpaper, reproducing Kate Greenaway's illustrations of the months of the year from her *Almanack*. Manufactured by David Walker, 1893. V&A: E.1823–1934.

Robert Edis regretted the 'dreariness which generally pervades the rooms especially devoted to children … the rooms in which our little ones spend so large a portion of their early lives', and likewise urged that they should be 'made more cheerful and more beautiful'. They should not be used as repositories for junk from elsewhere in the house, for 'the mildewed Landseer prints of foaming, dying animals, the sheep-faced Madonna and Apostles in bituminous draperies, commemorating a paternal visit to Rome in the days when people bought copies of the "Old Masters"', as Edith Wharton and Ogden Codman tartly commented.[15]

Parents were urged to use their imaginations in choosing bright colour schemes and appropriate pictures, in order to encourage artistic taste in their offspring. There was only one commercial decorative product that was particularly aimed at children, and that was nursery wallpapers (plate 76). To begin with these tended to reproduce illustrations in books: nursery rhymes, or such classics as *Robinson Crusoe* or *Pilgrim's Progress*. But from the 1870s Walter Crane began to make designs specifically for nursery wallpapers, and they have remained a subsidiary but popular line in the wallpaper trade ever since.[16]

The idea of designing a nursery as a visual unit only came in the closing years of the century. A trend-setting example, widely admired both in England and abroad, was a nursery suite exhibited at the Women's Exhibition at Earl's Court, London, in 1900. It was designed by the artists Cecil Aldin and John Hassall, and parts of it survive in the nursery at Wightwick Manor, West Midlands. The idea was at once taken up by architects in Britain, Germany, Austria and France, and was soon accepted at a more popular level, as instanced in the multi-volume manual *The Book of the Home* (1901; plate 77).

77 S. J. Waring & Sons, London, Nursery. Frontispiece to H.C. Davidson's *The Book of the Home*, vol. 7 (London, 1901). V&A: 47 W 392. An early example of a commercial 'through-designed' nursery in Arts and Crafts style.

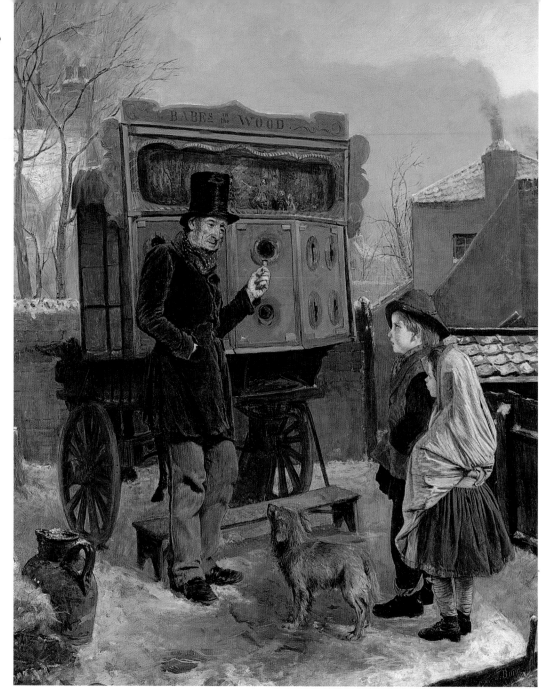

When children ventured out of their homes, they would have found a world that was to no great extent geared to their needs, but in which some diversions could be found. In the country children would entertain themselves with traditional seasonal games (tops in March, conkers in autumn), would relish the fun of local fairs and would find their lives brightened occasionally by the visit of a Punch and Judy show, or an itinerant peep show (plate 78). In town, poor children played in the gutters. Middle-class children, too, could derive some pleasure from the life of the streets and public places. As well as the shop windows of booksellers and toy and print dealers, there might be street traders selling toys, especially at Christmas, when Ludgate Hill in London was crowded with them (plate 79). There were public events which might attract children: in the 1840s the artist Richard Doyle, as a teenager, was always fascinated by the colour and dash of military parades (the 'glittering cuirasses', the 'distant sound of trumpets', the 'uproarious discharge of musketry').[17] Some of the many adult public entertainments appealed particularly to children, such as waxworks and zoos.

78 John Burr, *The Peep Show*. Oil on canvas, 1864. The Forbes Magazine Collection, New York.

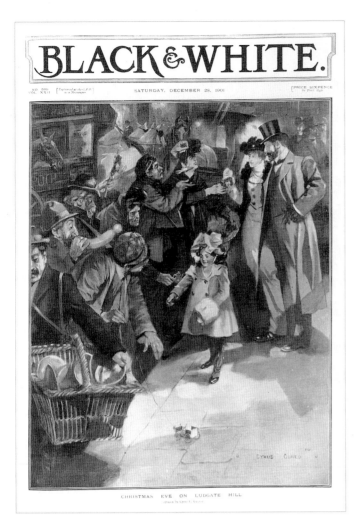

79 Cyrus C. Cuneo,
Christmas Eve on Ludgate Hill.
Illustration from *Black &
White* (28 December 1901).
V&A: National Art Library.

A new development in the Victorian period was the rise of museums and picture galleries, both in London and in big provincial towns. On the whole, people in charge of these did not like to promote them as pleasurable experiences; they echoed the art critic John Ruskin, who insisted that 'a museum is . . . not at all a place of entertainment, but a place of education'. Museum visiting tended, therefore, to be rather hard work. But as a mode of education, museum going was at least informal, exploratory, open to all and usually free. The South Kensington Museum, especially, cultivated popular appeal, at least to start with. It became rather stand-offish towards the end of the century, just as museum officials in general were beginning to try to reach out to ordinary people. A Museums Association, founded in Britain in 1889, helped to stimulate a sense of mission among curators, though it was largely concerned with the internal organisation of museums. The big step forwards in care for the audience was a Conference on Museums as Places of Popular Culture at Mannheim in Germany in 1903, dedicated to bringing museums 'into relation with men's daily life'. The use of 'men's' here (in a report in the *Museums Journal*, 1903, p.105) follows the linguistic conventions of the time, of course, but it inadvertently indicates that children (and women) were only marginally on the agenda of museums. The first, pioneering museum especially for children was founded in Brooklyn, New York, in 1899. Not much can be discovered about how children used Victorian museums in Britain, but occasionally there is a vivid flash, as when we read of the South Kensington Museum that 'the neighbouring wealthy residents are in the habit, on a wet day, of packing their children off in a cab to the so-called Brompton Boilers, in order that they may have a good run through the Galleries' (plate 80).[18]

80 Frontispiece to *The Baby's Museum* (London, 1880). Colour lithograph. V&A: Bethnal Green Museum of Childhood; Renier Collection.
This is a book of nursery rhymes. The idea that nursery rhymes were the traditional literature of childhood, and deserved as much respect as other historical relics, caught on in the second half of the nineteenth century. It obviously inspired the publishers of this book to commission an amusing frontispiece showing a children's museum before such a thing really existed.

A VISIT TO THE SOUTH KENSINGTON MUSEUM

81 Detail of a wood-engraving from *Leisure Hour* (14 April 1859). V&A: National Art Library. Did children visit the South Kensington Museum? The Victorians enthusiastically collected statistics, so we know the Museum's attendance figures right from the beginning. But audience analysis of the type we carry out today was not undertaken, so we have no precise figures for children, and have to rely on occasional clues like this magazine illustration. It shows children eagerly visiting the 'Food' section of the new Museum. Most early pictures of museum visitors show a 'family audience', and we cannot be sure whether they represent reality, or what the artist would have liked to see.

82 *An Easter Monday at Kensington Museum*, wood-engraving from *Leisure Hour* (1 April 1870). V&A: National Art Library. It was certainly the Museum's policy to encourage a family audience. The founding Director, Henry Cole, declared in a speech in 1857 that 'in the evening, the working man comes to this Museum . . . in his fustian jacket . . . accompanied by his threes, and fours, and fives of little fustian jackets, a wife, in her best bonnet, and a baby, of course, under her shawl'.

83 C. E. Emery, *View of the Main Entrance to the South Kensington Museum*. Detail. Watercolour, 1872. V&A: AL 7927.1. This detail from a painting of the Museum's main entrance in 1872 shows visitors flocking in. Those coming on foot include artists with easels and portfolios, a young couple, and little girls accompanied by women who might be their mothers or their nursemaids. Children figure prominently.

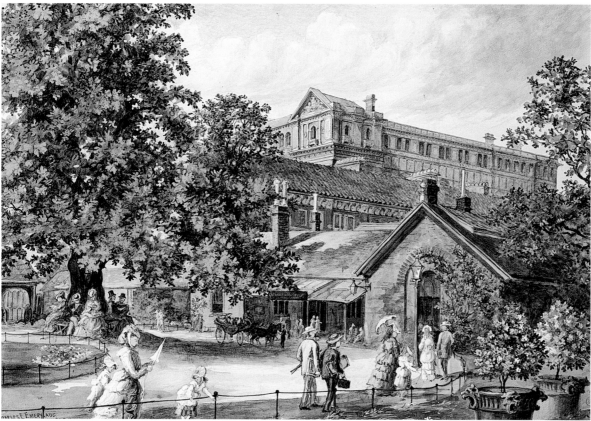

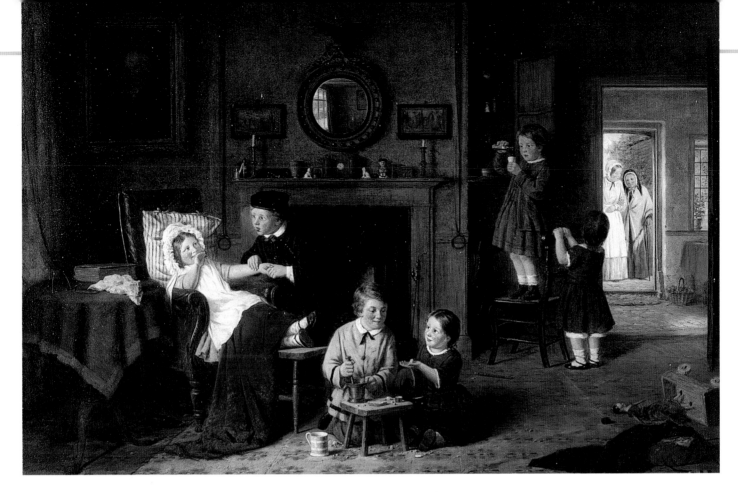

84 Frederick Daniel Hardy, *Playing at Doctors*. Oil on canvas, 1863. V&A: 1035–1886.
Children would have found much in the Museum to expand their minds, from steam-engines to silk-worms. Here and there, they could glimpse reflections of their own experiences in the world of childhood. The Museum's first picture collection, donated by John Sheepshanks in 1857, was devoted to contemporary British paintings, and included many scenes of child life by artists such as William Mulready and Thomas Webster.

85 Charles Keene, *Nota Bene*, wood-engraving in *Punch*. (25 June 1870). V&A: PP 8 L.
During its early days and for twenty to thirty years after, the Museum included building materials, food, animal products, architectural and sculptural plaster casts, educational equipment and machinery. To the eye of a child, all this may have seemed puzzling, or even comic. But grown-ups were always ready to inculcate a suitably respectful attitude, as the caption of this *Punch* cartoon makes clear. Exhibits were not to be called 'funny', but 'curious' or 'remarkable'.

86 Spelling game. *c*.1845. V&A: E.1745–1954.
In the Museum's earliest days, it was possible for children to find toys among the exhibits. The Education Collection put on view a wide range of school equipment – desks, globes, charts, text-books – including some of the kindergarten toys pioneered by Friedrich Froebel, and other educational toys and games. Around these clustered 'happy groups of children . . . prying with eager eye, under the direction of governesses and tutors, into the varied and instructive treasures of the glass cases'. This toy, a Victorian spelling game, is the sort of thing they might have seen. Today the V&A has a fine toy collection, built up since the 1920s at its branch museum, the Bethnal Green Museum of Childhood.

The world at large became more hospitable to children in the course of the nineteenth century. Children in comfortable families were best placed to enjoy this, but even the lot of poor, deprived children improved. Social provision for destitute children gradually expanded after the Poor Law Board was replaced by the Local Government Board in 1870. Dr Barnardo started his work in the 1870s, and the Waifs and Strays Society was founded in 1881. During the 1880s societies for the protection of children were founded in many English towns, joining together to found the National Society for the Prevention of Cruelty to Children in 1889. The Children Act of 1908 crowned more than two decades of effort on behalf of underprivileged children.[19]

Meanwhile, it was in the more privileged homes of the middle classes that a new culture of childhood was chiefly cultivated. The attractions of family and fireside were constantly extolled. Moralists held up the image of the happy, united family, while the domestic dwelling became an ever more snug nest, padded with soft upholstery. Each theme could easily be the subject of longer essays than this. Perhaps what mattered most was that in the Victorian period more and more children found themselves provided with secure space in which they could satisfy their own desires and explore their own ideas. Many of the representations of children in Victorian art depict them as mimicking or counterpointing adult attitudes, and one senses the artists' condescension showing through. An evocative picture which seems almost untainted by this grown-up gloss is the artist C. R. Leslie's portrait of his little son George (painted, undoubtedly, with love): in the dappled sunlight of an enclosed back garden this child is surely being utterly himself (plate 87).

87 Charles Robert Leslie, *A Garden Scene*. Oil on canvas, *c*.1838. V&A: FA 130.

VOTES FOR WOMEN AND CHASTITY FOR MEN:

Gender, Health, Medicine and Sexuality

JAN MARSH

The principle which regulates the existing social relations between the two sexes – the legal subordination of one sex to the other – is wrong in itself and now one of the chief hindrances to human improvement . . . it ought to be replaced by a principle of perfect equality, admitting no power or privilege on the one side, nor disability on the other. (J. S. Mill, *The Subjection of Women*, 1867, preamble)

INTRODUCTION

The gender history of nineteenth-century Britain can be read in two ways: as an overarching patriarchal model which reserved power and privilege for men; or as a process of determined but gradual female challenge to their exclusion. With the hindsight of a whole century, the latter view is perhaps more persuasive, for the situation in 2001 can be seen to have its beginnings in the Victorian era. But actual changes in gender dispositions during the queen's long reign should not be over-estimated.

While the period witnessed a distinctive shift in ideas respecting gender relations at the level of social philosophy, away from a traditional idea of 'natural' male supremacy towards a 'modern' notion of gender equity, the process was vigorously contested and by no means achieved. Important legal, educational, professional and personal changes took place, but by 1901 full, unarguable gender equality remained almost as utopian as in 1800. If some notions of inequality

88 Copy by George Frederic Watts, *John Stuart Mill*. Detail. Oil on canvas, 1873.
By courtesy of The National Portrait Gallery, London.

89 Eyre Crowe, *The Dinner Hour, Wigan*. Detail. Oil on canvas, 1874. Manchester City Art Gallery.

were giving way to the idea that the sexes were 'equal but different', with some shared rights and responsibilities, law and custom still enforced female dependency. As women gained autonomy and opportunities, male power was inevitably curtailed; significantly, however, men did not lose the legal obligation to provide financially, nor their right to domestic services within the family. Moreover, the key symbol of democratic equality, the parliamentary franchise, was expressly and repeatedly withheld from women.

In relation to health, the Victorian age saw major changes in knowledge and practice relating to public sanitation, largely in response to population growth and rapid urbanisation, with the gradual provision of piped water, sewerage and improved housing. In medicine, micro-bacterial understanding led to better control of infectious disease, avoidance of cross-contamination in surgery and prevention of specific diseases through vaccination. Traditional treatments and nursing practices evolved to improve recovery rates, but there were few effective drug remedies and overall morbidity and mortality remained high. Hospital-based medicine catered largely for the poor, many of whom ended their days in the local workhouse infirmary; middle- and upper-class patients were attended in their own homes. In mental health, patients were steadily concentrated in large, highly regulated lunatic asylums outside the urban areas.

A major change, towards the end of the century, lay in falling birth-rates and smaller families. Couples like Victoria and Albert, married in 1840, who had nine children in seventeen years, were from the 1870s steadily replaced, in nearly all sections of society, by those choosing to limit family size.

Most developments in public sanitation and medical practice were gender-neutral in their theoretical bases and actual effects. Ideas relating to reproductive health were the obvious exception, generally both 'read back' into gendered theories of individual health, and also deployed in prescriptive notions of sexuality and sexual behaviour. In the early Victorian period, sexual codes were governed by religious and social moralism. In later years science began to challenge religion as the dominant epistemology, but in support of similar ideas. While the end of the era saw some demand for 'free' partnerships without the sanction of marriage, and an increase in same-sex relationships, both were generally deemed deviant.

The mid-century was notable for its moral panic over prostitution, which developed – despite a 'permissive' interval in the 1860s – into demands for male continence outside marriage. At the end of the era, a socially shocking topic was that of the virginal bride (and her innocent offspring) infected with syphilis by a sexually experienced husband. Bringing together political and personal demands for equality, the slogan: 'Votes for Women, Chastity for Men' was coined.[1]

GENDER

The Queen is most anxious to enlist every one who can speak or write to join in checking this mad, wicked folly of 'Woman's Rights', with all its attendant horrors, on which her poor feeble sex is bent, forgetting every sense of womanly feeling and propriety . . . It is a subject which makes the Queen so furious that she cannot contain herself. God created men and women different – then let them remain each in their own position.

(Queen Victoria, letter 29 May 1870)

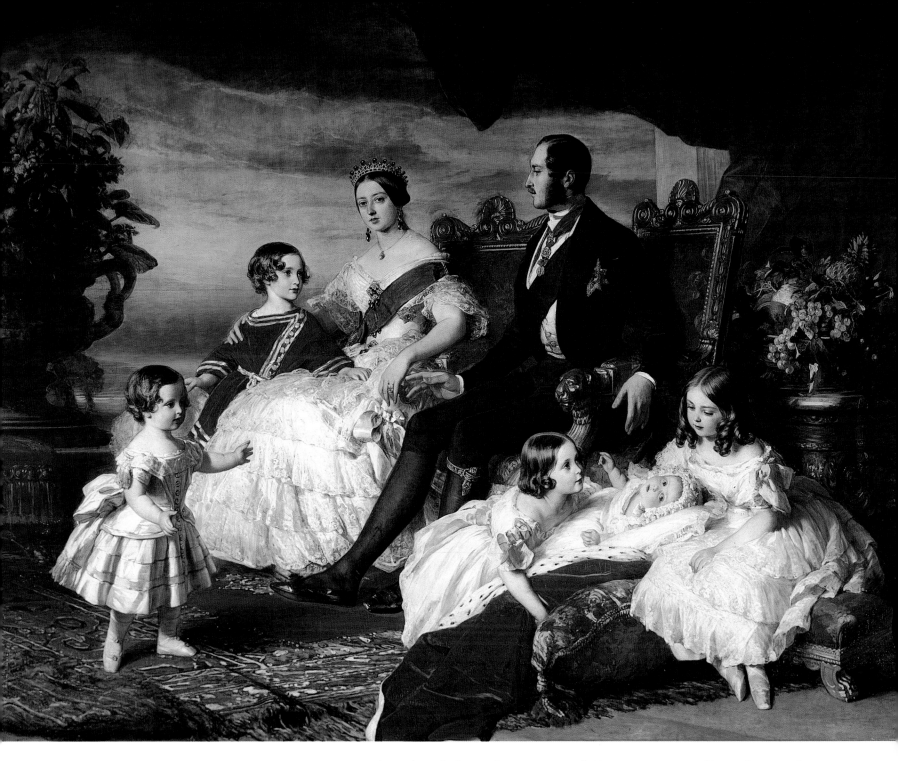

90 Franz Xavier Winterhalter, *The Royal Family in 1846*. Detail. Oil on canvas, 1846. The Royal Collection © HM Queen Elizabeth II.

In terms of gender ideology, the accession of Victoria was something of a paradox. Traditionally, women were defined physically and intellectually as the 'weaker' sex, in all ways subordinate to male authority. In private life women were subject to fathers, husbands, brothers and even adult sons. Publicly, men dominated all decision-making in political, legal and economic affairs. But as monarch, Victoria – who in 1837 was only 18 years old – was socially and symbolically superior to every other citizen in Britain, all men being constitutionally considered her subjects.

Throughout her reign Victoria succeeded in maintaining a dual aspect – as both a queen and a womanly woman. But the implicit contradiction is an emblem of many general and local situations where public and private gender relations were questioned, contested and re-formed.

Changing patterns of patriarchal authority fell within a wider scenario of expanding rights and diminishing subservience for many people, including employees and young people. In some ways resistance to change in gender relations thus represented a symbolically concentrated reaction against general democratisation. Early Victorian gender prescriptions featured men as industrious breadwinners and women as their loyal helpmeets. Reinforced by social philosophers like Auguste Comte, Arthur Schopenhauer, Herbert Spencer, Pierre-Joseph Proudhon and John Ruskin,[2] this developed into a mid-century doctrine of 'separate spheres', whereby men were figured as competitors in the amoral, economic realm while women were positioned either as decorative trophies or spiritual guardians of men's immortal souls. From the 1860s, to this social construct the Darwinian theory of 'survival of the fittest' added a pseudo-scientific dimension which placed men higher on the evolutionary ladder.

The man's power is active, progressive, defensive. He is eminently the doer, the creator, the discoverer, the defender. His intellect is for speculation, and invention; his energy for adventure, for war, and for conquest . . . But the woman's power is for rule, not for battle, – and her intellect is not for invention or creation, but for sweet ordering, arrangement, and decision . . . She must be enduringly, incorruptibly good; instinctively, infallibly wise – wise, not for self-development, but for self-renunciation: wise, not that she may set herself above her husband, but that she many never fail from his side . . .
(John Ruskin, *Sesame and Lilies*, 1865, part II)

The Victorian era is almost synonymous with the ideology of 'great men' – outstanding male individuals, whose features and life stories fill the National Portrait Gallery (founded 1856) and the *Dictionary of National Biography* (launched 1882) while their exploits were hymned in key texts like Thomas Carlyle's *Heroes and Hero Worship* (1841) and Samuel Smiles's *Self-Help* (1859). Throughout the era, 'masculine' values of courage and endeavour supported military campaigns and commercial expansion. Women were allotted a subsidiary role, with patience and self-sacrifice the prime feminine virtues. Motherhood was idealised, alongside virginal innocence, but women were subject to pervasive denigration. To the end of the century, strident misogyny was still strong in both popular and intellectual writing – but as loudly as female inferiority was declared immutable, women everywhere were demonstrating otherwise.

From infancy onwards, gender inequity permeated all aspects of British life (plate 91). 'Think what it is to be a boy, to grow up to manhood in the belief that without any merit or exertion of his own ... by the mere fact of being born a male he is by right the superior of all and every one of an entire half of the human race,' wrote John Stuart Mill in his 1867 polemic against *The Subjection of Women*, continuing:

how early the youth thinks himself superior to his mother, owing her forbearance perhaps but no real respect; and how sublime and sultan-like a sense of superiority he feels, above all, over the woman whom he honours by admitting her to a partnership of his life. Is it imagined that all this does not pervert the whole manner of existence of the man, both as an individual and as a social being?[3]

91 Kate Greenaway, *Garden Party*. Colour lithograph, late 19th century. V&A: E.2433–1953.

Whereas in 1800 the majority of Britons had a predominantly practical education, acquired at home and at work, by 1901 formal learning at primary level was universal, with higher instruction available to the better-off. These educational issues are dealt with in chapter 3, but it is worth noting that girls were beginning to move on to university study by the 1860s. This was gradually provided, in segregated colleges at Cambridge and Oxford,[4] somewhat more liberally at the Scottish universities and from 1878 at London University and elsewhere. Subjects studied acquired gender aspects, English literature and geography being for example regarded as appropriate for women, with Latin and geology for men. Overall, however, boys progressed to higher levels, producing an imbalance in qualifications that persisted until recently. One exceptional example was the classicist Jane Harrison (1850–1928), who trenchantly observed how scholarship was dominated by 'that most dire and deadly of all tyrannies, an oligarchy of old men'.[5] But it remained the case that the great Victorian adult education movement included predominantly male institutions such as the Mechanics' Institutes and Working Men's College. Later, however, the university extension movement also attracted many under-educated women.

Throughout the Victorian period, employment patterns evolved in response to industrial and urban factors, but occupational structures remained gendered and indeed in some ways became more distinct. Thus, whereas in the 1830s wives often assisted husbands in a small business or professional practice, by the 1890s work and home were commonly separated; exceptions included shopkeeping and upland farming. Nationally (which in this period included the whole of Ireland as well as Scotland, England and Wales), male employment shifted from agriculture to heavy industry, manufacturing and transport, with an accompanying increase in clerical and professional occupations. Men also left domestic service, which remained the largest category of female employment throughout the period (employing 10 per cent of the female population in 1851, for example, and over 11 per cent in 1891).[6] Women also worked in textile mills (see plate 89), potteries, agriculture and garment-making, as well as in seasonal or unrecorded employment, especially laundering.

Compared to the twentieth century, there was indeed some contraction in the work open to women, as protective legislation barred their employment underground or overnight. In the Lancashire coalfields, the 'pit-brow lasses' struggled to retain their jobs. Generally, male workers strove to secure wages that enabled wives to be full-time mothers – an aspiration in tune with bourgeois notions of orderly domestic bliss. The organised labour movement was overwhelmingly male, with a few trade union activists such as bookbinder Emma Paterson (1848–86), leader of the Women's Protection and Provident League, who in 1875 persuaded the Trades Union Congress to accept female delegates and successfully campaigned for female factory inspectors.

It is calculated that while most men worked, only one-third of all women were in employment at any time in the nineteenth century (as against two-thirds in 1978, for comparison.) There were only men in the army and navy, in shipbuilding, construction, printing, railways – to list some major occupations – and only male scientists, engineers, priests, City financiers and Members of Parliament.

From the mid-century, educated women began to prise open certain professional and clerical occupations, partly in response to the powerful Victorian 'gospel of work' that castigated

idleness, partly to provide for the perceived 'surplus' of single women, and partly for the sake of self-fulfilment. As a result of these struggles, by 1901 there were 212 female physicians, 140 dentists, 6 architects and 3 vets. Over a quarter of professional painters (total 14,000) and over a half of musicians (total 43,250) and actors (12,500) were female.[7]

In the aristocracy, neither men nor women normally worked for wages. But men managed their estates and took part in government, while 'society women' supported these activities through household management and political entertaining.[8] At the top of the tree, so to speak, lords and ladies attended Court for a variety of official functions.

However, the majority of upper- and middle-class women never worked outside the home. Nevertheless, although leisure time undoubtedly increased for many, the notion of idle, unoccupied Victorian ladies is something of a myth. Women ran the house, undertaking domestic work and child care themselves, as well as supervising the servants employed to cook, clean, carry coal and run errands. Moreover, almost from time immemorial, with a 'work-basket' to denote her tasks, each girl and woman was a needleworker, responsible for making and mending clothes and household linen. One major change in the period was the invention in the 1850s of the domestic sewing machine; which greatly assisted both private and commercial dressmaking. By 1900 ready-made garments were increasingly available in shops.

Traditionally, too, women cared for the sick and elderly. In a large Victorian household, at any time at least one member – child, great-aunt or servant – might require nursing, often for prolonged periods. 'All women are likely, at some period of their lives, to be called on to perform the duties of a sick-nurse, and should prepare themselves for the occasion when they may be required,' noted Mrs Beeton. Professional nurses might be hired, but in many homes 'the ladies of the family would oppose such an arrangement as a failure of duty on their part'.[9]

Female skills were also in demand outside the home. Throughout the Victorian period, when family needs allowed, women undertook unpaid work in a variety of fields, known collectively as philanthropy. Typically operating at local level, often through Church structures, these activities might today be classified as 'social work'; they included distributing clothes, food and medicines; teaching literacy, home care and religion; and 'parish visiting' of the poor and infirm. As the century progressed, such roles were increasingly professionalised, through local and central government institutions, which in time offered recognised occupations for able women. Those who would once have stitched for a church bazaar or carried bowls of broth to starving widows began to train themselves seriously. One famous example is provided by Octavia Hill (1838–1912; plate 93) who managed a slum housing scheme, collecting rents, overseeing repairs and demanding cleanliness from tenants. Although her work was on a small-scale, she also trained and inspired others, including Lily Walker, Housing Manager for Dundee Social Union, and Ella Pycroft, of the London East End Dwelling Company.

92 Mrs Patrick Campbell as Juliet. Photograph, 1895. V&A: Theatre Museum.

Religion, too, offered rewarding work and a satisfactory social niche. From the late 1840s dedicated women were able – often against family pressure – to fulfil their vocation in Anglican orders engaged in devotional and philanthropic work, or as lay deaconesses. The Dissenting churches, with their earlier but now curtailed tradition of female preachers, also expanded laywomen's role, especially in Sunday school teaching, while independent sects offered the stirring spectacle of women preaching publicly. The most notable of these was surely Catherine Booth, co-founder of the Salvation Army. Overseas mission work likewise required women's labour – usually as wife to a missionary husband, but on occasion for a single woman like the redoubtable Dr Mary Slessor (1848–1915), who ran a renowned service in eastern Nigeria.

'Good causes' were also open to both sexes. British women were initiators and activists in campaigns to abolish slavery in the United States, to revoke the Contagious Diseases Acts at home and to promote teetotalism, to cite three of many reform movements for which they gathered petitions, organised meetings and lobbied politicians. Identified as a primary cause of poverty and violence, alcohol abuse attracted campaigners from all social classes and regions. 'The demon drink' was castigated by the unlettered Scottish poet Janet Hamilton; the British Women's Temperance Association was founded in Newcastle; and the Countess of Carlisle devoted her considerable energies to the cause. For many men, abstinence became a marker of virtue, but by the same token for others drink signalled the individual right to choose one's own pleasures.

Throughout the period, daily life remained differentiated, despite changes in some customs. One small example demonstrates how in the 1830s and 1840s the habit of paying social calls still prevailed among the middle and upper classes, but as gentlemen increasingly took full-time work, by the 1870s and 1880s this practice had become largely feminised. Private letter writing, which hugely increased thanks to the penny post, was also a largely female task. While men customarily undertook business communication, social networking thus fell to women.

As numerous poems and paintings testify, mother love was central to ideas of family, but fathers were also allocated an increasingly affectionate role. As the ideal of companionate and complementary marriage flourished with the promotion of domestic harmony, so home life grew in significance for men, although from 1870 the attractions of home lost ground again to the 'bachelor' world of clubland and regiment.[10] Moreover, even in kindly, liberal households, men were entitled to be looked after. 'One thing I thoroughly enjoy', wrote Christina Rossetti when her brother married in 1874, '[is] that my mother and I can now go about just as we please . . . without any consciousness of man resourceless or shirt-buttonless left in the lurch!'[11]

In working-class homes, where there were often equal but different burdens of work, men were entitled to better food and more leisure. A major site of struggle focused on their right to spend money on themselves rather than family and household maintenance – expressed visually with the careworn wife and hungry children waiting forlornly outside the public house.

Economic and social pressures ensured that marriage remained the goal of women in all classes; statistics show that 85 per cent did so by the age of 50, in a society which expected them to be the subservient partner. Custom and common law supported the age-old notion that men could command, while women should obey. Since personal ambition was a masculine virtue but

93 John Singer Sargent, *Octavia Hill*. Oil on canvas, 1899. By courtesy of the National Portrait Gallery, London.

Ye Newe Generation.

a feminine vice, the highest female aspiration was to minister to a male genius – as the lives of Jane Carlyle and Emily Tennyson amply testify. Modesty, self-denial and sweet temper were the admired feminine qualities. The masculine ideal was self-control (the famous stiff upper lip of Empire) and mastery over others.

Over the seventy years of Victoria's reign, public spaces remained largely gendered; whereas men of all ages and classes were free to go where they wished, in town or countryside, many locations were 'off-limits' to unaccompanied women. At the end of the period as at the beginning, young ladies were obliged to have a chaperone – at least a servant – when out walking or attending an evening event. 'When it was explained to me that a young girl by herself was liable to be insulted by men, I became incoherent with rage at a society which shut up the girls instead of the men', recalled Helena Swanwick.[12]

Habits varied and changed. By 1880 daytime shopping was a popular female activity, for example; nevertheless only men enjoyed free access to bars, music halls, and most outdoor sports. Cycling was thought a bold activity for women, though genre painting suggests that the new game of tennis was enjoyed by both sexes. One marker of the end-of-century New Woman was greater independence, symbolised by her own door-key to the family home, so she might come and go as she pleased.

94 Barbara Bodichon, *Ye newe generation*. Sketch of Barbara Bodichon and friends. Pen and ink drawing. *c.*1854. Girton College, Cambridge.

Although to some degree a ridiculed media creation similar to the 'bra-burning Woman's Libber' of the 1970s, the New Woman – first identified by name in 1894 – emerged from widespread female discontent with marriage as currently constituted, and signalled the arrival of a newly vocal generation. And however small, each step towards gender equality meant a diminution – sometimes barely visible – of male power and privilege.

Those defending the status quo – who included a substantial number of women – argued that male duties to support families and to fight for their country were responsibilities, not privileges; and that British women possessed incomparable moral influence and power. Only in a few, 'advanced' circles was the ideal of equal partnership in earning, decision-making and domestic affairs discussed. Indeed, the vigorous humour directed against the dominant wife and her 'hen-pecked' husband indicates that equality aroused real fear of change.

In regard to equal legal and political rights, the century saw vigorous campaigns, if few gains. In 1854 *A Brief Summary, in Plain Language, of the Most Important Laws concerning Women*,[13] was drawn up by the young Barbara Bodichon (plate 94), a leading feminist of the age. This itemised the injustices of the legal system, including male rights to custody of children, to the wife's income and property, and to sexual ('conjugal') pleasure at will. Married women were especially ill-placed; as Mill observed: 'marriage is only actual bondage known to [English] law. There remain no legal slaves except the mistress of every household.' But spinsters and widows were also denied all rights to political representation, and by custom a younger brother or adult son was deemed senior male and 'head of the household'.

95 *Is Marriage a Failure?* Front cover illustration of the *Illustrated Police News* (4 April 1891). The British Library.

THE NEW WOMAN

The 'New Woman' was first identified by name in 1894. Although in part a media-driven caricature, she emerged from widespread female discontent with marriage as generally constituted, and signalled the arrival of a newly vocal generation – 'the Revolt of the Daughters' – who demanded freedom from control and convention, and the same civil and social rights as men. New women expected to travel and live independently, to earn their own living and to choose their own partners; they also paved the way for the militant Suffragettes of the 1900s.

96 Albert George Morrow, poster for *The New Woman* at the Comedy Theatre. Colour lithograph, 1894. V&A: E.2682–1962.
Sydney Grundy's play *The New Woman* opened at the Comedy Theatre London on 1 September 1894. Its comic plot involves four 'progressive', domineering women who threaten conventional relationships.

97 'Donna Quixote', *Punch* (28 April 1894). V&A: PP.8.L.
Initially, the 'New Woman' was a hostile term, satirising female independence:
'Tis a goal to those who long to roam
Unchaperoned, emancipated, and free
With the large Liberty of the Latch-key!'

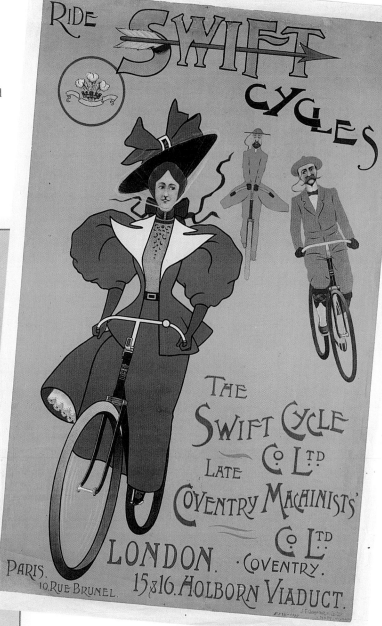

99 Advertisement for Swift Cycles. Poster, c.1895. V&A: E.533–1939. 'The Revolt of the Daughters', an article in *The Nineteenth Century*, promoted the right of young women to travel freely. Bicycles offered a cheap and easy means of doing so.

98 Aubrey Beardsley, advertisement for *Keynotes* series of books, 1893. V&A: E.444–1972. *Keynotes* (1893) presented vivid portraits of New Women. Written by Mary C. Dunne under the pseudonym George Egerton, its stories created a sensation and started a trend. Cover designs for each title in the series were commissioned from Aubrey Beardsley. In the popular press the New Woman was frequently attacked as lesbian, and linked to male dandyism and homosexuality, which also challenged dominant sexual codes.

At its worst, law and custom gave men the right to oppress female dependants, and to immure, beat and rape their wives. As Mill remarked, a husband might commit any atrocity against his wife short of killing her – 'and if tolerably cautious, can do that without much danger of legal penalty'.[14]

A brief summary of the most important legal changes shows how during the rest of the century some gender injustices were removed, although it was a slow process and only very partially achieved. Notable events included the Married Women's Property Acts of 1870 and 1882, and the 1891 Court of Appeal ruling that 'when a wife refuses to live with her husband he is not entitled to keep her in confinement in order to enforce restitution of conjugal rights'. But there was no legislation on equal pay or opportunity, and numerous other inequities also remained.

In 1837, as Chartist demands demonstrated, the majority of men remained unenfranchised. Thanks to legislation in 1867 and 1884, by 1901 virtually all adult men enjoyed the vote. But despite a long and sustained campaign, headed by the National Union of Women's Suffrage Societies led by Millicent Fawcett,[15] time and again women were expressly denied the right to take part in national elections.

By the 1870s, however, unmarried householders of either sex enjoyed the municipal franchise (1869, modified by case law 1872) so that by the late 1880s, for example, 1,600 women and 5,900 men in Bath were local electors. The 1870 Education Act allowed women both to vote and to serve on School Boards; Lydia Becker of Manchester became one of those playing a leading role in her locality. In 1875 the first woman was elected to a Poor Law Board, and by 1900 there were over 1,000, prominent among them Louisa Twining of Kensington and Agatha Stacey of Birmingham; nevertheless, these councils were still predominantly composed of and staffed by men. 'Local government ladies were the wives, widows, daughters and sisters of a town's civic and social elite, of its industrialists and its professional men; and they had years of philanthropic work in the roughest part of their towns behind them,' writes Patricia Hollis.[16] It was not always plain sailing: in Bristol the Liberal Party refused to accept women candidates until one captured a School Board seat on a temperance ticket, while in Brighton and Bedford 'some of the more spiteful men' kept women off key Poor Law committees, and in 1889 the election of Jane Cobden and Margaret Sandhurst to the new London County Council was thwarted by a legal challenge from a defeated (male) opponent. New political opportunities were provided by elected parish and district councils in 1894, but women were debarred from standing for London Boroughs in 1900. Taken together, this meant that education and welfare remained the chief 'female' spheres of operation, in continuance of time-honoured community roles.

Thus, at the close of Victoria's reign, gender inequality remained a fact of British life, most clearly symbolised by exclusion from the parliamentary franchise. The demand voiced for fifty years therefore became a keynote for the new century: VOTES FOR WOMEN.

HEALTH AND MEDICINE

Early Victorian ideas of human physiology involved a clear understanding of anatomy (at least among experts; but the populace often had hazy knowledge of the location and role of internal organs) allied to a concept of vital forces focused on the hematological and nervous systems that now seems closer to the ancient 'humours' than to present-day models. Little was known of biochemistry or endocrinology. Traditional ideas of the body, whereby women were regarded as smaller versions of men, and 'turned outside in' (i.e. with internal rather than external sexual organs) were gradually superseded by a binary concept of sexual determinism, in which difference governed all aspects of physiology, health and social behaviour. As the body was also defined as a closed system of energy, physical, mental and reproductive expenditure were held to be in competition; hence the notions that male sexual 'excess' led to debility and female reproductive health was damaged by intellectual study. Hence, too, must have derived the Victorian prescription for many ailments: rest.

In the early Victorian period disease transmission was largely understood as a matter of inherited susceptibility (today's 'genetic' component) and individual intemperance ('lifestyle'), abetted by climate and location, which were deemed productive of noxious exhalations (a version of environmental causation). Water- and air-borne infection was not generally accepted.

Thus the 1848 edition of Buchan's *Domestic Medicine*, with its coloured frontispiece showing the symptoms of smallpox, scarlet fever and measles, listed among the general causes of illness 'diseased parents', night air, sedentary habits, anger, wet feet and abrupt changes of temperature. The causes of fever included injury, bad air, violent emotion, irregular bowels and extremes of heat and cold. Cholera, shortly to be epidemic in many British cities, was said to be caused by rancid or putrid food, by 'cold fruits' such as cucumbers and melons, and by passionate fear or rage.[17]

Treatments relied heavily on 'change of air' (to the coast, for example), together with emetic and laxative purgation and bleeding by cup or leech (a traditional remedy only abandoned in mid-century) to clear 'impurities' from the body. A limited range of medication was employed, and the power of prayer was regularly invoked.

Diseases such as pulmonary tuberculosis (often called consumption) were endemic; others such as cholera, were frighteningly epidemic. In the morbidity statistics, infectious and respiratory causes predominated (the latter owing much to the sulphurous fogs known as pea-soupers; plate 100). Male death rates were aggravated by occupational injury and toxic substances, those for women by childbirth and violence. Work-related conditions were often specific: young women match-makers suffered 'phossy jaw', an incurable necrosis caused by exposure to phosphorous.

In Britain, epidemiological measuring and mapping of mortality and morbidity was one of the first fruits of the Victorian passion for taxonomy, leading to the clear association of pollution and disease, followed by appropriate environmental health measures. A major breakthrough came during the 1854 cholera outbreak, when Dr John Snow demonstrated that infection was spread not by miasmas but by contaminated water from a public pump in crowded Soho. When the pump handle was removed, cholera subsided. It was then possible for public health officials such as Sir John Simon to push forward projects to provide clean water (plate 101), separate sewage

100 W. Small. *A November Fog In London*. Engraving, Hulton Getty

systems and rubbish removal in urban areas, as well as to legislate for improved housing – one goal being to reduce overcrowding. The number of inhabitants per house in Scotland, for example, fell from 7.6 in 1861 to 4.7 in 1901.[18] Between 1847 and 1900 there were fifty new statutes on housing, ranging from the major Public Health Acts of 1848 and 1872 to the 1866 Lodging Houses and Dwellings (Ireland) Act, the 1885 Housing of the Working Classes Act and the 1888 Local Government Act. On a household basis, the indoor water-closet began to replace the traditional outdoor privy.

Scientific developments in the nineteenth century had a major impact on understanding health and disease, as experimental research resulted in new knowledge in histology, pathology and microbiology.[19] Few of these advances took place in Britain, where medical practice was rarely linked to scientific work and there was public hostility to the animal vivisection on which many experiments relied. The bio-chemical understanding of physiology began in Germany in the 1850s, together with significant work on vision and the neuromuscular system, while in France Louis Pasteur laid the foundations of the germ theory of disease based on the identification of micro-bacterial organisms. By the end of the century a new understanding of biology was thus coming into being, ushering in a new emphasis on rigorous hygiene and fresh air, and a long-lasting fear of invisible contagion from the unwashed multitude, toilet seats and shared utensils. British patent applications around 1900 include devices for avoiding infection via the communion chalice and the new-fangled telephone.

101 W. A. Atkinson, *The First Public Drinking Fountain*. Oil on canvas, *c*.1859–60. Geffrye Museum, London.

Technological developments underpinned this process, from the opthalmoscope and improved microscopes that revealed micro-organisms, to instruments like the kymograph, to measure blood pressure and muscular contraction. By mid-century, the stethoscope, invented in France in 1817 to aid diagnosis of respiratory and cardiac disorders, became the symbolic icon of the medical profession. However, the most famous British visual image, Luke Fildes's *The Doctor* (exhibited at the Royal Academy in 1891; plate 102) shows a medical man with virtually no 'modern' equipment.

Surgery advanced – or at least increased – owing largely to the invention of anaesthesia in the late 1840s. Significant events include a notable public demonstration of the effects of ether in London in October 1846 and the use of chloroform for the queen's eighth confinement in 1853. Anaesthetics enabled surgeons to perform more sophisticated operations in addition to the traditional amputations. Specialised surgical instruments and techniques followed, for some time with mixed results, as unsterile equipment frequently led to fatal infection.

102 Luke Fildes, *The Doctor*. Oil on canvas; exhibited 1891. Tate Gallery © 2001.

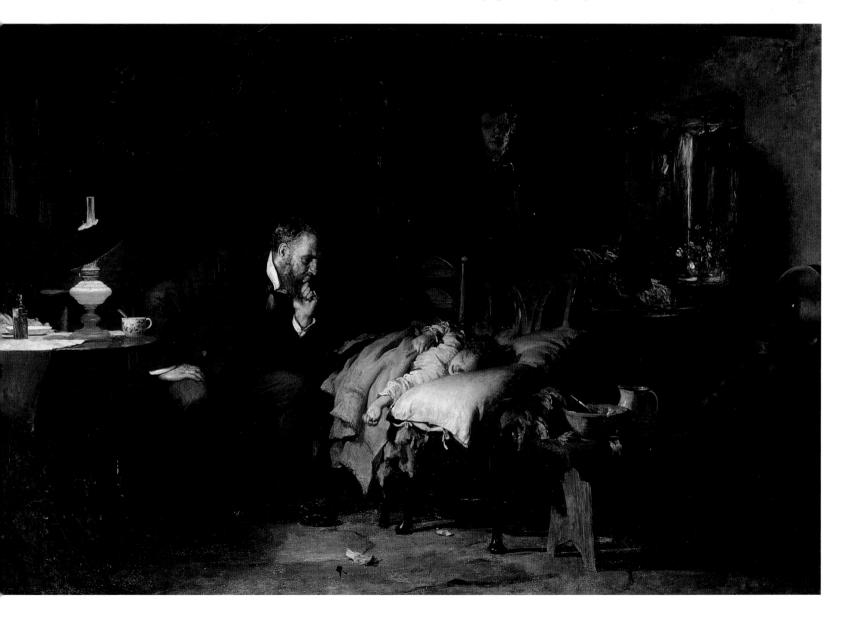

103 X-ray image of the ringed hand of Wilhelm Röntgen's wife Bertha, 1895. Science Museum, London/Science and Society Picture Library.
This first ever X-ray was taken when Röntgen was experimenting with cathode rays. He was awarded the first Nobel Prize for physics in 1901.

Antiseptic surgical procedures based on the practical application of Pasteur's laboratory work were developed by Joseph Lister (1827–1912) using carbolic acid (phenol) from 1869 in Edinburgh and in 1877 in London. Aseptic procedures followed, involving sterilisation of whole environments. Successful outcomes, such as Edward VII's appendicitis operation on the eve of his scheduled coronation, helped pave the way for the twentieth-century era of heroic surgery.

In 1895, at the end of the era, came Wilhelm Röntgen's discovery of X-rays, and in due course the photo of Röntgen's wife's hand became a potent sign of medical advance through scientific instruments (plate 103). But overall the nineteenth century is notable more for systematic monitoring of disease aetiology than for curative treatment.

Like other learned professions, medicine grew in size and regulation. In the early Victorian era it was dominated by the gentlemen physicians of the Royal College (founded 1518), with surgeons and apothecaries occupying lower positions. The British Medical Association was established in 1856 and from 1858 the General Medical Council (GMC) controlled entry through central registration. In the same spirit, the profession also resisted the admission of women, who struggled to have their qualifications recognised. Partly in response to population growth, however, numbers rose; for example, from a total of 14,415 physicians and surgeons in England and Wales in 1861, to 22,698 (of whom 212 were female) in 1901. At the turn of the century the GMC register held 35,650 names altogether, including 6,580 in military and imperial service.[20] The number of dentists rose from 1,584 in 1861 to 5,309 (including 140 women) in 1901. A growing proportion of qualified personnel worked in public institutions, and a new hierarchy arose, headed by hospital consultants. This reflected the rise in hospital-based practice, for this was also the era of heroic hospital building in the major cities (plate 104), accompanied by municipal and Poor Law infirmaries elsewhere. These were for working-class patients; those in higher economic groups received treatment at home.

A secondary aspect of growth and regulation was the steady medicalisation of childbirth, so that over this period traditional female midwives were superseded by male obstetricians, with all their 'modern' ideas and instruments. Under prevailing conditions, however, intervention through the use of forceps, for example, often caused puerperal fever and the high maternal mortality which was a mid-century concern.

Largely through the endeavours and energy of Florence Nightingale, whose nursing team at Scutari captured the public imagination amid military deficiencies in the Crimean War, hospital and home nursing was reformed, chiefly along sanitary lines. Rigorous nurse training also raised the social status of the profession and created a career structure largely occupied by women.

Despite these and other improvements, death rates remained relatively steady. Roughly one quarter of all children died in the first year at the end of Victoria's reign as at the beginning, and maternal mortality showed no decline. In some fields, however, survival rates improved and mortality statistics slowly declined; thus crude death rates fell from 21.6 per thousand in 1841 to 14.6 in 1901. Here, the main factors were public hygiene and better nutrition thanks to higher earnings – that is, prevention rather than cure. Although doctors made much of their medicines with Latin names and measured doses, effective remedies were few, and chemical pharmacology as it is known in 2001 only began at the end of the Victorian era. From the 1870s (animal)

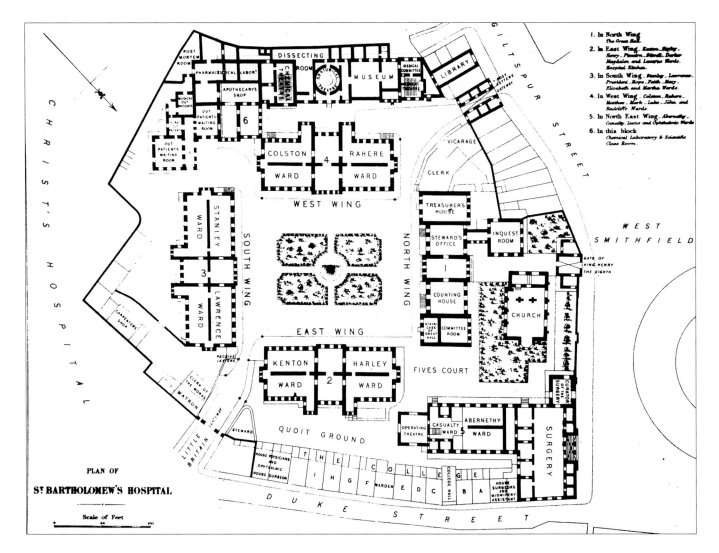

PLAN OF
S! BARTHOLOMEW'S HOSPITAL

Scale of Feet

thyroid extract was used for various complaints including constipation and depression, while from 1889 animal testicular extracts were deployed in pursuit of rejuvenation and miracle cures. At the same date aspirin was developed to replace traditional opiate painkillers.

As a result, many conditions remained chronic or incurable. These limitations, together with the relatively high cost of medical attendance, led to the rise (or extension) of alternative therapies including homeopathy, naturopathy ('herbal remedies'), hydropathy (water cures), mesmerism (hypnotism) and galvanism (electric therapy) as well as blatant fraudulence through the promotion of useless pills, powders and coloured liquids. From 1866 notions that disease was caused and cured by mental or spiritual power alone were circulated by the Christian Science movement.

Another highly popular fashion was that of phrenology, which claimed to identify temperamental characteristics such as aggression or lust ('amativeness') by means of lumps and bumps on the individual skull, and facial physiognomy. Psychology itself retained largely traditional concepts such 'melancholic' and 'choleric' tendencies, but in 1846 the term 'psychiatry' was coined to denote medical treatment of disabling mental conditions, which were generally held to have hereditary causes.

104 Plan of St Bartholomew's Hospital, *c.* 1848–77.
In 1843 St Bartholomew's Medical College was founded. Its first Warden, Sir James Paget (later Serjeant-Surgeon to Queen Victoria) allowed Elizabeth Blackwell, pioneer of medicine as a career for women, to study at the College in 1850.

The Victorian period witnessed an impressive growth in the classification and isolation (or strictly the concentration) of the insane and mentally impaired, in large strictly regulated lunatic asylums outside major cities, where women and men were legally incarcerated, usually for life. Opened in 1851, the Colney Hatch Asylum in Middlesex housed 1,250 patients. Wealthier families made use of private care, in smaller establishments.

Two major figures in the Victorian mental health field were James Connolly, author of *The Construction and Government of Lunatic Asylums* (1847) and Henry Maudsley, whose influential books included *The Physiology and Pathology of Mind* (1867).

Regarded at the time as progressive and humane, mental policies and asylum practices now seem almost as cruel as the earlier punitive regimes. Men and women were housed in separate wards and put to different work, most devoted to supply and service within the asylum. The use of mechanical restraints such as manacles and muzzles was steadily phased out in favour of 'moral management', although solitary confinement and straitjackets continued to be used. By the end of the era therapeutic hopes of restoring patients to sanity were largely replaced by programmes of control, where best practice was judged by inmates' docility. As part of the passion for measuring and classifying, patient records and photos were kept, in order to 'illustrate' the physical evidence or effects of different types of derangement. Particular attention was paid to female patients, whose lack of approved feminine qualities was tautologically taken to 'prove' their madness. Over the period, sexualised theories of insanity were steadily imposed on mad women, in ways that were unmistakably manipulative. Towards the end of the nineteenth century, the term 'neurasthenia' came into use to describe milder or temporary nervous conditions, especially among the educated classes.

Throughout the era, since disorders of both body and mind were believed to be heritable conditions, the chronic sick, the mentally impaired and the deranged were vigorously urged against marriage and parenthood.

POPULAR AND PATENT REMEDIES

Before the advent of modern medication, many conditions remained chronic or incurable. This resulted in the development of alternative therapies including homeopathy, naturopathy ('herbal remedies'), hydropathy (water cures), mesmerism (hypnotism) and galvanism (electro-therapy). The first modern diet regimes were promoted, as were elaborate patent devices and programmes. Traditional remedies remained popular, and were augmented by numerous pills, powders and potions, claiming to cure a multitude of ailments.

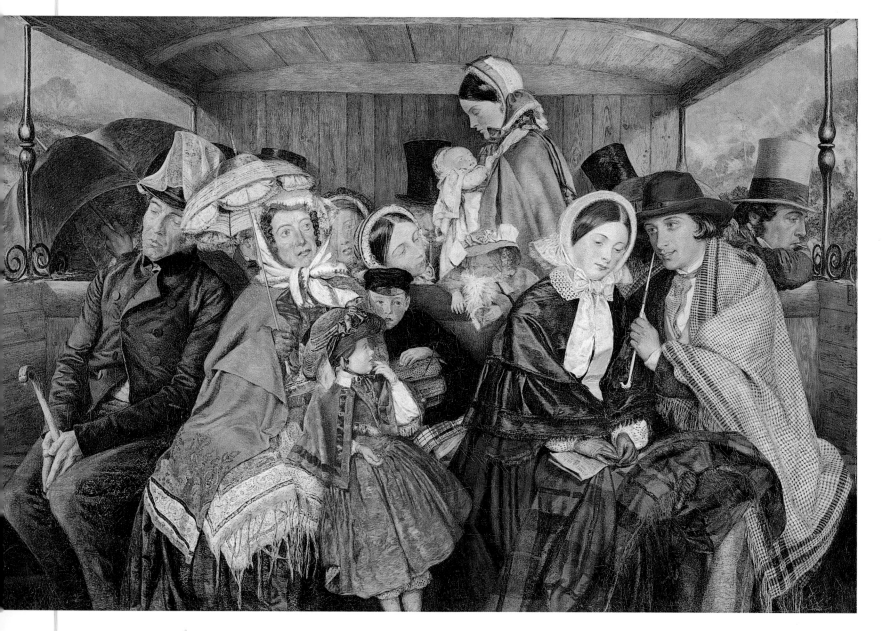

105 Charles Rossiter, *To Brighton and Back For 3s 6d*. Oil on canvas, 1859. Birmingham Museums and Art Gallery.
Brighton had been a popular health resort since the middle of the eighteenth century, when the benefits of sea-bathing, and even the drinking of sea-water, were 'scientifically' proven. A century later, a trip to the seaside had also become a cheap railway excursion.

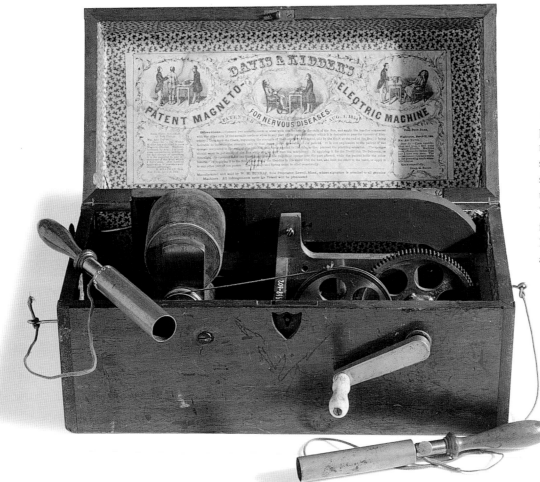

106 Davis and Kidder's patent electric-medical machine: used to deliver a series of high voltage electric shocks through the skin and tissue of patients with 'nervous diseases'. Produced from 1870–1900. Science Museum, London/Science and Society Picture Library.

107 Dispensing pots. Supplied by Holloway, 1867–82. Science Museum, London/Science and Society Picture Library.

108 Male anti-masturbation device. 1880–1920. Science Museum, London/Science and Society Picture Library.

SEXUALITY

Male anxieties in relation to both physical and mental health in the Victorian era often seem to have concentrated on the supposedly baleful effects of masturbation, which was alleged to cause a wide range of physical and mental disorders, and on venereal diseases, especially syphilis. This brings us neatly into the subject of Victorian sexuality, which has been a continuing topic of debate and fascination.

According to their own testimonies, many people born in the Victorian age were both factually uninformed and emotionally frigid about sexual matters. Historically, it appeared that the licentious behaviour and attitudes of the Regency period had been replaced by a new order of puritan control and repression – personified by the censorious figure of Mrs Grundy – which was imposed by the newly dominant bourgeoisie, steadily permeated all classes, and lasted well into the twentieth century. Then a hypocritical 'shadow side' to this public denial was glimpsed, in the 'secret world' of Victorian prostitution and pornography, and more openly in the 'naughty nineties'.[21] These perspectives were contested by the French scholar Michel Foucault (reminding us that Victorian attitudes were not confined to Britain), who argued that sex was not censored but subject to obsessive discussion as a central discourse of power, bent on regulation rather than suppression.[22] This helps explain why sexuality looms so large in art and medicine, for example, as well as in studies of the Victorian age.

Lately, evidence has shown that Victorian sex was not polarised between female distaste ('Lie back and think of England', as one mother is famously said to have counselled her anxious, newly married daughter) and extra-marital male indulgence. Instead many couples seem to have enjoyed mutual pleasure in what is now seen as a normal, modern manner.[23] The picture is occluded however by the variety of attitudes that exist at any given time, and by individuals' undoubted reticence, so that information on actual experience is often inferred from demographic and divorce court records. Certainly, the 1860s were briefly as 'permissive' as the same decade in the twentieth century, while the 1890s saw an explosion of differing and conflicting positions. Throughout, however, the public discussion of sexual matters was characterised by absence of plain speaking, with consequent ignorance, embarrassment and fear.

By mid-century the Victorian conjunction of moralism and scientific investigation produced ideas of orthodox human sexuality based on a combination of social and biological ideas. Popularly expressed, this amounted to 'Hogamus higamus, men are polygamous/Higamus hogamus, women are monogamous', with the added detail that 'the majority of women (happily for them) are not very much troubled by sexual feeling of any kind. What men are habitually, women are only exceptionally.'[24]

In order to curb men's habitual urges, and in response to Malthusian predictions that population increase would inevitably outstrip food resources, early Victorian social moralists proposed and to some extent imposed a socio-medical discourse based on masculine self-control in support of the bourgeois ideal of domestic life. 'A patriarchal culture which prizes eternal self-vigilance as the key to manliness, moral worth and material success' then projected its sexual anxieties on to its subordinates: women, children, the lower classes and other nations.[25]

In line with the physiological idea of the body as a closed system of energy, male sexual

'expenditure' and especially 'excess' (spermatorrhea) were said to cause enfeeblement. Thus it was seriously held, for example, that sexual appetite was incompatible with mental distinction and that procreation impaired artistic genius.[26] Men were vigorously counselled to conserve vital health by avoiding fornication, masturbation and nocturnal emissions (for which a variety of devices were invented)[27] and by rationing sex within marriage. Even when other causes were present, sickness and debility were frequently ascribed to masturbation – the great erotic subject described as vigorously as it was denounced. 'That insanity arises from masturbation is now beyond a doubt', declared one widely read authority, who also claimed that 'masturbators' became withdrawn, flabby, pale, self-mutilating and consumptive.[28] Ailments afflicting adolescent girls were similarly said to signify abnormal sexual excitation. With punitive therapy in mind, some doctors erased sexual pleasure through barbaric practices such as penile cauterisation and clitorodectomy.

For the same reasons, 'irregular' sexual activity was condemned. There is ample evidence that many working-class couples anticipated marriage (or rather married once a baby was on the way).

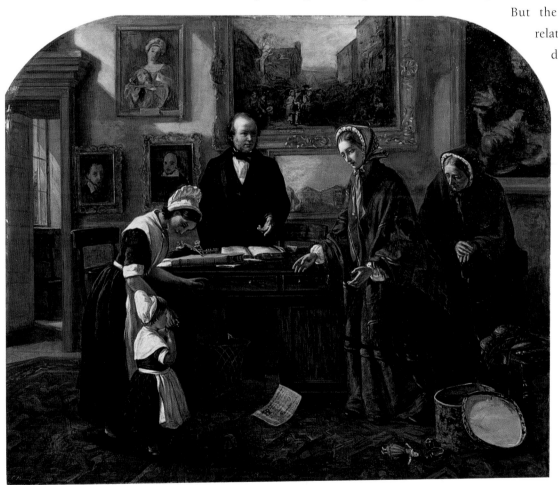

But the ratio of illegitimate births was relatively low, albeit a constant topic of drama in poetry, painting and fiction – notable examples being the outcast single mothers depicted in paintings by Richard Redgrave and Fred Walker, and in fiction by George Eliot's Hetty Sorrel and Thomas Hardy's Fanny Robin. In real life, social censure was so grave that many single mothers handed their babies to the Foundling Hospital (plate 109) or in desperation committed infanticide.

Prostitution remained a major topic of social concern. The early, time-honoured view that, like the poor, prostitutes were a fact of life was replaced in the 1840s by a social morality that anathematised sexual licence and especially its public manifestations. Gathering intensity as the urban population

109 Emma Brownlow, *The Foundling Restored to its Mother*. Oil on canvas, 1858. Coram Foundation, London.

rose, and with it the 'circulating harlotry' in the streets, theatres and pleasure gardens, moral panic over prostitution was at its height in the 1850s and early 1860s. In part, this was because it betokened visible female freedom from social control. As daughters, employees or servants, young women were subject to male authority; as whores they enjoyed economic and personal

independence. The response was a sustained cultural campaign, in sermons, newspapers, literary and visual art, to intimidate, shame and eventually drive 'fallen women' from the streets by representing them as a depraved and dangerous element in society, doomed to disease and death. Refuges were opened and men like future Prime Minister W. E. Gladstone patrolled at night to persuade girls to leave their life of 'vice'. In actuality, the seldom-voiced truth was that in comparison to other occupations, prostitution was a leisured and profitable trade, by which women improved their circumstances, helped to educate siblings and often saved enough to open a shop or lodging house.

The introduction of the Contagious Diseases Acts whereby prostitute women were medically examined and detained if deemed to suffer from venereal disease (in order to protect their sexual partners, mainly soldiers and sailors) – gave rise to one of the era's most successful and characteristic reform campaigns. The anti-contagious diseases (CD) movement, led by Josephine Butler, argued that CD examinations effectively encouraged prostitution; that women should not be thus scapegoated or deprived of civil liberty; and that male lust was to blame for public vice. These were important issues; in addition, the emergence of 'polite' women speaking on topics hitherto deemed improper for them to discuss underlined the changing roles of the Victorian period.

By the 1870s and 1880s, evolutionary ideas of male sexuality as a biological imperative, which added fuel to many male writings on gender, were countered by those who argued that 'civilisation' enabled humans to transcend animal instincts. This view acquired a public voice through the Social Purity campaign against the sexual 'double standard' (plate 110), and for male as well as female continence outside marriage. Though female Purity campaigners were often ridiculed as 'new puritans' who had failed to attract a spouse, the movement did succeed in raising public concern over brothels, indecent theatrical displays and images of naked women in art – the reason why Victorian female nudes are idealised and air-brushed.

Private sexual behaviour is hard to assess, though there are many hints that 'considerate' husbands, who did not insist on intercourse, were admired, not least because of the high maternal mortality rate. But there is plain evidence that the early Victorian family of six to eight or more children was on its way out by 1901: from the 1870s couples in all classes were choosing to limit and plan family size 'by a variety of methods within a culture of abstinence'.[29] This took place despite the fact that contraceptive knowledge and methods were not publicly available, as the famous obscenity trial of Annie Besant and Charles Bradlaugh for publishing a sixpenny book on the subject in 1877 made clear.

110 Wigan election poster. Black ink on paper, 1881. Fawcett Library. A striking example of material associated with the social purity campaign.

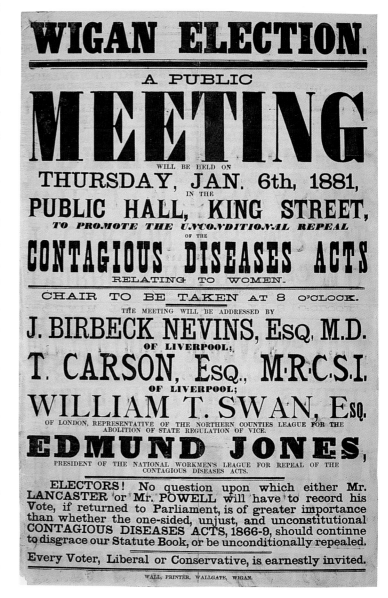

WIGAN ELECTION.

A PUBLIC

MEETING

WILL BE HELD ON

THURSDAY, JAN. 6th, 1881,

IN THE

PUBLIC HALL, KING STREET,

TO PROMOTE THE UNCONDITIONAL REPEAL

OF THE

CONTAGIOUS DISEASES ACTS

RELATING TO WOMEN.

CHAIR TO BE TAKEN AT 8 O'CLOCK.

THE MEETING WILL BE ADDRESSED BY

J. BIRBECK NEVINS, ESQ, M.D.

OF LIVERPOOL;

T. CARSON, ESQ., M.R.C.S.I.

OF LIVERPOOL;

WILLIAM T. SWAN, ESQ.

OF LONDON, REPRESENTATIVE OF THE NORTHERN COUNTIES LEAGUE FOR THE ABOLITION OF STATE REGULATION OF VICE.

EDMUND JONES,

PRESIDENT OF THE NATIONAL WORKMEN'S LEAGUE FOR REPEAL OF THE CONTAGIOUS DISEASES ACTS.

ELECTORS! No question upon which either Mr. LANCASTER or Mr. POWELL will have to record his Vote, if returned to Parliament, is of greater importance than whether the one-sided, unjust, and unconstitutional CONTAGIOUS DISEASES ACTS, 1866-9, should continue to disgrace our Statute Book, or be unconditionally repealed.

Every Voter, Liberal or Conservative, is earnestly invited.

WALL, PRINTER, WALLGATE, WIGAN.

111 Wilhelm von Gloeden,
Two Seated Sicilian Youths.
German, *c*.1893.
V&A:2815-1952.

Family limitation was accompanied by challenges to prevailing attitudes to sexual relations from the New Woman and her male supporters. 'But men are different Florence; you can't refuse a husband, you might cause him to commit sin', replies one fictional character when her daughter argues against 'conjugal rights'. 'Bosh,' retorts Florence, 'he is responsible for his own sins, we are not bound to dry-nurse his morality.'[30] The New Woman was hard on men, it was explained, in order to 'banish the beast' in him.[31]

Although heterosexuality was held to be both normal and natural throughout the period, the later years also witnessed a visible increase in homosexuality, mainly in men and especially but not exclusively in the intelligentsia. While largely clandestine owing to laws prohibiting 'indecency' in public (the artist Simeon Solomon was one of those so prosecuted), male homosexual activity was legal until 1885, when gay sex in private was made a criminal offence; this led, most notoriously, to the imprisonment in 1896 of Oscar Wilde, playwright and poseur.

112 Aubrey Beardsley,
Examination of Herald.
Lithograph, date.
V&A: E.300–1972.

113 Edward Hartley, *Edward Carpenter*. Photograph, 1905. Sheffield Archives.

Reasons for the emergence of a distinctly gay subculture within 1890s' Decadence include the promotion of 'Greek' or Platonic relationships by some university dons; the extended bachelor-hood that resulted from prescriptions of financial prudence and sexual continence; and a counter-cultural defiance of orthodox moral teaching, which gave added allure to the forbidden and deviant. The supremely Decadent drawings of Aubrey Beardsley (1872–98) vividly evoke the atmosphere of this moment (plate 112).

At the very end of the century, questions of sexual identity were also subject to speculative and would-be scientific investigation, dubbed sexology (1902). Writers such as Havelock Ellis (1859–1939) attempted detailed classification of 'normal' and 'perverse' sexual practices. This led to the identification of a 'third' or 'intermediate' sex, for which Ellis used the term 'sexual inversion'. Writer and social reformer Edward Carpenter (1844–1929; plate 113), who lived with a younger male partner, adapted the word 'Uranian' (1899) to denote male and female homosexuality, and around the same time, Lesbian and Sapphic came into use as terms for

114 Portrait of Anne Lister. West Yorkshire Archive Service, Calderdale.

female relationships. Apocryphally, these were also due to be criminalised in the 1885 legislation, until Queen Victoria declared them impossible, whereupon the clause was omitted – a joke that serves to underline a common, and commonly welcomed, ignorance, at a time when lurid, fictionalised lesbianism was often figured as an especially repulsive/seductive French vice.

Today, the best-known lesbian relationship in Victorian Britain has become that of Anne Lister (plate 114) of Shibden in south Yorkshire and her partner with its distinctly erotic as well as romantic elements; other couples include poets Katherine Bradley and her niece Edith Cooper, who wrote collaboratively from the 1880s under the name Michael Field, and the Irish writers Edith Somerville and Violet Martin. In the Victorian period itself, American actress Charlotte Cushman and French painter Rosa Bonheur were well known for their openly 'masculine' independence and demeanour.

In the fields of gender, health, medicine and sexuality, the Victorians seldom lived up to their stereotypes. As with so many other areas of their ideas and practices, they grappled with complex, dramatically developing fields, always influenced by a wider global view.

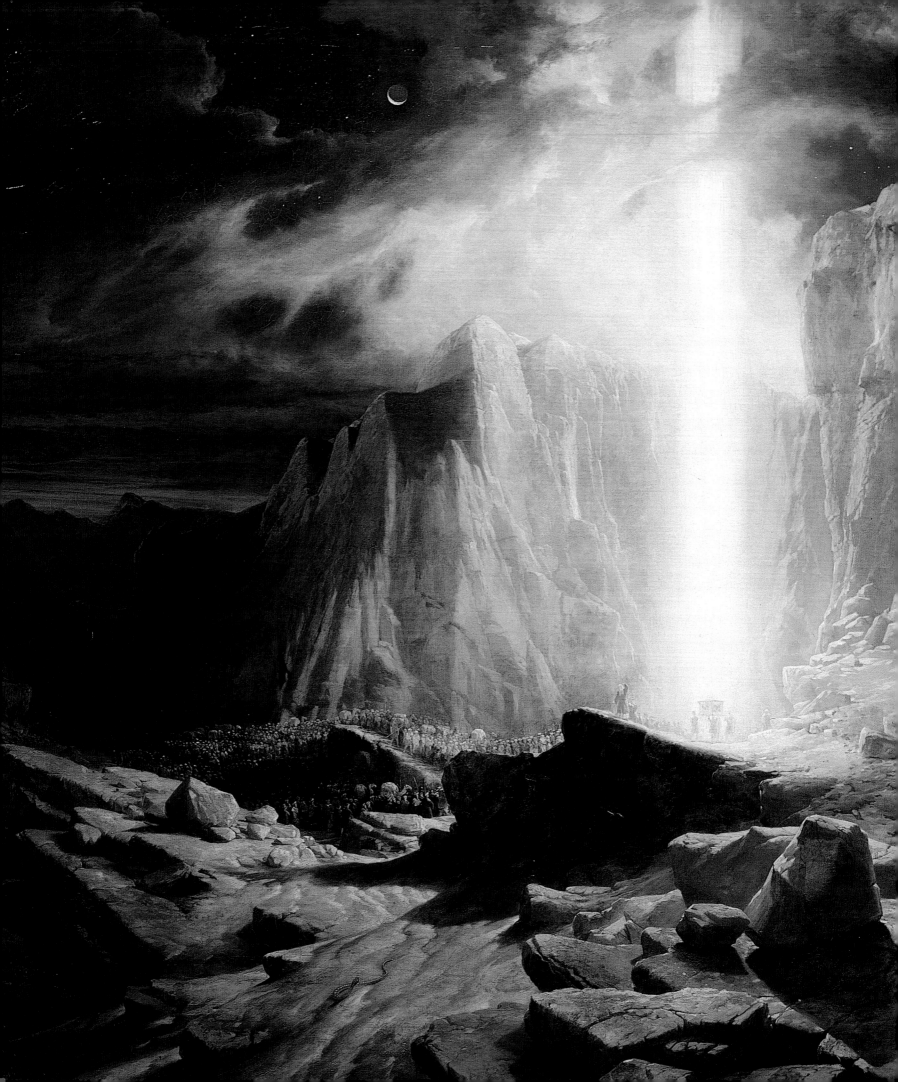

RELIGION AND DOUBT

SUZANNE FAGENCE COOPER
AND PAUL ATTERBURY

For the Victorians, religious belief was a burning issue. Faith determined their choice of school, university and profession: until the 1860s a convert to Roman Catholicism risked being disinherited and losing his job. New discoveries in geology and natural history seemed to undermine the established positions of man and God in Creation, and the ensuing arguments split families and friends. Extreme religious attitudes stirred up public emotions, so that both Primitive Methodist preachers and Ritualist priests were attacked in the street. The impact of these differences of opinion was felt not just in Britain, but across the world, as missionaries like David Livingstone linked Christianity to 'Commerce and Civilisation', in the drive to expand the Empire. The age of industry was still very much an age of faith.

Throughout the nineteenth century the role of the Church of England was hotly contested. As the Established Church, it was bound up not only with the spiritual life of the local community, but also with the political structure of the nation. The influence of the bishops in the House of Lords, the government funding offered to Church schools, and the Church rate or tax that was levied on all households until 1868, regardless of religious affiliation, were all controversial subjects. The Church of Ireland was disestablished during Victoria's reign, and the position of the Church in Wales was also under review, but in England, Church and State remained closely connected. Their relationship was reinforced by the Anglican monopoly on university education in England. This was partially shaken by the foundation of the non-denominational University College, London, in 1826, and then the establishment of Owens College in Manchester in 1851. However, until the 1850s all students at the Universities of

115 Frederick Havill, *David Livingstone*. Detail.
Oil on canvas, *c*.1870. By courtesy of the National Portrait Gallery, London.

116 William West, *The Israelites passing through the Wilderness Preceded by the Pillar of Light*. Detail.
Oil on canvas, 1845. City of Bristol Museum and Art Gallery.

Oxford and Cambridge were tested on their allegiance to the Church of England, and this test was not removed from fellows until the 1870s. John Henry Newman was only the most prominent among many Roman Catholic converts who had to resign their fellowships, and, as a result, 'give up rank, chances and all good things of this life'.[1] During the course of the nineteenth century the social and political difficulties faced by Dissenters, Roman Catholics and Jews gradually receded: from 1845 Jews could hold public office in municipal government, but it was not until 1858 that Lionel Nathan Rothschild, who had been elected as Member of Parliament for the City of London in 1847, was able to take his seat in the House of Commons. Despite these developments, the traditional alliance between the Church and the Tory party was never seriously shaken.

Perhaps the most striking feature of the Church of England was its flexibility, and the way it could retain worshippers who held many different shades of opinion. From Elizabeth I's reign, the Church had tried to hold a middle way, toning down the radical Protestantism of Edward VI's Reformation. Some Victorians were persuaded that the doctrines of the Church of England, established in the Thirty-Nine Articles, could be interpreted in a way that allowed continuity with past, Catholic, practices as well as the introduction of Reformed, Calvinist, teaching. Throughout the Victorian period, this tension between traditionalists and evangelicals continued, with both parties claiming to be the rightful heirs to the sixteenth-century reformers.

During the eighteenth century, the evangelical party within the Church had been in the ascendant, and evangelicalism continued to have an impact well into Victoria's reign (plate 117). With a stress on personal conversion, the authority of the Bible and sermons rather than sacraments, this strand within the Church of England had much in common with the Wesleyan Methodists and other Nonconformists who had split from the Established church since the seventeenth century. The strength of the Evangelicals within British politics had been proved by their successful lobbying for the abolition of slavery. This had finally been achieved throughout Britain's colonies in 1833. Evangelical philanthropists such as the Earl of Shaftesbury continued to campaign against physical and moral abuses, bringing in legislation to restrict dangerous and degrading work in the mining industry. From 1842 it was made illegal for women and children to be employed underground. Shaftesbury's enquiry had encouraged a public outcry against the appalling conditions found in the mines, but this focused as much on the immorality of half-naked boys and girls working together in cramped and isolated spaces, as on the physical toil of dragging coal carts through the tunnels. Throughout this period, the influence of Evangelical teaching meant that morality, particularly sexual morality, was constantly being examined and restated in order to establish standards of respectable behaviour (plate 119).

Evangelical employers believed it was their duty to foster the virtues of sobriety and self-discipline among their employees (plate 118). These values, encouraged by the

117 Interior of St Mary's Church, Avington, Hampshire, built 1768. Photograph from Country Life Archive.

118 Plate promoting the temperance movement. Earthenware, mid 19th century. Courtesy of Richard Dennis Publications.

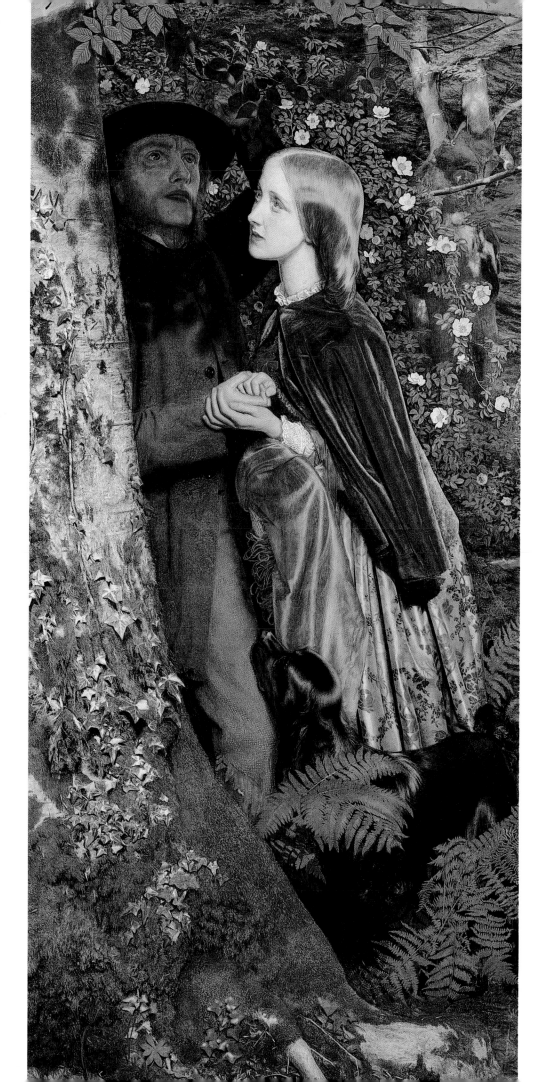

119 Arthur Hughes, *The Long Engagement*. Detail. Oil on canvas, *c*.1854–9. Birmingham City Museum and Art Gallery.

influence of their social superiors, gradually replaced the traditionally less rigorous working-class cultures. The new morality served both a secular and a spiritual purpose. Workers who were punctual non-drinkers and averse to loose living were more likely to fit into the disciplined structure of the factory system. They were also fulfilling the demands of Evangelical teaching, by demonstrating their choice of 'the narrow way' to salvation. Dissenters and Evangelical Anglicans, whose religious beliefs stressed the importance of each individual's striving for improvement, were prominent among industrial entrepreneurs. Although Nonconformists were excluded from the old universities, they benefited from the more scientific and commercial education that they could receive at their own academies. They also established networks among their co-religionists, so that their sons could more readily find apprenticeships in industry.

120 Interior of St Augustine's Church, Kilburn, London, designed by J.L. Pearson, built 1871. Photograph from Country Life Archive.

The spread of philanthropy was closely related to the Evangelical movement, and affected many aspects of urban life. Housing and the family were a general concern, demonstrated by the establishment of charities such as the Metropolitan Association for the Improvement of the Dwellings of the Industrious Classes (1841), the Peabody Trust (1862) and Barnardo's Homes (1866). Others concerned themselves with children, the blind and discharged prisoners, the domestic improvement of young women, and animal welfare. However, the National Society for the Prevention of Cruelty to Children was established only in 1884, sixty years after the RSPCA.

The Evangelical party within the Church of England, and the Wesleyan Methodists, Quakers, Baptists and other Nonconformists, all retained a strong position in the spiritual life of Britain, and indeed the wider world, until the end of the century. However, they were essentially products of the seventeenth and eighteenth centuries. From the 1830s a distinctively new spirituality developed, which was in many ways antagonistic towards Evangelicalism. The Church of England had to come to terms with a controversial ritualist or traditionalist movement arising from within its own ranks.

This movement began to emerge when a group of Oxford churchmen, including John Keble, E. B. Pusey and J. H. Newman, started to question the involvement of the state in ecclesiastical affairs. From 1833 they published a series of tracts which examined the historical basis of the Church of England, concluding with Tract XC (1841). In this, Newman argued that many of the Thirty-Nine Articles could be interpreted in a way that was compatible with Roman Catholic teaching. At every stage, the Tractarians hoped to demonstrate the value of continuity in the Church. Unlike the Evangelicals, they focused on the sacraments offered by the Church, placing emphasis on the celebration of the communion service, and on the importance of outward signs of spirituality, in architecture, vestments and ritual. Increasingly, churches began to resurrect a medieval internal structure, where the emphasis was on the altar rather than the pulpit. The use of Gothic architecture (plate 120), the introduction of choirs which processed in their new robes, and the placing of candles at the east end of the church all stressed the perceived links with the pre-Reformation church. (By contrast, churches in Scotland, and among many of the Nonconformists, maintained a classical form.)

121 William Burges, chalice and patten. Silver-gilt and semi-precious stones, 1867. Loan to V&A.

Many traditionalists felt that these forms of worship were the best way to interpret the intentions of sixteenth-century reformers and seventeenth-century divines such as Archbishop Laud. They argued that these theologians had cleared away the abuses of Roman Catholicism, while retaining the essential qualities of the ancient liturgy. However, when these changes were imposed on early Victorian parishes by enthusiastic young clergy, they were the subject of fierce controversy. To some observers, this colourful and heady ritualism (plate 121) was luring devout Anglicans into the jaws of 'popery', for, despite the passing of the Emancipation Act of 1829 which allowed Catholics to vote and hold public office, Roman Catholicism was widely feared well into the second half of the century. There were several reasons for this. Both Anglican parishioners and Nonconformists had long been subjected to emotional

campaigns from the pulpit, denouncing Roman Catholicism as idolatrous and aggressive. This attitude was reinforced by popular preachers, such as the Reverend John Cumming, who spoke to packed congregations in Covent Garden every Sunday from 1832 to 1879. He declared that 'Romanism is the master-piece of Satan . . . Anti-Christ is enthroned in the Vatican'.[2] Even among the more educated portion of the laity, there was extreme hostility to Rome. In 1846, Charles Wynne wrote to his son at university to warn him against 'falling into the trap laid for you by the horrible set of people who have lately infested Oxford'.[3]

Of course, the connection in the popular imagination between popery and tractarianism was only reinforced by high-profile conversions to Roman Catholicism. Newman was received into the Roman Church in 1845, and he was followed by a significant number of traditionalists, both clergy and laity, over the next decade. As one of Newman's former colleagues at Oriel College, Oxford, sadly remarked in 1846: 'One hundred and twenty persons have gone after him to Rome already, and more may be expected to drop off.'[4]

The establishment of Anglican convents in London also encouraged the suspicion that young Anglican women were being enticed towards Roman Catholicism. The first of these convents, the Park Village Sisterhood, was established under the inspiration of Dr Pusey in 1845. It was closely associated with Christ Church, Albany Street, a stronghold of High Anglicanism, which encouraged the participation of female parishioners in church life by undertaking embroidery projects and visiting families in the neighbourhood. During the late 1840s and early 1850s, feelings ran high in the popular press, as cartoonists imagined priests tempting young women to desert their family responsibilities and to be lured into the cloister.

Anti-Catholic feeling was intensified in 1850 by the so-called 'Papal Aggression' when the Vatican decided to establish thirteen bishoprics in Britain. For the first time since the Reformation, a complete Roman Catholic hierarchy was set up on English soil. To complement this, a massive church-building programme was launched, to create both cathedrals and parish churches. In 1840 there were 469 Roman Catholic churches and chapels. By 1891 the total had risen to 1,387. Antagonism towards Rome was stirred up again in the early 1870s, when William Ewart Gladstone challenged Roman Catholics to declare their allegiance to the Crown rather than the Papacy. Gladstone was responding to the Vatican Council's proclamation of 1870, which had stated that 'the see of holy Peter remains ever free from all blemish of error' and that 'the Roman Pontiff, when he speaks *ex cathedra* . . . is possessed of that infallibility . . . for defining doctrine regarding faith and morals',[5] which could not be overturned by Church Councils, or any other authority. This claim to jurisdiction over morals seemed to extend too far into the realm of secular government. Anxiety about the allegiance of Roman Catholics to an authority beyond national boundaries had been a constant feature of anti-Catholicism since the Reformation, and Gladstone's attack was just the latest version of this argument.

Of course, the middle classes of Victorian Britain had yet another reason to fear the incursion of the Catholics. The growth of factory production had brought large numbers of Irish immigrants into the industrialised towns, especially in the wake of the devastating famines of the 1840s. They were particularly visible in the itinerant gangs of navvies who built the railway network across the country. This gave cause for concern as they were regarded as having

122 John Rogers Herbert, *Bishop Thomas Walsh, Roman Catholic Bishop of the Midland District*. Oil on canvas, *c*.1842. St Mary's College.

undisciplined habits, and a tendency to drink, which could jeopardise all the hard work of the Evangelical temperance movement. In the factories, they also antagonised their fellow workers by their willingness to act as strike-breakers. Mrs Gaskell expressed this tension in her industrial novel, *North and South*: when the mill-hands decided to strike, their employer 'imported hands from Ireland', who were then threatened by the strikers.[6]

Novelists such as Gaskell drew attention to the problems of poverty and morality in the expanding cities, and encouraged church leaders from all denominations to turn their attention to the urban poor. As workers migrated from the country to the towns, they left behind the local parish communities, and entered the mass of the urban population. The few ancient parish churches that existed in Liverpool, Leeds, Manchester and Birmingham simply could not minister to all these people. There were not enough pews, nor clergy to be effective. The Church of England undertook a massive campaign of church-building, and from 1831 to 1851 some 2,029 new churches were established. The majority of these were in the newly industrialised areas, and so Lancashire gained 229 new churches, and 269 were built in the West Riding of Yorkshire. If the churches were to be accessible to the whole community, then parishioners could not be expected to pay the customary pew-rent. As a result, by 1868 the Incorporated Church Building Society claimed to have created 1,092,000 extra seats, of which 850,000 were free.

However, it became clear from the religious census of 1851 that the Anglican Church could no longer take loyalty for granted. Only one quarter of the population of England and Wales attended a Church of England service on Census Sunday. About another quarter were to be found in Nonconformist or Roman Catholic churches, but nearly half of the population did not worship anywhere. Even among those who were nominally religious, there was some flexibility in their allegiances. At least until the 1860s, many worshippers were prepared to attend their parish church in the morning, and a Nonconformist chapel in the evening, especially if it had a popular preacher. In addition, chapel-goers would often call on their parish priest to perform the rites of passage: baptisms, weddings and funerals. Although marriages could be performed in Nonconformist chapels from 1833, funerals in parish churchyards had to be carried out according to the Anglican Prayer Book until 1880. It seems that many Dissenters felt that the Church of England's sacraments could be more effective than the chapel equivalents. At least, that was the view of a Nonconformist, who asked his local vicar to baptise his twins in 1862: 'I ollus say *begin and end* with the Church, whatever you do between-whiles.'[7]

If the Church of England could appeal to the wider public by its role as an arm of the Establishment, Evangelicals had a more direct tool. They set out to encourage the conversion of individuals by preaching and popular tracts. In particular, they focused attention on the 'four last things': death, judgement, heaven and hell. Their literature and sermons offered methods to cope with the nearness of death. They presented examples of deathbed scenes, which contrasted the serenity of the godly with the torment of the unrepentant. The choices necessary for salvation were made clear, even to the simplest of souls.

123 Print after William Holman Hunt,
The Light of the World, 1851–3. V&A: E.135–1970

As mortality rates continued to remain high until the end of the century (21.4 per 1000 in 1841 and 17.7 per 1000 in 1900), formulae for dealing with bereavement were also well-established. Anglicans, Dissenters and non-church-goers all subscribed to the conventions of mourning. These became increasingly complex over the course of Victoria's reign, especially after the death of Prince Albert in 1861. The queen set the trend in making use of the paraphenalia of mourning: cards, jet jewellery and black crêpe. Mourning warehouses, such as Robinson's, were established to supply the costumes and accessories that became essential for respectable grief.

Of course, the urban poor could not afford the luxury of a special wardrobe for bereavement, and it was the pressure of the urban dead upon traditional burial sites that led to a change in funeral practices in the 1840s. City-centre graveyards were closed, and new cemeteries were opened on the edges of towns. Overcrowding, both among the living and the dead, was an obvious danger to public health: one Nottinghamshire district had tried to inter 2,292 corpses in a one-acre plot from 1830 to 1842. The first independent cemeteries, like the Liverpool Necropolis, had been built in the 1820s, usually by Dissenters. Those that followed, such as the Glasgow Necropolis, in use from 1832, were often non-denominational, and were distinguished by spectacular tombs and memorials in every style. Urban cemeteries were usually constructed by private companies, such as the London Cemetery Company which built Highgate Cemetery in north London, as part of the proliferation of the business of death. In 1852, partly in response to the 1849 cholera epidemic, the London Necropolis and National Mausoleum Company was set up to develop 2,300 acres of common land in Brookwood, near Woking, Surrey, of which four hundred acres became a cemetery. A novel feature of this cemetery was that, from its inception, it was served by special funeral trains from Waterloo Station in central London, a practice that continued well into the twentieth century. The cemetery was also multi-denominational and included sections for Muslims and Parsees.

The legalisation of cremation in 1884 also eased the pressure on space in the cemeteries. The first crematorium had been built at Brookwood in 1879, anticipating the change in the law, but it did not come into use until 1885. Others soon followed in Manchester and Golders Green.

As companies sought commercial answers to the problem of how to deal with the mortal remains of the urban masses, so all the churches were wrestling with the burden of their spiritual welfare. As well as providing conventional services, some felt that outreach was an essential part of Christian work. How else could the poor, who felt ashamed to attend church without their 'Sunday best', hear the Gospel? Pioneering work in establishing parishes in the slums was undertaken by all denominations. Priests from the High Anglican parish of St Saviour's in Leeds, for example, provided support for the victims of the cholera outbreak in 1849.

William Booth started his preaching career as a Methodist minister, but in 1865 he founded his own movement which grew into the Salvation Army. Targeting the sinners of London's East End, he and his fellow-workers were abused and attacked regularly as they tried to encourage a military discipline of prayer and charity in the crowds that gathered around them. Practical help was supplied in the form of a missing persons bureau, hostels for the homeless and a farm colony which provided training and self-respect for the unemployed. The adoption of a distinctive uniform from the 1880s added to the sense of fellowship and commitment within the movement.

DEATH AND MOURNING

During Victoria's reign, the process of mourning became more formalised and commercial. After the death of Albert in 1861, the queen withdrew from public life, and adopted a heavy mourning costume of veil and black crêpe, setting the standards for respectable widowhood. Her subjects could buy their own mourning dress from the many specialist shops established from the 1870s as part of a more general retail boom. Mortality rates, especially among children, remained high to the end of the century. Soldiers' families also had to be prepared for bereavement, as the army faced the dangers of disease as well as death in battle or skirmish, all in the name of Empire. This constant military activity lead to increased enthusiasm for public commemoration of heroes and martyrs. Novelists and painters responded to this proximity of death by producing heart-rending final moments and funeral processions, with Dickens's description of the death of Little

124 Advertisement for William Barker's, London, showing the correct outdoor wear for a widow in the first stages of mourning. From *The Lady* (4 October 1900). V&A: NAL.

125 Frank Holl, *Her Firstborn: Horsham Churchyard*. Oil on canvas, 1876. McManus Galleries, Dundee.

126 John Byam Liston Shaw, *Boer War 1900 – Last Summer Things Were Greener*. Oil on canvas, 1901. Birmingham City Museum and Art Gallery.

Nell being only the most famous example in a popular genre. Epidemics of cholera were particularly feared, as they spread swiftly among workers in industrial cities. Such crises highlighted the need to find better ways to dispose of the growing number of corpses, so out-of-town necropoli and cemeteries were established by entrepreneurs. With the spread of the crematorium from the late 1880s, the parish churchyard was becoming a thing of the past.

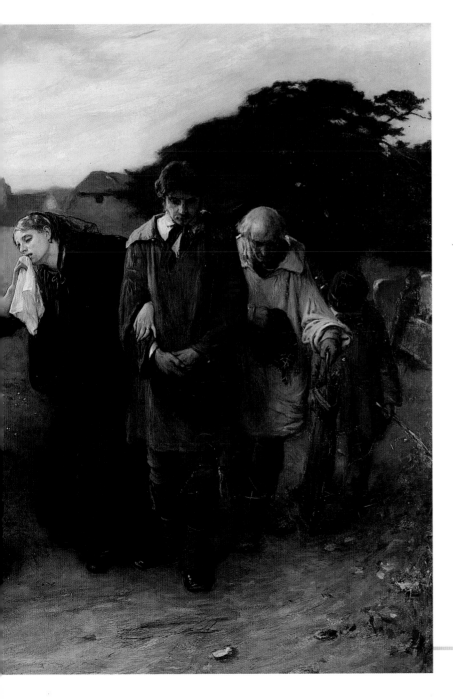

127 Emil Fuchs, *Queen Victoria on her Deathbed*. Watercolour, 1901. The Royal Collection © HM Queen Elizabeth II.

128 Salvation Army rally.
Photograph, *c*.1900.
Salvation Army Museum.

The rise of the Salvation Army (plate 128), even in the face of persecution, showed that the urban poor could be motivated to respond to the Gospel. This was also clearly demonstrated by the sensational work of Dwight L. Moody and Ira Sankey, two American evangelists who toured Great Britain in 1872. They encouraged spiritual revival through preaching, and also through hymn-singing. Their focus on music in communal worship was only the most visible face of a growing trend within Victorian spirituality. There was an upsurge in the composition of new

congregational hymns, and a large number of ancient hymns were also translated for modern usage. The rousing words (S.Baring-Gould) and music (Arthur Sullivan) of 'Onward, Christian Soldiers' perfectly captured a mood of mission in the churches.

For the Anglicans, the publication of *Hymns Ancient and Modern* from 1861, with several subsequent revisions to 1889, provided parishes with a compendium of new and well-loved music to revitalise worship. Some of these hymns contained references to the wider Victorian world. C. E. Oakley's hymn 'Hills of the North, rejoice . . . Isles of the Southern Seas, Deep in your coral caves . . . Lands of the East arise . . . Shores of the utmost West' was written early in Victoria's reign. Bishop Heber's 'From Greenland's icy mountains, From India's coral strand, Where Afric's sunny fountains Roll down their golden sand . . .' was set to music in Victorian times and became a great favourite. There was also a parallel movement within the church and cathedral choirs. Composers such as John Stainer (1840–1901) and Sir Charles Stanford (1852–1924) created new anthems for formal singing, overturning the influence of modern foreign composers, which had held firm until the 1860s. The Gothic revival in architecture and liturgy was also felt in the music of the parishes, as recent research into the singing of Gregorian plainsong was put into practice. Although this was always a minority taste, and did smack of Romanism, the churches played a significant role in the early music revival of the second half of the nineteenth Century.

The efforts to bring enthusiasm and revival to all denominations were of course not restricted to Britain. Christian missionary activity was an essential part of the expansion of British influence in the colonies and dominions. Captain F. D. Lugard, in his discussion of the foundation of Britain's East African Empire, was adamant that the establishment of Christian mission stations had made it possible for secular government to be set up in their wake. He believed that 'the missions became the administrators and lawgivers of the native community which grew up around them . . . so the little colony became a model'.[8] He was particularly impressed by those missionaries who offered practical services, as well as spiritual guidance. Dr David Livingstone (1813–73) was the ideal example of this approach (plate 115).

Livingstone originally intended to travel to China as a missionary, and had trained in medicine as well as theology, so that he could also provide a material benefit to his flock. However, the outbreak of the Opium War meant that he had to redirect his energies to Africa. With support from the London Missionary Society, he arrived in Cape Town in 1841. His intention to offer practical support was made clear when he established his early mission to the Bakwain people; he encouraged them to build a canal and dam, to irrigate their drought-stricken land. Livingstone's campaign to spread the Gospel in Africa was eventually combined with an attack on the East African slave trade, and he was convinced that it was essential for Christianity to be combined with commercial development. He was 'extremely desirous to promote the preparation of the raw materials of European manufactures in Africa, for by that means we may not only put a stop to the slave trade, but introduce the negro family into the body corporate of nations'.[9] Livingstone was not only disgusted by the native slave trade, but also by the treatment of unpaid black labourers by the white Boer settlers, 'whom the stupid prejudice against colour leads them to detest'.[10]

Livingstone's work was well-publicised. Accounts of his missionary work and exploration became best-sellers, and his lectures spurred others into action. In 1858 the Universities Mission to Central Africa was founded after a lecture he gave in Cambridge. But it was his attempt to find the source of the White Nile that probably created the greatest stir, for he lost contact with other white settlers and explorers, and nothing was heard from him for several years. The *New York Herald* decided to send a journalist, Henry Morton Stanley, to find him and bring him fresh supplies, and to create a popular scoop for the newspaper. In November 1871 Stanley tracked him down to Ujiji, on Lake Tanganyika and their meeting was widely reported by the world's press. When Livingstone died, two years later, his body was carried to the coast and brought back to Britain by his African followers, including James Chuma and Abdullah Susi, and his legendary status was assured.

Missionaries were being sent to Africa by every possible Christian denomination. The Baptist Missionary Society, established in 1792, had established a foothold in Cameroon in 1842, and began working in the Congo and Angola in 1878. Their missionaries also turned their attention to the Far East. Livingstone's early interest in China was shared by many pioneering Christians, although the work was particularly difficult, and missionaries were subjected to periodic persecution. The process of converting the Chinese had begun in the seventeenth century, when Jesuits had been invited to the imperial court. However, Christianity had been banned in the eighteenth century, and the Roman Catholic converts lived in fear. When Protestant missionaries, such as Hudson Taylor, began to preach to the Chinese, they were often impressed by the faithfulness of these native Christians. He described how they were 'living in concealment . . . ever and anon meeting with imprisonment and torture, and death itself, they have presented a remarkable fidelity to their calling'.[11]

James Hudson Taylor, a Methodist from Barnsley, founded the China Inland Mission in 1865. His work was pioneering in two respects. He was prepared to recruit young single women, such as Miss Jennie Faulding, whom he married in 1871, to bring the message of the Gospel to Chinese women and girls, and he also encouraged missionaries in his party to adopt Chinese dress. Unlike many other missions, they were not content to restrict their activities to the Treaty Ports, but they wanted to extend their message to the mass of the population in the interior. Like the Roman Catholics, they were also subjected to violence. In 1868 the Mission's residences in Yangzhou were attacked by a vast mob of 10,000 people. This led to the British consul ordering reprisals against the Chinese navy.

However, the worst assaults on Christian missionaries did not come until the Boxer rebellion of 1899 and 1900. The Boxers targeted foreign institutions, including mission stations and railway lines. Several hundred Christian missionaries and many thousand converts were murdered. In Shanxi province alone, 60 foreign missionaries and 2,000 Chinese Christians were killed.

The missionaries had a very different reception in Japan. They were generally treated with civility, and often had more trouble in dealing with the immorality of Westerners who were working for the Japanese government. There was certainly no likelihood of martyrdom or suffering in this country. Many Christians were delighted that the Japanese were following

western models as they strove for industrialisation. They hoped that the Japanese would adopt European religion as they were adopting European engineering skills. However, instead the missionaries had to come to terms with 'the extraordinary phenomenon of a fully civilised nation that does not know, nor believe in Christ'.[12] Some missionaries decided to use innovative approaches to evangelise the Japanese. The Reverend Barclay Buxton, for example, who was sent out in 1890 by the Church Missionary Society (CMS), took to wearing Japanese dress. He wanted to give converts positions of responsibility within the Church, and his Japan Evangelistic Band tried to treat the new converts 'just as I should in England, for I feel that men's hearts are the same everywhere'.[13]

Another missionary sent by the CMS became Bishop of Kyushu in 1894. Evington, who had been working in Japan for twenty years, emphasised the need for Christians to be receptive to the positive aspects of Japanese culture. He suggested that: 'Their ignorance of some of our customs, their freedom from some of our prejudices too, will enable them to see some things more clearly.'[14] Arthur Lloyd, a missionary who was attached to the Society for the Propagation of the Gospel in Foreign Parts, even went so far as to explore the resemblances between Buddhism and Christianity. He was not entirely alone in these attempts to deal directly with Eastern spirituality. James Legge made highly regarded translations of Confucian texts while working as a missionary in China.

These scholars were unusual among missionaries, and most Christians instead devoted their time to more practical outreach. Missionary societies supported schools, orphanages and hospitals, all attached to mission stations. In this way, they were fulfilling the ideals of Livingstone. The Chinese Inland Mission, for example, helped to organise relief work and run orphanages during the famine of 1878. Education and training was at the heart of missionary activity, and the results can be seen in many schools and colleges which flourished in the colonies. To take but one example, the work of the Delhi Mission of the Society for the Propagation of the Gospel included the foundation of a High School, which later became St Stephen's College. Its first principal, the Reverend M. J. Jennings, was killed during the uprisings of 1857, but the college survived. It was revitalised in the early 1880s by the Cambridge Mission, with the suggestion that scholars from Oxford and Cambridge Universities should be encouraged to teach in India. In 1881 the college began to prepare students for degrees, under the Reverend Samuel Scott Allnutt. The college received support not only from English universities, but also from British public schools, which provided funds for a cricket pavilion.

Back in Britain, the public-school system, which in the early nineteenth century had been a by-word for barbarism, was undergoing a religious revival of its own (plate 129). As indicated in chapter 3, the inspiring example of Thomas Arnold, who had been appointed headmaster of Rugby in 1828, began the process of reform and discipline. Christian

129 Arthur Hughes, chapter illustration for Thomas Hughes's *Tom Brown's Schooldays* (1869). V&A: 55 E 20.

WAKING. 135

CHAPTER VII.

SETTLING TO THE COLLAR.

"Says Giles, ''Tis mortal hard to go,
But if so be's I must:
I means to follow arter he
As goes hisself the fust.'"—*Ballad.*

EVERYBODY, I suppose, knows the dreamy delicious state in which one lies, half asleep, half awake, while consciousness begins to return, after a sound night's rest in a new place which we are glad to be in, following upon a day of unwonted excitement and exertion. There are few pleasanter pieces of life. The worst of it is that they last such a short time; for, nurse them as you will, by lying perfectly passive in mind and body, you can't make more than five minutes or so of

duty became a guiding principle. Boys were encouraged to emulate chivalric knights in their moral codes, by protecting the weak and maintaining strict honesty in their dealings with all men, regardless of class. Although there was a strong element of medievalism in this approach, there was an equally strong aversion to the effeminate monasticism of the Middle Ages. Physical and moral health went hand in hand, and 'muscular Christianity' was developed by team games as well as chapel attendance.

Unfortunately for the Establishment, education could not always guarantee Christian belief. In fact, new scholarship was providing the means to undermine conventional Christian teaching in two key areas. The first was the introduction of German literary criticism, which attempted to treat the Bible like any other historical document. The second was the study of natural history, which threatened the scriptural account of Creation, and suggested that humans were fundamentally no different from other animals. In many ways, both new approaches attacked the same target, as they questioned the way in which the Bible presented history. Could the Bible be trusted any longer as a source of information about the relationship between man, the natural world and God?

Among the first to embrace the new critical thinking was Benjamin Jowett, Professor of Greek at Oxford. He boldly declared that scholars should 'interpret the Scripture like any other book' and treat it in 'the same careful and impartial way that we ascertain the meaning of Sophocles or of Plato'.[15] He was supported in this attempt by several other academic colleagues, who published their ideas in a controversial book, *Essays and Reviews*, in 1860. Others were tending in the same direction. In the same year, Samuel Davidson was sacked from his position as Professor of Biblical Literature in the Lancashire Independent College, near Manchester. He had suggested that the first five books of the Bible, the Pentateuch, were not written by Moses and he had questioned the divine inspiration of Scripture. Literary criticism was making it clear that the Bible was the work of many hands, over many centuries, and that it was riddled with inconsistencies. Bishop John William Colenso, missionary bishop of Natal, was also deposed in 1863 for his publication on the Pentateuch, and later excommunicated. He had questioned, among other things, whether it was possible for three priests, that is Aaron and his two sons, to minister to the whole nation of Israel during the Exodus: 'The very pigeons, to be brought as sin-offerings for the birth of children, would have averaged, according to the story, more than 250 a day; and each Priest would have had to eat daily more than 80, for his own portion.'[16]

Fortunately for the Evangelical party, the New Testament seemed to stand up better to the rigours of scholarship, and by the 1890s most Anglican clergymen had reconciled themselves to a new, more liberal, interpretation of the Old Testament. However, in the 1850s and 1860s, arguments were raging over the biblical account of Creation. Questions were raised not only by biblical scholars, but also by geologists, such as Charles Lyell, who demonstrated that the earth could not have been created in just six days. Natural history seemed to prove that the developments observable in the strata of rocks were not the result of God's direct intervention in Creation. Instead, they were evidence of a more gradual process that could be analysed, being subject to natural laws. If changes in the earth's structure were the result of natural rather than divine forces, then perhaps the same was true for the development of animal life.

130 Julia Margaret Cameron, *Charles Darwin*. Allbumen print, 1868. By courtesy of the National Portrait Gallery, London.

This way of thinking was encouraged by an increased understanding of recently discovered fossils as evidence of early life-forms. In 1844 an anonymous publication, *Vestiges of the Natural History of Creation*, attempted to deal with these problems. Its conclusions were controversial, and seemed to distance God from the creative process. As one reviewer explained: 'Creation was not confined to the beginning of the world, but even on this earth has been a slow, and, as it were, continuous operation.'[17] In 1859 Charles Darwin (plate 130) attempted to explain the process by which these changes took place. The publication of *The Origin of Species by Natural Selection* was the culmination of research which he had begun twenty years before. Although in this book he did not deal directly with the relationship between man and lower animals, he did suggest the principle of common ancestry. The debates that followed, presented in the press without subtlety or refinement, divided the country. As Adam Sedgwick, Professor of Geology in Cambridge, complained, *The Origin of Species* 'makes sin a mere organic misfortune . . . If the book be true . . . religion is a lie.'[18]

When the dust had settled, it became apparent that the two sides of the argument could be reconciled by a broad shift in theological thinking and by the general acceptance that evolutionists did not necessarily set out to oppose theology. Their aim, rather, was to achieve a balance, on a scientific basis, between God, nature and man. When Lyell died in 1875 he was buried in Westminster Abbey, and at his funeral orator Dean Stanley underlined this point: 'The tranquil triumph of Geology, once thought so dangerous, now so quietly accepted by the Church, no less than by the world, is one more proof of the groundlessness of theological panics in the face of the advances of scientific discovery.'[19]

Although Dean Stanley was scathing of theological fear of scientific investigation, the discoveries of the nineteenth century did have a significant impact on faith. Scepticism and materialism were real alternatives to religious belief by the 1870s and 1880s. Many of the urban poor did not attend church because of ignorance, apathy or anti-clericalism, but some of the urban rich made a conscious decision to give up their faith. Instead they decided to put their trust in material explanations of the world. Frederic Harrison (1831–1923) described how his religious faith was undermined by his studies of astronomy, geology, physics and biology, under the influence of Richard Owen and Thomas Huxley. He also met George Eliot and George Henry Lewes, who contributed to the *Westminster Review*, a periodical that published free-thinking articles. As a result he became 'rooted in a conviction of the universal reign of Law, of the possibility of a real Social Science', and began to treat the Bible as 'a magnificent Allegory . . . no more to be admired as a moral standard, than Plato's ideas'.[20]

The focus on physical explanations for the structure of the universe, and man's position within it, had one unexpected result. The rise of spiritualism, which spread from America to Great Britain in the 1850s, seems to have been a direct response to the need for physical manifestations of supernatural realities. If the dead could materialise during séances, and be photographed and touched, would this not provide evidence that the afterlife did exist after all? Interest in mediums and spiritualist networks quickly sprang up, with both Christian and non-Christian adherents. One of the most influential leaders of the movement was Stainton Moses, an Anglican minister, who declared that spiritualism was 'that platform on which alone science and religion can meet'.[21] His ideas were mirrored by Samuel Carter Hall, who in 1884 suggested that spiritualism 'has mainly but one purpose – TO CONFUTE AND DESTROY MATERIALISM by supplying sure and certain and *palpable* evidence that to every human being God gives a soul which he ordains shall not perish when the body dies.'[22]

Although the followers of the movement could fall prey to charlatans, there were many reputable mediums whose séances were attended by leading figures of the day. Sir William Crookes, a leading physicist and chemist, was present when the medium Florence Cook produced the full-figure materialisation of the spirit guide Katie King. In 1874 he was even able to take photographs of this manifestation. John Ruskin, the art critic, became involved with a group of spiritualist enthusiasts in the 1860s, and attended séances conducted by one of the most well-known mediums of the day, D. D. Home, although he was later disappointed with the movement.

Spiritualist churches and meetings also had a strong following in less eminent circles. They were established both among the middle classes of London, and in the north of England, particularly among the better-educated sections of the working class. A surprising number of middle-class housewives developed a talent for automatic writing, trances and table-tipping. Photographic records of supernatural events became particularly sought-after. Georgiana Houghton's publication of the *Chronicles of the Photographs of Spiritual Beings and Phenomena Invisible to the Material Eye* (1882) seemed to suggest that new scientific inventions, like the camera, could encourage faith in the supernatural, rather than necessarily undermining it.

131 Sir Hubert von Herkomer, *The Druid*. Watercolour, 1896. The Forbes Magazine Collection, New York.

While the driving force behind spiritualism was the desire to contact the dead, and thus prove the existence of an afterlife, throughout the nineteenth century there was also a broader enthusiasm for exploring and manipulating the conscious and unconscious spirits of the living. This took many forms, including mesmerism and hypnosis, some manifestations of which bordered on the performance of magic and spectacle. More serious was the interest in the subconscious and the nature of dreams, studies which came to a head in Vienna in the 1890s. On a more popular level, the study of the spirit was often linked to a fascination with recently discovered physical phenomena such as magnetism and electricity, both of which were used extensively in medical treatments of both mind and body. Such studies were dependent upon eighteenth-century sources, particularly Franz Anton Mesmer's 1779 theory of animal magnetism, which promoted the idea of the aura, a universal magnetic force flowing through the whole natural world, which had to be maintained in balance to avoid illness. The interpretation of the auras surrounding living material was also one of the tenets of theosophy, a fashionable alternative religion at the end of the century which included a firm belief in reincarnation. Closely linked with theosophy was an enthusiasm for Hindu mythology, and thus for Indian religions generally. Leading lights of the theosophical movement, such as Madame Blavatsky, travelled to India with the hope of developing clairvoyant and other occult powers. Associated with such exotic religions was a tendency towards vegetarianism and new attitudes regarding sexuality.

132 Shah Jehan mosque, Woking, Surrey, founded 1889 by Dr G. Leitner.

The last decades of the nineteenth century were marked by a growing interest in, and tolerance of, alternatives to Christian belief. The growth in scientific knowledge inspired a reappraisal of traditional religions and the steady expansion of the Empire brought with it an understanding of exotic cultures. This was publicly reflected in Queen Victoria's sympathetic relationship with her Indian servants. It could also be seen in the opening in 1889 of the Shah Jehan mosque in Woking, Surrey (plate 132), which was the first to be built in Britain, established by Dr Gottlieb Leitner for his students at the nearby Oriental and Islamic Studies Centre. This mosque was perhaps the clearest indicator yet of changing attitudes to religion. Since the conversion of the Vikings, Britain had remained monolithically Christian, in spite of the influences of immigrant communities. Now, at the end of Victoria's reign, Britain was on the verge of becoming a recognisably multi-faith society.

SPIRITUALISM AND GHOSTS

In an age of encroaching materialism, it did not seem surprising to many Victorians that the souls of their departed friends should manifest themselves in tangible forms. From the 1850s there was an increasing awareness of spiritual phenomena, which apparently could be captured on camera, or experienced in séances. The mysterious figures who appeared in a haze in spiritualist photographs were also conjured up by painters such as Rossetti, when he created a vision of his dead wife as the figure of Beatrice. There was, of course, a strong desire to explain these uncanny phenomena. Could they be related to the apparently scientific discoveries of the unconscious brain, and its manipulation by

mesmerism or hypnotism? Du Maurier explored the power of suggestion in his story of Trilby, a tone-deaf artist's model who was controlled by the dubious power of Svengali, and turned into a singing sensation. Another explanation seemed to lie in the auras that surrounded objects, and photographers across Europe and America attempted to demonstrate the reality of these natural forces. Despite the obvious involvement of charlatans and the blurring of boundaries between spiritualism and entertainment, it would be foolhardy for later generations to dismiss these widespread phenomena. Certainly many Victorians were consoled by the apparent evidence of an afterlife which they saw with their own eyes.

133 Jakob von Narkeievicz-Jodko, *Electrograph of a Hand*. From Andreas Fischer's *Im Reich Der Phantome* (St Petersburg, 1895). V&A: NC980081.

134 S. C. Allen & Co. Ltd, poster for *East Lynne*, the play based on the novel by Mrs Henry Wood, *c*.1895. V&A: E.165–1935.

135 Frank B. Dicksee, *A Reverie*. Oil on canvas, 1895. National Museums and Galleries on Merseyside.

136 Dante Gabriel
Rossetti, *Beata Beatrix*.
Oil on canvas, *c*.1864–70.
Tate Gallery © 2001.

137 '*Au Clair de la Lune*',
book illustration from
George du Maurier's *Trilby*
(1895). V&A: G 29 W 4.

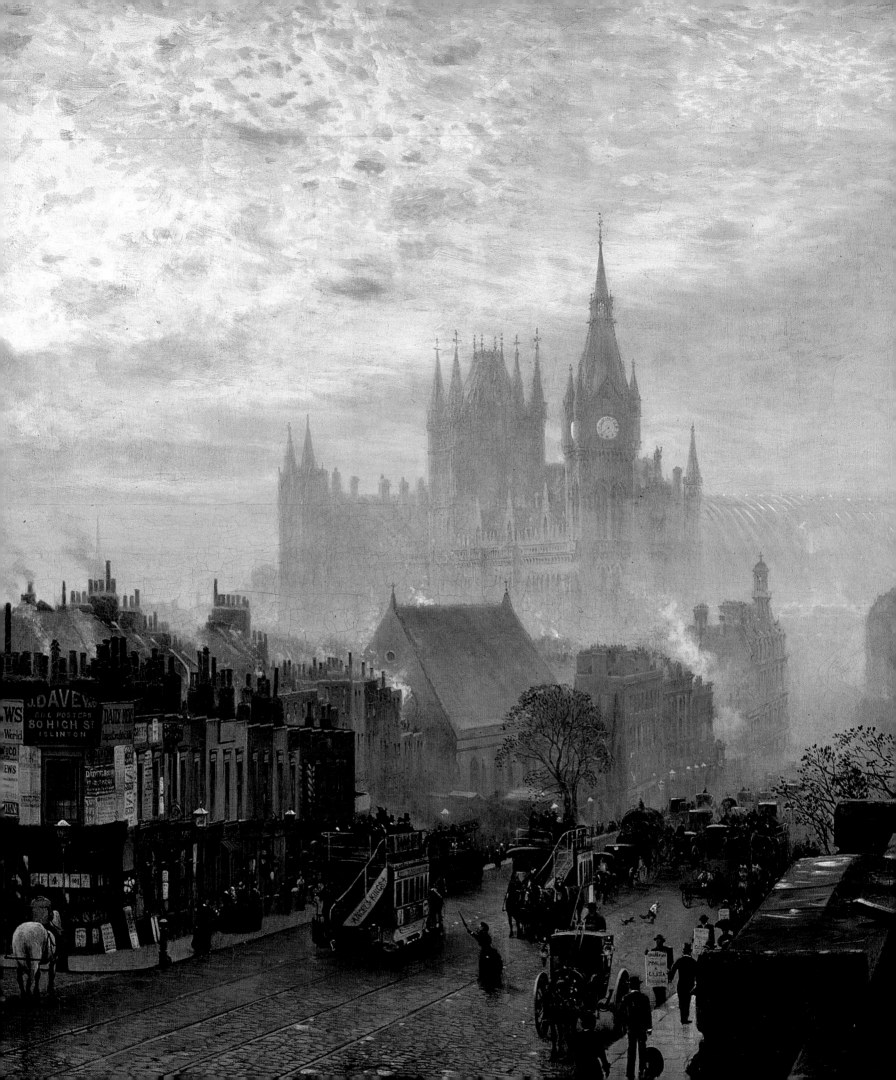

TECHNOLOGY

CHAPTER SIX

STEAM AND SPEED

Industry, Transport and Communications

PAUL ATTERBURY

INDUSTRY, POWER AND SOCIAL CHANGE

The emergence of Britain in the Victorian period as the world's most powerful trading nation was the direct result of the process of industrialisation that had transformed the nation since the latter part of the eighteenth century. This economic and social revolution had been driven by many elements, but the most significant by far was the widespread application of steam technology. Before 1800 brilliant engineers and entrepreneurs such as Matthew Boulton had made steam power a practical reality that had radically improved Britain's core industries, namely the production of textiles, metalwork and other manufactured goods, and the mining of coal and other raw materials. By 1820 the potential of the steam engine as a viable source of power for ships and railway locomotives had been realised.

Although the first decades of the nineteenth century were marked by wars, financial crises and social unrest, Britain's industrial base continued to grow, fuelled by the rapid expansion of international trade. Between 1809 and 1839 imports nearly doubled, from £28.7 million to £52 million, while over the same period exports tripled, from £25.4 million to £76 million. Ten years later these figures were £79.4 million and £124.5 million respectively. The expanding Empire partly explains this great pattern of growth, but Britain's export success was genuinely global. In both 1850 and 1900 the major export markets were Asia, Europe and, increasingly, the United States. When Victoria came to the throne, Britain's status as an industrial power was unchallenged and the pattern of expansion established since the end of the eighteenth century was set to continue.

138 and **139** John O'Connor, *From Pentonville Road looking West: Evening*. Details. Oil on canvas, 1884. Museum of London.

Inextricably linked to the process of industrialisation was the increasingly stratified structure of British society, made in any case more rigid by the application of the work ethic, a reflection of a revived Protestant philosophy that had been largely dormant in the pre-Victorian period. Classification was the order of the day in a society whose values were linked to a well-defined moral code fortified by concepts such as 'improvement' and 'self-help'. The Victorian vision of British society as a pyramid, with royalty, the aristocracy, the Church, the arts and the professions on top, supported by industry, and with the workhouse at the bottom, was very familiar. Inherent within this vision, and enshrined in society was the idea that the rungs of the social ladder could be climbed only by hard work and integrity, an idea that was constantly explored by painters and writers. By this process the concept of industry achieved its own morality, with the word consciously achieving the dual meaning of hard work and industrialisation. A frequently used metaphor for the industrial process was the beehive, and many Victorian buildings featured bees, symbols both of hard work and the acceptance of the social order, in their decoration. George Cruikshank's well-known 1840 print, *The British Bee Hive* (plate 140) underlines this and at the same time throws a spotlight on British society's classified view of itself.

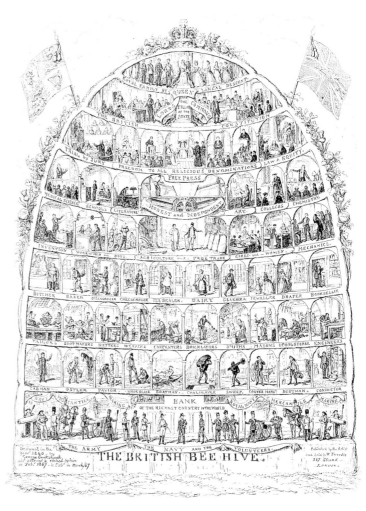

140 George Cruikshank, *The British Bee Hive*. Etching, 1840. V&A: 9779.6.

A parallel vision of British society was supplied by the census of 1851. Of a working population of about 15.75 million, nearly two million were employed on the land, and over one million worked in domestic service. Other major areas of employment were all aspects of the textile trade, the building trades, mining and manufacturing. When analysed in depth, the census, and those that followed, offered many insights into the changing nature of society, not least the great increase in the number of civil servants and those in other service industries (although the censuses do create some problems of definition). Such surveys also chart the major phenomenon of the Victorian period, the rise of the bourgeoisie, or the middle-class consumer society that was the driving force behind industrial expansion. In very simple terms, industry created wealth and the ability to spread that wealth through the various strata of society, both in terms of expenditure and buying power, and as investment. The growth of investments and savings was significant. In 1861 the Post Office Savings Bank was opened and between 1840 and 1900 savings bank deposits rose from £23.5 million to £191 million. Over the same period earnings from foreign investments rose from £7.1 million to £105 million.

As primary wealth-creators, the major producer industries of the Victorian period were agriculture, textiles, coal, iron and steel, and engineering. These industries were also the major employers, the major export earners and, in the latter part of the century, the major targets for the newly emerging trades unions (plate 141). In 1889 trades unions had 679,000 members, the majority of whom were in the primary industries. By 1900 there were over two million union

members in Britain. However, just as important was the diversification of industry in this period, along with the ever-increasing range of imported products. Entrepreneurial expertise generated enormous wealth from the manufacture or importation of products as diverse as biscuits, guano, pianos and ostrich feathers. The importance of agriculture was directly linked to the rapid growth in population. Food production was always a labour-intensive industry, but traditional skills and technologies were increasingly replaced by industrial processes. Fertilisers based on guano were first used in 1835 and the first combine harvester was developed in the United States in 1836. Clay drainage pipes were used from 1843, but before that date, in 1839, an engineer called Howden demonstrated to the Lincolnshire Agricultural Society a portable steam engine designed for farm use. He went on to make twelve such engines, but far more significant was the portable steam engine displayed at the Liverpool Royal Show in 1841 by Ransome's of Ipswich, the machine that really brought mechanisation to the farm. By the end of the century one of the many manufacturers of portable steam engines had alone produced over 33,000 machines. In 1842 Ransome's developed a self-propelled version, which paved the way for the thousands of traction and ploughing engines that revolutionised agriculture in Britain from the 1870s. Other important benchmarks were the reaping machine in 1851 and the widespread use of milking machines from the 1880s.

Despite the extensive improvements brought about by technology, and the huge increases in the amount of land under cultivation, peaking in 1872 at 9.6 million acres, Britain could never produce enough to feed its expanding population. Initially, imports were limited by the Corn Laws, which remained in place in one form or another until 1869. From that date onwards the growth was dramatic; imports of wheat from the United States, for example, increased over thirty-two fold between 1865 and 1900, and over the same period the price dropped by a half. Food imports, encouraged in any case by free-trade philosophies, had a direct effect upon the agricultural industry and between 1870 and 1900 the number of farm labourers also dropped by half.

141 Trade Union certificate for the National Union of Gas Workers & General Labourers of Great Britain and Ireland. Late 19th century. National Museum of Labour History, Manchester.

The spread of industrialisation and the expanding economy in Britain dramatically increased the demand for coal. In the second half of the century, new pits were opened in every British coalfield, but notably in South Wales, aided by the new technology that facilitated deep mining and coal extraction. Between 1860 and 1900 the number of miners increased from 307,000 to 820,000 and over the same period annual coal production soared from 80 million tons to over 225 million tons. A quarter of this was exported, making coal responsible for a tenth of all exports from Britain.

Another important industry was textiles but in this case the growth was not so dramatic, with an increase from 259,000 employees in 1835 to 523,000 in 1901. In addition, over 300,000 women were employed as seamstresses and dressmakers. Over the same period cotton production increased fivefold but the percentage exported was ten times greater. Cotton spinning and printing was the major part of the industry, but large numbers of both men and women were employed to work with wool, linen and flax, silk and lace, and as workers for the hosiery, glove-making and straw-plait trades

More significant in historical terms was the steel industry, which Britain dominated throughout the latter part of the century. The birth of the industry was in the new technology: Bessemer's Converter of 1856 and Siemen's open hearth process of 1869 both used hot gases to produce the steel, a technique that initially required low phosphorus ores, while the Thomas-Gilchrist process of 1879 used phosphoric ores. Annual steel production in Britain grew from 300,000 tons in 1870 to 5 million tons in 1900 and by the end of the century nearly a million tons were being exported. Much of this came from Barrow, a huge steel-making centre established from 1865 to exploit the low phosphorus haematite ores from the Lakeland region.

In 1900 Britain produced nine million tons of iron, and steel production did not outstrip iron until 1918. Steel was used increasingly for railways, in engineering, for tool-making, for armaments, in buildings and for ship-building. The construction of the Forth Bridge, completed in 1890 as one of the wonders of the world because of its pioneering cantilever construction, was made possible through the use of 50,000 tons of steel, as was the rapid growth in ship construction. In 1900 ships totalling 739,000 tons were built and registered in Britain, and the shipyards on the Clyde, the Tyne, the Mersey and in Barrow and Belfast dominated the world. The same year, 1900, the total tonnage of ships registered in Britain was over 11.5 million. Fifty years earlier, British yards had pioneered the use of iron in ship-building.

Cast iron continued as a staple product for British industry throughout the nineteenth century, with extensive uses in engineering, architecture and for the domestic market. There was also a thriving export business for all kinds of cast-iron products, from cooking pots to entire buildings. Scottish foundries in particular specialised in architectural cast iron, and made a feature of selling their products all around the British Empire (plate 142). For example, Scottish-made iron buildings still survive in India and elsewhere, while ornamental fountains are still to be seen in the West Indies.

142 Cast-iron durbar hall made by Macfarlane of Glasgow for export to India. *c.*1890. From *Illustrated Examples of Macfarlane's Architectural Ironwork* (*c.*1893).

THE POWER OF STEAM AT SEA

At the heart of the complex structure of international trade developed by the Victorians and upon which their process of wealth generation depended, were efficient means of communication, and it was the successful development by the Victorians of steamships and railways, together with the electric telegraph that gave them their unique place in history. The steamship has a long, pre-Victorian ancestry, dating back at least to 1783 when the Marquis de Jouffray d'Abbans steamed his little Pyroscaphe across the Seine. In 1801 the Scottish engineer William Symington developed a steam engine to power a small river boat, the *Charlotte Dundas*. On board on the maiden voyage was an American engineer, Robert Fulton, a pioneer designer of submersible craft. His steamship, the *Clermont*, went into service on the Hudson between New York and Albany in 1807. He followed this with the USS *Dermologos*, the world's first steam-driven warship. By 1818 steamships were operating in Germany and in the Mediterranean. All these early pioneers were driven by stern or side paddle wheels, and it was the development of this technology, with its suitable steam engine, that absorbed the first generation of steamship engineers. At this time, sail technology was still dominant, and so the steam engine was regarded as an auxiliary source of power. In May 1819 the *Savannah*, a sailing packet with an auxiliary engine and collapsible paddle wheels, sailed from Georgia to make the first crossing of the Atlantic. She reached Liverpool 633 hours later, having steamed for only 80 of those hours, but her achievement greatly encouraged support for the steamship. By 1833 the Atlantic crossing time had been reduced to 22 days, and steamships had begun to operate on the major imperial routes to India, South Africa and Australia.

The 1830s also saw the founding of three major shipping lines, the British and American Steam Navigation Company, the Peninsular Steam Navigation Company and the Great Western Steamship Company. The first of these planned to operate a fleet of eight huge vessels specially built for the Atlantic, but in the event, owing to delays in the completion of the first of these, the *Royal Victoria*, their transatlantic service was started in 1838 by a smaller, chartered ship, the *Sirius*. With 40 paying passengers on board, and 450 tons of coal, the *Sirius* sailed from Queenstown (now Cobh) in Ireland on 4 April. Four days later, her rival, the *Great Western*, sailed from Bristol and arrived in New York only four hours after the *Sirius*, having completed the crossing in fourteen days, twelve hours. This event marked the start of the modern steamship era, and it established the famous Blue Riband contest for the fastest transatlantic passage by passenger ships. It also launched a period of frenetic competition between the companies, made more intense by the founding of a new shipping line by Samuel Cunard who had won the contract to carry the mails across the Atlantic, on a fleet of four 1,000 ton ships under construction in Scotland. Meanwhile, on 10 July 1839 the *Royal Victoria*, finally completed as the largest steamship in the world and renamed the *British Queen*, sailed on her maiden voyage from London to New York.

The designer of the successful *Great Western* was the brilliant young Isambard Kingdom Brunel (plate 143), the dynamic engineer of the Great Western Railway, who had persuaded his directors that the establishment of a transatlantic shipping line was the natural way to expand the services offered by the railway. Brunel's response to the challenge posed by his rivals was

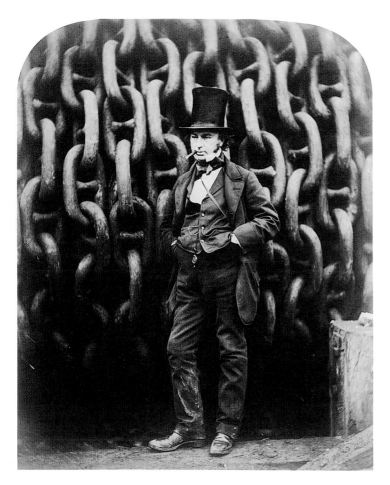

143 Robert Howlett,
*Isambard Kingdom Brunel and
the Launching Chains of the
Great Eastern.* Photograph,
1857. V&A: 246–1979.

to design a bigger and better ship than all of them and in July 1839 the keel was laid in Bristol for a new iron 3,270 ton super-ship, to be called the *Mammoth*. This was to be the most revolutionary ship of the early Victorian period. Designed for speed and comfort, she was also the first large ship to be screw-driven, Brunel making the radical decision to switch from the conventional paddle wheels at a late stage in the building programme. When completed this ship, renamed *Great Britain*, was equipped with cabins and state rooms for 360 passengers and the largest and most lavish dining-room on any vessel afloat. It set the standard for large ocean liners for many decades to come. The steam engine was a massive 1,000 horsepower, four cylinder unit, driving the propeller shaft via a complex arrangement of chains. As the *Great Britain* was being completed, the first Cunarder, the *Britannia*, went into service. On 17 July 1840 she docked in Halifax, having crossed the Atlantic in eleven days and four hours.

Through the 1840s competition on the Atlantic steadily increased, with the American line operated by Edwards Collins joining the battle from 1846. At the same time, the British government was sponsoring the development of other steamship routes. In 1840 the Peninsular Company became the Peninsular and Oriental Steam Navigation Company, with government contracts to expand services to Egypt, the Cape of Good Hope, to India, to Hong Kong, Japan and Singapore and ultimately to Australia and New Zealand. As the Cunard name was becoming synonymous with the Atlantic, so P&O developed its long-term association with routes east of Suez.

Other shipping lines were developed within the Empire and became crucial to its growth and development. A Scots agent in India, William (later Sir William) Mackinnon, founded the British India Steam Navigation Co. in 1856. It was to become the largest shipping line in the world, in terms of tonnage, and eventually connected India to South East Asia, the Far East, the Persian Gulf, Britain, East Africa and Australasia. Mackinnon became closely involved with missionary activities and with British expansion in East Africa, founding the Imperial British East Africa Company. Other lines were created in Australia, New Zealand and Canada, and became crucial in the expansion of trade, and of imperial influence, around the coasts of the great territories of the South Pacific, the Pacific islands, the routes to Japan, the great lakes of North America, and the North Atlantic.

GREAT SHIPS

The steam-powered ship was in regular use in many parts of the world before Victoria came to the throne, but the foundations of modern steamship travel date from the first decades of her reign. Improvements in technology and structural systems brought about a new generation of bigger, faster and more efficient ships, making possible the establishment of regular services across the north Atlantic, around the Mediterranean and to India and Australia via the Cape. In 1843 Brunel's *SS Great Britain* crossed the Atlantic in two weeks, a journey reduced to under a week by the end of the century. Timings for longer journeys were also steadily reduced, particularly following the opening of the Suez Canal in 1869. Bigger ships also brought about higher standards of comfort matched by a more luxurious and less maritime style of décor. Throughout much of the Victorian era British ship-builders,

144 *Britain's Empire on the Sea.*
Print by Johnson & Logan, *c.*1900.
Portsmouth City Museum.

notably in Scotland and in the North East, and British fleet operators such as Cunard and P&O, dominated the world market, for both passenger and freight transport, a position that reflected the economic power, stability and steady expansion of the British Empire. This, in turn, required an equivalent expansion of British naval power underlined by the increased use of iron and steel, the gradual replacement of sail by steam, greatly improved gunnery technology and the development of the torpedo, the submarine and the steam turbine. At the end of the century British naval dominance was increasingly under attack by the new navies emerging from Germany, France and Russia, marking the start of the arms race that would ultimately lead to the First World War. At the same time, Britain had established herself as the primary builder of warships for export to the navies of the world.

145 *Sunday morning muster in the Indian Ocean.* Watercolour published in W. W. Lloyd's *P&O Pencillings* (1890).

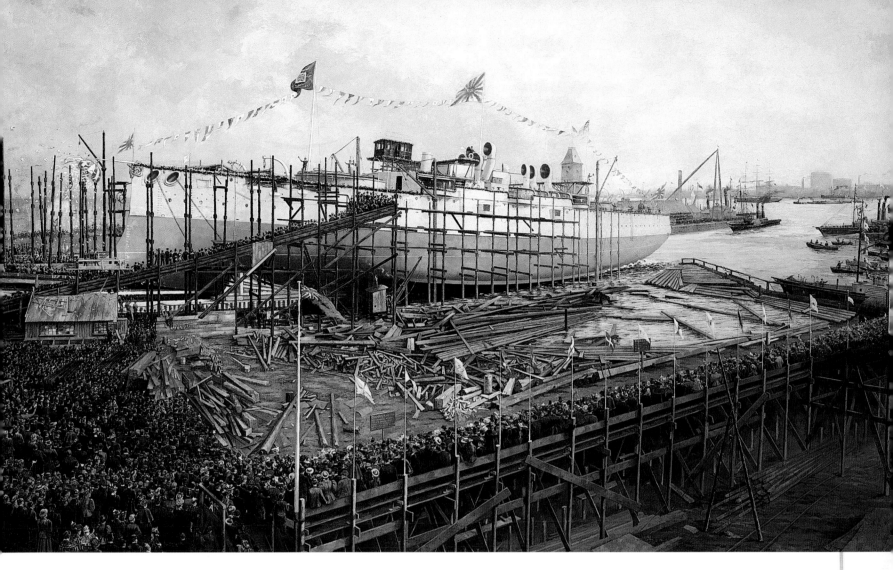

146 Gerald Maurice Burn, *Launch of the Fuji at Blackwall*. Detail. Oil on canvas, 1896. Science Museum, London/Science and Society Picture Library.

147 Submarine torpedo boat, 1879. Designed and built by Garret. Science Museum, London/Science and Society Picture Library.

148 The 'Turbinia', built in 1894, was the world's first steam turbine driven vessel. Sir Charles Parsons (1854–1931) invented the steam turbine, developing it for marine use. Science Museum, London/Science and Society Picture Library.

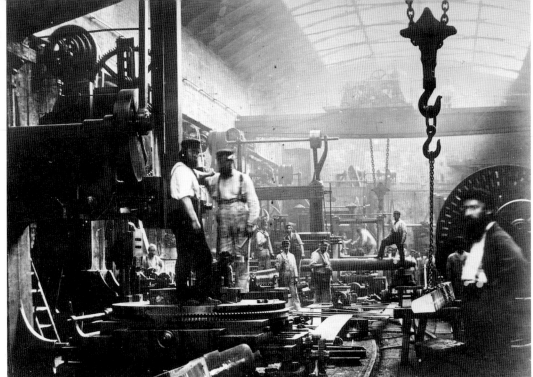

149 *The shipbuilding and engineering workshop and dry dock of the Thames Iron Works, London. Albumen print by unknown photographer, 1867. © Hulton Getty.*

To return to the famous Atlantic route, the Cunard ships were fast, reliable and punctual but their fittings were rather basic and passenger comfort was only adequate. In this area, the *Great Britain* was still unchallenged, even though her time on the Atlantic run was quite short-lived. By 1853, the *Great Britain*, refitted to accommodate up to 630 passengers, was operating an efficient London to Australia service, which she continued to do for nearly twenty years.

The continuing impact of the *Great Britain* encouraged Brunel and his backers to create one more ship. In 1854, work started at Millwall on the Thames east of London on the building of the *Great Eastern*. Designed to carry four thousand passengers and enough coal to sail to Australia without refuelling en route, the ship was 693 feet long, 120 feet wide and weighed over 18,900 tons. Nothing on this scale had even been considered before, and when she was finally broken up in 1888, the *Great Eastern* was still the largest ship in the world. The *Deutschland* of 1900 was the same length but weighed 2,000 tons less, and it was not until the next generation of super-liners, the *Lusitania* of 1907, the *Titanic* of 1912 and the *Imperator* of 1913, that the *Great Eastern*'s records were truly broken. In her construction Brunel pioneered the double-hull system for safety and strength and there was allowance for electric light. Massive steam engines totalling 2,600 horse power drove two 58-foot diameter paddle wheels and a 24-foot propeller. Over 2,000 workers were employed on her four-year construction period. Financial and technical problems plagued the ship and on her maiden voyage to New York in June 1860 she carried only 38 paying passengers. This became a pattern and the ship was never to sail with all berths filled, despite its reputation as an astonishing example of technical virtuosity. Her most successful voyage was a government contract to Canada in 1861 when she carried over 3,000 passengers and crew and 122 horses, a record for one ship that stood until the First World War. In 1863 the *Great Eastern* came out of passenger service and was chartered by the Telegraphic Construction and Maintenance Company to lay telegraph cables across the Atlantic and from India to Aden, and then ended her days as a floating amusement park in various British ports. The more cautious route followed by Samuel Cunard proved to be the right one. In 1856 the first iron Cunarder, the *Persia*, crossed the Atlantic is just over nine days, at an average speed of 13.82

knots, winning the Blue Riband in the process. Another Cunarder, the *Scotia*, the company's last paddle steamer, was to hold the Riband between 1862 and 1867. Great increases in speed and a matching reduction in operating costs were made possible by the development from 1854 of compound expansion engines.

The Cunard ships of this period, famous for their speed and reliability, were built in Glasgow by Robert Napier, one of a number of famous Clyde yards. Equally successful was John Brown's company, founded in 1851. Napier's had an interest in the Cunard company, a trading pattern followed by other yards and shipowners. Ten years later, Harland & Wolff was founded across the Irish Sea, in Belfast. In the first two years of their existence they built and launched sixteen ships. Harland & Wolff backed a new Atlantic challenger, the White Star Line, founded in 1871 and went on to have interests in other shipping companies, including Union Castle Line. The first White Star Line ship, the *Oceanic*, set new standards for comfort and started a period of White Star dominance of the Atlantic. It was not until 1881, when the *Servia* was launched, a ship of seventeen knots fully equipped with electric light, that Cunard could compete again on equal terms. Over the last decades of the century there was great competition between companies and countries to build the fastest and most comfortable ships, and the Blue Riband regularly changed hands. At the end of the century it was in German hands, held by the *Deutschland* which could cross the Atlantic in under five days.

Other well-known yards on Merseyside and Tyneside flourished, thanks to the apparently insatiable demand for British-built ships, not just for British owners, but also for Italy, Germany, France, Holland and many other countries including Japan. The British reputation for leading the world in ship design and building technology was not to be seriously challenged until the late 1880s, by which time the commercial competition from Germany was becoming increasingly apparent. At the same time, yards in Britain and other parts of the world were switching increasingly to the construction of warships, laying the foundations for the great international arms race of the Edwardian era. Britain's final flourish in the field of ship-building was the application to maritime engineering of the steam turbine, developed by Charles Parsons from 1884, initially to improve the technology of electricity generation. The first turbine-driven ship, *Turbinia* (plate 148), was demonstrated at the great naval review mounted to celebrate the Diamond Jubilee of 1897.

THE POWER OF STEAM ON LAND

Like the steamship, the railway predates the Victorian era. Steam locomotives were extensively used on colliery and quarry lines, particularly in the north east of England, and experimentally in other areas, during the first decades of the nineteenth century, with the technology being constantly improved by engineers such as George Stephenson and Richard Trevithick. However, the start of the modern railway age is usually marked by the opening of the Stockton and Darlington line in 1825. Other early steam-hauled lines included the Canterbury and Whitstable and the Liverpool and Manchester, both opened in 1830. It was on the latter's line that the Rainhill locomotive trials were held in 1829, won comprehensively by Robert Stephenson's *Rocket*. With its multi-tube boiler, blast-pipe exhaust and pistons connected directly to the

driving wheels, it set the standard for locomotive design. It also hauled its train easily at thirty miles per hour, proving to the world that locomotive haulage was the way to the future.

Railway building now began apace and a number of predominantly local lines opened during the 1830s. The first trunk routes to be completed, in 1837 and 1838, were the Grand Junction Railway, linking Birmingham to Manchester, and the London and Birmingham Railway, engineered by Robert Stephenson. The same year saw the opening of the first section of Isambard Kingdom Brunel's Great Western Railway, which was finally completed between London and Bristol ten years later. Other early lines were the Midland Counties Railway, linking Derby, Nottingham, Leicester and Rugby, and the London and Southampton, completed in 1840. A railway boom and mania followed during the 1840s, with promoters planning lines the length and breadth of Britain. By 1845 some 2,441 miles of railway were open and over 30 million passengers were being carried. The success of the railway was in part due to the legislation pushed through Parliament in 1844 by Gladstone, which ensured that trains conformed to standards of speed and comfort and that cheap travel was broadly available. This Act also compelled railway companies to allow the new electric telegraph to be carried alongside their lines.

There is no doubt that the popularity of the railways was immediate, despite public dismay expressed by figures as diverse as the Duke of Wellington and William Wordsworth. From the earliest days excursions were run by railway companies, to race meetings, to temperance gatherings, even to public executions. In 1840 an excursion from Leeds to Hull carried 1,250 passengers in a 40 carriage train and by 1844 a newspaper had commented that excursions were becoming 'our chief national amusement'. A considerable number of the visitors to the Great Exhibition in London in 1851 travelled on excursion trains. This traffic greatly increased after the Bank Holiday Act of 1871, when a day at the seaside became almost a national necessity.

Public enthusiasm for the railway was greatly increased after Queen Victoria made her first journey, from Slough to Paddington on 13 June 1842. (Albert had made his first journey soon after their marriage.) Throughout her reign she travelled regularly by train, for speed and convenience, and because it gave her ample opportunity to show herself and family to her subjects, thus turning monarchy into a physical reality. The first royal carriages, built by the Great Western and London and Birmingham companies, date from this period. Though relatively primitive by later standards, they established the pattern for royal trains that continues today. The trains were used particularly for the many journeys to Osborne and Balmoral.

Expansion of the network was rapid and continuous. Between 1852 and 1861, for example, the mileage grew by 43 per cent, while the traffic carried by that mileage increased by 71 per cent. Between 1861 and 1888, the mileage grew by 81 per cent and the traffic carried by 180 per cent. By 1900 18,680 miles were in use and over 1,100 million passengers were being carried.

The great increases in weight of traffic were due more to freight than passenger movements, for from 1852 freight provided the railway companies with the bulk of their income. In the 1860s it regularly generated 30–50 per cent more income, a pattern that remained unchanged until the end of the century. Constant expansion brought problems. Accidents were frequent, the result usually of excessive speed, inadequate brakes and poor traffic control. Signalling was rudimentary until the electric telegraph and the block control system came into widespread use. The effects

of accidents were often compounded by the fragile nature of the carriages, usually built of wood, and by the risk of fire that was frequently sparked off by the gas lighting. Despite the availability of electric lighting from quite an early date, gas-lit carriages were still in use as late as 1928.

Overall, improvements in comfort, convenience and safety marked the steady progress of the Victorian railway. The first lavatories appeared in family saloons in the 1860s, and the first proper sleeping cars were introduced by the North British Railway between London and Glasgow in 1873. Dining cars were pioneered by the Great Northern Railway in 1879, on the service between Leeds and King's Cross.

Locomotive technology increased at the same rate, and by the end of the century the steam locomotive was virtually indistinguishable from its twentieth-century counterpart. By this time, trains were run regularly at speeds in excess of seventy miles per hour. Unlike some European countries, Britain remained wedded to steam power. An experimental electric locomotive, drawing its power from a third rail, was exhibited at the Crystal Palace in London in 1882 and electric traction was subsequently used by narrow-gauge and tourist railways, tramways and underground railways. However, it was not applied widely to main-line railways until the start of the twentieth century.

The building of the railway network was a major achievement of the Victorian period, influencing in a lasting way both social patterns and the landscape of Britain. The great engineers – Stephenson, Brunel, Locke and many others (plate 150) – threw their lines across hills and valleys, across marshland, mountains and great rivers with determination and style, and often regardless of cost. Viaducts, embankments, tunnels and bridges changed the landscape for ever, and their stations, wondrous constructions in iron and glass, cathedrals to modernity, brought a new building type into British culture. Railway engineering is often the most tangible legacy of the Victorian world, simply because so much still survives, even if the trains themselves have long disappeared. Their greatest achievements are too numerous to list, their legacy so rich. Sometimes it is an entire railway, such as Brunel's Great Western, built to such generous standards because of its original seven-foot gauge, and sometimes it is the sheer power of the structures, for example the tunnels through the Pennines, Stephenson's Britannia Bridge over the Menai Straits, Brunel's Royal Albert Bridge at Saltash, the Ribblehead viaduct on the Settle to Carlisle line, the four miles of the Severn Tunnel and, towering above everything else, the Forth Bridge.

As the railway was, in essence, a British creation, it was readily exported to many parts of the world, as a concept, and in component form. British capital and British engineers and constructors were involved throughout the Empire and also in many parts of Europe and South America. A notable figure before 1870 was the contractor Thomas Brassey, who built railways in France, Italy, Belgium, Spain, Russia, India, Argentina and Australia. In France, the entire Western Railway from Paris to Rouen and Le Havre was a British creation, paid for with British capital, engineered by Locke, built by Brassey, and supplied with locomotives and most of its components by British manufacturers. British locomotives were displayed, and admired, at the Paris exhibitions of 1878, 1889 and 1900. By the late 1830s locomotives built by Robert Stephenson and Co. and the Vulcan Foundry had been supplied to France, Germany, Austria and Russia, and locomotives and rolling stock continued to be exported to many countries, both

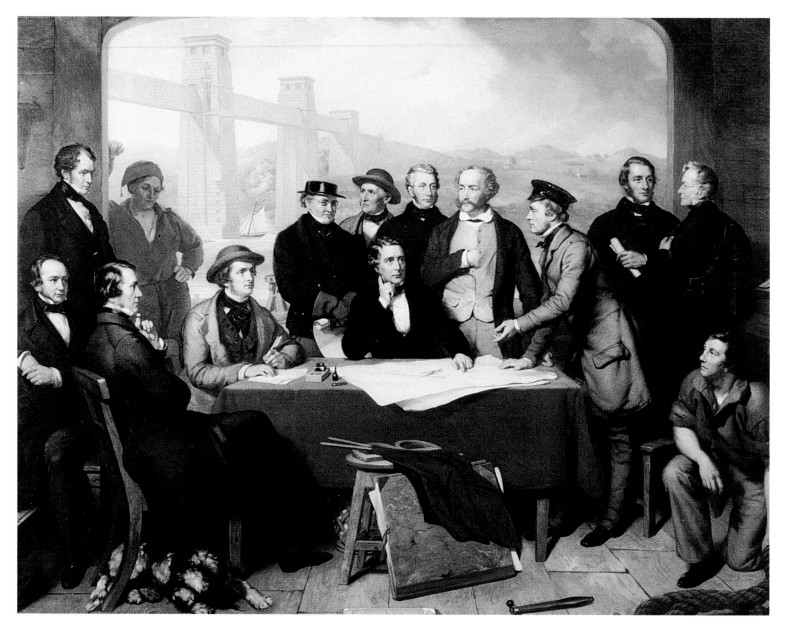

within and outside the Empire throughout the Victorian period. Over one hundred locomotives were supplied to the United States before 1841, and iron and steel rails, often from rolling mills in South Wales, represented a major and long-lasting export business for British companies, to North America and other parts of the world. Imperial railway building projects were often inspired by strategic as well as commercial and industrial motives, but such activities, notably in India and Africa, opened up huge and long-lasting markets to British manufacturers. By the end of the century British locomotive manufacturers, including those owned by railway companies as well as the independent private companies, were making 2,000 locomotives a year, many of which were sold abroad (plate 151).

By this time, railways had come to be seen as a vital aspect of nation building. The British provided India with one of the largest railway networks in the world and it has been seen as vital to the development of modern Indian nationalism. Canadian confederation in 1867 was to be

150 John Lucas, *Conference of Engineers at Britannia Bridge*. Oil on canvas, 1851–3. The Institution of Civil Engineers.
The engineers depicted include Robert Stephenson, Joseph Locke, I. K. Brunel, G. P. Bidder, Charles Wild, Latimer Clark, Edwin Clark, Frank Foster, Alexander Ross, Admiral Moorson and Captain Claxton.

followed by the binding of Canada together with rails of steel. The trans-continental line, connecting every Canadian province, was completed in 1885. When the Australian Commonwealth, bringing together the six Australian colonies, was created at the very end of the queen's reign, again a trans-continental railway (not completed until the inter-war years) was part of the agreement. Railways were vital in tapping the resources of West, East and Southern Africa, although they generally simply linked the interior to the coast, demonstrating their significance in the development of international trade. White settlers were also spread across Canada, South Africa, Australia and New Zealand by the railways. But the Cape to Cairo line, one of the great visions of late Victorian imperialists, was never built.

151 *The War in Egypt: The Armoured Train – Rear of the Train, with Gatling Gun.* The *Illustrated London News* (12 August 1882). V&A: PP.10.

OTHER FORMS OF VICTORIAN TRANSPORT

The other type of railway developed in Britain and then used worldwide was the urban Underground. The first passenger carrying underground railway was opened in London between Paddington and Farringdon on 10 January 1863. Steam-hauled and built on the cut and cover principle beneath the streets, this was the start of a rapidly expanding network which, by the 1880s, served much of central London and its financial heartland in the City, connected most of the major railway termini and was increasingly serving the expanding suburbs via conventional overground connections. The cut and cover technique was used by underground networks in many other cities, for example Paris and New York. Much more demanding technically were the deep-bored tunnel railways, pioneering examples of which were the steam-powered Mersey Railway of 1886 and the cable-hauled Glasgow Subway of 1896. However, the most revolutionary was the City and South London Railway, now part of London Underground's Northern Line, whose first section was opened in 1890. From the start this was wholly electric, with hydraulic lifts linking the surface stations to the platforms, a pattern rapidly followed by other early tube lines, for example the Waterloo and City Railway of 1898 and the Central London Railway of 1900.

Another important development was the urban street tramway, which first appeared in the United States in the 1830s. The first European tramway was opened in Paris in 1853, and the first in Britain was a short-lived route in Liverpool in 1859. However, the real founder of the modern street tramway was an American entrepreneur, George Train, who opened routes in several British cities, including London, in the early 1860s. All early tramways used horses: indeed the first Tramways Act passed by the British government only permitted horse-haulage.

TRAINS AND PUBLIC TRANSPORT

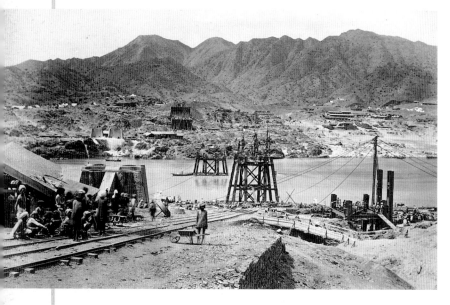

152 *Attach Bridge, Northern Punjab Railway under construction.* Photograph, March 1882. Institution of Civil Engineers.

153 Charles T. Prescott, *Underground Railway, Liverpool.* Oil on canvas, 1894. Walker Art Gallery, National Museums and Galleries on Merseyside.

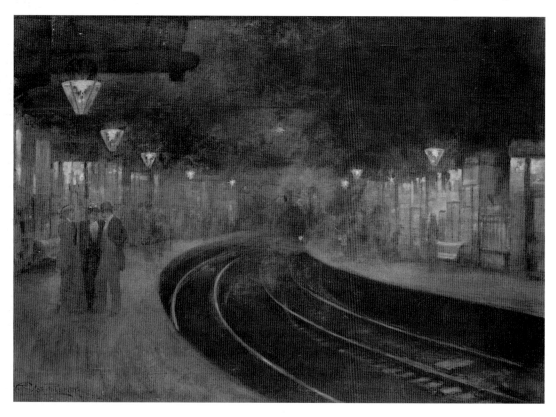

Although the public railway and the application of steam power to transport were pre-Victorian concepts, the widespread development of local, national and international railway networks was a Victorian phenomenon. The combination of great public enthusiasm, massive investment, highly skilled engineering and the application of modern technology ensured the rapid growth of railways in Britain and abroad. By 1850, 6,000 miles of railway were in use, and throughout Victoria's reign British engineers were involved in railway construction and operation in many parts of the world, which in turn created new export markets for British locomotive and vehicle builders. The transport of freight was always important, with the railways being directly involved with the growth of industry through the carriage of coal and iron, along with the distribution of all kinds of agricultural, commercial and domestic products, but the real impact of the railway was as an engine of social change, its universal accessibility having been underwritten by Gladstone's parliamentary bill of 1844. Among other things, this helped to encourage the creation of a huge network of local and suburban rail services which, with their connecting tram and bus routes, formed an integrated transport system that directly affected urban and rural life. For railways, the ever more efficient steam locomotive remained the dominant source of power, while the bulk of the bus network still relied on horse power. However, by the end of the century electrically driven tramways were in use in many parts of Britain, along with the first electric underground railways.

154 *The London & North Western Railway locomotive 'Jeanie Deans' picking up water at Bushey Trough*. Still from a film made by the British Mutoscope and Biograph Co. Ltd., 1899. National Railway Museum/Science & Society Picture Library.

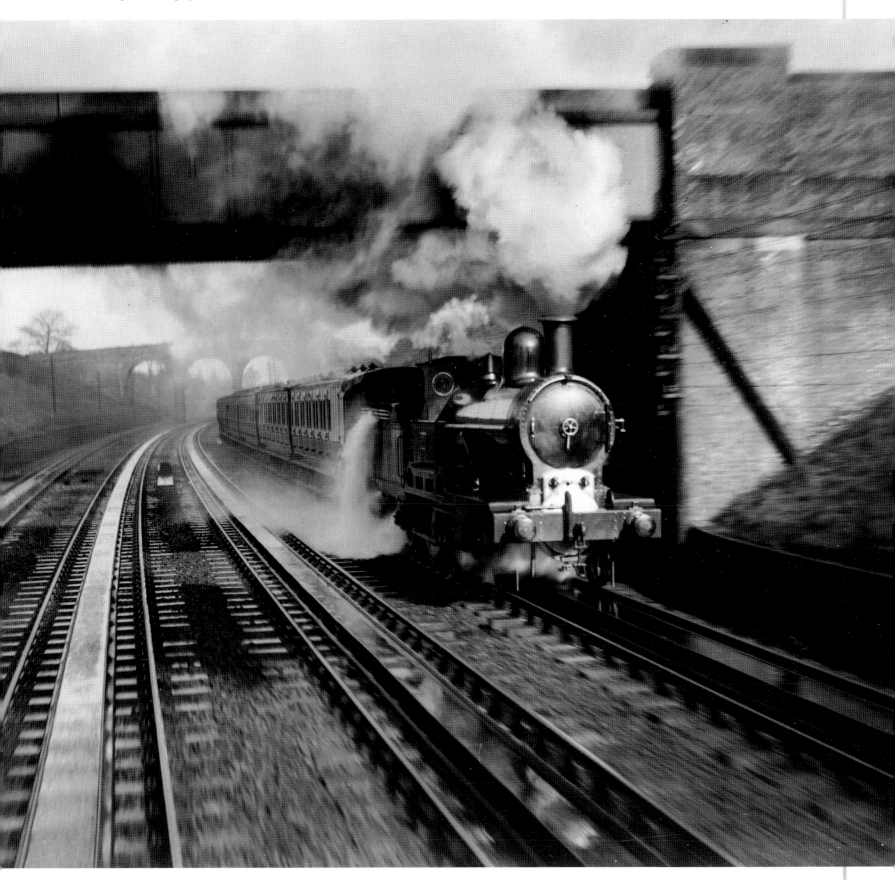

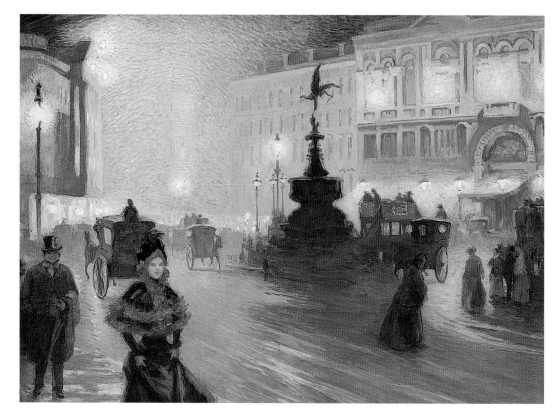

155 Ernest Dudley Heath,
Piccadilly Circus at Night.
Oil on canvas, *c*.1893.
© Photo: Museum of London.
© Painting: Artist's estate.

A further Act of 1879 permitted the use of steam locomotives, with the result that by the end of the 1880s over 50 systems nationwide were using over 500 steam trams. Edinburgh, uniquely, had a cable-hauled system, similar to that used in San Francisco. The first successful electric railway had been demonstrated in Germany in 1879, and four years later Magnus Volk opened his short all-electric line along the seashore in Brighton. In 1884 the first urban street tramway network to use electric power opened in Blackpool. This was powered by conduits laid beneath the track. Trolley connection to overhead cables was first used at Leeds in 1891, and from that date this became the standard system for many British networks. Typically, British street tramway networks were owned or operated by local authorities. The national network grew rapidly during the last years of Victoria's reign but it did not reach its peak until 1927 when 14,481 tramcars operated over 2,554 route-miles.

Despite the success of the tram, the horse-drawn bus carried the bulk of passenger traffic in urban areas throughout the Victorian period. Many artists and illustrators depicted these vehicles, drawn to comment on the way that bus travel broke down the well-defined boundaries of Victorian society. Bus networks were established in most major British towns and cities by the time Victoria came to the throne, generally operated by fiercely competitive private companies, and by the 1850s these were increasingly being absorbed into larger and more powerful groups. For example, the London General Omnibus Company dominated bus transport in the capital from 1856. The Highways Act of 1898 permitted the use of motor buses, and the first motor bus service in Britain started in Edinburgh on 19 May the same year. Other services quickly followed, in Falkirk, Mansfield, Llandudno, Torquay and Clacton, and the first service in London started in 1899. Development was rapid and by 1910 London had more motor than horse-drawn buses.

156 William Logsdail,
St Paul's and Ludgate Hill.
Oil on canvas, 1887.
Private collection.

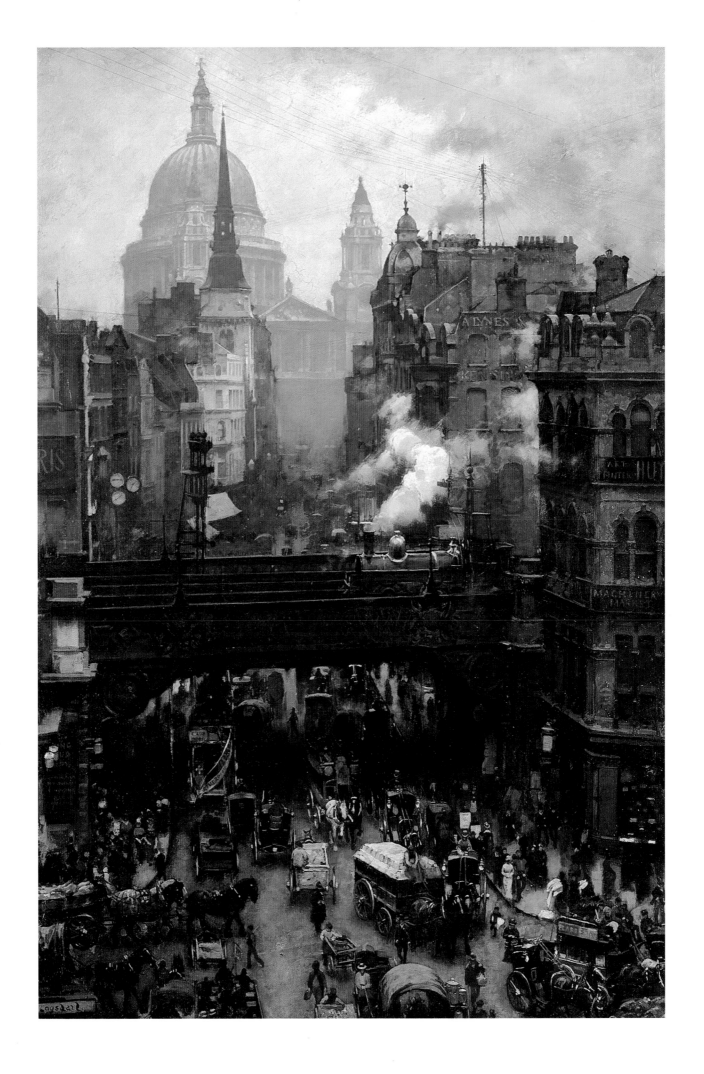

Self-propelled road vehicles were a source of constant interest and experimentation during the Victorian era but, until the first practical application of the internal combustion engine by Benz in 1885, the emphasis was always on the steam engine. However, the only steam-powered road and off-road vehicle to have any real impact was the traction engine, and from the 1870 these were in widespread use in agriculture, for road haulage, for engineering and road building and in the fairground industry throughout Britain, and, increasingly, overseas. The 1896 catalogue for Fowler's of Leeds, one of the major manufacturers, reveals branches in Berlin, Magdeburg, Prague, Budapest, Bucharest, Sydney, Calcutta, Kimberley, Johannesburg and Buenos Aires. Many makers produced so-called colonial models, adapted for wood or straw firing. Military applications of the traction engine were also considerable and were used extensively during the South African war, both for haulage and as armoured road trains. Steam and electric power were also applied successfully to cars, but the leaders in this field were French and American manufacturers.

More significant was the development of the internal combustion engine in the late nineteenth century, but this took place largely outside Britain. Two German engineers, Daimler and Benz, independently pioneered this type of engine and its application to self-propelled vehicles in the mid-1880s, although Edward Butler did make a motor-powered tricycle in 1884. The popularity of self-propelled vehicles in Britain was in any case severely limited by the Red Flag Act of 1865, which decreed that any road vehicle moving under its own power had to travel at walking speed, preceded by a man carrying a red flag. This was not repealed until 1896, when the emancipation of the motor car was celebrated on 14 November by a rally of 33 decorated vehicles from London to Brighton. The first British motor show was organised privately by Sir David Salomons in October 1895, but most early manufacturers in Britain assembled versions of German or French cars, with only Lanchester from 1895 and then Wolseley producing completely British-designed vehicles. The Prince of Wales was an early enthusiast. He had his first ride in 1893, in a French Serpollet steam car, and he bought his first car, a British-built Daimler, in 1899. By 1900, with the first 1,000-mile trial, which attracted 65 starters, Britain had begun to catch up with France, Germany and Italy.

THE BICYCLE: A SOCIAL REVOLUTION

While the impact of the motor car as a means of personal transport was limited in Britain before 1901, quite the opposite applies to the bicycle. Crank-driven boneshakers and velocipedes were common from the 1850s. These led to the ordinary, or penny-farthing, the most popular form during the 1870s and 1880s, despite their inherent instability and dangerous impracticality. However, the real ancestor of the modern bicycle is the Rover safety machine of 1885, designed by John Kemp Starley, the most successful of a new generation of bicycles featuring chain-drive from the pedals to the rear wheel, a rigid triangular frame and a low centre of gravity between two small diameter wheels. By 1888 the safety bicycle had been improved by the addition of gears, pneumatic tyres and good brakes, launching a cycling boom that not only made personal transport almost universally available but also inspired a major social revolution as women took to the bicycle in great numbers. Cycle manufacturers were also quick to exploit the export potential offered by their machines, particularly in colonial markets.

ELECTRICITY, THE TELEGRAPH AND THE TELEPHONE

The widespread application of electric power, not just to industry and transport, but also to urban and domestic life, and to leisure activities, greatly changed the face of late-Victorian Britain. The technology of power generation was vastly improved during this period, not least by the application of the steam turbine. However, the phenomenon of electricity was understood well before Victoria's reign, and in the eighteenth century it was appreciated that it should be possible to communicate via electricity. The key came with the understanding of electro-magnetism, following the experiments carried out in Denmark by Hans Oersted in 1820. With this knowledge Cooke and Wheatstone were able to develop the electric telegraph in 1837, which used an electric current to move magnetic needles, and thus transmit messages in code over a distance. The first operational telegraph was installed to link Euston station and Camden Town, and from there it spread all over the railway system, used both to carry messages and to introduce controls to signalling. The same year saw the development in America of Samuel Morse's code, which then became the standard language of the telegraph, initially using dot and dash symbols on a paper roll, and then sounding keys from 1856. Duplex and quadruplex systems, which allowed the simultaneous transmission of several messages in both directions, were commonplace from the 1870s. The electric telegraph made possible mass communication on a global scale and the networks of copper cables were soon spreading around the world. The first routes were overland, but the demands of both geography and security soon inspired the development of underwater cables and, later, the galvanometer, which made possible the transmission of messages over a long distance with a low voltage current. A telegraph connection across the English Channel was completed in 1851, followed by others across the Irish and North Seas, but the real challenge was the Atlantic.

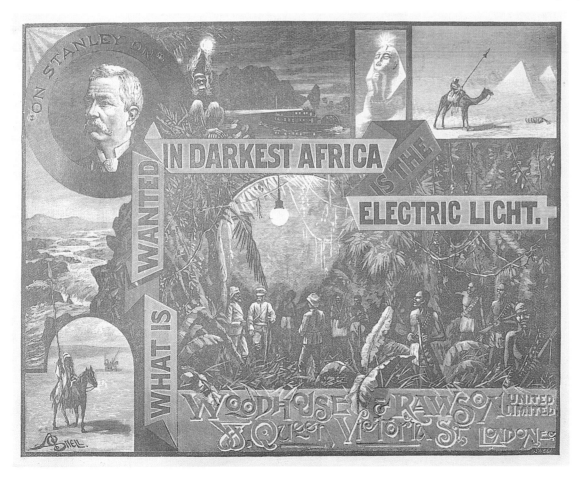

157 Advertisement for electric light company Woodhouse & Rawson United Ltd. 19th century. V&A: E.1519–1919.

The first transatlantic cable was completed in 1858, but it only worked briefly, and it was not until 1866 that Brunel's huge ship, the *Great Eastern*, managed to complete a durable telegraph link between Ireland and Newfoundland. The global network then spread quickly, with many countries establishing their own systems. The colonial and military implications were soon appreciated. By 1878 Britain had constructed three telegraph links, two overland and one maritime, to India (plate 158), part of an expanding network that by the end of the century had connected all the corners of the Empire. The first military use of the telegraph was in 1854, during the Crimean War, but it came into its own during the American Civil War.

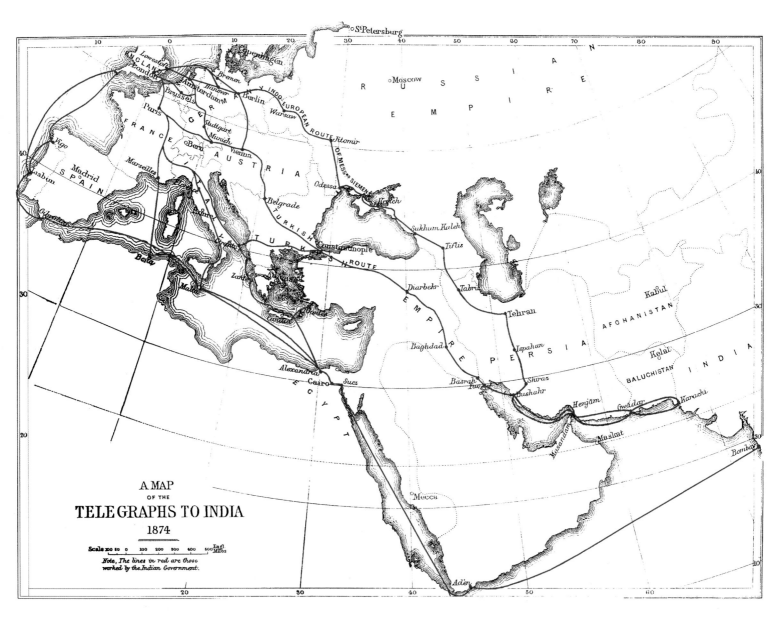

158 *A Map of the Telegraphs to India*. From Col. Sir Frederic John Goldsmid, *Telegraph and Travel* (London, 1874). Private collection.

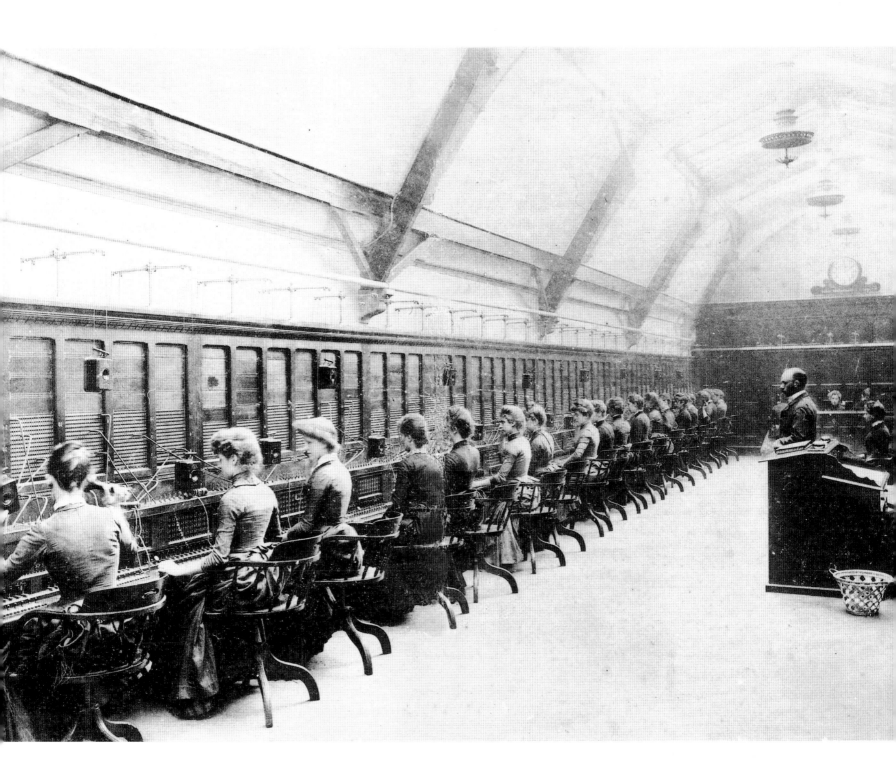

159 Photograph of the Western Electric earth circuit multiple telephone switchboard at the Royal Exchange, Manchester, installed in 1888. Telecom Technology Showcase, British Telecommunications plc.

Although Queen Victoria had her own telegraph machine from about 1851, the system was never designed for personal use. Far more useful in personal terms was the related technology of the telephone, patented by the Scots-born Alexander Graham Bell in March 1876, and demonstrated by him at the Philadelphia Centennial Exhibition of the same year. Two years later Bell demonstrated the telephone to Queen Victoria at Osborne House. By 1887 there were 26,000 telephones in use in Britain (and 150,000 in the United States) and multiple switchboards had been installed in most major towns and cities (plate 159).

TECHNOLOGY, THE ARMY AND THE NAVY

The telegraph and, to a much lesser extent, the telephone, greatly improved communication between the British government and its widely scattered armed forces (plate 160). Throughout Victoria's reign the British army was almost constantly in action, and the demands placed upon it increased significantly with the growth of the Empire in the second half of the century. Despite this, the army and the navy remained quite small in manpower terms: 99,128 in the army and 39,000 in the navy in 1850, and 153,483 in the army and 68,800 in the navy in 1890. Most campaigns involved the extensive use of locally raised troops, which supplied the armed forces with the necessary level of manpower. Until the latter part of the century, most campaigns were fought by troops dressed in uniforms and equipped with weapons that would have been broadly familiar to soldiers on the field of Waterloo. However, the last decades of the century were marked by quite significant technological changes that affected both the army and the navy. For the army the steady improvement in rifles and field guns culminated in the 1890s with the machine gun. From the 1860s there was increasing use of the hand cranked, multiple barrel weapons being developed in both France and the United States. In essence, these were merely improvements of early nineteenth-century technology, even if used with devastating effect during the American Civil War.

In 1884 the American inventor and entrepreneur, Hiram Maxim developed in Britain the first modern machine gun in which the recoil from the shot was used to eject the spent cartridge and reset the bolt, a process made possible by the use, from the early 1880s, of the new evenly burning smokeless powders. By harnessing the explosive power of the cartridge, Maxim produced a belt-fed water-cooled gun that could fire over 500 rounds a minute, operated by the simple process of keeping the trigger pulled. The Maxim gun was made under licence, and in a variety of calibres, in different parts of the world (plate 161), with Vickers in Britain being a major manufacturer for both home and export markets. The British army began to use Maxim guns in the early 1890s, notably in the campaigns in the North West frontier, by which time the weapons were already being traded by arms dealers. In one campaign the British army found itself facing tribesmen equipped with British-made Maxim guns bought from a British arms dealer in Bombay. The same technology and marketing practices were used for similar guns produced by other manufacturers, for example Lewis, Browning, Mauser and Hotchkiss.

The navy was also quick to adopt the machine gun in its various forms, having come a long way from the first ironclad warships of the 1860s. The fleet review of 1897 included 21 battleships, 44 cruisers, 25 gun vessels, 30 destroyers, 20 torpedo boats and 25 assorted naval vessels, including the turbine ship *Turbinia*, a display described by the *Portsmouth Evening News* as 'nine leagues of solid and superb seapower'. The 1887 review had included a submarine, but the navy did not acquire its first submarines, a fleet of five Holland-type boats, until 1901. The submarine was largely an American development, but the pioneering Holland boats were designed to carry three torpedoes to be fired from a bow tube. The modern torpedo was developed by Robert Whitehead, an English engineer, from 1866. With its compressed air engine, this could travel for up to 700 yards at a speed of six knots. By 1895 gyroscopic control had greatly increased the accuracy and range.

The submarine, the torpedo and the machine gun, supported by other examples of modern military technology such as long-range artillery, all detached the operator from the process of killing and so marked the beginning of twentieth-century warfare. In 1899 a local conflict in South Africa exploded into a major war that the British Army contained only with great difficulty and at considerable cost. When it came to the end of its first phase in October 1900, there was already a feeling that the world had witnessed the first modern war. Over 5,000 British soldiers had died and over 20,000 had been injured, and many in Britain were aware that South Africa marked the beginning of the end of the British Empire. On 2 January 1901 Queen Victoria welcomed home Lord Roberts, the hero of the Boer War. Less than three weeks later the queen was dead. Fifteen years later, on 1 July 1916, the first day of the Battle of the Somme, Victorian military tactics met twentieth-century technology head on, and 20,000 British soldiers died.

160 *The Ashantee War: Fixing Telegraph Wires on the Road to the Prah,* from the *Illustrated London News* (14 February 1874). V&A: PP.10.

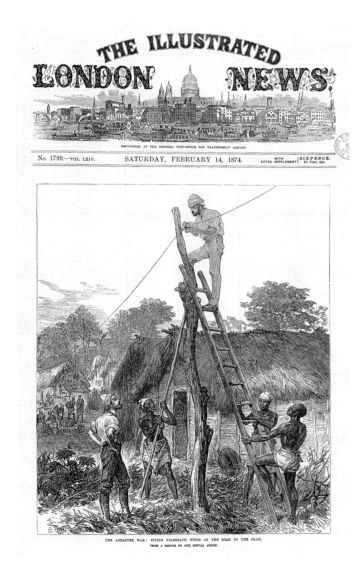

161 Maxim machine gun, 1896. National Army Museum.

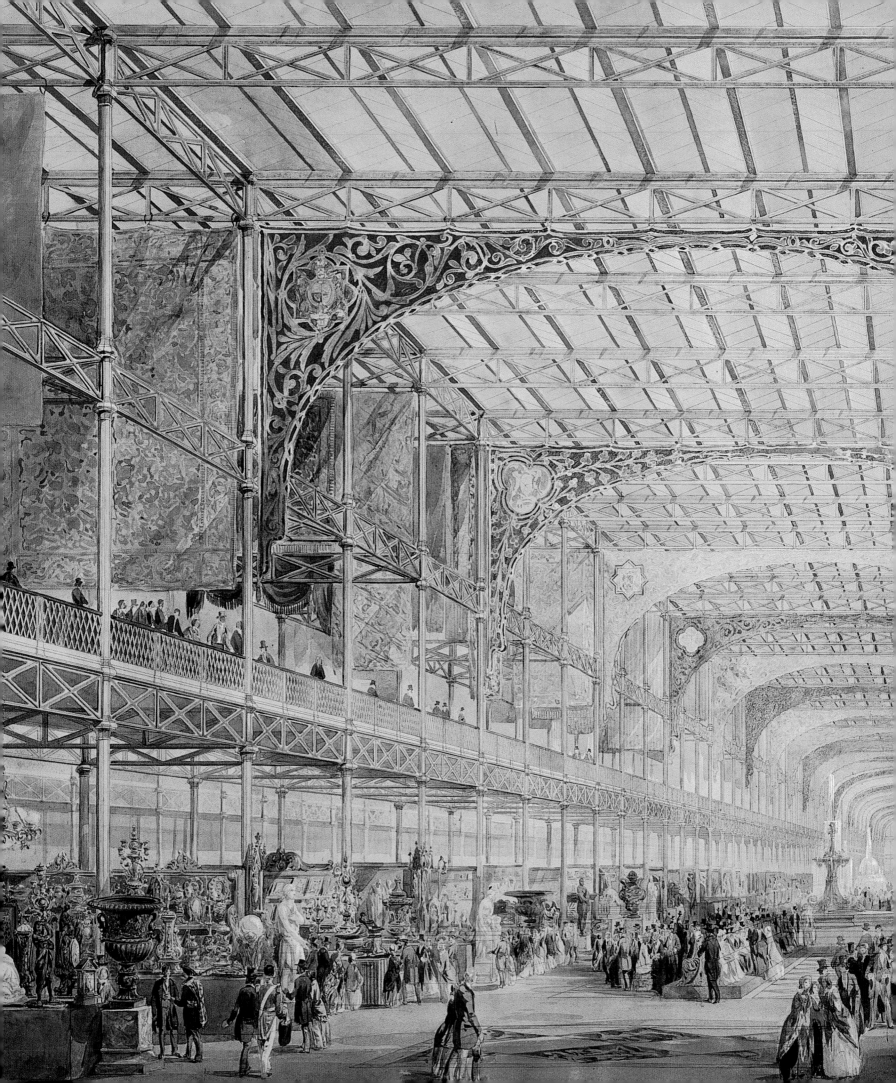

INVENTING A NEW DESIGN TECHNOLOGY:

Building and Engineering

ROBERT THORNE

The Victorians had available to them more building materials and methods of construction than ever before. Technological advances, transport improvements and international trade made possible new forms of building and structure, as well as new choices in design. The same enabling forces widened the range of knowledge that designers and builders could draw upon, in matters of style and in the way projects were executed. New ideas, inventions and techniques tumbled forth, to keep pace with the demands of an expanding and increasingly complex industrial society.

This abundance of possibilities in design and construction was exhilarating, but also confusing. The growth in opportunity on every front resulted in dilemmas of choice, but also in contradictions that were hard to resolve. Thus the merits of originality were pitted against the authority of tradition; craftsmanship had to learn to co-exist with machine production; and the pursuit of a new style had to be reconciled with the use of historically derived ornament. The need to address these and other apparently incompatible opposites could result in highly creative solutions, but just as often what was produced reflected conflict and uncertainty. As in politics, science and the other arts, so in architecture and building the rapid development of new ideas and techniques was often unsettling.

During the long period of the twentieth century, when most of the Victorian legacy went unacknowledged or derided, Victorian buildings were dismissed as muddled, dishonest and ugly. Thus G. M. Trevelyan pronounced in 1942: 'Those grandfathers and great-grandfathers of ours,

162 and **163** Owen Jones, *Crystal Palace, Hyde Park*. Details. Watercolour, 1850.
View showing Jones's scheme for the internal decoration. V&A: 546.1897.
The ethereal effect of the 1,848 foot long nave was heightened by Jones's decorative scheme,
based on the primary colours. Only a few appliqué hangings (as shown here) were used.

though they crossed sea and land to admire Roman aqueducts and Gothic cathedrals, themselves produced deplorable buildings.'[1] For him and most of his contemporaries, it was not worth the effort to try and understand what talented and well-meaning architects and designers had been trying to achieve. Or if it was worthwhile, apparently the only way to deal with the confusing results they had produced was by being ruthlessly selective. If choices had to be made, the favourites most often singled out for praise were the functional products of the engineering tradition, rather than the prestigious architecture of the time. It seemed easy to associate that tradition with twentieth-century modernism, and conversely it was simple to discard other architectural developments as retrogressive and irrelevant. Writing in 1951 the architect and lecturer R. Furneaux Jordan showed where the winners were to be found: 'The engineers – with only a handful of architects in tow – took the broad highway as the new masters of the visual world; the Battle of the Styles was fought out quite privately at the end of a cul-de-sac.'[2] Looked at in that way, the contradictions of the Victorian building world deserved little or no attention.

164 W. H. Fox Talbot, *London Terraced Houses under Construction*. Photograph, *c*.1846.
National Museum of Photography, Film and TV/Science and Society Picture Library.
The form and structure of the typical terraced house remained largely unchanged throughout the Victorian period: brick walls with timber floors and partitions. Small-scale building firms stuck to low-risk familiar construction methods.

Fifty years on we are less inclined to discriminate as Furneaux Jordan did. Engineering achievements such as Brunel's Saltash Bridge or the Albert Dock in Liverpool are still particularly admired, but they are not the measure against which everything else is judged. Post-modern relativism makes it easier to appreciate the paradoxes and diversity of Victorian architecture and design. For instance, not so long ago the Albert Memorial was ridiculed for masquerading as a medieval tabernacle when in fact it was designed to be reliant on a carefully engineered wrought iron armature. Today that incongruity is accepted as a major part of its interest. Or, to take another familiar case, the knowledge that Joseph Paxton, hero of the Crystal Palace, also designed Italianate villas and Tudor country houses was once an embarrassment for those who wished to see him as a wholly progressive figure. Now instead we are fascinated to understand why he practised in such a variety of ways. The confusion that seems to be manifest in these and countless other cases is no longer taken as demonstrating that the Victorians had lost their way, but as evidence that they were grappling with problems of a scale and kind which had never occurred before.

Amongst the paradoxes which interest historians of Victorian architecture and design, the most challenging concern the way that new materials were used. This again draws attention to the dichotomy which Furneaux Jordan identified between architecture and engineering – or function and ornament – but looked at this time in a less prejudiced manner. What most deserves reappraisal is why, after an immensely creative phase in the early Victorian period, culminating in the design and construction of the Crystal Palace, the pace of invention noticeably slackened. Is it that the 1840s were an aberration from the typically slow pace of change in the building world; or were there tendencies at work in the decades that followed which inhibited or reversed the inventiveness of the preceding years?

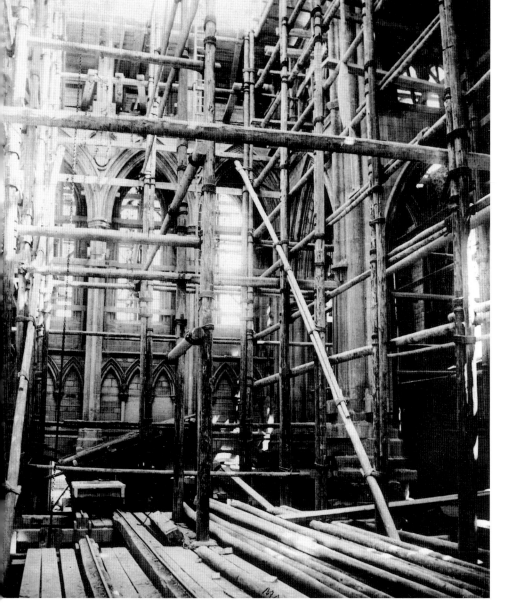

165 *Truro Cathedral under Construction*. Photograph, c. September 1882. National Monuments Record. Prestigious masonry buildings, especially churches and cathedrals, were built using traditional techniques. The granite and Bath stone of Truro Cathedral (1880–1910) were worked on on site and lifted into place using hand-powered derricks.

The technical boundaries of architecture and construction expanded because of industrial changes and the ease with which materials could be transported. For instance, bricks had traditionally been produced locally, often from clay on the construction site. The introduction of brick-moulding machines, which enabled previously intractable clays to be used, plus cheap railway transport, immensely widened the range of bricks available for any project: yellow or white gault bricks, Accrington reds, Staffordshire blues and, from the 1880s, widely promoted flettons, could be used almost anywhere in the country, on their own or in decorative schemes. They could be combined with stonework, also from a large range of sources, or with terra cotta, which was reintroduced for use as a more durable substitute for stone. Mid-Victorian architects delighted in this widening palette of traditional materials; Butterfield in the bold patterned brickwork of his churches, Gilbert Scott in his use of Nottinghamshire bricks at St Pancras Station, and the various designers of the South Kensington museums, area in amalgamations of red brick and buff terra cotta. Even suburban villas and modest public buildings incorporated materials which originated far from their local district.

Glass was another material transformed by mechanisation and the application of new techniques. Gilbert Scott called plate glass 'one of the most useful and beautiful inventions of our day', because it allowed natural light to stream through undivided window openings.[3] The multiple panes of Georgian windows had been limited in size and number by the technology of crown-glass production, as well as by taxes on both glass and windows. The introduction of sheet and plate glass, principally by Birmingham manufacturers using French expertise, resulted in larger, thinner panes. These made their appearance first in pub windows, shop-fronts and conservatories, but most spectacularly of all in the use of 300,000 panes of sheet glass in the Crystal Palace.[4] The removal of excise duties on glass in 1845, and the window tax in 1851, allowed the luxury of large windows and glazed spaces to be enjoyed far beyond affluent thoroughfares.

Allied with glass in many of these developments was the other most crucial material – iron, in both its cast and wrought forms. The iron industry had as long an ancestry as brick- and glass-making, producing cast iron predominantly for armaments and wrought iron for implements and decorative uses. Its transformation in the eighteenth century, through improved methods of smelting and then of forging and rolling, was fundamental to industrialisation and had begun to affect construction well before the Victorian period. In particular, cast iron had been used in the structure of textile mills and warehouses because of its supposedly fire-resistant qualities, and architects such as John Nash incorporated iron in their buildings when its load-bearing capacity suited their purposes. Also iron was already an alternative to masonry in bridge design. These first structural uses of iron prepared the way for its yet more inventive use in the 1830s and 1840s.

The number and uses of materials might not have proliferated so fast had it not been for the knowledge industry which spread the word about them. The earliest professional bodies for architects and engineers had been founded in the late eighteenth century, mainly in the form of clubs for London-based practitioners. Even when put on a more serious footing – the Institution of Civil Engineers in 1818 and the Royal Institute of British Architects (RIBA) in 1834 – there

166 *Crystal Palace: Column-girder connection.* Diagram from Charles Downes and Charles Cooper's *The Buildings Erected in Hyde Park for the Great Exhibition, 1851* (London, 1852). V&A: 399.B.03.
The main girders of the Crystal Palace were not bolted to the columns, but slotted into brackets and wedged into place. This facilitated their erection, but resulted in a structure with an inadequate margin of safety for such a major public building.

were many in the building world who had no contract with them: in 1851 only eight per cent of architects were RIBA members.[5] Those who joined no organisations, or were unable to attend their lectures, could keep up with what was happening through the building press. In 1842, the same year as the *Illustrated London News* first appeared, the *Builder* was launched, using the same formula of wood-engraved illustrations accompanied by dense, informative text. George Godwin, the ubiquitous editor of the *Builder* (1844–83), possessed a breadth of interest and a sense of the social responsibility of the building industry, which gained him a readership across all the professions and trades involved, not to mention public figures such as Prince Albert and Florence Nightingale. Other journals which followed (principally the *Building News*, started in 1854) were almost as comprehensive and detailed. The availability of such publications, plus a growing number of builders' manuals and textbooks, fuelled excitement about progress in construction.

The building press was established in time to catch the major developments of the 1840s, many of which involved the use of iron. Though cast iron had entered the repertoire of architects and engineers before then, the superior qualities of wrought iron – above all its tensile strength – were not fully understood and it was not readily available in forms suitable for structural use. However T-shaped wrought-iron sections began to be rolled in about 1830, and their advantages

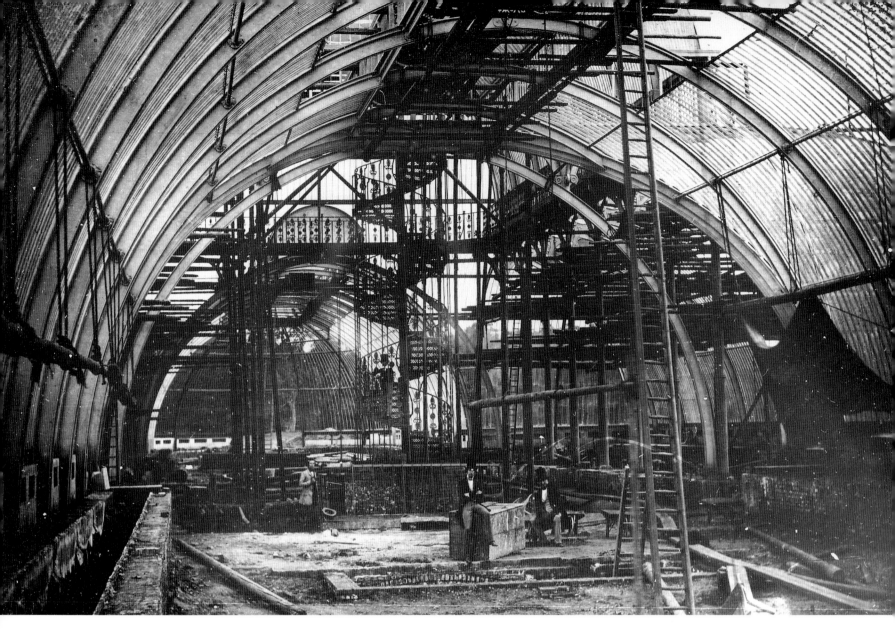

were exploited, first in ship-building and then in construction. During the evolution of the design of the Palm House at Kew (1844–8) the Irish ironwork contractor Richard Turner substituted wrought iron for cast iron in the frame, reducing its weight and allowing for more light to flow in and through the structure. The ribs were based on wrought-iron ships' deck beams, produced in 12-foot lengths and welded together to form sweeping arched curves. Turner went on to use the same principles in his early station trainsheds, notably the trainshed roof at Liverpool Lime Street (1848–50). During the same years the understanding of wrought iron was transformed through the experiments and calculations associated with the design of Robert Stephenson's Britannia Bridge across the Menai Straits. Neither a cast-iron arch nor a suspension bridge was feasible for the spans and clearance required, so Stephenson, working with the ironmaster William Fairbairn and the scientist Eaton Hodgkinson, arrived at the concept of a tubular bridge, with the trains running through it. The rectangular tubes, spanning between masonry towers, were constructed of riveted wrought-iron plate – again a cross-over from ship-building practice – strengthened by cellular flanges plus stiffness in the side plates. Only a few other bridges of the same type were built, but the lessons of the Britannia Bridge were fundamental to the design of iron structures.[6]

167 A. F. J. Claudet, *The Palm House, Kew Gardens, during construction.* Photograph, 1847. Royal Botanical Gardens, Kew. Richard Turner's decision to use wrought-iron ribs and glazing bars resulted in a conservatory of unprecedented lightness. There was under-floor heating and rainwater was stored in tanks, as can be seen on the left.

Both the Kew Palm House and the Britannia Bridge were widely reported, but there were other projects in the same years that were mainly known only to specialists. Few people who watched the new Palace of Westminster being built realised that its main roofs were constructed entirely in iron – composite iron trusses to which were fixed large cast-iron tiles and prefabricated iron dormers. Charles Barry resorted to such an unusual method for fear of a recurrence of the fire which destroyed the previous palace, and because ventilation ducts were run through the roof.[7] Almost equally unnoticed, because hidden behind the walls of naval dockyards, was a succession of iron roofs erected over shipbuilding slips. Eighteen of these were of iron, designed in conjunction with the leading ironwork contractors: they were just as impressive as any of the railway roofs of the time.[8]

Were it not for the experience of the dockyard roofs, the project to house the Great Exhibition of 1851 in a prefabricated iron, wood and glass structure might never have succeeded. The story of Joseph Paxton's intervention, when the building committee for the exhibition was floundering, is appealingly heroic. What is insufficiently emphasised is the role of the contractors Fox Henderson, who had worked in two of the dockyards. They took Paxton's concept sketches, did the necessary calculations, made the working drawings and tendered for the project. Having won (almost a foregone conclusion after the publicity their scheme had received), they not only masterminded the works on site but fabricated and tested most of the main iron components. At a celebratory dinner Sir Charles Fox summarised his role: 'If, as is usual in the construction of large buildings, the drawings had been prepared by an architect, and the works executed by a contractor instead of, as in the present case, these separate functions being combined by my making the drawings and the superintending of the execution of the work, a building of such dimensions could not have been completed within a period considered by experienced persons inadequate for the purpose.'[9]

As such remarks suggest, the real significance of the Crystal Palace was not in the spans achieved, nor in the materials used, but in the process of its assembly. It was acclaimed for the speed and ingenuity of its construction well before it was finished. Thanks to the illustrated press, everyone knew about the miraculous progress of the works down to the finest detail, which counted just as much as the size and ethereal effect of the completed building. The modular structure devised by Fox Henderson was based on the eight-foot span of each roof segment, which generated a basic grid of 24 feet focused on the central nave of 72 feet. This repetitive system was only interrupted by the transept, arched in laminated timber, which gave relief to the otherwise monotonous effect of the columns and girders of each bay.

The virtues of prefabrication were again demonstrated after the Great Exhibition had closed, when the building was dismantled and re-erected at Sydenham in an enlarged form, with three transepts instead of one and an arched roof over the nave. Paxton championed its retention and reconstruction, which was again carried out by Fox Henderson, but he was also ambitious in seeing his concept perpetuated in more than just one example. Detailed drawings of the Hyde Park building were published in 'a work so complete as to enable an architect or engineer to erect a similar building if necessary', and Paxton lectured on how the principles it embodied might be adopted across a much wider range of buildings.[10] He was convinced that a widely applicable

new form of architecture had been born, and in following the story of the Crystal Palace it is hard not to share that enthusiasm.

In the light of such expectations, what happened subsequently was in many ways a disappointment; so much so that the Crystal Palace has been described by some historians as the end of a line of development, not a beginning. In name at least the building was replicated in other places such as Dublin and New York, but only the Munich Glaspalast (1854) was equally inventive. Some of the details of its construction were absorbed into other types of building, including market halls, arcades and railway stations. At Paddington Station (1851–4) the design team (including, once again, Fox Henderson) sought to perpetuate the lessons of the Crystal Palace in more permanent form while memories of the original were still fresh. The bays at Paddington are on a 30-foot module, rather than the 24 feet at Crystal Palace, and the roofs are elliptical arches, but the similarities between the two projects are obvious. No other major railway station followed the language of the Great Exhibition quite so closely.

For ironwork contractors, in addition to such projects, there were increasing opportunities for the manufacture of prefabricated buildings and structures for export. The Royal Engineers – the military arm of British colonialism – had for some time appreciated the advantages of prefabrication to provide accommodation in outposts where skilled labour and materials were in short supply (plate 168). As well as official projects, portable buildings were marketed in Australia, South Africa and for the Californian Gold Rush in 1849. Andrew Handyside & Co. of Derby supplied building components, or whole structures, to India, Brazil and Sierra Leone. A flamboyant kiosk made by them, to designs by Owen Jones, was exhibited in South Kensington in 1866–9 before being exported, but their Indian client defaulted and it never reached its Bombay destination. One firm, James Allen & Son of Glasgow, prepared a magnificent catalogue entitled *Elmbank Castings* (their works were the Elmbank Foundry), bound in cloth gilt. The items illustrated ranged from railings, panels and friezes of all kinds, to gates, terminals and finials, columns and brackets, electric lighting, iron windows, staircases, bandstands and fountains, up to strikingly elaborate kiosks, verandahs, grandstands, shop-fronts and even a railway station. The catalogue had reached its eighth edition by the 1890s.

Paxton was often referred to as 'the founder of a new style of architecture', yet the Crystal Palace had a far more limited influence than that reputation suggests.[11] Part of the reason for this lies in the way it was procured and built. The resentment felt by architects at being excluded from the project was easily translated into a hostility towards iron and those involved in its use. George Godwin, supporting the architects' cause, emphasised that 'no-one would contend that the course that was taken as to the building of 1851 should be repeated';[12] but lest that seemed

168 'Colonel Smith's Prefabricated Barracks System for the West Indies', from *Papers on Subjects Connected with the Duties of the Corps of Royal Engineers*, vol. II (London, 1838). The Royal Engineers pioneered iron construction for export. This system was used in Antigua, Barbados and St Lucia

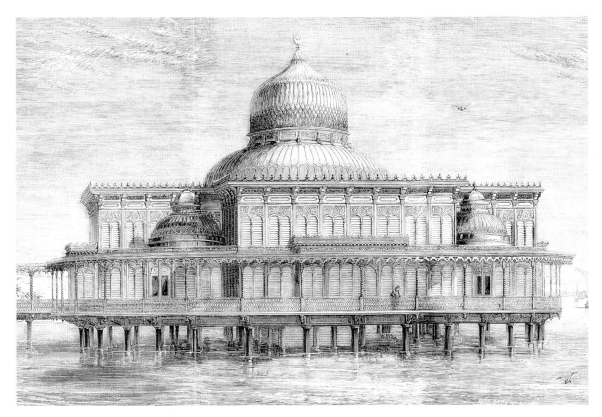

169 *Iron Kiosk for the Viceroy of Egypt.* Illustration from the *Builder* (1860), p. 73. British Architectural Library, RIBA, London. The ironwork contractor Henry Grissell fabricated this pleasure palace to stand on stilts in the Nile. Suspended from the central dome was a swimming bath, which could be adjusted in level to suit the level of the river.

no more than professional jealousy the same response was usually presented as an aesthetic objection to iron in building. Architects took their cue from Ruskin, who used the reopening of the Crystal Palace at Sydenham as the occasion to insist that 'mechanical ingenuity is *not* the essence either of painting or architecture, and largeness of dimension does not necessarily involve nobleness of design'.[13] In a more knockabout way the Gothic Revivalist William Burges made the same point when he contrasted the simple wooden buildings for the Florence exhibition of 1861 with 'our so-called Crystal Palace, [which is] apt to suggest ideas of ghosts of engine-boilers condemned to haunt the scenes of terrific explosions'.[14] The argument that

170 James Meadows Rendel and Sir Matthew Digby Wyatt, *Bridge over the River Sona, near Patna (Bihar), India.* Watercolour, c.1855. India Office Library: The British Library. Iron bridges for Indian railways were supplied from Britain. This bridge on the East India Railway, 28 spans of 150 feet each, was partly destroyed in the Mutiny of 1857 and not completed until 1870.

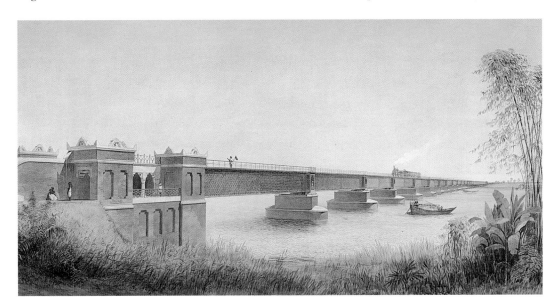

171 *St Pancras Station: Midland Railway Extension to London.* Contract drawing no. 6, 1860s. National Railway Museum, York. Completed in 1868, the 245-foot arch of the St Pancras train-shed was the widest span of its kind in the world. Each of the wrought-iron ribs is tied beneath the platforms by beams which form part of the basement structure.

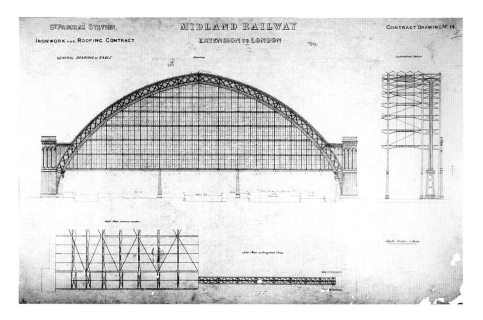

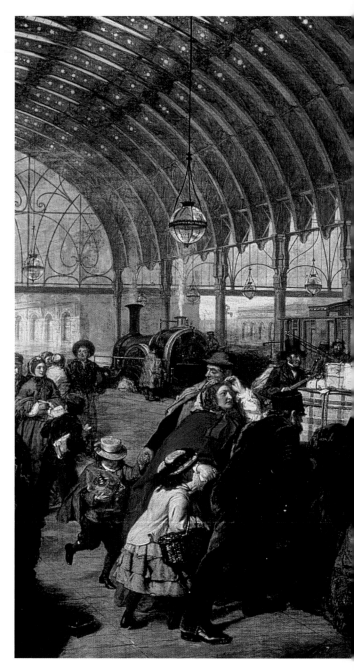

enduring architectural qualities were beyond the grasp of those involved with iron was a tactic to exclude non-architects such as Joseph Paxton, and even more Fox Henderson, from what architects regarded as their main prerogative. The development of an ever-increasing range of historically based styles helped protect architects' area of special expertise.

Yet despite this professional stance, iron, like other new materials, became a customary part of many architects' vocabulary. In an age which demanded larger and more complex buildings with wide-span spaces, its qualities were too useful to be shunned. The most obvious results were to be seen in buildings of mixed construction, with iron and glass roofs or covered courtyards combined with conventional masonry construction: the market halls of northern towns, pleasure pavilions, some types of commercial building, and above all railway termini. St Pancras Station (1865–74) was the sternest test of this approach, regarded either as an ideal example of the reconciliation of its two distinct functions (the station and the hotel) or a schizophrenic compromise demeaning to both parts. Because Barlow's trainshed was built slightly ahead of the hotel, there were from the outset those who wanted it to be seen on its own, yet there was no denying that the conjunction of the station and hotel was conscientiously designed and in its first years worked well.

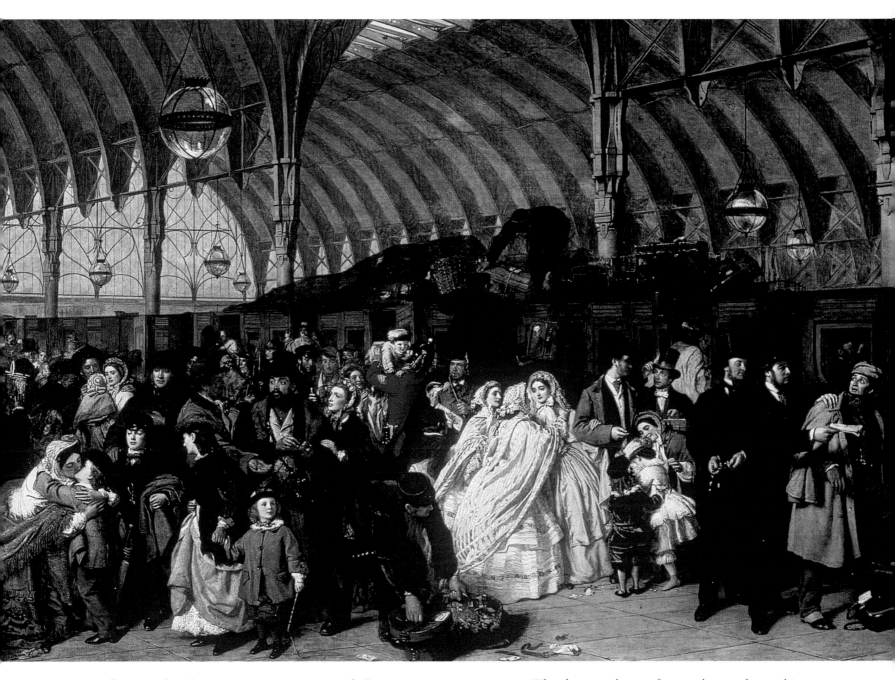

172 William Powell Frith, *The Railway Station*. Oil on canvas, 1862. Royal Holloway and Bedford New College. As well as the animation of the railway scene, Frith captured the architectural effect of Paddington Station, with its two 50-foot wide transepts. The team responsible for its construction – I. K. Brunel, Matthew Digby Wyatt and the contractors Fox Henderson – had all been involved with the Crystal Palace.

St Pancras was an extreme case. What happened more frequently was that architects resorted to the use of iron where necessary, usually in situations where it would not be conspicuous, ranging from window lintels and the supports for chimney breasts to whole roof structures. Few who attended the reopening of the Royal Opera House, Covent Garden, in 1858 can have realised that the auditorium ceiling was hung from a series of wrought iron trusses, and when the Royal Albert Hall was opened 13 years later only the professional press reported on the structure of its oval roof. Most often of all iron was called upon as a component in the patent fireproof floor systems used in public, institutional and commercial buildings. Such systems were comparatively easy to erect as substructures for traditional timber floors, but were still reliant on masonry walls and partitions.

The pragmatic approach to innovation illustrated by these episodes in iron construction seems to confirm that the design professions, especially architects, were principally responsible for the apparently lukewarm response to the lessons of the Crystal Palace. Engineering contractors and large builders, on the other hand, were less inhibited about the virtues of innovation. For instance Henry Grissell, contractor for Barry's iron roofs at the Palace of Westminster, was remembered as someone who 'scarcely ever had a contract but he must do something, at his own expense, to improve the details', and he suffered financially as a result.[15] Yet across the building world as a whole such firms, however progressive, were insignificant compared with the massed ranks of builders, most of them small enterprises dedicated to the avoidance of risk of any kind. Especially in house building small firms predominated throughout the Victorian period: in London in 1899, sixty per cent of firms were putting up fewer than six houses per year.[16] They may have obtained their materials from further afield than their predecessors, and have used machine-finished products, but the standard terraced house which they produced was almost identical to those built sixty years earlier. As far as they were concerned, the more exciting changes might never have happened.

Far from the realm of house building, the end of the century saw the introduction of two materials, steel and reinforced concrete, which were to have a more momentous impact than anything that had gone before. Neither was wholly new. The virtues of steel – its strength, hardness and ductility – had long been known, but it was not until improvements in the manufacturing process of the 1850s and 1860s that larger scale production became possible, and it took even longer for a reliable product to be available for structural purposes. Likewise the use of concrete, especially in foundations, had long been understood and the principle of reinforcing it with iron wires was patented in 1854, but it was not until the adoption in Britain of French reinforcement systems from 1897 that reinforced concrete became a real alternative for the design of buildings and structures. The Forth Railway Bridge (1882–90), with its giant riveted tubes, fully demonstrated the advantages of steel (plate 173), but where buildings were concerned its adoption was mainly in unglamorous and therefore unpublicised examples. The same was true of most early reinforced concrete buildings – mills, warehouses and railway sheds. Both architectural prejudice, and the limits imposed by conservative building controls, meant that these materials found their way into use through the most utilitarian applications.

As conventionally told, the history which begins at the Crystal Palace culminates in the skyscrapers of Chicago and New York of the 1880s and 1890s. In terms of a language of construction it is possible to trace that line of development through the period, essentially as the emergence of fully-framed construction, first in iron and later in steel. But the links between each stage are not always obvious, and the points at which the story falters or loses its way are just as important. Why some things did not happen is as interesting as why other things did occur. In design and construction, as in other spheres, the Victorians appeared to both advance and stand still. Given the complexities of the building world, and its internal rivalries, it would be foolish to expect otherwise.

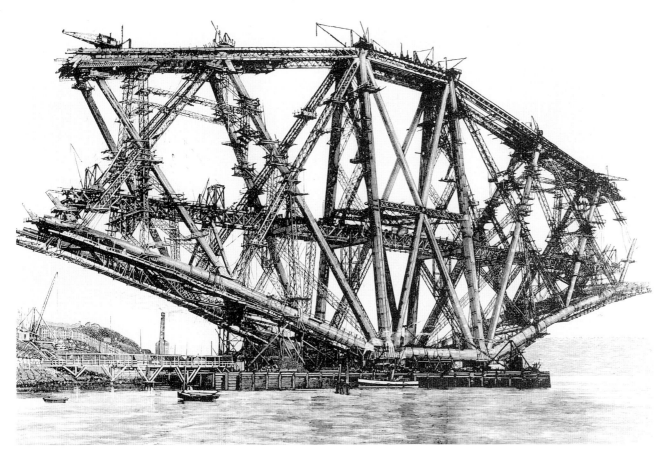

173 Forth Railway Bridge: suspended spans under construction, spring–summer 1889. © Institution of Civil Engineers.
The massive double cantilevers of the Forth Bridge were designed to resist winds of the kind that had destroyed the Tay Bridge in 1879. The use of all-steel construction marked the end of the age of wrought iron.

174 *Midland Hotel, Manchester: erection of the steel frame*. Photograph from *Builder's Journal and Architectural Record* (20 May 1903), p. 204. British Architectural Library, RIBA, London.
Erection of the Midland Hotel started in 1900, using steel supplied by Dorman Long. Although nowhere near the height of American skyscrapers, it demonstrated that British contractors were fully versed in steel-frame construction.

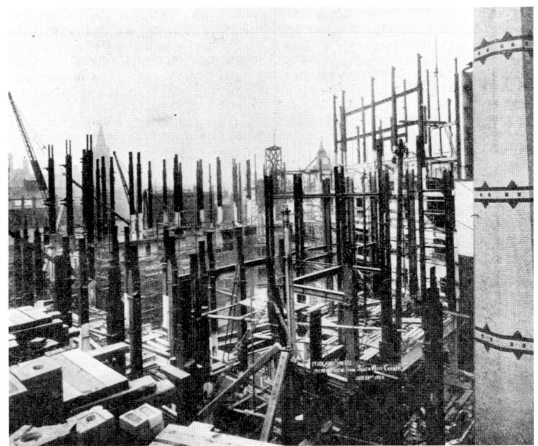

TECHNOLOGY, TRADITION AND THE DILEMMAS OF DESIGN

SUZANNE FAGENCE COOPER

 A 'crusade and Holy Warfare against the age'[1] was the slogan and driving force behind the design partnership of William Morris and Edward Burne-Jones. But perhaps recent accounts of Victorian art and design have focused too much on their 'hatred of modern civilisation'.[2] Surely it was not always necessary to run away from modernity, when it offered new markets, new materials and new prosperity. Even the most ardent Arts and Craftsman could find it hard to resist the commissions which were offered by the rising class of industrialists and entrepreneurs. However hard they tried, they could never entirely free themselves from the commercial realities of the Victorian art market.

Artists had a choice of three options. They could either embrace the innovations of their industrial society, or try to create an alternative escapist vision. A few took the third option of trying to solve the problems of their age by reinventing traditional relationships in design and production. Those artists who made the most of modernity used new techniques in photography, book illustration and product design to their own advantage, and explored industrial and urban subjects in their paintings. For those who rejected industrialisation, solace could be found in idylls of the classical, medieval or Georgian past. However, it was one of the constant ironies of this approach that these artists still took advantage of modern methods to promote and publish their works. Even artists who chose the third way, attempting to transform society through small-scale workshop production, also fell into this trap. They needed to attract customers, just like their more worldly colleagues. Each of these approaches will need to be examined in turn, in order to understand the range of artistic responses to Victorian technologies.

175 Charles Robert Ashbee, pendant. Detail. Enamelled silver set with semi-precious stones, 1901. V&A: M.23–1965.

176 W. H. Titcomb, *The Wealth of England: the Bessemer Convertor*. Detail. Oil on canvas, 1895. Sheffield Industrial Museums Trust Ltd.

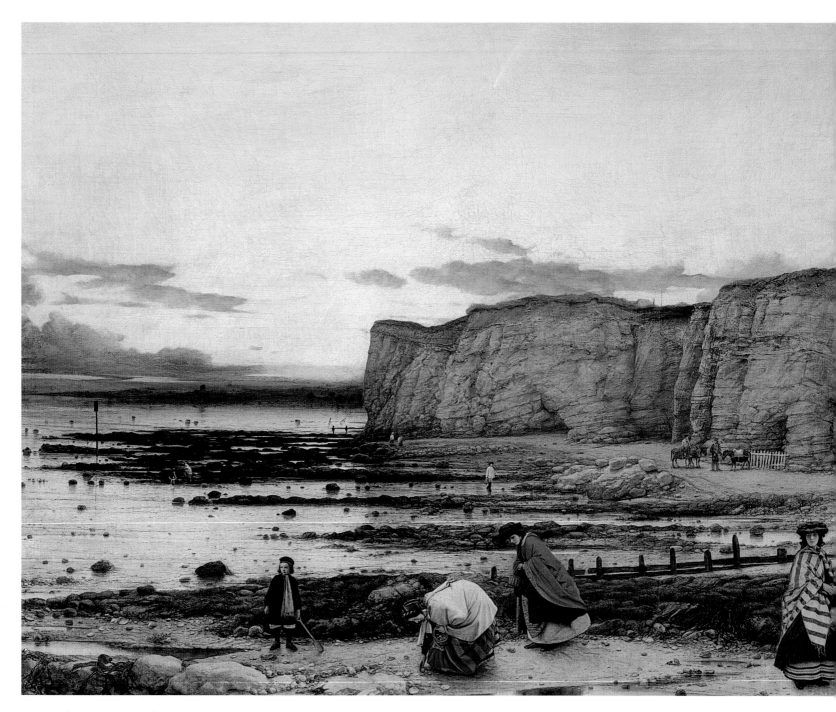

177 William Dyce, *Pegwell Bay, Kent – A Recollection of October 5th 1858.*
Oil on canvas, 1858–60.
Tate Gallery © 2001.

PAINTING AND PHOTOGRAPHY

From early in Victoria's reign, painters and engravers faced a technological challenge from the new medium of photography. Since 1839 photographic pioneers had been continually refining their processes, to produce shorter exposures and more detailed prints, which could mimic the subtleties of landscape paintings and portraiture. But despite a certain amount of scaremongering, this did not always lead to conflict between scientists and artists. In fact, many artists found that painting and photography could co-operate successfully. For example, the painter could benefit from the crisp and almost instantaneous images produced by photography. Some of the most popular panoramic paintings of the mid-century relied on photographs to supplement the artist's sketches. William Powell Frith proved how successful this trick could be in his painting of *Derby Day* (plate 51). Frith asked Robert Howlett to provide him with photographs of people milling around the racecourse. In his painting, he wanted to show the many layers of society, defining them by their dress and physiognomy. Frith referred to the photographic record of the scene in the interests of accuracy and completeness. Victorian painters still had a great advantage over their photographic colleagues, in that they could display the colours of costumes and the delicacies of cloud formations, giving the viewer a more satisfying record of a scene.

For the group of young artists who had taken 'truth to nature' as their motto when they formed the Pre-Raphaelite Brotherhood in 1848, photography became a tool as well as a rival when their careers developed and the influence of their ideas spread. John Everett Millais, for example, found that a photographic montage of models could help him to construct his complex figure composition in *Apple Blossom* (1856–9). From the 1870s, as demand grew for his work, he was supplied with photographs of his sitters and landscape backgrounds by Rupert Potter. His daughter, the illustrator Beatrix, noted in her diary that 'Mr. Millais says all the artists use photographs now'.[3]

Although most of Millais's contemporaries used photography simply as an aide-memoire, the relationship between the two media could be more intimate. A photograph provided the direct inspiration for William Dyce's painting of *The Ferryman* (*c*.1857). Dyce was a celebrated Royal Academician, and his work was favoured by the queen, yet he did not hesitate to copy the details of a photograph taken by George Washington Wilson. The photographer claimed that the painter reproduced his image 'literally, even to the threadbare knees of the boatman's corduroys'.[4] Even when he was not working directly from a photograph, Dyce's paintings often reflect the intense and highly focused vision produced by photography. The arrested movement of figures in the foreground of *Pegwell Bay* (plate 177), combined with geological detailing of the cliffs, seem to refer to photographic images. Although there is no evidence to suggest that Dyce was working directly from photographs in this instance, the muted colours of the painting reinforce this relationship.

Inspiration could also work in the other direction, and photographs which aspired to the status of fine art would reflect the conventions of painting. This might be done either through theatrical detailing or through a more suggestive process, which implied spirituality and fine emotions. Henry Peach Robinson took the Victorian painters' obsession with the Middle Ages,

and recreated scenes from the tale of Elaine and Lancelot in his photographic studio. With painted shields, Gothic windows and flowing gowns he attempted to reinvent the reality of medieval romances. However, these images seem contrived and ineffective. A much more successful treatment of the same subjects can be found in the photographs commissioned by Lord Tennyson to illustrate his Arthurian poems, *Idylls of the King*. His choice of photographer was Julia Margaret Cameron, a specialist in soft-focus dreaminess. She avoided precise narratives in her images, and instead suggested emotions of nostalgia and yearning (plate 178). Her lack of focus was criticised by some as sloppiness, but to many her figures appeared as in a vision. Despite the chain-mail and other medieval accoutrements, her photographs seemed to transcend realism and evoke the sentiment of Tennyson's poems. As a result, they were treated as art rather than science.

178 Julia Margaret Cameron, *The Parting of Lancelot and Guinivere*. Albumen print, 1874. Royal Photographic Society.

BOOK ILLUSTRATION

Towards the end of the century, photographs began to be used regularly as book illustrations. However, the majority of books were illustrated with engravings, and young artists who turned their hand to line drawing could benefit from the boom in affordable illustrated books and magazines. Publishers were finding new markets created by industrialisation, like the bookstalls set up from 1849 by W. H. Smith at railway stations. They cashed in on the new consumer interest in Christmas encouraged by the royal family's own celebrations, by producing lavishly bound Christmas editions of popular poetry and fiction. More generally, the introduction of state funding for elementary education in 1870 encouraged literacy, and the introduction of steam presses made the printing process quicker and easier. The development of steel engraving allowed for longer print runs, although wood engraving was still used in many of the cheaper magazines and newspapers, including the *Illustrated London News*, published from 1842.

From the 1830s, the invention of colour lithography revolutionised the market for children's books, as high-quality coloured picture books could be produced inexpensively for the first time. Established artists, such as Walter Crane, seized the chance to create fanciful designs for nursery rhymes and fairy tales; his *Sleeping Beauty* reclined in an exaggeratedly Aesthetic interior. For other artists, such as Kate Greenaway (plate 179) and Randolph Caldecott, this new process was essential to their careers, as they specialised in writing and illustrating children's gift books. However, their work represents one of the inconsistencies in the artistic response to new technologies, which was hinted at in the introduction to this chapter. Both artists developed a pseudo-eighteenth-century style which presented a pre-industrial idyll of childhood and rural life, yet they owed their success entirely to the new colour printing and mass distribution of affordable books. As we shall see, audiences at the end of the nineteenth century were all too willing to escape from the realities of their mechanised urban society, and many successful artists reflected this desire in images drawn from an idealised medieval or Georgian past.

179 Kate Greenaway, *Alphabet Book*. Late 19th century. V&A: E.2456–1953.

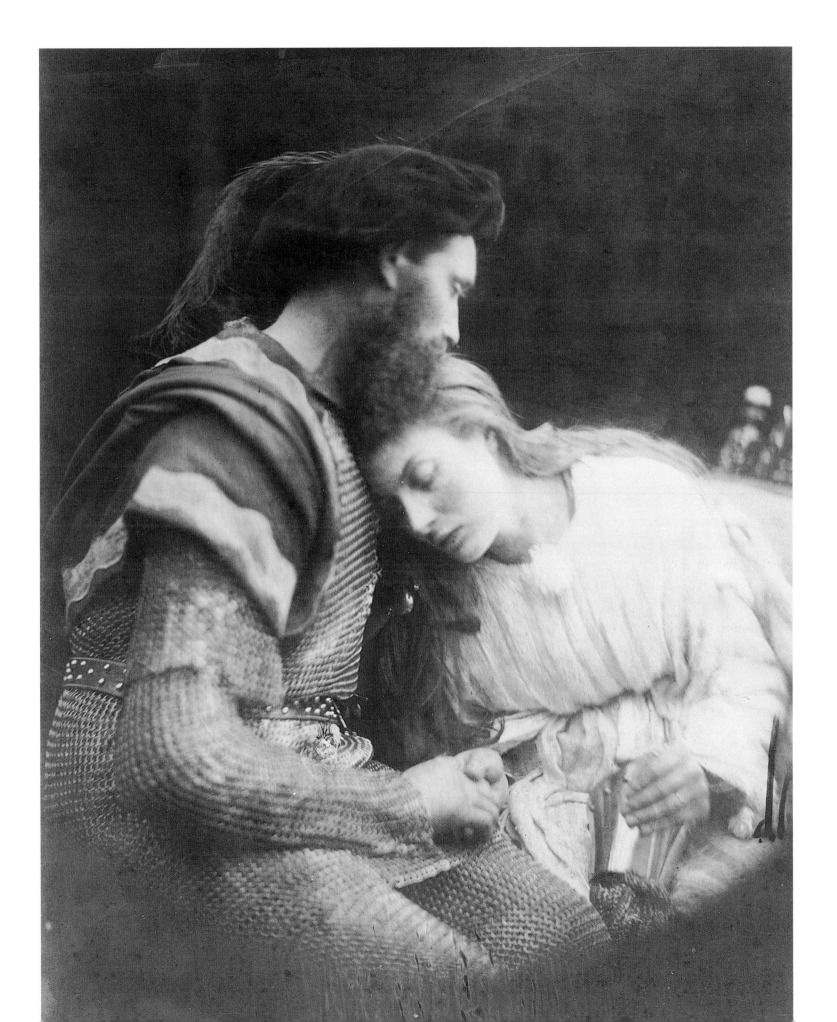

There were, of course, a few artists, who were prepared to challenge their audience, by overturning their expectations. Aubrey Beardsley, for one, found that he could manipulate the medievalism of the *Morte D'Arthur*, to create a distinctively modern style. His illustrations for the *Yellow Book* (1894-5) and Oscar Wilde's notorious play *Salome* (plate 180; 1893) caused a sensation, with their erotic subjects and stylised manner. He contrasted large areas of solid black

and white, with whipping lines for detailing, to give impact to his pared-down compositions. Add to this a hint of *japonisme* and a wicked sense of humour, and Beardsley stands as the archetypal *fin-de-siècle* artist, using the mass market for his own ends. He benefited from the development of the line-block printing process, which used photography, to transfer his precise drawings on to the printing block. Every detail could now be reproduced without the interference of an engraver. Beardsley's small-scale illustrations can be compared in many ways with the poster designs by Dudley Hardy and his contemporaries of the 1890s. Again, the ability to print solid blocks of strong colour was the driving force behind these images, which proliferated in the late Victorian city. Dudley Hardy's advertisements for the magazine *Today* or *The Gaiety Girl* play (plate 62), printed in striking red or yellow, were on a huge scale; even some of the more modest versions were well over 9 feet tall.

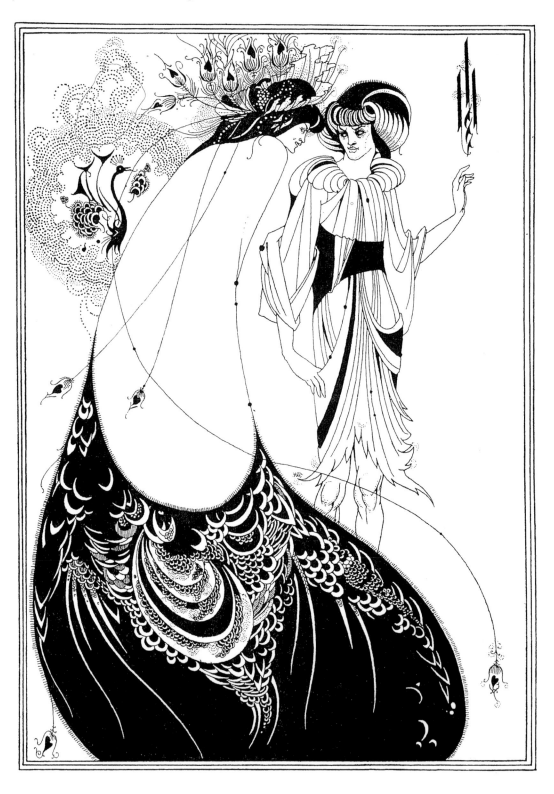

180 Aubrey Beardsley, *The Peacock Skirt*, illustration for Oscar Wilde's *Salome* (1893). V&A: E.426–1972.

181 Christopher Dresser, toast rack. Electroplated silver, 1881. Made by James Dixon & Sons. V&A: M.31–1971.

ADVERTISING AND PRODUCT DESIGN

This new technology used in advertising, and the recent inventions that had to be marketed, were a considerable challenge to Victorian designers. They were also expected to design for increasingly mechanised factories. This problem was partially tackled by Dr Christopher Dresser in his metalwork designs. His tablewares were made by the new method of electroplating silver, first commercially developed by Elkington & Co. in the 1840s. This affordable form of silver-plate could now be sold to the widest possible market. In addition, the extreme simplicity of some of Dresser's designs, notably the geometric toast-racks produced by James Dixon & Sons in the early 1880s, made them ideal for mass-production in a mechanised workshop (plate 181). However, he was not just responding to the needs of the new technology. The shape and surface decoration of his designs show that he was heavily influenced by Japanese style, and his work was as much a response to this oriental influence as to the demands of mechanised production.

For many designers, industrialisation in fact allowed them to indulge their taste for pattern and ornament, with cheaper machine carving, casting and inlay. As the art critic John Ruskin complained, designers delighted in 'all the stamped metals and artificial stones and imitation woods and bronzes over the invention of which we hear daily exultation'.[5] This confusion of material and function is certainly the overriding impression given by the catalogue of the Great Exhibition of 1851 (plate 182). The ability to mass-produce ornament turned the heads of many mid-century designers. Rather than simplifying their products, industrialisation enabled them to indulge in marvellous naturalistic objects, in florid colours, and vegetative forms.

182 Coventry ribbon and papier maché made by Jennens and Bettridge. Exhibited at the Great Exhibition, 1851. From the *Art Journal Illustrated Catalogue*, p. 65. V&A: 399.8.02.

They also had to deal with the problem of creating successful designs for innovative products. What should a telephone or typewriter look like? How would it fit into the Victorian domestic space? In the case of the typewriter, the earliest versions made in the 1870s by Sholes and Glidden clearly reflected the taste for ornament found on mid-century papier-maché. As a domestic object, the typewriter was deliberately decorated to fit in with workboxes, letter-racks and drawing-room chairs, and would not be intrusive in a female space. Early advertisements reinforced this connection by presenting the typewriter as the latest gadget for the modern woman (plate 183). The advertisements associated it with the new breed of liberated women who scandalised and fascinated 1890s Britain. So poster and object designers worked together to construct the market for a new invention.

183 Lucien Faure, *The Empire Typewriter*. Poster, 1897. V&A: Circ.586–1962.

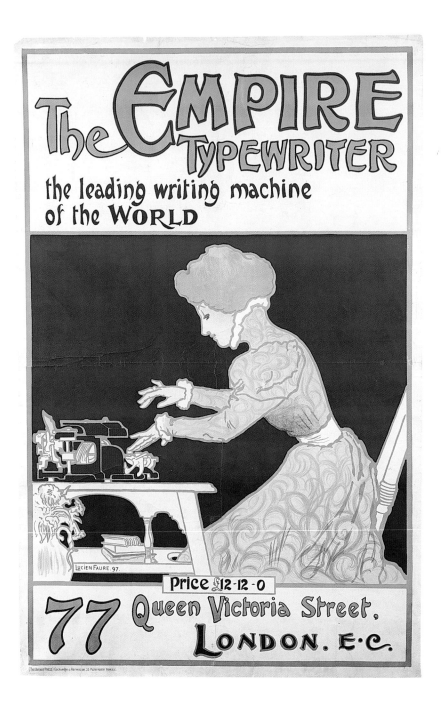

NEW AUDIENCES FOR ART

Through book illustration, product and poster design, artists were reaching new mass audiences. They could also benefit from fresh exhibition venues that sprang up throughout the century. The desire for art as entertainment and education was a characteristic Victorian phenomenon. The annual exhibitions of contemporary painting and sculpture at London's Royal Academy, for example, were extraordinarily well attended, with over 300,000 visitors to many of the Summer Exhibitions. The entrance fee was affordable at one shilling and half price during the last weeks.

Popular exhibitions were also held in the great cities of the north. One of the most successful was the 1857 Manchester Art Treasures exhibition, where fine art and industrial wealth coincided

visibly. Manchester hosted a display of the finest paintings, sculpture and decorative art from British collections, which were exhibited 'amidst the stern actualities of the smoke of her chimneys and the whirr of her machinery'.[6] Modern paintings, including a number by the now famous Pre-Raphaelite Brotherhood were shown, as were photographs, or 'sun-pictures'. Their status was certainly enhanced when they were hung alongside the most highly regarded paintings from Britain's past, including works by Reynolds, Gainsborough and Hogarth.

The location of the exhibition seemed to be particularly important to Victorian commentators. The correspondent for *Fraser's Magazine*, for example, suggested that the working man of Manchester would feel a pride in his own work, when he compared his skills with those of the artists on display: 'The machinist . . . out of his rough and shapeless materials . . . constructs his works of gigantic magnitude with as much precision and delicacy in the modelling as is required in a miniature statue.'[7] Indeed, the whole exhibition was intended as a celebration of British talent, wealth and taste, and as an education for the humbler visitor. Journalists were concerned that the paintings should be labelled clearly, and lecturers employed to 'go through the galleries at short intervals, in chronological order, with a popular running commentary', for the benefit of the 'lower, or even middle classes'.[8] These exhibitions helped to open up a new mass audience for modern British art.

The success of contemporary artists was also encouraged by innovations in the reproduction and marketing of paintings and sculpture. If a painting proved a great success at its first exhibition, the sale of the reproduction copyright could often earn the artist far more than the sale of the canvas itself. Detailed prints of favourite modern paintings were sold as works of art for the home. William Holman Hunt was one of the artists who particularly benefited from this trade in art prints. In 1860 the dealer Gambart paid him £5,500 for the picture and copyright of *The Finding of the Saviour in the Temple* (now in Birmingham City Art Gallery), which was the highest price then paid to any living artist for his work. It was exhibited in London, and around Britain, with tickets at a shilling each, making the dealer a substantial profit. The print was issued in 1867, along with an explanation of the complex religious symbolism.

Gambart had planned this campaign to cash in on the earlier success of Hunt's painting of *The Light of the World* (1851–3; plate 123), which was in such demand that he created three different versions. Gambart had recognised the commercial value of this work, and arranged that the original painting should tour Britain in 1860 in order to encourage orders for his print. Hunt soon learnt the value of his works, and by 1873, when he completed *The Shadow of Death* for the art dealer Agnew, he was demanding a half-share of the profits from the exhibitions and prints, amounting to £10,500.

Dealers were prepared to commission paintings from best-selling artists simply so they could tour the oil painting and sell the prints. Flatow made precisely this arrangement with Frith for his panorama of *The Railway Station* (plate 172), which was exhibited around Britain and then sold on to Henry Graves, who published it as a high-quality engraving. This painting, of course, was a detailed exploration of the impact of the railway on Victorian society, bringing the classes into close proximity, and separating families.

Modern-life subjects in art

However, painters as a rule avoided direct representations of heavy industry. Images of factories and workers were rarely seen on the walls of the Royal Academy. Social Realists such as Luke Fildes and Frank Holl tackled subjects like homelessness and sweatshop labour, but even they did not set up their easels inside the cotton mills or coal mines. Instead, we usually have to rely on novelists and magazine illustrators for descriptions of these environments. There may be practical reasons for these gaps in Victorian imagery; perhaps painters simply could not get access to factories and mines or perhaps their pictures would not find a buyer. After all, many newly rich patrons were collecting art as a way of reinforcing their desire for gentility, and distancing themselves from their industrial roots. They would not necessarily have welcomed images that focused on the uncomfortable labour that underpinned their wealth. But artists were still prepared to deal critically with the problems of agricultural poverty or urban prostitution, despite comments that these subjects were demoralising and inappropriate for public exhibition. Was it simply too difficult to find ways of representing the workers in a dignified and moral manner in these settings?

It was not until the very end of the century, in 1897, that W. H. Y. Titcomb showed his dramatic oil paintings of a Rotherham steel foundry at the Royal Academy exhibition. In *The Wealth of England: The Bessemer Convertor* (plate 176), he reflected the importance of steel workers to the imperial economy. Titcomb was clearly attracted to the subject by the challenge of capturing the blaze of coloured light from the furnace. He also presented the industrial workers in a heroic manner, showing off the strength of their bodies. However, such images were rare in Victorian painting.

Art for the home

The full range of acceptable Victorian subject matter was reproduced by the *Art Journal*, a magazine established by the London Art Union in 1839. The Union saw the reproduction of the latest works of art as one element in its campaign to develop the taste, and with it, the moral values of the public. Yet again, education was supported by the new publishing technologies, and artists could find their work presented to a far larger audience than would be found simply in the Royal Academy. Sculptors were also able to benefit. Using new techniques developed in France in the 1830s, small bronze casts of their works could be included as prizes in the regular lotteries held by the Art Union. Copies of monumental figures by Hamo Thornycroft and his contemporaries now found their way into middle-class homes.

Miniature versions of marble sculptures could also be produced in Parian ware. The slightly granular surface of this white porcelain resembled marble, and from 1847 the Art Union commissioned a range of replicas from the manufacturer Copeland. The results were so popular that Minton and many other factories soon introduced these ceramic figures into their ranges, under the title 'Statuary Porcelain'. Although these Parian sculptures were still relatively expensive, costing two or three pounds each, they enabled artists to reach a wider market than had previously been open to them. Many figures remained popular throughout the century; John Bell's *Dorothea*, for example, remained in production from the late 1840s to the 1890s (plate 184).

In addition to this extra publicity for their works, artists also became media figures in their own right. Magazines ran articles on the lifestyles of major painters, including Frederic Leighton and G. F. Watts, in which they were photographed in their studios. As they became rich through the sale of their paintings, and the copyrights for reproductions, so they also became famous. Both the *Magazine of Art* and the *Studio* (plate 185) brought contemporary painters to the public's attention, establishing them as personalities. By 1896, when Leighton died, he was so well known that his funeral became a major public event. Crowds packed the streets as his hearse was driven from the Royal Academy to St Paul's Cathedral. This was an artist whose life and works had been made visible by the recent innovations in print distribution and magazine publishing.

184 John Bell, *Dorothea*.
Parian porcelain, 1847.
V&A: 44–1865.

185 Front cover of *The Studio*. 1893. V&A: E.361-1899

IDEALISATION OF WORK

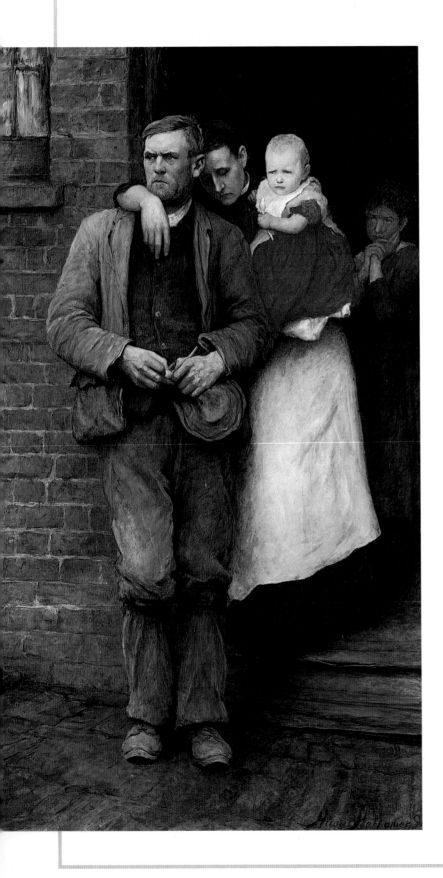

The realities of work changed dramatically during Victoria's reign, as the industrial cities drew labourers out of the fields and into the factories. By 1861 over half the population had moved to live in the rapidly expanding towns. Some artists responded to these changes by creating timeless images of agricultural labour, emphasising harmony with nature. However, in Clausen's paintings, realism intervened, and he demonstrated the back-breaking tedium of work on the land. A number of artists rose to the challenge of capturing the heroic qualities of industrial effort, which were contributing to Britain's imperial expansion, through ship-building, engineering and steel production. As factory employment spread, so the workforce became more organised in demanding improved pay and conditions, although, as Herkomer showed, the ensuing strikes could bring hardship as well as gain. Artists such as Luke Fildes later in the century caused consternation among middle-class audiences by focusing attention on the plight of the poor and the unemployed. Of course, many women were also expected to contribute to a meagre family income by working in the textile mills or smaller workshops. The greatest number of women, over one million in 1851, were employed as domestic servants or charwomen, but unlike the picturesque farm worker, or the modern figure of the industrial labourer, their efforts were barely acknowledged by artists. Woolner's life-size sculpture of a housemaid was a striking rarity.

186 Sir Hubert von Herkomer,
On Strike. Detail. Oil on canvas, 1891.
© Royal Academy of Arts, London.

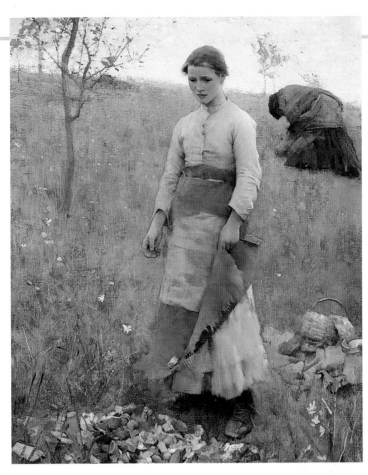

187 William Hamo
Thornycroft,
The Mower. Bronze, 1884.
National Museums and
Galleries on Merseyside.

188 George Clausen,
The Stone Pickers.
Oil on canvas, 1887.
Laing Art Gallery, Newcastle
upon Tyne. Photograph
© Tyne and Wear Museums.

189 Thomas Woolner,
The Housemaid. Bronze, 1890s.
Salter's Company.

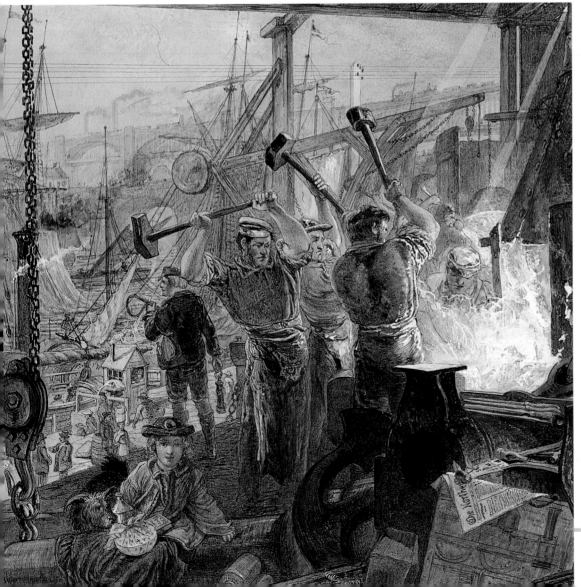

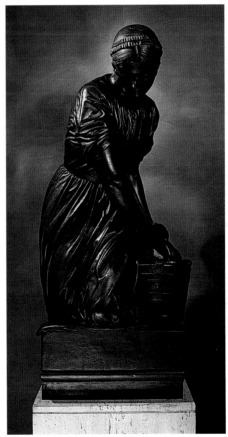

190 William Bell Scott,
Industries of the North East. Detail.
Watercolour, 1861. V&A: 362–1891.

ART PATRONAGE

Of course, artists could not rely only on the popular market for their works. They also had to find buyers for their original oil paintings and bronzes. Yet again, they found that the changes brought about by industrialisation were working in their favour. A new breed of collectors had developed early in Victoria's reign, who were eager to buy modern British art. Newly wealthy manufacturers, and older families who had made their money by trade, wanted to spend their fortunes on collecting art, in some cases as a form of self-aggrandisement, and in others, as a philanthropic gesture. They were wary of buying Old Masters, as the Art Union had been publishing horror stories about the trade in fakes. Buying direct from the artist was more prudent, and could also allow the collector to exercise some influence over the works produced. The painter C. R. Leslie described this new market to his daughter in a letter of 1851: 'The increase of the private patronage of Art in this country is surprising. Almost every day I hear of some man of fortune . . . who is forming a collection of the works of living painters; and they are all either

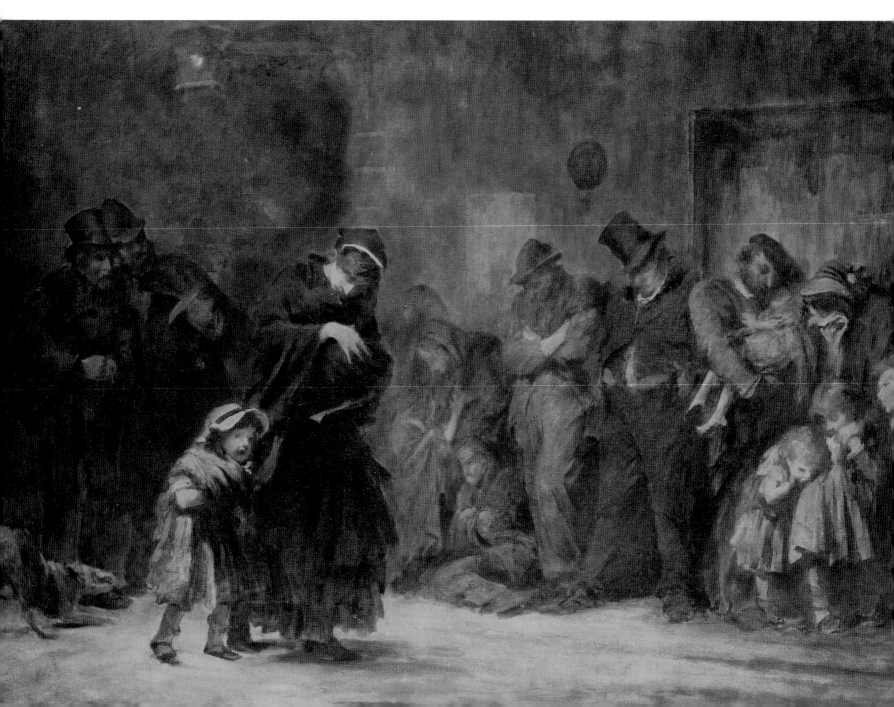

men in business, or who have made fortunes in business and retired.'[9] The collections that were built up by the new merchant princes were so spectacular that industrial cities like Liverpool were regularly compared with Renaissance Florence.

In the early years of Victoria's reign, pastoral scenes and conservative figure compositions seem to have been particularly popular with these collectors. Joseph Gillott (1799–1872), the son of a humble cutler, was typical of this generation. He made a fortune manufacturing steel pens, and spent a large portion of it on works by J. M. W. Turner, William Etty and John Linnell. He also ploughed some of his money back into a benevolent society for his workers, in a philanthropic gesture that was characteristic of many Victorian self-made men.

As the century progressed some entrepreneurs were developing a taste for more *avant-garde* art. By the 1860s, D. G. Rossetti's work was collected by a select group of connoisseurs, who appreciated his images of women, which were at once excitingly fleshy and distanced by exotic props. Samuel Mendel (1814–84), a Manchester cotton merchant, indulged his interest in contemporary art by collecting Rossetti's *The Blue Bower* (1865) and classically inspired paintings by Leighton.

A few industrialists were inclined to spend their money on paintings that more realistically reflected their society. They were not shy of patronising artists who commented on the injustices and hardships of Victorian Britain. Thomas Taylor (1810–92) profited from the upheavals in the cotton industry during the American Civil War, and employed up to 3,000 workers in his Wigan cotton mills. His private art gallery was open to the public on Wednesdays, but it seems unlikely that his own workers would have had the opportunity to admire his progressive taste. In 1874 he spent 2,500 guineas on one of the most devastating images of Victorian poverty, *Applicants for Admission to a Casual Ward* (plate 191), painted by Luke Fildes. The huddled figures waiting in the snowy night for a bed in the workhouse were an indictment of the economic forces of competition described by Friedrich Engels as 'a battle for life, for existence, for everything'.[10]

Life could be just as hard in the countryside, as George Clausen made clear in *The Stone Pickers* (1887; plate 188). Yet this image of agricultural drudgery was bought by James Staats Forbes (1823–1904), whose fortune was entirely based on the innovations of Victorian technology. Having worked with Isambard Kingdom Brunel, in 1861 he became General Manager of the London, Chatham and Dover Railway. He also saw the potential in telecommunications, as President of the National Telephone Company in 1892. His pioneering attitude to industry was reflected in his artistic taste, as he patronised Clausen's broad continental style of painting, and J. A. M. Whistler's controversial Aesthetic pictures.

Clausen and Fildes's hard-hitting images of distress were direct responses to the realities of a fast-changing society, which had been overwhelmed by the impact of industrialisation. But many Aesthetic and escapist paintings were also the result of these upheavals. These artists had taken the second of the three options outlined in the introduction, and were reacting against industrial production methods, and the dispiriting urban environment. Painters, novelists and designers all complained about the poor quality of products, the lack of individualism and the shabby standard of living that had been brought about by the new factory system.

191 Luke Fildes, *Applicants for Admission to a Casual Ward*. Oil on canvas, 1874. Royal Holloway and Bedford New College.

PATRONAGE

The industrial boom of the nineteenth century was the catalyst for substantial artistic and architectural patronage, as entrepreneurs began to spend their new fortunes. One of the most successful was Sir William Armstrong, a Newcastle engineer and armaments manufacturer, who asked Norman Shaw to design him a country house, set in extensive grounds, at Cragside, that reflected the vernacular architecture of England. By contrast, the 3rd Marquess of Bute, who benefited from the industrial development of his estates in Wales, including docks and several coalfields, employed William Burges to build a fairy-tale castle, on a hill overlooking Cardiff (plate 195). T. E. Plint (1823–61), Leeds stockbroker and Nonconformist, took a more level-headed approach and used commissions to reinforce his personal values of hard work and religious faith. When Plint asked Ford Madox Brown to paint *Work* (plate 196), he insisted that the picture should

include a girl distributing religious pamphlets. Others were more interested in aesthetic effect, like Alexander Ionides, a Greek emigré and successful stockbroker, who commissioned an ostentatious piano from Morris & Co. as part of a decorative scheme for his house at 1 Holland Park, London. Frederick Leyland (1831–92), the millionaire Liverpool shipowner, who also prospered through his involvement in telephone and electric lighting companies, similarly hoped to impress his guests by inviting James Whistler to create dramatic interiors for his London home. Many patrons bequeathed their paintings to public institutions, in an attempt to memorialise their own taste and munificence. Robert Vernon (1774–1849) built up his fortune as a stable owner, and spent £150,000 of it on paintings by modern British artists which he then gave to the nation. His collection, including fine works by Turner, is now held at the Tate Gallery.

192 Richard Norman Shaw, *South-West Prospect: Design for Cragside*. Pen and ink, 1872. National Monuments Record.

193 James Abbott McNeill Whistler, *Three Figures: Pink and Grey*. Oil on canvas, 1868–78. Tate Gallery © 2001.

194 Grand piano, designed by Sir Edward Burne-Jones, and decorated by Kate Faulkner, made by Broadwood. Oak with gesso, 1884–5. V&A: W.43–1926.

195 William Burges, turret bedroom, Castell Coch. Built 1875–81. National Trust.

THE INDUSTRIAL ENVIRONMENT

So what were the conditions of the industrial worker, and how did Victorian artists deal with them? The most startling shift was the growth of the cities. Engels calculated that the population of Birmingham had grown from 73,000 in 1801 to 200,000 in 1844.[11] He described the development of the cotton-spinning centres of Lancashire, which converted the region from 'an obscure, ill-cultivated swamp into a busy lively region, multiplying its population tenfold in eighty years' and the phenomenal increase in the size of Glasgow, 'from 30,000 to 300,000' inhabitants.[12] This movement of the workforce to the steam-powered factories broke up traditional relationships. 'Before the introduction of machinery, the spinning and weaving of raw materials was carried on in the working man's home. Wife and daughter spun the yarn that the father wove.' If he was fortunate, the weaver could invest in 'a little piece of land, that he cultivated in his leisure hours'.[13] Once the textile labourer had moved into the town, the conditions of the factory affected the family: 'Women often return to the mill three or four days after confinement, leaving the baby of course . . . a similar dissolution of the family is brought about by the employment of the children.'[14]

Of course, Engels was presenting an image of the lumpen proletariat for political purposes. His vision of a dislocated workforce was powerful, but did overstate the case. However his work, and the writings of other early Victorian critics of the industrial environment, notably Thomas Carlyle in *Past and Present* (1843), had a profound impact on their contemporaries. William Morris and Walter Crane were only two of the artists and designers who responded by embracing socialism.

Novelists were also influential in developing a critical vision of industrialised Britiain. The claustrophobia and gloom of the new cities was memorably evoked by Charles Dickens, especially in his descriptions of Coketown, with its 'high chimneys and the long tracts of smoke'.[15] The industrial heart of the town was an 'innermost fortification . . . where Nature was as strongly bricked out as killing airs and gases were bricked in; [a] labyrinth of narrow courts upon courts, and close streets upon streets.'[16] Throughout *Hard Times*, the inflexibility of the factory system was contrasted with the ideals of Nature and emotion. The harmful effect of the mills and their machinery was most impressively seen on a summer day when 'there was a stifling smell of hot oil everywhere. The steam-engines shone with it . . . The measured motion of their shadows on the walls, was all the substitute Coketown had to show for the shadows of rustling woods.'[17]

Mrs Gaskell, in her novel, *North and South*, was also quick to point out the unnatural miseries of factory labour, by focusing on its impact on the struggling families of the workers. However, she was equally aware of the difficulties faced by agricultural labourers at the same time, and presented a gloomy choice. For the farm-worker: 'There is very hard bodily labour to be gone through, with very little food to give strength . . . an old man gets racked with rheumatism and bent and withered before his time; yet he must work all the same, or else go to the workhouse.' However, the mill hand would still be glad to work 'away from the endless, endless noise and sickening heat'. [18]

In many nineteenth-century novels, the plight of the worker, whether in the city or the

country, was made worse by the introduction of modern technology. The steam-driven threshing machine which invaded Thomas Hardy's nostalgic view of Wessex was tended by an engineer who 'was in the agricultural world but not of it', a man displaced from his northern roots.[19] The reader becomes only too aware of the damage done to *Tess of the D'Urbevilles* by her toil on this machine. 'The ceaselessness of the work . . . tried her so severely',[20] that by the end of the day, 'the incessant quivering, in which every fibre of her frame participated, had thrown her into a stupefied reverie.'[21] In this state, she found herself at the mercy of Hardy's villain, Alec.

It was not only the working environment that had deteriorated. The end product also seemed to have suffered from the advent of industry. Engels recorded a litany of abuses. The change from woollen to cotton clothes among the workers was only one problem: 'The heavy cotton goods . . . afford much less protection against cold and wet, [and] remain damp much longer.' He also described how: 'The refuse of soap-boiling establishments . . . is sold as sugar . . . Cocoa is often adulterated with fine brown earth and chalk is mixed with flour.'[22]

Even at the higher end of the market, the introduction of new methods and materials in many cases only increased the ugliness of the products. Dickens satirised the over-blown decoration of the rising classes in his description of Mr Podsnap's drawing room, with its 'swarthy giants of looking glasses' and 'a corpulent straddling epergne [centrepiece], blotched all over as if it had broken out in an eruption rather than been ornamented'.[23]

Above all, it was the repetitive nature of the work, the enforced pace of the steam engines, which was most deplored by commentators. This point was reinforced by Engels in his analysis of *The Condition of the Working Class in England* (1846). His researches in Manchester and other industrial cities came to the conclusion that: 'In most branches, the worker's activity is reduced to some paltry, purely mechanical manipulation, repeated minute after minute, unchanged year after year. How much human feeling, what abilities can a man retain in his thirtieth year, who has made needle points, or filed toothed wheels twelve hours every day from his early childhood?'[24]

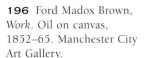

196 Ford Madox Brown, *Work*. Oil on canvas, 1852–65. Manchester City Art Gallery.

Many artists and designers felt compelled to react against these conditions of labour, and the products which they created. Some turned away from the realities of their environment, into fantasy worlds of the past. Others attempted to redefine the relationship between a workman and his product. In each case, there was an emphasis on a pre-industrial idyll, which focused on the Middle Ages, and elevated nature over the machine.

RUSKIN AND THE GOTHIC REVIVAL

John Ruskin (1819–1900) was the inspiration for both approaches. Although nominally an art critic, his vision encompassed political economy and morality. He thundered his opinions like an Old Testament prophet, and his word was enough to make or break an artist's career; he championed both J. M. W. Turner and the young Pre-Raphaelites (plate 197). They took up his challenge to work directly from nature, on the understanding that the natural world was the direct revelation of the divine Creator. Ruskin's influential study of *Modern Painters* (1843–60) began with the injunction that: 'Every alteration in the features of Nature has its origins in powerless indolence or blind audacity.'[25]

These young artists were also encouraged by him to consider medieval subjects, and especially the example of Gothic architecture. In his analysis of *The Stones of Venice* (vol. 1 published 1851 and vol. 2 1853), Ruskin established his most characteristic argument: the free worker produces the art of the highest quality. He praised the Gothic, as he believed it expressed this freedom in its 'perpetual change both in design and execution',[26] and for 'a sort of roughness and largeness and nonchalance, mixed in places with . . . exquisite tenderness'.[27]

In the 1860s Ruskin began directly to attack modern methods of manufacture. He deplored the division of labour created by the factory system, and the poverty of the urban workforce. He launched his tirade in his 1864 lectures published as *The Crown of Wild Olive*. He lamented: 'Our cities are a wilderness of spinning wheels, instead of palaces; yet the people have not clothes. We have blackened every leaf of English greenwood with ashes, and the people die of cold; our harbours are a forest of merchant ships, and the people die of hunger.'[28] Artists rallied behind Ruskin, and began their own offensive against the ravages of technology.

Some sought redress in the example of the past. Medieval subjects had attracted painters and patrons since the early years of the century, thanks to the popularity of Sir Walter Scott's novels, but now they had an added moral justification. They represented a time when craftsmen were free to explore their materials, and the workers responded to the cycles of nature. These images were also a reflection of an age of faith, when compared to the irreligion of the nineteenth-century urban masses. Medievalism in its most popular form was found in Tennyson's reinterpretations of the tales of Arthur for a Victorian audience. Tennyson also focused attention on Shakespeare's melancholic heroine Mariana (plate 198). Millais, always attuned to the mood of the moment, painted her in an ornate domestic interior, complete with pre-Reformation ecclesiastical accessories of altarpiece and votive lamp. The combination of religion and nature, which characterised the Gothic in the Victorian imagination, were juxtaposed in Millais's picture:

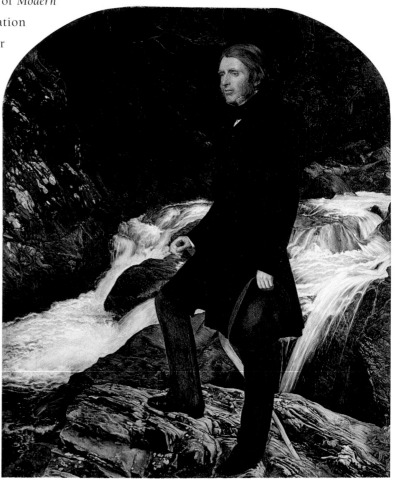

197 John Everett Millais, *John Ruskin at the Waterfall*. Oil on canvas, 1853–4. Tate Gallery © 2001.

198 John Everett Millais, *Mariana in the Moated Grange*. Detail. Oil on canvas, 1850–1. Tate Gallery © 2001.

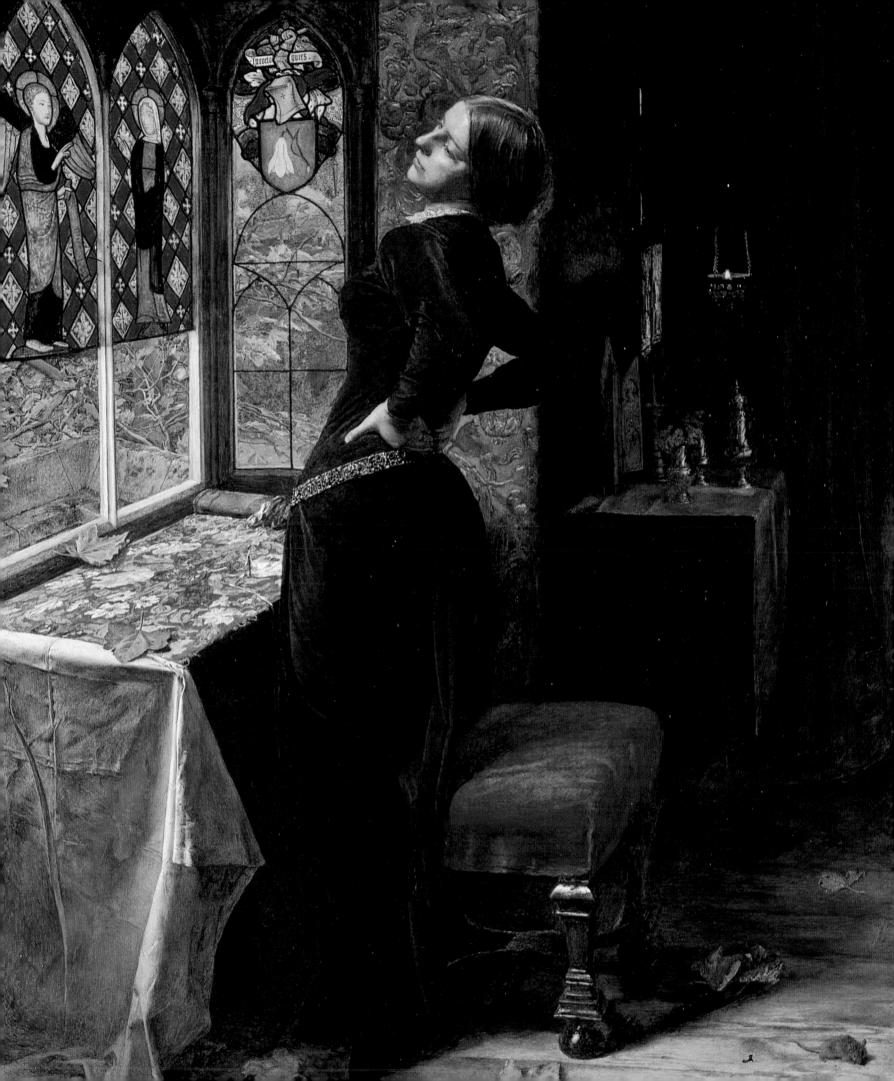

Mariana is embroidering the pattern of fallen leaves, by the light of a stained-glass window, which depicts the Annunciation. The studied unreality of this image found a ready buyer in B. G. Windus, a coachbuilder and medicine manufacturer.

The medieval impulse was felt as much by the Establishment as by entrepreneurial newcomers. In appropriating the costume of Edward III and Queen Phillippa for their Bal Costumé in 1842 (plate 10), Queen Victoria and the Prince Consort were reinforcing the stability of the monarchy in rapidly changing times. It was a mixture of escapism and historical good sense. But in each case, the trappings of medievalism were an attempt to deflect the realities of an urban industrial society.

For some artists, the Middle Ages were just a starting point for their imaginations. Edward Burne-Jones, for example, transformed the motifs of the medieval by mixing in elements from classical art, reflecting a refined idealism that expressed his distaste for the modern environment. As he explained: 'I love the immaterial. You see it is these things of the soul that are real.'[29] He specialised in representing the meeting points of the spiritual and the real worlds, where the supernatural interacted with the lives of men. As a result, he painted the legends of the Holy Grail, Annunciations and mermaids, deliberately avoiding references to the present. His idealised, imaginary worlds exerted a strong influence on a younger generation of artists and critics who, from the 1870s, congregated to form the Aesthetic movement. Satirised in *Punch* and other magazines as being hopelessly out of touch with the lifestyles of their contemporaries, Aesthetes busied themselves with creating a harmonious domestic environment, and enjoying the beauties of art, whether it be a Whistler *Nocturne* or an Oriental pot (plate 199). They drifted away from Ruskin's search for morality in art, refusing to draw lessons from what they saw. 'Not the fruit of experience, but experience itself',[30] was the self-indulgent motto they found in Walter Pater's *Studies in the History of the Renaissance* (1873), the Aesthete's primary text.

THE ARTS AND CRAFTS MOVEMENT

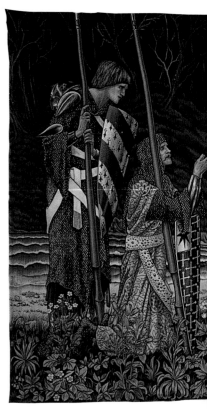

Burne-Jones found some of their flights of fancy hard to justify. He preferred to ally himself with an allegedly more practical response to the problems raised by the new technologies. In 1861, with a group of friends including William Morris and D. G. Rossetti, he formed a design studio for the decorative arts. They were embracing the challenge of the third approach outlined at the start of this essay. Their idea was to break down the barriers between designer and maker that had been created by the mechanised factory system. Inspired by Ruskin's vision of the medieval guild workshops, they designed textiles, tiles, stained glass and furniture for ecclesiastical and domestic use. Their intention was for the designer to oversee the creation of his product in co-operation with the workers, or, even better, for him to make the product himself. Morris felt strongly that a designer should thoroughly understand the manufacturing processes, adapting his

199 Alfred Concanen,
Quite Too Utterly Utter.
Song sheet,
colour lithograph, 1881.
V&A: S.34–1993.

ideas to the needs of the materials. He preached a 'hands-on' approach, and threw his considerable energy into perfecting the dyeing and weaving techniques for his textiles.

However, the ideal relationship between worker and object could not always be put into practice by Morris & Co. Many of their products were manufactured by other commercial firms, including the wallpaper made to Morris's designs by Jeffrey & Co. The printing blocks were also cut by another company, Barrett's. Morris personally kept a close eye on the quality of the products that were being turned out, but he could not guarantee the conditions of the workforces who made up the wallpaper to his specification.

From the outset, Morris & Co. had also run its own workshops. They initially specialised in stained glass, and expanded to manufacture textiles and other products. When the factory was moved to Merton Abbey in 1881 the workforce was able to enjoy light and spacious working conditions in a semi-rural setting. They were paid more than the going rate for their labour, and some of the more experienced staff were able to share in the profits. But the tapestry weaving and carpet making were still tedious jobs, and the workers had to keep closely to the designs provided by Burne-Jones or Henry Dearle (plate 200). They were rarely able to improvise, since the details of the product were carefully overseen. More significantly, the textiles which they were creating were so labour-intensive, that they could never find their way into the humble homes which Morris and his colleagues had hoped to beautify.

200 Detail from *The Attainment: The Vision of the Holy Grail to Sir Galahad, Sir Bors and Sir Perceval.* Tapestry from *Holy Grail* series, designed by Edward Burne-Jones, William Morris and Henry Dearle; woven at Merton Abbey by Martin, Taylor, Sleath, Ellis, Knight and Keach, 1890–94. Private collection.

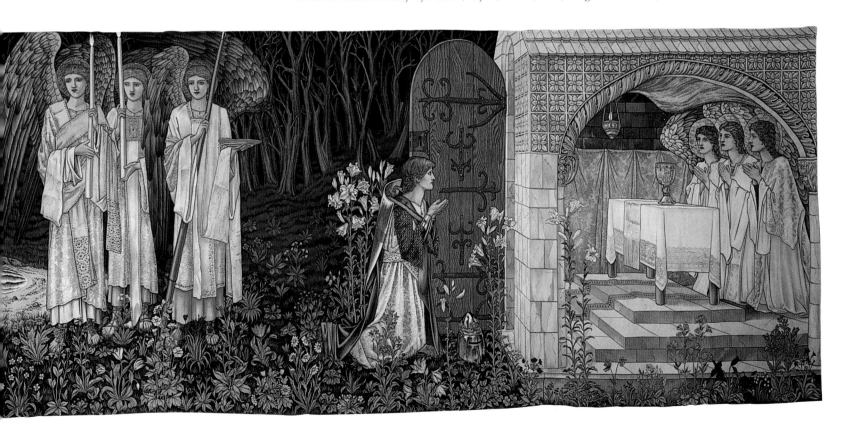

Morris & Co. also had an ambivalent attitude to the use of new technology. Although they refused to work with modern chemical dyes in their textile production, and only designed two machine-printed wallpapers, the firm was prepared to use photography in its design process. Even products which were most consciously harking back to the Middle Ages, like the tapestries, were created using photographic enlargements of original drawings. These helped the workers remain true to the imagination of the designer. Similarly, the typefaces and illustrations for the Kelmscott Press books were checked and adapted using photographic prints. In his writings Morris elevated the status of handwork, but he was prepared to use industrial methods to relieve the monotony or physical exertion of some tasks. He insisted on machines being used only where absolutely necessary, believing that 'it is allowing machines to be our masters and not our servants that so injures the beauty of life nowadays'.[31]

The writings of Ruskin, and the example of Morris & Co. encouraged a younger generation of artists and designers to develop alternatives to industrial production. C. R. Ashbee founded the School and Guild of Handicraft in the East End of London in 1888, in an attempt to bring hope to underprivileged lads by training them in design and craftwork. Yet again, the example of the Middle Ages was invoked in the references to a guild system of apprentices and master-craftsmen. And again, following Ruskin's principles, the ideal of nature was held up against the horrors of urban industry; Ashbee took this to its ultimate conclusion by moving his entire workforce to Chipping Camden in the Cotswolds in 1902. The Guild of Handicraft, which specialised in metal-work and furniture, was never really a commercial success, unlike Morris & Co. which had opened an Oxford Street shop in 1877, and another in the industrial heartland of Manchester in 1883.

Morris and Ashbee were both professional designers, hoping to create a sustainable alternative to industrial production. However, most of their wares were too expensive for the average worker, although Morris was prepared to make suggestions for furnishing a model workers' cottage, to be displayed in the newly opened Art Gallery in Queen's Park, Manchester (1884). More realistic attempts to improve the taste and environment of the lower classes came from the Home Arts and Industries Association. Founded in 1884, this Association organised classes in London and the provinces, enabling workers to try their hand at a range of crafts. Wood and metalwork were particularly popular. The classes encouraged productive leisure, or offered another source of income, especially for women. Their regular exhibitions, and those of the Arts and Crafts Exhibition Society, showed how far the gospel of fulfilment through decorative artwork had spread by the end of the century.

There was another measure of the success of Arts and Crafts methods, which was less welcome. The distinctive style of hammered metals and chunky furniture was being deliberately imitated by mainstream manufacturers. The Morris 'look' was reproduced in department store catalogues (plate 201), so that the aspiring middle classes could furnish their homes in a fashionable style, but without having to pay for the hand-made versions. So Ruskin's ethical structure, which stated that pleasurable labour created popular art, had been utterly undermined by commercial realities. Factories found it profitable to turn out metalwares that looked as if they had been hand-beaten, but were in fact produced by machine. Most worryingly, the customers did not seem to mind.

201 C. H. B. Quennell,
*The 'St Ives' Set of Plain Oak
Furniture.* Illustration from
Heal & Son catalogue, 1898.

COMPLETE BED ≈ ROOM·FURNISHERS. HEAL & SON N.º 195·196·197·198 TOTTENHAM·COURT·R.ᵈ

THE "S.ᵗ IVES" SET OF PLAIN OAK FURNITURE WITH DULL STEEL HINGES AND HANDLES: SOUND CONSTRUCTION ☒ INEXPENSIVE.

This attitude came as no surprise to William Morris. By the late 1880s, he had come to realise that even a radical transformation in the arts could not change the fundamental problems faced by the urban masses. When in 1887 Ashbee asked Morris to give his blessing to the Guild of Handicraft, he showed little interest in the project, since it did not address the underlying political and economic realities of Victorian Britain. Morris explained to his fellow Socialist, Andreas Scheu, in 1883, that in his view 'art cannot have a real life and growth under the present system of commercialism and profit-mongering'.[32] But many of his fellow artists had benefited from the Victorian commercial spirit, with its new markets and lavish rewards, and they were not likely to favour a return to some ideal past, however much they may have relied on it for their subject matter. They were willing to appropriate medieval images for their successful paintings or sculpture, but they used modern methods to put their images before the public. Through posters, books, magazines and photographs, art was now accessible to a mass audience. Department stores and art galleries allowed the public to browse, offering a range of styles from the past and the present. These consumers of art had a wealth of options laid out before them, as never before. Any artist versatile enough to reflect their anxieties and hopes, and who could effectively manipulate the new media, was destined to become a rich man. So, when Millais died in 1896, he was able to leave nearly £100,000 to his family, proving that modern art promoted by modern methods could bring handsome rewards.

VICTORIAN STYLES

The Great Exhibition of 1851 was a showcase for the eclectic tastes of the Victorian public. Pugin's Medieval Court was filled with household objects covered with pointed arches, which could give an air of historical respectability to the most nouveau-riche mantelpiece. The same was true of the classical and renaissance motifs which adorned many domestic objects. The influence of France was felt in the gilded and curvaceous furniture and ceramics favoured by the queen. This highly decorative look also began to merge with a rampant naturalism, where ferns, flowers and tendrils jostled for position, as popular interest in natural history and exploration grew. Over the next thirty years, the development of Britain as a trading power was reflected

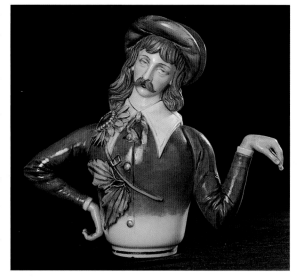

in the introduction of new style options. Middle Eastern, Indian and Japanese goods were imported and sold, initially in fashionable bazaars such as Liberty's. Orientalism found its way into more humble homes, in the design of British-made tableware and in the printed cottons brought over from India. Many of these ornamental alternatives were adapted to modern manufacturing techniques. However, one distinctive style emerged in the second half of Victoria's reign that attempted to side-step contemporary industrialism. Arts and Crafts makers explored traditional working methods and vernacular sources, but towards the end of the century, even this anti-industrial style was appropriated and mass-produced in less expensive forms for the ever-expanding middle-class market.

202 Satire of the Aesthetic movement: glazed porcelain teapot, 1882. Designed by James Handley. Museum of Worcester Porcelain.

203 Gothic: silver teapot, 1830–31. Designed by John Wrangham and William Moulson for Lambeth & Rowlings of Coventry Street. V&A: Circ. 269–1963.

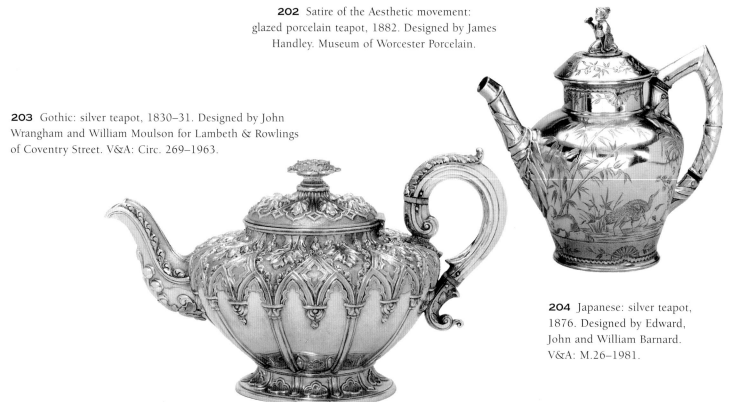

204 Japanese: silver teapot, 1876. Designed by Edward, John and William Barnard. V&A: M.26–1981.

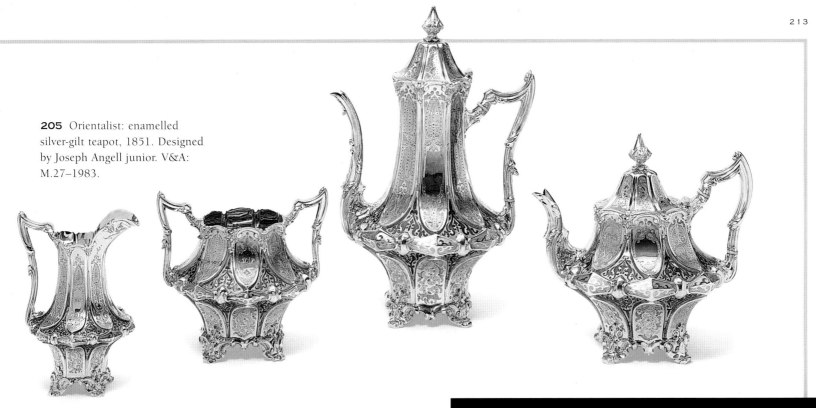

205 Orientalist: enamelled silver-gilt teapot, 1851. Designed by Joseph Angell junior. V&A: M.27–1983.

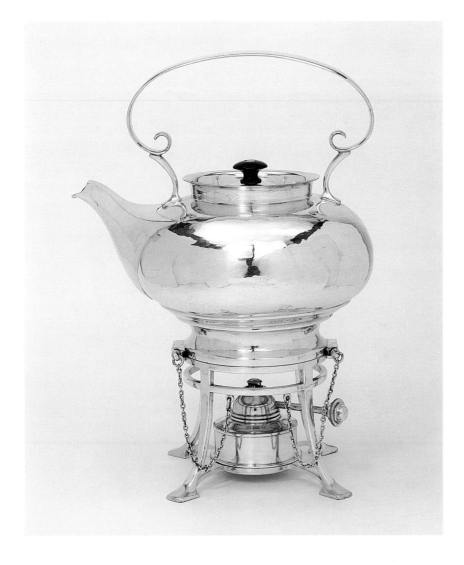

207 French: Spode, porcelain teapot, early 19th century. V&A: 553C&D–1902.

206 Arts and Crafts: kettle, stand and spirit burner, electroplate, c.1905. Designed by Arthur Dixon for the Birmingham Guild of Handicraft. V&A: Circ.341-B–1945.

IMAGES AND IMPRESSIONS:

Printing, Reproduction and Photography

JAMES RYAN

 It is often assumed that modern graphic technology and mass communication were children of the twentieth century. However, much evidence points to the Victorian period as the one that witnessed the arrival of mass visual culture. A massively expanded and transformed printing industry, together with new technologies of reporting and reproduction, notably photography, were crucial to this process. Increases in population, economic expansion, technological advances and communication improvements characteristic of Britain's Industrial Revolution each contributed to the social, political and economic climate for the expansion of printing and the development of new media such as photography.

Major changes were well underway in the technologies of printing, publishing and engraving when Queen Victoria came to the throne in 1837. These both fuelled and responded to an unprecedented expansion in the circulation and readership of books, newspapers, magazines, and printed ephemera of all kinds. The expanding middle classes and urban dwellers had a new thirst for printed images and texts that reflected their interests and achievements. Advertising and packaging of a widening range of commodities together with the growth of news and propaganda placed new demands upon printers and publishers for large quantities of cheap, mass-produced, good quality and visually appealing printed matter. As the century progressed, the growth of literacy, improvements in education, the increased provision of public libraries and museums, the expansion of science and growth of industry and commerce all fuelled demand for printed material with which to inform, educate, entertain and advertise to both specialist and mass audiences.

208 Lady Hawarden, *Study from Life*. Detail. Albumen print, 1857-64. V&A: Ph.457–1968.

209 Samuel Bourne, *Evening on the Mountains: View from below the Manirung Pass*. Detail. Albumen print, 1866. V&A: 53.099.

The growth of the Victorian press was dramatic. The number of serial publications (magazines, reviews and newspapers) in England and Wales, for example, grew from 129 in 1801 to 4,819 in 1900.[1] Most of this growth occurred after 1850, spurred on by the repeal of newspaper stamp duty in 1855 and excise duty on paper in 1861. This increase of some 37 times is far greater than the growth in population, which increased approximately eightfold in the same period. Paper production in the United Kingdom reflected this growth in printing and population, increasing from 11,000 tons in 1800 to 100,000 tons in 1860 to 652,000 tons in 1900.[2]

To be sure, adapting conventional and well-established processes accommodated much of this expansion in output; printing was, after all, not a new invention. However, technologies of printing and the organisation of printing firms had to evolve in radically new ways to suit a new economic and cultural climate. In 1800 printing was generally a small-scale, hand-operated process, which had changed little over some three centuries. By 1900 printing had developed into a highly complex industry. With the growth and mechanisation of most printing, firms tended towards specialisation as book printers, newspaper printers or jobbing printers, the latter producing posters, pamphlets, playbills and other ephemera. Nevertheless, the basic printing processes of relief (that is, printing from moveable type and woodcuts) and intaglio (that is where the print image is incised into the surface of the plate) both remained important as well as technically and socio-economically distinct into the Victorian era. Although many traditional processes, such as wood-engraving, remained in use many significant developments changed forever the nature of printing production and printed culture.

The relief (or letterpress) printing industry underwent major changes as the wooden printing press gave way to the iron press and, its successors, the platen and cylinder machines. The development of the iron press by Lord Stanhope around 1800 and the many subsequent iron presses which followed in Britain and America, including George Clymer's 'Columbian' (1813) and Richard Cope's 'Albion' press (c.1820), enabled more printing pressure to be delivered over a larger area. Larger sheets of paper and new varieties of typefaces were introduced and elaborated. Letterpress printing, though important in the everyday work of many Victorian printers, had less potential for ornate designs and artistry than intaglio and could not compete, especially after 1880, with chromolithography in the printing of coloured ephemera.

PRINTED VISUAL IMAGERY

One of the hallmarks of the expanded mass culture that emerged in the mid-nineteenth century was its increasingly pictorial character.[3] Until the 1830s the most inexpensive kinds of printed materials available included cheaply sold woodcuts, usually stock images on popular themes of misfortune, love or crime; chapbooks of romances and fairy tales, which tended to use wood-engravings, or the moral imagery of philanthropic and Christian societies. Despite the apparent interest in visual printed material, much was poor in quality and short on variety.

The arrival of the *Penny Magazine* (1832–45) of the Society for the Diffusion of Useful Knowledge in 1832, however, signalled the emergence of a new kind of printing venture. Founded by Charles Knight (1791–1873) the *Penny Magazine* had mass appeal and high visual

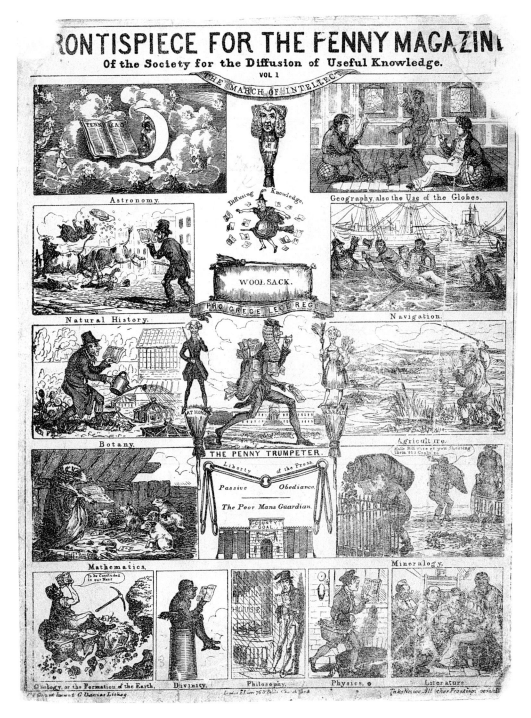

210 Frontispiece of the *Penny Magazine* of the Society for the Diffusion of Useful Knowledge. Wood-engraving, 1832. British Library. The frontispiece of the first volume expresses pictorially the noble aims of this magazine to forward the 'march of intellect' and 'diffusion of knowledge' among all levels of society.

content in the form of wood-engravings. The frontispiece of the first volume expressed pictorially the aims of this magazine (plate 210) to forward the 'march of intellect' among all levels of society. Vignettes showed the *Penny Magazine* diffusing knowledge of 'Divinity' to the chimney sweep, 'Literature' to the sailor and 'Astronomy' to the moon itself.

Wood-engraving such as that used in the *Penny Magazine* became the most popular method of reproducing illustration commercially in the Victorian era. Its popularity originated in the 1770s with Thomas Bewick's (1753–1828) 'white-line' technique in which engravers cut pictures into the surface of a boxwood block with a steel 'burin'. The process, in combination

with new kinds of 'wove' paper, allowed small-scale images with a full range of tones to be printed relatively cheaply along with type. By 1850 wood-engraving had all but taken over from woodcuts, except in the printing of large works such as posters and broadsheets, where the simpler and coarser woodcut image would suffice. As the demand for engravings grew the engraver's role became more specialised to cutting between lines drawn on the block (the 'black-line' technique). Artists often had to rely on engravers' skilful interpretations of their drawings. Artists might also draw directly on to the wood or have their pictures pasted on to the block for the engraver to cut from. By the 1870s designs were frequently photographed on to the wood to ensure greater fidelity and to allow enlargement or reduction. Wood-engraving demanded skill and craftsmanship, even as the process became more closely geared to machine printing. An 1886 wood-engraving from the firm of Ed. Badoureau shows the interior of the firm's workshop with engravers at work preparing boxwood engraving blocks. Despite the skilled nature of their craft, individual engravers were rarely credited for their work; signatures on images usually referred to the firm of engravers and/or the artist.

Although the *Penny Magazine* ceased production in 1845 its use of high quality wood-engravings and general pictorial content stimulated several other imitators and a second generation of pictorial magazines in the 1840s and 1850s. Technological advances by that period allowed relatively low-cost, high-speed mass reproduction of wood-engraved imagery. By 1860 pictorial magazines were highly popular and numerous, appealing to the non-literate as much as to the increasing numbers of literate consumers. Illustrated magazines such as the *London Journal* (1845–1906), *Reynolds's Miscellany* (1846–69), and *Cassell's Illustrated Family Paper* (1853–1932) attracted and maintained circulation figures well into the hundreds of thousands. Moreover, if we assume that each individual circulated magazine was read by up to five people then readership of these magazines extended into the millions.[4] Although such magazines were different in tone to the *Penny Magazine*, being overtly commercial operations appealing more to sensation than instruction, they relied on the use of quality wood-engravings for high pictorial appeal. Themes of education, religion and improvement were also presented alongside those of entertainment and escapism. The success of such publications point to the continuing expansion of a mass consumer culture that had first emerged in the late eighteenth century.[5] Yet the variety of imagery in such publications, ranging from current events to advertising, self-improvement to political protest, suggests that they had appeal across a range of social classes.

The increasing popularity of illustrative printed material is evidenced in the appearance of the world's first illustrated weekly paper, and one of the most successful printing enterprises of the Victorian era, the *Illustrated London News*, launched on 14 May 1842 and advertised in London, in characteristically spectacular style, by 200 sandwichmen. The *Illustrated London News* used wood-engraved illustrations to dramatic effect in its coverage of events at home and abroad (plate 211). However, even when based on photographs, the illustrations and texts of such newspapers and periodicals presented a thoroughly conventional picture of the world; one that distanced its readers from the realities of war, poverty or the struggles of modern urban life. The same might be said of *Punch* (launched July 1841), which used humour and satire in its text and illustrations to similar effect. Illustrated periodicals such as the *Illustrated London News* and daily newspapers

212 *View of the conflagration of the city of Hamburgh.* Wood-engraving, *Illustrated London News*, vol.1, no.1 (14 May 1842). V&A:NAL.

211 Pages of engravings in the *Illustrated London News* (30 May 1857). V&A: PP.10.

were affordable only by the better-off elements of the middle classes or above. However, penny weekly papers emerged in the 1850s and one of the most popular, *Lloyd's Weekly Newspaper*, was illustrated and had a circulation of around 100,000 by 1855.[6]

The first illustration on the front page of the first number of the *Illustrated London News* showed a fire in the city of Hamburg (plate 212). As later writers have noted, the source was an old print of the city copied in the British Museum to which crowds, boats and flames had been added.[7] The use of illustrations of news events in particular was governed less by the need for detailed accuracy and authentic sources than the short time available to find a suitable image to accompany text. Frequently stories would be illustrated with an image modified from a 'stock block'. The same general images, with altered details and captions, could thus accompany a number of different stories.

Wood was not the strongest or most durable printing material and as the quantity and quality of printed material increased new techniques developed to extend the lives of wood-engraving blocks. The development of stereotyping in the 1820s used plaster-of-Paris casting to produce replica printing blocks and was of considerable value to the wood-engraving industry, allowing wood-engravings to endure much longer print runs. Similarly, the development of electrotyping in the 1840s used electro-chemical processes to make type metal replica blocks. Much of the printing of illustrations in the Victorian period was from stereos or electros. Such techniques allowed far greater print-runs to be endured. One writer of 1885 noted that the wood-engravings for the Christmas edition of the *Illustrated London News* of 1882 had generated some 425,000 impressions.[8] As well as longer print-runs, electrotyping and stereotyping allowed greater accumulation of 'stock' blocks of standard engravings, of landscapes, ships, trains, figures and coats of arms, which printers could use for different occasions.

INTAGLIO AND LITHOGRAPHY

Relief printing, despite such technical improvements, was no match in quality with intaglio processes that had traditionally been deployed for more refined printing work. In the early Victorian period more ornate and artistic printing designs where text and images could be more elaborately produced and better integrated, for example on music covers, book plates or business cards, remained beyond the capacity of relief printing and were generally produced through intaglio. Intaglio processes involved printing from metal plates into which the printing image had been cut. The engraver cut the artist's designs into a metal plate (usually copper or, increasingly, from the 1820s, the more durable steel). The printer and inker, invariably separate individuals and distinct from the trade of the engraver, would then warm and ink the plate, cleaning the surface so that ink filled only the engraved incisions. The printer would next use a rolling press to force dampened paper into the engraving to capture the design as well as the imprint of the plate. The process of etching was similar, using a wax-coated plate that, subsequent to the design being drawn into the surface, was treated in acid in order to erode the design into the plate. Many plates combined both engraving and etching.

The period 1830–80 saw the dramatic expansion of the reproductive engravings and, in many instances, a booming trade for publishers, artists and engravers.[9] Much of this expansion was catering to the growth in demand for engravings, particularly of famous landscapes and portraits. Since the late eighteenth century printers attempted to improve the applicability of intaglio to the requirements of artists and to develop techniques of producing more complex imagery with longer print runs. One early development was aquatint, made by the use of resin dust on the etching plate to soften the effects of the acid and produce wider and softer tonal variation in the image. The technique was used particularly for reproducing watercolour paintings and although very successfully used in the early nineteenth century it was not commonly used in commercial work in the Victorian period. Indeed, although copper and steel-plate engraving remained important for the reproduction of works of art throughout the Victorian period, intaglio remained a craft technology, being the slowest area of printing to be mechanised, and never offered serious competition with letterpress or lithographic printing.

By the 1850s intaglio processes were rapidly being superseded by lithography, after photography the major graphic invention of the nineteenth century. Invented by Alois Senefelder and brought to England in 1800, lithography involved the drawing on limestone with greasy ink. The stone was dampened and water settled on the unmarked parts. The stone was then inked, the ink settling on the design but being repelled by the unmarked, dampened areas. Finally paper was applied and the stone run through a press, printing the design. Later developments saw the replacing of stone with grained aluminum or zinc allowing flexible plates to be made into cylinders for the rotary press.

Many early lithographs were hand-coloured. The pioneering English lithographer Charles Joseph Hullmandel (1789–1850) patented a 'lithotint' that emulated the effect of watercolour washes by printing a small range of dilute colours. Louis Haghe used his technique to great effect in reproducing the sketches made by the artist David Roberts (1796–1864) for his five volume *The Holy Land, Syria, Idumea, Arabia, Egypt and Nubia*, 1842–49 (plate 213). Roberts's volumes, published by subscription, were the result of his travels in Egypt and the Holy Land where, attracted by the contemporary romance of the Nile and landscapes of the Bible, he sketched picturesque views of monuments and ruins. Although these coloured lithographs were available only to the wealthy patrons, including Queen Victoria who subscribed to Roberts's work, colour printing in general was fast becoming available to a far wider audience.

213 Louis Haghe after David Roberts, *Tombs of the Khalifs, Cairo*. Lithotint from *Egypt and Nubia*, vol.2, (London, 1849). V&A: L.645–1920.

Colour printing

One of the most remarkable printing innovations of the Victorian period was the development of cheap colour printing. Indeed, it was the most popular of the printing attractions at the Great Exhibition of 1851. Demand was stimulated by a number of factors including the Gothic Revival and associated interest in medieval art. Books on colour such as William Savage's (1770–1843) *Practical Hints on Decorative Printing* (1822) and M. E. Chevreul's *The Principles of Harmony and Contrast in Colour, and their Applications to the Arts* (first published in France in 1839 and translated into English in 1854) were also important. Interest in colour printing was also encouraged by the growth of publications of science. Publications catering to the widespread interest in natural history by well-known authors such as P. H. Gosse's, *The Aquarium* (1854), and printers such as Benjamin Fawcett, were especially appealing in their depiction of the natural world in colour.

By the 1850s relatively inexpensive full-colour images had become available. For the more specialised and short-run visual productions, including aquatints, lithographs and some photographs, traditional hand-colouring remained the order of the day, but in the production of longer-run and inexpensive imagery there was much competition to refine processes for printing colour images.

In 1838 Charles Knight, the influential publisher and founder of the *Penny Magazine*, patented a wood relief colour process he termed 'illuminated printing', which he used with some success on publications such as his *Old England* (1844–5). In 1835 George Baxter (1804–67) patented a more commercially successful process that used ten or more woodblocks, one for each colour, to print on a toned outline produced by aquatint. Printers such as J. M. Kronheim, Leighton Brothers, Benjamin Fawcett and Edmund Evans exploited and adapted the process to produce good quality and relatively inexpensive colour illustrations, notably in books.

Besides colour wood-engraving the other main method of colour printing in the Victorian period was chromolithography. This was a process of full-colour lithography, patented by Godefroi Englemann in France in 1837 and adapted by printers in Britain. Many lithographic printers turned to chromolithography in their eagerness to supply the market for greeting cards, Sunday school texts and other kinds of cheap colour ephemera. The rise of branded goods and the growth of advertising in the 1870s, 1880s and 1890s were a great stimulus to chromolithography printers. New forms of commercial novelty advertising, such as the pictorial trade card, relied on the visual appeal of coloured pictures to sell products to new consumers. Chromolithography was also widely used in the printing of colour advertising posters. Such processes allowed, for example, the famous conversion of John Millais's 1886 painting *Bubbles*, by its owner T. J. Barratt, the proprietor of Pears' soap, into an advertisement for the product. Contemporary paintings, prints and photographs, particularly of major cities like London, occasionally show the effect of billposting on the urban landscape (plate 217). As commerce grew and printing sought to keep up, advertising posters grew in size, in their use of colour and in the use of large, eye-catching typefaces. Victorian print culture, from the street poster to the book illustration, was thus often both spectacular and colourful.

PHOTOGRAPHY

Whilst colour printing was certainly one of the most remarkable innovations of the Victorian era, perhaps the greatest graphic invention was a technology principally of monochrome reproduction: photography. Authors of contemporary photography manuals placed the 'art-science' of photography on a par with the steamship and telegraph as one of the wonders of the age. Photography, from the Greek words *photos* (light) and *graphy* (drawing), became a vital ingredient and witness of the Victorian culture of spectacle.[10] A. R. Wallace, author of *The Wonderful Century*, noted how the application of the sciences of chemistry and optics to the making of pictures 'belongs wholly to our time'.[11] To many Victorians photography presented a perfect marriage between science and art, a technical procedure of optics and chemistry that enabled nature to record herself with truth and exactitude. Although a new form of representation, photography relied upon well-established aesthetic and pictorial conventions, such as perspective realism, much of which it inherited from painting.[12] Nevertheless, photography offered Victorians a new kind of visual sensibility. Moreover, Victorians understood and marvelled at their experience of this modern vision. The photographer John Thomson claimed in a lecture on photography and exploration to the British Association in 1891: 'Where truth and all that is abiding are concerned, photography is absolutely trustworthy, and the work now being done is a forecast of a future of great usefulness in every branch of science . . . We are now making history and the sun picture supplies the means of passing down a record of what we are, and what we have achieved in this nineteenth century of our progress.'[13]

When Queen Victoria came to the throne in 1837, the term 'photography' had not yet been coined and its technical operations were almost wholly unknown. However in the previous two years Louis-Jaques-Mande Daguerre (1787–1851) working in France and Henry Fox Talbot (1800–1877), working in England, had managed independently to preserve permanently pictures of the camera obscura, a device used as an aid to drawing since at least the Renaissance. The sensitivity of silver salts to light had been known of since at least 1725. However it was not until the efforts of Daguerre, Talbot and Niepce – Daguerre's partner and the closest to the title of 'inventor' of photography – that knowledge of optics and chemistry was brought together in a desire to fix the images of the camera obscura. In January 1839, within three weeks of one another, Daguerre and Talbot made public news of their discoveries.

Early photographic techniques were extremely complex. Daguerre's process relied upon the use of an opaque metal surface upon which a one-off and rather fragile image was produced. Talbot's 'calotype' process, by contrast, made paper negatives from which any number of positive paper prints could be generated. Whilst calotype prints could be mounted in frames or albums, daguerreotypes were more fragile objects and were protected from oxidation and fingerprints by sealed glass covers and protective cases. Over the next few years their discoveries were im-proved upon by others and by 1842 a range of people besides their inventors were making 'daguerreotypes' and 'calotypes', although it was not until the late 1840s that reliable results were achieved from each process. Early photographic enterprise, particularly in England, was also hindered by the patent restrictions that existed on the processes. The pace of development quickened in 1851, the year of the Great Exhibition, when Fox Talbot released his patent on the

DEVELOPMENT OF COLOUR PRINTING

214 Kate Greenaway, Valentine card from *The Quiver of Love*, edited by W. J. Loftie (London, 1876). Chromolithograph. V&A:NAL.

Chromolithography became the primary process for jobbing printing in the later Victorian period. This is one of a collection of Greenaway's valentine cards produced for the Belfast-based chromolithographers Marcus Ward & Co., which were republished in a book with illustrations by Walter Crane. Greenaway was soon to earn much wider recognition as an illustrator of children's books.

215 'Zenobia', from *The Pictorial Album, or Cabinet of Paintings* (Chapman & Hall, London, 1837). Coloured wood-blocks on a steel engraving after a painting by William Pickersgill RA. Printed by George Baxter. British Library.

In 1835 George Baxter patented a process that overprinted an intaglio-printed outline with a series of finely engraved wood-blocks, each one with a different colour. Baxter's process used conventional equipment but remained an expensive means of colour printing and tended to be restricted to book illustrations or specialist prints. Printers like J. M. Kronheim and Edmund Evans developed the process to produce good quality and relatively inexpensive colour illustrations.

216 H. J. Mackinder, 'A Journey to the summit of Mount Kenya, British East Africa', *The Geographical Journal*, vol. 15, no. 5 (1900), pp. 453–86. Royal Geographical Society, London.

Journals of geography and geology were quick to employ colour illustrations and maps. *The Geographical Journal* was also an early user of half-tone processes to print photographs.

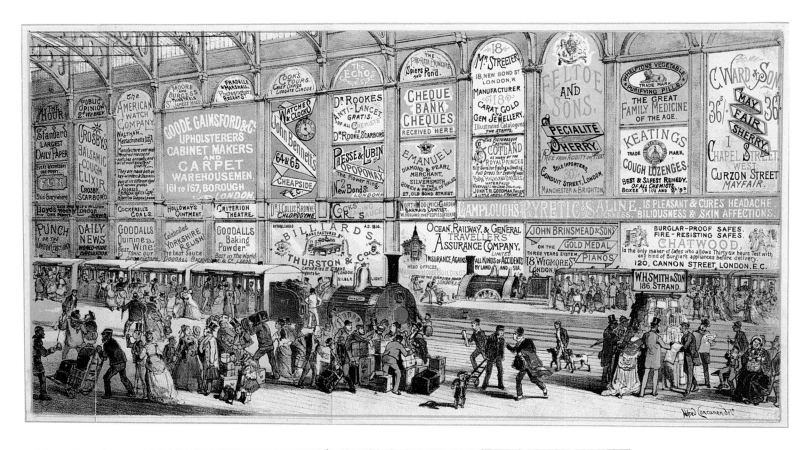

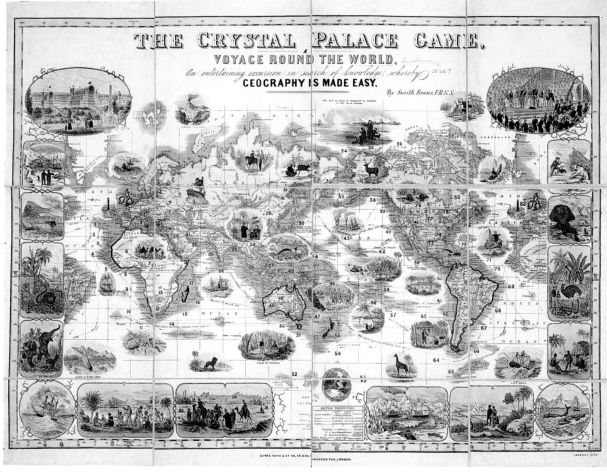

217 Alfred Concanen, *Modern Advertising: A Railway Station in 1874*. Lithograph in five colours, printed by Stannard & Son. Fold out frontispiece to H. Sampson, *A History of Advertising from the Earliest Times* (London, 1874). British Library. Alfred Concanen was a leading illustrator of music covers.

218 Smith Evans, *The Crystal Palace Game*, c.1854, Alfred Davis & Co. London. The British Library. This early example of a coloured map made by chromolithography was produced to appeal to audiences excited by the recent Great Exhibition.

calotype process, and following Frederick Scott Archer's invention of the 'wet plate' or 'collodion' process, which used glass plates coated in collodion (produced by dissolving gun cotton in ether mixed with potassium iodide) and sensitised in a bath of silver nitrate. Although a tricky process involving the sensitising, exposing, washing and fixing of the negative plate all in quick succession, the wet-plate process reduced exposure times dramatically and, like Fox Talbot's earlier process, allowed for the generation of multiple paper copies. By mid-century photography had acquired solid enough technical foundations to support a period of unprecedented expansion.

PROFESSIONAL PHOTOGRAPHY:
PORTRAITURE, STEREOSCOPES AND CARTES-DE-VISITE

As a profession photography grew massively from 1850. In the census of 1841 photography did not appear as a profession. The census a decade later recorded 51 photographers. By 1861 the number had risen dramatically to 2,879.[14] Much early commercial photography concentrated on portraiture. For example, the numbers of portrait establishments in London grew from 12 in 1851 to 66 in 1855 and over 200 in 1861. By 1860 'glasshouses', so called because of the designs allowing maximum use of daylight, had become a novel feature of the London skyline.[15]

The first public photographic studio in Europe was opened by Richard Beard at the Royal Polytechnic institution in London in March 1841. Beard, a coal merchant and inventor, had succeeded in reducing to a few minutes, depending on the amount of daylight, the exposure time necessary to make daguerreotypes. Beard's major competitor was Antoine Claudet, ultimately the most successful daguerreotypist in London in the 1840s. Claudet photographed all the major figures of the day including Daguerre himself (1846) and the Duke of Wellington (1845) – the latter in the only photograph for which he ever sat. In 1853 Claudet was invited to take portraits of Queen Victoria and other members of the royal family, leading to his appointment as Photographer-in-Ordinary to the Queen. Claudet was also the first to apply photography to the stereoscope and made a large number of stereoscopic daguerreotypes. One such image was a genre study *The Geography Lesson* (1851; plate 219) which restaged earlier studies of teachers and children. The figures were arranged in a pyramid-like structure, reflecting social hierarchies of the day with the adult male placed at the top, and focused on the sources of geography, the globe, the book and the photograph album. The inclusion of the latter was a careful reference to the ability of photography to bring home the wonders of the world.

The idea and technical wherewithal for making visual imagery that, when viewed stereoscopically, appeared to be three-dimensional, had existed for some three decades. However, it was not until the mid 1850s, stimulated by Archer's invention of the collodion process, Queen Victoria's interest in the stereoscope and the efforts of such individuals as Claudet, that the device was exploited commercially. In 1854 the London Stereoscopic Company was formed and within two years was selling a 'stereoscope for the million' at 2s. 6d. By 1858 the firm listed a stock of over 100,000 views of landscapes, monuments and people from around the world, and made its motto 'no home without a stereoscope'. With its staff photographers dispatched all over

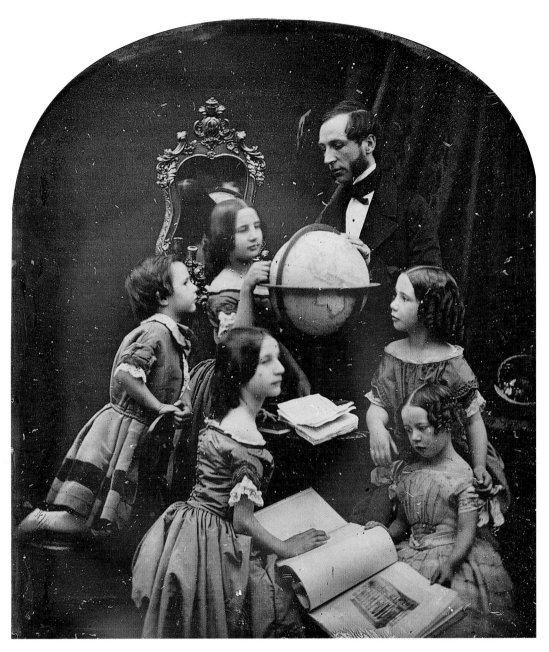

219 Antoine Claudet,
The Geography Lesson.
Stereoscopic daguerreotype,
1851. Gernsheim Collection.

the globe the company brought the world, in all its photographic, three-dimensional-effect splendour, into the homes of the Victorian middle classes. In an age increasingly dominated by positivism, a philosophy based on the realistic apprehension of the natural world, seeing, knowing and possessing were intimately associated. The stereoscope allowed the individual viewer to experience a virtual immersion in the field of view, to experience the sight, knowledge and imaginative control over the scene presented. This experience, at least in the 1860s, was limited to those who could afford the photographs and apparatus. Although stereoscopic views reached huge international audiences in the late 1880s through the commercial activities of American companies such as the Keystone View Company and Underwood & Underwood, the early stereoscopic boom did not extend far beyond the middle-class home and had reached its zenith by 1862.

The enthusiasm for stereoscopic photography was overtaken by another photographic craze, this time for *cartes-de-visite*. So named by the Frenchman Andre Disderi in 1854 who turned them to his great fortune, *cartes-de-visite* were small albumen silver prints pasted on to a card. These were cheap for photographers to mass produce and inexpensive for consumers to collect. Indeed, collecting *cartes* of family and celebrated persons captured the public imagination to such an extent that by 1860 'cartomania' had become an international phenomenon. It is estimated that between three and four hundred million *cartes* were sold annually in England alone at the height of the craze.[16] Many individual *cartes* sold in vast numbers. For instance, W. Downey's 1867 photograph of the Princess of Wales carrying her baby Princess Louise upon her back sold 300,000 copies, making it the most popular photograph then published in Britain.[17] Whilst *cartes* were made from photographs of everything from topographic views to architecture, the majority were portraits. Camille Silvy, a French aristocrat and enthusiastic amateur photographer who gave up his diplomatic career to set up as a portrait photographer, made some of the finest. From his Porchester Terrace house studio Silvy became the most fashionable photographer for those of high rank and wealth.

For many Victorians, the making and display of photographic portraits in general was an exercise in social demarcation, allowing them to project and reflect upon their distinctive position within society. *Cartes-de-visite* allowed their Victorian purchasers to place themselves visually within a complex social world. One novel attempt to express in a single image what many collections of *cartes-de-visite* amounted to was found in 'mosaics', introduced in 1862, which were compiled from a number of individual *cartes* and then rephotographed. An example produced by Ashford Brothers & Co. (c.1865) contains 'upwards of five hundred photographic portraits of the most celebrated personages of the age' prompting the accompanying text to suggest proper examination with a magnifying glass. Such photographs reflect the Victorian concern with social hierarchies and fascination with the rich, famous and high-ranking. The focus of this montage is the queen and Prince Albert, surrounded by the royal family. Indeed, it was the mass-produced *cartes-de-visite* portraits of the queen and her family, notably in the 'Royal Album' produced by the London-based American photographer J. E. Mayall in 1861, which helped start the craze for *cartes* in the first place. Queen Victoria and Prince Albert were influential pioneers and patrons of photography. They bought daguerreotypes as early as 1840, attended the first exhibition of the London Photographic Society in 1854 and set up their own dark room at Windsor Castle. The queen understood the technical procedures of photography and its effectiveness as a vehicle for public display. Indeed, she was the first monarch to be more frequently photographed than painted. An eager collector of royal *cartes-de-visite*, Victoria also used photography to record and popularise the royal family.[18] The first few pages of many Victorian family albums of the period were often given over to portraits of the royal family; the projection of the queen's family as the ideal thus encouraged other families to model themselves and their albums on this image.

Many portrait studios in the early years catered only to the well off. However, following the development of the ambrotype, an adaptation of the collodion process which converted a paper negative image into positive, cheap one-off portraits became available on an unprecedented scale.

One writer in the *Photographic News* of 1861 noted the democratic nature of such mass portraiture:

Photographic portraiture is the best feature of the fine arts for the million that the ingenuity of man has yet devised. It has in this sense swept away many of the illiberal distinctions of rank and wealth, so that the poor man who possesses but a few shillings can command as perfect a lifelike portrait of his wife or child as Sir Thomas Lawrence painted for the most distinguished sovereigns of Europe.[19]

Portrait photographers were soon to be found on almost every street, a ubiquity that led some commentators to question their contribution to the art. As a contributor to the *Photographic News* in 1865 claimed: 'The appetites as well as the vanity of the public are stimulated by the offer of "an eel-pie and your likeness for sixpence".'

Concerns over the vulgarisation of photography were also held by photographers who tried more directly to elevate photography to the higher arts by using the medium to make pictures of scenes from literature, history and art. The watercolour painter, photographer and critic William Lake Price, for example, made some well-known studies of figures from literature including *Don Quixote in His Study* (1855), as well as a series representing the adventures of Robinson Crusoe. Another artist turned photographer, Oscar Gustave Rejlander (1813–75), achieved notoriety with his large allegorical composition *The Two Ways of Life* (1857; plate 220). The 'two ways' facing the central figure in the composition and, by moral implication, the viewer were 'industry' and 'dissipation'. Printed from 37 separate negatives of figures and backgrounds the final image measured some 37 by 16 inches. It was exhibited at the Manchester Art Treasures Exhibition of 1857 where, for the first time and in keeping with Rejlander's ambitions, photographs were exhibited alongside paintings, drawings and engravings. The photograph provoked much controversy at the time for its use of photography to make allegorical pictures as well as for its display of nudity. The Photographic Society of Scotland refused to exhibit the picture. After protests it agreed to show only the side representing 'industry'. However, Queen Victoria (who had no objection to nudity in art) bestowed official approval by buying the print (at a cost of ten guineas) for Prince Albert who hung it in his study.[20]

Rejlander's work was a strong influence on one of the most prolific and influential Victorian writers on 'pictorial' photography, Henry Peach Robinson (1830–1901). Robinson also made some well-known allegorical and historical photographs, including *Fading Away* (1858) showing a dying girl surrounded by her family, which earned him the patronage of Prince Albert, *Lady of Shalott* (1861) and *Bringing Home the May* (1862), each of which he composed from a number of negatives. Many well-established amateur photographers, notably Julia Margaret Cameron (1815–79; plate 130) and Lady Hawarden (d.1865; plate 208), also made pictures that engaged with contemporary themes in literature and painting. 'Artistic' practitioners thus used photography to emulate romantic themes of the 'higher arts'.

(Overleaf) **220** Oscar Gustav Rejlander, *The Two Ways of Life*. Brown carbon print (printed in 1925 from the original collodion negatives of 1857). The Royal Photographic Society, Bath.

NEWS PHOTOGRAPHY

In contrast to such pictorial experiments, it was the capacity of photography for realism that rendered it of value in recording the events and progress of the Victorian age. Photography was soon adopted by both professionals and wealthy amateurs as a means of recording the notable and newsworthy events of the times. As early as 1842 two German photographers, Freidrich Stelzner and Hermann Biow, made a series of daguerreotypes of the immediate aftermath of the Hamburg fire,[21] ironically enough the same event that had featured in the wholly fabricated engraving in the first number of the *Illustrated London News* shortly afterwards (plate 212). Daguerreotypes and early calotypes were plagued by their long exposure times, which made it almost impossible to capture the action of such live, public events. Thus no photographer seems to have attempted to record the opening of the Great Exhibition in May 1851 and an attempt to photograph the Duke of Wellington's funeral on 18 November 1852 ended in failure.

P. H. Delamotte's photograph *Opening Ceremony by Queen Victoria of the Rebuilt Crystal Palace, Sydenham, 10 June 1854* marks an increased interest in recording official events in photographs. It shows the queen, Prince Albert, the King of Portugal and members of the royal family seated on a dais under a canopy. Arranged behind them were three bands and choir who sang the Hallelujah Chorus. Philip Henry Delamotte (1820–89) began his artistic career as an illustrator but took to photography in the late 1840s, taking out a calotype portrait licence from Fox Talbot and working closely with the publisher Joseph Cundall. He showed his skill as a photographer and his interest working with artists and engineers in his best-known work documenting the building of Crystal Palace at Sydenham between 1852 and 1855. This resulted in the two volume *Photographic Views of the Progress of the Crystal Palace Sydenham*, containing 160 photographs, published by Joseph Cundall in 1855. Delamotte, who was one of four photographers at the opening of Crystal Palace in 1854, secured his view during a lull in the proceedings occasioned by the Archbishop of Canterbury's prayer. Though it lacks the colour of contemporary engravings and lithographs, Delamotte's photograph captures the immediacy of a great event.

Following developments in photographic technology in the 1850s, it became easier to secure 'instantaneous' photographs. The photographer Valentine Blanchard (1831–1901) thus managed to secure 'snapshots' of London traffic as early as 1862. In other fields, professional photographers began working in both official and unofficial capacities recording national and international events. Roger Fenton (1819–69) photographed in the Crimea in 1854–5, but his photographs produced a thoroughly sanitised, official record of landscapes and figures for his patron Queen Victoria. The American professional photographer Matthew Brady (1823–96) photographed much of the American Civil War and, as a commercial operator, he was much less hesitant at recording the bloodier realities of conflict. British colonial wars of the second half of the nineteenth century received extensive media coverage. During the Abyssinia Campaign of 1867–8, for example, provision was made for reporters from all the major British newspapers and for the Royal Engineers to photograph the progress of the campaign. Although photographic technology was capable of recording live action it was not given the opportunity to do so. In reporting news the development of photography did not, as might be expected, herald a new era of documentary authenticity. The demands of speed in covering news and conventions of

journalism, engraving and printing ensured that illustrations in newspapers, even when 'taken from a photograph', were fabricated images designed to illustrate the text.

AMATEURS AND POPULAR PHOTOGRAPHY

Notwithstanding the importance of professionals, photography was, at least until the mid-1850s in Britain, dominated by an élite group of amateurs, headed by Henry Fox Talbot. A range of organisations, such as the Photographic Exchange Club and the Photographic Society Club served as important spaces for the interchange of ideas, techniques and photographs for amateurs in these years. Whilst portraiture was left largely in the hands of professional photographers many amateurs focused on photographing landscapes, trees, ivy-clad ruins (plate 221), scenes of provincial towns and architecture. In so doing these well-to-do amateurs of the 1850s thus projected their values and ideals of history, tradition and landscape on to the photographic record and forged many of the aesthetic conventions subsequently adopted by professionals.[22] The number of amateur enthusiasts increased greatly following improvements in photographic apparatus, and by 1861 over twenty photographic societies existed in Britain. Some, like the Amateur Photographic Association (1861) remained exclusive, but many others were increasingly accessible, hosting popular exhibitions where photographs covered walls, ceilings and floors. As one reviewer noted in the *Photographic Journal* of 1865, 'many excellent pictures were so placed as to necessitate the ungraceful attitude of "all-fours" to obtain a satisfactory view of them'.[23]

221 Benjamin Brecknell Turner, *Ludlow Castle – Causeway Entrance*. Photograph, 19th century. V&A: Ph.29–1982.

With the introduction of dry-plates in the 1870s and the increased portability of cameras, photography became accessible to an even larger body of enthusiastic amateur photographers, including women, for whom it became an increasingly acceptable leisure pursuit. In the 1840s and 1850s, by contrast, only a few women had, by fortunate circumstances, been given the chance to pursue photography. In addition, Anna Atkins (1799–1871; plate 222) and her assistant Anne Dixon (1799–1877) made remarkable studies of plant forms direct on sensitized paper in the 1840s and published the first photographically illustrated book, *British Algae*, in 1843.

By 1888, when George Eastman introduced the 'Kodak' to the world, photography could be practised by anyone who could afford a simple box camera. Chemicals and a dark tent were no longer necessary for photographing outdoors, and photography was not the exclusive domain of the expert amateur or professional. With Eastman's famous motto of 'you press the button – we do the rest', photography had reached new heights in popularity and availability.

PHOTOGRAPHY, TRAVEL AND EMPIRE

Photography shaped the ways that Victorians imagined the world. As the British artist, photographer and critic William Lake Price declared in 1868: 'In a multiplicity of ways, Photography has already added, and will increasingly tend to contribute, to the knowledge and happiness of mankind: by its means the aspect of our globe, from the tropics to the poles, – its inhabitants, from the dusky Nubian to the pale Esquimaux, its productions, animal and vegetable, the aspect of its cities, the outline of its mountains, are made familiar to us.'[24] The development of photography in parallel with the expansion of the British Empire made the medium a powerful vehicle for the projection of imperial values and recording of all aspects of empire.

Commercial photographers keen to exploit the European demand for foreign views set out as early as the 1840s to 'discover' foreign lands photographically.[25] Photographers such as Francis Frith, who toured Egypt, Sinai and Palestine between 1856 and 1859,[26] often followed in the pictorial footsteps of artists such as David Roberts, whose oriental scenes had been published in lithographs. Travel photographers covered so much ground that by 1863 the English photographer, Samuel Bourne (1834–1912), declared in the *British Journal of Photography*: 'There is now scarcely a nook or corner, a glen, a valley, or mountain, much less a country, on the face of the globe which the penetrating eye of the camera has not searched.'[27] Bourne operated as a photographer in India between 1862–72 and was most admired for his landscape views and for the series of photographic expeditions he undertook in the western Himalayas in 1863, 1864 and 1866. His photographs of Himalayan scenes such as *View from below the Manirung Pass* (1866; plate 209) were the results of arduous expeditions organized with military-style efficiency and zeal. By picturing Indian topography as picturesque views commercial photographers such as Bourne transformed unknown landscapes into familiar aesthetic frameworks for his predominantly British audience. Other contemporary commercial photographers such as John Thomson, who worked in China and Cyprus, and William J. Lindt, who photographed extensively in Australia and New Guinea, used similar pictorial techniques to make photographs that legitimated in visual terms the British imperial presence in the territory. Much Victorian

222 Anna Atkins, *British Ferns*. Cyanotype, 1854. V&A: PH.379–1981.

landscape photography of non-European territory tended to marginalise indigenous inhabitants, surveying ostensibly empty lands for colonial prospects and documenting the progess of railways, agriculture, mining and colonial settlement.

Commercial photographers were not the only ones to use the camera to record the expanding European presence in the world. Explorers, geographers and anthropologists also availed themselves of the technology in the hope of supplying visual evidence of their discoveries for popular and scientific audiences back home. For example, photographic equipment was taken on David Livingstone's Zambesi expedition of 1858–63 and used successfully to record the flora, fauna, geography and ethnology of the African territory traversed. Many of the resulting photographs were used as the basis of engravings in David and Charles Livingstone's popular expedition narrative (1865).[28] Other explorers followed suit and by 1880 few expeditions left Britain's shores without photographic equipment.

Many doctors and soldiers stationed across the Empire were quick to take up photography for both official and unofficial duties. The Royal Engineers received training in photography from 1856 and by 1860 were using photography as an accompaniment to topographic survey and a means of cartographic reproduction all over the world. British immigrants to Canada, Australia and New Zealand, as well as the United States, documented their experiences in new lands through photographs made by commercial operators and, as photography became more accessible, their own cameras. With the rise of mass tourism the making, collecting and viewing of photographs, as both visual guides and souvenirs, served to shape people's perceptions of places and their experiences of travel.

With the expansion of Empire came the encounter with, and exposure to, European eyes of non-European peoples. Commercial photographers made numerous studies for *cartes-de-visite*, stereoscopic views and lantern-slides of indigenous peoples, catering to a market hungry for portraits of exotic people. More generally, travellers, scientists and colonial officials interested in furthering knowledge of ethnology and anthropology used photography to document 'racial types'. Much of this practice stemmed from a widespread belief that aboriginal races were being destroyed through 'civilisation'.[29] This was one of the motives, for example, behind the commissioning of the professional photographer Charles Woolley to photograph the last few remaining Tasmanians for display at Tasmania's stand at the Intercolonial Exhibition in Melbourne in 1866. Woolley's photograph of Trucanini (plate 223) was one of five chosen for the exhibition from a set made by Woolley in his Hobart studio in 1866. The portrait of Trucanini appealed to contemporary audiences as a sad last glimpse of a dying race, particularly because of the look Trucanini gives the camera and by the use of the vignette. The picture's resonance as an icon of a vanished race was enhanced by widespread distribution in photographs and engravings in books such as James Bonwick's *Last of the Tasmanians* (1870), by which time Trucanini was the sole surviving indigenous inhabitant.[30]

Interest in 'race' in the Victorian period was directed at different faces and bodies at home as well as overseas. Just as photography was employed in the exploration of the lesser known parts of the overseas world so to was it turned on the 'terrae incognitae' of British cities, particularly London. Social exploration of the imperial metropolis stemmed from concerns over declining

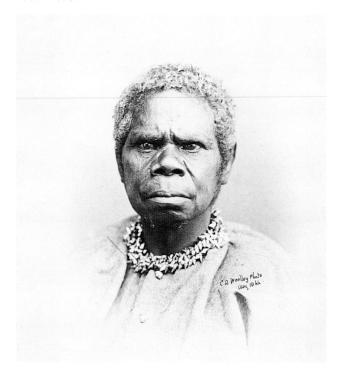

223 C. A. Woolley,
Trucanini. Photograph, 1866.
Royal Anthropological
Institute, London.

national and imperial vitality as well as the problems of urban society. In 1878 the professional photographer John Thomson embarked on a project, with the journalist Adolphe Smith, 'armed with note-book and camera' to explore the 'highways and the byways' of London. The resulting *Street Life in London* was one of the best-known photographically illustrated publications of the Victorian period.[31] The work described and categorised London's street characters, often in the ethnographic language of the day.

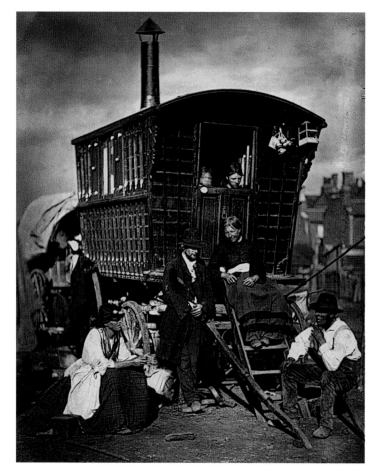

One of Thomson's photographs depicted what he called 'London Nomades' (plate 224), part of a 'tribe' of London poor who were 'improvident' and 'unable to follow any intelligent plan of life'.[32] The accompanying text described how William Hampton, around whose caravan on vacant land in Battersea the group were arranged, represented a 'fair type' of this 'tribe'. Although Smith and Thomson argued for various kinds of urban reform, notably in areas of hygiene and sanitation, the photographs and text reinforced the idea of London as a set of distinct spaces occupied by distinct ethnological groups. In this process photography was envisaged as a way of subjecting such spaces and people to scrutiny.

224 John Thomson,
'London Nomades',
from *Street Life in London*,
part 1, pl. 1 (1877).
V&A: Ph.315–1982.

From the early 1850s attempts were made, with varying success, to apply photography to branches of science, from astronomy to microscopy. Training in photography was given to Royal Engineers at Woolwich from 1856 and a placed on the curriculum of King's College London in the same year. Photography was soon being regularly employed within a wide range of institutions, notably hospitals and prisons, in the recording of various characterisations and classifications of the human body and mind, from 'the criminal' photographed by Francis Galton in the 1870s to 'the insane' photographed by Dr Hugh Diamond in the 1850s. Whilst such practices were certainly objectifying, turning their subjects into 'types' or specimens, it would be a mistake to assume that all such uses of photography in the period represent the controlling gaze of the state or that such photographs were interpreted in the same way. Although there is ample evidence that Victorian viewers regarded photographs as empirically objective records, ideal for amassing and ordering facts about the world, there is also much to suggest that the meanings of photographs, even in practices of science, were far from uncontroversial. Indeed, debates in Victorian Britain over photographic evidence across a range of spaces, including field outposts, the science laboratory and the spiritualist séance, suggest that Victorians were not always willing to read photographs as unconditionally true and, moreover, that they read photographic evidence in a range of different ways.[33]

LANTERN-SLIDES, HALF-TONES AND POSTCARDS

Photographs of all kinds of subjects reached ever-widening audiences through display via the magic lantern. As a technology for projecting images and texts from glass slides, the magic lantern pre-dated photography but was ideally suited to the display of photographs to large audiences. By 1890 lantern-slide shows of photographs were used extensively for both instruction and entertainment in a variety of venues, including schools, church and mission halls, popular theatres and scientific societies.[34] Their usefulness as a means of projecting particular values was such that in 1902 the Colonial Office set up a Committee of Visual Instruction to co-ordinate the making of sets of photographic lantern-slides with which to instruct school children of their role as citizens of the British Empire.

Besides their display in lantern-slide shows and exhibitions, photographs were increasingly easily reproduced in popular printed forms. From the 1880s the half-tone process (that used a cross-lined screen to produce a pattern of evenly spaced dots of differing sizes to convey tone) allowed photographs to be reproduced in print simultaneously with text. By the 1890s many publishers were mass-producing half-tone photographs for illustrated publications, often issued initially in weekly parts, catering to popular themes. Publications such as *The Queen, Her Empire and the English-speaking World* (1897), *Broader Britain* (1895) and the massive *The Queen's Empire* (1897)[35] presented popular photographic surveys of the queen, Britain and the Empire. The reproduction of photographs in publications was not limited to such popular works. Scientific journals such as the *Geographical Journal* were also quick to make use of half-tone techniques to publish photographs from the 1880s and published colour photographs as early as 1900 (see plate 216).

More generally, photography had a profound impact upon printing processes and was quickly adapted to reproduce designs for wood-engravings. In the 1890s line-block technology allowed positive images to be developed on zinc photographic plates that, after washing and hardening, could be used for printing.

Perhaps the greatest dissemination of the photographic image came through the mass craze for picture postcards from around the turn of the century. Along with the Kodak camera, the postcard represented the global triumph of photography and supplied further evidence, if any was needed, of just how far photography, printing and systems of mass communication had evolved since the start of Victoria's reign. In the early decades of the Victorian era the photographic print was the standard and final outcome of the photographer's operations. At the end of the period, the photograph was merely the starting point for a process of evolving graphic reproduction on a truly global scale.

By 1900 photography had become as simple a procedure as pressing the button on a mass-produced Kodak camera. Photographic images were displayed in a vast array of different forms from the stereoscopic view to the lantern-slide (plate 225). Devices such as the zoetrope, devised at the turn of the century, used photographs viewed in rapid succession to give the illusion of movement. A commercial zoetrope of Queen Victoria's funeral thus marks the end of an era where the still image had predominated into an age of the moving image.

As the inventors and developers of photography the Victorians, as amateur and professional photographers and as consumers of all kinds of photographic ephemera, established many of the technical and aesthetic frameworks that structured photographic practice well beyond 1900. Many photographic practices common in the Victorian period, such as the photographing of dead children for their families, have disappeared from cultural usage. However, many photographic conventions, such as the 'mug-shot' portrait, remain in currency today.

The making, circulation and consumption of photographs as everyday objects and the spaces in which they were situated, from the newspaper to the family album, were a central part of how they generated meanings. As complex material objects photographs were made, bought, exchanged and sold in an extraordinarily wide range of forms, from cabinet photographs to lantern-slides. Photographic images ranged in size from several feet across to the microscopic and in cost from the most expensive daguerreotype to the cheapest ambrotype. Nor were photographs limited to paper prints. By the end of the nineteenth century several photographic processes such as the 'transferrotype' had been devised to transfer images to practically any other support, particularly wood, glass and china. Such processes further widened the reach of photography whilst simultaneously blurring the criteria between different visual forms.

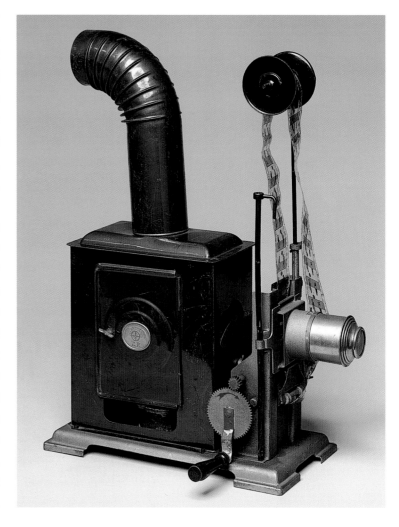

225 Magic lantern. Made by Ernst Plank, 1900. V&A: Misc.65–1966. This magic lantern can take either slides or continuous film.

THE VICTORIAN GRAPHIC WORLD

It is difficult today to appreciate the extraordinary variety of graphic processes used in the Victorian period that come under the umbrella headings of 'printing' and 'photography'. W. J. Stannard's *The Art Exemplar* (*c*.1859) listed 156 printing processes known to the author, from well-known and highly influential processes such as lithography, to obscure and short-lived techniques such as 'thermography'.[36] Similarly, Walter E. Woodbury's 1898 *The Encyclopaedic Dictionary of Photography* boasted over 2,000 entries on all aspects of the medium and its applications, from aerial photography to X-rays.[37] Such variety makes the very use of a term like 'photography', let alone assertions about the nature of medium, questionable.

The meaning that such productions held for Victorian viewers and readers depended not only upon the variety of graphic communication deployed but also upon the space in which it was practised. Looking at a single photograph in the home was thus different to its reading as part of a lantern-slide show in a meeting hall. Much of the production and consumption of printing and mass media was a metropolitan affair. Although the number of provincial publishers expanded from the 1800s, in the mid-nineteenth century London was the centre of printing in Britain, accommodating more than a third of the total labour force and over half the total output of the British letterpress printing industry.[38] The take-up of photography was also geographically uneven, with trade and patent restrictions in particular ensuring different practices in, for example, France and Britain as well as regional differences between cities within Britain.[39]

The expansion of the Victorian press and mass media paralleled, in graphic form, the rise of the Victorian city. The growth of printed information was faster even than the pace of Victorian urbanism and captured much of the latter's fractured, diverse and dynamic quality. New and heterogeneous populations of cities found in the press and mass media the ideal vehicle for reflecting and shaping public opinion and collective cultural identities.[40]

Printing, photography and graphic reproduction in the Victorian age were truly international enterprises. Britain's imperial position, in particular, ensured the extension of printed communication systems through, for example, the postage system, the telegraph and newspapers, as well as international trade and commerce. As the nineteenth century progressed printing and photography were increasingly incorporated into ever more complex global systems of communication.

The Victorian period witnessed an extraordinary growth of 'things', as well as the significance of this material culture, in people's lives. A good proportion of these things, ranging from treasured family photographs to an unwanted theatre ticket, consisted of printed matter. Never before had the printed word and image been reproduced on such a scale or penetrated so far into the everyday lives of ordinary people. Indeed, one of the distinctive characteristics of Victorian print and photography was its diffusion across almost all strata of society. Whilst not all Victorians could afford prints or photographs most could see them displayed in shop windows or through lantern-slides at school or church. By the beginning of the twentieth century however, newspapers, magazines, photographs and printed ephemera of all kinds had proliferated to such an extent that few people could avoid encountering the printed word or image on a daily basis, even if they had wished to. The Victorian world was thus a distinctly graphic and visual production; a spectacle constructed as much from paper and glass as from bricks and iron.

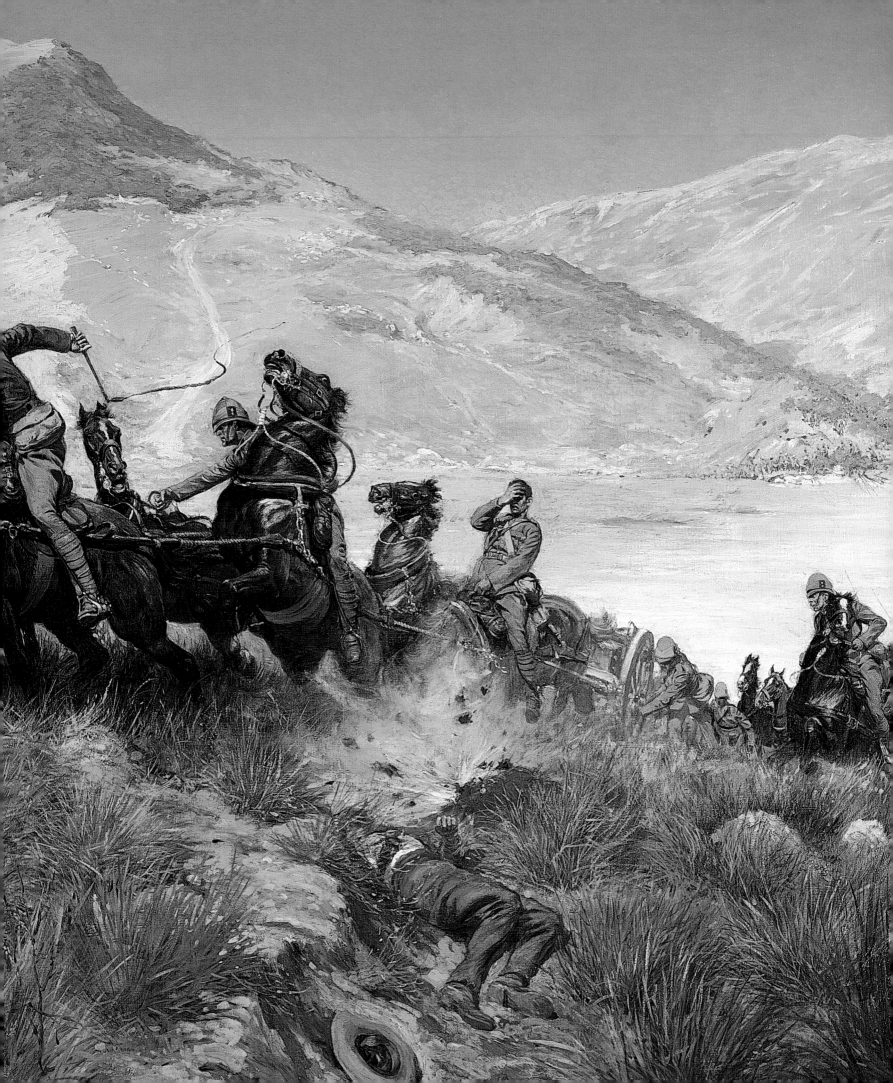

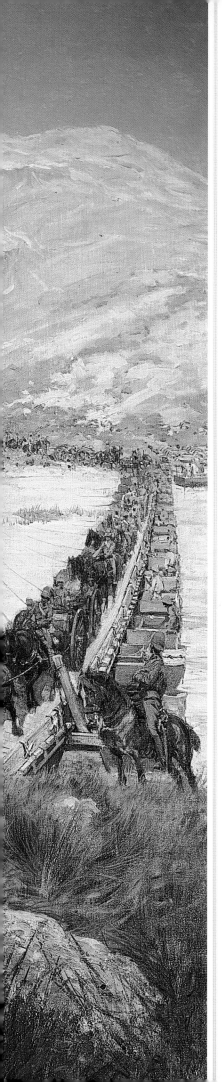

CHAPTER TEN

EMPIRE AND THE GLOBAL GAZE

JOHN M. MACKENZIE

By the start of Victoria's reign in 1837 British maps of the world were already coloured red for the British Empire. Mercator's projection greatly exaggerated the size of Canada and, to a lesser extent, Australia, offering a sense of dominance which was to grow mightily during the nineteenth century. In reality, the Empire consisted of several sparsely populated colonies of white settlement together with Caribbean islands and a number of strategically situated staging-posts. Large tracts of India were under the sway of the East India Company and were ruled directly only after the Mutiny, or revolt, of 1857 and the royal proclamation of 1858. The princely states, increasingly invested with an overblown orientalist glamour, came into a quasi-feudal relationship with the Crown at the same time. Various colonies in Canada and Australia were yet to be linked up and new ones were still to be founded. The Cape had been acquired from the Dutch, but Natal was yet to be annexed (in 1843). The acquisition of New Zealand through the Treaty of Waitangi occurred in 1840. Hong Kong was created as a colonial trading outpost after the Opium War in 1842. Further major accretions of territory throughout the African continent, South East Asia and the Pacific only came about in the last three decades of the queen's reign (plate 228).[1]

Victoria became progressively more interested in this vast Empire as she grew older and it helped to bring her back into public life after her long period of grieving for Albert. Benjamin Disraeli, who had earlier expressed reservations about colonies, used the Empire in the 1870s to

226 Section of wallpaper commemorating Queen Victoria's Golden Jubilee. Colour print from engraved rollers, 1887. V&A: E.791–1970.

227 Georges C. Scott, *Crossing the Tugela River Under Fire*. Detail. Oil on canvas, 1900. National Army Museum.

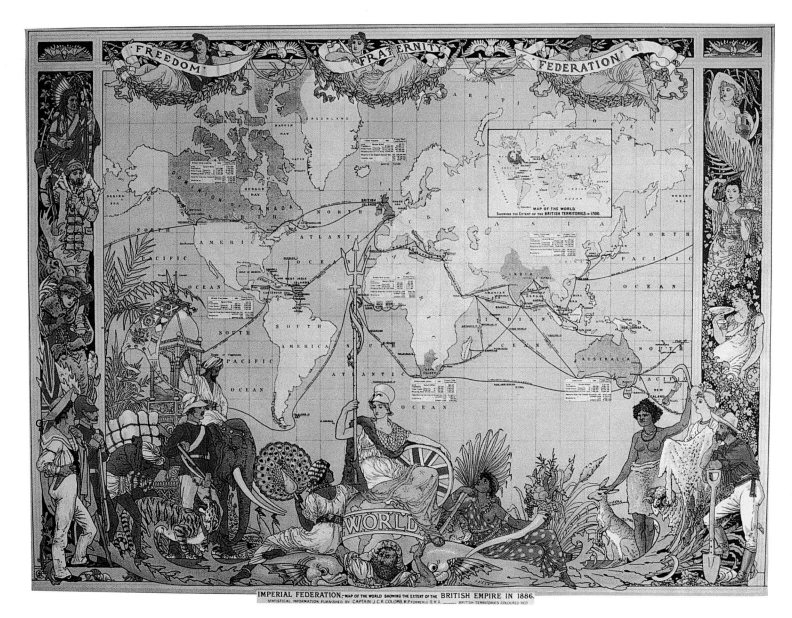

IMPERIAL FEDERATION. MAP OF THE WORLD SHOWING THE EXTENT OF THE BRITISH EMPIRE IN 1886.
STATISTICAL INFORMATION FURNISHED BY CAPTAIN J.C.R.COLOMB.M.P.FORMERLY R.M.A. ——— BRITISH TERRITORIES COLOURED RED

228 *Imperial Federation Map of the World* (colour fold-out), from *The Graphic* (24 July 1886). V&A: PP.8.D–E.

The world map displaying the British Empire in pink or red had its origins in the early 19th century. During Queen Victoria's reign the pink extended until it covered almost one-quarter of the surface of the globe. The map became an icon of British power.

229 Coronation handkerchief. Cotton, 1838. V&A: T.128–1971.

stimulate popular support for his policies and also to flatter the queen. By his Royal Style and Titles Bill of 1876, she became Empress of India and, although this title was supposed to be restricted only to the Asian sub-continent, in fact the queen came to take on an imperial ambience everywhere. In India she was proclaimed by a massive ceremonial durbar, invoking imagined medieval precedents, in 1877. By the time of her Golden and Diamond Jubilees in 1887 and 1897, statues of Victoria were appearing throughout the Empire. In these, she is invariably depicted taller than she was in reality. She often wears coronation robes and the open imperial crown, bearing the orb and sceptre.[2] No individual, almost certainly, has been so extensively portrayed in statuary in

the history of the world. In addition to the versions in stone and bronze, the queen was displayed in portraits and photographs in a multitude of public buildings and private homes (plate 230). Coins, stamps and medals disseminated her image more widely than any Roman emperor dreamed of. Moreover, many indigenous people, particularly in Africa, set about portraying the queen in sculpture (usually wooden; plate 231) and on drums.[3]

As if this were not enough, the name of Victoria was given to a city, an island, a park and a harbour in Canada. Mountains and mountain ranges were called after her in Burma, New Guinea and New Zealand; rivers in Australia and Africa; towns in the Northern Territories of Australia and the Cape Colony; and the largest lake and the grandest falls in East and Central Africa. Even an evocative rock formation in Utah was named after her. This list is far from exhaustive. Although she never visited any imperial territory except Ireland, her imprint was everywhere.

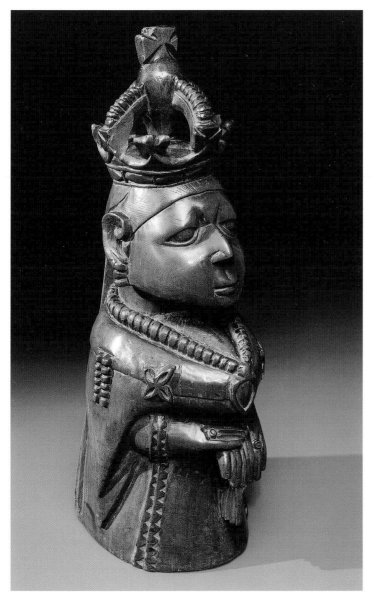

230 W. & D. Downey, photograph of Queen Victoria. 1890s. V&A: 81.495.

231 African statue of Queen Victoria. Wood, 19th century. Pitt Rivers Museum, Oxford.

HEROES OF EXPLORATION

The Victorian age marked the climax of the era of European exploration of the globe. The Royal Geographical Society was founded in 1830, and from 1850 its celebrated and long-standing president Sir Roderick Murchison ensured that it dominated the world of exploration. Instructions and equipment were issued; gold medals awarded; maps prepared; lectures given; and books published. As with plants, animals and peoples, the geographical and geological characteristics of the world were swept up for categorisation, storage and display at the Society's London headquarters.

If the eighteenth and early nineteenth centuries had been the great epoch of exploratory voyages, charting the coastlines of the world, Victorian explorers were interested in interiors. From the Arctic to the Antarctic, Asia to Africa, the Americas to Australia, explorers set out into the continents.

The search for the North-West Passage by Sir John Ross and his nephew James Clerk Ross brought the Arctic regions into great prominence just before Victoria succeeded to the throne. But it was the ill-fated expedition of Sir John Franklin (which set out in 1845) that was to heighten the region's fascination through tragedy. Franklin and his party simply disappeared. Many search parties went out, including those led by Sir John Ross, Dr John Rae, and Richard Collinson and Robert McClure. It was an enduring theme until the 1860s, whipped up by the funding and publicity efforts of Lady Franklin.

The Franklin saga was matched by that of Dr David Livingstone. Livingstone went to South Africa in 1841 and began to concentrate on exploring northwards from 1849. By 1856 he had visited the Victoria Falls and crossed the continent from west to east. He returned to Britain to a hero's welcome. The Zambezi expedition of 1858–64 dented his reputation, since it did not achieve its objective of establishing the navigability of the River Zambesi. Moreover, there were recriminations among its members and his wife died when she went out to visit him. However, his search for the source of the Nile from 1866, his disappearance into the interior of Africa, the search parties which went out for him (of which only that of H. M. Stanley was successful), his death in Central Africa, and the publication of his journals, ensured his heroic status. Many other explorers of Africa, including W. B. Baikie, John Hanning Speke, Sir Richard Burton, and James Grant became celebrated, though none aspired to the heroic fame of Livingstone.

Such explorations were about wealth as well as knowledge. Nowhere was this more obvious than in the exploring of

233 G. Durand after H.M. Stanley, *The meeting of Livingstone and Stanley in Central Africa*. Wood-engraving from the *Graphic* (3 August 1872). By courtesy of the National Portrait Gallery, London. In 1869, Henry Morton Stanley was commissioned by the New York Herald to find David Livingstone in Central Africa. He finally encountered the missionary explorer in November 1871 at Ujiji on Lake Tanganyika, greeting him with the celebrated remark 'Dr Livingstone, I presume'. The incident became part of the mythology of 19th-century exploration. The two men were together for several months, and Stanley emerged from Africa with what was widely regarded as the most remarkable journalistic 'scoop' of the century.

232 Sir Frederic Leighton, *Sir Richard Francis Burton*. Detail. Oil on canvas. *c*.1872–75. By courtesy of the National Portrait Gallery, London.

234 Thomas Baines, *The Ma Robert and Elephant in the Shallows of the Shire River, Lower Zambezi, Mozabique*. Oil on canvas, *c*.1859. Royal Geographical Society.

Thomas Baines was the artist-storekeeper on Livingstone's Zambezi Expedition. He depicted an incident in January 1859 when Livingstone took a steamer up the Shire River. Large herds of elephants were encountered and were hunted by the exploring party.

235 Map showing part of David Livingstone's route from Loanda to Quilmare (1855–56), including his discovery of the Victoria Falls. Royal Geographical Society.

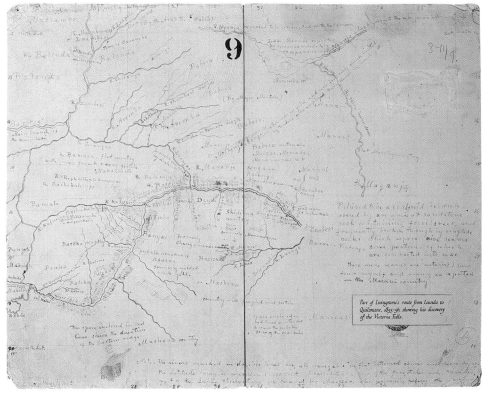

Australia, which was specifically about the search for gold and other minerals. The successive Victorian journeys of Edward Eyre (1839–41), Sir Thomas Mitchell (1835–6 and 1845–6), A. C. Gregory (1855–6), J. M. Stuart (1858–62), Burke and Wills (1860–61) and others mapped the interior and surveyed its prospects for mining and settlement. Thus exploration and exploitation invariably went hand in hand.

By the end of Victoria's reign so much of Asia, Africa and the Pacific had been partitioned that there was a sense of the great era of exploration coming to an end. Extensive surveys had now taken place and the world seemed to be largely mapped in an accurate, scientific manner. Explorers now turned to the Antarctic, paving the way for the fresh heroic legends of Captain Scott and Ernest Shackleton.

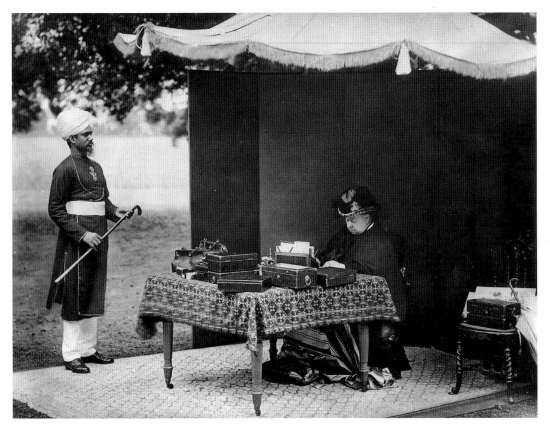

236 Queen Victoria and her servant Abdul Karim. Photograph, 1893. By courtesy of the National Portrait Gallery.

If the Empire thus exhibited a fascination with the queen who headed it, this was reciprocated by the monarch herself. She took on Indian servants, including a secretary or *munshi*, Abdul Karim (plate 236). She attempted to learn Indian languages. She corresponded directly and frequently with those senior governors-general who, as her representatives overseas, had the right of access to her (plate 237). She received visitors from throughout the Empire, including Indian princes and African chiefs and kings. She took a keen interest in notable events such as the explorations of David Livingstone and his celebrated encounter with Henry Morton Stanley (plate 233), the Zulu War of 1879, the death of Gordon at Khartoum in 1885 and the outbreak of the Boer War. Explorers, senior officers, governors and politicians were expected to report to her whatever exploits had enhanced their fame in the further corners of the continents of the world. Her political sympathies (often related to imperial issues) and her sense of agitation over disasters and reverses were such as would never be tolerated in the royal family of today. She was even upset when the British Government returned the North Sea island of Heligoland to Germany in 1890.

237 *Lord Curzon in full viceregal robes.* Photograph, *c.*1900. Hulton Getty Picture Library.

238 Sir Alfred Gilbert:
Jubilee Monument. Bronze,
1887. Winchester Great Hall.

As her own extended family grew and inter-married with the royal houses of Europe, her image as a universal matriarch became increasingly prominent. She even began, imperceptibly, to merge with the very symbol of Britannia herself. Sir Alfred Gilbert's Jubilee monument in Winchester Great Hall places Victoria and Britannia back to back, complementing each other and combining their national significance at the same time (plate 238).[4]

Yet this vast Empire, the largest in the history of the world, on which, famously, the sun never set, was an extraordinarily decentralised one. The concept of 'responsible government', in which white settlers took control of all internal matters, spread throughout Canada, Australia, New Zealand and southern Africa during the queen's reign. A separate Colonial Office was only created in 1854 (before that the colonies had been run from the War Office). The India Office controlled India from 1858, while the Foreign Office had responsibilities for protectorates. These were territories which were theoretically under the protection of, but were not ruled directly by, Britain. By the 1890s this had become a fiction and protectorates were just another form of colony. From 1882 the British were in all respects the rulers of Egypt, but it was not even a protectorate until 1914. It was run by one of the grandest pro-consuls of the age, Sir Evelyn Baring, later the Earl of Cromer, yet he held the relatively lowly office of consul general.[5]

Still other offices of state were involved in the running of the Empire. The War Office and the army administration were intimately concerned with the colonial campaigns which occurred in almost every year of the queen's reign. The Admiralty was also closely connected with imperial matters, both through its patrolling of the shores and rivers of imperial territories and by virtue of the anti-slavery squadrons which were active on the west and east coasts of Africa. These squadrons attempted to prevent the export of slaves across the Atlantic and the Indian Oceans, but also gave the British a significant presence in these regions. The East India Company had its own army and navy, the latter known as the Bombay Marine.

Even after India came under the Crown, India had its own army, two-thirds Indian and one-third British in personnel, which was entirely paid for by the Indian tax-payer.[6] This army had its own uniforms, regimental traditions, training establishments and officer corps. Its existence meant that imperial campaigns could be conducted without reference to the Westminster parliament or the British tax payer. As well as the campaigns within India itself, including the increasingly celebrated North West Frontier, this army was involved in wars in Burma, South East Asia and East Africa. For example, the campaign against Abyssinia in 1867, to free westerners allegedly held by the king, involved units of the Indian army, under the command of General Napier, and was entirely paid for out of the Indian revenues.

QUEEN VICTORIA AND INDIA

After the 1857 revolt, the queen issued a royal proclamation which was designed to placate the princes of India and to assure all Indians that their religions would be respected and that they would have equal rights. Reality often diverged from theory, but the queen was fascinated by India and Indians henceforth. The Prince of Wales visited India in the winter of 1875-6 and sent back many artefacts from the sub-continent. Indian princes constantly attended the queen's court and she gradually surrounded herself with objects and paintings that reminded her of her Asiatic imperial role.

239 Alexander Caddy, *Delhi Durbar: Celebration on the occasion of Queen Victoria becoming Empress of India*. Detail. Oil on canvas, 1877. Private collection.

240 Valentine Cameron Prinsep, *A Nautch Girl*. Oil on canvas, 1877. The Royal Collection © HM Queen Elizabeth II.

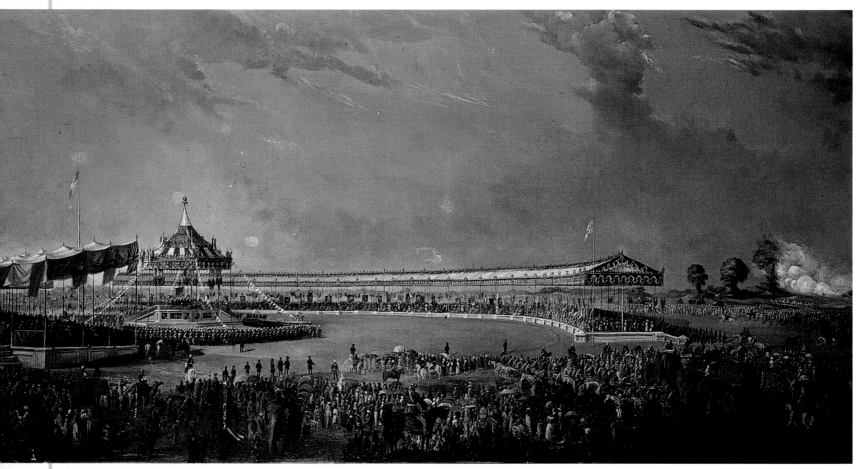

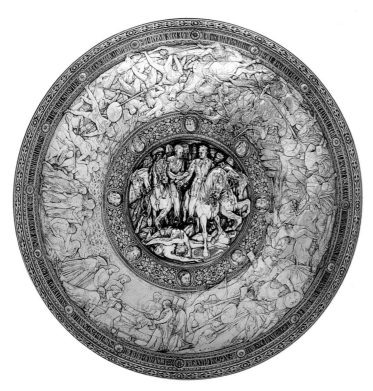

241 The Outram Shield. Damascened steel, 1862. On loan to the V&A. Presented to Lieutenant-General Sir James Outram to commemorate his military successes in India, including the relief of the siege of Lucknow during the Mutiny of 1857.

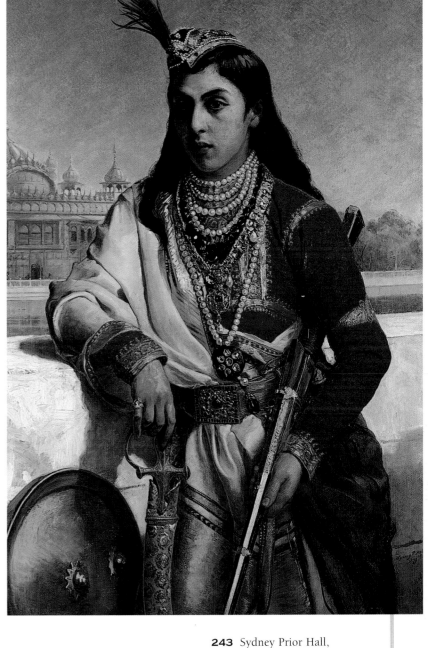

242 Abraham Solomon, *The Flight From Lucknow*. Oil on canvas, 1891. © Leicester City Museums Service.

243 Sydney Prior Hall, *Victor Albert Jay Duleep Singh*. Oil on canvas, 1879. The Royal Collection © HM Queen Elizabeth II. The son of the Maharaj Duleep Singh, dispossessed of his throne in the Punjab but nevertheless a favourite of Victoria's (her godson) and a friend of Albert.

VICTORIA'S IMPERIAL WARS

The Victorian age seemed to be a period of comparative peace in Europe. The unifications of Italy and of Germany were achieved through a succession of wars in which the British were not involved. For Britain, the Crimean War of 1854–6 was the one major conflict of the time. But imperial wars took place in almost every year of Victoria's reign. In Asia alone, there were wars in China, 1839–42 and 1859–60; in Afghanistan in 1839–42 and 1878–9; in Burma in 1852–3 and 1884–6; and in India, the Sikh wars of the 1840s were followed by the revolt of 1857 and a succession of campaigns on the North-West Frontier which continued until the end of the century.

In Africa, the Abyssinian campaign took place in 1867–8; there were a series of wars against the Asante or Ashanti of the interior of the Gold Coast in 1873–4 and 1895–6, Benin in 1897 and Sierra Leone in 1898 (the 'Hut Tax War'); the 'War of the Axe' in the Cape in 1846–7 and the Zulu War of 1879–80; the first Boer war of 1880–81; major campaigns in Egypt and the Sudan in 1882, 1884–5 and 1896–8; a war against the Ndebele or Matabele people of Zimbabwe in 1893; among many others. There were rebellions in Canada in 1870 and 1885 and endemic Maori wars throughout the period, but particularly between 1863 and 1872. The queen's reign opened with a Canadian rebellion in 1837 and at its close the British were involved in a major war

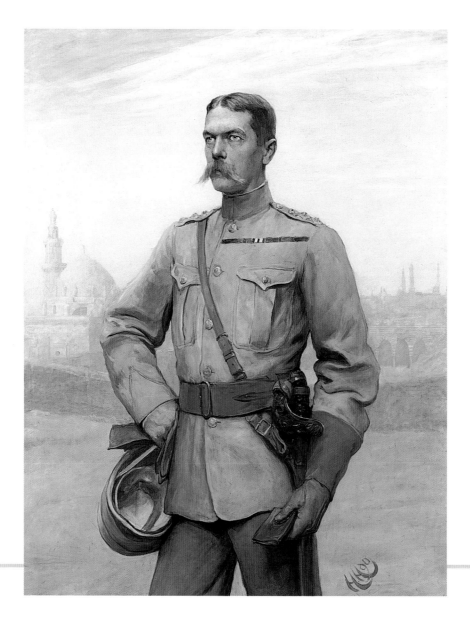

244 Sir Hubert von Herkomer, *Horatio Herbert Kitchener, 1st Earl Kitchener of Khartoum*. Oil on canvas, 1890. By courtesy of the National Portrait Gallery, London. Kitchener, one of the most celebrated of imperial officers, is here shown symbolically dominating the landscape from which he took his title.

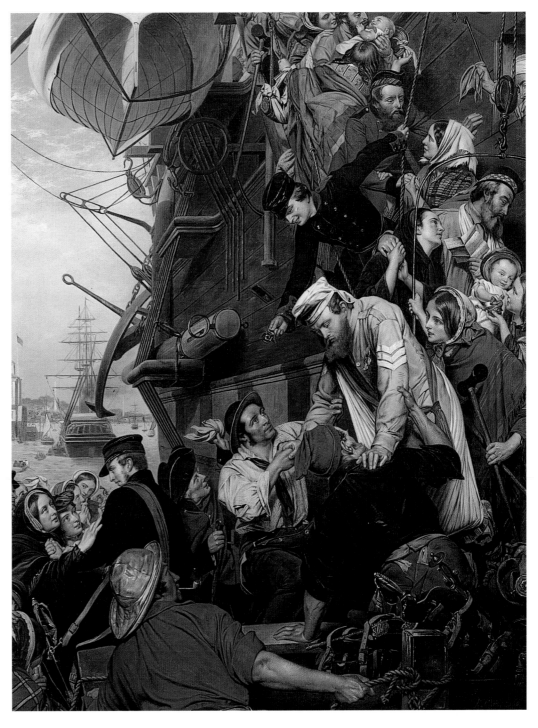

245 Henry Nelson O'Neil, *Home Again*. Oil on canvas, 1859. National Army Museum. O'Neil's *Eastward Ho!* (1858) depicted soldiers as respectable family men, leaving wives and families for India to suppress the Indian Mutiny, while *Home Again* displays them as returning wounded heroes. The paintings demonstrate the changed status of the soldiery in Victorian times.

246 Victoria Cross awarded to Private John Ryan, 1st Madras Fusiliers, for gallantry during the Indian Munity, 1857. Killed in action at Cawnpore, 1858. National Army Museum.

in South Africa, in the Boxer rising in China, and in a further expedition against the Asante in West Africa. The 'Pax Britannica' was imposed only through considerable acts of belligerence.

War became 'a distant noise', an interesting 'spectator sport' which affected relatively few people at home. With these wars, the reputation of the soldiery grew. The military now performed acts of 'pacification' in exotic places. They were depicted in art and popular literature as performing heroic deeds in faraway places, although there was a certain fascination with the military

events which had gone wrong. This sense of distancing was further enhanced by the development of firearms. From the 1850s a technological gap began to open up between Europe and the rest of the world, further developed by the invention of the machine gun (see chapter 6). Victoria's 'little wars' often involved very considerable numbers killed on the side of the native peoples of empire and relatively light casualties on the British. They were not such little wars for the peoples of India, Burma, China, Africa and New Zealand.

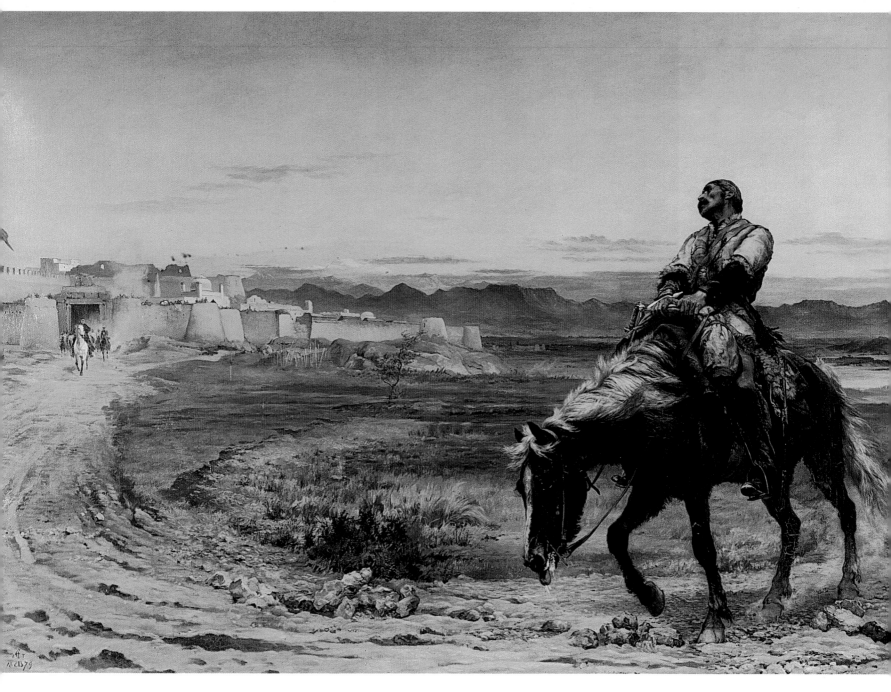

Yet the record of the Victorian period was not one of repeated imperial triumphalism. On the contrary, the Victorian psyche gave far more prominence to failure than to success. It was the failures and the reverses which were most likely to be depicted in Victorian art (plate 247). Such events were regarded as 'no end of a lesson', retribution for easy complacency or incompetence. Soon after Victoria came to the throne, the British suffered a major reverse in Afghanistan in 1839. The Crimean War was to throw up any number of errors of command, tactics, organisation, commissariat and medical care. The Indian Mutiny also stimulated much military anxiety and produced many dramatic pieces of art and striking artefacts. Disraeli's romantic and rather more aggressive approach to Empire, symbolised by the Conference of Berlin in 1878 (which brought

247 Lady Butler, *Remnants of an Army*. Oil on canvas, 1879. Tate Gallery © 2001. Lady Butler's painting depicted the return of Dr William Brydon to Jellalabad after a forced retreat from Kabul in 1842. Only a handful of others survived from a force originally 16,000 strong.

to an end the Russo-Turkish War) and his acquisition of Cyprus for the British, had its seeming retribution in the reverses of the renewed Afghan war of 1879 and in the Zulu War of the same year. The defeat of the British at Majuba Hill in 1881 led to the return of sovereignty to the Boers in the Transvaal (or South African Republic) and the Orange Free State. The death of Gordon at Khartoum just days before the arrival of the relief column of Sir Garnet Wolseley seriously damaged Gladstone and his government. There were to be further reverses on the North West Frontier of India in the later 1890s and the Boer War opened disastrously with the sequence of defeats of 'Black Week' in October 1899.

Although the Victorians seemed to develop a high degree of conviction in their right to expand and rule others, reassuring themselves that they were transporting a beacon of civilisation around the world, they remained morally anxious in the present and apprehensive of the future. On the one hand their technology, their science and their medicine (with major developments in the understanding of tropical disease occurring at the end of the queen's reign) offered a good deal of self-confidence. But on the other, as the Empire expanded to its full extent, their fascination with the ancient and classical worlds (much enhanced by the development of archaeology in the period) gave them a sense of a coming nemesis. In a celebrated phrase of Joseph Chamberlain just after the queen's death, they saw the weary imperial Titan as staggering under the too great orb of its fate.[7] Rudyard Kipling, writing at the time of the greatest imperial triumph of the century, the queen's Diamond Jubilee of 1897 (plate 21), warned that the British Empire might one day be 'as one with Nineveh and Tyre'.[8] Victorian success offered much gloom and despondency, an imperial condition in which there was little to hope for and much to fear.

These national mood swings were equally apparent in the economic life of the imperial state. The British were caught in the iron grip of both longer- and shorter-term economic cycles. Even moderate booms led inevitably to slumps. Unemployment followed upon financial crises in 1857 and 1866. Depressed times invariably led anxious interest groups to argue more vehemently for the extension and development of imperial territories. Just such a campaign broke out in the early 1880s with regard to Africa, and chambers of commerce and newly founded bodies like geographical societies pleaded with the government to extend British influence and therefore, as they saw it, economic potential. Yet the Empire never contributed any more than 25 per cent of British imports and received little more than 30 per cent of British exports.

There were at least three other dimensions to economic, social and political anxiety. The first was fear of the manner in which downturns in world trade might tear the social fabric of the country and ultimately destroy what seemed to be a delicate political balance. The population of England and Wales more than doubled between the censuses of 1841 and 1901. The population of Scotland rose by 70 per cent in the same period despite considerable outward migration. This rapid, for some almost terrifying, growth fed the continuing industrialisation and urbanisation of the country. Towns and cities which were still relatively small when Victoria came to the throne were much enlarged by the end of the reign. The population of the city of Glasgow, for example, grew almost fourfold from just over 200,000 on the accession of Victoria to over 760,000 at her death.[9] The town of Middlesborough, which was a small rural community in 1837, grew to be a major industrial centre of more than 100,000 persons by 1901.[10] People were increasingly cut off

from all rural roots, utterly dependent on urban employment. The Chartist agitations of the 1840s seemed to offer potential for revolution at a time when Europe, particularly in 1848, was in turmoil. Developing trade unionism and strikes in the 1880s offered further evidence of working-class misery and associated discontent. Although the Victorian élite was fully aware of the economic origins of such social problems, they had a tendency to moralise them. The working classes were divided into those who were seen as respectable and aiming at self-improvement and those who were rough and rowdy, supposedly prone to drink and unwilling to help themselves.

The Victorians also moralised, fatally, the question of Ireland. At a time when the population of Britain was growing so considerably, the Irish population almost halved, from more than eight million to four and a half million. Famine, disease, death and massive emigration had taken their toll. The queen herself never understood the economic and social misery of Ireland. For her, the Fenian outrages merely demonstrated the contrast between a loyal Scotland and a disloyal Ireland. Ireland was the first, the most acute, and the most dangerous imperial problem. Gladstone recognised it as such and tried to offer the panacea of internal self-government through Home Rule, but the political strains imposed by such a policy defeated him.

By the 1890s the third anxiety (after those of a revolutionary workforce and a rebellious Ireland) was connected with the rise of rivals. As in a race, states in the economic lead have to motivate themselves by glancing over their shoulders. At her zenith, Britain commanded more than a quarter of the world's trade and owned over a third of the world's shipping. Within a few years of the opening of the Suez Canal in 1869, four out of every five ships passing through it were British. But both British industrial supremacy and this extraordinary command of trade and shipping routes were thoroughly disturbed by the appearance of major industrial rivals such as the United States and Germany. Other states were industrialising too. Even Japan, frequently seen as a sort of Britain of the Far East, was beginning its dramatic adaptation to the methods of the West from which it was to emerge as a powerful competitor in the twentieth century. If Britain failed to hold its own then the combustible social material of the towns and cities, not to mention the increasingly distressed rural areas from the start of the agricultural depression in the 1870s, might well explode into social conflagrations.

A number of strategies were evolved to avoid such potential crises. One was to embrace the male population in the political process through the extension of the franchise. Reform bills in 1867 and 1884 created virtually full adult male suffrage, and it is interesting that these developments were associated with imperial events which caught the imagination of the populace. In 1867 Disraeli (not yet Prime Minister, but the most powerful member of the government) seemed to see the excitements of the Abyssinian campaign as a sort of political safety net for what was characterised as a political 'leap in the dark'.[11] The year 1884 appeared to coincide with increasingly forward imperial policies which gave the Conservatives (modern-style political parties were yet another development of Victoria's reign) a long period of power and also brought the 'Liberal Imperialists' (figures like Lord Rosebery, Sir Edward Grey and Herbert Asquith) to prominence in the Liberal party.[12]

The second strategy was to continue to 'improve' the working classes and their social conditions. Workers were encouraged to join mechanics' institutes, artisans' colleges, clubs and

248 Empire clock, 19th century. The clock is positioned here to show North America and the time at various longitudes. Science Museum, London/Science and Society Picture Library.

institutes, thus developing a spirit of auto-didacticism. Local authorities were authorised (in legislation of 1845 and after) to levy a rate for the creation of museums and libraries and it became a source of civic pride that such should be provided, often in appropriately grand buildings. Such 'visitor attractions' (which came to be open, after much controversy, on Sunday afternoons), together with public parks, botanical gardens and zoos, were viewed as forms of 'rational recreation' designed to educate as well as relax. Public funds were also directed towards improvements in health and social circumstances through the provision of fresh water, sewage systems, gas supply and cheap public transport as well housing improvement trusts.

The third strategy was the continuing encouragement to the members of the supposedly surplus population of the United Kingdom to emigrate to the colonies and the United States. Government itself was seldom directly involved in this, but a large number of voluntary agencies, shipping companies, colonial recruiters, and church and philanthropic organisations were active in promoting such emigration. Because the population of the white settler territories appeared to be unbalanced with an excess of males, various female emigration societies encouraged single women to migrate, to seek marriages overseas and produce a new and sturdy imperial race in the supposedly better conditions of Canada, Australia, New Zealand or South Africa. Of the more than five and a half million people who emigrated from England, Wales and Scotland in the second half of the nineteenth century, over three million headed for the United States and almost two and a quarter million to territories in the British Empire.[13]

But it would be wrong to see the social composition of this migration as being made up entirely of the poor and disadvantaged, those who had failed to make their way in the home economy. All levels of society were involved. The poor did indeed migrate (invariably to North America). Some continued to find their way to Australasia, even after the ending of the policy of transporting convicts in 1853. But people with capital also sought better opportunities and, as they envisioned, a healthier and more prosperous future. Some of the single women migrants were 'distressed gentlefolk'. Even scions of aristocratic houses migrated to secure large landholdings, often in an ambitious re-creation of the feudal estates of old, in western Canada and the United States. By the turn of the century they were also heading for the settler territories, mainly Kenya and Southern Rhodesia, of East and Central Africa. Some sought their fortunes in the diamond and gold mines of South Africa.[14]

These complex patterns of migration were sufficiently extensive that they touched almost every extended family in the country. There can have been very few Britons by the end of the century who did not have relatives overseas, whether as migrants, soldiers, sailors, officials or expatriate traders. These trends also reached out beyond the formal Empire and the United States. Latin America, the Far East and other regions apparently outside the European empires have been seen as realms of 'informal imperialism', where trade, finance and technological developments such as railway building established areas of influence that were imperial in all but name.

The extensive settling of Britons overseas led to further conflicts of loyalty and interest. Free trade had become the dominant commercial mode in the early decades of Victoria's reign and imperial preference, though much debated, was only attempted in the 1930s. Most British trade was still with Europe, the United States and regions like the Far East. For many it seemed as though the Empire was a convenience rather than an obligation. The Canadian economy was inevitably sucked into the vortex of its larger neighbour. By the end of the century imperial markets were being penetrated by cheaper products, more efficiently produced – and therefore more cheaply sold – in Germany. Various attempts to tie the Empire of white settlement more closely to Britain through imperial federation failed.

Yet the Empire was certainly important to the British economy. The Indian subcontinent remained a key trading partner, offering cotton, jute, silk and dyestuffs for the mills of Lancashire, Dundee and elsewhere; tea, timber, cinchona (for the manufacture of anti-malarial quinine) and many other products. The extent to which the British damaged the Indian economy by shifting its emphasis from manufactured products to raw materials and from foodstuffs to industrial staples remains a source of debate among historians. It is certainly the case that there was widespread distress among Indian producers, for example in trades like handloom weaving, whose practitioners were much disadvantaged in Britain as well. Moreover, famine continued to be endemic in India and the celebrations of the Diamond Jubilee in London and throughout the Empire were accompanied by the outbreak of a major famine in India.

British finance secured a safe haven in India, where guaranteed dividends, underwritten by the Indian tax-payer, could often be secured. The supply of railway lines, rolling stock and engines kept British companies in business until well into the twentieth century. The dominance of the British merchant marine ensured work for the shipbuilders of the Clyde, the Tyne, the Mersey and Belfast. Many lesser companies supplied hundreds of smaller steam vessels for the rivers, lakes and coastal trades of the Empire. The palm oil of West Africa became vital in the manufacture of soaps and industrial lubricants. Timbers from around the Empire were crucial in furniture manufacture and interior decoration, particularly satisfying a Victorian predilection for hardwoods. In the last quarter of the nineteenth century, new manufactures drew on natural products and base metals like rubber and copper. Where these were secured from outside the Empire (as with rubber from the Amazon regions of Brazil) efforts were made to transform these into imperial products. Just as tea had been transferred from China to north-eastern India and Ceylon (Sri Lanka), so was rubber moved to Malaya, cocoa to the Gold Coast, while tea, coffee and various fibres were introduced to several African and Asian colonies. We should also not forget inter-colonial trades, for example in cattle and foodstuffs. The considerable demands of the Indian army for horses led to the development of horse-breeding on a major scale in New South Wales, the resulting mounts being known as 'walers'.

As one by one the western currencies shifted on to a gold standard (sources of silver were becoming increasingly rare in the world), gold galvanised the economies of a number of colonies, from British Columbia in western Canada, to Victoria in Australia and the South Island of New Zealand, sucking in large numbers of migrants from Britain and elsewhere, including China. The discovery of diamonds in the Cape Colony by the early 1870s, followed by the world's greatest

source of gold (though locked into a very poor ore) on the Rand in the Transvaal in the 1880s, created a social, racial, political and geo-political revolution in southern Africa. As other chapters in this book reveal, all this economic and product dynamism was strikingly reflected in the raw materials, manufactured goods, and art and design products at the many exhibitions of the Victorian period.

It was also reflected in the popular culture of the period. As noted in chapter 9, the costs of printing and reproductions fell dramatically during this period. Moreover, literacy rates were further developed after the 1870 Education Act and somewhat higher disposable incomes (which contributed to the growth of leisure pursuits described in chapter 2) offered opportunities for the purchase of books and magazines for both adults and children. Any survey of these materials reveals the extent to which they were imbued with the imperial global gaze of the period. The lavishly illustrated journals described in chapter 9 must have been read in libraries and by countless servants in middle- and upper-class homes when they were passed on 'below stairs'. All newspapers, including those read by the working classes, showed considerable interest in the exploits and alarms and excursions of a wider imperial world. By the end of the century, daily papers had come within the reach of all classes. A number of children's magazines were published for the first time from the 1850s, often by religious organisations, but all of these were dramatically surpassed in popularity by the *Boy's Own Paper*, first issued by the Religious Tract Society in 1879. It was swiftly followed by the *Girl's Own* equivalent and by many imitators. The papers of all of these journals were suffused with the ethos of Empire. The opportunities presented by migration or work overseas were also a common theme of many Victorian novels that are regarded as the 'high literature' of the period.[15]

249 John Charlton, '*Buffalo Bill' at Windsor*. Watercolour, 1892. The Royal Collection © Queen Elizabeth II.

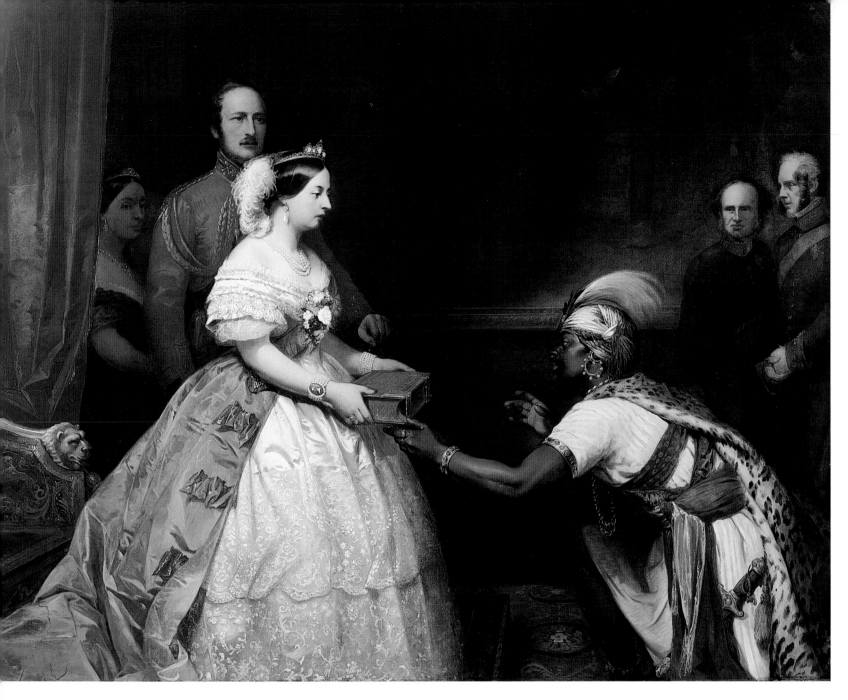

Such books also tended to disseminate some of the racial ideas of the time. These ranged from highly paternalistic modes of thought to pseudo-scientific racism. 'Harder' racial ideas were less prevalent in the earlier nineteenth century and it may be that Victoria herself and some of her subjects born in the early decades (like David Livingstone) were relatively free of the more rigid forms of racial thought. But Darwin's *The Origin of Species* (1859) and *Descent of Man* (1871) encouraged others to apply his evolutionary concepts to human society. It is yet another of the paradoxes of the age that after the emancipation of slaves, and at a time when philanthropic organisations exerted considerable influence, notions of racial difference were propounded more extensively. Yet the expressions of such ideas remain complex. Missionaries and philanthropists were certainly highly paternalistic, if not at times patronising, in their approach. But the essence of their position was that, in time, non-Europeans could be 'raised', by education and Christianity, to the level of Victorian civilisation (plate 250). Others created a hierarchy of races, from the supposed Aryan down through the various peoples of Asia, to Africans and finally to hunters and

250 Thomas Jones Barker, *The Secret of England's Greatness (Queen Victoria presenting a Bible in the Audience Chamber at Windsor)*. Detail. Oil on canvas, *c*.1863. By courtesy of the National Portrait Gallery, London.

251 Headdress of Cetshwayo, Zulu chief. Mixed media, 19th century. The South Wales Borderers Museum.

gatherers such as Australian aborigines and southern African 'bushmen'. Those lower down the scale were doomed to disappearance according to some inexorable law of social Darwinian 'survival of the fittest'. Such ideas were also applied to Europe and a severe distinction drawn between the supposedly successful energetic northern Europeans and those of the Mediterranean lands. It is a legacy of the later Victorian period which has taken all of the twentieth century to shake off.[16]

Victorian social and cultural institutions sometimes reflected these concepts. The Boy's Brigade was founded as an evangelical and quasi-militarist organisation in Glasgow in 1883. It soon spread to the whole of the United Kingdom and overseas to the Empire, quickly followed by the Church Lads' Brigade, and the Catholic and Jewish Lads' Brigades. The combination of evangelical purposes and pseudo-military forms was a common characteristic of Victorian Britain, as evidenced by the Salvation Army of General Booth and hymns such as 'Onward Christian Soldiers'. Both youth organisations and hymns once again projected character-building and Christian endeavour within an imperial context. Missionary societies and their parent churches, sometimes reluctantly at first, but enthusiastically by the end of the reign, also took up aspects of an imperial ideology. Empire became part of the religiosity of the age.[17]

This same world view, replete with concepts of a civilising mission and containing aspects of the Victorian global monarchism, militarism and racial ideas, was also propagated through the music hall, the theatre, popular music, school textbooks of the period and all the forms of rational recreation mentioned above. The organisation of museums often explicitly invoked the empires of the ancient world or exhibited global natural historical or cultural taxonomies which were inseparably bound up with the Victorian passion for classification. Continents were effectively reinvented for the engrossing gaze of the Victorian public.[18] Memorials, statuary, allusive architecture adorned with imperial symbols or busts (like the Foreign Office in Whitehall) all served in this dissemination of an imperial ideology.[19] Advertisements sought to link products to the Empire in what was becoming akin to a modern mass market by the last decades of the century. By the 1890s new advertising and postal media like cigarette cards (also issued by tea companies) and postcards were also redolent of imperial images, such as flags and armorial arms, regiments, settler opportunities, products, wars, all relating to Empire.

If the British public was exposed to Empire through any number of cultural forms, it was also impossible to escape imperial connections on the rivers and streets of her cities. Many of the docks and wharves of London were devoted to imperial trades. The warehouses of St Catherine's Dock, for example, were invariably filled with tusks from Africa, ivory which was intended for the cutlery makers of Sheffield (who used it for handles) or for the many manufacturers of pianos or billiard balls around the country. Great firms such as Lever Brothers or the Quaker chocolate-makers Cadbury, Rowntree and Fry were totally dependent on imperial products and their workers were well aware of the fact. Those who worked for the small-arms and tools manufacturers of Birmingham, the naval builders and armaments producers of Barrow or Newcastle, the engine builders of Manchester, Newcastle and Glasgow, shipbuilders, cotton, silk and jute mills everywhere were well conscious of the imperial trades or raw materials upon which their employment depended. There is also good evidence to suggest that the full range of products of Empire was demonstrated to children in schools through 'sample boxes'. When

steam railway engines were hauled through Glasgow from the North British works to the Clyde for loading on to ships for India and elsewhere, the spectators in the streets never had any doubts that such mighty locomotives were themselves symbolic of the power of the Empire.[20]

Yet Victorian governments seldom indulged directly in imperial propaganda. This was left to voluntary agencies and cultural and educational institutions. Indeed, governments often exhibited considerable reluctance to become involved in imperial exploits. Victorian Liberals most notably, and to a lesser extent politicians of other factions and parties, believed that government should allow private interests to pursue their objectives with a relatively free hand. Gladstone was constantly alarmed by jingoism and imperial aggression, yet he was persuaded to invade Egypt (where he himself was a bond-holder) in 1882. His successor, Lord Salisbury, was bemused by the expressions of the so-called new imperialism in the last two decades of the century and could not fathom the French interest in what he called 'areas of light soil', by which he meant the Sahara desert. As a result of the oversights and delays of the Liberal Government of the early 1880s the Germans established themselves in West and South West Africa as well as in the Pacific, in areas that were vaguely regarded as coming within the British sphere. In East Africa, to the fury of many British imperialists, Salisbury permitted the Germans to secure Tanganyika.

Governments appeared to demonstrate this reluctance when they chartered new imperial companies – for North Borneo, the Niger, East Africa and Central Africa – in a desperate attempt to secure Empire both on the cheap and at arm's length. It was a technique copied by the Germans and others, but generally it led to disaster. In this, as is so many other matters, the reactions of Victorian governments can be fully understood only in the context of Treasury parsimony. Indeed, it often seemed as though there was a greater drive for imperial aggrandisement at the periphery than at the centre. In 1884 the Australian colonies, fearful of the arrival of other European powers, agitated for British expansion in the Pacific. In southern Africa Cecil Rhodes, son of a Bishop Stortford vicar, who made himself immensely rich on the diamond fields at Kimberley and was premier of the Cape by 1890, dreamed and schemed from his base in Cape Town. He wanted nothing less than British dominance of the continent from the Cape to Cairo. He then manipulated the political élite, journalists and other opinion-formers to achieve his ambitions.

One of these journalists was a woman. From the 1880s Flora Shaw (later Lady Lugard) developed a particular concern with imperial issues. She wrote initially for the *Pall Mall Gazette* and, from 1890, for *The Times*. She travelled extensively throughout the Empire, and became Colonial Editor of *The Times*, the first woman to rise to such a position within journalism. A confidante of both Cecil Rhodes and Joseph Chamberlain, she maintained a strongly patriotic imperial position, for example with regard to the Jameson Raid and the outbreak of the Boer War.[21] Mary Kingsley, a niece of Charles Kingsley, was a very different personality who, once free from looking after ailing parents, began a series of journeys in West Africa which brought her considerable fame. She wrote two notable books and travelled widely, lecturing and lobbying on West African issues.[22] Mary Kingsley was a firm believer in cultural relativism, valuing African cultures as worthy of respect. She was opposed to missionary activity and to the extension of imperial rule, favouring a form of indirect rule conducted by traders rather than officials. Yet Kingsley also opposed female suffrage and was not troubled by the fact that, as a woman, she was

252 Carbon water filter. Glazed earthenware, late 19th or early 20th century. Made by Atkins of London. Science Museum, London/Science and Society Picture Library. Contains a carbon filter element to trap microbes and other particles, and has a zinc tap.

unable to address the Royal Geographical Society directly (her papers had to be read for her).[23] But although some of the learned societies in London maintained their barriers against woman membership throughout the Victorian period, others admitted women without controversy. These included a whole sequence of geographical societies which were founded in 1884–5, in Manchester, Liverpool, Newcastle, Hull, Southampton, Glasgow, Edinburgh, Dundee and Aberdeen. Indeed, David Livingstone's daughter was influential in founding the Edinburgh society.[24]

Distinguished female novelists such as George Eliot (Mary Anne Evans) and Mrs Gaskell had their counterparts in the Empire. If Eliot and Gaskell were concerned, in their different ways, with the social problems of country and town, Flora Annie Steel in India and Olive Schreiner in South Africa confronted some of the crises of race and imperialism head on. India also stimulated a number of female 'pulp' novelists, mainly published by Mills & Boon, widely read for their romantic tales in an exotic environment.[25] Women were also closely involved with churches, missionary societies and organisations which raised money for the education of Indians and others. Since most primary teachers after the 1870 Education Act were women, their involvement in such bodies was important for the dissemination of the Victorian world view. Very few were ignorant of the main issues and controversies of the Victorian age. An imperial world view was widely disseminated and this inevitably had its effects upon material culture, as this book makes clear.

At the very time that so many women were coming to prominence in association with the Empire, the greatest of them all was celebrating a Diamond Jubilee which resounded around the globe. Increasingly, towards the end of her reign, troops, officials, missionaries, indigenous people and schoolchildren had turned out annually for the celebration of her birthday on the 24 May. It would soon be known as Empire Day and would be observed in many places until the Second World War. But the Jubilee invoked triumphal displays on a new scale. As well as parades, bands, speeches, games and the like, arches, statues, new buildings and many other commemorations were opened and unveiled. In Calcutta a fireworks display climaxed with the outline of the queen's head, which 'unexpectedly burst upon the vision of the astonished crowd'.[26]

Despite all this triumphalism, Victorian governments were far from being single-minded, consuming the world in an aggressive imperial expansion. Rather, they were often hesitant and resistant, surprised at the contemporary forces and major controversies (like Gordon in Khartoum) swirling around them. Through foreign competition, the cries of interest groups and occasional popular passions they sometimes gave the impression of being forced to act. Only at the end of the century does the imperial ideology appear fully to have taken over the upper echelons of both principal parties. The major paradox of the all-embracing global gaze is that it comprehensively took over so many aspects of Victorian culture, religion and education, while remaining a considerable source of debate, much factional in-fighting and governmental hesitation. Yet the vast expansion of the offices, bureaucratic methods and publications of Victorian government were also solidly founded on the needs of Empire. Victoria, like so many of her subjects, seldom seems to have had doubts about the rightness of the imperial cause. By the last few years of her reign, when Joseph Chamberlain commanded the Colonial Office, Empire was ubiquitous in British culture and ideas. Yet the anti-imperial forces were already gathering themselves. The great fall predicted by Kipling was only a few decades away.

COLLECTING THE WORLD

The Victorians were insatiable ethnographic collectors. Explorers and travellers collected the arts of the peoples of the world, as did many private connoisseurs. Specialist museums were founded and many others contained ethnographic departments. The search for African art has even been described as a 'scramble' akin to the European partition of the continent in the later nineteenth century. Victorians were fascinated by what they saw as being the 'barbaric' but visually powerful characteristics of such materials. Although they only dimly understood the spiritual and cultural significance of many of these artefacts, they were sometimes confronted by qualities in design and technique which caused them to re-evaluate their perceptions of racial hierarchy.

253 Blue mask with moustache and moveable eyes. Haida, Queen Charlotte Islands. Pitt Rivers Museum, collected by Dr Dally 1862–70. Displayed at the South Kensington Museum 1881–4.

254 Igie (ceremonial vessel) decorated with reptiles. Benin brass, part of the 1897 Punitive Expedition collection. Pitt Rivers Museum/Collection of Mary Kingsley.

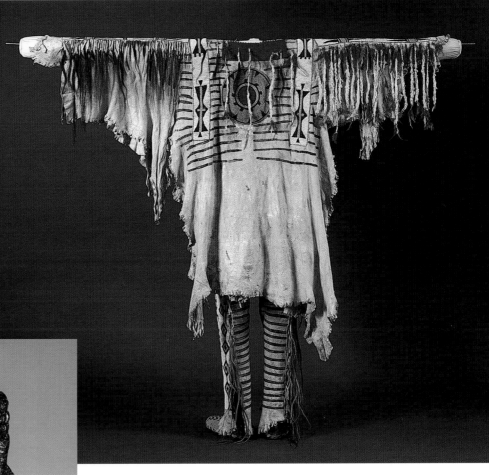

255 Crowfoot's shirt, Blackfoot. Buckskin, feathers, beadwork, hair, late 19th century. Royal Albert Memorial Museum, Exeter.

256 Carved door from Maori raised storehouse. Wood. Carved by Tuuwharenihoheke of Te Aitanga a Mahaki of Poverty Bay. Pitt Rivers Museum, probably collected before 1867.

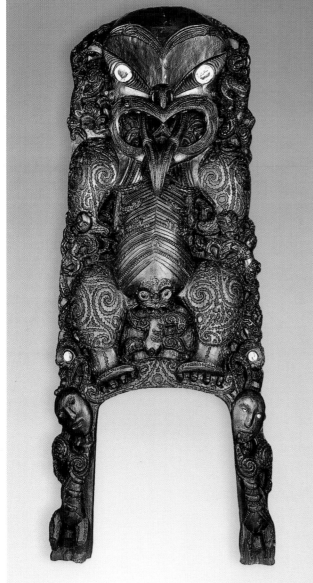

257 Zande shield. Basketry, Zande, Congo/Sudan. Pitt Rivers Museum, from the collection of John Petherick.

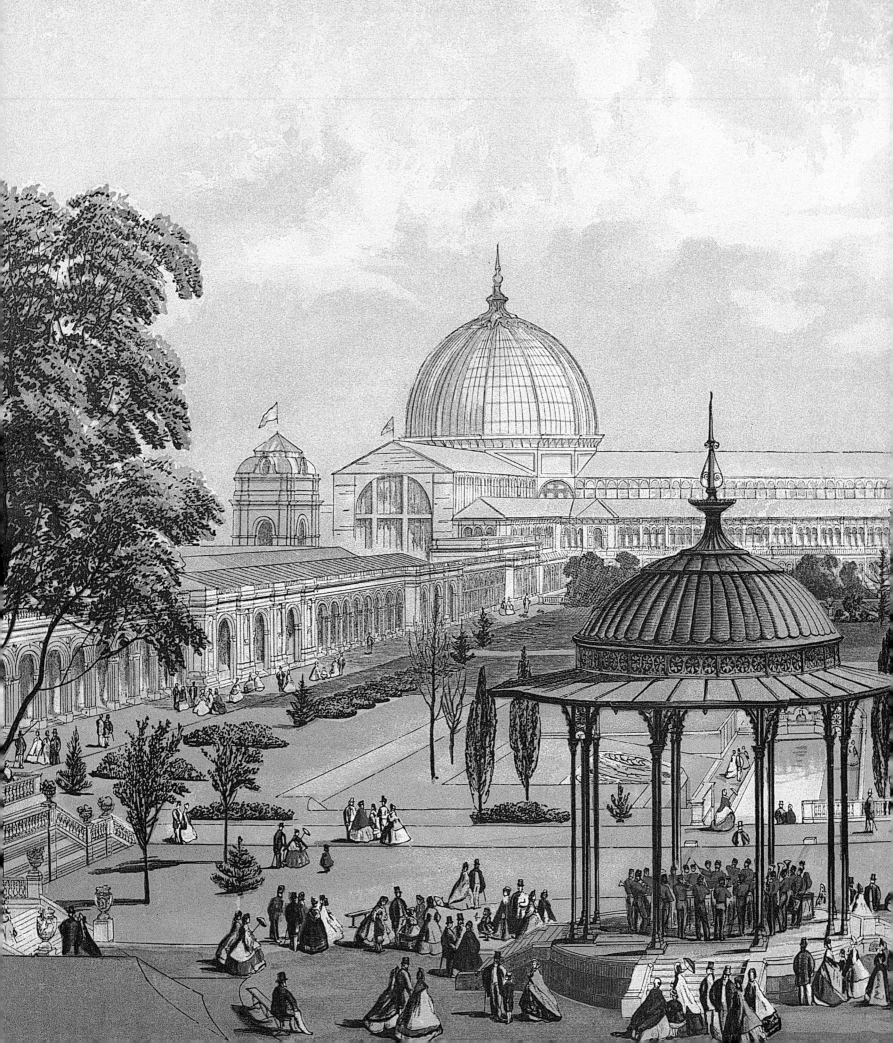

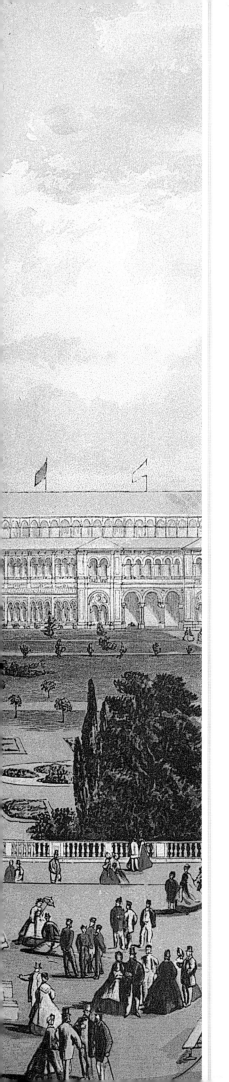

CHAPTER ELEVEN

THE ART AND INDUSTRY OF MAMMON:

International Exhibitions, 1851–1901

PAUL GREENHALGH

The Great Exhibition of the Works of Industry of all Nations closed its doors to the public on 15 October 1851. Wholly unprecedented in its format, scale, visitor numbers and profits, it had been a resounding success.[1] Many senior figures in British life, including the royal family, had been involved in its realisation. The queen expressed a sadness at its passing that was echoed by millions of Britons: 'I could not believe that it was the last time I should behold this wonderful creation of my beloved Albert's.'[2]

It was not to be the last time. She reopened the original Crystal Palace on a new site three years later, and the 'wonderful creation' of Albert's gave rise to an extraordinary number of offspring. During her reign Britain, and most nations with anything approaching the necessary material resource, acquired the desire to organise large-scale temporary exhibitions. An observer of the Great Exhibition wrote in 1850 that: 'Grand projects are now the order of the day. Great Projectors occupy an important position in society. They add to their numbers even without a ballot.'[3] The observation was to be strikingly true not only of the exhibition before him, but of the whole phenomenon of temporary display. The Great Exhibition was endlessly matched and outstripped in size, range and attendance by temporary events staged across the face of the planet, as 'projectors' realised their dreams.

258 *The Two Colossal Statues from the Crystal Palace.* One plate of a stereoscopic photograph, 1851. V&A: Ph.62–1939.

259 View of the exhibition building, the Great International Exhibition, London 1862. *Illustrated London News* (24 May 1862). V&A: NAL.
Heavily derided as an architectural failure, the building for the 1862 show by Captain Francis Fowke, a Royal Engineer, was originally intended to be adapted for permanent use. It occupied a site which is now partly covered by the Natural History and Science Museums. Fowke went on to design several of the buildings that make up the estate of the V&A.

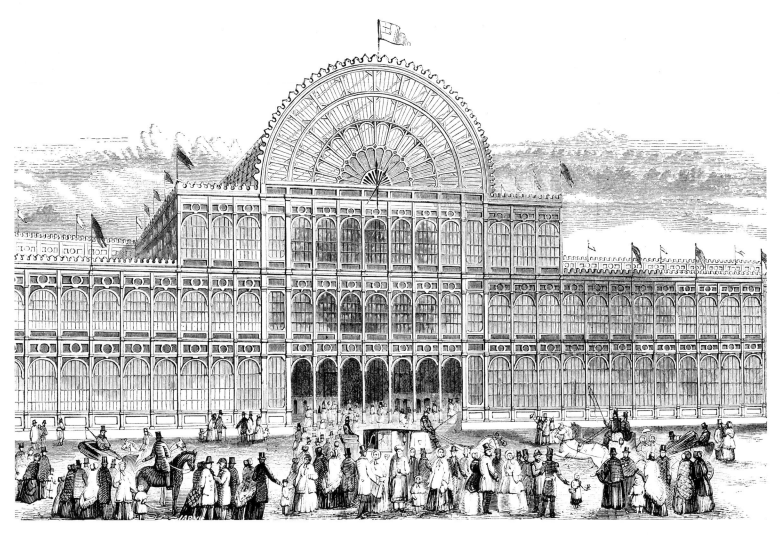

260 View of the Grand Entrance to the Great Exhibition of 1851. The *Official Illustrated & Descriptive Catalogue* (vol. 4, 1852). V&A: EX.1851.21.

Exhibitions illustrated the modernising drive of the Victorian hinterland better than any other cultural phenomenon. They embodied the processes of transformation of the most potent aspects of their existence: economy, demography, technology, the arts and consequently the national profile itself. Hence they contributed significantly to the shaping of the Victorian consciousness.

In many respects exhibitions exemplified the Victorian vision of progress but it would be a mistake to imagine such progress to be a simple or linear affair. Under the respectable macrostructure of positivist display swirled complex, multi-faceted concerns, designed to satisfy a myriad of agendas. Exhibitions functioned as political propaganda; they were among the first events committed to mass education; they were sale-rooms for all kinds of produce, from toys to military hardware; they celebrated religion; they promoted spectator sports; they gathered intellectuals from all disciplines; they celebrated high culture; and they were the fodder of the fledgling mass-tourist industry. Sometimes they were designed to inspire confidence when progress was dented by economic recession or political danger. As often, their complexity and plurality meant that the messages they conveyed escaped official control of any kind.

There were around thirty large-scale temporary exhibitions of consequence held in Britain after 1851. These can be divided into three broad types.[4] The first was the classic large-scale general international exhibition much on the model of the original Great Exhibition. Known internationally as *expositions universelles*, these had a range of subject types, a wide international

participation and could be seen to belong to a global community of like events (plate 261). They were expensive, heavily attended and widely reported. The following major *expositions universelles* were held in Britain during Victoria's reign:

1851 London, Great Exhibition of the Works of Industry of All Nations
1853 Dublin, The Great Industrial Exhibition
1862 London, International Exhibition
1865 Dublin, International Exhibition of Arts and Manufactures
1871 London, International Exhibition of Arts and Industries
1872 London, International Exhibition of Arts and Industries
1873 London, International Exhibition of Arts and Industries
1874 London, International Exhibition of Arts and Industries
1886 Edinburgh International Exhibition of Industry, Science and Art
1888 Glasgow International Exhibition
1901 Glasgow International Exhibition.

261 Great Exhibition Building, Dublin 1853.
John Allwood Collection.
Designed by John Benson, the building broadly followed the lines of the Crystal Palace. The Dublin Exhibition of 1853 was largely paid for by philanthropist William Dargan.

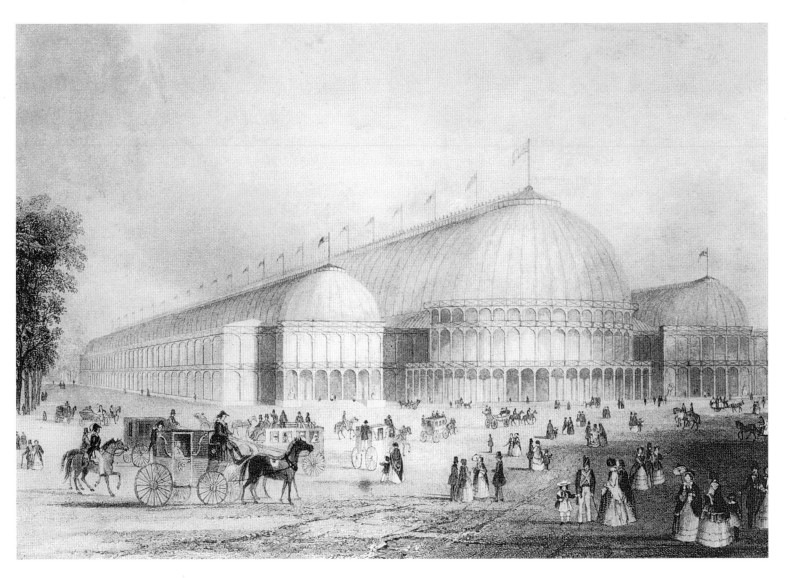

The second type, the single-subject international exhibition, was effectively a British invention. These exhibitions had the appearance of the *expositions universelles* and sometimes had just as wide an international participation, but were generally more modest affairs because of their specialist character. Part trade fair, part congress and part giant museum display, the variant was invented after 1880 as it became increasingly difficult to predict costs or attendance. Targeting particular exhibitors and audiences allowed organisers to control and differentiate exhibitions better in an increasingly crowded marketplace (plate 262). The major British single-subject international exhibitions were:

1865 Birmingham, Metals and Trades Exhibition
1882 Edinburgh, International Fisheries Exhibition
1883 London, International Fisheries Exhibition
1884 Edinburgh, International Forestry Exhibition
1884 London, International Health Exhibition
1885 London, International Inventions Exhibition
1886 London, Colonial and Indian Exhibition
1892 London, International Horticulture Exhibition
1894 Manchester, British and Colonial Industrial Exhibition
1900 London, Women's International Exhibition.

The third type was brilliantly vulgar. Many exhibitions after 1880 were, first and foremost, spectacles or festivals. They were used to commemorate events or to celebrate specific places, often owing their existence to a proud city council, to chambers of commerce or to enthusiasts for monarchy. This category offered, in many respects, an official enhancement of the timeless concept of the fair. With added pomp and ceremony, it was a mechanised and urban vehicle for traditional collective pleasures. Largely because of this it was susceptible to exploitation by shrewd entrepreneurs from the wider world of entertainment. This kind of exhibition was where Court and army met with music hall and circus: where Queen Victoria met Buffalo Bill (plate 263).[5] The exhibitions played a part in the growth of the mass-tourist industry, entrepreneurs using and even creating events to promote travel and consumption. The following festive exhibitions were held in the period:

1887 Liverpool, Royal Jubilee Exhibition
1887 Manchester, Royal Jubilee Exhibition
1887 London, The American Exhibition
1888 London, The Italian Exhibition
1890 London, The French Exhibition
1891 London, The German Exhibition
1897 London, Imperial Victorian Exhibition
1898 London, Universal Exhibition.

262 Official Catalogue for the International Fisheries Exhibition, 1883. Collection Paul Greenhalgh. Specialist, single subject events became a common feature within the British exhibition tradition during the last quarter of the century. The Fisheries Exhibition was one of a sequence of four held between 1883 and 1886 in South Kensington.

263 William Cody at the
Earls Court Exhibition.
Plate from Charles Lowe's
*Four National Exhibitions in
London and Their Organiser.*
(London, 1892). Collection
Paul Greenhalgh.
William Cody, as 'Buffalo Bill',
appeared with his troupe at
Earls Court Olympia in 1887.
Entertainments and education
mingled freely in some sites,
and entrepreneurs like
Cody and P.T. Barnum were a
frequent presence. Olympia
remains a major venue for
fairs and exhibitions.

All three types had their equivalents abroad. Between 1851 and 1901, several hundred million people attended an international exhibition somewhere in the world. Britain sent official contingents to many of these and individual manufacturers took stands and pavilions to many more. During Victoria's reign there was a significant British public or private presence at the following foreign or imperial exhibitions:[6]

1853	New York, Exhibition of the Industry of All Nations
1855	Paris, Exposition Universelle
1865	Dunedin, New Zealand Exposition
1866	Melbourne, Intercolonial Exhibition
1867	Paris, Exposition Universelle
1873	Vienna, Weltaustellung
1876	Philadelphia, Centennial International Exposition
1878	Paris, Exposition Universelle
1879–80	Sydney, International Exhibition
1880–81	Melbourne, International Exhibition
1883	Amsterdam, International and Colonial Exhibition
1883–4	Boston, American Exhibition of the Products and Manufactures of Foreign Nations
1883–4	Calcutta, International Exhibition
1884–5	New Orleans, The World's Industrial and Cotton Centennial Exposition
1885	Antwerp, Exposition Universelle
1887–8	Adelaide, Jubilee International Exhibition
1888	Barcelona, Exposició Universal
1888–9	Melbourne, Centennial International Exhibition
1889	Paris, Exposition Universelle
1889–90	Dunedin, New Zealand and South Seas Exhibition
1891	Kingston, Jamaica International Exhibition
1893	Chicago, World's Columbian Fair
1894	Antwerp, Exposition International
1894	San Francisco, California Midwinter International Exposition
1894–5	Hobart, Tasmanian International Exhibition
1897	Brussels, Exposition Internationale
1897	Guatemala, Exposición Internationale
1897	Nashville, Tennessee Centennial and International Exposition
1897	Stockholm, All Männa Konst-och Industriutställingen
1900	Paris, Exposition Universelle
1901	Buffalo, Pan-American Exposition
1901	Calcutta, Indian Industrial and Agricultural Exhibition.

The scale of the enterprise becomes apparent. In the last quarter of the century, when exhibition activity peaked, the British were participating in an average of two events per year and in some years they created as many as six displays of some substance.

Participation abroad was in many respects more remarkable than the effort at home. Industrial manufacturers and individual producers of all kinds would be orchestrated into national contingents in the search for export trade. Sizable collections of paintings, sculptures and architectural models, often from private collections, were sent to hang in vast temporary galleries in order to guarantee the collective national cultural standing. The five Paris exhibitions attracted the largest showings, but Philadelphia (1876), Chicago (1893), Antwerp (1885 and 1894) and Brussels (1897) all had large numbers of major historic and contemporary works. In the last quarter of the century the British, alongside other nations, built endless numbers of pavilions in what current thought believed to be the national style, and often erected additional structures to present India and Empire.

At home, the two most important temporary exhibition sites in Britain were at South Kensington in London and Kelvingrove Park in Glasgow. During (and after) Victoria's reign, the two cities regularly staged events of national and international importance and, significantly in the present context, both consolidated this legacy by becoming sites of major permanent museums.

The 1862 exhibition was the largest of nine events held in South Kensington. While in most respects it performed well, it was beset by drawbacks which prevented it from being an unequivocally popular runaway success. The most visible and tragic drawback came just before the opening. Prince Albert, who was closely associated with the exhibition medium generally, and South Kensington in particular, died in 1861. The opening ceremony in 1862, held in the absence of the grieving queen, was dogged by a collective melancholy:

Of the hundreds and thousands who lined the streets and thronged the building, few forgot the Prince by whom the great work of the day was encouraged and helped on – who sowed, but reaped not; and many were the kindly and regretful words spoken of the Royal lady who would have been so gladly welcomed, and who yesterday was so sorely missed.[7]

The Albert Memorial was later placed at the heart of the site of the Great Exhibition site.

The 1862 building made the exhibition few friends. Universally and hilariously recognised as being mediocre (plate 259), an Irish critic gave a consensual view that 'charity can go a long way, but its widest stretch will not hide from our view the essential ugliness of Captain Fowke's International Bazaar'.[8] The Times noted 'that the exterior is very ugly no one denies, nor ever attempted to deny', and cited an extraordinary letter received from an irate Frenchman:

Sir, – I am told that . . . you go to ask our Emperor to open your exhibition. I hope in charity you will bring him into the building blindfolded, and so he shall save the miserable indignation we have suffered from looking at your horrid building . . . We mock ourselves at you when we see from the park the big Dome built on boards and half hid by the big shed.[9]

CLEARLY NOT A CRYSTAL PALACE

Architectonic problems accepted, in several respects the 1862 show was more important for the exhibition medium than its forebear. While maintaining a commitment to science and industry, the exhibition organisers capitalised on initiatives taken in Dublin (1853) and Paris (1855) by considerably increasing the sections devoted to the fine arts. Large-scale Salon-like showings of painting, sculpture and architecture surveyed contemporary works and the British school from Hogarth onwards. The exhibition itself was bedecked with dramatic decorative objects and ensembles. The huge polychrome metal screen, designed by Gilbert Scott for Hereford Cathedral, for example, was shown before being carried off to the West Country (plate 264). Displays from actual and informal Empire lent the interior spaces the feeling of an exotic treasure house. India, South East Asia, the Far East, the Arab countries, Africa, the Americas and Australasia sat alongside the European nations, all of them using decorative displays to differentiate themselves. This heady, promiscuous eclecticism provided a model to others of its kind. While the whole was very much in keeping with the development of the relocated Crystal Palace, it differed noticeably from the more utilitarian and even ethical aims and atmosphere of the 1851 exhibition. Some recognised the shift and saw it as a mistake. One writer read an unacceptable decadence into the whole:

It is no temple of 'Art Divine', which you are exploring, but rather an immense shrine set up to the great god, Mammon, and crammed with offerings little more lovely than the many-sized images in a Burmese temple. Works of money-making industry, masterpieces of inventive oddity, wonders of prosaic usefulness, or lavish adornment, first court the eye; while tokens of purer taste and a finer culture, gleam forth faintly here and there, or await discovery in far corners.[10]

264 Hereford Screen. Wrought and cast iron, 1862. V&A: M.251–1984. Displayed at the 1862 exhibition in London, the screen was then sited in Hereford cathedral. It is now in the collections of the V&A.

He was unfairly harsh, but the materiality of the whole, as expressed through the scale, quantity and the use of statistics to impress, was a notable feature of the enterprise. A giant gilded pyramid representing the quantity of gold mined in Australia during the previous decade especially annoyed the critic: 'Where else, save in a temple of Mammon, could this piece of unrivalled Mammon-worship find any room, much more a place of honour?'[11] The answer to this rhetorical question was to be in the very large numbers of international exhibitions after 1862. Internationally, exhibitions were set to become boastful displays of exotica, amid which the intellectual, educational and even commercial elements had to fight to maintain a profile.

The accusation of Mammon-worship could not be made of the exhibitions held at the South Kensington site between 1871 and 1874. The practice of erecting temporary buildings and maintaining them for successive annual seasons was a peculiarly English phenomenon in the period.

The four annual exhibitions were marked by their dryness and lack of spectacle, to the point at which the absence of drama could be construed to be a conscious policy. Decadence had been replaced here, if in no other international events, by the ethic of the classroom. The emphasis throughout the series was on education, cultural and commercial development. Concern for the improvement of British taste – a constant theme of the South Kensington Museum which adjoined the site – was ever present. Manufacturers were encouraged to produce objects in good taste, and consumers had to learn how to identify them. The official guide of the 1872 exhibition was self-congratulatory in this regard: 'Exhibitions in modern times . . . have, to a considerable extent, exorcised the evil spirits of ugliness and deformity which once existed in our homes.' There was no need, the writer felt, to identify:

the wonderful advance of decorative art in all branches during the last twenty years, which is undeniably traceable to the seeds sown by the system of International Exhibitions – seeds which have fructified and ripened in the various national displays in this country, where the power to compare object with object has wrought such incalculable benefit.[12]

A decade later the South Kensington site played host to a series of single-subject exhibitions, beginning with the International Fisheries Exhibition in 1883. This was followed by the themes of Health, Inventions and, finally, India and the Colonies. The last of these signalled a return to dramatic display and romantic subject matter. It was by far the most spectacular and popular of all series exhibitions, boasting an attendance of 5.5 million.

The Colonial and Indian Exhibition explored what was by far the most important theme in temporary exhibitions, that of Empire, and it did it with a completeness that marks it out as a seminal cultural event of the later nineteenth century. The celebration of Empire and the expression of a competitive pride in the face of rival European imperialisms had become a key characteristic of the last two decades of Victoria's reign. The Times listed the aims of the exhibition as being to display all aspects of the colonial empire:

We shall have the history of the colonies illustrated; their geography; their varied ethnography; their natural products, mineral, vegetable and animal; their industries, agricultural, manufacturing, artistic;

their commerce, its wonderful development and manifold character; their political and social life; their literature, art, and architecture. The commission has wisely left to each of the individual colonies the arrangement of its own exhibits.[13]

Commentators noted that the Indian display was five times larger than any previously attempted, and it was also widely accepted that the economic, social and technological character of the Indian Empire was better described than before. Similar points were made about the displays of most other colonial possessions. But the exhibition as a whole, and India specifically, felt like a treasure house, leaving the spectator, in the words of one commentator, 'dazzled and bewildered by the variety and beauty of the wares displayed' (plate 265).[14] Hundreds of objects and architectural structures were given to museums all over Britain after the close of the exhibition.[15]

Much of the most interesting and spectacular exhibition activity took place outside of London. Dublin, capital city of an Ireland still very much under British control, held two striking events. The first of these was held in an impressive, domed Crystal Palace; as noted above, it was the first to develop a substantial fine-art section. The industrial Midlands and North stepped regularly into the fray with limited but nevertheless loud events. Manchester staged the enormous Art Treasures Exhibition in 1857, the most impressive gathering ever in northern England of European works of art (see chapter 8). In 1865 Birmingham celebrated its vast metal industry and in 1887 Manchester and Liverpool held events to mark the queen's Golden Jubilee year. The Liverpool organisers shrewdly purchased several of their buildings from the organisers of the 1885 Exposition Universelle in Antwerp, reconstructing them to great effect on Merseyside (plate 266).

265 View of the Colonial and Indian Exhibition, London 1886. *Illustrated London News* (17 July 1886). V&A: NAL.
The last of a sequence of single subject exhibitions that began with the Fisheries Exhibition of 1883 (with Health in 1884, Inventions in 1885). The Colonial and Indian was heavily attended.

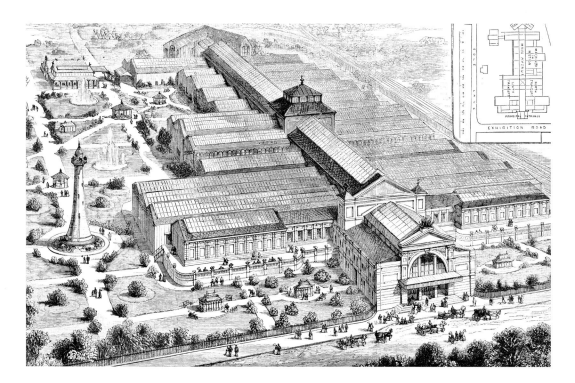

266 View of the Liverpool Jubilee Exhibition, 1887. *Illustrated London News* (8 May 1886). V&A: NAL.
This exhibition was the only foray into the exhibition medium by the city fathers of the great port.

In Scotland, Edinburgh hosted two single subject exhibitions before ambitiously – and very successfully – staging an *exposition universelle* in 1886. Launched and largely directed by the Merchant Society, the Exhibition of Industry, Science and Art was attended by 2,700,000 appreciative spectators.[16]

But Glasgow was, alongside London, the great city of exhibitions. During and after Victoria's reign, 'the second city of empire', as it fashioned itself, gave over considerable funds to the staging of events of impeccable international stature. Glaswegians had the means, the pride and the motivation to commit themselves to the vast enterprise of constructing a temporary city in order to inscribe their own idea of modern Scottishness within a global and imperial context. Alongside Barcelona, Antwerp and Brussels, Glasgow was a particular type of exhibition city, in which the presence of key ingredients made exhibitions likely, if not inevitable: fierce civic pride fired by a powerful ethnic identity residing within a larger imperial culture; a large population; a vast new industrial wealth enhancing a traditional cultural centre; an active port centred upon overseas and imperial trade; and a desire to develop the cultural dimension to add to the existing, largely industrial one. Civic rivalries were a major motivation: Glasgow vied with Edinburgh for the right to be thought of as the premier Scottish centre; and with Liverpool and Manchester for industrial and commercial supremacy. Improving on the efforts of all three of these cities, in both scale and quality, was an openly discussed aim of the Glasgow organisers.

The popular magazine *The Cabinet Maker and Art Furnisher* enthusiastically reported progress on the 1888 exhibition immediately before its opening:

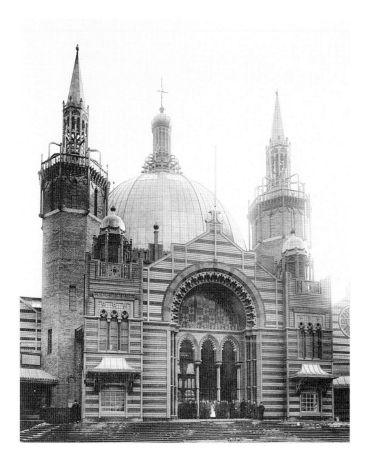

The exhibition . . . is fast emerging from its embryonic state, and it is announced to open during this month, the ceremony being performed by the Prince and Princess of Wales, accompanied by a large party. The guarantee fund is said to already amount to £300,000, and exhibits are being received on a very extensive scale. The leading manufactures in Glasgow are hard at work making every effort to promote the success of their exhibition, and the prospects generally are decidedly pleasing . . .[17]

Indeed they were. The exhibition covered sixty acres of land at Kelvingrove Park. The buildings, designed by architect James Sellars, seemed barely appropriate for a grand, northern industrial centre. Yet he felt able to justify his design on functional grounds. He explained the choice of an oriental style 'not only from its suitability to the purpose, but because it lends itself readily to execution in wood'.[18] He might have added that experimentation with Arabic and Byzantine forms was currently fashionable (plate 267).

267 View of the Glasgow Exhibition, 1888. *Art Journal* supplement, 1886. V&A: NAL.
Staged in the same year as major exhibitions in Barcelona, Brussels and Melbourne, the Glasgow exhibition was deliberately designed to emphasise the cultural dimension of the great industrial and urban centre.

The profits from the exhibition were given over to the cause of art, display and education, with the founding of the Kelvingrove Museum and Art Gallery. The foundations of the museum were laid in 1897 and a second major international exhibition was proposed in the same year to accompany its opening.

The resultant exhibition of 1901 was far grander in feel than 1888. The pomp and drama of the main building, though in many respects less interesting than its peculiar and unsure forebear, exuded confidence (plate 268). An attendance of 11,497,000 made it by far the most successful staged so far in Britain, and one of the most heavily attended anywhere up to that date.

While there were considerable sections given over to industry and the sciences at both Glasgow exhibitions, they can be seen principally as celebrations of the arts and humanities, with a specific agenda to add complexity to the dominant image of Glasgow as a powerhouse of trade and industry. Fabulous displays of art from many nations, with Scotland specially showcased, attracted admiration all over Europe, and an interesting insistence on emphasising the pre-industrial heritage of the city gave the whole a sense of place rooted in tradition. At both exhibitions a reconstruction of the Bishop's Castle of Glasgow housed a Scottish History and Archaeology Section.[19] Both exhibitions, and those that followed them, were thus very much concerned with the status of Glasgow.

At the same time these events showed a greater willingness to include elements of the more radical movements in art and design than any other British events. Glasgow wanted to feel old, but it also wished to maintain a modern edge. While the authorities in 1901 were not quite brave enough to appoint the city's greatest artistic son, Charles Rennie Mackintosh, as site architect, his colleagues and followers in the Glasgow School could be found in various places. And the exhibition bore witness to the fact that the Glasgow painters were at the leading edge of British modernity.

South Kensington and Kelvingrove Park moved from being sites for temporary extravaganzas to become homes for grand permanent museums. Museums in the modern sense were indeed invented in the period. Alongside developments in Glasgow and London, the great municipal institutions (occasionally starting out as private foundations) that remain the backbone of the British museum system largely appeared in the later Victorian period: Birmingham Museum and Art Gallery (founded 1867); the Bowes Museum, Barnard Castle (1869); Harris Museum, Preston

268 Postcard for the Glasgow Exhibition, 1901. Collection Paul Greenhalgh. This exhibition established Glasgow as the only alternative British exhibition centre to London. Realised partly from the profits of the 1888 exhibition, and fired by the desire to make Kelvingrove Park into a permanent site of cultural activity, the exhibition witnessed the opening of the Kelvingrove Museum.

(1877); the Mappin Art Gallery, Sheffield (1887); Bolton Museum and Art Gallery (1884); Bury Museum and Art Gallery (1897); Cartwright Hall, Bradford (1898); and dozens of others opened their doors for the first time.[20] And as they did so, the myriad complexities surrounding public displays that are still current came into being. Not the least of these was the relationship of museums to temporary exhibitions. The two shared a common heritage, but early on differences between them began to emerge.

The South Kensington site provides numerous examples, between 1852 and 1874, of what would become archetypal museological problems. After the closure of the Crystal Palace, the issues arose as to what exactly exhibitions were for, whom they were for, and who was to pay for them. A related issue involved questions about what was to happen to their buildings. A famous debate surrounded the erection of the Crystal Palace in Hyde Park.[21] A less well known, but in many ways a more important argument concerned the fate of the Crystal Palace after the exhibition closed.

The immense popularity of the building led to a campaign for its preservation on the Hyde Park site. Joseph Paxton, its architect, declared that 'a great question must very shortly be decided, viz., whether the Crystal Palace is to be preserved or destroyed'.[22] He was somewhat disingenuous, as he was well aware that a clear condition of its erection in Hyde Park was that it was to be removed at the close of the exhibition and he himself had long been investigating new sites for the building. Nevertheless, he was not alone in his enthusiasm and a hastily convened Crystal Palace Preservation Committee organised meetings and demonstrations, including one on 3 April 1852 at which over 70,000 people gathered at the building to show their support for its survival there. At a public meeting of 7 April it was moved 'that it is eminently desirable that the Crystal Palace should be preserved upon its present site, for purposes of public utility and recreation'.[23]

Parliament debated the issue on 27 April 1852 and determined that it should be removed. But the objections continued. At a meeting on 15 May the campaign took on a political dimension, with the suggestion that the Palace embodied the aspirations of 'the industrial classes', that their 'moral influence and power [had] been greatly extended by the memorable display of last year', and that its removal would cause 'those classes feelings of discontent'.[24]

The Palace was perceived as belonging in the public domain. Public pleasure and education, or 'instruction, refinement, and rational amusement',[25] were understood to be paramount: 'The Crystal Palace should be preserved on its present site for the instruction and recreation of the people.'[26] However, it was never suggested that government was materially responsible for the Crystal Palace. Paxton, alongside all other campaigners, understood the venture to be to do with private, not government, funding: 'The self-supporting principle upon which it is proposed to effect the preservation of the Palace, is the same as that upon which the Great Exhibition was so successfully carried out.'[27]

The Crystal Palace Company, in which Paxton was a lead player, raised £500,000 of capital and purchased the Palace from Fox & Henderson, the contractors who had initially created it. After a considered search, land was purchased at Sydenham, in south London (plate 269), and on 5 August 1852 the re-siting of the Palace began. As part of the business plan, the Crystal

Palace Company invited the Brighton Railway Company to become investors, and a proposal to move the Palace to Brighton was briefly considered. The rail company ultimately declined involvement, as key principals were unconvinced that the success of a one-off event could be repeated on a week-by-week basis. They believed the numbers of visitors necessary to pay for the upkeep of the building and the creation of new displays was too great. Moreover, they suggested that if the Palace would not work in Brighton, it had less chance of success in an unfashionable part of south London. For them it was bad business and their view exemplified the inevitable tension between altruism and economics. The queen eventually opened a remodelled and far larger Palace at Sydenham on 10 June 1854 in the absence of the Brighton Railway Company.

The new Crystal Palace curiously combined cultural, educational and recreational agendas. In some respects a continuing exhibition, with exotic gardens and 'Winter Palace', a hall for musical performances and political events, and a place for popular entertainments, sports and other events, it was to hang awkwardly (though successfully and popularly) between the new orthodoxies of public museums and commercial entertainment until it burnt down in 1936.

Populism was an issue at the 1862 exhibition with regard to the size and demographic spread of the audience. The charge of one shilling, lauded then and later by historians as a price designed to bring in the masses, was widely felt to be too expensive. It could be seen as a means of preventing the lowest orders from gaining access. Robert Bowley, general manager of the relocated Crystal Palace, noted that 'to induce the *really* working classes, VERY MODERATE outlay is necessary.'[28] The French had a standard charge of one franc, but had also created a far lower special fare of four sous at the Exposition Universelle of 1855, a price over two million people had taken advantage of. Bowley, suspecting that the organisers were attempting to use entrance charges to control the types of visitor to the exhibition, also raised issues around provisions for travel to the site:

It is not, however, to the price of admission that attention should be solely directed, but to that more important, because far wider question, the difficulty of access by the working classes to the 1862 Exhibition. No exhibition in England can be properly developed which does not afford the opportunity for day excursions from all parts within reach of six or seven hours railway travel. This the 1862 Exhibition, with its present prospects will fail to effect, and it may be safely affirmed, that this alone will prevent many hundreds of thousands, probably millions, from visiting it.[29]

A gap of one and a half miles between the site and the railway station was also, in his view, a disadvantage to potential poorer visitors.

A decade later in 1871, pessimism about attendance was voiced from the opening of the first of the series of international exhibitions. An article from *The Times* suggested that:

The fancy for Exhibitions on the part of the public – the interest in industry for its own sake – has decreased . . . Zeal for the peaceful arts has cooled, and they now occupy the thoughts only of those who profit by them. The necessaries, the luxuries, the ornaments of life have their market, but people think of them only as they want them, and care little to make heroes of their producers and a worship of their production.[30]

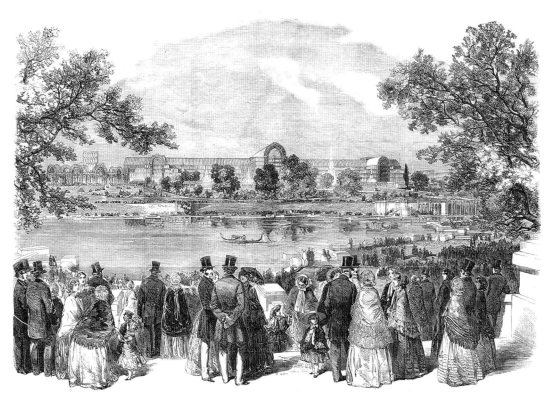

269 'The Crystal Palace at Sydenham, As It Will Appear When Completed'. *Illustrated London News* (10 June 1854). V&A: P.P.10.1854.

The statement was scarcely based on evidence of exhibitions elsewhere, where many millions were still happily flocking to their sites. Rather, the writer pointed to the fact that the organisers of the South Kensington exhibitions had failed to analyse and then provide for their potential audience. In consequence, they progressively lost it. The aim had been to hold ten exhibitions, finishing in 1880. In the event, the enterprise ran out of steam – and visitors – after the fourth year. Attendance dwindled from an acceptable 1,142,000 in 1871 to a barely respectable 467,000 in 1874.

As exhibitions and museums grew in numbers, only certain kinds of display, on an appropriate scale, with a large communications support system and a formidable marketing input, could guarantee an audience of the greatest size. Exhibitions may have spawned museums, but they were not the same thing. The exhibition had to survive in a harsher commercial world, while the museum was generally less driven by the need for vast attendances cherished as a cultural cabinet of national and international treasures. In our own times, museums have to a considerable extent returned to the attendance and fund-driven ethos of the international exhibitions, making effective communication and marketing systems a vital element of museum life once more.

The destruction of the Crystal Palace was tragic not simply because a seminal architectural work was lost, but because it was, as the container of the Great Exhibition, a most potent symbol of Victorian modernity (see chapter 7). As a physical presence it proved to be ephemeral, but its effects are all around us. The exhibitions and museums that followed in its wake have played an enormous role in shaping world culture. In many respects the international exhibitions sum up the age. They were highly complex mechanisms that did not owe their existence to any one driving force – to altruism, profiteering, propaganda or pride – but to all these things simultaneously.

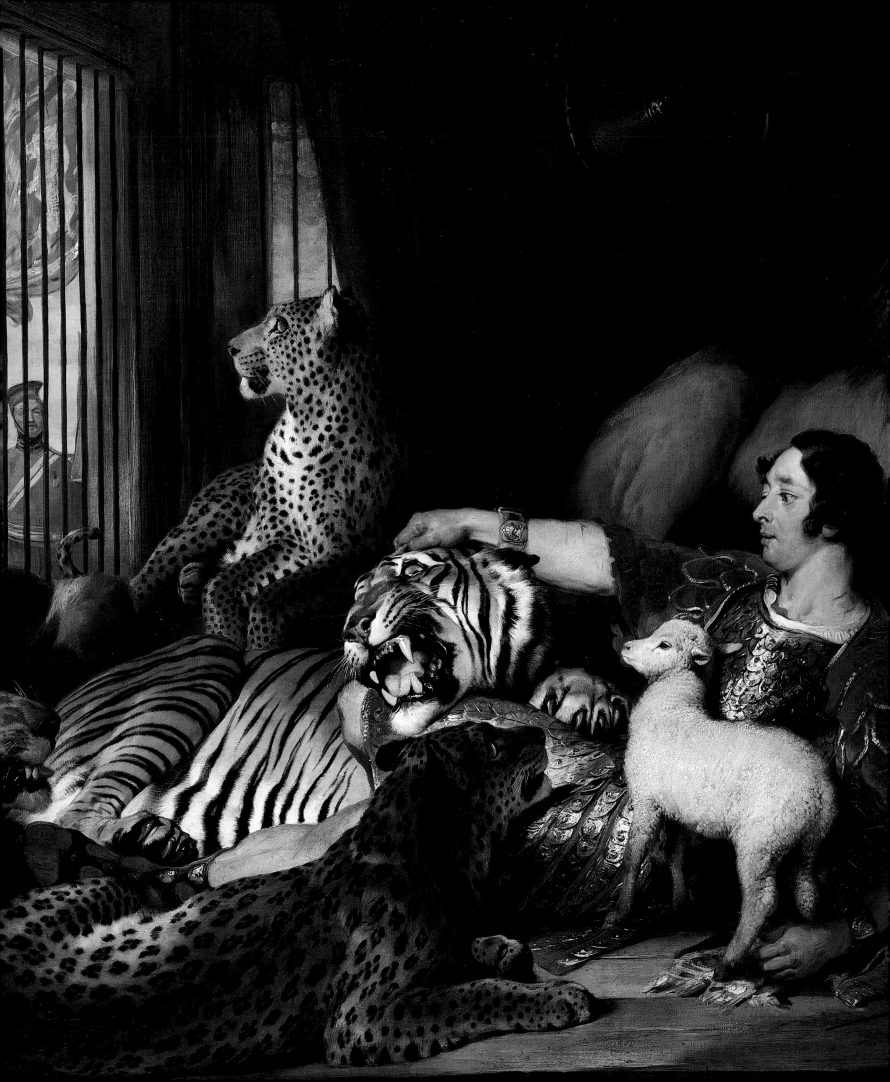

THE NATURAL WORLD

HARRIET RITVO

The Victorians were the inheritors of a period which had seen great changes in attitudes toward the natural world. At the end of the seventeenth century, as for many preceding centuries, most Europeans understood their relationship to nature as essentially passive, whether its predominant tone was admiration or (more frequently) fear. By the middle of the nineteenth century confidence and self-assurance – even cockiness – had become the rule. No longer, or at least not primarily, looming as a threat or a challenge, nature could be made to serve even such trivial human purposes as decoration (plate 270) and entertainment (plate 271). To some extent this transformation reflected material alterations – among others the harnessing of the power of coal, the emergence of modern industrial methods and organisation, and the rapid improvements in transportation and communication. Impressive as these developments are in retrospect, however, and multiply impressive as they seemed while underway, they are insufficient to explain such a wholesale reorientation. That is, although technology had advanced vigorously on a staggering variety of fronts (and, of course, continued to do so), the forces of nature could hardly have been considered effectively conquered. Distances remained vast, wildernesses intractable, natural catastrophes overwhelming and epidemic diseases lethal and swift in their courses.

But if the Victorians lacked complete physical control of these powerful phenomena, they had other ways of comprehending the natural world. One striking consequence of centuries of increasing access to remote and exotic ports had been an exponential growth in the apparent

270 C. W. Cope, *Palpitation*. Detail. Oil on canvas, 1844. V&A: FA52.

271 Sir Edwin Landseer, *Isaac van Amburgh and his Animals*. Detail. Oil on canvas, 1839. The Royal Collection © HM Queen Elizabeth II.
The American lion (and tiger and leopard) tamer Isaac Van Amburgh enjoyed an enormous vogue in the first part of Victoria's reign. His mastery proved that even the king of beasts had his share of intelligent docility.

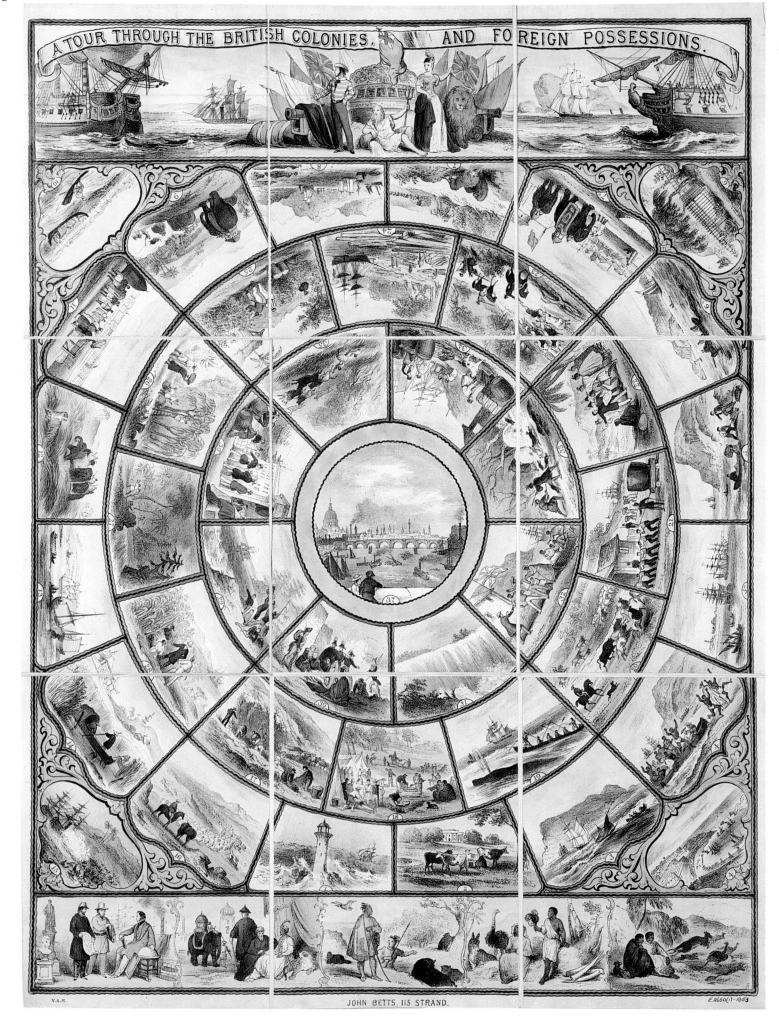

A TOUR THROUGH THE BRITISH COLONIES, AND FOREIGN POSSESSIONS.

V.A.M.

JOHN BETTS, 115 STRAND.

E.2650(I)-1953

272 Board game: *A Tour Through The British Colonies and Foreign Possessions*. 19th century. V&A: E.2650–1953.

diversity of nature. Ships returned from their voyages laden not only with official or commercial cargo, but also with information. This information took various forms, of which exotic animal, plant and mineral specimens were the most palpable. Beginning in the eighteenth century, the profusion and variety of these novelties presented naturalists with a daunting challenge. The newly demanding scientific standards of the Enlightenment (natural history was then, as it is still, struggling with a sense of inferiority with regard to natural philosophy) made it necessary to do more than provide these previously unknown objects with labels. Each specimen had to be located within a system of classification comprehensive and rational enough to provide it with a uniquely appropriate position, and flexible enough to offer similarly appropriate positions to the further surprises that the future inevitably held in store.[1] Nature could thus be caught in an analytic web, subjected to an intellectual control that was metaphoric and insubstantial, but none the less powerfully suggestive, even exhilarating. And this figurative grasp extended beyond these chips off the natural block to embrace their larger context, the globe itself (plate 272).

The association of knowledge, especially abstract and systematic knowledge, with control was practical as well as rhetorical; natural history was intertwined with more explicit modes of exercising authority. The classificatory web closely resembled the web that colonial officials used in their analogous efforts to consolidate political influence over large and refractory swathes of alien territory. Indeed, the Empire was often read as 'nature' in opposition to the 'culture' or 'civilisation' of the mother country, and, in the sparsely populated imperial bureaucracy, naturalists and administrators tended to be the same individuals wearing different hats. Where, as was frequently the case, a few officials were charged with governing large populations or land areas, the quotidian basis of their rule was not physical force but information. One of the most effective ways to consolidate political sway over a territory was by abstracting its essence through a survey or catalogue of its attributes, including topography, climate, mineral resources, flora and fauna, human population and commercial products.

Much of this information could be presented most efficiently through mapping (plate 273). The relation of national purposes – political and commercial, as well as military – to cartographical research led to naval sponsorship of voyages of exploration, which often also carried official or unofficial naturalists. Thus the main purpose of the *Beagle* voyage on which Charles Darwin sailed in the 1830s was to map the South American coast; a decade later assistant surgeon Thomas Henry Huxley ministered to the crew of the *Rattlesnake* on a similar mission off New Guinea. Ashore the connections were even closer. Thus, Britain's most valuable colony was the site of the most sustained and extensive exercise in imperial cartography. Begun in eighteenth-century Bengal, the Survey of India ultimately encompassed the entire subcontinent and lasted through the nineteenth century. In addition to offering a detailed representation of Indian geography, this project made a range of other points. It demonstrated British political interest in increasing chunks of Indian territory, the ability of British science to master the topographical and mathematical challenges posed by the Indian terrain (both especially severe in the mountainous north), and the economic power that could subsidise such an elaborate enterprise. The fact that the maps recording its results, which were collectively known as the *Atlas of India*, were published in London implicitly located intellectual as well as

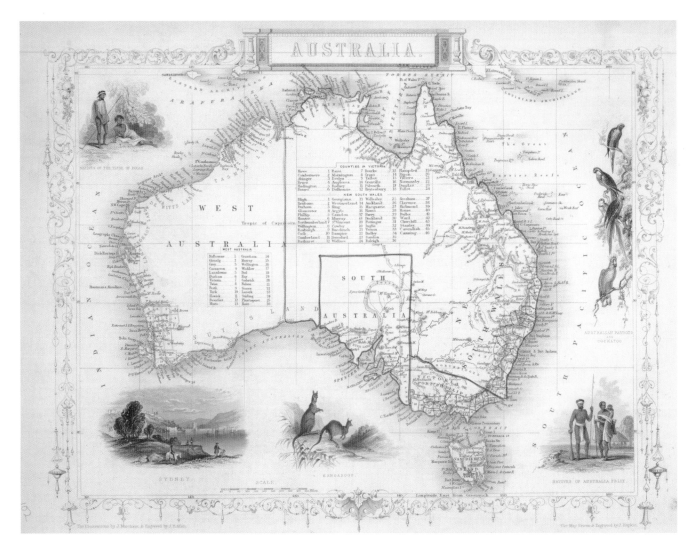

political authority over the landscape of India in the metropolis, where it could be exercised by policymakers acquainted only with these powerful abstractions.[2] And this sense of comprehension could be vicariously shared by the much larger audiences for popular atlases and schoolroom maps. They saw the enormous and diverse landmass represented on a single map, perhaps of the same dimensions as were allotted to maps of the United Kingdom and other European countries, and amalgamated into a single unit by the agency of imperial administration and imperial information management.

Administration was not exclusively, or even primarily, a long-distance affair. Territory at home equally required analysis and comprehension; indeed, metropolitan cartography provided the model for many colonial projects. The Ordnance Survey was established in response to eighteenth-century military needs (the invasion of Scotland and the later defence of the English coast against feared invasion from France), but it was elaborated to meet a variety of civilian functions in the nineteenth century: assessing taxes, defining boundaries, planning the routes of railways, implementing sanitary reform and other social legislation. As the Royal Geographical Society supported the national push to map the remote corners of the globe,[3] so other special-interest groups supplemented official cartographic efforts at home. For example, when Victorian

273 Map of Australia, from *Tallis's Illustrated Atlas and Modern History of the World: Geographical, Political, Commercial and Statistical*, ed. R. Montgomery Martin (London, 1851).
This map of Australia from the popular *Tallis's Illustrated Atlas* combined two forms of representation: technologically up-to-date cartography, showing both the extent of the territory and the penetration of European settlement, and pictures that evoked an earlier mapping tradition.

geologists identified and sequenced the strata underlying the superficial topography of Great Britain, they mapped both the deep history of the island and the likely location of coal seams and other mineral resources. At the suggestion of Henry de la Beche of the Geological Society, the Geological Survey of Great Britain was attached to the Ordnance Survey in 1839.[4]

On a less rarefied and abstract level, interest in the natural world was also widespread. The task of collecting new botanical, zoological, and geological information, and – often much more taxing – of managing it after it had been collected, was shared among many individuals and institutions. Even so resources were sometimes strained to the breaking-point. When Darwin returned from the *Beagle* voyage in 1836, he readily found geologists eager to accommodate his rocks, but had a harder time identifying specialists willing to store, classify and describe his zoological specimens.[5] The Linnean Society incurred a heavy debt, under which it laboured until 1861 (more than three decades) in order to purchase and preserve Linnaeus's library and herbarium. And the burden of novelty grew heavier as the century wore on. By the late nineteenth century more than one thousand new genera of animals were being described each year, a number characterised in *Nature* as 'simply appalling'.[6]

Finding a physical home for specimens was, furthermore, only the first step. They also had to be identified – either as belonging to a category with which naturalists were already familiar, or as representing the first instance of a species yet undiscovered. Either kind of assertion was difficult to make, considering how many intrinsic variables might be involved (age and sex, for two obvious examples), not to speak of variables introduced by the skill and preservation techniques of the collectors, by no means all of whom were trained, or even serious naturalists. During the nineteenth century procedures for preserving specimens and for recording the circumstances in which they had been collected became better defined and more widely disseminated. Thus, late Victorian collectors would have been unlikely to repeat the young Darwin's lapse, when he failed to note on which of the Galapagos Islands he had gathered each of his finches (fortunately several of his more careful, though less inspired ornithological shipmates were able to repair his omission after he realised its potential importance).[7]

Of the societies founded in response to the interests of serious and casual naturalists, the most comprehensive in several senses was the British Association for the Advancement of Science (BAAS). It was subdivided into sections that covered the range of the physical, biological and social sciences; at its annual meetings, which attracted heavy press coverage, members of the lay public rubbed shoulders with distinguished specialists. Some of its publications also suggested the breadth of the Association's audience. For example, the object of a handbook published in 1874 was to 'promote accurate anthropological observation on the part of travellers, and to enable those who are not anthropologists themselves to supply the information which is wanted for the scientific study of anthropology at home'. Novice observers were supplied with several series of questions that needed to be answered about any 'modern savages' that they encountered, as well as colour charts to help with precise description of skin and eye tone.[8]

Nevertheless, the BAAS existed primarily to serve the interests of élite naturalists, and this was also the case with most of the more specialised national (that is, metropolitan) societies. Catering to less exclusive constituencies were the city and county natural history societies

scattered throughout the country. These organisations were more apt to admit women than were the metropolitan societies (the London-based Botanical Society was a significant exception, as was the Zoological Society),[9] as well as reaching lower down the social scale. Field clubs, whose activities emphasised expeditions into the countryside rather than the presentation and publication of learned papers, were particularly catholic in their membership.[10] Local naturalists' groups often collected and studied the zoology, botany, geology and antiquarian history of their immediate area in collaboration with a neighbouring museum. The Cardiff Naturalists' Society, for example, was founded specifically to provide local specimens for the Cardiff Museum.[11]

Such geographic limitation was considered particularly appropriate for provincial collections, as well as for collections associated with schools, but distinguished national institutions also attempted to serve this relatively modest audience. The British Museum gave special attention to native botanical and zoological productions, seeking them as enthusiastically as it did the most exotic specimens and displaying them more comprehensively. Among its magnificent and varied collections, the exhibit of British animals proved disproportionately appealing to humbler visitors, piquing the curiosity of the ignorant and supplementing the field observations of veteran naturalists, who often came to discover the scientific names of specimens they had acquired.[12] Indeed mastery of Linnaean terminology, whether derived from museum visits, or from field-club meetings, or from the study of hard-to-come-by books, could certify the expertise of working-class naturalists, and thus help bridge the gap that separated them from other aficionados.[13]

The pleasures of natural history were also available on an individual basis. The study of botany in particular had traditionally appealed to women, whose access to the world of public learning was limited. Women were active producers as well as consumers of the botanical books and periodicals, often beautifully illustrated, that began to appear in the late eighteenth century.[14] By the 1830s the market for natural history publications was strong enough to support the first specialist booksellers, as well as several elaborate and sustained publishing projects.[15] For example, William Jardine launched the forty-volume *Naturalist's Library* in 1833; before the series concluded a decade later the standard edition size had been fixed at an impressive 4,000 copies, with particularly successful volumes selling twice as many.[16] From time to time the steady increase of this audience was jolted by a dramatic, if temporary expansion, as some facet of natural history caught the public imagination. Such fads could have devastating effects on the objects of fascination. In the 1850s Great Britain was seized by what has been called 'the great fern craze', which led collectors and the entrepreneurs who served them to plunder woodlands and hillsides throughout the island.[17] This was soon followed by a rage for collecting the inhabitants of tidal pools and displaying them in home aquaria, which resulted, according to Edmund Gosse, whose father's books had inadvertently sparked the passion for beach combing, in the destruction of 'these rock-basins . . . thronged with beautiful sensitive forms of life' by 'the rough paw of well-meaning, idle-minded curiosity'.[18]

Horticulture offered a way of interacting with the natural world whose popularity proved more enduring, as well as less drastic in its apparent consequences. It also effectively expressed continuing changes in public attitudes. The extent to which nineteenth-century gardens were occupied by plants that evoked the wildest and most exotic parts of the globe signalled the extent

to which those territories, like wild nature itself, had ceased to inspire uneasiness. Stay-at-home gardeners benefited as intrepid plant collectors explored the world's remotest corners. One hothouse gardening manual urged its readers to appreciate – even to savour – the sacrifices represented by the profusion and variety of nursery stock: 'Many highly intelligent and talented travellers have fallen victims either to the pestilential climate, the wild beasts of the country, or the treachery of . . . the equally wild aborigines.'[19] The North American introductions of the eighteenth century, such as rhododendrons and mountain laurels (*Kalmia*), were thus augmented by orchids and water lilies from the jungles of South America and alpine plants from the mountains of Africa and northern India. Because these new arrivals were awaited by a growing body of enthusiastic consumers, even obscure provincial nurseries stocked the latest and rarest exotics. So quickly and widely adopted were some nineteenth-century introductions that for the first time the content of the preferred flora began to determine the form of gardens rather than vice versa. In particular, gardeners increasingly designed their beds to exploit such vigorous subtropical introductions as verbenas, calceolarias and pelargoniums, which, unlike the traditional garden flowers that stopped blooming in mid-August, provided brilliant colour until they were killed by autumn frosts.[20]

If the eager incorporation of individual exotic plants or species into British gardens demonstrated a growing inclination to view the wild as a source of entertainment or relaxation, the grouping of foreign plants according to their geographical provenance may have signalled the more assertive side of this reconstituted relationship with nature. The practice of designating particular areas as Chinese and American gardens originated in the eighteenth century, as part of the elaborate landscaping of grand estates. By the Victorian period it had become possible for any middle-class hobbyist to construct a miniature empire in the back garden, representing at least the globe's temperate zones. And indeed the invention of the glassed-in Wardian case, which made it much easier to transport delicate plants, along with the popularisation of greenhouses, hothouses, and the habit of keeping potted plants indoors, meant that the domestic empire could easily expand to include a slice of the tropics as well.[21]

On their much smaller and more informal scale, private Victorian gardens seemed to echo the mission of the Royal Botanic Gardens at Kew, which was reorganised early in Victoria's reign as a 'great popular yet scientific establishment'. At that time Parliament constituted this century-old collection of exotic plants as a 'national garden', the centre of a network of subsidiary gardens at home and in the colonies that would 'aid the mother-country in every thing that is useful in the vegetable kingdom,' relating to 'medicine, commerce, agriculture, horticulture, and many valuable branches of manufacture', as well as providing botanical information on 'points connected with the founding of new colonies'. In the fulfilment of this charge, Kew Gardens supplemented its extensive outdoor plantings of hardy exotics with houses devoted to Australian plants, to palm trees, to exotic pines, to tropical water-plants, to orchids, to cacti, to rhododendrons and to plants from New Zealand, among many others – creating a horticultural synecdoche for the entire globe. And botanical imperialism was more than an official pursuit; it also attracted crowds of visitors (allowed to walk on the grass, but not to touch the plants), many of whom were doubtless in search of ideas they could apply back at home.

PLANT HUNTING

Plant-hunting became a key aspect of the Victorian fascination with exotic botany. The hunters travelled to Asia (mainly the Far East and the foothills of the Himalayas), southern Africa, South America, the Pacific and other corners of the globe to collect plants and trees. These were brought back, often in Wardian cases, to be propagated in nurseries or on great estates. The owners of estates and gardens vied with each other to display the most magnificent and exotic specimens, many being grown in heated greenhouses. Entire hillsides, as at Ingleborough in Yorkshire and in Argyllshire were planted with such exotica; catalogues were issued; and illustrated books and advice manuals were published. The fern fascination extended to the planting out of complete gardens with fern types from all over the world.

274 Advertisement for plant and fern cases, from Shirley Hibberd's *The Fern Garden* (London, 1869). Royal Botanic Gardens, Kew.

275 *Meconopsis Nepalensis – Yellow Himalayan Poppy*, from J. D. Hooker's *Illustrations of Himalayan Plants*, pl. 9 (London, 1855). V&A: 48 E 40.

276 *Petunia nictaginiflora . . .* Plate 47 from Mrs [Jane W.] Loudon's *The Ladies' Flower-Garden of Ornamental Annuals* (London, 1840). Royal Botanic Gardens, Kew.

277 View of the Botany Gallery of the Natural History Museum. Photograph, 1892

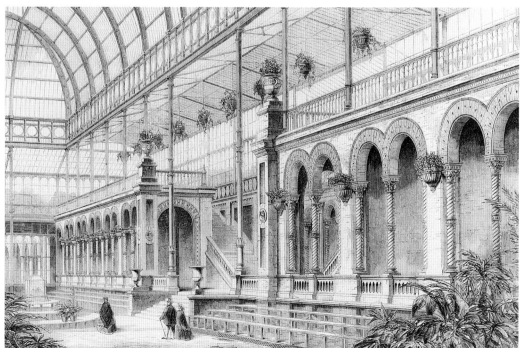

278 'Interior of the Conservatory; Horticultural Gardens, South Kensington'. *The Builder* (20 July 1861). V&A: PP.20.A.

279 Edward Lear, *Eyed Tyrse. Tyrse Argus*, from *Gleanings from the Menagerie and Aviary at Knowsley Hall*, pl. xvii (Knowsley, 1846). The 13th Earl of Derby, an influential patron of the London zoo in its early days, also owned the most extensive private menagerie of the 19th century. Its inhabitants included exotic deer, antelopes, llamas, zebras, lemurs and armadillos, as well as turtles.

Their snowballing numbers, which grew from just over 9,000 in 1841 to almost 400,000 in 1857, testified to the public appeal of wild nature when it was displayed in orderly, predictable and accurately labelled form.[22]

In its complex presentation of wild nature and human control, as well as in its simultaneous appeal to scientific, technical and popular constituencies, Kew resembled the other prominent national garden of its time. The Regent's Park menagerie (also known as the zoological gardens) of the Zoological Society of London similarly conflated scientific investigation and display with instructive and patriotic entertainment. Indeed, although it was operated by a private society (albeit significantly subsidised by the official donation of the site), the London Zoo had from its beginnings functioned explicitly as both a symbol and an agent of national power. It was founded by the very successful imperialist Sir Stamford Raffles, who was also the founder of Singapore. Among the rationales set forth in its early fundraising was Britain's shameful lack of an institution for the study and display of living exotic animals, despite being 'richer than any other country in the extent and variety of our possessions' while its neighbours could boast 'magnificent institutions' devoted to this purpose.[23]

280 Ernest Griset, *Tremendous Excitement at the Zoological Gardens at the Arrival of the Penguin*. Pen, ink and watercolour, 19th century. V&A: E.776–1948.

Any embarrassment on this score quickly faded, however. Only a few decades after opening its gates in 1828, the Regent's Park Zoo was pronounced 'the finest public Vivarium in Europe'.[24] Its inhabitants represented several different modes of British pre-eminence. After 1831, when William IV donated the collection of the centuries-old royal menagerie at the Tower of London to the Zoological Society of London, the royal family regarded Regent's Park as the appropriate home for animate acknowledgements of Britain's international position. Queen Victoria routinely diverted the 'stream of barbaric offerings in the shape of lions, tigers, leopards, &c. which is continually flowing from tropical princes' in this direction; and her eldest son followed suit, donating not only animals he accumulated when touring the outposts of Empire as Prince of Wales, but also gifts such as the five lions and two zebras he received from Emperor Menelik of Abyssinia on his coronation as Edward VII.[25] British regiments contributed exotic animals that had been captured in the field, or had been adopted as regimental pets. The well-stocked national zoo also illustrated the reach of British commerce, one reason being that the Hudson's Bay Company was among the most generous early contributors.

Considered abstractly, this pre-eminent menagerie staked a more rarefied claim to intellectual dominion (plate 280). The Zoological Society strove to realise in its collection the goal of the whole science of zoology, 'to furnish every possible link in the grand procession of organised life'.[26] The animals were conceived as part of an interrelated, graduated zoological series – as a living representation of the standard vertebrate taxonomical categories. When, as was the case at Regent's Park beginning in 1840, animals were arranged taxonomically – equines with other equines, for example, and felines with other felines – the exhibits showed nature kept in figurative as well as literal order.

The audiences that flocked to see captive animal displays – in provincial zoos and travelling menageries, as well as in the national showplace – enjoyed them in more immediate terms, while imbibing the underlying message. As it had been since the days when lone tigers and opossums were shown at fairs and in the back rooms of taverns, simple novelty provided a major enticement. In 1850, the year that Obaysch, the first live hippopotamus to be displayed in Europe since Roman times, arrived at Regent's Park, annual zoo attendance leaped from 168,895 to 360,402.[27] Uncanny familiarity was equally attractive, embodied in anthropomorphised chimpanzees and orang-utans, who wore clothes, sipped from cups and turned the pages of books. As post-Darwinian ideas of evolution by natural selection spread in the late nineteenth century, such displays both confirmed and parodied the proximity between humans and apes. The spectacle of dangerous animals behind bars – the more ferocious the better – was less subtle in its appeal; feeding time was especially popular. Zoo managers therefore felt a constant need to replenish their stock of big cats, which were inclined to succumb quickly when exposed to the damp northern climate.

The inclination of some menagerists to indulge public bloodlust by offering live prey to animals who required or appreciated it was watched carefully by the RSPCA and other humane societies, at least as concerned with the moral well-being of the human spectators as with the physical well-being of the animal sacrifices. The design of Victorian zoos provided many chances for more or less risky contact with the inmates. Some were unintentional side effects of the

proximity of pathways to cages and paddocks. Visitors, especially those equipped with umbrellas or walking sticks, were able to tease the animals mercilessly, and their victims responded according to their abilities and opportunities, by biting, grabbing (primates and elephants), throwing cage detritus (primates), and spitting (llamas). Feeding was considered a legitimate interaction, however, and zoos encouraged it by selling such comestibles as stale buns for the bears. A closer physical relationship with the animals could also be purchased, in the form of rides on an elephant or a camel, or in a cart pulled by a llama or an ostrich.[28]

From this intimate perspective zoo animals resembled larger versions of domestic pets, and they therefore aroused analogous emotions. The most famous example was the elephant Jumbo, whose purchase by the American showman P. T. Barnum in 1882 was widely lamented as the sacrifice of a faithful friend to Yankee lucre. To lavish such tender feelings on the likes of a zoo elephant seems like a quintessentially Victorian indulgence, and even as applied to dogs and cats this kind of sentimentality was relatively new in the nineteenth century. Previously, only very privileged and secure people kept domestic animals primarily for amusement or for love – that is, as pets; however fond ordinary citizens may have been of their dogs and cats, they justified their presence in the household on utilitarian rather than emotional grounds. Nor was such fondness universal, or even widespread. The modern tradition of extravagant British concern for animals, turns out, like many others, to have been a relatively recent invention. As late as 1868 Queen Victoria, herself both an enthusiastic partisan of animals and a devoted pet owner, complained that 'the English are inclined to be more cruel to animals than some other civilised nations are'.[29]

By this time, however, the Victorian pet fancy was well developed. Cosseted pets no longer had to earn their keep, and well-funded local humane societies, a novelty when Victoria ascended the throne, vigilantly prosecuted people who abused the stray mongrels that roamed the streets. Dogs and even cats (less tractable in physique and behaviour, and therefore more difficult to co-opt and institutionalise) had risen not only in social and emotional status, but in cash value. Much of this value reflected the definition and differentiation of newly commodified breeds, now defined by pedigree rather than by function. (Breeding techniques were borrowed from the worlds of horse racing and stock breeding, where the most spectacular products of human discipline and skill were equally cherished and celebrated, although not invited into the domestic circle.) Societies were established to 'defend the interests' of each breed, as fanciers liked to put it, by defining standards – often rather arbitrarily, once practical criteria of excellence were abandoned – and by enforcing them through the apparatus of stud books and shows. Such enforcement was, however, often more apparent than real. The Kennel Club, which offered overarching co-ordination and regulation, was founded in 1873 and published its first *Stud Book* in 1874; the National Cat Club assumed control of the still more chaotic cat fancy in 1887.

If prize-winning animals were themselves expensive items – by 1891 some champion collies and St Bernards could command as much as £1,000 – they inspired their proud owners to emphasise their value by spending yet more money. Catering to this lucrative market were purveyors of special food, luxury accommodation, collars of brass or silver, fancy clips and tailored clothes.[30] As livestock paintings memorialised the esteem in which stock owners held their prize horses, cattle and sheep, so Victorian artists recorded the affection lavished on cats

281 William de Morgan, *Lions*. Design for a tile. Watercolour, before 1888. V&A: E.1074-1917.

and dogs. Most celebrated was Sir Edwin Landseer. His portraits of dogs, often in the bosom of a loving human family, emphasised the closeness of the inter-species bond (plate 26), while his popular allegorical paintings, such as *Laying Down the Law*, in which an elaborately groomed white poodle looms as the judge over a deferential group of anthropomorphised hounds, terriers and spaniels, who serve as lawyers, court officials and jurors, made the connection between canine and human still more pointed and direct.

But, as the range of Landseer's subjects shows, sentimentality did not exclude more aggressive attitudes. In addition to cosy domestic cameos, he depicted many scenes that highlighted the human propensity to dominate, as demonstrated by the popular lion-tamer Isaac Van Amburgh (plate 271), and even to destroy. Much of Landseer's work is devoted to the hunt; its noble quarry occasionally appeared in full majesty as the centre of a portrait, for example *The Monarch of the Glen* (plate 15), but more frequently as a corpse surrounded by triumphant hunter and dogs.[31] Most of Landseer's hunts were located at home, where the kinds of quarry were limited – mostly deer and game birds. The hunting fields of Africa and Asia offered greater scope

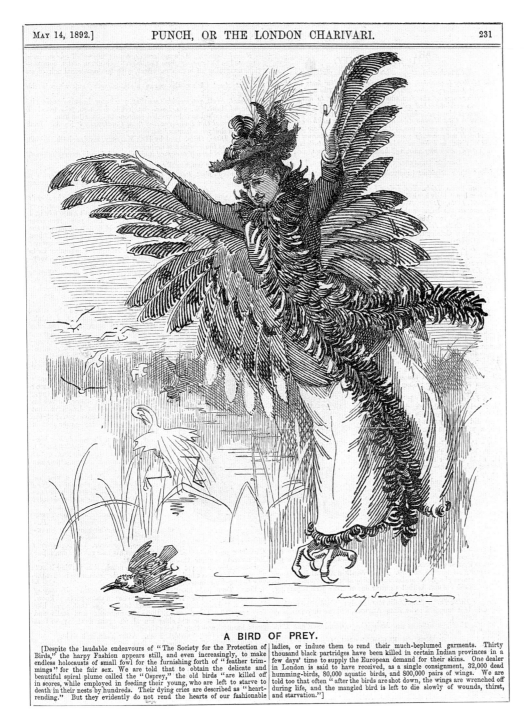

A BIRD OF PREY.

[Despite the laudable endeavours of "The Society for the Protection of Birds," the harpy Fashion appears still, and even increasingly, to make endless holocausts of small fowl for the furnishing forth of "feather trimmings" for the fair sex. We are told that to obtain the delicate and beautiful spiral plume called the "Osprey," the old birds "are killed off in scores, while employed in feeding their young, who are left to starve to death in their nests by hundreds. Their dying cries are described as "heart-rending." But they evidently do not rend the hearts of our fashionable ladies, or induce them to rend their much-beplumed garments. Thirty thousand black partridges have been killed in certain Indian provinces in a few days' time to supply the European demand for their skins. One dealer in London is said to have received, as a single consignment, 32,000 dead humming-birds, 80,000 aquatic birds, and 800,000 pairs of wings. We are told too that often "after the birds are shot down, the wings are wrenched off during life, and the mangled bird is left to die slowly of wounds, thirst, and starvation."]

282 *A Bird of Prey, Punch* magazine, 14 May 1892. V&A: PP.8. J.

and variety, to the military officers and colonial officials who used intervals of wild sport to repair their spirits after weary months of administration, and to the tourists whose numbers increased steadily after the advent of reliable steam transport. Hunters' success was measured both in kinds of animals killed and also in crude numbers. A good day's bag might include 29 buffalo or 9 bears, while the yield of an expedition could run to 150 hippopotamuses or 91 elephants.[32]

Such campaigns were celebrated in the sporting memoirs that poured from the presses of late Victorian publishers and, more concretely in the mounted heads, tiger-skin rugs, elephants' foot umbrella stands, furniture made from antlers (plate 283) and cases filled with the stuffed

remains of smaller creatures that adorned homes far from the scenes of the chase. The profusion of such trophies, along with the numbers of fashionable hats adorned with the feathers, or even the entire carcasses, of native and exotic birds (plate 282) should have offered some indication of the extent to which wild animal stocks were diminishing.[33] Nevertheless, colonial administrators and naturalists were often reluctant to acknowledge this decline, even in the face of significant corroborating evidence. It had long been remarked, for example, that game tended to thin out in the vicinity of settlements. This phenomenon was routinely explained in terms of retreat to the interior, rather than simple elimination of local populations, but as time went on those untroubled interior regions became more difficult to locate.

283 Austrian or Germam armchair. Horns, antlers and teeth with green velvet upholstery, c.1865. V&A: W.2–1970.

The sudden near-disappearance of a numerous and widely distributed species – the bison of the North American plains – in the 1870s gave a dramatic indication of the impending possibility of extinction. This narrowly averted crisis was followed by one that actually happened, and within imperial territory: the quagga, a modestly striped relative of the zebra, had once been numerous throughout southern Africa. As late as 1875 an expedition to Matabeleland observed a lot of them, but a decade later they were all gone, shot for their hides.[34] Gradually, administrators began to understand wild fauna as a valuable resource in need of husbanding, rather than a source of diversion (and sometimes a nuisance) whose disappearance was an inevitable by-product of the progress of civilisation. This protection assumed a variety of forms: enhanced or newly introduced game laws, game reserves, conservation societies, and international treaties. Since words and actions are very different things, the effectiveness of these efforts varied widely.[35] Whether or not they preserved wild animals, however, they made one thing clear. The perceived balance between humans and the natural world had definitively shifted. The role of people was now to protect.

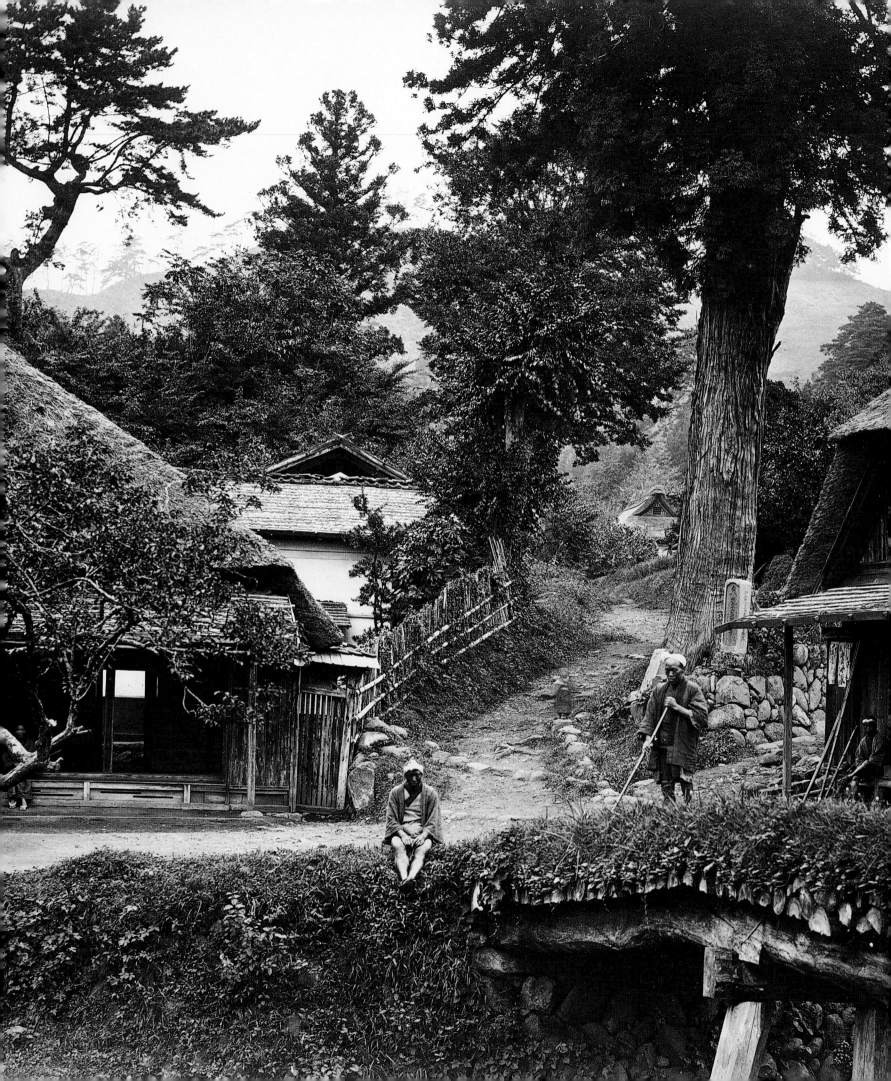

ART AND DESIGN:

East Asia

ANNA JACKSON

 The myth of the exotic East has always been a potent one in the western imagination. A romantic vision of fabled Cathay with its 'stately pleasure-domes'[1] was fuelled in the eighteenth and early nineteenth centuries by the large quantity of ceramics and silks that reached British shores. By the time Victoria ascended the throne, a yearning to penetrate hidden worlds was driven by the desire to exploit the apparently enormous, but hitherto untouched, markets of East Asia. The story of Britain's intrusion into China and Japan is one of fantasy confronting reality and finding it wanting. The new mythologies and stereotypes that were created in response were informed by Britain's sense of superiority, but such attitudes were often tempered with a sense of nostalgia for worlds, real and imagined, that seemed forever lost.

By the nineteenth century, British trade with China via the port of Canton was well established,[2] although the activities of foreign merchants were severely restricted by the Chinese. Tea was the major export, but China showed little interest in the products of the West. Britain redressed this trade imbalance with two products from India, raw cotton and opium. Trade in the latter, although illegal, proved extremely profitable for British merchants, but to the Qing authorities the damage it inflicted on the health and economy of the country was of grave concern.[3] When, in 1839, attempts were made forcibly to prevent the trade, Britain responded by dispatching warships and troops. China's subsequent defeat in this, the first Opium War, fundamentally changed its relations with foreign powers. By the terms of the 1842 Treaty of Nanking it was forced to open five ports to foreign residence, trade and consular establishment. The island of Hong Kong, occupied in 1841, was ceded to Britain in perpetuity.

284 Detail from Chinese cushion cover. See plate 289.

285 Felix Beato, *View of Eiyama, Japan.*
Albumen print, *c.*1863–8. V&A: 305–1918.

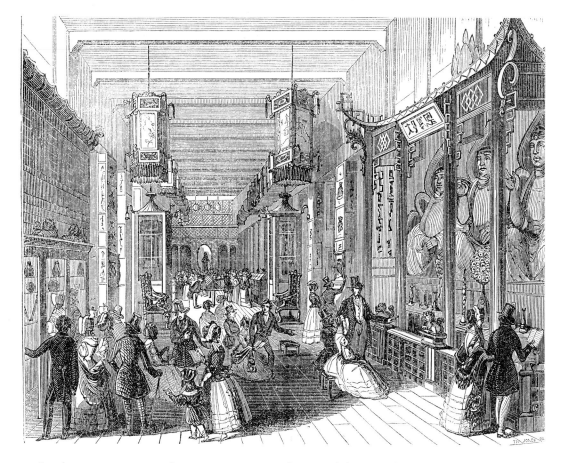

286 The Chinese Collection, Hyde Park Corner. Engraving from the *Illustrated London News* (6 August 1842), p. 204. V&A: PP 10.

In the same year as the treaty was signed, an exhibition of Nathan Dunn's 'Chinese Collection' was held in London (plate 286). Dunn (1782–1844) was a Philadelphian who had spent 12 years as a merchant in China. Although it is unlikely that he obtained his objects from anywhere other than Canton, the collection was presented and accepted as an encapsulation of the entire 'Celestial Empire'. Whatever its limits the exhibition was certainly the most comprehensive presentation of Chinese material culture yet seen in Britain and included displays of decorative arts, painting, architectural models and flora and fauna as well as a series of tableaux of life-size Chinese figures modelled from clay. Interest in China was at its height and the exhibition was extremely popular, remaining open until 1846. Although it may have increased knowledge about the country, it did not radically alter established views of China. Reviews stressed either the stagnation of Chinese civilisation compared with the progressive West or emphasised the exotic: 'the elaborate carvings . . . the embroidered silks . . . the immense decorative lanterns . . . seem to realize those imaginings of the gorgeous East, which have haunted us like dreams . . . We seem to be in the China of the Arabian Nights'.[4]

In 1851, while the Great Exhibition was taking place, a much-diminished version of Dunn's exhibition was shown in London. The educative mission of the original show was now lost in favour of sensationalism and the exploitation of racial stereotypes, the objects serving merely as a backdrop to the display of a Chinese family, including a woman 'with small lotus feet only two and a half inches in length.'[5] The custom of binding feet had been featured in the 1842 exhibition, but by 1851 it had become the main attraction. Comments made throughout the

Victorian period highlight the obsession the West had with what was seen as the ultimate image of China's barbaric 'otherness'.[6]

A small number of Chinese objects was also on show in the Great Exhibition. Official participation had been requested from China, but it was not forthcoming. The Royal Commission did manage to elicit the help of Rutherford Alcock (1809–97), British Consul in Shanghai, who sent examples of porcelain, silk and other items. However, the majority of East Asian objects were exhibited by the London dealer William Hewett, who also engaged the services of a Chinese attendant, perhaps a member of the family being 'exhibited' with Dunn's objects or one of the crew of a Chinese junk that arrived in London in 1848.

Following Britain's lead other western powers had signed treaties with China and, by the time of the Great Exhibition, the number of foreigners on Chinese soil was growing. Merchants continued to press for greater access to China's markets while missionaries, eager to tap into the millions of Chinese apparently waiting not only to be sold western goods but also to be converted to Christianity, often attempted to stray beyond the treaty port boundaries creating problems for consuls such as Alcock. One person also making illegal forays beyond the ports in the 1840s and 1850s was plant-hunter Robert Fortune (1812–80), sent to China by the Royal Horticultural Society. Just as the reviewer of Dunn's exhibition was imagining himself in an 'Arabian Nights' romance, Fortune was discovering that 'this celebrated country [that] has long been looked upon as some kind of fairy-land' was not matching such expectations.[7] Like the many visitors that were to follow him, Fortune comments most vociferously on the filth and smell of Chinese towns, but he was captivated by the beauty of the country and developed a strong sympathy for the Chinese people. By the time of his second visit to the country in the 1850s he expressed the hope that his book might help people 'to look with more kindly feeling on a large portion of the human family'.[8] When these words were published in 1857, however, China and Britain were again at war. China was defeated once more and by the terms of the 1858 Treaty of Tianjin, negotiated by the Earl of Elgin (1811–63), was forced to open more ports, allow greater travel within China, and give Britain the right to an ambassador in Peking.

After his success in China Elgin went on to negotiate another treaty, this time with Japan. Since the 1640s the country had maintained a 'closed country' policy. It was the United States which breached this national isolation, arriving off the coast of Japan in 1853 with the demand that the country open its ports to foreign powers. Japan was aware of the events that had taken place in China and realised that it would have no chance of resisting the West. Thus, the 'opening' of Japan took place without a resort to arms. Elgin arrived on 3 August 1858 and the Treaty of Edo was signed on the 26th of the same month.

The view of Japan given by the first visitors was rosier than that afforded to its neighbour. Laurence Oliphant (1829–88), who accompanied Elgin as his private secretary, declared: 'The contrast with China was so striking . . . the circumstances of our visit were so full of novelty and interest, that we abandoned ourselves to the excitement and enthusiasm they produced. There exists not a single disagreeable association to cloud our reminiscences of that delightful country.'[9] Given the contrasting experiences in China and Japan, this view is not surprising. Elgin himself felt that his 'trip to Japan has been a green spot in the desert of my mission to the East'.[10]

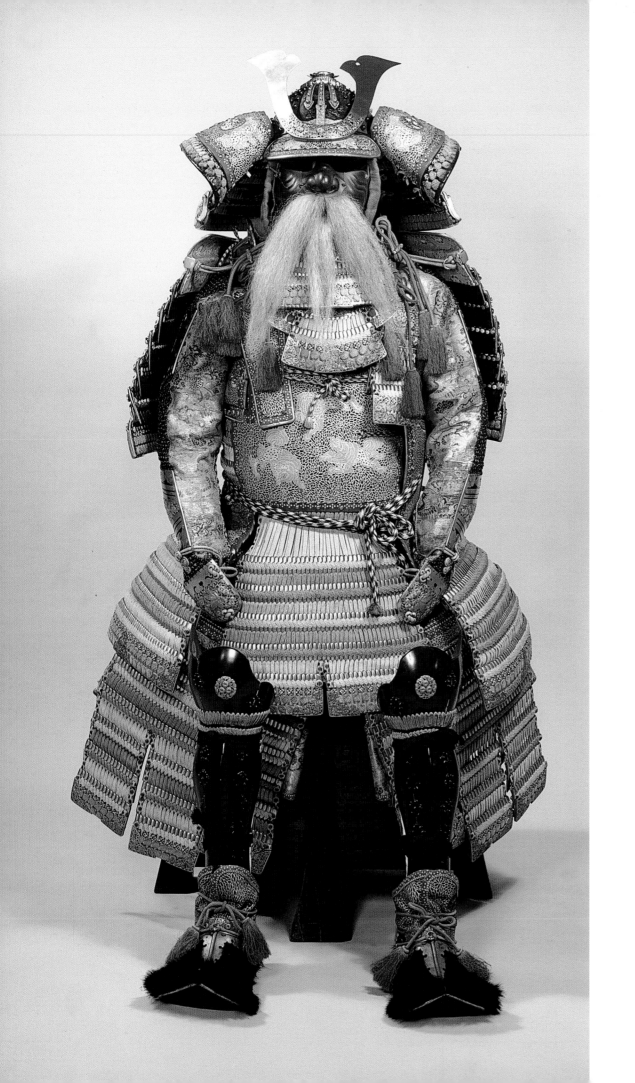

287 Suit of armour in the Ōyori Style. Japanese, c.1859. V&A: 362–1865. Given by Queen Victoria. Iron helmet-bowl with gilt fittings, iron mask with whiskers of animal hair, gold lacquered iron and leather small-plates laced with silk, iron chain-mail sleeves and leg guards, stencilled leather breast-plate, shoulder strap protectors and other details, figured silk sleeves, gilt openwork trimmings, red silk cords, stencilled leather, gilt and fur boots.

Elgin presented the shōgun[11] with the steam yacht *Emperor*, a gift from Queen Victoria. Two years later Alcock, Britain's first minister to Japan, helped to arrange a return diplomatic gift of ceramics, textiles, lacquerware and a suit of samurai armour (plate 287). This exchange of technology for art was to be a common theme in the relations between Britain and Japan in the nineteenth century. Travelling on the ship transporting the objects in December 1860 was Robert Fortune who, as in China, had taken advantage of the new treaty in his search for plants. He had found the Japanese 'happy and contented' and Japan itself 'neat and clean',[12] comments that were to be echoed by many visitors to Japan in the succeeding decades.

As Fortune was travelling out to Japan, conflict erupted again in China. When it became apparent that the Chinese had no intention of allowing foreign ambassadors to reside in Peking, Elgin was again dispatched, with a combined British and French army, to deal with the situation. Landing in August 1860 the foreign forces proceeded to march on Peking. On 5 October they arrived at the Summer Palace, a large complex of buildings and parklands on the outskirts of the capital that served as a retreat for the emperor (plate 288). Here the troops found 'a mine of wealth and of everything curious in the Empire'.[13] The sight of such riches proved irresistible and frantic looting commenced. On 18 October news was received that British and French prisoners, captured by the Chinese at the end of September, had been tortured and the majority killed. Elgin decided to retaliate. He ordered that the Summer Palace be torched.

288 Felix Beato, *Temple in the Summer Palace Grounds*. Albumen print, 1860. V&A: 161–1975.

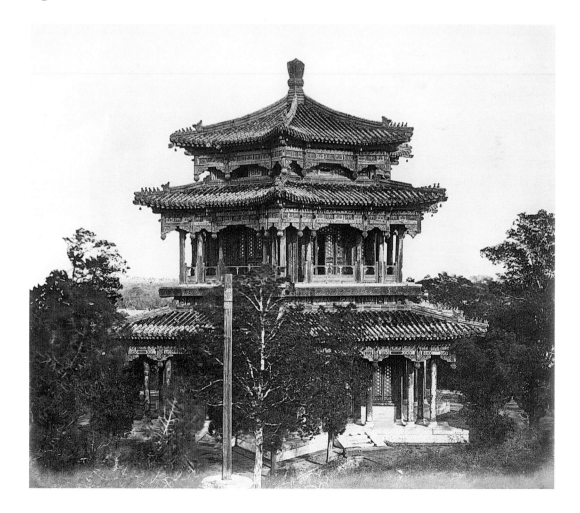

289 Cushion cover from the Summer Palace. Silk with gold and silk embroidery, Chinese, c.1800–20. V&A: T.139–1917.

Charles Gordon (1833–85), a member of the British forces present that day, recorded that '[we] went out, and, after pillaging it, burned the whole place, destroying in a Vandal-like manner most valuable property . . . You can scarcely imagine the beauty and magnificence of the places we burnt. It made one's heart sore to burn them.'[14] The devastating fire raged for two days, after which all that remained of the Summer Palace, famed for its beauty and its treasures, were a few scattered ruins and the images taken by Felix Beato (1825–1904).[15] The Chinese capitulated and Britain and France were granted right of representation in Peking.

Although British reaction to the destruction was mixed, there seemed little doubt what the act of 'righteous retribution' signified: 'The destruction of the Summer Palace . . . destroys the Emperor's prestige, and dissipates . . . that halo of divinity with which he has been surrounded in the imagination of his people.'[16] The 'looted' objects brought back to Britain from the Summer Palace also acquired a particular significance because of their imperial provenance.[17] Lieutenant-Colonel Wolseley (1833–1913) commented on the 'cushions . . . covered in the finest yellow . . . with figures of dragons and flowers' that he observed at the Summer Palace. 'Yellow is the imperial colour and none but those of royal birth are permitted to wear it.'[18] It was just such objects that Wolseley chose to bring back with him, his ownership of something once reserved for the use of the emperor signifying the imperial humiliation that China had suffered (plate 289). Queen Victoria herself was able to partake in this sense of superiority over a defeated monarch when a Pekinese dog found in the Summer Palace and christened 'Looty' was presented to her.[19]

Although Gordon took the part of destroyer in the 1860 campaign, he was soon to become China's 'saviour'. In 1863 he took command of the foreign-officered 'Ever Victorious Army' which helped to defeat the Taiping rebels threatening to overthrow the Qing dynasty. His actions made 'Chinese' Gordon a hero at home and in China where he was awarded the 'yellow jacket' of the highest military rank.

Some of the objects taken from the Summer Palace were shown in the Chinese section of the London International Exhibition of 1862. This display was overshadowed, however, by that from

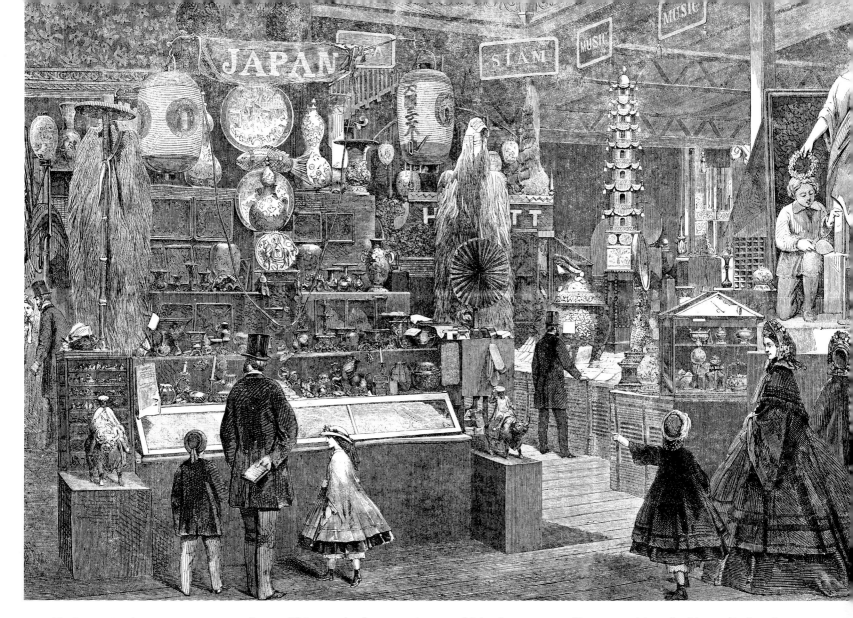

290 *The International Exhibition: The Japanese Court*. Engraving from the *Illustrated London News* (20 September 1862), p. 320. V&A: PP 10.

Japan. This was the first occasion on which a large group of Japanese objects had been displayed before a wide public, the majority of the objects having been sent from Japan by Alcock (plate 290). Comparisons made between objects from the two countries, even at this relatively early stage in the critical appraisal of Japanese art, reveal what were to become standard views: 'From China the art of bronze-casting would appear to have passed to the Japanese; but as with all the industrial arts, it received a development there which gives its production a much higher character than those of the Chinese, as was evinced by the comparative simplicity, purity of form, and strong feeling for nature indicated in the Japanese collection of 1862.'[20] The display proved a great success. Critics advocating the need for design reform urged British manufacturers 'to study' the Japanese objects in order to 'improve their present system of decoration, which is fundamentally bad'.[21] The Japanese Court made the greatest impact on Gothic revivalists such as the architect and designer William Burges (1827–81) who believed that in contemporary, feudal, Japan could be found the ideal society of the Middle Ages.[22] Members of the first Japanese diplomatic mission, which by coincidence arrived in Britain at the time of the exhibition, were less impressed by the objects Alcock had assembled. One member of the party thought that 'it was such a ramshackle assortment of artefacts that it looked just like an old antique shop, and I could not bear to look'.[23]

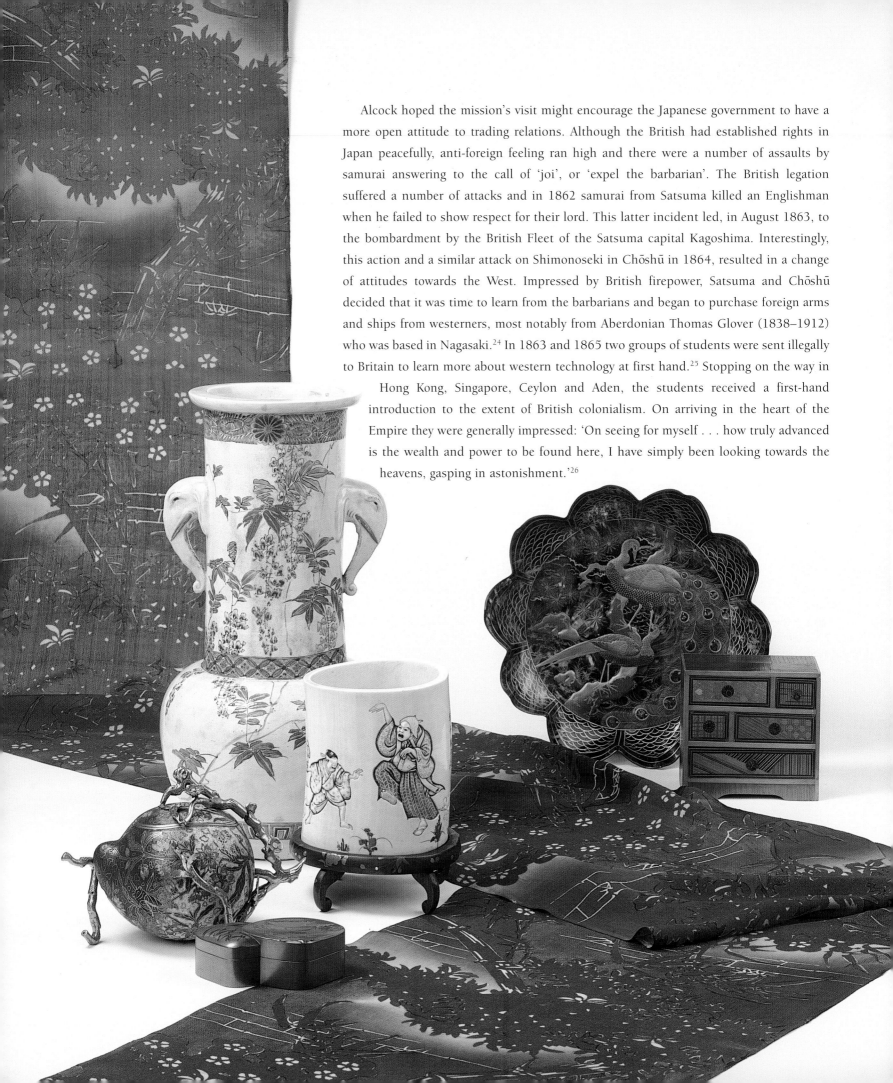

Alcock hoped the mission's visit might encourage the Japanese government to have a more open attitude to trading relations. Although the British had established rights in Japan peacefully, anti-foreign feeling ran high and there were a number of assaults by samurai answering to the call of 'joi', or 'expel the barbarian'. The British legation suffered a number of attacks and in 1862 samurai from Satsuma killed an Englishman when he failed to show respect for their lord. This latter incident led, in August 1863, to the bombardment by the British Fleet of the Satsuma capital Kagoshima. Interestingly, this action and a similar attack on Shimonoseki in Chōshū in 1864, resulted in a change of attitudes towards the West. Impressed by British firepower, Satsuma and Chōshū decided that it was time to learn from the barbarians and began to purchase foreign arms and ships from westerners, most notably from Aberdonian Thomas Glover (1838–1912) who was based in Nagasaki.[24] In 1863 and 1865 two groups of students were sent illegally to Britain to learn more about western technology at first hand.[25] Stopping on the way in Hong Kong, Singapore, Ceylon and Aden, the students received a first-hand introduction to the extent of British colonialism. On arriving in the heart of the Empire they were generally impressed: 'On seeing for myself . . . how truly advanced is the wealth and power to be found here, I have simply been looking towards the heavens, gasping in astonishment.'[26]

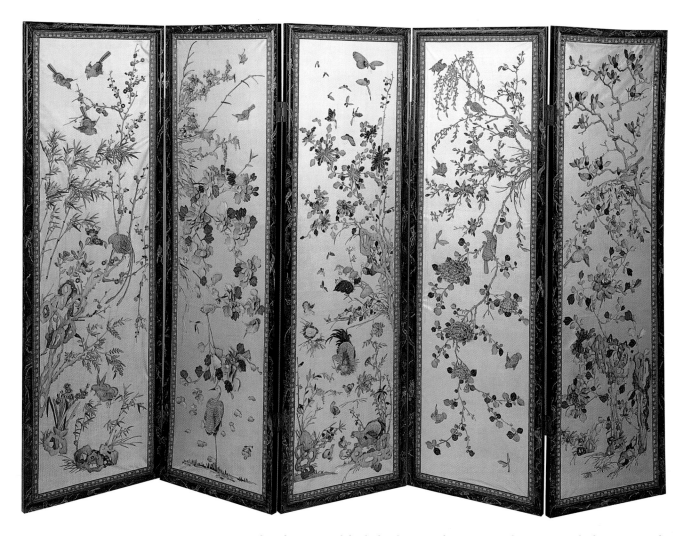

292 Fivefold screen shown at the Paris International Exhibition of 1867. Silk with kingfisher feathers and silk embroidery, wooden frame, Chinese, c.1800–60. V&A: 648–1869.

291 Objects shown at the Paris International Exhibition of 1867. Japanese, c.1850–67. V&A: 842–1869, 883–1869, 814–1869, 876–1869, 873–1869, 887–1869, 847–1869.
Left to right: length of resist-dyed silk crepe; cloisonné box in the form of a peach with gilt mounts; stoneware vase with decoration in overglaze enamels and gilt; gold lacquered box in the form of two shells; carved and stained ivory vase with gold lacquer details and wood stand; tortoiseshell dish decorated in gold lacquer and mother-of-pearl; straw-work cabinet.

In 1866 the shogunate lifted the ban on foreign travel. In 1867 diplomats, students and merchants flocked to Paris to see the International Exhibition. At this event the Japanese participated directly for the first time and their contribution was extremely popular with the Parisian crowds. Satsuma, in a deliberately antagonistic move, sent its own exhibit to rival that of the shogunate and it was from this display that the South Kensington Museum (now the V&A) made a number of purchases (plate 291). A year later rebellion by Satsuma and others led to civil war in Japan, the overthrow of the shogunate and the restoration of the power of the emperor. The new Meiji government initiated a major transformation of Japan along western lines, its aim being to achieve parity with the West rather than to be dominated by it. The country participated in all the subsequent international exhibitions, this arena providing them with the perfect opportunity to garner prestige, acquire the latest technological information and promote their own products.

At the Paris exhibition of 1867 the South Kensington Museum also bought a magnificent Chinese screen decorated in kingfisher feathers (plate 292). Unlike Japan, China did not organise its own display, and the Museum acquired this object from a Parisian dealer. The screen is not an export piece, however, so presumably its appearance in Europe resulted directly from the opening of China to the West. By this time more foreigners were travelling to China. Many

ventured little further than treaty ports such as Shanghai which had 'all the accessories of Western luxury and civilisation'.[27] Others, such as intrepid explorer Isabella Bird (1831–1904) and Mrs Archibald Little (d.1926), whose husband sailed the first steamboat up the Yangtze, travelled further, developing a greater understanding and consideration of China and its people than many of their contemporaries. Finally being able to enter Peking, which 'we in Europe have always been in the habit of associating with the wonderful' many found they were 'disappointed', however.[28] Mrs Little found the capital a place of 'horrors . . . a survival from the Middle Ages so agreeable to read about, so disagreeable to live in'.[29] Algernon Mitford (1837–1916), who arrived in 1865 to serve under Alcock who was now British Minister to China, found 'much to offend the senses at every step'. Yet, writing these words in his memoirs, Mitford still felt some nostalgia for 'Peking as I knew it fifty years ago had about it a certain mysterious charm . . . the magic of the old . . . ruinous city'.[30] Most visitors to China shared Mrs Little's view of China as 'discouraging: to think it got so far so long ago, and yet has got no further'.[31] Whether with pity or contempt, China was regarded as a moribund nation, unable to rely any longer on past glories.

Some changes were taking place in China, however. In the 1860s western-style arsenals and shipyards had been established and in 1876, realising that it must engage with the West, the country sent its first diplomatic mission to Britain. The arrival of ambassador Guo Songtao (1818–91) aroused much interest and was taken as an indication that China had 'at last awakened to a sense of her position among the nations. Hitherto she has remained aloof . . . indulging in dreams of her former greatness but now a gleam of light has broken in on her.'[32] Nevertheless, the encounter between East and West did little to change established Victorian stereotypes. The presence of Guo's wife inspired *Punch* to publish a satirical verse 'To the Tottering Lily', which declared that 'An inability to stand, Is not the charm we most demand, In Western women'.[33] The picture that accompanied the verse showed a woman in a *Japanese* kimono, revealing that, even after more than twenty years of direct interaction, the differences between the two 'oriental' nations were by no means clear.

Although there is often some initial similarity between comments about China and Japan, attitudes towards the two countries did differ. China's defeat in two wars and its continued reluctance to embrace the civilisation of the West lowered its prestige while Japan was viewed more favourably. Early visitors to Japan discovered, like Burges at the 1862 exhibition, that 'with the Japanese we take a step backward some ten centuries, to live over again the feudal days'.[34] If Japan, like China, was in the Middle Ages, it was the romance, rather than the backwardness, of that era that was envisaged. If the Japanese, like the Chinese, were 'a nation of children',[35] they were happy, well-behaved ones, not those who only once they had 'received a good flogging . . . become very good boys'.[36] Japan was viewed as a 'fairyland',[37] a charming scene laid before western eyes and 'the number of tempting pictures was truly tantalizing'.[38] Such a vision of Japan was also formed through the medium of photography. Beato's *View of Eiyama* (plate 285), was published in 1868 with a commentary that described 'the neatness and order which prevails in the humblest cottage in Japan . . . the rustic bridge with its simplicity of form and material, and general picturesqueness forms a charming bit of foreground'.[39] The Japanese were seen not

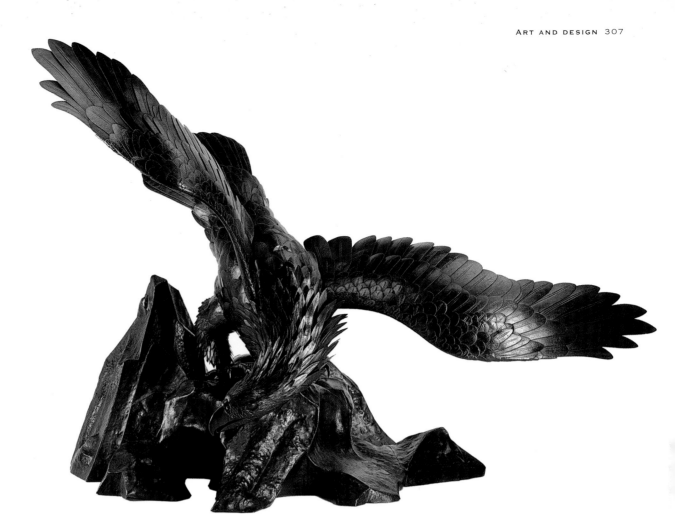

293 Incense Burner in the form of an Eagle. Hammered iron, Japanese, *c*.1860. V&A: 603–1875. Formerly in the collection of Algernon Mitford.

merely as picturesque, but as the literal embodiment of their own art. When Isabella Bird first arrived she felt as though 'she had seen them all before, so like are they to their pictures on trays, fans and tea pots.'[40]

Shopping for souvenirs was an important part of any visit to Japan. Most people were content to visit the curio shops that sprang up in the treaty ports and main tourist destinations and to buy the small decorative pieces that appealed to the western eye and were, indeed, designed specifically for this purpose. Others returned from Japan with more unusual items. Mitford, who served in the British legation in Japan from 1866 to 1870, brought back a number of bronzes, including a spectacular incense burner in the form of an eagle which he later sold to the South Kensington Museum (plate 293). The Museum, and perhaps Mitford himself, believed the bronze to be by a celebrated sixteenth-century metalworker, but the eagle was made in about 1860. The object reflects the changing application of Japanese craft skills that occurred as Japan became more westernised and traditional objects became obsolete. Many craftsmen turned their talents to the making of works for the foreign market. The promotion and export of such objects formed an important part of the Meiji government's efforts to expand industry and increase productivity.

Japan's artistic goods flooded into Britain during the Victorian period, creating a craze for all things Japanese. By the 1870s no middle-class drawing room was complete without one of Bird's 'trays, fans and tea pots'. Objects could be bought from a growing number of specialist dealers and from shops such as Liberty's in Regent Street, founded by Arthur Lasenby Liberty (1843–1917) in 1875. The appearance of a new and different aesthetic seemed to offer possible

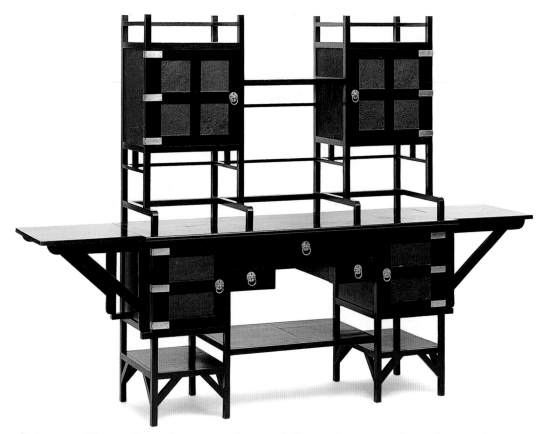

solutions to debates about the nature of art and design that were taking place at this time. Designer and theorist Christopher Dresser (1834–1904) believed that Japan could 'supply the world with the most beautiful domestic articles that we can anywhere procure'.[41] Dresser's own work was greatly influenced by Japan and, as a writer and importer, he played a crucial role in the dissemination of Japanese art in Britain. In 1876 he travelled to Japan, visiting numerous artists and manufacturers and advising the Japanese on their art products. Despite his understanding of Japanese artistic principles, Dresser's view of the country was still clouded by the dominant western images. He saw the Japanese as 'a simple and humorous people',[42] and the objects he so admired as 'the children of happy contented men who love their labour as their lives'.[43]

Another leading exponent of *japonisme*, as the artistic phenomenon was known, was E. W. Godwin (1833–86). A major collector of Japanese art, Godwin began to design 'Anglo-Japanese' furniture in the 1860s. In pieces such as his famous sideboard (plate 294) Godwin sought to express the simplicity and elegance that he admired in Japanese art. While Japan certainly provided the main inspiration, many of Godwin's furniture designs suggest that he was also influenced by China.[44] Godwin's close friend, the painter James McNeil Whistler (1834–1903), was also strongly influenced by the Japanese art he admired and collected. He was able to gain a more personal insight into Japan from being 'perpetually in and out of . . . [the] house' of his neighbour and friend Algernon Mitford.[45] Whistler also had a collection of Chinese blue and white porcelain. His first 'Oriental Painting' *Purple and Rose: The Lange Leizen of the Six Marks* (plate 295) is full of such ceramics, yet it is often considered a major document of *japonisme*. To add to the oriental confusion the woman in the painting is wearing a Japanese kimono under her Chinese robe.

294 E. W. Godwin, sideboard. Ebonised wood with silver plate fittings and inset panels of Japanese embossed leather paper, British, *c*.1867. V&A: Circ.38–1953.

295 James Abbott McNeil Whistler, *Purple and Rose: The Lange Leizen of the Six Marks*. Detail. Oil on canvas, 1864. Philadelphia Museum of Art: The John G. Johnson Collection.

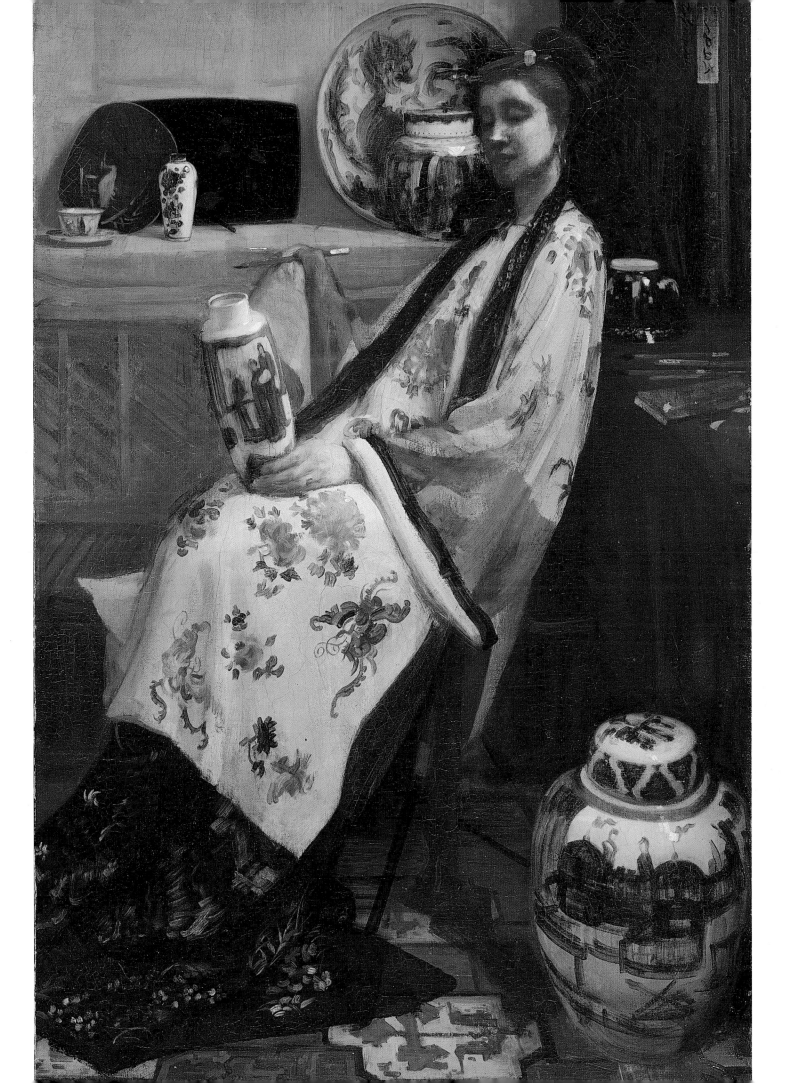

Chinese art did provide inspiration to Victorian artists, yet this was, and indeed still is, largely overlooked. Tarnished by China's fallen reputation and by centuries of half familiarity, Chinese art was compared unfavourably with the recently revealed artistic achievements of its neighbour: 'In contrasting the arts of China and Japan, what strikes one most forcibly is the marked difference of labour . . . the Japanese aiming to produce the greatest possible effect by the least expenditure of trouble, whilst the Chinese make pains the principal virtue; they lack inventive power.'[46] Vast amounts were written about Japanese art in the Victorian period, but there were virtually no general surveys on Chinese art. One exception was the South Kensington Museum handbook published in 1872, but this served only to stress British 'possession' of Chinese art by emphasising that 'we have ample means of judging [cloisonné], the sacking of the Summer Palace having led to the best examples to be found in the country finding their way to Europe'. Such examples revealed that the Chinese had 'the very highest degree of aesthetic perception', but they were 'utterly deficient in artistic power'.[47]

One aspect of Chinese art that was admired, and still much collected, was ceramics. The man who did most to broaden western understanding of Chinese ceramics in the nineteenth century was Stephen Bushell (1844–1908), who from 1868 to 1899 was the doctor to the British legation in Peking. In 1883 the South Kensington Museum employed Bushell to purchase ceramics in China. The 246 objects that were shipped to the Museum reveal Bushell's discerning eye and include ceramics made for the imperial court and for the scholar's table, examples of which would not have been very familiar in Britain at the time (plate 296). It is not known how Bushell acquired the ceramics although it is tempting to think that some of the imperial pieces might have been among those being smuggled out of the storerooms of the Forbidden City by dishonest palace servants.

Chinese objects could also been seen at the international exhibitions. From 1873 China sent an official contribution, the display being organised by the Chinese Imperial Maritime

296 Objects bought in Peking by Stephen Bushell.
Left to right: V&A: 85–1883, 109–1883, 717–1883, 706–1883.
Porcelain dish with decoration in overglaze enamels, mark and reign of Qianlong (1736–95); porcelain ewer with decoration in underglaze blue, mark and reign of Qianlong (1736–95); stoneware bowl, Guan ware, Southern Song Dynasty (1128–1279); white porcelain vessel altar vessel, Yongle period (1403–24).

Customs. This foreign-run organisation was set up in 1854 to supervise the collection of customs duties. In 1863 the post of Inspector General of the Customs passed to 28 year old Robert Hart (1835–1911), one of the most remarkable and ultimately the most powerful, westerners in China. Hart's efforts to organise displays that would adequately represent China seemed to pay off, and most reviews of the country's contributions to the exhibitions were favourable, critics remarking that: 'In Paris, Vienna and London, China has put in an appearance and . . . presented contributions in a manner worthy of associations with other great nations.'[48] Hart was well aware of the distance that existed between Britain's still fanciful perception of the East and the reality. While organising the display for the 1884 London International Health Exhibition, he wrote: 'The English idea of the Chinese tea-house . . . has nothing corresponding to it in China except the fact that there are buildings in which people can . . . drink tea; if we could supply you with one of them bodily, you would indeed have a slice of the real life of China, but English sightseers would neither eat in it or sit in it.'[49]

This problem was solved by having 'Messrs Holland and Son' erect a Chinese teahouse and restaurant based on 'designs taken from old ivory carvings'.[50] The effect of 'Chineseness' was obviously entirely convincing, the electric lights that were hung in the Chinese lanterns on the veranda of the tea house being 'the only instance in which the extremes of civilisation will touch, for all the rest will be Chinese from the tea to the servants'.[51] Indeed, Hart sent 31 Chinese to staff the exhibition including cooks, waiters and musicians for the teahouse and restaurant.

The Chinese obviously added an 'exotic' dimension to the 1884 exhibition, but the small Chinese community that had developed in East London by this time was usually viewed with suspicion. The supposed 'opium dens' were the subject of sensational reporting, while the fictional descriptions by Charles Dickens (1812–70) and later Oscar Wilde (1854–1900) stirred the popular imagination.[52] By contrast the Japanese village erected in Knightsbridge in 1885, which featured over ninety craftsmen and entertainers, conformed to the less threatening and more picturesque view of the East.

Visitors from Japan were not an unusual sight in Britain by this time. After the Meiji Restoration more and more Japanese visited the country in order to gain western expertise. In 1872 the Iwakura Mission arrived in Britain with the aim of initiating revision of the 'unequal' treaties and studying the industrial might of the West. In their first aim the Mission did not succeed, but during their four-month stay Victorian Britain proudly displayed all its achievements. The mission visited factories and shipyards in the industrial centres of Scotland, the North of England and the Midlands, the naval dockyard in Portsmouth and the Houses of Parliament as well as police stations, court houses, libraries and schools. The 1870s saw a Japanese boom in London. Vast numbers of Japanese students came to the capital, the majority studying science and engineering subjects. They also went to other parts of Britain, notably Glasgow, which became a major centre of scientific study for Japanese students. Such contacts resulted in an interesting exchange of 'art for industry'.[53] In 1878 the City of Glasgow received a gift of over 1,000 items of contemporary ceramics, furniture, lacquerware, metalware, textiles and paper, and in return sent a selection of industrial samples to Tokyo National Museum. Apprentices, engineers, naval cadets and officers were also regular visitors to the shipyards of the

Clyde and other major British ports either working on or supervising the building of ships.

In its quest for industrial and technological knowledge the Meiji authorities not only sent people to Britain to learn, it also employed British engineers and scientists in Japan. The decade 1872–82 saw large numbers of foreign experts engaged in Japan. British engineers constructed railways, lighthouses and telegraph systems, while British shipbuilders and naval architects helped to build up Japan's commercial and naval fleets. Foreign instructors were engaged to teach English, mathematics, physics, chemistry and engineering. Japan also employed British architects to transform its cities along western lines, the most famous being Josiah Condor (1852–1920) who had trained under William Burges.

Having taught the Japanese so well, most of the foreign experts found their services were no longer needed after the mid-1880s and they returned home, although Condor remained in Japan for the rest of his life. Japan was keen to learn as much as it could from the West and keener still to take control of its own destiny. Although initially encouraged by the eagerness of Japan to embrace the West, Britain began to get a little uneasy as the country started to develop industrially and militarily. Despite the increasing knowledge and interaction with the 'realities' of Japan, British commentators retreated into more comfortable 'fantasies'. Old stereotypes persisted and were even reinforced by the increasing number of visitors to Japan.[54]

While the West's vision of China was of a glory long past, the image of Japan was a romance of something only recently lost. Regret was coupled with a vague sense that the West was responsible for this; it had found paradise only to corrupt it. Mitford marvelled at the way in which 'at a bound Japan leapt out of the darkest Middle Ages into the fiercest light of the nineteenth century',[55] but towards the end of his life found that although 'feudalism is dead . . . its ghost haunts me still. I shut my eyes and see picturesque visions of warriors in armour with crested helmets.'[56] Mitford helped create one of the most fanciful, and enduring, images of Japan advising Gilbert and Sullivan on *The Mikado*, the 1885 production of which did so much to popularise the picturesque stereotype of Japan in Victorian Britain.[57]

There was also concern that Japanese art was suffering as 'contact with the West unfortunately brings about the deterioration of Eastern art'.[58] Given the amount of goods that were being produced in Japan for the western market at this time it is not surprising that quality was sometimes lost, but implicit in comments such as this is the idea that something 'pure' had been 'tainted'. There was, however, no suggestion that the western appropriation of eastern aesthetics raised such problems. In 1889 Liberty travelled to Japan, where he lectured on 'Japanese Art Productions'. He warned Japan not to be 'too ready to undervalue the precious heirlooms of a splendid past, to comply with European demands by all means, but let the outcome be still Japanese in character and thought'.[59] In other words Japan was expected to provide plenty of whatever the West wanted of it.

Rudyard Kipling (1865–1936) also travelled to Japan in 1889. He had no doubts about what to expect. He had reached 'the Japan of cabinets and joinery, gracious folk and fair manners', and the appearance of a rickshaw when he arrived at Nagasaki 'shot me into *The Mikado*, First Act'.[60] Such an image of Japan, although more positive than that afforded to China, was still ultimately based on a conviction of British superiority. Japan could be admired artistically, but Britain had

the industrial might and imperial power. As Kipling wrote: 'Verily Japan is a great people. Her masons play with stone, her carpenters with wood, her smiths with iron, her artists with life . . . Mercifully she has been denied the last touch of firmness in her character which would enable her to play with the whole round world. We possess that – we, the nation of the glass flower-shade, the pink worsted mat, the red and green china puppy dog, and the poisonous Brussels carpet. It is our compensation.'[61]

In the 1890s the West was forced to realise that Japan had in fact developed some 'firmness' with which to 'play' with the world. In 1876 it signed a western-style treaty with Korea, forcing the country to abandon its long-standing isolation. Britain was content to take a back seat in the peninsula, signing a treaty only in 1882,[62] and was not willing to become involved in the growing tensions between Japan and China, Korea's traditional protector. War between the two Asian powers broke out in 1894. Defeat at the hands of a country that had for centuries lived under its shadow was a humiliating blow for China.

At the end of the 1890s, as China was being carved into 'spheres of influence', anti-foreign feeling began to run very high. In 1899 a series of orchestrated attacks on missionaries and on railways began, another visible manifestation of the foreign intrusion, by the 'Boxers United in Righteousness'. The Boxer Rebellion culminated in the siege of the legations in Peking. In the British legation, the biggest and easiest to defend, the entire foreign community of the capital, which numbered some 500 people, plus 350 Chinese and over 200 horses and mules (which were later eaten) took shelter. The story of the '55 Days in Peking' has become part of the British imperial legend. Newspapers around the world carried stories of the 'massacre' of foreigners, but when the relief force, which included soldiers from Japan, arrived on 14 August they found the death toll to be quite low. The foreign troops revelled in a frenzy of looting and, for the first time, penetrated the Forbidden City. A formal peace treaty, by which the Chinese had to pay crippling indemnities, was signed in 1901. The rebellion left a lasting imprint on western perceptions of the East, as the Boxers became a symbol for everything feared and hated about China.[63]

The West was quickly having to change its attitude towards Japan, however, as the country started to realise its own imperial ambitions. Although Japanese art, neither traditional enough nor modern enough to satisfy European tastes, began to fall out of favour, Japan finally achieved its political goal. By the terms of the 1902 Anglo-Japanese Alliance it was accepted as an equal power. There is some irony in the fact that Britain had admired Japan's art for decades, but only after the country began fighting wars came to regard it as 'civilised'.

The twentieth century witnessed enormous changes in China and Japan. Britain's relationship with East Asia has also altered dramatically, the final lowering of the Union Jack in Hong Kong in 1997 marking the end of British imperialism in East Asia. Yet many of the myths and stereotypes constructed in the Victorian period remain potent. Despite the radically transformed physical and social environments, thousands of tourists still travel to China in search of the imperial past, an 'exotic experience . . . and an enigmatic journey',[64] and still hope to find 'old Japan' in the temples of Kyoto.

IMPERIAL VISIONS:

Responses to India and Africa in Victorian Art and Design

TIM BARRINGER

The memorial to Prince Albert in Kensington Gardens, designed by George Gilbert Scott and completed in 1872, has long symbolised the Victorian era.[1] Beneath the familiar Gothic canopy and the gilded statue of the Prince Consort stand four large sculptural groups representing the continents, one at each corner of the plinth. These sculptural allegories, often overlooked, neatly encapsulate the subject of this chapter. The female figure of Europe stares proudly outward: the official guidebook explains that her regalia of royal authority, the orb and sceptre, denote 'the influence Europe has exercised over the other continents'.[2] Around her, England, France, Germany and Italy carry symbols of civilisation and progress in the sciences and arts. By contrast, the allegory of Asia (plate 299) is dominated by the figure of a bare-breasted Indian woman, atop a seated elephant. Elaborately bejewelled, she is draped with fine textiles; by her side sits a cross-legged Chinese figure holding a fine porcelain vase. This allegory of the richness of the products and the skills of Asian craftsmen, was, as the official guidebook to the monument explained, 'an allusion to the important display of the products of Asia which was made at the Great Exhibition of 1851'.[3] Flanked by a 'Persian poet', a warrior of 'Central Asia', and an 'Arab merchant', India is only now awakening after a long period asleep. The clear implication is that only through the intervention of Britain, in the form of commercial activity and imperial control, was the revival of Asia, and especially India, possible. Africa (plate 300), likewise, lives mainly in the past. The Sphinx identifies the continent as the home of the ancient Egyptians; a figure in a turban kneels nearby, symbolising the timeless, traditional crafts of Islamic North Africa. A black figure, whom the guide describes as

297 and **298** Edward Lear, *Kingchinjunga from Darjeeling*. Details. Oil on canvas, 1879. Yale Center for British Art, Paul Mellon Collection: Gift of Donald C. Gallup.

'representative of the uncivilised races of this continent', listens to the Christian teachings of a European woman, while 'broken chains at his feet refer to the part taken by Great Britain in the emancipation of the slaves'.[4] Enshrined in these sculptural groups are the main trends in British responses to Africa and India during this period; an appreciation of Asian and North African arts and crafts combined with a sense of racial and cultural superiority to the peoples of both continents, and a belief in the need for British colonial intervention.

In the history of the British Empire during Queen Victoria's reign, India was the most significant territory. The Victorians were heirs to a tradition of cultural interaction with India, based on trade and the exchange of goods, reaching back to the seventeenth century. The mighty East India Company, which held the monopoly right of Indian trade with Britain from 1698, became a central element in the British economy. Its trading networks were increasingly backed up by armed force and eventually, as the Mughal Empire collapsed, the Company took over the government of much of India. By the nineteenth century an unprecedented range of Indian goods and raw materials, textiles, furniture and paintings was available in Britain. British architects, too, had begun to absorb the influence of the Mughal architecture of north India; the Prince Regent's fantastic summer residence, the Brighton Pavilion, was very freely adapted from Mughal sources.[5] But the adoption of Indian styles in decoration, and the exploration of Indian and African subjects in visual art during the Victorian period, should not be thought of as the result merely of the random stylistic choices of individual artists. Rather, these works of art and design, like other art forms such as the novel or poetry, both reflected and contributed to the imperial culture of the era.[6]

299 F.H. Foley, *Asia*. Sculptural group from the Albert Memorial, seen at night.

300 W. Theed, *Africa*. Sculptural group from the Albert Memorial.

PICTURESQUE AND SUBLIME: EARLY VICTORIAN VIEWS OF INDIA AND THE MIDDLE EAST

The formation of the Victorian public's image of India and Africa owed much to the work of British landscape painters travelling abroad. Although photography (invented in 1839 but too cumbersome for travellers to use effectively until about 1850) would soon partially usurp this role, for the first two decades of Victoria's reign topographical artists equipped with pencil and watercolour had the monopoly on visual reportage of distant terrains. Often, such images would be disseminated through newly mechanised printing techniques and would be made available to a far wider audience than ever before.

British artists in India were struck by the beauty and antiquity of the monuments they encountered and struggled to find a visual language with which to capture the unfamiliar scenery. As early as the 1790s William Hodges had completed a series of spectacular landscape paintings for Warren Hastings, the Governor-General of Bengal, and published a series of 48 hand-coloured aquatints in his book *Select Views in India* (1785–8) which together with the lavish *Oriental Scenery* by Thomas and William Daniell (1795–1808), established India's claims to be a land of rare picturesqueness and beauty, epitomised by such wonders as the Taj Mahal at Agra. Given the promise of such scenery, an invitation from the Viceroy of India, Lord Northbrook, was enough to lure the intrepid Victorian artist, Edward Lear (now remembered most fondly for his nonsense poetry) to India in 1873–5. Before leaving England he was commissioned to paint an Indian subject of his own choice; he wrote to accept the commission, jesting 'Shall I paint Jingerry Wingerry Bang, or Wizzibizzigollyworryboo'.[7] The reality of India proved too impressive for any such dismissive stereotypes. Lear made a vast number of small sketches in watercolour of the monuments of India. Contemplating Mount Kangchenjunga on a trip to the Eastern Himalayas, he wrote in genuine awe:

Kinchenjunga is not – so it seems to me – a sympathetic mountain; it is so far off, so very god-like & stupendous, & all that great world of dark opal vallies full of misty, hardly to be imagined forms . . . make a rather distracting and repelling whole.[8]

Lear's finished canvas of 1879 (plate 298) articulates the sublimity of the scene through a striking clash between the lush foreground and the brilliantly lit background, implying a transition from the human to the divine. A group of tea-pickers grouped around a Buddhist shrine are presented as being unmoved by this spectacular imperial vista, a part of the scenery rather than observers of it.

Watercolour painting was considered an appropriate amateur accomplishment for ladies, to most of whom a career as a professional artist – or indeed any career – was forbidden. Many of the British women in India, often wives or daughters of civil servants or military men, made sketches and paintings of the scenery around them. An accomplished watercolourist, Charlotte Canning was the wife of the first viceroy, Lord Canning and lived in India from 1855 until her death in 1861 (plate 301).[9] Her swift, intimate paintings encapsulate British colonial life in India, in some ways a replication of the habits and customs of home, yet conducted in social and geographical circumstances radically at odds with those of England.

The landscapes, monuments and peoples of North Africa and the Middle East, like those of India, exerted a great fascination over the Victorian imagination. David Roberts, already an established artist, made a trip to Egypt and the Holy Land at the beginning of Victoria's reign in 1838–9. Roberts was motivated by a wish to see the surviving sites of the biblical narratives so familiar to every literate Victorian; traces of biblical life could still, it was believed, be discerned in contemporary oriental customs. Like the Pre-Raphaelite painter William Holman Hunt, who followed the same path in 1854, Roberts presented his trip – 'the great central episode in his artistic life'[10] – as a form of pilgrimage though he was also well aware of the potential financial rewards. In addition to a series of dramatic, broadly topographical oil paintings, 247 lithographs were made after Roberts's drawings by Louis Haghe and published under the title *The Holy Land, Syria, Idumea, Arabia, Egypt and Nubia*. These brilliantly inventive works meditate on the magnificence of ancient Egypt, seen in the monumental landscape of the *Ascent to the Summit* (plate 302). The contemporary population of Egypt is presented as picturesque but

301 Charlotte, Viscountess Canning, *Cottage at Coonoor*. 1850s. Sepia ink, watercolour and white heightening. V&A: E.1156–1987.
This was painted shortly after the artist arrived in India with her husband, Lord Canning, Governor-General of India. Although reluctant to go, Charlotte Canning was delighted by India's landscape, flora and fauna.

degenerate, hopelessly overshadowed and unable to emulate the grandeur of their ancestors. The implication, a message enshrined also in the Egyptian Galleries of the British Museum at the time, is that the true heirs to the ancient Egyptians were modern Europeans, and particularly their imperial successors, the British, rather than the contemporary inhabitants of the African continent. Though not formally a part of the Empire in Victoria's reign, Egypt was effectively under British control from 1882. In the lithographs, Roberts's detailed antiquarian interest in the monuments of ancient Egypt is balanced, as with Lear in India, with a sense of the sublime, the overwhelming, poetic impression made on the traveller by the sheer grandeur of the landscape and history of Egypt.

302 Louis Haghe after David Roberts, *Ascent to the Summit*. Lithograph from *The Holy Land, Syria, Idumea, Arabia, Egypt and Nubia* (London, 1842-9). V&A: L.642-1920.

VICTORIAN ORIENTALISM

In 1978 the literary critic Edward Said argued that modern European culture had adopted the belief that the cultures of the 'West' and the 'East', the 'Occident' and the 'Orient', were absolute, polar opposites.[11] Said characterised this stereotypical view, which he termed 'orientalism', as follows: the Westerner was portrayed as active, dynamic and masculine, while the Oriental was decadent, passive and feminine; the West represented the present and future, the Orient the past. Said presented significant literary evidence from Victorian Britain, but ignored the visual arts. While the Albert Memorial sculptures broadly conform to his characterisation, a closer study of Victorian orientalists – and especially of artists who made the Islamic world their main subject matter – reveals a more complex engagement with the eastern cultures. Before Said's intervention, the term 'orientalist' simply referred to a western specialist who had acquired an expertise in the history, languages or arts of Islamic or Far Eastern cultures. Sir William Jones (1746–94), for example, wrote admiringly of Persian literature and made a groundbreaking historical study of Hindu and Islamic law; and British artists in India, such as Hodges and Francis Swain Ward, made careful and admiring representations of ancient Indian monuments, acknowledging them as parallel, and equal, to the great architectural achievements of Europe. With the development of a Romantic sensibility in the early nineteenth century, eastern cultures came to seem both more distantly exotic and more desirable, more the basis for fantasy than the subject for historical research. Lord Byron self-consciously adopted an 'oriental' persona, distancing himself from the social norms of British society.

The greatest of British orientalist painters was undoubtedly John Frederick Lewis (1805–76). Deeply impressed, like David Roberts, by the Islamic (Moorish) architecture of the Alhambra at Granada, Lewis became not merely a traveller in the Islamic Near East, but a resident of Cairo for most of the 1840s.[12] Described in a celebrated – and no doubt exaggerated – account by Thackeray, who visited Lewis in Cairo in 1844, as a 'languid Lotus-eater' given over to the pleasures of oriental life, Lewis certainly modified his persona and behaviour while in Cairo, adopting Turkish (but not authentically modern Cairene) dress. In a series of brilliantly illusionistic works, mainly produced after his return to England in 1851 (plate 303), Lewis explored more fully than any of his contemporaries the aesthetic potential of Islamic decoration. His British viewers were fascinated by Lewis's vignettes of life in the harem – the all-female enclosure to which, surely, a male artist should be forbidden access – and his work offered an astute and appreciative observation of the visual splendour of Islamic design, from textiles to ceramics and woodwork. Although some of his figures conform to the stereotypes Said identified, Lewis seems to have embraced the visual and cultural richness of modern Egypt rather than evincing a sense of western superiority.[13]

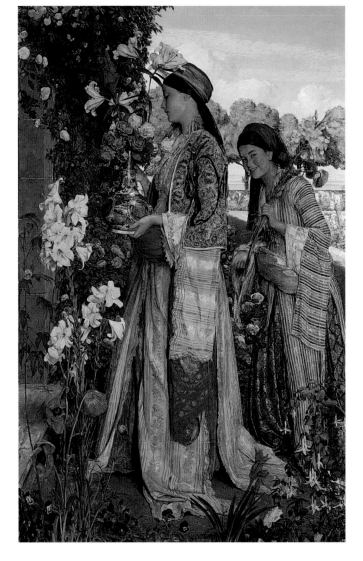

303 John Frederick Lewis, *Lilium Auratum*. Oil on canvas, 1871. Birmingham City Art Gallery.

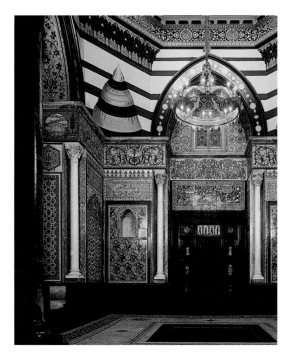

304 The Arab Hall,
Leighton House. 1877–79.
V&A: NAL.

The richly patterned interiors represented in many of Lewis's most notable works, and so attractive to advanced mid-Victorian taste, derived from his own house in Cairo.[14] In later decades a number of attempts were made to apply elements of Islamic architecture and ornamentation to the British domestic interior. The most spectacular orientalist interior in Britain is, perhaps, the Arab Hall, designed and built in 1877–9 for the artist Frederic Leighton by his friend George Aitchison.[15] A leading member of the art establishment, but also a champion of the Aesthetic movement's belief in 'art for art's sake', Leighton painted several luxuriant orientalist canvases and travelled himself in Turkey and Egypt in 1867 and 1868.[16] At the request of the Prince of Wales, the Khedive of Egypt, Ismail Pasha, placed a steamer at the well-connected Leighton's disposal for sketching trips on the Nile. The Arab Hall, a purely decorative structure with no domestic function, was built to house Leighton's collection of Islamic tiles and ceramics, the former collected for him by the explorer and orientalist Richard Burton in Persia and Syria; their rich peacock colours and lavish ornamentation inspired Leighton to create one of the most spectacular interior spaces of Victorian London, though by no means an authentic replica of any Islamic structure (plate 304).

EASTERN ART AND DESIGN REFORM

While Indian goods were circulating in Britain for two centuries before 1851, the Great Exhibition of the Industry of All Nations held that year marks a watershed in British responses to Indian and Islamic design. The modernity of its building, the Crystal Palace in Hyde Park designed by Joseph Paxton, provided an appropriately dramatic setting for the astonishing variety of manufactured objects and raw materials. Organised by the reforming civil servant Henry Cole under the patronage of Prince Albert, the Great Exhibition effected a noticeable change in popular attitudes to Britain's colonial possessions. Displays emphasised the commercial importance of more than thirty colonies and dependencies whose manufactures and raw materials were exhibited.[17] The Indian Court, appropriately for the grandest of British territories, covered 30,000 square feet, and its array of exotic objects was highly significant in popularising Indian design for the British consumer market. Prominent in representations of the Indian Court was a howdah with magnificent trappings in gold and silver, given to Queen Victoria by the Nawab of Murshidabad, displayed with some panache on an elephant discovered at the last minute in Bury St Edmunds (plate 305). Alongside such visible tokens of British political supremacy in India were jewellery, goldsmithwork and precious stones confiscated from India's deposed or subordinated Mughal rulers during years of British military expansion.[18] Examples of Indian craft and manufacturing skill included metalware, enamels, woodwork and, most of all, a wide variety of textiles.

Although they had been adopted by European women of fashion since the late eighteenth century, Kashmir shawls proved to be one of the greatest successes of the Great Exhibition. Typically, the European market for these luxury items, which burgeoned throughout the nineteenth century, dramatically changed the circumstances of their producers, and even the product itself.[19] The value of shawls exported from India rose from £171,709 in 1850-51 to

305 W. Goodall, *The Indian Court, Crystal Palace.* Lithograph, 1851. V&A: 19538.13.

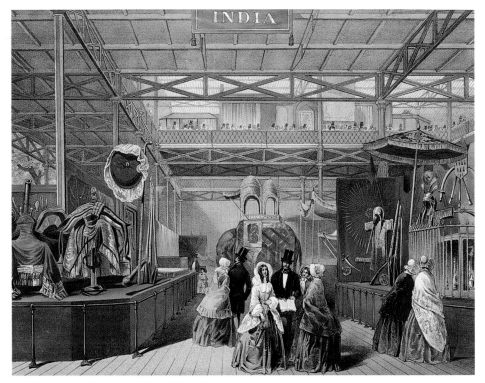

£351,093 ten years later. Reports on the shawls exhibited at the 1867 Exposition in Paris worried about an increasing French influence, which was thought to corrupt the authentic designs. But it was the manufacture by power loom of imitation shawls, in the Scottish town of Paisley (whose name has been given to the formalised cone-shaped motif typical of shawl ornamentation) which finally destroyed the European market for true Kashmir shawls, decimating a key area of the northern Indian economy.

Taken as a whole, the cornucopia of objects gathered in the Crystal Palace confirmed the worst fears of the exhibition's organisers about the state of contemporary British design. Owen Jones (1809–74), the Welsh architect and designer, who had been charged with the interior decoration of Paxton's iron and glass structure (using a colour scheme developed from a study of Islamic decoration),[20] was the most vocal of critics of the naturalistic, imitative design which typified the exhibits of 1851. For Jones and his fellow design reformers, ornament and decoration should follow their own rules rather than imitating nature.[21] British manufacturing skill and ingenuity were not in question, but in matters of taste, the simplicity and dignity of the Islamic art of India and Tunisia seen in 1851 (for the Victorians, the art of 'backward' cultures) seemed, paradoxically, to offer a way forward. The most significant contribution to these debates is Jones's *The Grammar of Ornament*, first published in 1856.[22] Lavishly illustrated with vivid colour plates made with the new technique of chromolithography, *The Grammar of Ornament* provides a textbook not only of ornamental styles but of the cultures – distanced from Victorian Britain by historical time and geographical distance – which produced them. The text is didactic; its intention is to teach both producers and consumers in Victorian society the rudiments of good taste through commentaries on examples of ornament from across the world. Jones's work presents a scientific thesis, organising ornament according to the racial and cultural identity of the producers. His taxonomy opens with an account of the 'Ornament of Savage Tribes' based on travellers' accounts and on objects from the South Pacific held in the United Service Museum in London. While noting that 'the efforts of a people in the early stage of civilisation are like those of children'[23] he found much to admire in the bold geometric designs of textiles from the Friendly Islands. Jones sets forth a broadly hierarchical, evolutionary schema in which such objects, though perhaps made in the recent past, precede the 'higher' cultures of ancient Egyptian, Assyrian, Greek and Roman ornament.

306 *Indian No. 5*, from Owen Jones's *The Grammar of Ornament* (1856). V&A: 111 Q 18.

The most radical aspect of Jones's work, however, was the high status it gave to the ornament of Islamic cultures (plate 306). Far from adopting the 'orientalist' stereotypes identified by Edward Said, Jones made a learned and admiring study of Islamic art and architecture. The Great Exhibition of 1851, he claimed, had demonstrated the superiority of Mughal (Islamic) Indian design over that of modern Europe:

Amid the general disorder everywhere apparent in the application of Art to manufactures, the presence of so much unity of design, so much skill and judgement in its application, with so much of elegance and refinement in the execution as was observable in all the works, not only of India, but of all the other Mohammedan contributing countries – Tunis, Egypt and Turkey – excited a degree of attention from artists, manufacturers and the public which has not been without its fruits.[24]

307 Sari from Benares (now Varanasi) in northern India. Silk and gold thread, *c*.1850. V&A: 769–1852.

By contrast, the arts of sub-Saharan Africa are not mentioned by Jones.

The movement for design reform did not proceed unopposed. Traditionalists such as Ralph Wornum, influential editor of the *Art Journal*, felt that whatever the superficial excellences of Indian art, for him, 'the best shapes remain Greek'.[25] John Ruskin was also antagonistic towards Indian art, though for other reasons. While he acknowledged the 'fine arrangement of fantastic hue',[26] Ruskin, whose commitment to 'truth to nature' had inspired the Pre-Raphaelite painters in the late 1840s, could not accept the stylised and conventionalised natural forms he found characteristic of Indian art. Although Ruskin was probably thinking of Hindu art, he dismissed all Indian art as a single entity which 'will not draw a man, but an eight-armed monster; it will not draw a flower, but only a spiral or a zig-zag'.[27]

Despite these objections, it was widely recognised that the presence of Indian Mughal and other Islamic objects on permanent display in London would be of incalculable use as a source of reference for British designers and manufacturers. Shortly after the publication of Jones's book, an institution dedicated to the reform of design, the South Kensington Museum (renamed in 1899 the Victoria and Albert Museum) was opened, again under the direction of Henry Cole.[28] The core of the collection was formed by a group of objects purchased by the museum's organisers from the Great Exhibition using a government grant of £5,000; of this more than a quarter was spent on Indian objects.[29] These were purchased in order to 'illustrate the correct principles of ornament [even if they] are of rude workmanship'.[30] The exquisite sari from Benares (now Varanasi) in northern India (plate 307), for which the high price of £50 was paid, epitomised the type of object which displayed these principles in its flat, stylised design, renunciation of representation, and bold, simple colouring. By the 1880s the South Kensington galleries

contained the world's most significant collection of Indian design and were widely consulted by British artists and designers.[31] In addition, the 'specimens of the arts and manufactures, and illustrations of the industry, manners and customs of the various races',[32] presented Indian cultures in a way which promoted British popular interest in the imperial project.

THE 'MUTINY' AND AFTER

Between January 1857 and June 1858 a series of events unfolded in northern India which changed the face of the British Empire. Historians disagree about the fundamental causes of the rebellion, which began as a mutiny of the Indian troops (known as sepoys), who felt that military reforms and the cartridges of a new rifle were challenging their status and their religion. Many other groups in Indian society – such as the Indian princes displaced by the British and the heavily taxed small landowners, as well as the rural poor of the Ganges plains – had grievances against the British and the 'Mutiny' acquired the characteristics of a popular uprising. The sieges of Cawnpore and Lucknow, in which large numbers of British civilians died, made clear the tenuous nature of the British grip on power in a subcontinent in which the indigenous population massively outnumbered the British.

There were no professional British artists in India at the time, and landscapes and battle scenes recreated afterwards did not capture vividly enough the human dimension of what, for the British, was a uniquely grave imperial crisis. Instead, representations of women played a crucial part in the portrayal of the 'Mutiny' for British audiences.[33] It was, above all, the alleged rape and murder of English women colonialists which caused anguish among the British public.[34] Ruskin merely articulated popular sentiment when he wrote: 'Since the race of man began its course of sin on this earth, nothing has ever been done by it so signicative of all bestial, and lower than bestial degradation, as the acts of the Indian race in the year that has just passed by.'[35] Joseph

308 Fealice Beato, *Street of Harmony*. Albumen print, 1860. V&A: Ph.172–1975.

Noel Paton's painting, *In Memoriam*, caused a scandal when exhibited at the Royal Academy in 1858; it portrayed what *The Times* called 'maddened sepoys hot after blood' bursting into a cellar where a group of English women and their loyal Indian servants were hiding.[36] The outraged responses to this subject were enough to persuade Paton to adjust the composition, replacing the sepoys with Highlanders – supposedly the hardiest soldiers, and certainly the most iconic, in the British army – arriving to rescue the captives; a narrative of catastrophe became one of redemption. In this form it was engraved with the inscription: 'Designed to Commemorate the Christian Heroism of the British Ladies in India during the Mutiny of 1857, and their ultimate Deliverance by British Prowess.'[37]

A new development at this time was the direct reporting of India and Africa by photographers. While some photographers, such as Samuel Bourne, made expeditions to India in search of the picturesque and sublime in the tradition of Roberts and Lear, producing results of great sophistication and beauty, others concentrated on more political subjects. Felice Beato, a professional photographer who travelled in India, China (plate 308) and elsewhere, took a series of harrowing images showing the damage caused to official and domestic buildings during the

'Mutiny'.[38] As noted in chapter 9, the camera could also be turned on the indigenous population of colonised lands, contributing to ethnographic research into the physical, racial and cultural traits of the many population groups in both India and Africa. The first substantial ethnographical study of India to utilise photography was *The People of India*, a series of 468 photographs, a taxonomic catalogue of supposedly typical ethnic types of India (plate 309).[39] This project was begun under the patronage of Charlotte Canning, watercolour painter (plate 301) and wife of the last Governor-General under the East India Company regime, leader of British India during the 'Mutiny'. British military action to quell the revolt was brutal and, ultimately, effective. When the British government dissolved the East India Company, Canning was made first Viceroy under direct Crown rule. His relatively lenient treatment of the rebels in this role earned him the nickname 'Clemency Canning'. It was felt that a greater ethnographical knowledge of the peoples of India, with their different 'racial' characteristics, would aid the new British Raj in keeping order.

A DARK CONTINENT?

If India was the proudest of imperial possessions, a problematic but none the less richly endowed territory, Africa seemed far less economically and culturally attractive at the beginning of Victoria's reign. The importance of securing passage around the Cape of Good Hope for British shipping to reach India had long been recognised. Until the mid-nineteenth century most of inland sub-Saharan Africa, however, remained largely a blank on the map, an unknown territory whose inhabitants (including the Boers who had left the Cape in the 'Great Trek' of the 1830s) appeared to the British colonists to be both uncivilised and hostile. Natural resources seemed limited (this was to change with the development of gold and diamond mining in the late nineteenth century) and local products of negligible value, though some travellers exaggerated their significance to direct attention to the continent.

British popular interest in sub-Saharan Africa was awakened less by commercial than by moral issues. In 1807, after a sophisticated campaign led by Quakers and the Evangelical Movement, Britain abolished the slave trade and in 1833 slavery was banned throughout the British Empire.[40] The Victorians were proud of this inheritance, and justified colonial expansion in Africa later in the century on the grounds that it would further the campaign against slavery. The promotion of Christianity among the peoples of Africa was also keenly supported in Victorian Britain, and Protestant missionaries won a special place in the affections of the Victorian public. It became widely accepted that to spread the Word of God was a moral duty almost synonymous with – and dependent on – the expansion of British political and economic influence. The Victorian figurehead of this movement was undoubtedly David Livingstone, whose combination

309 *Oodassee*. Albumen print, c.1862. From *The People of India* (London, 1868-75). V&A: 59.0.21.

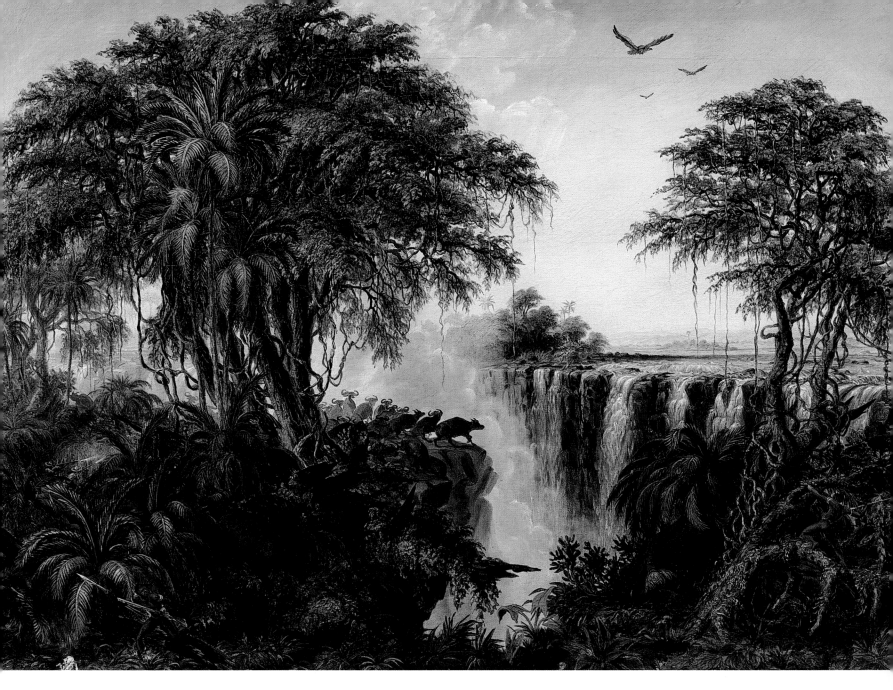

310 Thomas Baines,
Herd of Buffalo, opposite the
Garden Island, Victoria Falls.
Detail. Oil on canvas, 1862.
Royal Geographical Society,
London.

of missionary zeal with a courageous passion for exploration in the African interior made him a popular hero. The publication of Livingstone's illustrated account of his life and journeys in Africa, *Missionary Travels*, 1857, and a highly successful lecture tour the same year, were instrumental in increasing the Victorian public's interest in Africa (plate 310). The wood-engraved frontispiece, a broad panorama of the natural phenomenon which Livingstone had named Victoria Falls, gave the British public an unprecedented view of the African interior, though hardly an accurate one, since it was reconstructed by a London artist from Livingstone's crude sketches. Livingstone returned to Africa on a secular, government-sponsored mission to explore the Zambesi river. Its aims summarise British interest in Africa at this time:

to extend the knowledge already attained of the geography and mineral and agricultural resources of Eastern and Central Africa, to improve our acquaintance with the inhabitants, and engage them to apply their energies to industrial pursuits, and to the cultivation of their lands with a view to the production of the raw material to be exported to England in return for British manufactures.[41]

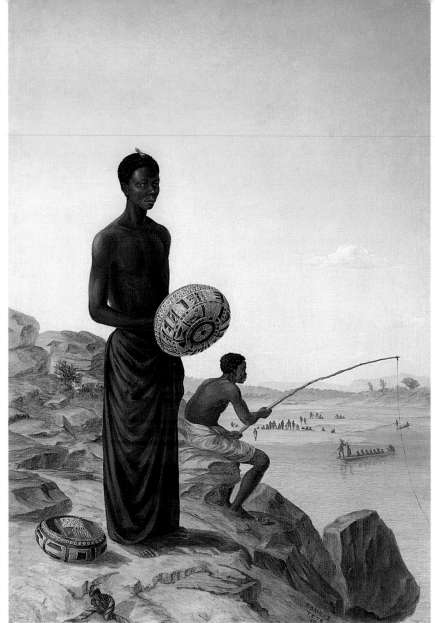

311 Thomas Baines, *Shibante, a Native of Mazaro, Boatman and Pilot belonging to Major Secard.* Oil on canvas, 1859. Royal Geographical Society, London.

In Livingstone's famous phrase, only 'commerce and Christianity'[42] could redeem Africa. This time Livingstone took an official artist, Thomas Baines, with him. Although Livingstone required of Baines 'portraits of natives for the purposes of Ethnology' and 'Birds and animals alive',[43] the artist (whom Livingstone soon dismissed from the expedition for apparently spurious reasons) produced paintings which far exceeded this brief. His landscapes, though naïve in execution, move beyond picturesque tourism to provide a revealing portrait of the African landscape and its inhabitants. While, unsurprisingly, he shared many of the prejudices of his generation, Baines made memorable portraits of Africans, such as *Shibante, a Native of Mazaro . . .* , which acknowledge the individuality and dignity of the sitter (plate 311). Livingstone's brother Charles acted as official photographer on the Zambesi expedition, although John Kirk, the botanist-doctor, was rather more successful in taking photographs.[44] Their images provided a new way for the Victorian public to view Africa, through a medium which was considered uniquely truthful in its depiction. Photography soon became the dominant medium for the visual representation of the landscapes and peoples of Africa.

Most vivid of the representations of Africa accessible to the Victorian public were exhibitions of African objects and even of people in stage shows and popular exhibitions.[45] The South

Kensington Museum largely ignored sub-Saharan Africa, but objects of ethnographic interest from Africa, along with those from the South Pacific and elsewhere, were displayed at the British Museum and new institutions, such as the Horniman Museum in South London and the Pitt-Rivers Museum in Oxford, opened in 1884. Such objects were not considered to be works of art but more often described by terms such as 'fetish'. Methods of display and interpretation varied, but in late-Victorian England African objects were generally placed within an evolutionary scheme based on the theories of Charles Darwin, in which they were considered to show a state of human development anterior to that of advanced societies. These assumptions were challenged in 1897, when a complex series of events in Benin, in what was then the Niger Coast Protectorate in West Africa, led to the plundering of royal insignia by a British 'punitive expedition'. These included large numbers of ivory carvings and cast metal sculptures of great beauty and technical accomplishment.[46] Many Victorian scholars believed that objects of this sophistication could not have been of African manufacture, and developed theories to connect them with Egyptian, Chinese or even European origins or influences. The bronzes were soon accepted as works of 'art' and are now considered to be of the highest aesthetic quality.

The impact of British colonial activity on African art is hard to assess. Certainly, economic, demographic and cultural change across Africa gained pace in the nineteenth century, with often disastrous effects; whole populations were decimated by war and disease and traditional ways of life radically altered. Yet in colonial situations, hybrid objects are often produced which bind together in unexpected ways images and image-making techniques from radically differing cultures, a process exemplified by the carved wooden statue of Queen Victoria (plate 231), which probably originated from a print or photograph, or possibly a public statue in a colonial city.

ARTS AND CRAFTS IN INDIA

While the generation of 1851 had been wedded to the Victorian liberal ideal of progress through economic and industrial growth, and saw design reform as a means to this end, a new generation of scholars, influenced by Ruskin's historical and prophetic book *The Stones of Venice* (1851–3), began to question the whole project of industrial modernity. Ruskin and his follower William Morris looked back to the Middle Ages as a golden age of craft production, in which labour was a creative, expressive act rather than the repetitious, dehumanised industrial wage-slavery which they perceived in the Victorian city. India, commonly thought of as an unchanging society, preserving traditional craft skills, offered interesting parallels to the Europe of the Middle Ages. Indeed, the eminent Victorian lawyer Henry Maine argued in *Village Communities in the East and West* that contemporary India closely resembled the social organisation of medieval England.[47] It followed, then, that Indian art, as William Morris declared, was 'founded on the truest and most natural principles'.[48] His own designs for textiles, eschewing both naturalism and geometry, but based on organic forms, drew on Indian models as well as medieval European ones.

George Birdwood, a civil servant at the India Office who curated the Indian collections of the South Kensington Museum, evinced a new, Ruskinian abhorrence of industrialisation.[49] For him the beauty of Indian art was the result of its roots in village life: 'In India, everything is hand wrought, and everything, down to the cheapest toy or earthenware vessel, is more or less a work

of art.'[50] The galleries he organised at the South Kensington Museum focused on the processes of production as well as the product: accordingly, 'Sepia drawings of native handicraftsmen' by John Lockwood Kipling, the father of the writer Rudyard, were displayed alongside original objects.

The anxiety of Birdwood, Kipling (plate 312) and others about the effects of mechanisation and industrialisation at the imperial centre led them to invert the standard account of imperialism's triumphal technological transformation of 'backward' colonised lands:

We are beginning in Europe to understand what things may be done by machinery, and what must be done by hand work, if art is to be of the slightest consideration in the matter. [To introduce machinery into India] would inevitably throw the traditional arts of the country into the same confusion of principles . . . which has for three generations been the destruction of decorative art and of middle class taste in England.[51]

Morris and a number of other Victorian luminaries signed a petition in 1878 deploring the 'rapid deterioration of the historical arts of India' under colonial influences.[52]

Meanwhile, in British India art schools were being founded on the model of the Government Schools of Art in South Kensington. Schools were established in Madras (1853), Calcutta (1854) and Bombay (1857), but the nature of the curriculum – whether it should perpetuate Indian or European traditions – remained a matter of controversy. Some students aimed to become fine artists in the European tradition, learning by drawing from casts of classical sculpture and exhibiting oil paintings at the Simla Fine Arts Exhibition, the 'Royal Academy of Anglo-India'. When Lockwood Kipling was appointed in 1875 to head the new Mayo School of Art in Lahore, he emphasised traditional Indian craft skills which were rapidly declining in the face of cheap European imports.[53] Kipling's principal protégé was the Sikh woodcarver Bhai Ram Singh (d.1916), who created masterly objects which incorporated traditional motifs from the wood-carvings of his home town, Amritsar, into the production of such western objects as writing desks and sideboards.[54] Determined to secure patronage within the British Empire for Ram Singh and for Punjabi craftsmen in general, Kipling found in Arthur, Duke of Connaught, the third son of Queen Victoria, an ideal patron. In 1882, the duke had taken part in the military campaign with resulted in Egypt being brought under British control, and purchased Islamic art objects in Cairo after the military operation was concluded.[55] After transferring to the Indian army in 1883, the duke visited the Calcutta Exhibition (a colonial successor to the London 1851 and 1862 exhibitions) where he met Kipling. The result was a commission for 241 panels carved in deodar wood to be installed in the billiard room at Bagshot Park, the new English home of the Duke and Duchess of Connaught, to be carved by Ram Singh in Lahore. This spectacular, hybrid, colonial interior was of a unique type; woodwork of this kind was not used for interiors in India, but for door-panels. None the less, the room was irresistible to Queen Victoria. When she saw it with Kipling in 1890, she commissioned one for herself. Accordingly, Ram Singh and Kipling came to Britain in 1891 to work on the new dining room at Osborne House, on the Isle of Wight, where a grandiose plaster ceiling in Indo-Saracenic style, based on Ram Singh's models, was installed (plate 313).

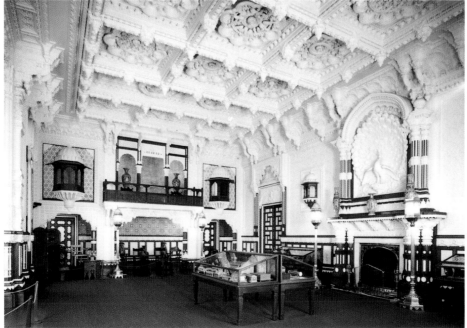

312 John Lockwood Kipling, *Carpet Weavers*. Charcoal, ink and watercolour on paper, 1870. V&A: 0929:33 (IS).

313 The Durbar Room, Osborne House, Isle of Wight. Completed 1893. Photograph courtesy of English Heritage.

THE THEATRE OF EMPIRE

In 1876 Queen Victoria was declared Empress of India, inaugurating a period of more assertive imperialism in Britain. After the grandiose proclamation durbar in Delhi on 1 January 1877 imperial ceremony became an increasingly important part of Victorian culture, both in Britain and the colonies. The Colonial and Indian Exhibition of 1886 at South Kensington, which was attended by 5.5 million people, opened in a blaze of ceremonial glory, a part of the invented traditions of empire.[56] *The Graphic* carried a large engraving of the Queen-Empress, depicted 'twixt East and West', processing between beefeaters and Indian troops, symbolising the marriage of Britain and India. The exhibition was a massive exercise in publicity for the imperial ideal and a bonanza of national self-aggrandisement, as *The Graphic* boasted:

No alien, of whatever race he may be – Teuton, Gaul, Tartar or Mongol – can walk through the marvellous collection at South Kensington . . . without feeling the enormous influence that England has had, and still has, over every part of the globe.[57]

A key feature of the Indian court was a display of models of ethnic types made from body casts. The 'Durbar Hall' of the 'Indian Palace', in which the Prince of Wales held receptions, was superbly carved by the Punjabi craftsmen, Muhammad Maksh and Juma.[58]

Queen Victoria became increasingly preoccupied with India. Her imagined relationship with its princes and peoples perhaps offered a reminiscence of the feudal authority of medieval England. Following the Duke of Connaught's advice, she purchased a series of 'portraits of natives in national costume' by the Viennese artist Rudolf Swoboda depicting Indian craftsmen who had demonstrated their skills at the 1886 exhibition.[59] The queen subsequently paid for Swoboda to visit India, and commissioned portrait heads 'of the various types of the different nationalities'[60] which were installed near Ram Singh's Indian dining room at Osborne, where they remain today. The project clearly recalls the photographic study of *Heads of India*, supported by Charlotte Canning,[61] a quasi-ethnographic project allowing Victoria to survey representative India types. In addition to more than eighty portrait heads, the queen also purchased from Swoboda a genre painting, *A Peep at the Train* (plate 314), which addresses the relationship between traditional Indian society and the modern India of the British Empire. The artist's view, from the window of the train and over a fence, raises him above the family – probably sketched in the Punjab – who stare up with somewhat melancholy fascination, while craftsmen operate a loom in the middle distance, plying their traditional crafts. Indian life, glimpsed in this tourist vignette, seems both picturesque and outmoded.

EPILOGUE

The late Victorian period, marked by explicitly imperialistic celebrations of the queen's Silver (1887) and Diamond (1897) Jubilees, saw an increasingly shrill promotion of empire at home, but problems for the imperial project overseas. The final imperial crisis of Victoria's reign, the Boer War, a result of the Afrikaners' resistance to British policies in South Africa, was to shake Britain's imperial confidence profoundly. John Byam Liston Shaw's painting of 1901, *Boer War, 1900* (plate 126), reflects these uncertainties. Instead of offering a battle scene or an allegory of

Shaw (as he was known) chose feminine suffering as an emblem of imperial insecurity. Despite its title, his painting presents a landscape at Dorchester on the Thames, and the grieving fiancée of a soldier killed in battle. Perhaps the artist chose this moment to reassert a provincial, rural Englishness as an escape from a colonial engagement which was troubling not only because of British military failures, but also because of the widely reported brutality of both sides, including the British use of concentration camps and a scorched-earth policy. If the rhetoric and pageantry of empire had reached their zenith by the close of Victoria's reign in 1901, the new century would see dramatic changes in the relationship between Britain and its colonies. In India, partition and independence in 1947 would conclude a campaign begun during Victoria's reign with the founding of the Indian National Congress in 1886, and Africa, where the Suez crisis of 1956 hastened the process of de-colonisation completed by the independence of Zimbabwe in 1980. In the face of socio-political change and economic stagnation, twentieth-century British culture became less preoccupied with the distant terrain of empire, and, under external threat in two world wars, veered more often towards a more introspective, post-imperial reflectiveness.

314 Rudolf Swoboda,
A Peep at the Train.
Oil on canvas, 1892.
The Royal Collection
© HM Queen Elizabeth II.

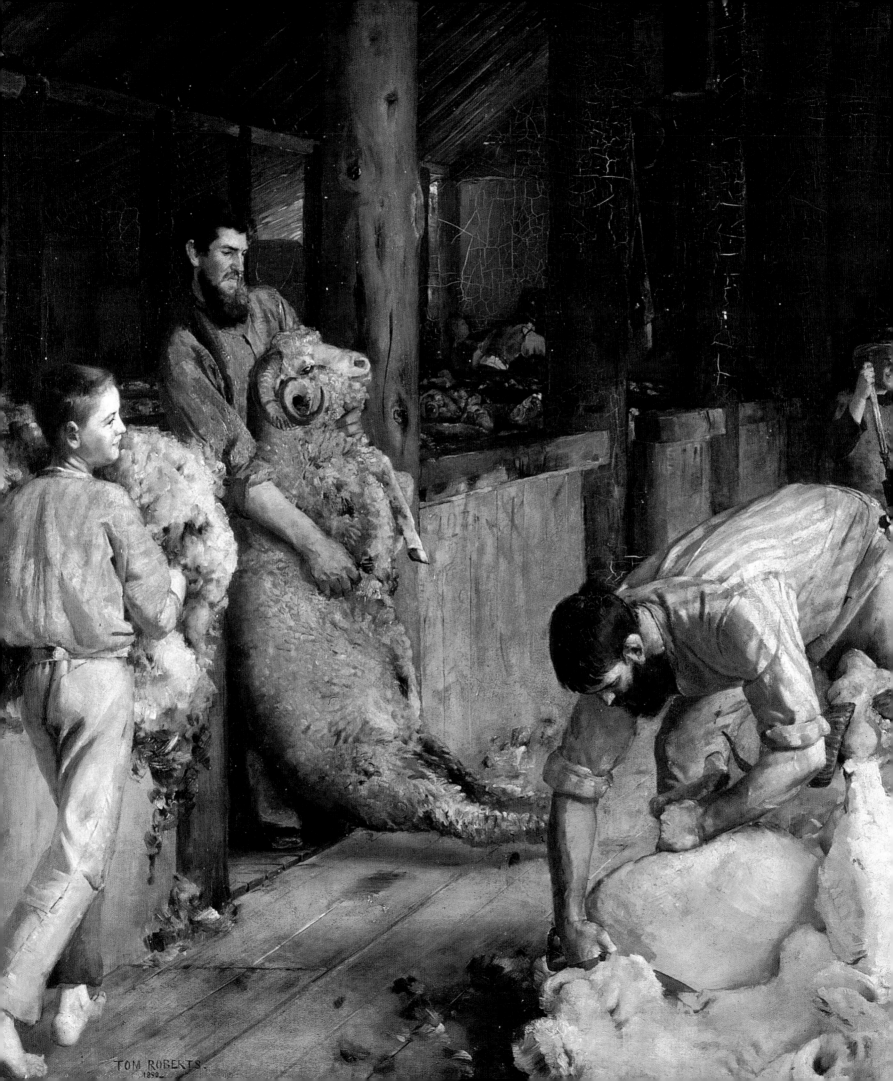

THE WORLD OF ART AND DESIGN:

White Colonials

JONATHAN SWEET

FRATERNITY

In the annals of Victorian England there is evidence of a curator's dream for a museum which united the pieces of a vast colonial jigsaw puzzle. The role of this museum, The Imperial Museum for India and the Colonies (1876), was to promote the products of all the territories, islands and backwaters of the Empire. The author, J. Forbes Watson, was a specialist on the art and culture of India but he also appreciated many other things colonial. Of particular interest, however, is that he did not locate the significance of the white settlement colonies, Australia, Canada, New Zealand or South Africa, in any distinctive contribution to the arts of the world (plate 318).[1]

Unlike the British Museum or the South Kensington Museum, the Imperial Museum was to house exhibits of colonial products. But more importantly perhaps the scheme also implied a celebration of fraternity, symbolising the idea that emigrants with blood ties and a common language linked the white colonies together. Clearly, therefore, the grouping of these colonies with India made little sense beyond the convenience of displaying all colonial products under one roof. To the mid-Victorian mind the scheme had another significance, as Forbes Watson explained: while India was blessed with a poetic past of great antiquity, the settlement colonies were clearly devoid of any 'historical and artistic element' and were seen to be 'essentially modern and utilitarian'.[2] The museum therefore conceptualised an historical time-line that linked the ancient past to contemporary events and future opportunities.

315 Royal Engineers US/Canada Border Commission, *Guard House, Lower Cascades, Right Bank of Columbia River*. Detail. Albumen print, 1860-1. V&A: 40.042.

316 Tom Roberts, *Shearing the Rams*. Detail. Oil on canvas, 1889. National Gallery of Victoria, Melbourne.
In search of subject matter which might unambiguously stand for Australian colonial culture, the painter looked to the experience of workers in the pastoral industry.

317 *Colonial and Indian Exhibition 1886*. Frontispiece engraving, 1886. Supplement to the *Art Journal* (1886). V&A: PP.6.B–C.
The entrance to the Colonial and Indian Exhibition was a startling representation of a global Empire. It featured a series of synchronised clocks showing the time in five locations around the globe, and a huge canvas map (700 square feet) upon which the colonies and dominions were highlighted in bright scarlet oil paint.

Although this particular Victorian dream failed to materialise, the efforts of Forbes Watson and others to promote growth in the colonies were realised in the form of the Colonial and Indian Exhibition of 1886. This exhibition was a celebration and a marker of a vibrant Empire. In turn it inspired the establishment of the Imperial Institute, a permanent facility opened by Queen Victoria in 1893. The façade of the main exhibition building in South Kensington followed the theme of unity. It presented an impressive novelty clock, with five distinct faces simultaneously showing the time in five locations around the globe: Greenwich, Ottawa, Cape Town, Calcutta and Sydney. In one important sense this mechanised graphic display suggested the synchronised rhythm of the entire world, underscored by empirical practice, steadily measuring, marking, and celebrating knowledge and progress (plate 317).

Throughout the Victorian world intellectual, economic and cultural developments were inextricably linked to technological progress, particularly in communications. In 1887, for instance, Thomas Humphry Ward summarised the progress made in the visual arts during the reign of Queen Victoria. His appraisal emphasised the social significance of new technology, in this case photography. With a degree of paternalism Ward wrote that, 'on the social side photography has done much to preserve the sense of kinship among the scattered members of

318 Frontispiece to J. Forbes-Watson's *The Imperial Museum for India and the Colonies* (London, 1876). Published to accompany the ambitious project of a permanent facility in London where colonial products could be displayed, and growth in the settlements promoted.

English families all over the world'.[3] This was primarily because portrait photography, in particular, offered an immediacy and transportability never before realised.

For Forbes Watson and others the white colonies were synonymous with exploration, discovery and development. New collecting domains for the natural sciences provided many strange curiosities, which fuelled the interest in the theory of evolution. The territories were rich in industrial raw materials, gold and iron ore, and while successful graziers of livestock had laid the foundations of long-standing primary industries, urban colonists embraced modernity and utilised photography as a tool to document and promote the development of new cities. It was perhaps partly because of this overwhelming pioneering exuberance, determination and colonial gusto – fed by sophisticated trade routes – that Victorians in London could not locate any obvious 'distinctiveness' in the art and design of the colonies. Clearly, the diverse arts and cultures of 'First Peoples' were another matter, existing outside traditions of European artistic practice, design and craftsmanship. As settlements grew from a process of colonisation, emigrants from the British Isles and other European countries established communities in the New World that supplanted indigenous cultures with their own.

During the reign of Victoria, therefore, settlers naturally favoured the styles of architecture, applied arts and painting which were popular with their kin in Europe. These styles embodied an acceptable range of meanings, drawn from historical, intellectual and folk traditions. The Gothic Revival and the neo-classical styles particularly, were associated with British political and religious culture, and were disseminated and adopted for public buildings throughout the colonial world. In Canada for instance, the Parliament Buildings in Ottawa (1859–66) show the profound influence of the Palace of Westminster (1837–67),[4] while the Public Library and Museum in Melbourne (1854–70) is almost a replica of the British Museum (1823–47), complete with domed reading room and temple façade. Museum interiors too, were the product of empirical practice. The first exhibition at the museum in Sydney in 1855, while thematically eclectic, nevertheless aspired to a systematic arrangement of objects presented in a neo-classical room (plate 319).

The establishment of official colonial art collections also followed improvements in transport and communication systems. Collections grew quickly as prominent advisers in London, Sir Charles Eastlake for instance, and others of the Royal Academy circle, dispatched paintings to their new homes around the globe.[5] A government grant enabled the first purchases of works of art for a permanent national collection in Melbourne in 1859. Acquisitions during the following decade included a significant number of classical sculpture plaster casts, which were displayed in a sculpture gallery and used as models by the School of Design.[6] In 1877 the Canterbury Museum in New Zealand held an 'Art Exhibition' where a life-size portrait painting of Captain James Cook was displayed alongside a collection of English ceramics.[7] In Toronto the works of contemporary British artists entered the national collection through donation: Frederic Leighton's painting *Sansone* was presented in 1883, and George Frederick Watts presented his work *Time, Death, and Judgement*, a replica of the picture in St Paul's Cathedral, in honour of Queen Victoria's Jubilee in 1887.[8]

Some artists were able to travel. Painters such as the Australian, Tom Roberts (1856–1931)

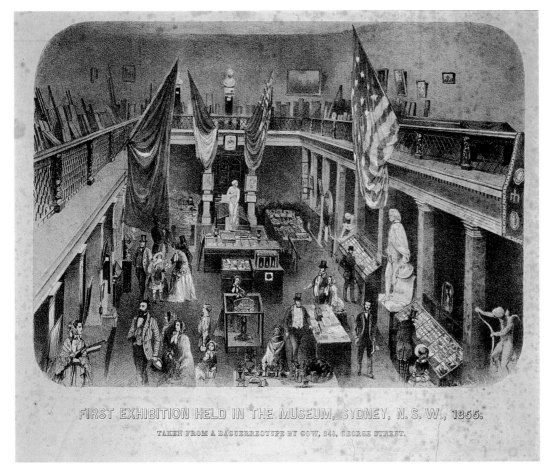

FIRST EXHIBITION HELD IN THE MUSEUM, SYDNEY, N. S. W., 1855.

TAKEN FROM A DAGUERREOTYPE BY GOW, 243, GEORGE STREET.

319 John Degatardi after F. C. Terry (del.) and James Gow (photographer), *First Exhibition Held in the Museum, Sydney, NSW, 1855*. Lithograph. Mitchell Library, Sydney.
The first colonial museums housed an eclectic range of exhibits, which typically included raw materials, architectural models and plaster casts of classical sculptures. The neo-classical style was often adopted as a fitting architectural backdrop, as is evident in this gallery at the museum in Sydney in 1855.

and the Canadian Allan Edson (1846–88), took advantage of faster steamer services to further their artistic careers by dipping into the art scene of Victorian London or Impressionist Paris. Roberts's painting *Coming South* (1886) is an admixture of his own steamer experience and contemporary European representational concerns, in composition, modernity and allegory. Emigration was a topical issue, and soon after Roberts's return to Melbourne the painting was dispatched to London to be displayed at the Colonial and Indian Exhibition.

As well as personal contact, artists, designers and the public could also see objects displayed in the colonial cities themselves. In 1877 Cape Town hosted the successful South African Exhibition,[9] and in the case of Australia, tons of manufactured goods and selected works of art were shown at international exhibitions in Sydney in 1879 and prosperous Melbourne in 1880 and 1888.[10] Oil paintings by Sir Lawrence Alma Tadema for instance, were exhibited in Sydney before travelling south to the Melbourne Exhibition.[11] Luxury goods came from the British Isles, Germany, Italy and France, amongst other places. British furniture manufacturers, such as C. & R. Light of London, sought to expand their markets thorough exhibition display and the publication and circulation of illustrated trade catalogues.[12] These popular exhibitions, like their counterparts in Europe and America, profoundly influenced taste and in some cases, through particular associations of origin and product, laid the foundations of long-standing trade patterns. International exhibitions encouraged diplomacy and enhanced the European flavour of the colonies.[13]

Of consistent influence were publications. Theories of art and design as well as aids to practice were packaged in specialist books, magazines and catalogues and regularly transported from Britain. For example, J. C. Loudon's *Encyclopedia of Cottage, Farm and Villa Architecture and Furniture* (1839) was a standard reference for domestic architecture and interiors in the colonies. Another example, J. J. Stevenson's *House Architecture* (1880), successfully promoted the Queen Anne style throughout the world, and was particularly influential in Canada.[14] Also disseminated widely were complete sets of catalogues and reports from the Great Exhibition of 1851. Reports and catalogues of later exhibitions followed systematically. The Great Exhibition catalogues included lengthy appraisals of agricultural and mining machinery and critiques of household furnishings and labour-saving devices, many accompanied by accurate line engravings. As early as 1853 a set of these catalogues was deposited in the Hobart Town Library, where they helped the designer George Whiting towards the conception of the striking Tasmanian Timber Tower.[15] By 1858 the City of Toronto had constructed a local version of the Crystal Palace in cast iron and glass.[16] Also influential were publications such as the *Magazine of Art*, a truly global art magazine. This periodical was not only available in London, Paris and New York, but was also regularly shipped to the colonies. During the 1880s it was apparently displayed in colonial shop windows and widely read.[17]

As was recognised by Forbes Watson in his plan for the Imperial Museum, the white settlement colonies were colourful quarters in a global Empire. Yet while colonists generally shared his patriotic enthusiasm, it was also clear that by the 1870s a disposition towards cultural distinctiveness was emerging in the most established settlements. This germinated from the promotion of democratic values, the notion of a 'common-wealth' and the cosmopolitan and opportunistic atmosphere of some colonial cities. Yet, even as feelings of colonial nationalism and cosmopolitanism variously took hold amongst sections of the colonial communities, it remained the case that officially, at least, British artistic innovations, conventions, historical models and institutions were most highly and consistently valued. The development of colonial culture was overwhelmingly filtered through Empire aspirations. Even so, as the settlements became established entities the art and design produced in them more and more reflected the understandable tensions between patriotic conservatism, regional consciousness and the wilful embrace of modernity.

Forbes Watson was perhaps too constricting in his scheme for an imperial museum and he failed to gain the necessary support of the colonial governments. Amongst other things, his narrow conception of the white settlement colonies demonstrated an understandable reluctance to take account of the emergence of individual colonial histories. The white settlement colonies were founded by a paternalistic culture in the spirit of fraternity, and administered with the aid of new technologies. But just as these technologies enabled the dissemination of common ideals, the reproduction of images and the transference of skills, the emergence of a global Victorian culture also fostered a natural if tempered desire for a degree of cultural, historical and artistic distinctiveness in the white colonies.

FIRST PEOPLES

It is generally accepted that the art and culture of the Aboriginal people in the Australian colonies had little bearing on the art and design of white settlers in the nineteenth century. On the whole, colonists failed to appreciate the spiritual significance of Aboriginal arts and were generally reluctant to acknowledge their existence.[18] In other colonies too, there is little to suggest that the colonists absorbed much from the art of the indigenous people. Indeed it was commonly believed in Canada, as elsewhere, that indigenous people belonged to prehistoric times, living in 'a static prelude to real history', which began upon the arrival of the first Europeans.[19] Indigenous people were associated with the pre-settlement landscape or wilderness. In keeping therefore, with empirical methodology and the mapping and documentation of the natural world, Empire artists took a great deal of interest in First Peoples as subject matter for their work, and museums assiduously collected artefacts and tools, indeed with prodigious and encyclopaedic ambition.

During the eighteenth century perceptions of indigenous people in the New World were filtered through romantic ideas of the noble savage.[20] In the following century, however, as images of the dramatic death of Captain James Cook at the hands of Polynesians were disseminated widely, the programme of exploration, scientific investigation and colonisation diluted this romanticism.[21] Increasingly, these developments were accompanied by an ambivalent attitude towards indigenous people and resulted in artistic responses which ranged from extreme naivety, through exercises in social and scientific documentation, to those of wilful subjugation.

Mid-century silversmiths in the Colony of South Australia, for instance, established successful businesses manufacturing and retailing decorative centrepieces, trophies and candelabra that depicted mythical Australian bush scenes. These pieces were regularly displayed at international exhibitions. Miniature Aboriginal people were grouped together with other distinctive elements of the pre-settlement world, such as the emu and the kangaroo.[22] Similarly, life-size three-dimensional dioramas depicting wilderness scenes were sent to London for the Colonial and Indian Exhibition of 1886. A visit by the queen to the South Australian Court bought her face to face with one such scene, an event featured in the *Illustrated London News*.[23] Amongst other things, the engraving demonstrated the great divide between Her Majesty, confident and prosperous on the one hand, and the anachronistic Aboriginal fisherman on the other. They seemed to represent extreme poles of the Victorian world.

Where an artistic material culture was recognisable the response was different. In New Zealand, for instance, Joseph Jenner Merret (1816–54) painted many watercolour portraits of Maoris during the 1840s. Some of these highlighted distinctive features of the native costume, such as the geometric border patterns on traditional woven cloaks (plate 320).[24] More dramatic examples of Maori design were also of great interest, and in England Owen Jones included examples drawn from Maori carving in the monumental *Grammar of Ornament*. In the colony itself

320 J. J. Merrett, *Standing Maori in Cloak and Holding Mere*. Pencil and watercolour, 1840s. Rex Nan Kivell Collection, National Library of Australia.
Portraits of indigenous people in the colonial world were stereotyped for a European audience. Tools and weapons were often included to provide an indication of technical proficiency or cultural sophistication. In this case, although the traditional Maori kaitaka (flax fibre cloak) is prominent, the artist has also sought to produce a portrait of an individual.

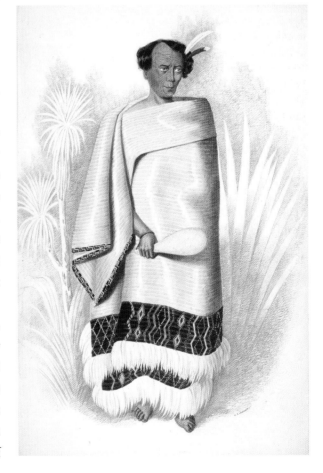

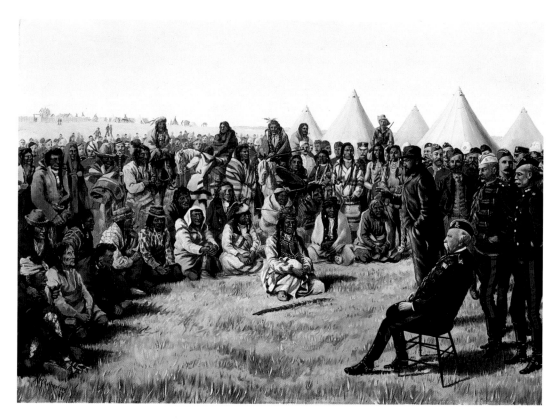

321 Robert Rutherford, *The Surrender of Poundmaker to Major General Middleton at Battleford, Saskatchewan, May 26, 1885.* Oil on canvas. Public Archives Canada. The advance of colonisation through military action was a popular Victorian theme. The painter and illustrator Robert Rutherford served in the Royal Canadian Artillery and was at the Battle of Cut Knife Hill in the Northwest Frontier, when the colonial force retreated. This painting though, marks the result of a consequent engagement, where the Cree chief Poundmaker was induced to surrender.

examples of Maori architecture were relocated by 1870 to both the Canterbury Museum and the Colonial Museum in Wellington, where they were promoted as 'really magnificent specimens of the carver's art'.[25] Likewise, the façade of a 'store-house' was displayed in the Native Section of the New Zealand Court at the Colonial and Indian Exhibition.[26] However, despite the apparent appreciation of craft skill there is little to suggest that these displays had, or were intended to have, any significant impact on the European art of the period. They were primarily viewed from an ethnological perspective as a 'very valuable memorial to early Maori art'.[27]

The acquisition of artefacts and their subsequent display in exhibitions and museums directly resulted from colonisation, but colonial art was also proffered to demonstrate the success of this process. In a medium most often associated with grand ecclesiastical and historical themes, a painted glass window displayed at the London International Exhibition, of 1862, depicted a classically statuesque Canadian Indian 'in his full war dress'. This work by W. Bullock of Toronto was illustrated in the *Art Journal Illustrated Catalogue*, where it was described prosaically as 'accurate in character and costume'.[28] Almost a generation later though, in 1887, Robert Rutherford (1857–1933) painted *The Surrender of Poundmaker to Major General Middleton at Battleford, Saskatchewan, May 26, 1885* (plate 321). Gone is the noble composure. The painting depicts a group of over sixty Indians squatting in submission to the seated Middleton. Rutherford was a handy frontier artist, adept at capturing the newsworthy moment. He had studied at the Ottawa School of Art in the early 1880s, served in the Royal Canadian Artillery and was a regular contributor to the *Canadian Illustrated News*.[29] In 1886 Middleton returned to London when Queen Victoria appointed him Keeper of the Crown Jewels, while the colonial government purchased the painting in 1888.

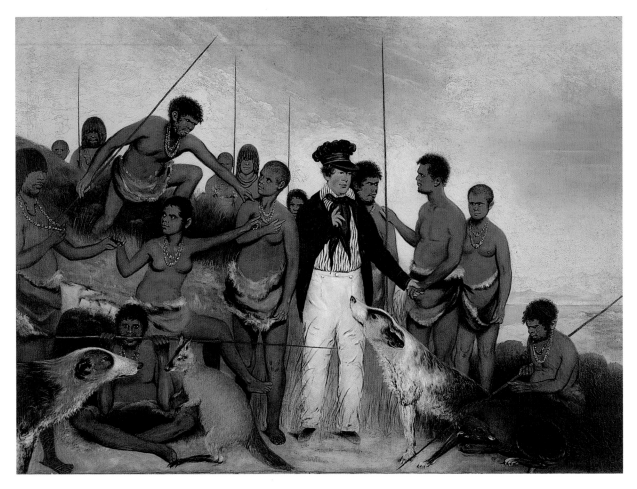

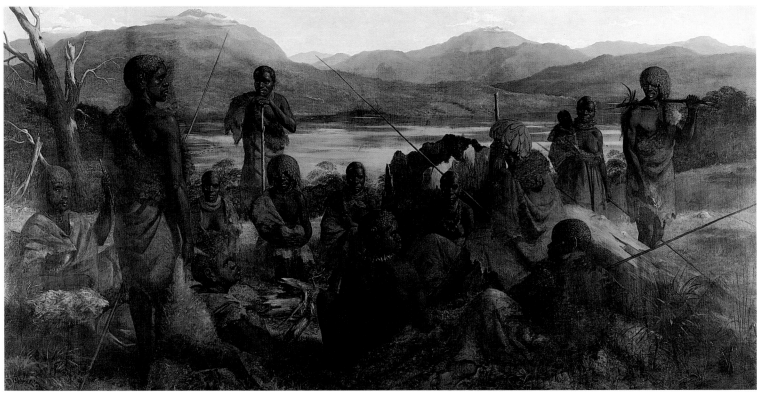

322 Benjamin Duterrau, *The Conciliation*. Oil on canvas, 1840. Tasmanian Museum and Art Gallery, Hobart. This Tasmanian painting celebrates the attempt to 'civilise' a group of Aborigines by a lay Methodist preacher.

Indigenous peoples were of enormous interest in Europe, where the theory of evolution was a topical and emotive issue, but clearly images such as the *Surrender of Poundmaker* were commissioned for political and strategic motives as well. Colonisation implied hope and success through unimpeded possibilities. In the drive to attract settlers, for instance, the colony of Tasmania assured prospective emigrants that they would not encounter the same resistance from hostile Aboriginals as that presented by the North American Indians. In the midst of conflict, the painting *The Conciliation*, by Benjamin Duterrau, was intended to promote an attitude of negotiation and protection of local communities, rather than support for their destruction. Yet, even so, the painting is founded on a starkly symbolic contrast between the centralised white settler and the group of Aboriginal people who surround him. The settler is safe and in control. The painting implies a virtuous and successful process of colonisation (plate 322).

In a mid-century atmosphere of expanding colonial territories the painter Robert Dowling (1827-86) built upon this theme during his mid-career visit to London.[30] In the monumental canvas *Aborigines of Tasmania* (1859) the members of a disappearing culture are posed like models in an exhibition diorama. The painting records characteristic and distinguishing details of the individual subjects (plate 323).[31] In turn these people seem to inhabit a picturesque wilderness scene from prehistory, from which Europeans are altogether absent. This, like many other representations of First Peoples, arose from the interest in ethnography and was produced within the process of colonisation. Like many others examples, the attention to detail and the ambiguous melancholic mood belie a lack of profound understanding of the indigenous cultures of the settlement colonies.

GROWTH

National representation was a feature of the competitive nineteenth-century world, which was clearly divided along imperial lines. From the mid-nineteenth century onwards the white settlement colonies were active participants at the increasingly popular international exhibitions, where they presented views of colonial life, products and resources to many and diverse audiences. Although displays were often constructed from a patchy range of objects, including examples of raw materials and topographical paintings, they nevertheless systematically aimed to illustrate effectively colonial advancement, thereby promoting emigration and investment. Usually situated within the domain of the British Section, critics often viewed colonial exhibits as markers of Empire progress.

323 Robert Dowling, *Aborigines of Tasmania*. Oil on canvas, 1859. Queen Victoria Museum and Art Gallery, Launceston, Tasmania. Painted while the artist was resident in London, this monumental study documents the physical characteristics of a group of Tasmanian Aborigines. The absence of Europeans and the dark mood implies a wilderness scene from prehistory. The painting was exhibited at the opening of the Launceston Mechanics Institute in 1860.

Amongst the earliest exhibits to draw media attention was a Canadian pianoforte that was displayed at the Crystal Palace in 1851. Amidst the glistening paraphernalia, this piano probably had much greater significance than is at first obvious. As a showpiece of colonial raw materials, for instance, it probably had wider appeal than the taxonomically arranged timber samples sent to London by some other colonies. But more than this, the piano also had a symbolic function. With one eye fixed on the pugnacious French Canadians, a writer for the *Illustrated Cyclopedia of the Great Exhibition* praised the piece as evidence of 'Saxon industry' and hoped that the colony would continue to avoid restricting itself 'to mere articles of utility' in the future.[32]

The pianoforte was an indication of colonial prosperity and cultural aspiration. Social intercourse in the Victorian drawing-room often occurred around the piano, where people demonstrated a familiarity with and love of music. Moreover, most importantly, printed sheet music was a cheap and effective means of disseminating patriotic ideas, and like newspapers, linked the residents of settlement societies through a degree of shared experience. The proliferation of pianos in the colonies, therefore, whether locally made or imported, indicated the spread of culture and signalled an improvement in Empire communications. Exhibition objects, like the piano, echoed the gradual forging and strengthening of links in a chain of cultural fraternity.

In the production of other exhibition pieces craftsmen and designers continued to work with traditional and contemporary forms, rooted in European traditions, techniques and styles. To help promote raw materials in the timber trade, for instance, the use of inlay and marquetry techniques was a practical and engaging way to demonstrate the variety, suitability and decorative quality of a large range of native woods. The ubiquitous 'specimen table' was popular with cabinet-makers throughout the colonial world. They took advantage of the flat top of the standard Regency pedestal table to create inlaid designs and illustrations using decorative native timbers. These tables were made throughout the British Empire.

An especially active enthusiast of New Zealand woods was London-based J. M. Levian. He promoted the use of colonial cabinet timbers extensively and sent a very complex example of a 'specimen table' to the Paris International Exhibition of 1855, and in 1861 published an illustrated pamphlet entitled *The Woods of New Zealand and their Adaptability to Art Furniture*.[33] There are many other examples. The Cape Colony in South Africa sent a table featuring 15 different local varieties of wood to the Centennial International Exhibition in Philadelphia, 1876.[34] Meanwhile, in the South Pacific, the contemporaneous New Zealand cabinet-maker James Petherick Junior made an exhibition table using 2,620 individual pieces in a complex design which illustrated the early history of the city of Wellington. This successful exhibit was displayed at the Melbourne International Exhibition in 1880 and the Colonial and Indian Exhibition six years later (plate 324).[35]

Other exhibits were purely representational and underlined the importance of political and economic relationships within the Empire. The colony of Victoria, for instance, was granted a form of self-government in 1850. A decade or so later it contributed one of the most striking exhibits of all to the London International Exhibition of 1862: a giant gold pyramid (gilt plaster) which in size and mass exactly equalled the volume of gold exported from the goldfields in the previous decade. Its scale, colour and location not only appealed to the Victorian fancy for the spectacular, but was also understood to be of equivalent monetary value to one eighth of the national debt of Great Britain.[36] The pyramid also illustrates the importance of fraternity within the design profession. The designer, J. G. Knight, was a Fellow of the Institute of British Architects and keen exponent of the contemporary neo-classical style. Aiming to create an engaging exhibit, he combined a romantic allusion to antiquity with

324 James Petherick Jnr, Exhibition specimen table. Various woods, 1876. Te Papa, National Museum of New Zealand. Colonial cabinet-makers were experts at designing and making 'specimen tables', which displayed native woods in engaging geometric surface patterns. This masterly example depicts the early history of Wellington, and was exhibited at the Colonial and Indian Exhibition.

325 View of London
International Exhibition,
1862. State Library of
Victoria, Melbourne.

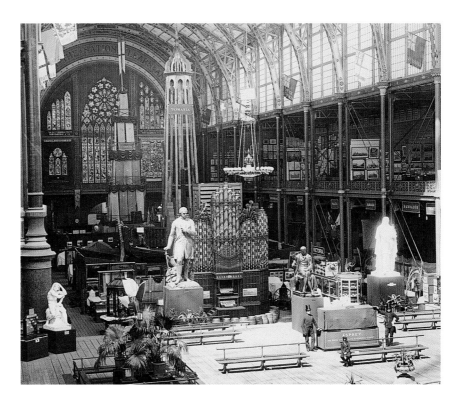

the utilitarian practice of displaying raw materials in stacked configurations at industrial fairs. Knight refined the standard shape, making it slender and sharper, to create an attractive, powerful and transportable icon. He also cleverly understood the importance of human scale, and fashioned embossed gold nuggets on the lower surfaces. These were based on real examples found on the goldfields and each was matched with the name of the fortunate emigrant who had made the find.

This brash exhibit asserted the importance of gold to the whole Empire and also sought to impress prospective emigrants. But the white colonies, like other exhibitors, also used real gold to fashion virtuoso exhibits. The design and manufacture of sophisticated metalwork was understood to require craft skill and know-how, gained within a workshop tradition. Writing in his influential book *Masterpieces of Industrial Art and Sculpture at the International Exhibition, 1862*, J. B. Waring was moderately encouraging about a handful of Australian works which were sent to the London International Exhibition, 1862. He wrote:

In this history [of Australian colonisation] the discovery of gold will always form a principal episode and we now see that not only have thousands of stalwart arms been at work in its production, but delicate fingers and minds have not been wanting in Australia itself to fashion the rugged nuggets into well designed and finely executed works of art, characterised by very good taste and much originality of treatment.[37]

This response not only acknowledged the importance of raw materials but also recognised the successful transference of a high level of European skill and taste. This was an important appraisal by an influential critic, which indicated to both emigrants and investors that the colony not only possessed natural wealth but also the wherewithal to make something of it.

The attraction of new settlers and the promotion of raw materials were vital for colonial growth. Through an encounter with exhibition displays, visitors were invited to become metaphorical gold-field prospectors and to imagine their own success in the New World. Furthermore, these colonial displays provided evidence of cultural fraternity in liberal societies quickly moving towards a degree of self-reliance. Nevertheless, in the mid-Victorian world stratification was remarkably immutable, and a decade and a half after J. B. Waring's generous appraisal of 1862, Forbes Watson continued to promote the association of the white settlement colonies with praiseworthy utility rather than inspirational art.

COMING OF AGE

Nineteenth-century painting in the white settlement colonies has often been viewed as a staged progression towards the achievement of a distinctive and representative art, which began to flower in the 1880s.[38] With the growth of cities and increasing wealth came the establishment of cultural institutions and the luxury of artistic activity. Yet, even so, Forbes Watson's opinion that the settlements could not be characterised as places with a differentiated history of art was basically true, because artists took their lead from their European heritage. Nevertheless, in the 1880s a new maturity and confidence was marked by the inclusion of Australian and Canadian paintings in the galleries of the Colonial and Indian Exhibition. This confidence encouraged a generation of younger artists who had grown up in the colonies to review the colonial landscape and to evoke new meaning in the experience of colonial city life and rural work.

The mid-century art scene in Australia, with which Forbes Watson would have had some familiarity, was fairly representative of a general pattern. Prominent colonial landscape artists such as Eugene von Guerard (1811–1901) and Nicholas Chevalier (1828–1902) were trained in the art schools of Europe before travelling to Australia. In Canada too, their contemporary, William Armstrong (1822–1914), was also a settler.[39] His watercolour painting, *Thunder Cape, Lake Superior* (1867) shows a remarkable similarity to Chevalier's chromolithograph *Mount Arapiles at Sunset* of 1865 (plate 326). In both works topographical conventions have been fused with European landscape traditions, influenced by Caspar David Friedrich. This suggests that the two artists not only shared a degree of common artistic experience but also a desire to project colonial aspirations through dramatic depictions of the landscape.

However, in Australia by the 1880s the work of a new generation of painters including Tom Roberts, Frederick McCubbin and Arthur Streeton, members of the Heidelberg School, started to show a degree of distinctiveness not evident in the generation before.[40] As was recognised by the historian Asa Briggs, by the 1880s Melbourne was one of the great Victorian cities of the world,[41] and these painters benefited enormously from the cosmopolitan atmosphere of the city. Local museums and art schools, and in some cases, international travel, helped them to acquire the skills and confidence to address their subject matter with a renewed vigour. They too had their counterparts in Canada, among them Homer Watson (1855–1936), who was born in Ontario. Watson's early travels in North America included a visit to the Centennial International Exhibition, Philadelphia, 1876, where a large collection of French painting was on display, and a stop in cosmopolitan New York where he saw the paintings of the Hunter River School.[42]

These painters looked once more at the landscape and were influenced by the rural themes of the Barbizon School. Paintings by Watson of rural workers such as *Log-Cutting in the Woods* (1894) are illustrative of this interest. In Australia, in addition, the Heidelberg School painters worked outdoors, and went in search of evocative subject matter, which drew on the unique experiences of colonists. In preparation for the painting *Shearing the Rams* (plate 316) Roberts travelled to the Riverina in New South Wales in two successive seasons to make sketches of working shearers.[43] This iconographic work, and another by Frederick McCubbin, *The Lost Child* (1886), reflect the growth of regional consciousness. Here are memories of pioneer vulnerability and loss on the one hand, and the stoicism of colonial enterprise on the other. In these paintings both artists demonstrated a desire to participate in the development of a distinctive Australian history, as the colonies moved towards federation in 1901.

During the 1880s colonial painters often submitted work to the Royal Academy, but it was the Colonial and Indian Exhibition of 1886 which provided the white settlement colonies with the best opportunity to exhibit the work of their artists in London. Forbes Watson may have been sceptical, but this exhibition had the potential to prove that colonists were not solely concerned with utility. The Canadian section included paintings by Homer Watson, and the Tom Roberts's work *Coming South* was one of over 100 works sent from the colony of Victoria alone.[44]

However, despite the breadth of related displays, which comprehensively demonstrated that colonial cities such as Melbourne were flourishing, many critics remained unimpressed by colonial fine art, judging it just as they would the work of other British artists. The relatively sympathetic view of the art critic R. A. M. Stevenson is a fair example of this tendency. When he appraised the colonial paintings for the *Magazine of Art*, he pointed to the general lack of skill and inspiration, particularly in the work of the Australians. Ironically, it seems that, despite the sophisticated cultural networks that operated throughout the Victorian world, Stevenson proffered the influential view that the artistic naivety of the colonists clearly resulted from the great terrestrial distances between the colonies and the artistic centres of London and Paris.[45]

326 Nicholas Chevalier, *Mount Arapiles at Sunset*. Chromolithograph, 1865. La Trobe Collection, State Library of Victoria, Melbourne.

AUSTRALIA

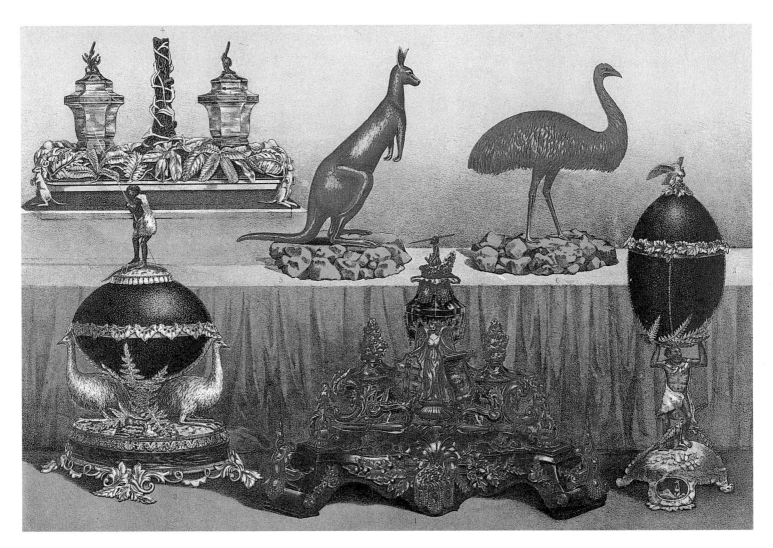

327 *Goldsmiths Work from Australia*, from J. B. Waring's *Masterpieces of Industrial Art and Sculpture at the International Exhibition of 1862* (London, 1862). V&A: 49 D 20. Silversmiths in the Australian colonies were adept at manufacturing ornamental metalwork featuring distinctive signs of the pre-settlement wilderness. The influential critic, J. B. Waring, believed that the design and craftsmanship demonstrated in works shown at the 1862 International Exhibition was evidence of intellectual progress in the colonies.

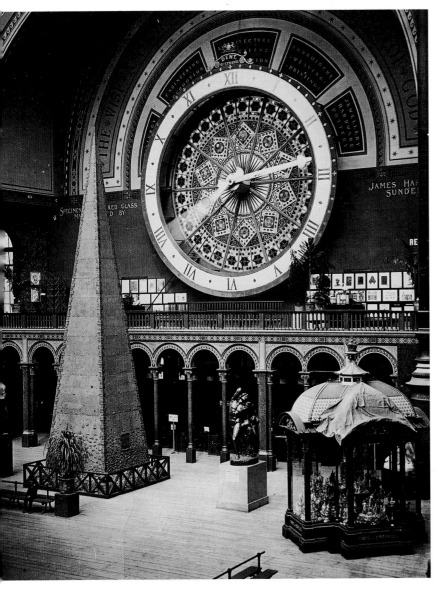

330 *The Queens' visit to the South Australian Court, on Friday, May 21.* Engraving from *Illustrated London News* (29 May 1886), p. 575. V&A: PP 10.

Concepts of progress and civilisation were often demonstrated by juxtaposing the signs of material abundance and technological superiority in European society, with the poverty of the pre-settlement wilderness. This illustration of Queen Victoria's response to an exhibition diorama of an Aboriginal fisherman at work succinctly captured the great cultural divide between two poles of the Victorian world.

328 London Stereoscopic Company, *Gold Pyramid, London International Exhibition*. Photograph, 1862. La Trobe Picture Collection, State Library of Victoria, Melbourne.

One powerful symbol of the Empire trade in raw materials was the 'Gold Pyramid'. It was displayed at the apex of the British Nave at the London International Exhibition 1862. Designed by J. G. Knight, it was 44 feet high and equal in mass to the quantity of gold exported from the Colony of Victoria since the Great Exhibition, 1851.

329 *Maori Store-house, in the Native Section*. Engraving from *Illustrated London News* (2 October 1886), p. 365. V&A: PP 10. The distinctive designs and bold carving of Maori village architecture fascinated Europeans. At the Colonial and Indian Exhibition this example was augmented with traditionally clothed and decorated models of Maori people.

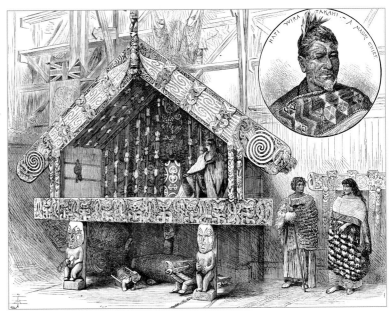

ENDPIECE:
1837 and 1901

In 1897, the Jubilee edition of the *Illustrated London News* published a page devoted to the progress of the queen's reign. Three striking contrasts were held up for the public to reflect upon. Early sailing ships with what were in effect auxiliary steam engines and side paddles were contrasted with large modern liners, on which rigging had disappeared and power was transmitted to the more efficient screw. A horse-drawn carriage struggling across a snow-covered landscape was contrasted with the power and comfort of a steam train passing under a bridge, its progress marked by accompanying telegraph wires. A narrow, ill-lit urban street was contrasted with a broad thoroughfare illuminated by electric light.

In all of these images, the common factor was command of the environment: humans were no longer at the mercy of the elements or of the mysteries and dangers of the night. Through new technologies, they had created a fresh authority over their surroundings which neatly mirrored their rule in the imperial outer world. These illustrations were surrounded by cameo pictures of the great men (and they were all men) of an age indelibly marked and symbolised by a woman. These were men who had helped to bring about such change. Their very appearance illustrated the changes of Victoria's reign. They were mainly grey-haired, their faces framed by side-whiskers and beards, dressed in the dark, sober fashion that remains distinctively Victorian. Their faces and their clothing indicated the manner in which the raffish style of Victoria's youth had been banished. Progress had been secured by sobriety, ambition, application and character.

331 Argyll voiturette, 1900. Glasgow Museums: Museum of Transport.

The transformations of Victoria's reign were indeed startling:
• In 1837 it could take at least a month to reach New York on a fast packet vessel. By 1901 it took a little over five days.
• In 1837 a letter could take several months to reach India, particularly if it went by sail around the Cape of Good Hope. If it travelled via the Middle East, it went overland between Alexandria and the Red Sea. In the early 1840s paddle steamers took three months to reach Calcutta via Cape Town. By 1901 a letter could reach India by a direct P&O steamer via the Suez Canal in under three weeks. The Marseilles–Bombay journey was down to less than a fortnight.

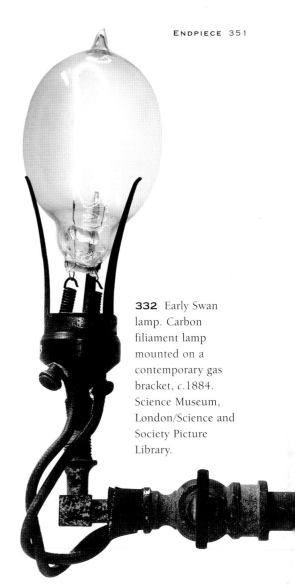

- In 1837 letters and despatches were the only means of communication. By 1901, the world was girdled by telegraph cables, and messages could be sent to the furthest corners of the globe in a matter of minutes. By that time, the élite could communicate with each other by direct voice contact on the telephone.

- In 1837 printing technology was such that an eighteenth-century person would have recognised it. By 1901 the production of printed material outstripped by some seven times the contemporary increase in population. By then there was cheap mass-production of both print and images, together with moving film and cheap popular photography. Queen Victoria was so fascinated by photography that she possessed a signet ring which contained five miniature photographs of members of her family. The glass stone on top served to magnify them.

- In 1837 builders were still constructing in a massively classical style, as at Euston Station in London. By 1901 the Hackney Empire theatre had all the latest stage technology and boasted steel supports to the balconies.

- In 1837 children's toys were still crudely made of wood and were generally available only to the middle classes. By 1901 there was greater mass-production of toys and they were being made of tinplate.

- In 1837 sports were unorganised and generally chaotic. By 1901 most sports had been codified and had associations to control them. Grounds and stadia were being established so that large audiences could enjoy sporting spectacles.

- In 1837 very few women had entered professions and none had graduated from universities. By 1901 there was a large number of women graduates and certain professions, such as teaching and nursing, had become almost female preserves. A number of women doctors were establishing their skills in Britain and abroad, and women were also embarking upon careers in journalism and local government.

- In 1837 many different time zones existed around Britain. For example, places in the west often observed time that was twenty minutes or more behind London. The railways standardised the country on Greenwich time by the 1850s. By 1901 clock towers on stations and other public buildings displayed the time to the public and punctuality had become a national habit.

- In 1837 markets were highly localised and prices highly variable. By 1901, there was a national market, with goods and services transferred all around the country. Prices were consequently much more uniform.

- In 1837 capitalism remained essentially local and national, knitted together only by international trade. By 1901, greatly facilitated by the telegraph and by transport systems, capitalism had become a global phenomenon, with international currency transfers and sales of shares. Businessmen communicated with each other, with their suppliers and their markets on world-wide networks of information gathering and exchange which carried on 24 hours a day, 365 days of the year. The modern world had arrived.

In short, 1837 had more affinities to the world of the eighteenth century. But 1901 would appear very much like the threshold of our own times. The reign of Queen Victoria had seen transformations like none other.

332 Early Swan lamp. Carbon filiament lamp mounted on a contemporary gas bracket, *c.*1884. Science Museum, London/Science and Society Picture Library.

333 Ericsson table telephone, 1890. Science Museum, London/Science & Society Picture Library.

Notes

Introduction

1 In 1996 David Livingstone was the subject of an exhibition at London's National Portrait Gallery and the Royal Scottish Academy, Edinburgh. See MacKenzie (1996).

2 There were a number of events commemorating the centennial of John Ruskin's death in 2000. See Hewison, Warrell and Wildman (2000).

3 A useful introduction to Samuel Smiles is 'Samuel Smiles and the Gospel of Work', in Briggs (1965), pp.124–47.

4 There are many works on Queen Victoria. Marshall (1972) remains a good general, well-illustrated introduction. Longford (1964) and Woodham-Smith (1972) are detailed biographies. More modern works include Thompson (1990), Munich (1996) and Homans and Munich (1997).

5 Biographies of Prince Albert include James (1983) and Weintraub (1997).

6 On Victoria as artist, see Warner (1979).

7 Jacobs (1986), passim.

8 Buckle (1926–8), vol.3, 1879–85, pp.587, 597–8.

9 MacKenzie (1999;b), pp.125–6.

10 The 1879 volumes, particularly, illustrate the obsession with both royalty and Empire.

11 The inaugural lecture can be found in Cook and Wedderburn (1907), vol.20, pp.17–43. See also introduction in MacKenzie (1992), pp.1–24.

12 For more on these imperial events and their relationship to popular culture and the monarchy, see MacKenzie (1984) and MacKenzie (1986).

Chapter 1

RA: Royal Archives, Windsor Castle.
Journal: Journal of Queen Victoria, Royal Archives. Taken from the abbreviated copy made by Princess Beatrice at her mother's request, before the original was destroyed. These references are made by gracious permission of H.M. The Queen.

1 [Eastlake] (1862), pp.178–9.

2 Hamilton (1920), pp.39–40.

3 RA Vic/Y 88/45/ 19 June 1837, letter to Leopold I, King of the Belgians.

4 RA Vic/LB 50/ 23 October 1837, letter to Feodora, Princess of Hohenlohe-Langenburg.

5 RA Vic/LB 55/ 24 January 1838, letter to Leopold I, King of the Belgians.

6 Journal, 10 October 1839.

7 Jagow (1938), p.69, May 1840, letter to Prince William zu Löwenstein-Wertheim-Freudenberg.

8 Fulford (1949), p.219.

9 Benson and Esher (1907), vol.1, p.322, 15 January 1841, Viscount Melbourne, noted in a memo by George Anson.

10 Benson and Esher (1907), vol.2, p.54, 10 October 1845.

11 Martin (1875–80), vol.4, p.10, letter from Sir C. Phipps.

12 Frith (1887–88), vol.1, p.286.

13 RA Vic/Add A 8/390/48–50. Duchess of Cambridge to Ella Taylor.

14 Benson and Esher (1907), vol.1, p.371, 27 July 1841, memo by George Anson.

15 RA Vic/Y170/50. Queen Victoria to Sir Theodore Martin.

16 Journal, 30 June 1863.

17 In the Belgian Royal Collection, Ciergnon. See Millar (1992), 303, p.97.

18 Journal, 8 May 1837.

19 RA Vic/Add U 171/141/ 16 March 1841.

20 Journal, 12 November 1847.

21 Benson and Esher (1907), vol.1, p.424, letter from Lord Melbourne, 5 October 1841.

22 Stanley (1916), p.97, 24 March 1845; she was maid of honour to the queen.

23 RA Vic/Add U 32, 12 July 1873, letter to the crown princess.

24 Ponsonby (1951), p.52.

25 RA Vic/X32/270 30 November (year). Sir John Fortescue, Royal Librarian, to Sir A. Davidson.

26 Journal, 5 January 1848.

27 RA Vic/Y 190/12/ 28 April 1858, letter from Prince Albert to Princess Frederick William.

28 Journal, 3 May 1855.

29 Jerrold (1891), p.126.

30 Helps (1862), p.128.

31 Journal, 1 October 1873.

32 RA Vic/Z 491/30 v 32 RA Vic/Z 491/30 v.

33 Athenaeum (10 May 1856), p.591.

34 Waagen (1838), vol.2, pp.154–5.

35 Art Journal (July 1861), p.223.

36 The collection included Antinous (now on loan to the British Museum) which once belonged to Napoleon and Jerôme Bonaparte. See Ames (1967) and Read (1982).

37 Matthews (1911), pp.232–3. List of Roman artists and purchases, pp.235, 242–3. See also Darby (1981).

38 Fulford (1971), p.167, 4 January 1868.

39 Art Journal (October 1864), p.315.

40 Art Journal (December 1852), p.357.

41 RA Vic/Z491/24. See also McBurney (1983), pp.57–61.

42 Carlyle (1904), vol.2, 10 November 1854.

43 Martin (1875–85), vol.1, p. 123, fn 8.

44 Cook and Wedderburn (1907), vol.4, p.393, letter to Ruskin's father for Joseph Severn.

45 Robertson (1978) p.65.

46 Journal, 25 June 1847.

47 Journal, 29 September 1847.

48 Art Union (June 1843), p.148. Built on a mound dredged out of the lake, the frescoes deteriorated from the damp and were removed in 1875. The Pavilion was demolished in 1928.

49 Pointon (1979), p.103.

50 Millar (1992), p.xxxix.

50 Ibid., p.xxxix .

51 Hobhouse (1983), p.91.

52 Waagen (1854), vol.1, p.34.

53 Journal, 1 September 1853.

54 James (1983), p.181.

55 Temperley (1986), p.18.

56 Wyndham (1912), p.305. Lady Lyttelton was governess to the royal children.

57 Buckle (1930–2), vol.3, p.373.

58 RA Vic/M 20/8/ 2 November 1841.

59 Journal, 8 February 1837.

60 RA Vic/M 34/132/30 September 1841.

61 [Eastlake] (1862), p.183.

62 Rhodes James (1983), p.276.

63 Benson and Esher (1907), vol.3 (1907), p.603, 20 December 1861.

64 Journal, 30 June 1863.

65 Journal, 20 June 1868.

66 Journal, 22 June 1868.

67 Arengo-Jones (1995), p.147, for Zelger family papers.

68 Buckle (1926–8), vol.1, p.233, 30 June 1864.

69 Journal, 11 May 1887.

70 Benson (1930), p.122.

71 Journal, 22 June 1897.

72 Physick (1982), p.214.

73 Buckle (1930–2), vol.3, p.522.

74 Ibid., pp.579–80.

75 Strachey (1921), p.309.

Chapter 2

1 Thompson (1988), chaps 2-3.

2 Wohl (1978).

3 Perkin (1989); but see Dolin (1997).

4 Davidoff and Hall (1987); Spiers (1975).

5 Seccombe (1993).

6 Stedman Jones (1971); Walton (1992).

7 Stone (1977).

8 Girouard (1979).

9 Lummis and Marsh (1990).

10 Horn (1995).

11 Neale (1981).

12 Huggins (2000).

13 Banks (1993).

14 Walton and Wilcox (1991).

15 Simpson and Lloyd (1977).

16 Allwood (1982), p.29.

17 Gissing (1936), p.90.

18 Ross (1993;b); Hartmann (1977).

19 Honey (1977).

20 Stanley (1984).

21 Freeman (1977).

22 Vickers (1996), pp.383–93.

23 Harvey and Press (1991).

24 Gooderson (1996).

25 MacCarthy (1994); but see Thompson (1977).

26 Hunt (1982); Taylor (1997).

27 Allen (1994).

28 Hassan (1998).

29 Wohl (1977); Wright (1966).

30 Wilson (1991).

31 Mosley (1998).

32 Hardyment (1992) and (1988).

33 McKenzie (1983).

34 Stanley (1984); Anstruther (1992).

35 Gray (1996).

36 Prochaska (1988).

37 Ross (1993;a); Davin (1996); Walton and Wilcox (1991).

38 Golby and Purdue (1986).

39 Richardson (1980); Armstrong (1988).

40 Mayall (1988).

41 Benson (1989).

42 Roberts (1971); Davies (1992); Reeves (1979).

43 Fraser (1981).

44 Bailey (1986).

45 Vamplew (1988).

46 Russell (1997).

47 Sandiford (1994).

48 Nicholls (1992).

49 Huggins (2000); Wigglesworth (1992).

50 Malcolmson (1973).

51 D'Cruze (1998); Tebbutt (1995).

52 Davies (1992); Murfin (1990).

53 Walton (1983) and (1998).

54 Caw (1932), p. 22.

55 Taylor (1997); Orr (1982).

56 Walkowitz (1992); Richards (1991); Hosgood (1999).

57 Lowerson (1993).

58. Walton (forthcoming).

Chapter 3

1 For an introduction to methods and concepts in the history of childhood, see Cunningham (1995).

2 Fildes (1988).

3 Gathorne-Hardy (1972).

4. Renton (1991)

5 Kamm (1965).

6 Gathorne-Hardy (1997).

7 Collins (1965), p.13.

8 Horn (1989).

9 R.H. Horne in the Illuminated Magazine, vol.1 (1843), p.46.

10 Hopkins (1994), p.231.

11 Coveney (1967), pp.29, 31–2.

12 Whalley and Chester (1988).

13 Brown (1996).

14 Muthesius (1979), p.93.

15 Beeton (1880), p.433; Edis (1881), p.226; Wharton and Codman (1898), p.178.

16 White (1984); Kevill-Davies (1991).

17 Doyle (1885), pp.70, 87.

18 Greenwood (1888), p.249.

19 Pinchbeck and Hewitt (1969–73).

Chapter 4

1 Best known for its use by Christabel Pankhurst in The Great Scourge (1913), based on the parallel campaigns of the previous half century.

2 See for example, Herbert Spencer, Social Statics (1850); Proudhon (1858).

3 Mill (1867), part iv.

4 However, women were not admitted to full membership.

5 Harrison (1911), p.4.

6 Owing to changing categories and aims, census figures should be used with caution.

7 England and Wales figures only: see T.R. Gourvish, 'The Rise of the Professions', in Gourvish and O'Day (1988), p.22. See also in this collection Pat Thane's chapter on women in the late 19th century.

8 See, for example, part 3 in Jalland (1986).

9 Beeton (1861), p.1017.

10 See Tosh (1999)

11 Harrison (1998), vol.2, p.35.

12 Swanwick (1935), p.82

13 Summarised from J.J.S. Wharton's 500 page Exposition of the Laws relating to the Women of England (1853).

14 Mill (1867), part ii.

15 The 'suffragists' of the NUWSS (formed by amalgamation in 1897, but here used to denote the organised suffrage movement before that date) are not to be conflated with the militant 'suffragettes' of the Women's Political and Social Union led by the Pankhursts, who dominated after 1900.

16 Hollis (1987), pp.195–7.

17 Buchan (1848), pp.v, 116, 249.

18 Gauldie (1974), App.2.

19 For details, see Bynum (1994).

20 Gourvish (1988), pp.13–35.

21 See most notably Marcus (1966) and Pearsall (1969).

22 See Foucault (1979).

23 See, for example, Gay (1984–6) and Mason (1995).

24 'Hogamus higamus', attributed to the philosopher William James; the rest is from Acton (1857), p.112. This approached the 'reproductive organs' almost solely in terms of sexual behaviour rather than physiology; opening, for example, with 'Masturbation in Childhood'.

25 Szreter (1996), 136ff.

26 Acton (1857), pp.48–9.

27 For this and related issues, see Porter and Hall (1995), ch.6.

28 Acton (1857), pp.69–75.

29 Szreter (1998), p.432.

30 Egerton (1894), p.155.

31 See Bland (1995) for discussion of many fin-de-siècle sexual issues.

Chapter 5

1 William Makepeace Thackeray, quoted in Pollen (1912), p.246.

2 Cumming's sermons were described by George Eliot in the Westminster Review (1855); reprinted in Moore (1988), p.222.

3 C.W.G. Wynne to John Wynne, quoted in Pollen (1912), p.53.

4 W.B. Barter, quoted in Pollen (1912), p.53.

5 'The Vatican decrees on the primacy and infallible teaching of the Roman Pontiff, 1970', quoted in Moore (1988), p.108.

6 Gaskell (1994), p.205.

7 Knight (1995), p.25.

8 Luguard, The Rise of our East African Empire (http://www.fordham.edu/halsall/mod/1893luguard. html, p.2).

9 Livingstone (ftp://sailor.gutenberg.org/pub/ gutenberg/etext97/mtrav10.txt, Sourcebook, p.32).

10 Livingstone (ftp://sailor.gutenberg.org/pub/ gutenberg/etext97/mtrav10.txt, Sourcebook, p.34).

11 Wood (1998), p.155.

12 Ballhatchet, 'British Missionaries in Meiji Japan', in Nish (1994), p.38.

13 Ibid., p.41.

14 Ibid., p.42.

15 Benjamin Jowett, quoted in Moore (1988), p.29.

16 Colenso, quoted in Moore (1988), p.37.

17 F.W. Newman, quoted in Moore (1988), p.427.

18 Robert M. Young, 'The Impact of Darwin on Conventional thought', in Symondson (1970), p.17.

19 Ibid., p.26.

20 F. Harrison, quoted in Moore (1988), pp.452–3.

21 Oppenheim (1985), p.62.

22 Ibid., p.63.

Chapter 7

1 Trevelyan (1944), p.524.

2 R.F. Jordan, 'The Architectural Significance of 1851', The Builder (22 June 1951), p.897.

3 Scott (1858), p.36.

4 Hollister (1974), vol.16, p.106.

5 Kaye (1960), pp.173–5.

6 Rapley (1999).
7 Weale (1844).
8 Sutherland (1988–9), pp.107–26.
9 *Illustrated London News* (5 July 1851), p.22.
10 Downes and Cowper (1852), p.i.
11 *The Times* (9 June 1865), p.9.
12 *The Builder* (24 June 1865), p.443.
13 Cook and Wedderburn (1907), vol.12, p.419.
14 *The Builder* (19 October 1861), p.710.
15 *Minutes of the Proceedings of the Institution of Civil Engineers* (1883), vol.73, pp.77–8.
16 Dyos (1968), p.660.
17 Stratton (1999), pp.5–24.

Chapter 8

1 Burne-Jones (1993), vol.1, p.84.
2 Morris, 'How I became a Socialist', 1894, quoted in Naylor (1988), p.219.
3 Quoted by Bartram (1989), p.77.
4 Ibid p.82.
5 Ruskin, 'The Seven Lamps of Architecture', in Cook and Wedderburn (1907), vol.8, ch.5, p.219.
6 *Saturday Review* (9 May 1857), p.426.
7 *Fraser's Magazine* (October 1857), p.380.
8 *Saturday Review* (date), p.427.
9 Quoted by Macleod (1987).
10 Engels (1999), p.87
11 Ibid., p.26.
12 Ibid., p.21. Engels's figures are reasonably accurate, but Glasgow's growth may have been even greater than he suggested.
13 Ibid., p.15.
14 Ibid., pp.153–4.
15 Dickens (1994), p.84.
16 Ibid., p.56.
17 Ibid., p.99.
18 Gaskell (1994), p.156.
19 Hardy (1986), p.405.
20 Ibid., p.406.
21 Ibid., p.414.
22 Engels (1999), pp.78–82.
23 Dickens (1998), pp.130–31.
24 Engels (1999), p.129.
25 Ruskin, 'Modern Painters', Preface to 2nd ed., Cook and Wedderburn (1907), vol.3, p.25.
26 Ruskin, 'The Stones of Venice', Cook and Wedderburn (1907), vol.10, p.205.
27 Ibid., p. 268.
28 Ruskin, 'A Crown of Wild Olive', Cook and Wedderburn (1907), vol. 18, p. 502.
29 Burne-Jones (1993), vol.2, p.300.
30 Pater (1935), Conclusion, p.220.
31 William Morris, 'How we Live and How we Might Live', 1887, in Naylor (1988), p.221.
32 Naylor (1988), p.16.

Chapter 9

1 Figures compiled from *Tercentenary Handlist of English and Welsh Newspapers, Magazines and Reviews* (1920), *Newspaper Press Directory* (1861–1900), cited in Wolff and Fox (1973).
2 Steinberg (1955) p.191. In Twyman (1970), p.10.
3 Anderson (1991).
4 For example, Anderson (1991) estimates a readership of 2.25 million for *The London Journal* in 1855, working from a circulation figure of 450,000 and 1 : 5 circulation : readership ratio.
5 See McKendrick, Brewer and Plumb (1982).
6 Anderson (1991), pp.157–91.
7 Vizetelly (1973).
8 Jackson (1885), p.326. In Twyman (1970), p.22.
9 Dyson (London, 1984).
10 Briggs (1988), pp.103–41.
11 Wallace (1898), cited in Briggs (1988) p.122.
12 Ivins (1928); Galassi (1981).
13 Thomson (1891), p.673.
14 Gernsheim and Gernsheim (1955), p.166.
15 Heyert (1979).
16 Gernsheim and Gernsheim (1955), p.232.
17 *Photographic News* (1885), p.136. Cited in Gernsheim and Gernsheim (1955), p.228.
18 Gernsheim and Gernsheim (1958); Hobsbawm (1983), pp.1–14.
19 *Photographic News* (day / month 18 October

1861), p.500; cited in Gernsheim and Gernsheim (1955), p.174.
20 Ibid., p.178.
21 Ibid., p.203.
22 Seiberling and Bloore (1986).
23 *Photographic Journal* (16 March 1865), p.16. Cited in Gernsheim and Gernsheim (1955), p.165.
24 Price (1973), pp.1–2.
25 Herchkowitz (1980); Rouillé (1987), pp.53–9; Fabian and Adam (1983).
26 Talbot (1985).
27 Bourne (1863), p.268.
28 Livingstone and Livingstone (1865).
29 Stocking (1985), pp.78–109.
30 For a more detailed account of this see Rae-Ellis (1992), pp.230–33.
31 Thomson and Smith (1878), preface. 37 photographs reproduced in Woodburytype. Initially issued in 12 monthly episodes (3 photographs and accompanying commentaries per part) between Feb 1877 and Jan 1878, by Woodbury Permanent Photographic Printing Co. London, followed by publication as a whole.
32 Thomson and Smith (1878), 'London Nomades'.
33 Tucker (1997), pp.378–408.
34 Humphries (1989).
35 Arnold-Forster (1897).
36 Stannard (1859).
37 Woodbury (1898).
38 Alford (1965), p.1. In Twyman (1970), p.5.
39 Gernsheim and Gernsheim (1955), p.165.
40 Wolff and Fox (1973), pp.559–82.

Chapter 10

1 The most recent survey of 19th-century Empire is Porter (1999). See also Judd (1996).
2 Excellent examples are in front of the provincial assembly building in Victoria, British Columbia, and Dalton Square, Lancaster, Lancashire.
3 For an examination of just one manifestation of this tendency, see Doran H. Ross, 'Queen Victoria for Twenty-Five Pounds …' in *Art Journal* (vol. 47, no. 2, summer 1998), pp.114–20.
4 For an analysis of the meaning of this monument, see Munich (1966) pp.201–4.
5 Something of the flavour of Cromer's rule in Egypt can be derived from Cromer (1908).
6 Omissi (1994).
7 Chamberlain made these remarks at the Colonial Conference of 1902.
8 In Kipling's poem, 'Recessional', published in *The Times* on the day of the Jubilee, 1897.
9 Fraser and Maver (1996), pp.141–52.
10 Briggs (1968), pp.241–76. Briggs (1988) is another very valuable survey.
11 Harcourt (1980), pp.87–109.
12 Matthew (1973).
13 Porter (1999), p.47.
14 For a recent brief survey, see Harper (1999), pp.75–87. Also Hammerton (1979) and Dunae (1981).
15 Further discussion of these issues can be found in MacKenzie (1984); Said (1993); Castle (1996).
16 Bolt (1971); Lorimer (1978); West (1996).
17 Springhall (1977); Oliver Anderson, 'The Growth of Christian Militarism in Mid-Victorian Society', *English Historical Reviews* LXXXVI (1971), pp.46–72; Stanley (1990).
18 Coombes (1994); Schildkrout and Keim (1998).
19 Toplis (1987).
20 MacKenzie (1999), pp.215–37.
21 Helly and Callaway (2000), pp.50–66.
22 Kingsley (1897); *idem* (1899).
23 Birkett (1992); Pearce, (1990).
24 MacKenzie (1995).
25 These have been studied by Omissi (1995).
26 Quoted in Munich (1996), p.200. For the jubilee years, see also Thompson (1990), ch.7.

Chapter 11

1 6,039,000 visitors, £186,437 profit. See Findling and Pelle (1990).
2 Diaries, October 14, taken from Gibbs-Smith

(1964), p.24.
3 *Projects and Prospects of the Day* (1850), p.5.
4 The Paris Convention of 1928, signed by 92 nations, defined 'international exhibition' as being an event with free international participation and a wide range of disciplines, beyond those of a trade fair. Under this definition, many of the exhibitions discussed here would not qualify. They have been selected, however, for their scale and type of layout, their stated ambitions, and the significance they were thought to have at the time.
5 W.F. Cody, or Buffalo Bill, appeared with his troupe at the American Exhibition in Earls Court, London, 1887. See Lowe (1892), p.83; Greenhalgh (1989), pp.79–82.
6 This list only includes the *expositions universelles*. Public and private contingencies were also sent to many smaller scale national and specialised events.
7 'The Opening of the Great International Exhibition', *The Times* (2nd May 1862), p.11.
8 *Dublin University Magazine*, no.355, vol.60 (August 1862), p.131.
9 *The Times* (18 March 1863), p.12.
10 *Dublin University Magazine*, no.355, vol.60 (August 1862), p.132.
11 Ibid., p.134.
12 Whiting (1872), pp.11–12.
13 'The Colonial and Indian Exhibition', *The Times* (1 April 1886), p.3.
14 'The Colonial and Indian Exhibition', *Westminster Review* (July 1886), p.32.
15 Dramatic architectural edifices are now in Hastings and Hove Museums, and the V&A acquired numerous objects.
16 See Findling and Pelle (1990), p.93.
17 'The Glasgow Exhibition', *The Cabinet Maker and Art Furnisher* (1 May 1888), p.303.
18 Kinchin and Kinchin (1988), p.21.
19 See the *Official Catalogue of the Scottish History and Archaeology Section* (Glasgow 1901).
20 See Waterfield (1991).
21 See, for example, Allwood (1977); Gibbs-Smith (1964); Greenhalgh (1988); Luckhurst (1951); Auerbach (1999).
22 Paxton, Joseph, 'Report of the Sub-committee on the Preservation of the Crystal Palace', unpublished minutes, 1852, NAL (National Art Library).
23 'Preservation of the Crystal Palace', unpublished minutes, meeting 7 April 1852, NAL.
24 'Preservation of the Crystal Palace', unpublished minutes, meeting Kings Arms Hotel, 15 May 1852, NAL.
25 'Preservation of the Crystal Palace', unpublished minutes, meeting Exeter House, April 1852, NAL.
26 Ibid.
27 Paxton, Joseph, 'Report of the Sub-committee on the Preservation of the Crystal Palace', unpublished minutes, 1852, NAL.
28 Bowley (1862) p.3 (my italics, his capitals).
29 Ibid, p.5.
30 'The Opening of the 1871 Exhibition', *The Times* (2 May 1871), p.9.

Chapter 12

1 On the development of scientific classification in the eighteenth and nineteenth centuries, see Ritvo (1997), esp. chs. 1 and 2.
2 Edney (1997), chs. 9 and 10.
3 Livingstone (1992), pp.161–6.
4 Allen (1976), pp.87, 156; see also discussions of the Geological Survey in Secord (1986) and Oldroyd (1990).
5 Desmond and Moore (1991), p.198.
6 'The Zoological Record', *Nature*, 27 (1883), p.310.
7 Desmond and Moore (1991), pp.209, 227–8.
8 British Association for the Advancement of Science, *Notes and Queries on Anthropology, for the use of travellers and residents in uncivilized lands* (London, 1874), p.iv.
9 Allen (1986), p.12.
10 On field clubs, see Allen (1976), ch.8.
11 Rees (1969), pp.326–237.
12 Günther (1912), p.61.

13 Secord (1996).
14 On women and botany, see *Cultivating Women, Cultivating Science: Flora's Daughters and Botany in England 1760 to 1860* (1996).
15 Swann (1972), p.118.
16 Sheets-Pyenson (1981), p.60.
17 For an extended discussion, see Allen (1969).
18 Gosse (1983), p.125.
19 Williams, quoted in Carter (1984), p.93.
20 Stuart (1988), pp.146–9.
21 Elliott (1986), pp.18, 28.
22 Hooker (1858), pp.9, 11. For an extended discussion of the relation of Kew to British imperialism, see Brockway (1979) and Drayton (1993).
23 John Bastin, 'The First Prospectus of the Zoological Society in London…' *Journal of the Society of the Bibliography of Natural History,* 5 (1970), p.385.
24 Timbs (1855), p.779.
25 'The Zoological Gardens', *Quarterly Review*, 98 (1855), p.245; Peel (1903), pp.181, 188. For a fuller discussion of Victorian zoos see Ritvo (1987).
26 'The Zoological Gardens', *Quarterly Review*, 98 (1855), p.220.
27 Ritvo (1987), p.217.
28 For photographs of such interactions, see Edwards (1996).
29 Hibbert (1984), p.205.
30 Ritvo (1987), pp.86–7.
31 On Landseer's work, see Ormond (1981).
32 Ritvo (1987), p.277.
33 On wild bird protection, see Doughty (1975). The Society for the Protection of Birds was founded in 1889. Ten years later orders were issued forbidding the wearing of osprey feathers by British army officers. The export of wild bird skins and feathers from British India was soon outlawed, but legislation against the use of plumage took longer.
34 Ritvo (1987), pp.283–4.
35 For an extended account, see MacKenzie (1988).

Chapter 13

1 'In Xanadu did Kubla Khan a stately pleasure dome decree,' is the opening line to Samuel Taylor Coleridge's poem *Kubla Khan*, (1816). Cathay was the European name for China from the Middle Ages.
2 Chinese place names are given in the form used by Westerners in the Victorian period, e.g. Canton rather than Guangzhou, Peking rather than Beijing. All other Chinese words are written in the pinyin system of transliteration.
3 The Qing dynasty was established in 1644 by the Manchu, non-Chinese conquerors originating from the region later known as Manchuria. The majority of those living in China were of Han Chinese origin: the two ethnic groups remained distinct throughout the Qing dynasty. The dynasty was overthrown by the revolution of 1911.
4 *The Athenaeum*, quoted in Saxbee (1990), p.221.
5 Richardson, 'The Exhibition London Guide and Visitors Pocket Companion, describing a New Plan, the Great Metropolis and its Environs' (1851), p.199, quoted in Saxbee (1990), p.273.
6 Footbinding was a Chinese practice. Manchu women did not bind their feet.
7 Fortune (1847), p.2.
8 Fortune (1857), p.vii.
9 Oliphant (1860), p.51.
10 Walrond (1872), p.272.
11 The shōgun was Japan's military ruler. Westerners called him the Tycoon. The Emperor, who, since the late twelfth century had been merely a figurehead, was known as the Mikado.
12 Fortune (1863), pp.95, 16.
13 Wolseley (1861), p.224.
14 Quoted in Spence (1960), p.74.
15 Beato was the semi-official photographer to the British Army in China in 1860.
16 *Illustrated London News* (5 January 1861), p.18.
17 See Hevia (1994), pp.319–45.
18 See Wolseley (1861), p.236.
19 See Cheang (1999), pp.55–8.

20 Waring (1863), vol.3, pl.267.
21 Ibid., pl.288.
22 Burges, 'The International Exhibition', *Gentleman's Magazine* (July 1862), pp.3–12.
23 Fuchinobe Tokuzō, quoted in Cobbing (1998), p.95.
24 In the Edo period (1615–1868) Japan was divided into provinces called 'han'. Each was ruled by a daimyō ('great name') who had a retinue of samurai warriors. Satsuma was on Kyūshū, the south-western island of Japan, and Chōsū in the far south-west of the main island Honshū.
25 It was illegal for Japanese individuals to travel overseas at this time. The 1865 group of students were helped by Glover.
26 Nakai Hiroshi, quoted in Cobbing (1998), p.64.
27 Bishop (1899), p.24.
28 Wolseley (1861), pp.302–5.
29 Little (1899) pp.30, 470–71.
30 Mitford (1915), p.342.
31 Ibid., p.544.
32 *Illustrated London News* (24 September 1877), p.171.
33 *Punch* (17 February 1877).
34 Alcock (1863), p.xix.
35 Sladen (1892), p.78, quoted in Littlewood (1996), p.94.
36 Fortune (1863), p.326. Fortune was referring to the 1860 war and the burning of the Summer Palace.
37 Ibid., p.188.
38 Alcock (1863), p.83.
39 Beato (1868), commentary to *View of Eiyama*. The commentary was by James William Murray. Beato arrived in Japan in about 1863 and stayed over twenty years.
40 Bird (1880), p.12.
41 Dresser (1873), p.11.
42 Dresser (1882), p.271.
43 Dresser, 'The Art Manufacturers of Japan, from Personal Observations', *Society of Arts Journal* (1 February 1878), p.177.
44 See Wilkinson (1987), pp.174–9.
45 Mitford (1915), p.646.
46 Leighton (1863), p.596.
47 Ibid., p.2.
48 Standard (17 July 1884), in *Illustrated Catalogue of the Chinese Collection of Exhibits* (1884), p.181.
49 Letter to James Duncan Campbell, 14 January 1884, see Fairbank, Bruner and Matheson (1975), letter 458, p.517.
50 *Illustrated Catalogue of the Chinese Collection of Exhibits*, p.134.
51 *Society* (5 July 1884), in ibid., p.135.
52 Charles Dickens, *The Mystery of Edwin Drood* (first pub. 1870), Oscar Wilde *The Picture of Dorian Gray* (first pub. 1891).
53 See Lovelace (1991).
54 See Yokoyama (1987).
55 Algernon Mitford, 'Old and New Japan', Lecture to the Japan Society of London, 14 November 1906. Quoted in Cortazzi (1985), p.11.
56 Algernon Mitford, 'Feudalism in Japan', Lecture to the Authors' Club, 6 November 1911. Quoted in ibid., p.15.
57 Gilbert and Sullivan also got help from members of the Japanese Village in London that year.
58 Dresser (1873), p.161.
59 Liberty (1889), pp.694, 697.
60 Quoted in Cortazzi and Webb (1988), pp.35, 37.
61 Ibid., p.92.
62 This was revised two years later.
63 See Cohen (1997), p.15.
64 Thomas Cook Worldwide Travel Brochure 2000.

Chapter 14

1 See Smith, N. (1985), pp.65–72, and Bayly (1981).
2 *The National Memorial to His Royal Highness the Prince Consort* (London 1873), p.58. The sculpture of *Europe* is by Patrick Macdowell RA, *Asia* by the Irish sculptor F.H. Foley.
3 *The National Memorial*, p.71. See also Smith and Darby (1983).
4 *National Monument*, pp.59–60.
5 See Summerson (1980), pp.101–13.

6 Conclusions at this point, however, can only be tentative, since historians of Victorian art have so far largely neglected the imperial dimension of the visual culture of the era.
7 Noakes (1985), p.155; Dehejia (1989), pp.24–31.
8 Noakes (1985), p.155. This work was commissioned by Lord Northbrook. See Warner (1998), pp.166–7.
9 Millar (1996). See also Surtees (1975).
10 James Ballantyne, *The Life of David Roberts, R.A.* (1866), p.78, quoted Llewellyn (1986), p.69.
11 Said (1979). For critiques of Said's book, see Clifford (1988) and MacKenzie (1995). See also Sweetman (1988).
12 This interpretation of Lewis draws on the work of Emily M. Weeks, completing a doctoral dissertation on the artist at Yale. I am grateful for permission to refer to this unpublished material. See also Weeks (1998), pp.46–62; Llewellyn (1986).
13 Lewis's work replicates standard types, but is generally far more sympathetic to modern Egyptian life than most 19th-century European observers. He was isolated from British culture for a long period and, indeed, criticised it when Thackeray visited him. Sweetman (1988), pp.131–44, suggests that Lewis's paintings are directly influenced by Persian paintings but the evidence is not conclusive.
14 See Sweetman (1988), p.131. James W. Wild's watercolour, *Interior of J.F. Lewis's House in Cairo*, 1842, is in the V&A (E3763-1938).
15 On Leighton House, see Campbell (1996); Campbell (1999), pp.257–94.
16 Ormond and Ormond (1999), pp.95–101.
17 Greenhalgh (1989), pp.53–6.
18 Metcalf (1989), p.142.
19 See Irwin (1973), pp.24–5; see also Ames (1986), and Murphy (1988), pp.4–9.
20 See Sweetman (1988), pp.128–30.
21 See Lubbock (1995), pp.248–70.
22 See Jespersen (1984). My interpretation of Jones owes much to discussions with Kate Lanford, who has kindly allowed me to consult her essay 'Imperialism and the Parlor'. See also Sweetman (1988), pp.112–210, and Crinson (1996).
23 Jones (1910), p.14.
24 Ibid., p.77. The Alhambra, the 13th-century Moorish fortress at Granada in Spain, was singled out for special praise. It was also admired by Roberts and Lewis, and Jones published a separate, detailed study.
25 Quoted in Mitter (1977), p.225.
26 John Ruskin *The Two Paths*, I: 'Conventional Art', in Cook and Wedderburn (1907), vol.16, p.261. See also Metcalf (1989), p.141.
27 Ruskin, *The Two Paths*, ibid., p.265.
28 For a more detailed exposition of what follows, see Barringer (1988), pp.11–27.
29 Wainwright (1994).
30 *Catalogue of the Articles Selected from the Great Exhibition of 1851* (1852), p.iv.
31 In 1880 the India Museum, formerly the private collection of the East India Company, was split between the British Museum and the South Kensington Museum. This added to the latter's already impressive Indian collections. See Desmond (1975).
32 John Murray, *Handbook to London As It Is* (1874), quoted in Mitter (1998).
33 The pioneering treatment of this theme is Nunn (1995), pp.73–93.
34 See Ballhatchet (1980).
35 Ruskin, *The Two Paths*, in Cook and Wedderburn (1907), vol.16, p.262.
36 See Hichberger (1988), pp.174–5.
37 Text from the lettering on W.H. Simmons's engraving after the work, quoted Allen, cat. 325 in Bayly (1990), p.241.
38 Beato based his studio initially in London. See Worswick and Embree (1977).
39 C. Pinney, in Bayly (1990); Ryan (1997).
40 A six year 'apprenticeship' followed this; so the final freedom of all slaves began in 1839.
41 D. Livingstone to N. Beningfield, 10 April 1858, quoted Ryan (1997), p.31.

42 Stanley (1983), pp.71–94.
43 Livingstone to Baines, 11 July 1859, quoted Wallis (1941), p.171. For a fuller account of the arguments put forward here, see also Barringer (1996), pp.171–97.
44 See Ryan (1997), pp.30–44.
45 See Altick (1978).
46 A full account and historical analysis of the Benin incident is in Coombes (1994). The sculptures, often referred to as 'the Benin bronzes', are largely made of brass. See John Picton's discussion in Phillips (1995), pp.396–7.
47 Metcalf (1989), p.152; on Maine see also Diamond (1991).
48 Quoted Metcalf (1989), p.151.
49 See Mitter (1977), pp.236 ff.
50 Birdwood (1880), pp.131–2.
51 Ibid., pp.134–5.
52 Metcalf (1989), p.157.
53 Kipling utilised the newly established *Journal of Indian Art* to assert the significance and quality of Indian, and notably Punjabi, craft traditions.
54 Ata-Ullah, Naazish, 'Stylistic Hybridity and Colonial Art and Design Education: A Wooden Carved Screen by Ram Singh', in Barringer and Flynn (1988), pp.68–81.
55 See Head (1985), p.140. See also Head (1986).
56 On the 1886 Colonial and Indian Exhibition, see Barringer and Flynn (1988) and MacKenzie (1984).
57 *The Graphic* (8 May 1886).
58 Adapted after the exhibition to provide a smoking room for Lord Brassey's Park Lane residence, it is now permanently installed in the Hastings Museum and Art Gallery.
59 Millar (1992), pp.242–52.
60 Quoted Millar (1992), p.245.
61 Charlotte Canning was a lady of the bedchamber to Queen Victoria, 1842-55, and they maintained a copious correspondence thereafter. See Surtees (1975).

Chapter 15

1 Forbes Watson (1876), p.7.
2 Ibid., p.6.
3 Ward (1887), p.558.
4 Kalman (1994), vol.2, pp.534–5.
5 Kirker and Tomory (1997), p.12.
6 Galbally (1992), p.80.
7 Silver, S.W. & Co. *The Colonies and India, A Weekly Journal for the Interchange of Information throughout the British Commonwealth*, no.30 (28 July 1877), p.3.
8 Hubbard (1959), vol.2, pp.103, 163.
9 Silver, S. W. & Co., *The Colonies and India*, no.24 (5 May 1877), p.3.
10 For an insight into the Melbourne Exhibition, see Dunstan (1996).
11 *Official Catalogue of the British Section, Sydney International Exhibition, 1879*, p.5, and *Official Record, Melbourne International Exhibition, 1880–1881*, p.517.
12 *Official Catalogue of the British Section, Sydney International Exhibition 1879*, pp.99–100. A rare copy of C. and R. Light, *Designs and Catalogue of Cabinet and Upholstery Furniture* (1880), survives in the library of the National School of Design, Swinburne University, Melbourne.
13 See, for example, Veit-Brause (1986).
14 Lane and Serle (1990), p.13, and Kalman (1994), vol.2, pp.613.
15 Sweet (1997).
16 Arthur and Ritchie (1982), p.155.
17 Loftie (1886), p.174.
18 Jones (1988), p.7.
19 Bruce Trigger, quoted in Nemiroff (1996), p.414.
20 For more detail see Smith, B. (1985).
21 For example, the 1843 edition of *Cook's Voyages Round the World* cost 4s. and included two engravings. Both depicted the death of Cook. One caption read, 'As he was rising and before he had time to recover his feet, another Indian stabbed him in the back of the neck'.
22 Examples are illustrated in Hawkins (1990).

23 'The Queen's visit to the South Australian Court', *Illustrated London News* (1886), p.575.
24 Minson (1990), p.42.
25 Anon. (Anglo-New-Zealander), 'The Wellington Museum N.Z.', *The Colonies* (26 June 1875), p.199.
26 A view of this 'store-house' was published in the *Illustrated London News* (2 October 1886), p.365.
27 Anon. (Anglo-New-Zealander), 'The Wellington Museum N.Z.', *The Colonies* (26 June 1875), p.199. The sentiment is echoed in the *Illustrated London News* (2 October 1886), p.364.
28 *The Art Journal Illustrated Catalogue of the International Exhibition 1862*, p.226.
29 Marleau (1984), p.73.
30 J. Joners, 'Dowling, Robert Hawker', *Encyclopedia of Australian Art* (new ed 1994).
31 These portraits were based on earlier drawings of Tasmanian Aborigines made by Thomas Bock. See Smith (1971), pp.56–8.
32 Anon. 'The Canadian Court', *The Crystal Palace and its Contents, being an Illustrated Cyclopedia of the Great Exhibition of the Industry of all Nations, 1851* (11 October 1851), no.2, p.22.
33 Northcote-Bade (1971), p.63 and ch.4.
34 Cited in *The Colonies* (2 September 1876), p.231. The cabinet-maker was Mr W. Lesar.
35 Northcote-Bade (1971), p.142.
36 Hunt (1862), vol.2, p.320.
37 Cited in Hawkins (1990), pp.276–7.
38 See the influential histories, Smith (1971) and Reid (1973).
39 Reid (1973), pp.70–72.
40 Smith (1971). Bernard Smith calls the period 1851–5 'Late Colonial' and the period 1885–1914 'Genesis'. Clearly this implies that a distinctive Australian art was born during this period.
41 Briggs (1968), ch.7.
42 Reid (1973), pp.106–7.
43 Smith (1971), p.88.
44 *Catalogue of the Oil Paintings and Water-colour Drawings of the Victorian Court, Australian Section, Colonial and Indian Exhibition, 1886.*
45 Stevenson (1886), p.517.

BIBLIOGRAPHY

Acton, W. Functions and Disorders of the Reproductive Organs (1857)

Alabaster, C. Catalogue of Chinese Objects in the South Kensington Museum (1872)

Alcock, Rutherford. The Capital of the Tycoon: A Narrative of a Three Years' Residence in Japan (1863)

Alcock, Rutherford. Art and Industries in Japan (1878)

Alford, B.W.E. 'Business Enterprise and the Growth of the Commercial Letterpress Printing Industry, 1850–1914', Business History, vol.7, no.1 (January 1965), p.1

Allen, David Elliston. The Victorian Fern Craze (1969)

Allen, David Elliston. The Naturalist in Britain: A Social History (1976)

Allen, David Elliston. The Botanists: A History of the Botanical Society of the British Isles through 150 Years (1986)

Allen, David Elliston. The Naturalist in Britain (1994)

Allwood, John. The Great Exhibitions (1977)

Allwood, Rosemary. George Elgar Hicks: Painter of Victorian Life (1982)

Altick, Richard D. The Shows of London (1978)

Ames, Frank. The Kashmir Shawl (1986)

Ames, W. Prince Albert and Victorian Taste (1967)

Anderson, Patricia. The Printed Image and the Transformation of Popular Culture 1790–1860 (1991)

Anstruther, Ian. Coventry Patmore's Angel (1992)

Arengo-Jones, Peter. Queen Victoria in Switzerland (1995)

Armstrong, Alan. Farmworkers (1988)

Arnold-Forster, H.O. The Queen's Empire: A Pictorial and Descriptive Record (1897)

Art Journal Illustrated Catalogue of the International Exhibition 1862 (1862)

Arthur, E., and T. Ritchie. Iron: Cast and Wrought Iron in Canada from the Seventeenth Century to the Present (1982)

Ata-Ullah, Naazish. 'Stylistic Hybridity and Colonial Art and Design Education: A Wooden Carved Screen by Ram Singh', in Barringer and Flynn, eds, Colonialism and the Object (1988), pp.68–81

Atterbury, Paul, and Marian Batkin. The Parian Phenomenon: A Survey of Victorian Parian Porcelain Statuary and Busts (1989)

Auerbach, J.A. The Great Exhibition of 1851: A Nation on Display (1999)

Bailey, Peter, ed. Music Hall: The Business of Pleasure (1986)

Ballhatchet, K. Race, Sex and Class under the Raj (1980)

Banks, J.A. Prosperity and Parenthood (1993)

Barringer, Tim. 'Fabricating Africa: Livingstone and the Visual Image, 1850–1874', in MacKenzie (1996), pp.171–97

Barringer, Tim. 'The South Kensington Museum and the Colonial Project', in Barringer and Flynn, eds. Colonialism and the Object: Empire, Material Culture and the Museum (1988), pp.11–27

Bartram, Michael. The Pre-Raphaelite Camera: Aspects of Victorian Photography (1989)

Bayly, C. Atlas of the British Empire (1989)

Bayly, C., ed. The Raj: India and the British, 1600–1947 (1990)

Bayly, Stephen. The Albert Memorial: The Monument in its Social and Architectural Context (1981)

Beato, Felix. Photographic Views of Japan (1868)

Beeton, Isabella, ed. Beeton's Book of Household Management (1861)

Beeton's Housewife's Treasury of Domestic Information (1880)

Benson, A.C., and Viscount Esher, eds. The Letters of Queen Victoria: A Selection from Her Majesty's Correspondence Between the Years 1873 and 1861, 3 vols (1907)

Benson, E.F. As We Were (1930)

Benson, John. The Working Class in Britain, 1850–1939 (1989)

Bird, Isabella. Unbeaten Tracks in Japan: An Account of Travels in the Interior including Visits to the Aborigines of Yezo and the Shrine of Nikkō (1880)

Birdwood, G.C.M. The Industrial Arts of India (1880), pp.131–2

Birkett, Dea. Mary Kingsley (1992)

Bishop, Mrs J.F. [Isabella L. Bird], The Yangtze Valley and Beyond: an Account of Journeys in China chiefly in the Province of Sze Chuan and among the Man-tze of the Somo Territory (1899)

Bland, Lucy. Banishing the Beast (1995)

Bolt, Christine. Victorian Attitudes to Race (1971)

Bourne, Samuel. 'Photography in the East', British Journal of Photography, no.10 (1863)

Bowley, Robert. The Exhibition of 1862… (1862)

Briggs, Asa. Victorian People (1965)

Briggs, Asa. Victorian Cities (1968)

Briggs, Asa. Victorian Things (1988)

Brockway, Lucille H. Science and Colonial Expansion: The Role of the British Royal Botanical Gardens (1979)

Brooks, Chris, and Andrew Saint, eds. The Victorian Church: Architecture and Society (1995)

Brown, Kenneth D. The British Toy Business: A History Since 1700 (1996)

Buchan, William. Domestic Medicine, or a treatise on the prevention and cure of diseases by regimen and simple medicines (new ed. 1848)

Buckle, George Earle, ed. The Letters of Queen Victoria: A Selection From Her Majesty's Correspondence Between the Years 1862 and 1885, 3 vols (1926–8)

Buckle, George Earle, ed. The Letters of Queen Victoria: A Selection From Her Majesty's Correspondence Between the Years 1886 and 1901, 3 vols (1930–2)

Burne-Jones, Georgiana. Memorials of Edward Burne-Jones, (1904; new ed. 1993)

Bynum, W.E. Science and the Practice of Medicine in the Nineteenth Century (1994)

Campbell, Louise. 'Decoration, Display, Disguise: Leighton House Reconsidered', in Barringer, Tim, and Elizabeth Prettejohn, eds, Frederic Leighton: Antiquity, Renaissance, Modernity (1999), pp.257–94

Campbell, Louise. 'The Design of Leighton House: The Artist's "Palace of Art"', Apollo (February 1996), pp.10–16

Carlyle, A.C., ed. New Letters of Thomas Carlyle, 2 vols (1904)

Carter, Tom. The Victorian Garden (1984)

Castle, Kathryn. Britannia's Children (1996)

Catalogue of the Articles of Ornamental Art Selected from the Great Exhibition of the Industry of All Nations in 1851 and Purchased by the Government (1852)

Catalogue of the Oil Paintings and Water-colour Drawings of the Victorian Court, Australian Section, Colonial and Indian Exhibition, 1886 (1886)

Caw, James L. Sir James Guthrie (1932)

Chadwick, George F. The Works of Sir Joseph Paxton, 1803–1865 (1961)

Chadwick, William Owen. The Victorian Church (1966)

Chaudhury, Nupur, and Margaret Strobel, eds. Western Women and Imperialism (1992)

Cheang, Sarah. 'The Dogs of Fo: The Blanc de Chine Lion Collection of Lady Ellen Thomas-Stanford.' MA thesis (University of Sussex 1999)

Checkland, Olive. Britain's Encounter with Meiji Japan, 1868–1912 (1989)

Chrimes, Mike. Civil Engineering 1839-1889: A Photographic History (1991)

Clifford, James. 'On Orientalism', in The Predicament of Culture (1988)

Clunas, Craig. 'Oriental Antiquities/Far Eastern Art', Positions: East Asia Cultures Critique, vol.2, no.2 (1994)

Cobbing, Andrew. The Japanese Discovery of Victorian Britain: Early Travel Encounters in the Far West (1998)

Cohen, Paul. History in Three Keys: The Boxers as Event, Experience and Myth (1997)

Collins, Philip. Dickens and Education (1965)

Condit, Carl W. American Building Art: The Nineteenth Century (1993)

Cook, E.T., and Alexander Wedderburn. The Works of John Ruskin, 39 vols (1907)

Coombes, Annie E. Reinventing Africa: Museums, Material Culture and Popular Imagination in Late Victorian and Edwardian England (1994)

Cortazzi, Hugh, ed. Mitford's Japan: The Memoirs and Recollections, 1866–1906, of Algernon Bertram Mitford, the First Lord Redesdale (1985)

Cortazzi, Hugh, ed. A British Artist in Meiji Japan: Sir Alfred East (1991)

Cortazzi, Hugh, and George Webb, eds. Kipling's Japan: Collected Writings (1988)

Cortazzi, Hugh, and Gordon Daniels, eds. Japan and Britain 1859–1991: Themes and Personalities (1991)

Coveney, Peter. The Image of the Child (1967)

Crinson, Mark. Empire Building: Orientalism and Victorian Architecture (1996)

Cromer, Earl of. Modern Egypt, 2 vols (1908)

Cunningham, Hugh. Children and Childhood in Western Society Since 1500 (1995)

Darby, E. 'John Gibson, Queen Victoria, and the Idea of Sculptural Polychromy', Art History, vol.4, no.1 (March 1981), pp.37–52

Davidoff, L., and C. Hall. Family Fortunes: Men and Women of the English Middle Class, 1780–1850 (1987)

Davies, Andrew. Leisure, Gender and Poverty (1992)

Davin, Anna. Growing up Poor (1996)

Dawson, Raymond. The Chinese Chameleon: An Analysis of European Conceptions of Chinese Civilization (1967)

D'Cruze, S. Crimes of Outrage: Sex, Violence and Victorian Working Women (1998)

Dehejia, Vidya, with an essay by Allen Staley. Impossible Picturesqueness: Edward Lear's Indian Watercolours, 1873–1875 (1989)

Desmond, Adrian, and James Moore. Darwin (1991)

Desmond, Ray. The India Museum (1975)

Diamond, Alan, ed. The Victorian Achievement of Sir Henry Maine: A Centennial Reappraisal (1991)

Dickens, Charles. Hard Times (1854; Penguin ed. 1994)

Dickens, Charles. Our Mutual Friend (1864–5; Oxford ed. 1998)

Diestelkamp, Edward J. 'Richard Turner and the Palm House at Kew', Transactions of the Newcomen Society, vol.54 (1982–3), pp.1–26

Dixon, Roger, and Stefan Muthesius. Victorian Architecture (1978)

Dolin, T. Mistress of the House (1997)

Doughty, Robin W. Feather Fashions and Bird Preservation: A Study in Nature Protection (1975)

Downes, Charles, and Charles Cowper. The Buildings Erected in Hyde Park for the Great Exhibition of the Works of Industry of All Nations (1852)

Doyle, Richard. A Journal Kept . . . in the Year 1840, introduction by J. Hungerford Pollen (1885)

Drayton, Richard. 'Imperial Science and a Scientific Empire: Kew Gardens and the Uses of Nature, 1772-1903'. Diss (Yale University 1993)

Dresser, Christopher. Principles of Decorative Design (1873)

Dresser, Christopher. 'The Art Manufacturers of Japan, from Personal Observations', Society of Arts Journal (1 February 1878)

Dresser, Christopher. Japan: Its Architecture, Art and Art Manufacturers (1882)

Driver, Felix, and David Gilbert, eds. Imperial Cities (1999)

Dunae, Patrick. Gentlemen Emigrants (1981)

Dunstan, D., ed. Victorian Icon, The Royal Exhibition Building, Melbourne (1996)

Dyos, H.J. 'The Speculative Builders and Developers of Victorian London', Victorian Studies, vol.11 (1968), p.660

Dyson, Anthony. Pictures to Print: The Nineteenth-century Engraving Trade (1984)

[Eastlake, Lady Elizabeth]. 'Review of Addresses delivered on different Public Occasions by H.R.H. The Prince Albert and Prince Albert's Speeches' (1857), Quarterly Review, vol.3 (January–April 1862)

Edis, Robert. Decoration and Furniture of Town Houses (1881)

Edney, Matthew H. Mapping an Empire: The Geographical Construction of British India, 1765-1843 (1997)

Edwards, John. London Zoo from Old Photographs, 1852–1914 (1996)

Egerton, George [Mary Chavelita Dunne]. 'Virgin Soil', in Discords (1894)

Elliott, Brent. Victorian Gardens (1986)

Elliott, Cecil D. Technics and Architecture: The Development of Materials and Systems for Building (1992)

Engels, Friedrich. Condition of the Working Class in England (1846; Oxford ed. 1999)

Evans, Eric J. The Forging of the Modern Nation State: Early Industrial Britain, 1783–1870 (1983)

Fabb, John. Victoria's Golden Jubilee (1987)

Fabian, R., and H. Adam. Masters of Early Travel Photography (1983)

Fairbairn, William. On the Application of Cast and Wrought Iron to Building Purposes (1854; 2nd ed. 1857–8)

Fairbank, John King, Katherine Frost Bruner and Elizabeth MacLeod Matheson, eds. The I.G. in Peking: Letters of Robert Hart, Chinese Maritime Customs (1975)

Faulkner, Rupert, and Anna Jackson. 'The Meiji Period in South Kensington: The Representation of Japan in the Victoria and Albert Museum, 1852–1912', in Impey and Fairley (1995), vol.1, pp.152–95

Fildes, Valerie. Wet Nursing: A History from Antiquity to the Present (1988)

Findling, J.E., and K.D. Pelle. Historical Dictionary of World's Fairs and Expositions, 1851–1988 (1990)

Forbes Watson, J. The Imperial Museum for India and the Colonies (1876)

Fortune, Robert. A Residence Among the Chinese: Inland, on the Coast, and at Sea (1857)

Fortune, Robert. Three Years' Wanderings in The Northern Provinces of China, including a Visit to the Tea, Silk and Cotton Countries (1847)

Fortune, Robert. Yedo and Peking: A Narrative of a Journey to the Capitals of Japan and Peking (1863)

Foucault, Michel. Histoire de la sexualité (1976; 1979)

Fraser, W.H. The Coming of the Mass Market, 1850–1914 (1981)

Fraser, W.H., and Irene Maver, eds. Glasgow: 1830–1912, vol.2 (1996)

Freeman, Sarah. Isabella and Sam (1977)

Frith, William Powell. My Autobiography and Reminiscences, 3 vols (1887–8)

Fulford, Roger. The Prince Consort (1949)

Fulford, Roger, ed. Your Dear Letter (1865–71) (1971)

Galassi, Peter. Before Photography: Painting and the Invention of Photography (1981)

Galbally, A. 'Sculpture and Casts', The First Collections, The Public Library and the National Gallery of Victoria in the 1850s and the 1860s (1992)

Gaskell, Elizabeth. North and South (1854–5; 1994)

Gathorne-Hardy, Jonathan. The Rise and Fall of the British Nanny (1972)

Gathorne-Hardy, Jonathan. The Public School Phenomenon, 1597–1977 (1977)

Gauldie, Enid. Cruel Habitations, 1780–1918 (1974)

Gay, Peter. The Bourgeois Experience, 2 vols (1984–6)

Gernsheim, Helmut, and Alison Gernsheim. The History of Photography (1955), p.174

Gernsheim, Helmut, and Alison Gernsheim. Queen Victoria: A Biography in Words and Pictures (1958)

Gibbs-Smith, C.H. The Great Exhibition of 1851 (1964)

Girouard, M. The Victorian Country House (1979)

Gissing, A.C. William Holman Hunt: A Biography (1936)

Golby, J., and W. Purdue. The Making of the Modern Christmas (1986)

Gooderson, P. Lord Linoleum (1996)

Goodrich, L. Carrington, and Nigel Cameron. The Face of China as Seen by Photographers and Travelers (1978)

Gosse, Edmund. Father and Son: A Study of Two Temperaments (1907; Penguin 1983)

Gourvish, T.R. and Alan O'Day, eds. Later Victorian Britain (1988)

Gray, R.Q. The Factory Question and Industrial England (1996)

Greenhalgh, Paul. Ephemeral Vistas: The Expositions Universelles, Great Exhibitions and World Fairs, 1851–1839 (1988)

Greenhalgh, Paul. 'Education, Entertainment and Politics: Lessons from the Great International Exhibitions', in Peter Vergo ed. The New Museology (1989)

Greenwood, Thomas. Museums and Art Galleries (1888)

Günther, Albert. *The History of the Collections Contained in the Natural History Departments of the British Museum, II: Appendix. General History of the Department of Zoology from 1856 to 1895* (1912)

Halen, Widar. *Christopher Dresser* (1990)

Hamilton, Lord Frederic. *The Days Before Yesterday* (1920)

Hammerton, A. James. *Emigrant Gentlewomen* (1979)

Harcourt, Freda. 'Disraeli's Imperialism: A Question of Timing, 1866–68', *Historical Journal*, vol.23 (1980), pp.87–109

Hardy, Thomas. *Tess of the d'Urbervilles* (1891; Penguin ed. 1986)

Hardyment, C. *From Mangle to Microwave* (1988)

Hardyment, C. *Home Comfort: A History of Domestic Arrangements* (1992)

Harper, Marjory. 'British Migration and the Peopling of the Empire', in Porter (1999), pp.75–87

Harrison, A.H. ed. *The Letters of Christina Rossetti* (1998)

Harrison, Jane. *Heresy and Humanity* (1911)

Hart, Robert. *These From the Land Of Sinim: Essays on the Chinese Question* (1901)

Hartmann, Mary S. *Victorian Murderesses* (1977)

Harvey, Charles, and Jon Press. *William Morris: Design and Enterprise in Victorian England* (1991)

Hassan, John A. *A History of Water in Modern England and Wales* (1998)

Hawkins, J. B. *Nineteenth-Century Australian Silver* (1990)

Head, Raymond. 'Bagshot Park and Indian Crafts', Sarah Macready and F.H. Thompson, eds., *Influences in Victorian Art and Architecture* (1985), p.140

Head, Raymond. *The Indian Style* (1986)

Hearn, Lafcadio. *Glimpses of Unfamiliar Japan* (1894)

Helly, Dorothy O., and Helen Callaway. 'Journalism as Active Politics: Flora Shaw, *The Times* and South Africa', in Donal Lowry, ed. *The South African War Reappraised* (2000), pp.50–66

Helps, Sir Arthur, ed. *The Principal Speeches and Addresses of HRH The Prince Consort* (1862)

Herbert, Gilbert. *Pioneers of Prefabrication: The British Contribution in the Nineteenth Century* (1978)

Herchkowitz, Robert. *The British Photographer Abroad: The First Thirty Years* (1980)

Hevia, James L. 'Loots Fate: The Economy of Plunder and the Moral Life of Objects "From The Summer Palace of the Emperor of China"', *History and Anthropology*, vol.6, no.4 (1994), pp.319–45

Hewison, Robert, Ian Warrell and Stephen Wildman, eds. *Ruskin, Turner and the Pre-Raphaelites* (2000)

Heyert, Elizabeth. *The Glass-House Years, Victorian Portrait Photography, 1839–1870* (1979)

Hibbert, Christopher, ed. *Queen Victoria in her Letters and Journals* (1984)

Hichberger, J.W.M. *Images of the Army: the Military in British Art, 1815–1914* (1988)

Hoare, J.E. *Embassies in the East: The Story of the British Embassies in Japan, China and Korea* (1999)

Hoare, J.E., ed. *Britain and Japan: Biographical Portraits*, vol.3 (1999)

Hobhouse, Hermione. *Prince Albert: His Life and Work* (1983)

Hobsbawm, Eric. 'Introduction: Inventing Traditions', E. Hobsbawm and T. Ranger, eds., *The Invention of Tradition* (1983), pp.1–14

Hollis, Patricia. 'Women in Council: Separate Spheres, Public Space', in Jane Rendell, ed. *Equal or Different: Women's Politics 1880–1914* (1987)

Hollister, Paul. 'The Glazing of the Crystal Palace', *Journal of Glass Studies*, vol.16 (1974)

Homans, Margaret, and Adrienne Munich, eds. *Remaking Queen Victoria* (1997)

Honey, J.R. de S. *Tom Brown's Universe* (1977)

Hooker, W.J. *Kew Gardens, or A Popular Guide to the Royal Botanic Gardens of Kew* (1858)

Hopkins, Eric. *Childhood Transformed: Working-Class Children in Nineteenth-Century England* (1994)

Horn, Pamela. *The Victorian and Edwardian School Child* (1989)

Horn, Pamela. *The Rise and Fall of the Victorian Servant* (1995)

Hosgood, C. 'Mrs Pooter's Purchase: Lower-Middle-Class Consumerism and the Sales, 1870–1914', in A. Kidd and D. Nicholls, eds, *Gender, Civic Culture and Consumerism* (1999), pp.146–63

Hubbard, R.H. *The National Gallery of Canada, Catalogue of Paintings and Sculpture: Modern and European Schools*, vol.2 (1959)

Huggins, Mike. *Flat Racing and British Society, 1750–1914* (2000)

Huish, Marcus. *Japan and its Art* (London 1889)

Humphries, S. *Victorian Britain Through the Magic Lantern* (1989)

Hunt, Dr R. *Handbook to the Industrial Department of the International Exhibition 1862*, vol.2 (1862)

Hunt, John Dixon. *The Wider Sea: A Portrait of John Ruskin* (1982)

Illustrated Catalogue of the Chinese Collection of Exhibits (1884)

Illustrated Paris Universal Exhibition (1878)

Impey, Oliver, and Malcolm Fairley, eds. *Meiji no Takara: Treasures of Imperial Japan, the Nassar D. Khalili Collection of Japanese Art*, 5 vols (1995)

Irwin, John. *Shawls: A Study in Indo-European Taste* (1955); revised as *The Kashmir Shawl* (1973)

Ivins, William M. 'Photography and the Modern Point of View', *Metropolitan Museum I* (1928)

Jackson, Alastair A. 'The Development of Steel Framed Buildings in Britain 1880–1905', *Construction History*, vol.14 (1998), pp.21–40

Jackson, Anna. 'Imagining Japan: The Victorian Perception and Acquisition of Japanese Culture', *Journal of Design History*, vol.5, no.4 (1992), pp.245–56

Jackson, M. *The Pictorial Press: Its Origin and Progress* (1885)

Jacobs, Arthur. *Arthur Sullivan, a Victorian Musician* (1986)

Jagow, Dr Kurt, ed. *Letters of the Prince Consort 1831–1861* (1938)

Jalland, Pat. *Women, Marriage and Politics, 1860–1914* (1986)

James, Robert Rhodes. *Albert, Prince Consort* (1983)

Jeal, Tim. *David Livingstone* (1973)

Jerrold, Blanche. *Life of Gustave Doré* (1891)

Jespersen, J.K. 'Owen Jones's The Grammar of Ornament of 1856…' PhD thesis (Brown University 1984)

Jones, S. *Early Painters of Australia 1788-1880* (1988), p.7

Jones, Owen. *The Grammar of Ornament: Illustrated by Examples from Various Styles of Ornament* (1910)

Judd, Denis. *Empire* (1996)

Kalman, H. *A History of Canadian Architecture*, vol.2 (1994), p.613

Kamm, Josephine. *Hope Deferred: Girls' Education in English History* (1965)

Kaye, Barrington. *The Development of the Architectural Profession in Britain* (1960)

Kevill-Davies, Sally. *Yesterday's Children: The Antiques and History of Childcare* (1991)

Kiernan, V.G. *The Lords of Human Kind: European Attitudes Towards the Outside World in the Imperial Age* (1969)

Kinchin, Perilla and Juliet Kinchin. *Glasgow's Great Exhibitions* (1988)

Kingsley, Mary. *Travels in West Africa* (1897)

Kingsley, Mary. *West African Studies* (1899)

Kirker, A., and P. Tomory. *British Painting 1800–1990 in Australian and New Zealand Public Collections* (1997)

Knight, Frances. *The Nineteenth Century Church and English Society* (1995)

Ko, Dorothy. 'Bondage in Time: Footbinding and Fashion Theory', *Fashion Theory*, vol.1, no.1 (1997), pp.3–28

Krauss, Rolf. *Between Light and Shadow: The Role of Photography in Certain Paranormal Phenomena: An Historical Survey* (1995)

Lane, T., and J. Serle. *Australians at Home: A Documentary History of Australian Domestic Interiors from 1788 to 1914* (1990)

Langdon, William B. *Ten Thousand Chinese Things Relating to China and the Chinese* (1843)

Lehmann, Jean-Pierre. *The Roots of Modern Japan* (1982)

Leighton, John. 'On Japanese Art', *Journal of Society of Arts* (24 July 1863)

Liberty, Arthur Lasenby. 'A lecture on the "Art Productions of Japan" delivered by Mr Lasenby Liberty, June 1, in the building of the Bijitsu Kiokai, at Sakuragaoka, Uyeno, Tokio', *Journal of the Society of Arts*, vol.37 (12 July 1889), pp.694–7

Light, C., and R. Light. *Designs and Catalogue of Cabinet and Upholstery Furniture* (1880)

Little, Mrs Archibald. *Intimate China: the Chinese as I have seen them* (1899)

Littlewood, Ian. *The Idea of Japan: Western Images, Western Myths* (1996)

Livingstone, David, and Charles Livingstone. *Narrative of an Expedition to the Zambesi and its Tributaries and of the Discovery of the Lakes Shirwa and Nyassa, 1858–1864* (1865)

Livingstone, David N. *The Geographical Tradition: Episodes in the History of a Contested Tradition* (1992)

Llewellyn, Briony. 'Roberts's Pictures of the Near East' in Helen Guiterman, and Briony Llewellyn, eds. *David Roberts* (1986)

Loftie, W. J. 'Art in Australia', *The Magazine of Art* (1886), p.174

Longford, Elizabeth. *Victoria RI* (1964)

Lorimer, Douglas A. *Colour, Class and the Victorians* (1978)

Lovelace, Antonia. *Art for Industry: The Glasgow Japan Exchange of 1878* (1991)

Lowe, Charles. *Four National Exhibitions in London* (1892)

Lowerson, John. *Sport and the English Middle Classes, 1870–1914* (1993)

Lubbock, Jules. *The Tyranny of Taste: The Politics of Architecture and Design in Britain, 1550–1960* (1995)

Luckhurst, Kenneth. *The Story of Exhibitions* (1951)

Lummis, Trevor, and Jan Marsh. *The Woman's Domain: Women and the English Country House* (1990)

MacCarthy, F. *William Morris: A Life for Our Time* (1994)

MacKenzie, John M., ed. *Propaganda and Empire* (1984)

MacKenzie, John M., ed. *Imperialism and Popular Culture* (1986)

MacKenzie, John M. *The Empire of Nature: Hunting, Conservation and British Imperialism* (1988)

MacKenzie, John M. *Popular Imperialism and the Military* (1992)

MacKenzie, John M. *Orientalism: History, Theory and the Arts* (1995)

MacKenzie, John M. 'The Provincial Geographical Societies in Britain, 1884–1914' in Morag Bell, Robin Butlin, and Michael Heffernan, *Geography and Imperialism, 1820–1940* (1995)

MacKenzie, John M., ed. *David Livingstone and the Victorian Encounter with Africa* (1996)

MacKenzie, John M. '"The Second City of the Empire": Glasgow, Imperial Municipality' in Felix Driver and David Gilbert eds. *Imperial Cities* (1999;a)

MacKenzie, John M. 'India's Role in the Victorian Concept of Empire', in Franz Bosbach and Hiermann Hiery eds., *Imperium/Empire/Reich* (1999;b)

Macleod, Dianne Sachko. 'Art Collecting and Middle Class Taste', *Art History*, vol.10, no.3 (September 1987)

MacMillan, Margaret. *Women of the Raj* (1988)

Malcolmson, R.W. *Popular Recreations in English Society* (1973)

Marcus, Steven. *The Other Victorians: A Study of Sexuality and Pornography in Mid-Nineteenth Century England* (1966)

Marleau, M. *The Painted Past: Selected Paintings from the Picture Division of the Public Archives of Canada* (1984), p.73

Marshall, Dorothy. *The Life and Times of Queen Victoria* (1972)

Martin, Theodore. *The Life of HRH the Prince Consort*, 5 vols (1875–80)

Mason, Michael. *The Making of Victorian Sexuality*, 2 vols (1995)

Matthew, H.C.G. *The Liberal Imperialists* (1973)

Matthews, T. *Biography of John Gibson RA: Sculptor, Rome* (1911)

Mayall, D. *Gypsy-Travellers in Nineteenth-Century Society* (1988)

McBurney, Henrietta. 'Prince Albert and the Royal Collection', *Antique Collector* (1983), pp.57–61

McKay, Alexander. *Thomas Blake Glover: Scottish Samurai* (1993)

McKean, John. *Crystal Palace: Joseph Paxton and Charles Fox* (1994)

McKendrick, Neil, John Brewer and R.H. Plumb. *The Birth of a Consumer Society: The Commercialization of Eighteenth Century England* (1982)

McKenzie, Peter. *W.G. Armstrong* (1983)

Meeks, Carroll L.V. *The Railroad Station* (1956)

Menpes, Mortimer. *Japan: A Record in Colour* (1901)

Metcalf, Thomas R. *An Imperial Vision: Indian Architecture and Britain's Raj* (1989)

Mill, J.S. *The Subjection of Women* (1867)

Millar, Delia. *Watercolours by Charlotte, Viscountess Canning, Lady-in-Waiting to Queen Victoria* (1996)

Millar, Oliver. *The Victorian Pictures in the Collection of Her Majesty the Queen* (1992)

Minson, M. *Encounter with Eden, New Zealand 1770-1870: Paintings and Drawings from the Rex Nan Kivell Collection* (1990)

Mitford, Algernon. *Tales of Old Japan* (1871)

Mitford, Algernon. *The Attaché in Peking* (1893)

Mitford, Algernon. *Memories* (1915)

Mitter, Partha. *Much Maligned Monsters: History of European Reactions to Indian Art* (1977)

Mitter, Partha. 'The Imperial Collections: Indian Art', Richardson, Brenda, and Malcolm Baker, eds., *A Grand Design: The Art of the Victoria and Albert Museum* (1998)

Moore, James R., ed. *Religion in Victorian Britain III: Sources* (1988)

Morris, Jan. *The Spectacle of Empire* (1982)

Morris, William. 'How we Live and How we Might Live', *William Morris by Himself* (1887)

Mosely, S. 'The Chimney of the World…' PhD thesis (Lancaster University 1998)

Munich, Adrienne. *Queen Victoria's Secrets* (1966)

Murfin, Lyn. *Popular Leisure in the Lake Counties* (1990)

Murphy, Veronica. 'Kashmir Shawls', in *Kashmir Shawls: Woven Art and Cultural Document* (1988)

Musgrave, Toby, Chris Gardner and Will Musgrave. *The Plant Hunters: Two Hundred Years of Adventure and Discovery Around the World* (1998)

Muthesius, Hermann. *The English House* (1904–5; 1979)

Muthesius, S. *The English Terraced House* (1982)

National Memorial to His Royal Highness the Prince Consort (1873)

Naylor, Gillian. *William Morris by Himself: Designs and Writings* (1988)

Neale, R.S. *Writing Marxist History* (1981)

Nemiroff, D. 'Modernism, Nationalism and Beyond: A Critical History of Exhibitions of First Nations Art', *Thinking about Exhibitions* (1996)

Nicholls, Robert. *The Belle Vue Story* (1992)

Nish, Ian, ed. *Britain and Japan: Biographical Portraits*, vol.1 (1994)

Nish, Ian, ed. *Britain and Japan: Biographical Portraits*, vol.2 (1997)

Noakes, Vivien. *Edward Lear, 1812-1888* (1985)

Northcote-Bade, S. *Colonial Furniture in New Zealand* (1971)

Nunn, Pamela Gerrish. 'Broken Blossoms', in *Problem Pictures: Women and Men in Victorian Painting* (1995), pp.73–93

Official Catalogue of the British Section, Sydney International Exhibition, 1879 (1879)

Official Record, Melbourne International Exhibition 1880–1881 (1882)

Oldroyd, David R. *The Highlands Controversy: Constructing Geological Knowledge through Fieldwork in Nineteenth-Century Britain* (1990)

Oliphant, Laurence. *Narrative of the Earl of Elgin's Mission to China and Japan in 1857, 1858, 1859* (1860)

Omissi, David. *The Sepoy and the Raj, 1860–1940* (1994)

Omissi, Dominic. 'The Mills and Boon Memsahibs'. PhD thesis (Lancaster University 1995)

Oppenheim, Janet. *The Other World* (1985)

Ormond, Richard. *Sir Edwin Landseer* (1981)

Ormond, Richard, and Leonée Ormond. *Lord Leighton* (1999), pp.95–101

Orr, W. *Deer Forests, Landlords and Crofters* (1982)

Pagani, Catherine. 'Chinese Material Culture and British Perceptions of China in the Mid Nineteenth Century', in T.J. Barringer, and Tom Flynn, eds. *Colonialism and the Object: Empire, Material Culture and the Museum* (1998)

Parry, Linda. *William Morris* (1996)

Pater, Walter. *Studies in the History of the Renaissance* (1873; new ed 1935)

Pearce, Nick. 'Photographs of Beijing in the Oriental Museum, Durham', *Apollo*, vol.147, no.433 (March 1998), pp.33–9

Pearce, Robert D. *Mary Kingsley* (1990)

Pearsall, Ronald. *The Worm in the Bud: the World of Victorian Sexuality* (1969)

Peel, C.V.A. *The Zoological Gardens of Europe: Their History and Chief Features* (1903)

Perkin, Joan. *Women and Marriage in Nineteenth-Century England* (1989)

Peters, Tom F. *Building the Nineteenth Century* (1996)

Pevsner, Nikolaus. *A History of Building Types* (1976)

Phillips, Tom, ed. *Africa: The Art of a Continent* (1995), pp.396–7

Physick, John. *The Victoria and Albert Museum* (1982)

Pinchbeck, Ivy, and Margaret Hewitt. *Children in English Society*, 2 vols (1969–73)

Pointon, Marcia. *William Dyce, 1806–1864* (1979)

Pollen, Anne. *John Hungerford Pollen* (1912)

Ponsonby, Sir Frederick. *Recollections of Three Reigns* (1951)

Porter, A.N., ed. *Atlas of British Overseas Expansion* (1991)

Porter, Andrew, ed. *The Oxford History of the British Empire:The Nineteenth Century*, vol.3 (1999)

Porter, Roy, and Lesley Hall. *The Facts of Life: the Creation of Sexual Knowledge in Britain 1650–1950* (1995)

Price, [William] Lake, *A Manual of Photographic Manipulation, treating of the practice of the art; and its various applications to Nature* (1868; 1973)

Prochaska, F.K. *The Voluntary Impulse: Philanthropy in Modern Britain* (1988)

Proudhon, P.J. *La Pornocratie, ou les Femmes dans les Temps Modernes* (1858)

Rae-Ellis, V. 'The Representation of Trucanini', in E. Edwards, ed., *Anthropology and Photography, 1860–1920* (1992), pp.230–33

Rapley, John. *The Britannia Bridge, 1945–1850* (1999)

Read, Benedict. *Victorian Sculpture* (1982)

Rees, William. *Cardiff: A History of the City* (1969)

Reeves, M. Pember. *Round About a Pound a Week* (1979)

Reid, D. *A Concise History of Canadian Painting* (1973)

Renton, Alice. *Tyrant or Victim? A History of the British Governess* (1991)

Richards, Thomas. *The Commodity Culture of Victorian Britain* (1991)

Richardson, Joanna. *Gustave Doré: A Biography* (1980)

Ritvo, Harriet. *The Animal Estate: The English and Other Creatures in the Victorian Age* (1987)

Ritvo, Harriet. *The Platypus and the Mermaid, and Other Figments of the Classifying Imagination* (1997)

Roberts, Robert. *The Classic Slum* (1971)

Robertson, David. *Sir Charles Eastlake and the Victorian Art World* (1978)

Ross, Ellen. *Labour and Love* (1993;a)

Ross, Ellen. *Love and Toil* (1993;b)

Rouillé, A. 'Exploring the World by Photography in the Nineteenth Century', eds. A. Rouillé and J. Lemagny, *A History of Photography: Social and Cultural Perspectives* (1987)

Russell, D. *Football and the English* (1997)

Ryan, James R. *Picturing Empire: Photography and the Visualization of the British Empire* (1997)

Said, Edward W. *Orientalism* (1979)

Said, Edward W. *Culture and Imperialism* (1993)

Sandiford, Keith A.P. *Cricket and the Victorians* (1994)

Sato, Tomoko, and Toshio Watanabe, eds. *Japan and Britain: An Aesthetic Dialogue, 1850–1930* (1991)

Saxbee, Helen. 'An Orient Exhibited…' PhD thesis (RCA 1990)

Schildkrout, Enid, and Curtis A. Keim. *The Scramble for Art in Central Africa* (1998)

Schmiechen, James, and Kenneth Cauls. *The British Market Hall: A Social and Architectural History* (1999)

Scott, G.G. *Remarks on Secular and Domestic Architecture* (1858)

Seccombe, W. *Weathering the Storm: Working-Class Families from the Industrial Revolution to the Fertility Decline* (1993)

Secord, Anne. 'Artisan Botany,' eds. N. Jardine, J.A. Secord, and E.C. Spary, *Cultures of Natural History* (1996), pp.378–93

Secord, James A. *Controversy in Victorian Geology: The Cambrian-Silurian Dispute* (1986)

Seiberling, Grace, and Carolyn Bloore. *Amateurs, Photography, and the Mid-Victorian Imagination* (1986)

Shang, Antony. 'The Chinese in London', Nick Merriman, ed., *The Peopling of London: Fifteen Thousand Years of Settlement from Overseas* (1993)

Sheets-Pyenson, Susan. 'War and Peace in Natural History Publishing: The Naturalist's Library, 1833–1843', *Isis*, 72 (1981)

Sigsworth, Eric M., ed. *In Search of Victorian Values: Aspects of Nineteenth-Century Thought and Society* (1988)

Simpson, M.A., and T. Lloyd, eds. *Middle-Class Housing in Britain* (1977)

Sladen, Douglas. *The Japs at Home* (1892)

Smith, B. *Australian Painting, 1788–1970* (1971)

Smith, B. *European Vision and the South Pacific* (1985)

Smith, N. and E. Darby. *The Cult of the Prince Consort* (1983)

Smith, Nicola. 'The Albert Memorial', in Sarah Macready and F.H. Thompson, eds., *Influences in Victorian Art and Architecture* (1985)

Spence, Jonathan. *The China Helpers: Western Advisors in China, 1620–1960* (1969)

Spence, Jonathan. *The Search for Modern China* (1990)

Spence, Jonathan, and Clark Worsick. *Imperial China: Photographs 1850–1912* (1978)

Spiers, M. *Victoria Park* (1975)

Springhall, J.O. *Youth, Empire and Society* (1977)

Stanley, Brian. '"Commerce and Christianity": Providence Theory, the Missionary Movement, and the Imperialism of Free Trade, 1842–1860', *Historical Journal*, vol.26, no.1 (1983), pp.71–94

Stanley, Brian. *The Bible and the Flag* (1990)

Stanley, Eleanor. *Twenty Years at Court* (1916)

Stanley, Liz, ed. *The Diaries of Hannah Cullwick* (1984)

Stannard, W.J. *The Art Exemplar* (limited edition of ten copies: 1859)

Stedman Jones, G. *Outcast London* (1971)

Steinberg, S.H. *Five Hundred Years of Printing* (1955)

Stevenson, R.A.M. 'Art in Canada', *The Magazine of Art* (1886)

Stocking, George W. *Objects and Others* (1985)

Stone, L. *The Family, Sex and Marriage in England, 1500–1800* (1977)

Strachey, Lytton. *Queen Victoria* (1921)

Stratton, Michael. *The Terracotta Revival* (1993)

Stratton, Michael. 'New Materials for a New Age: Steel and Concrete Construction in the North of England, 1860–1939', *Industrial Archaeology Review*, vol.21 (June 1999)

Stuart, David. *The Garden Triumphant: A Victorian Legacy* (1988)

Summerson, John. *The Life and Work of John Nash, Architect* (1980)

Summerson, John. *The London Building World of the 1860s* (1973)

Surtees, Virginia. *Charlotte Canning* (1975)

Sutherland, R.J.M. 'Shipbuilding and the Long-Span Roof', *Transactions of the Newcomen Society*, vol.60 (1988–89) pp.107–26

Swann, C. Kirke. 'Natural History Bookselling',

Journal of the Society for the Bibliography of Natural History, 6 (1972)

Swanwick, Helena. *I Have Been Young* (1935)

Sweet, J. 'Colonial Exhibition Design: The Tasmanian Timber Tower at the London International Exhibition, 1862', *Papers and Proceedings* (Hobart, Tasmanian Historical Research Association), vol.44, no.4 (1977), p.241

Sweetman, John. *The Oriental Obsession* (1988)

Symondson, Anthony, ed. *The Victorian Crisis of Faith* (1970)

Szreter, Simon. 'Victorian Britain 1831–1963: towards a Social History of Sexuality', *Journal of Victorian Culture* (Spring 1996)

Szreter, Simon. *Fertility, class and gender in Britain 1860–1940* (1998)

Talbot, Joanna. *Francis Frith* (1985)

Taylor, Harvey. *A Claim on the Countryside* (1997)

Tebbutt, M. *Women's Talk: A Social History of Gossip in Working-Class Neighbourhoods, 1880–1960* (1995)

Temperley, Nicholas. 'The Lost Chord', *Victorian Studies*, vol.1 (Autumn 1986), p.18

Thiriez, Régine. *Barbarian Lens: Western Photographers of the Qianlong Emperor's European Palaces* (1988)

Thompson, Dorothy. *Queen Victoria, Gender and Power* (1990)

Thompson, E. P. *William Morris: Romantic to Revolutionary* (1977)

Thompson, F.M.L. *The Rise of Respectable Society* (1988)

Thomson, J., and A. Smith. *Street Life in London* (1878)

Thomson, John. *Illustrations of China and Its People: A Series of Two Hundred Photographs with Letterpress Description of the Places and People Represented* (1873)

Thomson, John. 'Photography and Exploration', *Proceedings of the Royal Geographical Society*, n.s. 13 (1891)

Thomson, John. *Through China with a Camera* (1899)

Thorne, Robert, ed. *The Iron Revolution: Architects, Engineers and Structural Innovation 1780–1880* (1990)

Timbs, John. *Curiosities of London* (1855)

Toplis, Ian. *The Foreign Office* (1987)

Tosh, John. *A Man's Place: Masculinity and the Middle-Class Home in Victorian England* (1999)

Trevelyan, G.M. *English Social History* (1944)

Tucker, Jennifer. 'Photography as Witness, Detective, and Imposter: Visual Representation in Victorian Science', in Bernard Lightman, ed., *Victorian Science in Context* (1997), pp.378–408

Turner, R. 'Description of the Iron Roof over the Railway Station, Lime Street, Liverpool', *Minutes of the Proceedings of the Institution of Civil Engineers*, vol.9 (1850), pp.204–14

Twyman, Michael. *Printing, 1770–1970: An Illustrated History of its Development and Uses in England* (1970)

Usherwood, Paul, and Jenny Spencer-Smith. *Lady Butler, Battle Artist, 1846–1933* (1987)

Vamplew, W. *Pay Up and Play the Game: Professional Sport in Britain 1875–1914* (1988)

Veit-Brause, I. 'German-Australian relations at the Time of the Centennial International Exhibition, Melbourne, 1888', *The Australian Journal of Politics and History*, vol.32, no.2 (1986), pp.201–14

Vickers, N. 'The Structure of the Whitby Jet Industry in 1871', in D. Mills and K. Schurer, eds, *Local Communities in the Victorian Census Enumerators' Books* (1996)

Vizetelly, Henry. *Glances Back Through Seventy Years* (1893)

Waagen, G.F. *Treasures of Art in Great Britain*, 3 vols (1854)

Waagen, G.F. *Works of Art and Artists in England* (1838)

Wainwright, Clive. 'Principles True and False: Pugin and the Foundation of the Museum of Manufactures', *Burlington Magazine*, vol.126, no.1095 (June 1994), pp.357–64

Walkowitz, Judith. *City of Dreadful Delight* (1992)

Wallace, Alfred Russel. *The Wonderful Century: Its Successes and Failures* (1898)

Wallis, J.P.R. *Thomas Baines of Kings Lynn: Explorer and Artist 1820–1875* (1941)

Walrond, Theodore, ed. *Letters and Journals of James, Eighth Earl of Elgin* (1872)

Walton, J.K. *The English Seaside Resort: A Social History, 1750–1914* (1983)

Walton, J.K. *Fish and Chips and the British Working Class, 1870–1940* (1992)

Walton, J.K. *Blackpool* (1998)

Walton, J.K. 'Towns and Consumerism', in M. Daunton, ed., *The Cambridge Urban History of Britain*, vol.3 (forthcoming)

Walton, J.K., and A. Wilcox, eds. *Low Life and Moral Improvement in Mid-Victorian England* (1991)

Ward, T.H. *The Reign of Queen Victoria: A Survey of Fifty Years of Progress* (1887)

Waring, J.B. *Masterpieces of the Industrial Art and Sculpture at the International Exhibition 1862* (1863)

Warner, Malcolm, Julia Alexander and Patrick McCaughey. *This Other Eden: Paintings from the Yale Center for British Art* (1998)

Warner, Marina. *The Dragon Empress: Life and Times of T'zu-his, 1835-1908, Empress Dowager of China* (1972)

Warner, Marina. *Queen Victoria's Sketch Book* (1979)

Watanabe, Toshio. *High Victorian Japonisme* (1991)

Waterfield, Giles. *Palaces of Art: Art Galleries in Britain, 1790–1990* (1991)

Weale, John. *Quarterly Papers in Engineering*, pt.5 (1844)

Weeks, Emily M. 'About Face: Sir David Wilkie's Portrait of Mehemet Ali, Pasha of Egypt', in Julie F. Codell and Dianne Sachko Macleod, *Orientalism Transposed: The Impact of Colonies on British Culture* (1998)

Weiler, John. 'Colonial Connections: Royal Engineers and Technology Transfer in the Nineteenth Century', *Construction History*, vol.12 (1996), pp.3–18

Weintraub, Stanley. *Victoria, Biography of a Queen* (1987)

Weintraub, Stanley. *Albert, Uncrowned King* (1997)

West, Shearer, ed. *The Victorians and Race* (1996)

Westhofen, W. *The Forth Bridge* (1890)

Whalley, J.I., and T.R. Chester. *A History of Children's Book Illustration* (1988)

Wharton, Edith, and Ogden Codman. *The Decoration of Houses* (1898)

White, Colin. *The World of the Nursery* (1984)

Whiting, Sydney. *Official Guide to the International Exhibition* (1872)

Wigglesworth, N. *A Social History of English Rowing* (1992)

Wilkinson, Nancy Burch. 'Edward William Godwin and Japonisme in England'. PhD thesis (University of California 1987)

Wilson, John F. *Lighting the Town* (1991)

Winkel, Margarita. *Souvenirs from Japan: Japanese Photography at the Turn of the Century* (1991)

Wohl, A.S. *The Eternal Slum* (1977)

Wohl, A.S., ed. *The Victorian Family* (1978)

Wolff, Michael, and Celina Fox. 'Pictures from the Magazines', in H.J. Dyos and Michael Wolff, eds., *The Victorian City: Images and Realities*, vol.2 (London 1973), pp.559–82

Wolseley, Lieut-Colonel G.J. *Narrative of the War with China in 1860* (1861)

Wood, Frances. *No Dogs and Not Many Chinese: Treaty Port Life in China 1843–1943* (1998)

Woodbury, Walter E. *The Encyclopaedic Dictionary of Photography* (1898)

Woodham-Smith, Cecil. *Queen Victoria: Her Life and Times* (1972)

Woolf, Janet, and John Seeds, eds. *The Culture of Capital: Art, Power and the Nineteenth-Century Middle Class* (1988)

Worswick, C., and A. Embree. *The Last Empire: Photography in British India, 1855–1911* (1977)

Wright, L. *Clean and Decent* (1966)

Wyndham, The Hon. Mrs Hugh, ed. *Correspondence of Sarah Spencer, Lady Lyttelton, 1787–1870* (1912)

Yokoyama, Toshio. *Japan in the Victorian Mind: A Study of Stereotyped Images of a Nation, 1850–1880* (1987)

INDEX

ACKNOWLEDGEMENTS

This book has genuinely been a collaborative exercise, and the editor wishes to thank all the contributors for their many suggestions and active support in all stages of its production. I am also grateful for their forbearance in accepting many editorial amendments.

Special thanks are due to Lord Briggs, the doyen of Victorian scholars, for supplying the foreword. I also gratefully acknowledge the help of Paul Greenhalgh and Linda Lloyd Jones in framing many of the ideas for the content of this book and the exhibition. Jonathan Marsden of the Royal Collections provided courteous and inestimable advice and introductions.

The team at V&A Publications dealt highly professionally with the many complexities of a book of this sort. They included Mary Butler and Miranda Harrison in masterminding the progress of the publication, Vic Poskitt for resolving many editorial issues, Mary Wessel for extensive picture research, Janet James for the design, Geoff Barlow and Clare Davis for dealing with production and Judith Waterman for the index.

Extremely grateful thanks are due to all those private individuals and staff of institutions who have been so generous with their time in supporting the exhibition and in lending objects from their collections. Their help and advice is also represented in this book, for which warm thanks. Finally, Francesca Vanke of the Camberwell College of Arts, Brenda King of UMIST, Anna Jackson of the V&A, and Claire Longworth and Eszter Carpati of the joint V&A/RCA course offered invaluable help in various forms.